708.1471KAN

Alfred H. Barr, Jr.

and the Intellectual Origins of
the Museum of Modern Art

The MIT Press
Cambridge, Massachusetts
London, England

Alfred H. Barr, Jr.

and the Intellectual Origins of
the Museum of Modern Art

Sybil Gordon Kantor

This book was set in Futura by Graphic Composition, Inc., Athens, Georgia, and was printed and bound in the United States of America.

Library of Congress Cataloging-in-Publication Data

Kantor, Sybil Gordon.
 Alfred H. Barr, Jr., and the intellectual origins of the Museum of Modern Art / Sybil Gordon Kantor.
 p. cm.
 Includes index.
 ISBN 0-262-11258-2 (hc. : alk. paper)
 1. Museum of Modern Art (New York, N.Y.)—History. 2. Barr, Alfred Hamilton, 1902–
3. Art museum directors—United States—Biography. I. Title.
N620.M9 K36 2001
708'.147'1—dc21

 2001044034

frontispiece: Jay Leyda, *Alfred H. Barr, Jr.,* New York, 1931–1933. Gelatin silver print, 4 3/4 × 3 5/8 in. (12.1 × 9.2 cm). The Museum of Modern Art, New York, Gift of the photographer.

For Marvin,

whose fellowship, in every sense of the word, has sustained me

CONTENTS

ILLUSTRATIONS

ACKNOWLEDGMENTS

This book grew out of my dissertation, and I am grateful for the guidance of professors Milton W. Brown and Rose-Carol Washton Long at the Graduate Center of the City University of New York, not only for their knowledge but especially for their patience in seeing the project to its fulfillment. Professor Brown's retelling of his personal experiences at Harvard during the period under discussion enlivened the project. Franklin Ludden, Professor Emeritus and former Chairman of the Department of History of Art at the Ohio State University, was a friend and mentor who suggested the topic, and with whom I had an ongoing dialogue; he also had been through the Museum Course at Harvard and contributed to the substance and tenor of this study.

A project like this could not go forward without the cooperation and good will of a myriad of archivists. For their courtesy and help I thank Phoebe Peebles and Abigail G. Smith at the Fogg Art Museum; Liz Hanson and Eleanor Gombosi of the Harvard photographic services; Patrice Donoghue of the Harvard University

Archives; James Cuno, Director of the Harvard University Art Museums; Eleanor Apter at Yale University; Eugene Gaddis at the Wadsworth Atheneum; and Ronald J. Grele at the Oral History Research Project at Columbia University.

Because this is, in a sense, a history of the Museum of Modern Art (MoMA), I was constantly at its door. The archivist, Rona Roob, and her staff, and more recently Michelle Elligott, who took her place, and Michelle Harvey made it all possible. Librarians Clive Philpot and Janet Eckdahl were always good-tempered and helpful. Michael Maigraith, MoMA's publisher, and Mikki Carpenter, director of the Department of Photographic Services and Permissions, bent some rules to supply the many images in this book; Enid Schulz from that department was more than cooperative. I am indebted to Terence Riley, curator in the Department of Architecture and Design at MoMA, for generously allowing me access to Philip Johnson's correspondence in the Mies van der Rohe Archive and for allowing the photographs from that archive to be reproduced. Riley also paid me the compliment of critically reading the chapter that resulted. The resources of archives at Wellesley College, Princeton University, Columbia University, and Harvard University were generously made available to me.

I spoke to many people involved personally with Alfred Barr who were interesting and forthcoming; the ones who were most helpful to my project were Edward King, Barr's youthful friend; Agnes Mongan, a continuous presence in Barr's life since his Harvard days; Dorothy Miller, Barr's assistant and a lovely, gracious woman; William Lieberman, curator of drawings at MoMA and later curator of twentieth-century art at the Metropolitan Museum of Art; William Rubin, who succeeded Barr as chief curator of Painting and Sculpture at MoMA; and Philip Johnson, one of the linchpins in Barr's career. Also interviewed and helpful: Agnes Abbott; Jere Abbott; Bernard Bandler; John I. Bauer; Elizabeth Parkinson Bliss; Mary C. Bostwick; Louise Bourgeois; Milton W. Brown; Mildred Constantine; Elodie Courter; Helen Franc; Lloyd Goodrich; Lily Harmon; Henry-Russell Hitchcock; Sidney Janis; Theodate Johnson; Jay Leyda; Franklin Ludden; Dwight A. Macdonald; Beaumont Newhall; Elinor Robinson; Peter Selz; Anne Smith; Leo Steinberg; Randall Thompson; Virgil Thomson; John Walker; Edward Warburg; Monroe Wheeler.

I thank Susan Woolard for her invaluable technical support, Daniel Fader, re-tired professor of English at Michigan University, for his wisdom and expertise, and Adrienne Bosworth for her very competent professional help.

I am especially grateful to Roger L. Conover at the MIT Press for validating my years of work by publishing this book. He and his staff, including his assistant Mar-garet Tedeschi, senior editor Matthew Abbate, and manuscript editor Joyce Nevis Olesen, were nothing but courteous; they made the whole process a privilege and a pleasure.

My family, including my husband, children, and grandchildren, provided a lov-ing ambience and I know will continue the intellectual curiosity that nourished me.

PREFACE

The work of art is a symbol, a visible symbol of the human spirit in its search for truth,

freedom and perfection.

Alfred H. Barr, Jr.

With more rebellion, vision, and discipline than most, Alfred Barr (1902–1981) harnessed the cataclysm that was modern art. As founding director of the Museum of Modern Art, the most admired institution of its kind, Barr's prominent place in this movement is assured. But because the adulation and complaint that surround his legend are difficult to penetrate, his qualifications as a serious scholar have been scanned only superficially by most chroniclers of the Museum. No assessment has been made of the unique, pivotal role Barr played in the evolution of crit-

ical and philosophical precepts of modernism in visual art in the first half of the twentieth century.[1]

As a student at Princeton he gained a historical perspective, then at Harvard a connoisseur's ability to assess the technical attributes of a work of art. The art movements of the 1920s—constructivism, dadaism, surrealism, de Stijl, and the activities of the Bauhaus that were centered on the machine—were part of the cultural fabric of the time. Cinema, photography, and industrial design were viewed as equal to "fine" arts at the German school and were elements in Barr's self-taught intellectual program that would become departments in the Museum.

But Barr disassociated the theoretical writings of the new internationalists—programs both of "materialism" and of "spiritualism"—from the art. After his visit to the Bauhaus in 1927, he added Gropius to the list of those who most influenced him, even though Barr's viewpoint was weighted toward a formalism that differed significantly from Gropius's. Rather than following the concept of "functionalism," which he was witness to on his European trip in 1927, Barr maintained his perspective of examining the intrinsic traits of a work of art that result from the styles and techniques used. Together with his awareness of the commingling of the arts, Barr had a necessary and irrepressible urge toward the practice of formal description. Barr was receptive to a perspective devoid of subjectivity or interpretation, with its emphasis not on content, representation, or imitation of reality but on form, the language that elucidates it, and the structure that composes it. His turn of mind drew him inevitably to an expanding world defined by universal order in which science was a model for all thought. He developed only the more obvious criteria of history, quality, and open-endedness into a quasi-scientific program.

The purpose of this investigation is to follow the threads of the basic approach of formalism—a concept often used indiscriminately—as Barr learned it, used it, contradicted it, and established its basis in criticism. Barr's taste was classical, his drive for accuracy uncompromising. His correspondence reveals that he made no statement, however prosaic, without evidence to support it. What rescued Barr's rigor from pedantry was a touch of poetry maintained in his peripheral view and an ironic sense of humor sometimes self-mocking and sometimes bordering on the hostile.

Two landmark exhibitions of 1936, examined in detail in this volume, "Cubism and Abstract Art" and "Fantastic Art, Dada, Surrealism," bring into focus the essentials of his aesthetic philosophy. He habitually devised charts—diagrammatic schemes that were synchronic in structure and juxtapositional rather than linear—that aimed at furthering his formalist evolutionary system and ordering the chaotic expressiveness of avant-garde art by summarizing time, place, artist, and style. While responsive to the humanity of the world, his own sense of order precluded any historical contingencies, substantial or not, that would complicate the resolute flow of his charts. These syntheses of style cover a number of epochs charted in genealogies. By using fragments of past art as influential objects rather than as symbols of transcendence or culture, Barr confirmed the notion that contemporary art was deeply rooted in Western historical tradition.

Despite his fascination with the rational, the objective, and the classical, he was equally enthralled with the irrational, the mystical, and the incongruous. The tension between these two sets of foci and tendencies, which sometimes posed a contradiction that many critical minds could not accommodate, had for Barr, in retrospect, a creative relevance. The mysteries of surrealism, the subconscious, the evanescent, all were subjected to his cool analysis. Ultimately, he was able to reconcile his ongoing struggle between classical objectivity and mythic irrationality. This allowed him to perceive modernism as an open-ended phenomenon that went beyond purist abstract modernism to include surrealist, nationalist, realist, and expressionist art.

As Museum director, Barr had the task of integrating the art of American and European culture in a balance favorable to both. Rigorously and consistently applying his idiosyncratic rules of quality to all activities of the Museum of Modern Art, Barr emphasized those American arts that met his standards. He gave prominence to the leading American arts of architecture, film, and industrial art in his multidepartment museum. As Terence Riley, the chief curator of architecture at the Museum of Modern Art, has written, "The International Style has come to be near analogous to the history of modernism in America."[2]

Barr's choices of what he considered important art for the Museum's exhibitions and collections provided a basis for the establishment of "high modernism" in the

critical discourse of the art world, but it would ultimately be seen as narrow by some hostile denizens of that world. Persistently following his idiosyncratic anti-dogma approach, he predictably ignored the revolutionary political climate of the thirties. His catalogues—for decades the only books available as teaching tools—demonstrated with scholarly precision his method of structural analysis and his resistance to integrating external ideas that would further illuminate the work of art. Nevertheless the catalogues established the central issues of modernism in contemporary discourse.

The galleries at the Museum—utopian spaces of white boxes with multimedia exhibitions—displayed a narrative of modernism that allowed room for exegesis. The separate, coexisting departments prepared the way for the eventual explosive interaction of the various media and the end of modernism. When the eruption of postmodernism and multiculturalism placed formalism under attack, Barr's reputation was in jeopardy, as if he had been shortsighted in not foreseeing these developments. His avoidance of ideology or transcendent interpretation of art was regarded as critical refinement that bordered on aestheticism.

Two ideas governed Barr's aesthetic: commitment to quality as essential to establish a style, and modernism as open-ended; "pluralism" as a term had not yet been applied. In a discipline that considers dilettantism one of its weaknesses, his belief in an empirical method of defining quality in all the arts resisted a transcendent response to an individual object, a righteous view that made him too many enemies. He escaped preciosity by his loyalty to process, technology, and the everyday object. In his view, a poster or a toaster was subject to the same laws of formal logic as a painting or a sculpture. He was wary of art that was perceived as "decorative"; the new, the experimental, and the "difficult" were the directives in his evaluations of art. Barr's aesthetic philosophy of freedom of expression in art held that critical judgment has no permanent values.

Following the nineteenth-century art historians' approach to the analysis of form and the categorization of styles, Barr codified modernism from the postimpressionists through Picasso and Matisse of the forties, laying groundwork for the abstract expressionism of the fifties and for Clement Greenberg's formalist criticism. My premise is that what has been assumed to be Greenberg's original

concept actually harks back to Barr's groundbreaking achievements at the Museum of Modern Art. Both men were lauded for their taste and taken seriously for their historical stance. Where Greenberg wanted each art to be true to its own medium, Barr found reassurance in the ubiquity of style.

Barr's ability to be precise and concise in describing and categorizing the various movements of the modernist period, and his obsessive habit of clarifying minutiae, permit us to approach his aesthetic reasoning and to explore the depth of his complex thinking. These traits propelled his pioneering catalogues at the Museum of Modern Art into the forefront of the historiography of the avant-garde.

While it is true, as some of his contemporaries claimed, that Barr seemed to contemplate works of art with his intellect rather than his senses, he in fact hid a fervent involvement behind an unnervingly inscrutable demeanor, a secret smile similar to the one on an archaic Greek sculpture frequently confounding observers.[3] His preoccupation with finding the exact word or term to describe a particular moment in an artist's career was an effect not only of the undeveloped state of criticism at the time but also of the drive and passion he brought to the endeavor.

Barr was teacher to his public audience, critic for artists, and historian and connoisseur for patrons and collectors. Although he seemed to use archaeological methods to categorize styles, a subtext of irony and optimism remained. Barr ran his museum like a university with a program of research, publishing, and teaching. He approached the radical avant-garde through the perspective of academic training, enabling him to document and institutionalize the efforts of these artists in the museum. But he never abandoned the romantic notion of the artist as genius. Despite his occasional temporary vacillations, his overriding guide was his belief that art reflects the multifaceted verities of life, and modern art reflects those of modern life.

The fascination with Barr's person springs from the man's ambiguity. He overcame opposition by his reliance on a rigorous sense of right but not self-righteousness; by his ability to exert his will tenaciously against more powerful people; and by his resolve to maintain his plan for the Museum despite the onslaughts of men and women on the board of trustees who disagreed with him. Barr's intellectual achievement was entrenched by an obstinacy that withstood a

barrage of contentiousness and misunderstanding. His protective flaw, his secretiveness—a resolute silence, the core of his personality—covered, among other things, his indecisiveness. Barr's conflicted inner reality—self-assured but modest and shy; rebellious but concerned with history; conscientious but manipulative—was shaped by his personal history, his educational opportunities, and the general ceremonial nexus of the times. From the beginning, he seemed to be preparing for a role without precedent. Although he belonged to a group of people going in the same direction, he was able to forge ahead because his passion was focused and his courage steadfast as he mapped a teleological course for modernism. The question remains, what propelled a scholarly, timid boy out of a classical historical path onto the wildly radical one that was modern art?

Alfred H. Barr, Jr.

and the Intellectual Origins of
the Museum of Modern Art

PROLOGUE: KNOWING ALFRED BARR

Alfred Barr's training as art connoisseur, historian, and museologist was achieved in a charged context of change and innovation in the 1920s. In the United States, the most important academic centers were Princeton and Harvard, whose art history departments, each in a fledgling stage, joined forces to enrich the education of their graduate students. A Harvard-Princeton Fine Arts Club was formed in 1921 to promote exchange of professors and graduate students and to meet once a year in alternate cities for the reading of papers. The two universities cooperated in developing a more efficient means of educating students and furthering research, going so far as to agree to buy books in separate fields to avoid duplication. An annual publication, *Art Studies,* edited by Frank Mather of Princeton and Kingsley Porter of Harvard, was published jointly between 1923 and 1927. Barr published a paper in it entitled "A Drawing by Antonio Pollaiuolo."[1]

A product of the cooperation between Harvard and Princeton, Barr obtained his B.A. and M.A. from Princeton in 1922 and 1923. His record shows that he

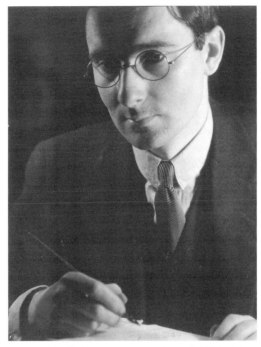

1. Jay Leyda, *Alfred H. Barr, Jr.*, New York, 1931–1933. Gelatin silver print, 4 3/4 × 3 5/8 in. (12.1 × 9.2 cm). The Museum of Modern Art, New York, Gift of the photographer.

was poor in languages, better in science courses, and, of course, outstanding in art and archaeology, for which he received honors at graduation. He was also elected to Phi Beta Kappa. Because his father was in the ministry, scholarship funds were available to him at Princeton. He was a University Fellow for his year of graduate work for his master's degree and, having obtained a Thayer Fellowship, he passed his oral examinations for a doctoral degree at Harvard in 1925. Barr had adopted a plan of work and study to finance his doctoral degree. After graduation from Princeton at the age of twenty-one, he decided "to be in a different place every year for the next five years as a sort of journeyman."[2]

After teaching at Vassar for a year starting in September of 1923, he had enough money to go abroad in the summer of 1924 with his boyhood friend Edward S. King. They had attended Boys Latin School together in Baltimore from the age of eight and then were roommates at Princeton through their master's degrees. With the help of an 1896 Baedeker on this first European grand tour, they spent thirty days in Italy visiting as many towns "to solidify our knowledge," King said.[3] They also visited Paris and Oxford.

After his year at Harvard, in 1925–1926 Barr taught at Princeton under a preceptorial program in modern architecture. In 1926–1927, he taught at Wellesley College and participated in Harvard activities, writing articles, making friends, and sitting in on a course. After spending a pivotal year in Europe on a research project for his dissertation, Barr returned to Wellesley in September of 1928. A year later, about to enter New York University on a fellowship to write a doctoral dissertation in the field of modern art, he was offered the directorship of the Museum of Modern Art. Seventeen years later, in 1946, he submitted the manuscript *Picasso: Fifty Years of His Art,* a revised version of the exhibition catalogue *Picasso: Forty Years of His Art,* to fulfill the requirements for a Ph.D. degree from Harvard.[4] Within this chronological framework, Barr developed his modernist aesthetic and contributed to establishing modernism in America.

Observers have frequently commented that Barr's zeal in proselytizing for modern art reflected his upbringing in a firmly determined Presbyterian family. His father, Alfred H. Barr, Sr. (fig. 2), graduated from Princeton in 1889; he and Barr's two uncles on his mother's side, Samuel Wilson and Robert D. Wilson, were graduates of the Princeton Theological Seminary, and the elder Barr taught there. Barr's grandfather, John Campbell Barr, had also been a minister. Barr reported that at least since the latter half of the seventeenth century "most of my ancestors were Presbyterian ministers or teachers."[5] The lasting effect of this heritage was evident in Barr's role as an educator within the framework of the Museum and in the rigorous intellectual standards of his approach to art.

The legend that he was an "evangelist" for modern art has had a long and flourishing life. Among such descriptions were: "He was a crusader and a missionary by nature and by inheritance, and he believed in the ultimate conversion and sal-

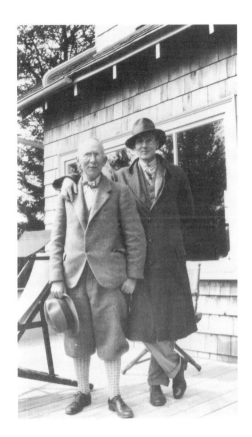

2. Alfred H. Barr, Jr., and Alfred H. Barr, Sr., on the porch of the house in Greensboro, Vermont (no date).

vation of the philistines. . . . He was a zealot in the cause of art."[6] "If there is an ecclesiastical sobriety in Barr's manner and an evangelical fervor in his approach to modern art, it is hardly surprising."[7] His lifelong friend and colleague, the architect Philip Johnson, remarked that Barr had "[a] passion . . . very narrow, very clear in his own mind. It went to the learning and the diversifying and the spreading of the word of modern art."[8]

Alice Marquis made good the title of her unauthorized biography[9] *Alfred H. Barr, Jr.: Missionary for the Modern*. Barr, she judged, "prodded and shamed and proselytized his countrymen into embracing his vision of modern art. Wrathful as an Old Testament prophet, he did battle with the ever present philistines and harried them even as they fled."[10] Marquis even suggested that in the task of raising

money for the Museum, Barr was echoing his father's fund-raising sermons on behalf of the endowment of the church. Each of her chapter titles described Barr's career in the Museum as if he was functioning within the church: "A Pulpit for Mr. Barr"; "Building the Congregation"; "Preaching the Gospel." Chapter 6, "Converting the Heathen," concluded with a biblical quotation comparing Barr's task to that of King David: "And David perceived that the Lord had established him king over Israel. . . ."[11] These descriptions, instead of appraising Barr's real worth, trivialized his accomplishments. Barr did not envision himself as a "king." On the contrary, modesty was a trait that he valued in himself as well as others. He usually demurred, finding it "embarrassing"—a term he frequently used—when praised for the success of the Museum of Modern Art and for facilitating the public acceptance of modern art in general. His rebuttal was that he didn't work alone; the staff and the board of trustees of the Museum shared his responsibilities. At one juncture, when John Canaday in the *New York Times* referred to Barr as "the most powerful tastemaker" in the art world, Barr rejoined, citing a favorite Aesop fable of two flies hitching a ride on a chariot axle who, looking back, exclaimed: "What a dust we do raise."[12]

Apparently, correlating Barr's enthusiasm for art with his religious heritage has been irresistible. But the case is more complex; Barr's intensity did not manifest itself in zealotry. His consummate involvement with art, rarely disclosed even to his closest associates, did not replicate his spiritual life; in a nonspecific sense it replaced that life, as it did for many of his generation. From all accounts, Barr was not a religious man in the ritualistic sense.[13] On December 23, 1921, he wrote to his friend Katherine Gauss: "How can you be pessimistic if you open the shutter of your soul to beauty. . . . My Christianity is intellectual and therefore feeble. Belief is emotional and I have never had an experience strong enough to require an emotional religion. But I hear the bones of generations of Scotch Highland ancients stirring in their graves at this—besides it is ineffectual."[14]

What guided Barr and, more to the point, had a profound effect on his turn of mind was the nonauthoritarian organization of Presbyterianism, which was among the Protestant sects that featured congregational self-government. This aspect of Presbyterianism engendered in the young Barr a questioning attitude and

supported a fierce independence—just skirting rebellion—that he ultimately expressed in a modernist aesthetic systematized within the context of traditional art history. The structure of Presbyterianism required a passionate commitment to a cause; if Barr appeared to be a zealot, it was not fanaticism that drove him but an ingrained devotion to an ethical stance that assiduously avoided dogma. In addition, a set of scrupulous rules governed his daily life that were part tactics of self-defense and part engraved tablets of morality enduring from his childhood.

His friend King suggested that Barr's frequent illnesses and bouts of insomnia were expressions of "his moral sense of selfless action that inevitably made his task more difficult."[15] The rectitude of character and the resolve that Barr brought in restraint of his fervent imagination exacted its toll on his personal life, both physical and emotional,[16] but enabled him, in the 1920s, to be one of the spearheads in the movement for the acceptance of modern art in the United States. Alfred Barr, in his reticence, was a man of rectitude disciplined to whet the passions of others while restraining his own to the point of invisibility. Philip Johnson said of him, "When Barr gets enthusiastic, he just gets more quiet than ever. He delivers his praise in a well considered, rounded quotable sentence in a low voice."[17]

He could also frequently appear literal-minded. Examples abound in his correspondence of what could be construed as either exactitude or petty insistence on observing precepts to the letter. He seldom speculated on questions if he couldn't be absolutely sure of the answer; faced with a request for a recommendation for a student he couldn't remember after ten years, he said so. But he also replied that because the person in question received an A in the Medieval course she took with him at Wellesley, and because standards at Wellesley were as high for undergraduates as those at Vassar, Princeton, or Harvard, "and that the courses are on the whole as difficult or more so," a recommendation was in order.[18] When Frank Crowninshield inquired about his publications, Barr's reply might be seen as too literal and petulant: "I believe . . . (I am) author of some 19 or 20 catalogues, editor and part author of about eight more, and unofficial editor of some ten more. This does not count the various texts by other writers which I have gone over carefully, revised etc."[19] But this behavior, again, was in the mode of steadfast adherence to Calvinist regulation. Of Leo Stein's contribution to the world of art, Barr

meticulously observed that "for two brief years, between 1905 and 1907, he was possibly the most discerning connoisseur and collector of twentieth century painting in the world."[20] The incongruity of high praise that is subtly questioned by the short time frame of the reference perfectly displays Barr's frequently witty exactitude as well as his ability to sidestep an issue.

A rebellious young man fascinated with the new, Barr repeatedly said that he developed an interest in modern art partly because he liked what he saw of it in *Vanity Fair* and the *Dial* and partly because his teachers made fun of it. "I've always had to guard against a tendency to be opposition for the sake of opposition. . . . Maybe it's got something to do with being Scotch and Presbyterian. It's also a feeling for the underdog. I like to see him win."[21]

Barr's conflicts regarding the church and his father's role in it could, at times, be paralyzing; he had a "fastidious aversion" to his father's preaching.[22] The elder Barr left the pastorate in Baltimore where he had been the minister from 1911 to 1923 to teach "Homiletics and Missions" from 1923 to 1935 at the McCormick Theological Seminary in Chicago. In an epistolary confession, Barr distanced himself from his father and the church:

> My father and I are probably not entirely agreed but I admire and envy his position which is tolerant and liberal but at the same time utterly implicit. I feel little religious necessity either intellectual or emotional, at least of an orthodox and conventional nature. I take communion but it is more a gesture of alignment than any inner urge which is not as it should be but I do not find the atmosphere congenial; particularly the music—ugh.[23]

Presumably Barr's extreme difficulty with—in fact, dread of—lecturing was a manifestation of his recoil from preaching. His correspondence is filled with his candid feelings of inadequacy in lecturing and his refusals of invitations to do so.[24] What he passed off as deliberate taciturnity was actually more deeply rooted in his personal history. Nonetheless, his parents were among the sources for Barr's all-embracing liberalism, which provides a logic for his career.

One view of Barr has it that his enthusiastic eloquence, focused on works of art, was highly persuasive and generally prevailed with a recalcitrant board of trustees. A contrary account holds that he was cold and analytical, with no perceptible genuine response to the art under consideration. Perhaps his obdurate dedication to art, plus an almost palpable shyness that distanced him from people as well as his frail demeanor—he was sick frequently—encouraged both legends; ultimately his frailty was misconstrued as a manifestation of spirituality.

Generally, Barr's reserve functioned to hide his enthusiasm. King described Barr as "having a transparent shield around him. . . .His habit of appraising everything gave him a strange air. . . . Alfred's manner put people off." But King's extraordinarily close relationship with Barr gave him the insight, not available to others, that Barr was essentially "not cold," that his "apparent strange manner was a pose." King thought that Barr was "low-key, deliberate, strong-willed, tactful, but whom you couldn't unseat in an argument." He was also "tender, thoughtful, sensitive." King made the analogy that Barr had the appearance of "sampling things as if scenting a flower, a connoisseur par excellence." His appearance was important—he dressed very carefully, to the hilt. [He was] conscious of appearance, of deportment. That he was not without mannerism there can be no doubt."[25]

King described Barr's stance toward art as continually critical, appraising everything both analytically and synthetically. Barr "was always interested in the platonic underlying forms . . . the structure." An example of Barr's analytical approach, he thought, was the cold perfection he saw in the work of Michelangelo, while King, in contrast, felt that a "boiling" lay beneath the exterior of the works. King continued: "I felt that Barr focused on style alone and that he misread or overlooked Michelangelo's essential content, which I interpreted in the usual way, as one of the most monumental psychomachias in human annals. Barr did not reply to my assertion to this effect, and I think he came to agree with me, if perhaps very grudgingly."[26]

Jere Abbott, another of Barr's close friends, also shared youthful experiences with him.[27] They met at Princeton in 1924 where Barr was conducting tutorials in modern architecture. Abbott's description of Barr corresponded with King's. Although he enjoyed looking at art with Barr, Abbott commented that when they did,

"not a flicker that an impression had been made" showed on Barr's countenance. Years later a staff member, Alan Porter, commented: "Barr has absolutely no sense of enjoyment. I don't think it has ever occurred to him that art is something to enjoy. He turned down a since famous Matisse because it was just a pretty picture, didn't offer any problems at all."[28] "Pretty" was, indeed, a pejorative term in Barr's lexicon; "difficult" was an unqualified description he often used for paintings that held his interest.

Abbott characterized Barr's "aesthetic side" as being "relegated to a mental process which was the basis of everything. He was not a spontaneous person. He did not go berserk about something." Barr's habit was to study a work of art for a protracted period. For example, at the Museum he would keep a potential acquisition "at the end of the corridor outside his office a while so he can worry about it. To decide whether it stands up or not."[29] Abbott stressed Barr's "intellectual balance. He had a complicated analytical mind."[30]

Both King and Abbott complained about Barr's reticence, his indisposition to share his innermost thoughts. Yet Barr could write to a German art dealer in New York, J. B. Neumann—a wildly enthusiastic man who served as Barr's mentor for many years—that "when I first saw [Corot's *Montigny les Corneilles*] in your bedroom it hurt. It made my throat feel queer and my eyes smart. It is very beautiful."[31]

And again, Philip Johnson recalled Barr's erudition in persuading the museum's collections committee to buy a triptych of Marilyn Monroe painted by James Gill: "He was intensely interested in the Monroe mythology, the symbolism. He harked back to Aphrodite and even the White Goddess. By the time he finished his exegesis there wasn't a dry eye in the house."[32]

Johnson, who probably knew him better than anyone, spelled out three aspects of Barr's character: "The first was his unbridled passion, a torrential passion that I have never known anyone else in my lifetime to have had. The second was his stubbornness, his obdurate, bulldog tenacity. The third was his unbelievable love, fierce and flaming loyalty to this institution and to his friends."[33] Behind a mask of reserve, Barr's passion, extended to the multifarious details of running the Museum, was integral to his creativity.

Alfred Barr's life was shrouded in secrecy. His stoic mask, maintained with un-changing rigor, enabled him to perform in a role that he had to make up as he went along. Discretion was his watchword, from telling his father "don't breathe a word" about his forthcoming job as the founding director of the Museum of Mod-ern Art, to his uncompromising leadership amidst the inevitable fiefdoms that ac-cumulated at the Museum. His position as a keeper of esoteric material was, in that particular sense, not dissimilar from his father's pastorate. The ethics of museum life manage the conduct of privileged activities much as the moral regulations of the church circumscribe the spiritual life of its parishioners. Clearly the kind of rit-ualistic structure that Barr thought he was evading was, in fact, held in reserve by him for his work. What concerns us is not so much that he certainly was a rigor-ously principled man but that he managed to find a life style in which he could in-dulge a sense of moral order on a continuing basis. Along with his rectitude, Barr assumed a personal manner and form that eschewed any display of emotional re-sponse in his aesthetic activities.

Barr explained away his "coldness" when he wrote to Gauss:

> You called me impersonal and artistic—lost in the extreme—I wonder if you be-lieve the former quality truly characteristic. As for the latter I must be very care-ful—true artistry is that which is self-concealed. But impersonal? It is a position not a point of view, a frame of mind, a coat of mail which I have cultivated for years and now that it is become a habit I am "hoist by my own petard" in the most tragic manner. . . . It is fortunate tho that I do have the imperturbable shell, for being sensitive and emotional I should undoubtedly make a continuous and monotonous fool of myself without it.[34]

Barr's letters to Gauss, in a correspondence that bespeaks the emerging matu-ration of a young man in his twenties, are the most revealing personal source of his contradictory, complex character—unyielding in the face of opposition to his programs and, at the same time, retiring and modest. He had the ability to be self-disciplined, self-taught, self-directed while seeming to participate in the group ac-tion so necessary to promoting and establishing a new movement. His letters are

full of humor, tenderness, sensitivity, erudition, and poetry, as well as expressions of unrequited love, as Barr positioned himself as teacher, his most comfortable role, to Katherine Gauss, a girl he was trying to impress. His emotional life, including religion, sexuality, and a social conscience, only revealed now and then, remained strongly intact. The letters, in fact, give the lie to the claim that he was cold and unemotional. But they support the contention that he was analytical in his approach to art. His usual guardedness was relaxed with Gauss, but his descriptions of paintings nonetheless follow a formalist mode—that is, his observations focus on forms and structure rather than on subject matter or iconography.

On many occasions he wrote to Gauss of the painter Jan Vermeer who was and remained a "favorite" for Barr. He wrote: "You do well to remember P. Potter and Albert Cuyp but don't forget Vermeer who was 5 (five) times as great as P. P. and Cuyp put together."[35] His advice taken, he then wrote on February 1922, to Gauss at Smith College:

> You know as well as I how great a pleasure it has been to have you interested in Vermeer. Vermeer is my best beloved among painters. I'd like to have you meet also Mynheir Gerhart Terborch who is even more fastidious than Vermeer in his choice and arrangement of subjects. He builds up his figures out of a velvety black envelope instead of the cool light of Vermeer . . . wonderful painting of texture and surface especially silk which I know will appeal to your feminine eye. He is a bit more aristocratic than Vermeer—but not quite so genuine in his sentiment. There is nothing in his work so monumental in its simplicity as *The Milkmaid* but there is nothing in Vermeer so gentle in conception and so polished in execution as the Louvre *Concert* or the Berlin *Musician*.[36]

Barr seemed to be attracted to what he called Vermeer's apparent "simplicity—more than a realist." Placing emphasis on the means of expression and the simplicity of execution explicitly foretold the formalist direction that Barr would take. In another letter he listed his favorite paintings by Vermeer, including the location of the works, as if he was already a museum man in the making. He also sent

Gauss excerpts from his notes on Vermeer that revealed his study habits and his total absorption in learning art as a connoisseur:

> Vermeer not a cold realist—but a refined realist—and more. Subjects—a very limited range—a small canvas showing some little household or social event. Usually 1 print 2 figures—one a woman—beauty in domestic accessories. Possessed chivalric attitude toward women—unknown among contemporary painters. His women fine . . . V[ermeer] a feminist—a painter marvelously expressed blond background not darkened to accent figures. Modeling—highly simplified and discreet—textures admirable—stipling occasional. Composition highly conventional—a pattern of rectangles against which a human figure is contrasted.[37]

Barr's use of the word "feminist" was not a political judgment; it demonstrated his strong appreciation of feminine attributes that served him well in the many relationships he had with women collectors and curators. It is tempting to speculate that Barr's attachment to his mother was the inspiration for his idealization of women. He wrote to Gauss: "Some letter I shall discourse on the self-suppression and sacrifice of our mothers which grows more amazing as I grow older." Barr remained close to his mother all her life, sharing with her some of his intellectual pursuits including his highly liberal political bent, his bird-watching, and his love of art. In various places in his correspondence he was rhapsodic on the beauty of particular women that pleased his visual appetite. He would, of course, play the role of teacher to many grateful women patrons and the boss to many adoring women staff members. Women played a central role in the establishment of museums in America, and Barr's relationship with women in connection with the Museum of Modern Art facilitated that role. He was quoted as saying, "The patronage of arts is largely in the hands of women, just as money is. The feminization of taste is a factor."[38]

In his letters to Gauss, a correspondence that marked the years 1922 to 1929 in poetic cadence, we learn much about Barr's inner life: his love of music, both classical and jazz, his preoccupation with bird-watching (which he shared with his

parents) as well as butterflies, his love of literature, and, of course, art. Their rela-
tionship seemed to be platonic—he confessed to a paralyzing shyness—in which
they alternated the roles of pursued and pursuer. By 1929 when Gauss announced
to Barr her plans to marry someone else, he seems to have been relieved. He writes
to her that now he can marry Marga, his nickname for Margaret Fitzmaurice-
Scolari: "There's no use in my hesitating any longer, Marga Fitzmaurice her jolly
is my joy."[39]

His future wife was born in Rome in 1901: her mother, Mary Fitzmaurice, was
Irish and her father, Virgilio Scolari, was an Italian antiques dealer. Margaret Sco-
lari's linguistic talents, which she pursued at the University of Rome from 1919 to
1922, were central to her career and to her role as informal assistant to Barr. Af-
ter she emigrated to the United States in 1925, she taught Italian at Vassar, and at
the same time obtained a master's degree in art history.

In September of 1929 she moved to New York City, where she studied art his-
tory at New York University. Sometime at the end of that year Margaret Scolari met
Alfred Barr.[40] They were married first in New York, on May 8, 1930, then, at the
senior Barr's request and to accommodate her mother in a religious ceremony, in
Paris, on May 27.[41] The next day they started on a tour of France, England, and
Germany to borrow pictures for a forthcoming Corot-Daumier show, with Mrs.
Barr acting as his translator and secretary. This arrangement continued through-
out his museum career: Margaret Barr was fluent in French, Italian, Spanish, and
German and she helped him as his interpreter with the non-English-speaking artists
he had to interview, with research, and with translations.

She taught art history at the Spence School, and had an independent intellec-
tual life with friends such as Erwin Panofsky and Bernard Berenson. She was the
author of *Medardo Rosso (1858–1928)*, a monograph on the Italian sculptor pub-
lished by the Museum of Modern Art in 1963. Neither of Barr's most important
books on Picasso and Matisse would have been possible without her.

Despite the many innuendos to the contrary, Margaret and Alfred Barr seemed
to have had a mutually devoted marriage. Correspondence in the Barr Archives
supports this, as does the testimony of Philip Johnson, who recalled that though
Barr would be distraught when Margaret Barr wasn't around, he would "cover it

3. Alfred Barr, Philip Johnson, and Margaret Barr, Cortona, Italy, 1932.
The Museum of Modern Art, New York: Margaret Scolari Barr papers.

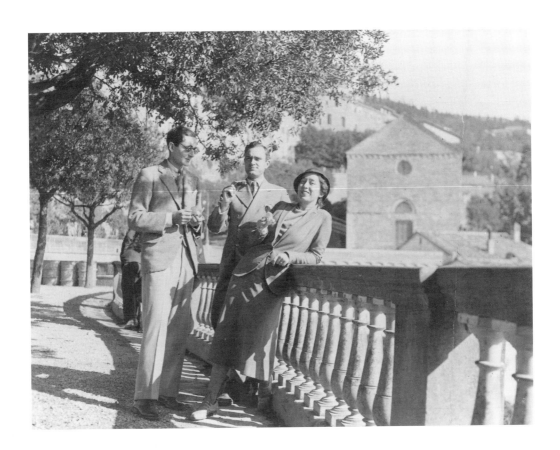

up with reasonableness." Johnson corroborated that "Barr was tearjerkingly, ro-
mantically attached to Marga and to art. His rationality gave way to: 'God, how
I love this woman'"(fig. 3).[42]

Agnes Mongan in a letter to Bernard Berenson agreed:

> You have never met Alfred, have you? When you do many of the questions you
> asked me last year about Marga will be answered, I know of no pair more di-
> verse in background, in emotional inheritance, or in outward manner—& more
> devoted or more reliant upon the well-being of the other, and I like & admire
> them both immensely. Marga's Italo-Hibernian ebullience, quickness & force, Al-
> fred's Scotch quiet steadiness & tenacity, her gaiety, energy, his contemplative
> judgments & almost silent perceptions—& both for their extraordinary intelli-
> gence and taste and loyalty.[43]

The description of Barr that appeared in the individual profiles of the "Com-
mencement Issue" of his high school newspaper hardly would change over his life-
time: "a sincere nut of the silent but deadly type. Steadfast, calm, has a very clear
insight and is remarkably well-read. . . . He shows the human faculty of acquisi-
tiveness in the form of a collector of stamps, butterflies, botanical specimen and
many other oddities. A fine sense of humor and benevolence, with music also. He's
a born scientist with a real desire for things bizarre, grotesque and occult."[44] The
last sentence, a seemingly contradictory characterization, was a constant pattern,
revealing a combination of traits at the core of Barr's personality and proving most
fruitful for his ultimate accomplishments. It found expression in Barr's ability to em-
brace the openendedness of modern art. Despite seeming to be analytical to the
point of coldness, the suppression of his spiritual life in the interest of "scientific ob-
jectivity" (an emerging cultural value) characterized his demeanor. This scientific
attitude was a keystone of a formalist aesthetic.

On entering college, Barr expected to pursue a long-held interest in paleontol-
ogy. His enduring friendship with King extended to their common interests in pa-
leontology, music, butterflies, and art. King spent his first year at Johns Hopkins
and then transferred to Princeton because Barr "had to have him," as Barr wrote

to Gauss.[45] King, as well as Jere Abbott, described the young Barr as having a scientific mind—adept at analysis and synthesis. Meyer Schapiro, speaking at Barr's memorial service years later, conjectured that Barr "must have had a scientific training" in his early years. "He was always sober in his statements and attentive to fact; he tended to be analytic as well."[46]

Applying his own words about Matisse to Barr himself seems appropriate: "[His] leadership was due to factors of personality, ability and circumstance . . . [and] exceptional critical intelligence, courage, talent, extraordinary pertinacity and a profound seriousness of purpose."[47]

A subtheme is the remarkable affinity Barr had for this material: In the words of Merleau-Ponty, who was referring to Cézanne, "The truth is that *this work to be done called for this life.*"[48]

1

THE PRINCETON YEARS

When Barr entered Princeton University in 1918 at the age of sixteen, the department of Art and Archeology had been in existence for only thirty-five years. Princeton has been identified as the model that shaped most art history departments in America because in the late nineteenth century it effected "the separation of archaeology from classics, the introduction of art history as an academic discipline removed from art appreciation, and the marriage of the two in administrative autonomy."[1] The founder of this seminal department was Allan P. Marquand, an 1874 graduate of the College of New Jersey, as Princeton was then called.[2]

Marquand also received a master's degree in theology from Princeton Theological Seminary, where he prepared to enter the ministry, continuing his studies at the Union Theological Seminary in New York. He then turned from theology to philosophy, receiving a doctorate in philosophy from Johns Hopkins University in 1880. He began teaching at Princeton in 1881 as an instructor in Latin and logic but was soon diverted to teach the history of art, starting with a course on the development of Christian architecture. Of his preparation for this teaching, he is

quoted as having said: "It was a new field for me, but I put up a good bluff and stumbled along lecturing on Early Christian and Byzantine architecture as if I understood it well, and as if I knew beforehand all there was to follow in the unexplored fields of Romanesque and Gothic."[3]

Like their colleagues shaping the new discipline at Harvard, professors in the first generation at Princeton were usually trained in literature or classical studies or science and largely self-taught in art history. The confluence of theology and art history, as well as science and art history, in the shaping of the art history graduate departments had an impact on Barr's ultimate career. Many ministers—and in the next generation, sons of ministers—could be found lecturing on the history of the fine arts in neophyte departments of art history. This connection, moral in tone and rooted in the subject matter of Renaissance and medieval art, equated aesthetic response with religious feeling. This equation could have eased the way for a young Barr to slip into the arts rather than theology, thus breaking a family tradition. Yet in opposition to his personal history, Barr's aesthetic was rigorously stripped of any suggestion of transcendental aspects.

The man who first appeared as a lecturer in art history at the College of New Jersey at Princeton was Joseph Henry, who built the first electromagnetic telegraph in 1831 and was the first secretary of the Smithsonian Institution. A scientist who was drawn to the arts, he gave a series of lectures on architecture from 1832 to 1848, even as he taught chemistry, geology, mineralogy, and astronomy. His course in architecture was the first in fine arts at what would in 1896 become Princeton University.[4] This interplay of art and science was integral to the development and establishment of modernism in art during the early part of the twentieth century, especially at Harvard.

MOREY AS MENTOR

Barr's interest in art history was already piqued in high school when his Latin teacher, William Serer Rusk, awarded him Henry Adams's *Mont-Saint-Michel and Chartres* as a prize, a book that attracted a cult of students throughout the 1920s at Harvard. But not until his sophomore year at Princeton, after he took two courses

with Professor Charles Rufus Morey in art history, did he decide to major in the field. One of the courses was a survey of ancient art taught by George W. Elderkin, with Morey as the preceptor. Barr said of this experience: "I had to do an essay on the Greek temple, and for the first time I read more than one book on the same subject. . . . I was amazed and rather shocked to find that authorities disagreed on even so simple a point as how many columns a certain Greek temple had. That was my introduction to scholarship."[5] Openness rather than certainty appealed to him. The model of self-determining independence that he observed in his father's pastorate would also have made him receptive to the indeterminacy of art history.

The second course with Morey, in medieval art, fixed his decision to pursue art scholarship. Synthesizing multiple aspects of medieval culture, from folklore and handicrafts to theology, fascinated Barr from the beginning. Recognized as one of the leading scholars of medievalism, Morey established it as a course of study in the United States.

Joining the faculty in 1906, Morey was among the second generation of professors appointed by Marquand who were Barr's teachers. In the American spirit of exploration, Morey turned to areas characterized by their scarcity of documents and monuments, such as Hellenistic, pre-Gothic, and so-called "primitive" Italian art. His method was to examine objects from all aspects of cultural life to mark the proliferation and evolution of stylistic elements. Like many of the newly designated art historians at the beginning of the century, Morey followed Heinrich Wölfflin and Alois Riegl in their theoretical approach to art.[6]

In 1907–1908 Morey gave the first course on medieval art at Princeton, which was one of the first in the country. The catalogue described the subject of the course as "the decadence and final breaking up of the classical tradition and the subsequent rise of medieval schools under the transforming influence of Christianity . . . down to the Revival of Learning." This conceptual approach to art that included other cultural influences was, in Morey's definition, "Truth"—that is, the "rendering in sensible form [of] . . . human experience" as interpreted by "an individual, epoch or race."[7] From Morey's approach to medievalism, Barr received the grounding for his interest in the proliferation of modernism both within a specific

country and throughout the West. This inclusiveness implicitly positioned him in the camp of aestheticians who claim that the forces of the *Zeitgeist* have a synergistic effect on changes in style.

In tracing the evolution of a style, Morey developed the bold concept of interweaving "Hellenistic naturalism . . . ; Latin realism; and Celto-Germanic dynamism" as sources of influences on early Christian and medieval art.[8] Morey's methodology was established in 1913 as he followed the chronology of the evolution of manuscript illumination from the fourth to the fourteenth century in his classroom. This involved classifying periods and schools within Western stylistic trends from the Carolingian period to the Renaissance.[9] In 1924, following the example of Alois Riegl's theory of *Kunstwollen,* which broadly examines the development of styles, Morey wrote "The Sources of Medieval Art" in which, "to avoid being lost in the countless eddies and backwaters of style," he plotted a schema, a genealogical chart tracing the development of the main currents of medieval art and their interactions, reducing them to "two parent streams into which the Hellenistic divide—the Neo-Attic and the Alexandrian,"[10] which made an indelible impression on his protégé Barr. In the view of art historian Erwin Panofsky, Morey's panoptic survey was effective because "where the European art historians were conditioned to think in terms of national and regional boundaries," distance enabled the Americans to overcome those restrictions.[11]

The Index of Christian Art, organized to catalogue images according to iconography among the different styles of early Christian art and later extended to the early Renaissance, was an ongoing project initiated by Morey in 1917 with his students. Shoeboxes were filled with examples of like iconographic subjects, arranged alphabetically in every medium. This monumental project involved listing every published example of early Christian art, describing it, compiling opinions on its date and significance, and cataloguing it with a photograph. The Index was required to cover not only every illustration of sculpture, frescoes, paintings, coins, medals, and tapestries inspired by the Bible but also those based on the lives of the saints, writings of the church fathers, and the history of the church.[12] Barr was said to have found the collecting of such data "too mechanical."[13] Mrs. Barr wrote to her long-time correspondent Bernard Berenson, "There are cases when

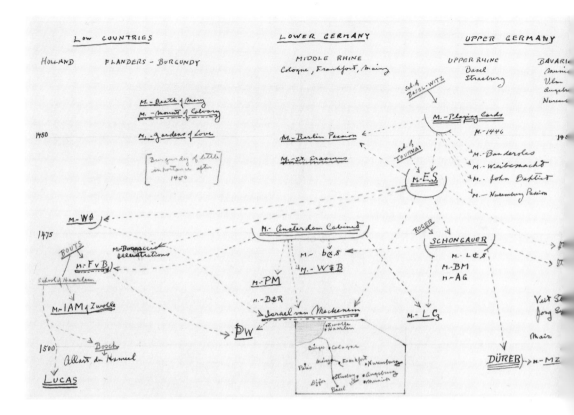

the students submitted to [Morey's] régime have little taste or interest for the material that Morey makes them work upon—lifelong frustration (I know of two outstanding cases) or rebellion and departure are the result."[14] We can assume that one of these two was Barr, who very soon deserted medievalism.

Still, Morey's example of historiographic significance prepared Barr to treat modernist art within the continuous historical framework of Western tradition. Like Morey, he analyzed complex material in search of patterns and stylistic order. On at least four occasions, Barr used a system of chronological charts, precisely drawn, to illustrate the pervasiveness of interlocking developments. The first, at Harvard in 1925, was a flow chart (fig. 4) for Paul J. Sachs outlining the chronol-

4. Barr's chart showing the history of prints, enclosed with letter from Barr to Sachs, August 3, 1925. Harvard University Art Museums Archives, Paul J. Sachs files.

5. Book jacket for the catalogue of the exhibition "Cubism and Abstract Art," March 2–April 19, 1936, The Museum of Modern Art, New York.

6. Revised version of the chart prepared by Barr for the jacket of the catalogue of "Cubism and Abstract Art," 1936; penciled revisions by Barr at a later date. The Museum of Modern Art Archives: Alfred H. Barr, Jr. Papers, 3.C.4.m.

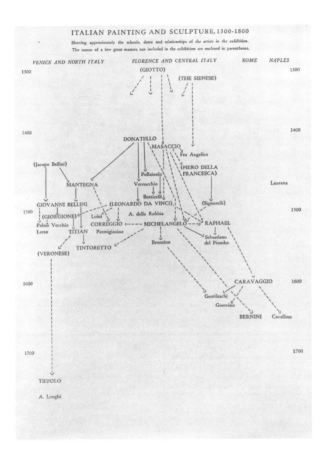

7. "Italian Painting and Sculpture, 1300–1800": chart prepared for the front endpaper of the exhibition catalogue *Italian Masters Lent by the Royal Italian Government* (New York: Museum of Modern Art, 1940).

ogy of printmakers as their influences spread from country to country throughout Europe. Second was a wall label devised to accompany a circulating exhibition of reproductions, "A Brief Survey of Modern Painting," 1932, covering the period from 1850 to 1925, with crosscurrents mapped within a chronological framework from impressionism through surrealism.[15] This was the predecessor for a more comprehensive, detailed third chart, diagramming the sources and influences of

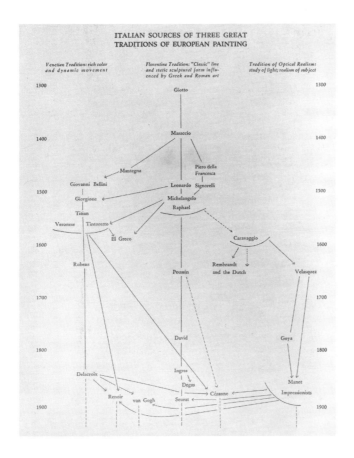

ITALIAN SOURCES OF THREE GREAT
TRADITIONS OF EUROPEAN PAINTING

8. "Italian Sources of Three Great Traditions of European Painting": chart prepared for the back endpaper of the exhibition catalogue *Italian Masters Lent by the Royal Italian Government.*

modernism that appeared on the cover of the "Cubism and Abstract Art" exhibition catalogue in 1936; with the machine as the central abiding source, it included modern architecture (figs. 5 and 6).[16] The fourth effort consisted of two charts; one appeared as the front endpaper of the catalogue for the 1939 traveling exhibition of Italian painting and sculpture from the fifteenth to the eighteenth century that traced the three Renaissance traditions (fig. 7), the other as the endpaper on which

he traced these influences through the nineteenth century (fig. 8).[17] (In earlier writings, Barr linked the artists of the Quattrocento to Manet and the impressionists and then to the postimpressionists.) These charts demonstrated Barr's spatial visualization of the sources and influences that interact in the art process, momentarily turning his back on the tradition of the individual creative genius. His wife considered Barr's preoccupation with "discipline and neatness" the progenitor of the charts: "With stamps, butterflies and birds as well as with works of art his mind was tidy."[18] Barr's gift was to assemble whole styles—charting raveled, complicated artistic relationships without sacrificing the individual entities—into an outline of coherent structural patterns. Surveying both music and art by this method, he could go so far afield as baroque art; as Margaret Barr reported: "When we spent some months in Rome in 1932–33 he was intent on arranging the whole course of Italian baroque painting in his mind and as we looked and looked in museums and churches I could see the restlessness and searching that would lead up to another logical chart of dates and influences."[19] Or he prepared "bluff sheets" so that his young friend Katherine Gauss could participate in conversations as if she knew music.[20]

Barr's interest in music was apparently equal to his passion for art. He wrote to Gauss that he felt dissatisfaction with painting when he heard Brahms's First Symphony.[21] His critical approach to music was always alert, straining to be objective and comprehensive. And his art criticism, fashioned within nineteenth-century parameters, judged art as if it were music. With his attraction to classical abstraction went a contrapuntal theme of poetic lyricism, perhaps stemming from his deep interest in music, which regularly broke through his austere veneer.

Morey's teaching methods prompted Barr's interest in the sources, patterns, chronology, and spread of a style—an approach that he would apply to modern art, first in teaching modernism at Wellesley in 1926–1927, and then in the very structure of the Museum of Modern Art and its multidepartmental organization. Barr later attributed his famous 1929 plan for the establishment of the various curatorial departments at the Museum of Modern Art to Morey's course.[22] Inspired by Morey, Barr was majoring in art history by his junior year.

BARR AND MATHER

Morey assumed chairmanship of the department at Princeton when Marquand retired in 1922.[23] Barr was in Marquand's last class, a graduate course in Italian sculpture of the early fifteenth century that he attended for his master's degree. Frank Jewett Mather took over Marquand's other position as director of the Princeton Museum of Historic Art, and Barr took Mather's course on modern art in his junior year, the first such course in his career.[24] The course in modern painting began with Renaissance masters and stopped with the impressionists, much to Barr's dismay. Mather, extremely conservative, looked with disdain at modernist artists.[25]

Mather had been an art critic for the *New York Evening Post;* he left to become Marquand Professor of Art and Archeology, bringing the journalist's worldliness and interest in modern art—at least through the nineteenth century—to Princeton.[26] Besides his newspaper writings, Mather published books on nineteenth-century American art and twentieth-century modern art, but his personal taste did not reach beyond the impressionists.

Recognizing the seriousness of contemporary art, Mather wrote about it and probably apprised his students of the Armory Show, but he was not young enough in spirit to understand its power.[27] His position as an art critic at the *Post* had brought him to the show, which he viewed with critical condescension. Like most of the other critics at the time, Mather felt that the work of the avant-garde artists had a "strangeness and apparent ugliness."[28] He considered the origins of the modernist movement a reaction against the impressionists by van Gogh and Gauguin, "artists of high emotional tension and of somewhat grotesque power, and [by] Paul Cézanne, an eccentric doctrinaire of high intellectual ability."[29]

As the various movements had not yet been categorized, Mather grouped the postimpressionists (he considered the term merely a chronological device) with the expressionists, by which he meant Matisse and the fauves and the German expressionists. He felt that these artists "ignored the always pertinent question of value, assumed that the artist was free from all constraint, including that of his own reason, and appealed to an anarchistic individualism in the name of liberty."[30] Consistent with the common practice of regarding the expressionists as products

of the romantic movement, their art was considered an expression of raw emo-
tions.[31] With no understanding of the techniques of contemporary artists, Mather
mistakenly pointed out their departure from the tradition of using nature or previ-
ous art as sources for the forms in their work. Deprecating the execution of their
work as "summary," he wrote: "the creative, emotional detonation is necessarily
of brief duration, and the whole effort was toward simplicity and emphasis. The
movement has in my opinion produced few works of value, but it has encouraged
simplicity of composition and a bolder use of color, and has given new formulas
for expressing mass."[32]

Mather was equivocating. Although he closely described what he saw, he
could not distance himself enough from destructive contemporary criticism to be
more receptive to the new art. He saw the various changes in style as intellectual
exercises that outran the abilities of the painters to execute them, and recognized
Cézanne's rejection of impressionism for its "superficial contentment with momen-
tary appearances and its neglect of structure." Mather contended that Cézanne
expanded on the impressionists' scientific interests, aptly describing his "tilting
planes . . . in dynamic relations of balance and thrust hence implicitly in motion."
He also held that Cézanne and the impressionists obeyed an "inner emotional-
ism," using the concept of "emotionalism" in a derogatory sense. He placed
Cézanne outside the main body of expressionists because he felt that the artist's
aims were not in the expressive content of the painting but in its "uninterpreted ap-
pearance."[33] These observations approached, albeit negatively, a formalist posi-
tion that Barr would eventually embrace.

Mather's ability to analyze a modernist picture in formal terms was impressive;
his awareness of the continuity of history—in accordance with the Princetonian
method—brought a scholarly content to his writings that did not exist in the work
of the other critics of the period. But his inflexible loyalty to traditional art pre-
cluded his ability to understand the value of experimentation.

If he dismissed Cézanne as an "amateur," he equally blundered with the cubists
who, he acknowledged, based their style on Cézanne's "great geometrical
planes . . . the starting point of cubism."[34] Mather had a few kind words for cubism,
although he saw no great masterpieces among its works. He moved the cubists out

of the realm of the expressionists into a category of "intellectualist" with a "habit of distortion," but he did not think it was necessary to discuss them: "For in its uncompromising form [cubism] was never much followed in America, while abroad it had already passed. Its legacy is merely a tendency to compose in geometric patterns—a harmless and often an amusing expedient, and less novel than it seems."[35]

Mather dismissed all modernists as artists who were better theorists than painters but whose innovations were openended. "[Modernism's] program seems tainted on the one hand by an oversubjective impulsivism, and on the other by a quite eccentric intellectualism—in plainer words, seems either crazy or cranky."[36] Again, Mather sensed the forms of modernism, but ridicule debased his criticism because he was unable to overcome his innate conservatism.

Even though he deprecated their efforts, Mather correctly observed that avant-garde artists were influenced by primitive art: "High among those are the Congo blacks who have fixed their fears and obscenities in ebony images nearly as enduring as bronze. Indeed there is such a monotony about the pure spontaneity of the Expressionists that their most benevolent critics can only conclude that the movement had paradoxically developed an academism of its own, merely substituting for the academism of civilization that of barbarism."[37]

Mather's found almost nothing of worth in Matisse, calling his work "garish and unsteady . . . betraying no sign of development or maturity."[38] This view of Matisse eventually caused an open conflict between Barr and Mather. While Mather considered Matisse's work to have fallen short of the decorative, art failed Barr's test of quality if it succumbed to decoration. Mather considered that Matisse was a fine draftsman gone wrong: "His line is tight and minutely descriptive in the rare instances where he wants it to be so, but generally it is loose and dynamic, the preoccupation being with the larger truths of mass and balance. At his best his drawing has extraordinary bravura and equal truthfulness."[39] Still, Mather's descriptive writing has an edge and truthfulness of its own. He describes a "little crouching nude" drawing by Matisse at the Armory Show of 1913: "An unbroken thick line told the whole story of torso settling into thighs and thorax bending into abdomen. The little study, an affair of two minutes, would have stood up beside a Hokusai."[40] But not a Raphael.

Mather had the power of his journalistic experience to aid him, reinforced by a probing intelligence, a gift for words, and the merit of looking for the strengths in modernism (though unfortunately not finding them). Despite the advantage of his more scholarly prose, Mather joined the panicked critics who used unseemly epithets in responding to the inaccessibility of the abstract forms. Mather's attitude perversely served to rally the young Barr to the cause of modernism, although Barr did, indeed, consider him "monstrously clever."[41]

In his junior year at Princeton, Barr made a trip with Mather to the exhibition "Impressionist and Post-Impressionist Painting" held at the Metropolitan Museum in 1921.[42] Some of the most important American collectors loaned their works of art to the show, including Lillie Bliss (the future benefactor of the Museum of Modern Art), who did so anonymously. The show was organized by John Quinn, whom Barr considered to have one of the greatest collections of modern paintings in America at the time. Bryson Burroughs, the director of the museum, wrote in the introduction to the catalogue that the exhibition consisted of paintings that would not be entirely familiar to the public. This was a direct consequence, he said, of the necessity of selecting from a generously offered larger group of works that reflected the growing interest in modernism.[43]

Mather's denigration of modern art ultimately became a point of dissension between teacher and student. In 1931 Barr declined a request to write on Mather for the *Saturday Review:* "I am both a former pupil and a friend of Mr. Mather, while at the same time I find myself in frequent disagreement with his opinions. For this reason I cannot accept your invitation much as I admire the bulk of Mather's work."[44] Barr later summed up his feelings in his characteristic style of telling the truth as he saw it, mitigated by fine nuances. He wrote to Mather:

You speak of yourself as conservative. Which I suppose is true. Yet none of my teachers was nearly as open to new ideas and so tolerant of contemporary art they didn't like. Furthermore I always felt that you had a real sense of the importance of first hand contact with a work of art and of qualitative judgements. This was valuable especially with an education overwhelmingly based on photographs. However conservative you may find yourself to be, you will always

have philosophical objectivity. . . . To admit the things you don't like might yet have virtue.[45]

BARR MOVES ON TO VASSAR

Barr had set a five-year plan for himself of working and going to school in alternate years to finance his education. After graduating from Princeton in the summer of 1923 and spending his vacation time in Vermont, he arrived at Vassar College in the fall to teach art history for a year. This obliged him to assist in teaching several courses—one in Italian sculpture, another in Italian painting from early Christian times through the Renaissance, and a third in northern European painting—all in the first semester. In the second semester, he assisted in a course in Venetian painting as well as one in Modern painting. He wrote to his mother about his excitement: "I am intoxicated with work—imagine it, never have I been so utterly buried—the work moves on over my head and for the moment I must let it move. I have completely rearranged the Modern Painting course. It took eight and a half hours merely to plan it. A continuous urge to learn more, to understand what before was woefully superficial—and then I have no energy for anything else and I am far behind in sleep. Perhaps during Spring vacation I may look about."[46]

At Vassar, Barr had firsthand experience with the work that Katherine Dreier and the Société Anonyme were doing when he saw the Kandinsky exhibition of four large oil paintings and nine small watercolors that she mounted there in 1923.[47] On November 14, the *Vassar Miscellany News* reported that the Kandinsky exhibition was the subject of much discussion by both students and professors, none of whom seemed to be sympathetic. The editor wrote that the quality of newness could be legitimate but dangerous because it allowed so many poseurs who paint "tortured cubes and inebriated squares and call them 'The Temptation of St. Anthony.'" The writer reported on the reaction of a Mr. Chatterton, a professor of art at the college, who said that the language of the pictures was "unintelligible": "Both [Chatterton] and Mr. Barr are unable to look at the pictures emotionally. . . . Barr gets the outer sensation of an emotion which he can qualify but

cannot name. Both agree that the color is the best thing about the pictures, particularly in water-colors; and therefore their chief value is a decorative one. . . . Mr. Barr on the other hand thinks that they lack rhythm and hence lose some of their decorative quality. . . . Barr however thinks the artist has failed because he does not give an emotion to the observer."[48]

Reported elsewhere was Barr's final sardonic remark about Kandinsky: "It is hashish."[49] Clearly Barr had not curated the show[50] nor did he understand Kandinsky's art. He eventually learned to appreciate Kandinsky's early period, although he did not like the work of the painter's Bauhaus period, finding it too geometrical.[51]

BARR'S INCIPIENT INTEREST IN MODERNISM

Barr took his first trip to Europe in the summer of 1924, which he later referred to as his "Grand Tour," a two-month vacation for $500 with his roommate Edward King. Covering as much ground as possible, they began in Italy visiting three or four cities in a day. Barr reminisced that "things were not like what you expected— scale especially different." From Italy they went to Paris and Chartres where, King said, they were guided by Étienne Houvet, a specialist in Gothic art. They also spent time in London and Oxford, but they saw no modern art.[52]

King recalled that Barr had begun to show interest in "the battle between the ancients and the moderns" in their graduate year at Princeton, 1922–1923. King acknowledged, however, that he could not be certain if this was the inception of that interest or, as he was absent from school because of illness in his senior year, it only seemed so.[53] But as Barr recounted in his diary, he revealed some interest in modern art in his senior year by giving a talk before the Art Journalists Club at Princeton, referring to the subject as it appeared in "*Vanity Fair*(!), *Studio*, etc. . . . Morey and the other gray beards do laugh."[54] (Barr had subscribed to *Vanity Fair* as a freshman at Princeton.)[55] On another occasion in the same year, he demonstrated his interest in modern art by suggesting a list of art history books to Gauss. He recommended Brownell's *French Painting*, "short and wonderfully written"; Fromentin's *Old Masters* for Dutch painting; Von Marck's *The Art of Painting in the*

19th Century; and "Fat Little Bernhardt Berenson's series on Italian Painting, very short, succinct, critical essays and extremely readable—not illustrated." Then he wrote: "For very modern Painting Clive Bell's *Since Cézanne* is the book—Clive Bell's *Art* is a really exciting system of aesthetics. It is stimulating in the extreme, his point of view is convincing and radical."[56]

At graduate school in Princeton, 1922–1923, while working on "medieval art, Cimabue, etc.," and learning the "scholarly method," he was able to maintain an interest in modern art by making frequent trips to New York City to visit art galleries, including those of Montross and Stieglitz.[57]

His growing interest in modernism, which he deemed a "marginal hobby," strengthened after he graduated from Princeton in 1923. Barr summed up those years: "Since my sophomore year, I passed through successive periods in which my interests were concentrated in classical, medieval, renaissance, baroque, and now for the past two years [1923–1925] . . . the modern field. . . . Contemporary art is puzzling and chaotic but is to many of us living and important in itself and as a manifestation of our amazing though none too lucid civilization. . . . I confess I find the art of the present more interesting and moving than the art of the Sung or even of the quattrocento."[58]

Barr had the lonely task of educating himself in modern art, but was either not ready or unable to position himself as a modernist within the university system. His teachers were either "querulously resentful" or "wittily condescending." One professor dismissed any painting after Cézanne with "a glib retelling of the 'donkey's tail legend.'" Mostly they regarded contemporary art as either "ephemeral, or too new, too untested by time, or too trivial or eccentric."[59]

HARVARD VERSUS PRINCETON

In the fall of 1924 Barr attended Harvard University to work on his doctoral degree. Having belonged to the Harvard-Princeton Club, he was well acquainted with the professors and the program there. In the 1920s, the methodology of the two art history departments was different. As they evolved, Princeton's became

known for its historical and iconographic research and Harvard's excelled in con-
noisseurship. Before he went there, Barr had been disdainful of the lack of method
at Harvard;[60] he wrote about "aesthetic Harvard where there is more music and
a gentler atmosphere."[61] The divergent methodological directions may have had
deep roots; Marquand for example characterizes an early lecturer who was at
Princeton in 1837: "It was said that he did not give mere descriptions of styles and
dates. . . . It was nothing like the subjective rhapsodies of Ruskin . . . but rather in
the spirit of Vischer and Taine . . . that is, the spirit of *historical development*."[62]
Charles Eliot Norton on the other hand, who first lectured in 1874 at Harvard and
established the division of Fine Arts in 1891 when the Fogg Museum was founded,
was said to have lectured "passionately" in the subjective manner of his friend
John Ruskin.

In establishing the Art History department, the founding fathers at Princeton
hoped that aesthetic considerations would play an important role in the design of
objects of everyday life that were in process of becoming industrialized. Authors
of a fund-raising pamphlet for the new department were concerned with wedding
art to the practical, so that "accomplished and instructed men and women seated
at luxurious tables [could] tell whether their plates and cups are of pottery or porce-
lain. . . . If the clergy, the lawyers, the educated men in all professions and walks
of life, had received in College such instruction as this department proposes to
give, they would exercise in the community a power which would overcome . . .
barbaric conditions . . . a power for good in all departments of usefulness among
their fellows."[63] Marilyn Lavin, the historian of Princeton's department of Art and
Archeology, interpreted the principles set forth by the founders in pursuance of
scholarship in both high art (salon painting, marble sculpture) and low art (crafts
and artifacts) as "manifestations of material culture in a historical context. The fun-
damental connection of classical education, with a respect for man's creative pro-
duction, and the need to accept art as an important and necessary part of daily
life gave the frame to the Princetonian branch of art history as it developed, and
that has remained salient as a characteristic to the present day."[64]

At Harvard the decorative arts played a minor part in the curriculum, except at
the Busch-Reisinger Museum, where collections of German decorative arts were

systematically acquired and would include, eventually, the manufactured products of the Bauhaus artists. Norton, consistently moralistic in his tone, would not have been interested in the "'merely decorative.'"[65] Having developed his interest in the decorative arts at Princeton, Barr later incorporated this interest into the Museum of Modern Art as a curatorial department of industrial art.

In another respect, Morey and Norton had the same ideals for their respective departments. A talk Morey gave at a College Art Association meeting appeared in the *Boston Transcript,* December 30, 1926; the heading was "Professor Morey of Princeton asserts students never were more bewildered." Morey proposed to his audience that the weight of "perverted values" generated by science and its offshoot, materialism, needed to be balanced by an extension of courses in the study of the arts. He bemoaned the generally held attitude that the history of art was "decorative but not intrinsically useful." He felt that art branching from classics or classical archaeology or modern language courses had "a measure of strength because it based its method of research upon older and established methods of philology and archaeology." European in origin, this was a more historical perspective, and Morey's graduate work was in philology.

Morey quoted Norton, who was of the same mind: "After all, what we learn in college is the history of man's past achievement and its bearing on the present. The trouble with the method by which we learn it just now is the unavoidable emphasis on man's material, economic and scientific advancement without reference to the changing viewpoint of what these material phenomena reflect or what they have produced. In the history of art the student is conducted to the spirit of an epoch by his most direct sense, the eye. Art history is the history of civilization."[66] Keeping the spirit of this philosophy intact, Barr would carry it much further by including contemporary life.

To the methodologies of historical scholarship that Barr acquired at Princeton, he would add the methods of connoisseurship that he learned at Harvard. In 1951, he dedicated his book on Matisse, his magnum opus, to Morey, Mather, and Sachs.[67]

2

THE FOGG METHOD AND PAUL J. SACHS:
BARR AND HIS HARVARD MENTOR

In the fall of 1924, after a summer of traveling in Europe, Barr arrived at Harvard to continue his graduate studies under the tutelage of Paul J. Sachs, the associate director of the Fogg Museum (fig. 9). An instant accord with Sachs began an affiliation that would endure for forty years. The mentoring relationship between them led Sachs gradually into modern art and the young student into museum life, and it proved to be decisive in Barr's career.

Unlike Barr, who came from a relatively poor clerical family and had to create his own path to the art world, Sachs arrived at his position through the advantages of wealth (at that time the more usual way). Not surprisingly, they were an unlikely pair with dissimilar temperaments. Sachs was bombastic and gregarious, given to outbursts of rage and joy. Barr, if not painfully shy, was uninterested in social intercourse. Fastidiously private and broadly sanctimonious, he nevertheless had a gift for friendship. However different their backgrounds, their aims and methods were comparable. Both were starting on paths that had few precedents and, like

9. Paul J. Sachs.

most adherents of movements that originate in radical notions, each often gave the impression of being doctrinaire and hypersensitive.

Barr wrote to Gauss in the fall of 1924:

Cambridge is a horble [sic] place to live in loud and noisy and ugly. Harvard makes up for it though and more. Listen to the sweet tale of my courses: 1. Byzantine Art [Porter]; 2. Engravings and Etchings [Sachs]; 3. Theory and Practice of Representation and Design (Fun with water colors and pencil and tempera) [Pope]; 4. Drawings—14th Italian, 14, 15th German, 18th French [Sachs]; 5. Modern Sculpture; 6. Florentine Painting; 7. Classical Culture in the Middle Ages with *Rand*; 8. Prose and Poetry, Tudor and Stuart. 9. Russian Music. The last five I merely listen to and take notes—but aren't they swell? I will be buried under work but will sing in my sepulchre—and Marcel Dupré is coming to play Bach's organ works complete and I will lunch with him I am scarce contained![1]

With these courses, Barr was inducted into a program that would direct him toward a formalist point of view, which first supplemented the historicist approach he had learned in Princeton and then overtook it. The basis of the training at Harvard was the analysis of styles explored through materials and techniques with the aim of discovering universal formal principles. Epochal styles were characterized by the study of morphological conventions and confirmed by connoisseurship. Formalist practices presupposed the cultivation of Barr's exacting "eye."

Barr went to Harvard from Princeton specifically to take Sachs's courses and be trained in the technical regimen that could develop the skills of a connoisseur, although his professors at Princeton disdained the Harvard method. Harvard and Princeton had begun their programs within a decade of each other, but a sharp contrast arose from the beginning between Princeton's investigative historical and iconographic approach and Harvard's hands-on exploration of styles and technical processes.

When he began at Harvard in 1915, Sachs was part of the second generation of art historians who were establishing the parameters of the discipline but were still functioning without the advantage of doctoral degrees in the subject. Sachs acquired his knowledge of art primarily through collecting prints and drawings, and he quickly earned a reputation at Harvard for his power in the art market.

In "Three Decades of Art History in the United States," Erwin Panofsky observed:

> After the First World War [American art history] began to challenge the supremacy not only of German-speaking countries, but of Europe as a whole. This was possible not in spite but because of the fact that its founding fathers—such men as Allan Marquand, Charles Rufus Morey, Frank J. Mather, A. Kingsley Porter, Howard C. Butler, Paul J. Sachs were not the products of an established tradition but had come to the history of art from classical philology, theology and philosophy, literature, architecture or just collecting. They established a profession by following an avocation.[2]

These men, among others, were Barr's teachers at Princeton and Harvard.

NORTON, THE FATHER OF ART HISTORY

Inexplicably, Panofsky made no note of Charles Eliot Norton (fig. 10), one of the fathers of art history in America, who had inaugurated the Art division at Harvard in 1874 as "Lecturer on the History of the Fine Arts as Connected with Literature."[3] Norton instilled an enthusiasm for works of art in his students by his rhetoric alone. No illustrations were available to him and few textbooks were written in English; Norton expected his students to read in Greek, German, French, and Italian. What would seem an improbable situation became a highly successful program and a model for many universities.

Henry James in 1908 wrote a memorial tribute to his close friend Norton, who was also his editor and advisor in art matters. James described Shady Hill (fig. 11), Norton's art-filled home in Cambridge, and characterized the American scene for his English readers: "His so pleasant old hereditary home, with its ample acres and numerous spoils . . . at a time when spoils at all felicitously gathered, were rare in the United States. . . . The main matter of his discourse offered itself just simply as the matter of 'civilization'—the particular civilization that a young roaring and money-getting democracy, occupied with 'business success,' most needed to have brought home to it."[4]

Norton attracted to Shady Hill some of the most important figures in the intellectual life of America. The Cambridge circle alone included Ralph Waldo Emerson, Henry Wadsworth Longfellow, James Russell Lowell, and Oliver Wendell Holmes. Together they extended the notion of "good taste" as a protection against the crudeness of modern life in the New World. Norton's displeasure in confronting the proliferation of America's commercial enterprises strengthened his resolve that art maintain its moral purpose.

Norton's importance to Harvard was that, as an Anglophile, he kept close contact with John Ruskin and Thomas Carlyle and had intellectual connections with John Stuart Mill, Elizabeth and Robert Browning, Charles Dickens, John Forster, Dante Gabriel Rossetti, Edward Burne-Jones, and William Morris. Harvard faculty and students in general—for example, Van Wyck Brooks, class of 1908, or T. S. Eliot, class of 1909—were linked with England until the 1920s when Paris be-

10. Charles Eliot Norton, 1903.

11. Charles Eliot Norton on the grounds of Shady Hill.

came the center of intellectual life. "This was the Norton," wrote his student Brooks, "who never set foot in England without feeling that he was at last at home."[5] Intent on the nineteenth-century notion of "self-improvement," Norton had been to Europe from 1855 to 1857 and again from 1868 to 1873 to mingle with the educated elite. He studied the art of Italy, particularly the great cathedrals at Siena, Florence, and Venice. From studying original documents of the medieval age in Italy, he traveled to England and attended Ruskin's lectures on Italian art at Oxford. Ruskin, already widely popular in America,[6] became Norton's devoted confidant and mentor in a long-standing relationship. It was he who encouraged Norton to give a course in art history in America.

Norton was said to have lectured in the rhapsodic manner of his friend Ruskin, a personal style that drew crowds of students, as many as 1,000 at a time. He shared Ruskin's views on "the intimate relation between art and life," the theoretical source for the arts and crafts movement created by Ruskin and William Morris. The intense admiration that these men had for the art of the Middle Ages and its guild system—essentially an antiindustrial concept—was the central idea engaging them. But this connection, basic to the establishment of art history as a discipline, was focused upon the moral life and "the ethical and social implications of the Fine Arts."[7]

Norton led the resistance to accepting the shift toward a more technological modernist point of view with a cultural program that was still entangled in the staid moral values of the nineteenth century. George Santayana, a well-respected professor of aesthetics who contributed to the interest in art radiating from Harvard, pinpointed the struggle between the old and the new. He saw that the younger generation involved in "invention and industry and social organization" was at odds with those dedicated to maintaining a moralistic slant to the arts that expressed religion, literature, and all the "higher emotions." Santayana called the hereditary spirit that prevailed the "Genteel Tradition."[8]

The phrase "genteel tradition" became both famous and ubiquitous, characterizing the climate at Harvard in the first three decades of the century. Everything was permissible as long as "good taste" conflated with "morality" was affixed to art. The genteel tradition did not relinquish its hold on the imagination of Harvard students until the 1920s, when technology in the guise of modernism began to take hold.

KIRSTEIN THE STUDENT, RUSKIN THE CRITIC

Of all the young men around Paul Sachs at Harvard in the 1920s, the one who seemed to have a sense of cultural history that paralleled Barr's was Lincoln Kirstein. Although his approach differed from Barr's, their commitment was equal and Kirstein would play a continuing role in Barr's career. In his memoir, Kirstein described his education and ambitions and the intellectual climate that developed at Harvard through several generations.[9] Born in 1907, he identified himself with the previous century and found Boston in the 1920s intellectually and culturally suitable to that style of life.[10] "This epoch," said Kirstein, "was still redolent of the nineteenth century."[11] With specific reference to Norton, he wrote: "The memory of Norton had a great influence on Harvard through [his] advocacy of John Ruskin who would be a guiding and abiding influence in the development of my visual taste and in liberation from received ideas about art."[12]

Perhaps Ruskin's impact stemmed from his aesthetic stance (stripped of its moral content), which gave art its value as an extension of all experience. This was particularly true of Kirstein who, like Ruskin, could call on the sensibilities of an *artiste manqué*. The writings of both men reveal that special conflation of the visual and verbal that considers the aesthetic response to a work of art an act as creative as the work itself. Kirstein's aim, like Ruskin's, was to embrace the public and introduce it to the wonders of art. This lofty critical aim was sharpened by both men's extraordinary literary acumen, including the writing of poetry, as well as their ability to draw (although both jettisoned painting careers they considered unworthy).

INITIATION OF FORMALISM AT HARVARD

In obeisance to Ruskin, Norton imbued art with moral overtones, but neither man neglected its formal aspects. Norton followed Ruskin's responses to art as expressed in his book *The Stones of Venice* of 1851 in which Ruskin adumbrated the formalist approach to aesthetics: "The arrangement of colours and lines is an art analogous to the composition of music, and entirely independent of the representation of facts. Good colouring does not necessarily convey the image of anything but itself."[13]

Norton introduced this point of view into the curriculum by gaining the coop-
eration of Charles Herbert Moore, the first instructor in freehand drawing and wa-
tercolor at the Lawrence Scientific School at Harvard.[14] Moore initiated this
method in the Fine Arts division in a course called Principles of Delineation, Color,
and Chiaroscuro, in which he required his students to make paintings and draw-
ings that imitated the technical methods of the various historical styles in order to
gain a deeper understanding of artmaking. Moore modeled his course on Ruskin's
book *Elements of Drawing*.[15]

With Moore joining the Fine Arts department, Norton implemented a program
of instructing students in the history of art and theory, supplemented by the equally
important training of eye and hand for the development of visual memory. These
were the ideals firmly established by Norton:

> that the history of the arts should always be related to the history of civilization;
> that monuments should be interpreted as expressions of the peculiar genius of
> the people who produced them; that fundamental principles of design should
> be emphasized as a basis for aesthetic judgments; and that opportunities for
> training in drawing and painting should be provided for all serious students of
> the subject.[16]

The insistence on the necessity of studying the technical basis of the arts and
the fundamental principles of design became, in due time, one of the foundations
of a formalist approach in methodology at Harvard. Based on analysis of the struc-
tural elements of a work of art, which borrowed its vocabulary and organization
from the new scientific explorations, it became known as the Fogg method. It was
Sachs's opinion that Norton was "the spiritual founder" of the Fogg Museum.[17]

THE CONTRIBUTION OF BERENSON

Contributing to this method, and an important link between Norton and the rebels
of the 1920s, was Bernard Berenson, one of Harvard's first internationally known
art critics. Berenson maintained contact through the years with mentors and dis-

ciples alike at Harvard and, although he never taught there, his influence was strongly felt. Kirstein registered the strength of his influence in his memoirs: 'There were lecture halls where the gospel according to Bernard Berenson was preached to his honorary heirs.'[18]

On his first trip to Europe in 1887, just after graduation, Berenson decided to devote his life to studying Italian art. His reputation was made on the lists he developed of those paintings he considered authentic. His attributions were made by focusing on the details of the works—Berenson relied on a keen visual memory as well as on photographs—and by deducing the style or "personality" of the artist revealed in the specific qualities of the artist's idiosyncratic hand. Making use of the art historian Giovanni Morelli's method of concentrating on the most minute details (such as nostrils or ear lobes), Berenson made a major contribution not only to the procedures of connoisseurship but also, in his early writings, to furthering a formalist method that disregarded interpretive alignments.

At Harvard, Berenson had studied literature and been influenced by Norton. Although they both paid homage to Ruskin, Berenson went in a different direction. In his work and personal life he succumbed to the critic Walter Pater's aestheticism and made the aesthetic experience the central motivating force of his existence. Pater, whose phrasing was as felicitous as Ruskin's, pointedly excluded references to any moral purpose that the older English critic had suggested was encoded in the work of art. Instead, Pater cultivated art as a replacement for religion, and Berenson made that a cult for Harvard students for the next two decades. On Berenson's recommendation, Norton read Pater's *Studies in the History of the Renaissance,* but he returned the book and, remaining faithful to Ruskin, said: "It was only fit to be read in the bathroom."[19]

Berenson's influence became widespread in the beginning of the twentieth century through his pioneer writings on Italian art[20] and later as a result of his advice given to those forming important collections. Connoisseurship and the emphasis on a formalist aesthetic as developed by Berenson emerged concomitantly with the interest of the middle class in acquiring collections of art. Concern for authenticity presupposed the act of acquisition.

For Harvard and Boston, the most important collection that Berenson supervised was the one by Isabella Stewart Gardner, whom he met at a lecture given

by Norton. She financed his education in Italy, enabling him to become a connoisseur, and he repaid her by amassing for her one of the early, great old-master collections in America. Accompanying the medievalism that fascinated the Harvard intellect was a passion for the Renaissance, which Norton also taught, a style Berenson permanently fixed in Boston by helping to form the Gardner collection. According to Brooks, "It filled the Harvard mind with images that cropped out in scores of novels and poems—in Eliot's phrase about Umbrian painters, for instance."[21]

Paul Sachs, a contemporary of Berenson's, was influenced by and maintained an active relationship with him. Sachs followed Berenson in placing the work of art at the center of the historian's investigation as an empirical study. In his role as the associate director of the Fogg Museum, Sachs was the most important bridge between the museum world and the university. Also like Berenson, he helped form the collections and the taste of many Americans. But unlike Berenson, Sachs, once he became part of the academic community, broke firmly with the tradition of "dealing" with gallery owners and lectured against it. Berenson had been supporting himself by buying art for Isabella Stewart Gardner and receiving commissions from a number of dealers. In this, Berenson was a transitional figure: as an independent connoisseur, he marketed his scholarship before such commerce was regarded as compromising the scholar.[22]

PROFESSORS OF THE FOGG METHOD

During the first decade of the twentieth century, many of the professors who would be teaching Barr and his generation began their careers in the division of the Fine Arts at Harvard. Upon Norton's retirement in 1898 no replacement could be found, and the "young fellows" who were products of the department were permitted to see what they could do (fig. 12). As a result, the curriculum remained largely the same; based on a scientific model, a formalist aesthetic continued to evolve over the next thirty years.

The teachers of Barr and a Harvard circle of modernist thinkers were still not trained specifically as art historians, but they did bring to bear philological and

12. Fine Arts department faculty, Harvard University, in the Fogg Art Museum courtyard, 1927. Standing (from left): Meyric R. Rogers, Langdon Warner, George H. Edgell, Arthur Kingsley Porter, Chandler R. Post, Martin Mower, Kenneth Conant; seated (from left): Paul J. Sachs, George H. Chase, Denman Ross, Edward W. Forbes, Arthur Pope.

archaeological methods as counterpoint to the aesthetic values of the Ruskin-Norton-Berenson era. They refined Norton's Ruskinian theories and set the tone of connoisseurship known variously as the "Harvard" or "Fogg" method through the 1930s.[23] Scholars trained in the Harvard method avoided theorizing in the German manner about the social and psychological context of the object. They concentrated instead on the physical attributes of the work of art and on the "grammar" of the object, an empirical approach that emphasized color and composition.

One such scholar and member of the second generation of Harvard professors was Denman W. Ross, who succeeded Moore in first giving a course for architectural students, followed by one in the Fine Arts department on the theory of design. Like Ruskin and Moore, Ross was a practicing artist. He was also a significant collector who gave important works of oriental art to the Boston Museum of Fine Arts and study material of drawings, paintings, textiles, prints, and photographs to the Fogg Museum.

Ross wrote in 1907 that he had devised a "scientific language" of art intended to "define, classify and explain the phenomena of Design." By "Design," Ross meant "order . . . particularly—Harmony, Balance, and Rhythm."[24] In the vernacular of the day, Ross felt that art, like music, could benefit from precision systems based on mathematical logic. He developed an objective system using two-dimensional "constant-hue" triangles to describe the values and intensities of individual colors. Ross's theories were widely influential with modernists such as Roger Fry, who visited him in Cambridge.

Not oblivious to Norton's teachings, Ross visited Ruskin (fig. 13) in Oxford in 1879 and followed his precepts. Ross admired the painters of the Middle Ages and the Renaissance "who used carefully set palettes and definite tone relations." Ross felt threatened by modern painters "who were mistakenly depending on visual feeling or native genius."[25]

Barr first encountered the Fogg method in a technical course covering the principles of drawing called "General Theory of Representation and Design," given by one of Ross's students, Arthur Pope. Also an artist, Pope led his students through a practicum of drawing and painting, not to increase artistic abilities but, like his progenitors, to intensify the experience of seeing and understanding the work of

13. John Ruskin, self-portrait. The Pierpont Morgan Library, New York, 1959.22.

art as a connoisseur. Also indebted to Ruskin, Pope was inspired to supplement Ross's work with books such as *Tone Relations in Painting* and *The Language of Drawing and Painting*.[26] Pope further expanded Ross's theories of technical methods in 1909. He extrapolated Ross's system of triangles of color and organized hue, value, and intensity into three dimensions on a wooden cone that he built, plotting them in an absolute relationship.[27] Students were required to make color notes when viewing works of art or to list colors from memory after leaving the museum. The development of an "eye"—a prerequisite for the recognition of "quality" and the corollary of good taste—was a rigid requirement of the connoisseur-art historian at Harvard.

Members of this generation of scholars acquired a reputation for seeking and documenting works of art in uncharted places. Also in this group, A. Kingsley Porter was brought to Harvard as a research scholar in 1920 to teach one course a semester, which Barr attended.[28] An incessant photographer, Porter traveled throughout Europe photographing the sculptural decorations of churches. By all accounts, Porter's method, which may be compared with Berenson's empiricist connoisseurship, created a new chronology of works based on comparisons of the formal qualities of sculpture revealed in his photographs. One major work, his *Romanesque*

Sculpture of the Pilgrimage Roads of 1923, consisted of one volume of text and nine volumes of photographic plates. His method concentrated closely on the object itself, with a fastidious attention to details and facts. Porter amassed a collection of some 40,000 photographs, his own and others, which he gave to Harvard.

THE FOGG MUSEUM

The Harvard method was facilitated by the accessibility of works of art and representations at the Fogg Art Museum, presided over by Paul Sachs and Edward Forbes, and was encouraged by the productive relationship that developed between the museum and the department of Art History. This pairing was one of the crucial factors in the shaping of the "Fogg Method." The approach promoted a concern for museology and supported research directed toward the accumulation of documentation and the publication of catalogues by the faculty. In addition to showing the collections of the Fogg, the museum's practice was to mount other important collections and special exhibitions by the faculty, staff, and students. One of the earliest, in 1909, was a loan exhibition of Ruskin's drawings, in memory of Norton, with a catalogue written by Pope.[29]

The Fine Arts division at Harvard was established formally in 1890–1891 and the Fogg Museum was conceived as a home for it. The museum opened in the autumn of 1895, offering the opportunity for students to concentrate in the field. Moore, who was first curator and then director of the Fogg, resigned in 1909; Edward Waldo Forbes (1873–1969), class of 1895, a grandson of Ralph Waldo Emerson and a student of Norton and Moore, was then named director. With no room at home to hang his own collection, Forbes considered sending his paintings to the Boston Museum of Fine Arts, but on the advice of Richard Norton (the son of Charles Eliot Norton), whom Forbes called his "guide, philosopher and friend,"[30] he chose the Fogg instead. He began, in 1899, to deposit at the museum, on indefinite loan, many works of classical sculpture (fig. 14) and Italian painting from the Duecento to the Renaissance. Forbes placed the original work of art at the center of the education of the Harvard student by replacing the Fogg's

14. Old Fogg Museum Sculpture Gallery.

collection of reproductions and casts with his own collection. He became director
to be near his art.[31]

A practicing artist, Forbes in 1915 reactivated Moore's program on material
and technical processes in a course called Methods and Process of Italian Paint-
ing that included a survey of all the various techniques and processes in the his-
tory of painting and sculpture. The students were required not only to replicate oil
paintings, frescoes, and tempera panels in the Renaissance manner but also to
prepare their own plaster and gesso and lay on their own gold leaf. It soon came
to be known as "the egg and plaster" course (fig. 15).[32]

Barr wrote to his parents in Chicago in the fall of 1924 describing his studies
and the course he took with Forbes, which Barr called "Technical Processes":

15. Fogg interior, fourth-floor workroom with students (in the egg and plaster course), c. 1932. From left: James S. Plaut, Perry Townsend Rathbone, Henry McIlhenny, Katrina van Hook, Elizabeth Dow, Charles C. Cunningham, Edward W. Forbes, Mr. Depinna, and John Murray.

The last is genuinely an over-all course plaster in your hair and paint in your eyes. We fresco walls, prepare gesso panels, grind colours, analyze fakes, read [Cennino Cennini] and have a glorious time of it. Haskins course [History of thought, 500–1500,] is monumental. . . . Caskey's course [Greek vases] is in the Boston Museum . . . we have the jugs before us on the table during the discussion. Oh yes, in addition I am instructing; I have one Radcliff class of twenty and one Harvard class of thirty in Edgell's course. At present I am working on a magnificent drawing of Tintoretto and on a couple of lectures on XX century engravings.[33]

On a fellowship, Barr was an instructor as well as a student.

Forbes's concentration on techniques, together with Pope's course General The-
ory of Representation and Design and Ross's course Advanced Practice in Pure De-
sign and Representation, were the mainstays of Harvard's reputation for focusing
on connoisseurship.

SACHS, THE ASSOCIATE DIRECTOR

Forbes remained true to his conservative New England education and resisted in-
cluding contemporary works of art at the Fogg. But the structure of the museum
changed when, in 1915, Forbes invited Paul Joseph Sachs, class of 1900, to be
his assistant for the ever-expanding division. His interest had been aroused be-
cause Sachs, as a former student of Moore's, had been more generous than most
in contributing funds to acquire some of Ruskin's drawings for the Fogg Museum;
they were to be a testimonial to Moore and his relationship to Ruskin. Sachs had
already inaugurated his gifts to the Fogg in 1911 with a Rembrandt print, *The Jew-
ish Bride.* When the overseers asked for suggestions for members for the visiting
committee, Forbes suggested Sachs, who later was named chairman.

At the Fogg, Sach's contribution to the art world was unique, a function of a
particular place and time. As interest in establishing museums surged in America,
he initiated a course devoted to the study of their organization and structure, an
effort that helped art museums acquire a professional self-consciousness within the
discipline of art history. The overriding aim of Sachs's philosophy of museum prac-
tices was to engage as many people as possible in the learning process. The re-
sult was a museum that would serve as an educative experience rather than merely
be a treasure house.

Born November 24, 1878, Sachs was raised in New York City amidst the op-
ulence and acquisitiveness of a prosperous family in a prosperous country. He de-
veloped a precocious interest in art by the time he was thirteen, lining the walls of
his bedroom with illustrations from magazines. Before graduating from Harvard,
with $800 inherited from his grandfather he had begun his collection of prints that
included works by Dürer, Cranach, Rembrandt, Claude, and Turner. The European
origins of his family brought him to Europe frequently when he accompanied his

father on business; there he could satisfy his passions as a bibliophile and art col-lector. By the time he began his position at the Fogg, Sachs's consummate interest in prints had given way to an equal and balancing absorption in drawings.

Sachs, financier and partner in the family firm of Goldman Sachs, brought with him to a second career at Harvard a specialized knowledge of prints that he learned as an amateur in the art galleries of America and Europe while amassing his collection. Historically, *amateur* indicated a person whose collection was of museum quality, who had knowledge of all the great collections, public and pri-vate, and who had an intimate working relationship with curators, collectors, dealers, and bibliophiles. When he was on Wall Street, Sachs's habit of spending his lunch hours browsing through art galleries was a rewarding activity because the dealers were then the specialists in matters of criticism, scholarship, and con-noisseurship. Sachs's unique experiences developed into a discipline at the Fogg.

At the age of 37, after fifteen years on Wall Street, Sachs changed his profes-sion, adapting business techniques to sustain his activities in the art world. Rather than being motivated to buy art as an investment, his ventures into purchasing art seemed to be controlled by a disciplined, long-term plan. A deep sense of orderli-ness regulated the time, energy, and money Sachs expended on his daily agenda and future goals, together with a quickness of mind shaped by his business training that enabled him to grasp the exigencies of a situation and act decisively upon it.

THE OLD BOY NETWORK

His lack of formal art education notwithstanding, Sachs's power in the art market was the basis of his success. He could name some of the richest men in America and Europe as his lifelong friends—people who served as sources for money, art loans, visits to their collections, and so forth. His European contacts included the Rothschilds, David Weill (whom he called the "present day prince of French col-lections"), and Carl Dreyfus of the Louvre.[34] Sachs's social relationships were re-sources for the expansion of his knowledge of art and the growth of his collection. According to his assistant, Agnes Mongan, he acquired the finest, earliest, and most personal collection of drawings and prints in America.[35]

Having donated drawings and prints before he joined the Harvard faculty, Sachs continued giving from his collection through the years, as well as acquiring examples of prints from various European schools to show his students in the courses he taught. He had an agreement with Harvard that anything he bought—a work of art or book—would be bequeathed to the Fogg.[36] His pride of personal possession had been replaced by the mission of building the collection of the museum and thus strengthening the Fine Arts department.

Mongan claimed that Sachs was a collector of drawings and prints before the idea took hold in America; he was, she said, the "pacesetter." He honed his collection by trading a work of art he owned for a better example—a habit to which Barr would become heir. Sachs's guiding principle was that "every distinguished collection is, in a very real sense, a work of art in itself, revealing qualities of proportion and harmony which spring from a controlling idea; a true collection manifests a sense of design."[37]

Sachs built the collections of the Fogg not only with gifts from other professors and from his own collection but also from his wealthy friends for whom he acted as guide. When Sachs could not afford to buy Titian's *Personification of Fidelity* owned by Ruskin, his father bought it for the Fogg. Friends and family not only donated works of art but also made up deficits in the budget or financed students' education. For instance, in 1922, Felix Warburg, Sachs's closest friend, and Arthur Sachs, his brother, together gave $20,000 to supplement the insufficient funds of the program. It was a self-perpetuating system and eventually included gifts from former students who, under Sachs's inspiration, had developed into collectors. A specialist in the field, Mongan with full authority wrote: "The practice of collecting drawings in this country . . . was dependent on the writing of Bernard Berenson and the teaching of Paul Sachs."[38]

During some twenty-five years, as he formed his collection of prints and drawings, Sachs cultivated and developed what now would be called an "old boy" network. Spread throughout the world, it included dealers in works of art and books, journal editors, and museum administrators, in addition to collectors and scholars. One by one the most noted specialists were invited into the classroom to share their

knowledge. By the time he retired, Sachs could boast that sixty-five scholars of international reputation had visited the Fogg to lecture to his students.[39]

Sachs used these contacts as resources for the future museum directors in his class. He involved students in the expansion of these resources as they traveled, wrote articles for publications, or mounted exhibitions at the Fogg for which they used works loaned by Sachs's associates and Harvard alumni who had already learned the Sachs method. Sent forth to Europe with dozens of introductory letters (one student might have more than a hundred such letters and cards), students were expected to add detailed information about conditions in the art world, country by country, to the lists of names and addresses, books, collections, paintings, and galleries that Sachs had been accumulating. He had been collecting the data, as he had been collecting prints and drawings, since his own graduation from Harvard. Sachs updated two "little black books" continually[40] that, in the end, were insufficient for the mass of information he collected; in the Harvard University Archives in the Pusey Library are dozens of boxes of 3×5 cards containing the accrued material. The old boy network functioned to the ultimate benefit of the students: if a student cultivated Sachs's good will, he could be assured a job; Barr's relationship with Sachs was a case in point.

From the testimony of his former students, the image of Sachs emerges of a small (five feet, two inches), fastidious man who was irreconcilably insecure about the fact that he had failed in his first attempt to enter Harvard. He inspired affection (he was referred to by his former students as Papa Sachs) but also awe. Barr would write about his mentor: "His strength of feeling led him to some magnificent outbursts of temper which everyone rather liked—except the object of his anger—because he was so forceful, overwhelmingly, and usually quite justified."[41]

To prepare himself for his new job, during the first five months of 1915 Sachs traveled across America and Europe visiting as many collections as possible, both private and public, to study patronage and museum problems.[42] Once he began at Harvard, Sachs moved quickly into the existing structure of the academic art world, serving a double role both as teacher and associate museum director. After his first year at Harvard, he was invited to give a course at Wellesley College.

Sachs's teaching career began with a course in French painting because he was a Francophile. According to Forbes, the course was "so successful" that Harvard invited him to give a course the next year on Dürer.[43]

In 1918, after having volunteered for the wartime ambulance corps, he returned from France and continued offering courses at Harvard in German and Dutch masterpieces of the Renaissance. His major teaching contributions were his courses in the history of drawings of the great masters, which he began in 1921–1922. In the next year, he began his important offering on the history of prints, including etching and engraving.[44] He also served as associate editor of the *Art Bulletin*—all of this on a self-taught regimen not unlike Barr's later involvement with modernism.

In 1895, when the Fogg Museum opened, only two professors were giving four courses; by the early 1920s, more than forty courses were offered. The conditions at the original Fogg were uncomfortable and inadequate. Exhibition space, woefully scarce, served for classroom use as well; classes also were held outside the museum. For example, Forbes found it necessary to hold his classes in Methods and Processes of Painting at his home, which proved especially inconvenient;[45] in addition, parts of the library were housed in private homes. Forbes and Sachs, aware of the inadequacies of the museum building, raised two million dollars as part of a university-wide drive in 1923–1925 to replace the Fogg.

Although Sachs politely deferred to Forbes, he had an equal if not greater role in administering the museum; together, Sachs and Forbes, known as "the heavenly twins," created a teaching museum that was a singular experiment. What had been private rituals in the "genteel tradition," enjoyed only by men of wealth who could travel extensively and collect stores of information in order to enhance their collections, became under their direction part of the academic system. Neither man was on the Harvard payroll until the 1930s when Sachs, having spent all his funds on gifts to the Fogg, began drawing a salary.

Sachs dedicated the new Fogg as "a laboratory of the fine arts"; the notion of a laboratory was consistent with the authority of science found in the critical writings of the period. The climate of experimentation and technical research engendered by Pope and Ross was further enhanced by the addition of Alan Burroughs, class of 1920. Burroughs came back to Harvard in 1925 from the Minneapolis In-

stitute of Art, where he had developed the technique of studying paintings by means of X rays. He added to the Fogg's prestige by gathering "shadowgraphs" of many paintings from museums in the United States as well as Europe. A department of conservation was set up at the Fogg in 1925 and Burroughs and George L. Stout worked in the laboratory. By pioneering a conservation laboratory, Forbes was emulating the technical explorations of the industrial and art worlds. The Fine Arts division was developing a national stance in keeping with the aims of Harvard.[46]

Sachs considered Harvard's strength to lie in integrating the technical approach with historical studies: "Technique and style cannot actually be separated as the scholar does not often possess adequate technical knowledge. The modern conservationist technician is able to offer him the results of new scientific methods of investigation to supplement or to corroborate his own labors."[47] The conservation laboratory became world famous and, indeed, was one of the means by which the tone was set for objectifying the art history approach.

THE MUSEUM COURSE

Widely recognized, Sachs's major achievement was the museum course (officially known as Museum Work and Museum Problems), which, he said, was instituted to counteract the European tendency to separate the connoisseur-curator and the university professor. Rather than teaching only "the techniques of the trade which is best learned on the job,"[48] Sachs designed the course to instill scholarly standards and cultivate visual acumen. He believed that "by combining historical investigation with study of individual works of art, connoisseurship is studied at Harvard in the 'broadest sense.'"[49]

In his teaching methods, Sachs used Berenson's techniques of concentrating on the object to develop a visual memory, of relying on photographs for comparison, of tracing scientific documentation, and of encouraging future benefactors who needed assistance. Grace Boucher, Norton's sister, revealed to Sachs that the popular courses given by Norton were as much about life and manners as about art. Sachs commented: "I know that Charles [Norton], convinced of the signifi-

cance of the fine arts as an expression of the spirit of the past, was exerting a wide influence. I was puzzled however, by what seemed to me his purely literary, non-visual approach to the subject. He spoke eloquently about Greek civilization, but failed to show large classes either original works of art or even photographic reproductions of them, although he referred now and again to books with engraved or woodcut illustrations."[50]

Not uncharacteristically, Sachs was criticizing Norton's minimal use of visual material; but perhaps Sachs was too close to the subject to realize that he was part of a shift taking place in the discipline in the United States. Sachs set himself the task of gathering photographs, slides, books, and objects to rectify the situation. From fewer than 500 photographs and less than 1,000 slides in the old Fogg Museum after World War I, the collections grew to 20,000 slides and 50,000 photographs when the new Fogg opened in 1927.[51] Sachs donated his personal library over the years to fill the gaps in the Harvard Fine Arts collection.

In his memoirs, Sachs wrote that he first conceived of the idea of a museum course in 1919 when he met Henry Watson Kent, secretary of the Metropolitan Museum of Art in New York, and they discussed the need for trained museum personnel. Sachs was impressed with the advances Kent had made at the Metropolitan: the educational procedures, the exhibitions promoting relations between art and industry, the high standards in museum publications, and the pioneering work in American decorative arts. Sachs designed a course of study for future museum workers from his observations of Kent, whom he considered a model for museum administrators—well-trained scholar, specialist, good speaker, and writer with "a bowing acquaintance in other fields."[52]

Sachs was already aware of the one-year course of study in museum work given at Wellesley for graduate students. Set up by Myrtilla Avery in 1910–1911 for the training of art museum assistants (it was assumed then that women would not become directors), the course, given sporadically, included art library and office training as well as care of objects, exhibit design and installation, and methods of museum instruction.[53] Having served as an instructor in the museum course at Wellesley while he also taught a course in French painting, Sachs solicited advice and printed material from Avery for his own course.

Yet the story of the beginning of the museum course is more complicated. In the summer of 1925, at Sachs's request, Barr wrote a critical evaluation of Sachs's print course that he had taken the previous semester. Sachs had solicited the entire class for anonymous evaluations. Barr answered with a ten-page letter, ignoring the cloak of anonymity because he was sure his "critique would be transparent."[54] It was the first letter of a forty-year correspondence. In it he encouraged Sachs to contribute his own knowledge to the course instead of quoting others. But, more significantly, Barr outlined a detailed historical survey of printmakers using a method similar to that of Morey at Princeton.

After working for five days culling information from articles by "Leiris and Friedleander and others," Barr drew a chart for the evaluation, organically connecting the artists from different countries through the centuries and thus showing various influences (see fig. 4). "Simplified," he wrote, "it might be of use because it would combine at one glance geographical distribution."[55] The diagram conveyed the comprehensiveness of his mind and his need for viewing particulars in a system not unlike those in a scientific hypothesis. Perhaps the first of many such charts that Barr constructed, it was a prototype for the kind of chart he would use to graph various styles and trends, in particular the renowned chart that he drew for the catalogue cover of the "Cubism and Abstract Art" exhibition (see fig. 5).

The letter discussed Sachs's lectures on the history of prints, century by century, expanding Sachs's coverage in places, contracting it in others: too much Dürer, too little Altdorfer in the sixteenth century; in the seventeenth century, "we would have appreciated a discussion of various landscape traditions . . . too many inferior prints were shown and the discussion of the great prints was too external." Barr omitted the eighteenth century because he could find no common denominator, either in form or in genre, that would enable him to categorize the prints of that era: "It was a difficult century," he wrote, "to make coherent through prints alone. It has no *zeitgeist* which will explain them."[56] He felt that Sachs should not have neglected the nineteenth century with such artists available as Cotsman, Menzel, von Lieberman, Slevogt, Corinth, and Köllwitz. He also appealed for at least five lectures devoted to the twentieth century that could include such artists as Pascin, Steinlen, and so forth. He thought that the "marvelous collection of Japanese prints

in the Boston Museum of Fine Arts" should be included in the course because "of their beauty of line, design and color. Their collectibility, their popularity—they are more a part of our lives than any group of European prints."[57] (Barr's experiences at the Boston Museum of Fine Arts—he visited it once a week for a year—was one of the reasons he would later consider, as a topic for his dissertation, "primitivism" as a source of modernism.[58] Any art that was nonclassical was considered primitive at that time—for instance, pre-Renaissance Italian art.)

In the print course, Sachs's pattern was first to give an overview of the technical processes used by the artists through the centuries, and then, in the latter half of the course, to discuss the works. Barr thought the two parts should be integrated: "Taking the technical matter at a gulp seemed to me indigestible and a little tedious. [A] more vivid relation [should] be established between process and master."[59] Barr's criticisms were explicit and mature. They presaged the modernists' interest in art as process, and Sachs agreed with him. By integrating "process and master," Sachs's course reinforced the Fogg method.

Barr's letter continued, fervently acclaiming Sachs as "the greatest collector" he had ever known, and the "most modest lecturer. . . . I wish you had talked about dealers, auction catalogues, states, prices—the story of your outbidding the British Museum . . . for the Pollaiuolo[60] was one of the memorable moments of the course. I wish you had told us more of your own feeling for prints, you loved them before most of us were born, but your modesty made you quote Campbell Dodgson [Keeper of Prints at the British Museum], Roger Fry, [William] Ivins [Curator of Prints at the Metropolitan]. I wish it hadn't."[61]

Sachs was on a leave in Rome in 1925, and awaiting him when he returned was a pile of forty-seven letters from the usual friends, students, dealers, and collectors, including the one from Barr, which delighted him. He wrote back that "among these not one that has interested me more or one that I value more highly, than your perfectly frank letter with its full *constructive* criticism of my Print Course. No one has ever given me such real help during my ten years of teaching and so I am very grateful indeed."[62]

Sachs's answer to Barr was detailed and point by point. He responded on what he called "*The Art of Collecting:* that is a subject about which I certainly do feel I

have a right to talk—but can I do it in the Class Room? I did so much of this in my Museum course and also the French Course—that I suppose I felt that every student I met must have heard it all from me until he was sick of it."[63]

He continued on the subject from a personal perspective: "*On Collecting & My Personal Opinions & Enthusiasms:* These I had hoped to dwell on at meetings at Shady Hill which I hoped would be frequent—but which the pressure of *many* things made too infrequent. Now that we have the new Building etc etc I hope to have the Print Course meet at my house once a week in future. It is encouraging to hear that in your opinion students care about that sort of thing for *of course* I care a lot since all this is so very much a part of my life."[64] Sachs later penciled in the comment, on a copy of Barr's letter, that it was immensely valuable and led to the museum course where "I thought many things about collecting better handled than [in an] historical undergraduate course."[65] If Barr's letter didn't actually lead to the museum course, it led to expansion of it.

A form of Sachs's museum course had already been in place when Barr arrived at Harvard; the first class (a half-year course) was offered in 1922 and had one student, Arthur McCoomb.[66] Five students enrolled in the course in 1924–1925. Sachs's reputation was spreading and in the year 1926–1927, when it was offered again in an expanded fashion, interest in the course surged, with over thirty students attending.[67] Among those listed in the museum course in this pivotal year were Kirk Askew, A. E. Austin, Henry-Russell Hitchcock, James Rorimer, and Paul Vanderbilt. All had illustrious careers in the art world and were important to Barr's career. Sachs commended Vanderbilt and Barr as being his best students. Vanderbilt later worked at Weyhe's bookstore and was the librarian at the Philadelphia Museum of Art.[68] While Barr was listed as attending the course, he no longer was registered as a graduate student and the course does not appear on his record. At one time, when asked to describe the museum course, he wrote: "I am afraid I am not a graduate of Professor Sachs' course in Museum work at Harvard. While I was teaching I visited the course several times but did no work in it and could not give an authoritative account of it."[69] Nonetheless, he absorbed the essence of Sachs's museum concerns.

Sachs bought Norton's home, Shady Hill, and lived there from 1915 to 1953, filling it with his own "spoils" of European art. Students gathered there regularly—as Sachs promised—where they had the advantage of being surrounded by his personal collection (fig. 16, here shown at the Fogg Museum). Mongan described her experiences with his method: Sachs would sit behind a little desk full of art and books; on the top shelf of the bookcases were various objects—ivories, Syrian bronzes, Chinese sculptures; taking down a painted terra cotta, he would query the students: "Now what do you think of it? What does it say to you?"[70]

Mongan was asked Sachs's usual question: Would she or wouldn't she acquire it for the museum collections? Having studied with Clarence Kennedy of Smith College for her master's in art history and having spent the previous year looking at Quattrocento sculpture and painting in Italy and France, she had no trouble answering the question. Kennedy had his students clean interstices of the sculpture with distilled water, cotton, and toothpicks so that he could photograph them "as Desidero wanted it." She identified the artist of the bust for Sachs, even though the proportions were wrong because the flowered garland was cut off from the bottom. Building on this impressive beginning, Mongan subsequently secured the job of assistant to the associate director of the Fogg. She traveled to Europe and, as a favored student, she was armed with fifty letters of introduction from Sachs to the British, the Victoria and Albert, the Louvre, the Uffizi, and the Brera museums to extend her expertise in drawings. As Sachs's assistant, she became world renowned as a specialist in prints and drawings.

Other students reported on being faced with a table full of objects—with some important works placed among discarded junk—and given the task of assessing their value. Using a Socratic method, Sachs queried the students as to probable origin, meaning, state of conservation, comparable object, and bibliographical data. His teaching was based on an empirical method of close observation of the object and careful recording of that observation.[71]

At times accompanied by Sachs, students made frequent visits to local museums where they would be required to choose the best painting in the gallery or memorize the works of art in the order they were hung on the walls.[72] Students were expected to make a daily habit of examining art works. Sachs combined

16. Paul J. Sachs with a group of students in the Naumberg
Room of the Fogg Art Museum, 1943 or 1944.

this program for developing visual memory with detailed expounding on the
state of the art world. He named some of the best dealers and their specializations,
as well as the strengths and weaknesses of various private and public collec-
tions.

The outline of the museum course that Sachs distributed each term to his stu-
dents allows a closer look at his method. Topic headings include: The Museum: Its
Philosophy, History, Organization, Building, Administration, Collections; Person-
alities in the Art World; Policies and Ethics. Not surprisingly, Personalities in the
Art World had its own topic heading. Along with Policies and Ethics, the Person-
alities lectures offered Sachs the opportunity to relate his most personal experi-

ences. The anecdotes, illustrative of the indirect method Sachs used, embodied a set of values, modes of conduct, patterns of establishing relationships with collectors, and procedures for acquiring art works of high quality.

Sachs's gossip and reminiscences about the cast of people who generate the art enterprise are indispensable to the functioning of the museum world. Directors must be social; museum people need to know who is married to whom, where the money comes from, who is collecting what, where to go for a loan, who is talking or not talking to whom. Sachs would later boast that Barr and his assistant, Jere Abbott, were "helped immeasurably in assembling material for exhibitions by knowing who the collectors are, and where the important works of art are to be found; knowledge assimilated while working at the Fogg."[73]

Sachs's expectations for his students were implicit in the narrations listed under Personalities.[74] A typical story would be how the founding of the John and Mable Ringling Museum of Art in Sarasota, Florida, evolved from the needs of a small circus. With his wife Mable as the trick rider, John Ringling and his brother started the circus. "Gradually the circus grew and with it John's fortune, as he was in the habit of investing in real estate and railroads all over the country." In the interest of better advertising, Ringling bought art books with animal illustrations by artists such as Delacroix, Van Dyck, and Rubens; his interest then turned to the works of art themselves. Ringling spent his summers abroad buying animals and old masters' paintings. He built a "very fine collection . . . by constantly sifting and adding," and housed it in the museum he founded in Sarasota, his winter headquarters for the circus.[75]

In addition to imparting his knowledge of collections and museums, Sachs read his mail to the students and offered personal impressions of his correspondents. He exhorted his students to visit Dr. Kurt Weigelt, the Sienese painting specialist of the Kunsthistorisches Institut in Florence, "trained with that fine German discipline." Sachs felt that Weigelt was kind and would go to a great deal of trouble to aid students, not only in their work in the library but also in taking them on field trips. Another friend of Sachs was Carl Dreyfus at the Louvre, "a very kind hardworking man [who] will be very helpful to the serious students."[76] Sachs peppered his anecdotes with directives on the students' behavior, implying promised rewards for good conduct.

The course notes reflect a kind of associative method that necessarily wandered over an impressive accumulation of facts but that had, in the end, a basic integral quality strengthened by Sachs's compelling enthusiasm. Because he considered the museum a "laboratory," he insisted that "everything going on in the building should be 'grist to the mill.'" For example, upon moving the Warburg tapestry from the Great Hall at the Fogg, he asked that the students note "How it was hung? How packed? Where bought? How should it be transported to New York? How insured? Etc."[77]

Probably because of his focused interest in the market, Sachs believed that the important future contributions to the field of art history would not be made in large surveys or biographical studies but through scholarly periodical material. Students were assigned to write reviews and articles that were published in such journals as Arts, the Nation, and the Saturday Review of Literature. Because he was a confirmed bibliophile, he was thorough in surveying books and bibliographies.

Sachs read articles from the Art News regularly as a text for the course, choosing various names from the magazine and building lectures around them. For example: "Botticelli, owned by Wildenstein; why was it not included in the Philadelphia acquisition?" or: "William R. Hearst, numerically one of the world's greatest collectors," who, Sachs related, "purchased a wrought iron gate, knowing that it was a forgery. He generally buys through Joseph Brummer, the best of characters in dealers' circles, the most knowing."[78] He related the story of Brummer, who came to Paris from Romania and with great enterprise sold objects from one shop to another. He thought Brummer "the most skillful cleaner of sculpture in America."[79] After cleaning "a hideous 17th century Spanish Crucifix," Brummer recognized that it was an 11th or 12th century object that was very valuable. He sold it for $10,000 to Isabella Stewart Gardner, who bought it from a photograph on her own initiative without anyone's advice. These stories were told with irony, for Sachs was firmly convinced that prices that had been rising since 1914 would come down.[80]

Sachs also described the organization of such museums as the Vatican, the Louvre, and the British Museum, and was able to send his students to staff members at those places to see for themselves how the museums were run. He showed slides

of American museums and discussed their physical plants. Although some of the information now seems self-evident or trivial, it was unassembled then and Sachs described an otherwise unavailable picture of the art world to his class. He seemed to believe in keeping nothing secret. His course was built on revelations of sources secured by fraternity and cooperation. But because the museum world is rife with sensitive issues, he would caution his students that the information was confidential.

Over the years, Sachs accumulated stories from the transactions of his former students that illustrated museum ethics. One later story involved Henri Rousseau's *The Sleeping Gypsy,* 1897 (fig. 17), acquired by Barr in 1939 for the Museum of Modern Art. Of all the Museum's masterpieces, Sachs felt that it was one of the most important paintings influencing public taste. Barr had first seen the painting at the "Memorial Exhibition for John Quinn" when his collection was put up for sale in 1926 at the Art Center in New York. Barr thought Quinn had the best collection of contemporary art in America at the time and he told Sachs that Rousseau's painting—"more than anything else in a show of wonderful pictures"—had made a profound impression on him.[81]

The critic Louis Vauxelles had discovered *The Sleeping Gypsy* at a small charcoal merchant's establishment; it had been traded by Rousseau. Daniel-Henry Kahnweiler, the Paris art dealer, bought it in 1924 and put it in his cellar. He then sold it to Quinn through Henri-Pierre Roché. The ethical issue arose around the question of the painting's authenticity. Sachs told his class that Barr, "meticulous as always,"[82] made sure that all the members of the committee knew that the painting was suspect. Among those who doubted its authenticity was André Breton, "the Surrealist Pope," who, in spite of claiming Rousseau as a precursor of the surrealist movement, attacked the Museum for "palming off a forgery on a gullible public." Nevertheless, the trustees honored Barr's judgment and supported the acquisition.[83]

Future collectors and potential museum curators were lured into Sachs's system by the expectation of visiting the great collections on the East coast, a yearly ritual for all his classes. At Christmastime, Sachs took his students to New York, Philadelphia, Washington, and Baltimore to see collections in the homes of Sam Lewisohn,

17. Henri Rousseau, *The Sleeping Gypsy*, 1897. Oil on canvas, 51 × 79 in. (129.5 × 200.7 cm). The Museum of Modern Art, New York, Gift of Mrs. Simon Guggenheim.

Henry McIlhenny, Etta and Claribel Cone, Robert Widener, Lessing Rosenwald, and Robert Lehman. The students were primed beforehand on the details of how these great collections had been formed. If Sachs couldn't accompany them, they were given his personal calling card as introduction, but they were warned not to let the card out of their possession.

Barr reported to Katherine Gauss on April 25, 1925: "Yesterday a rich professor took me down to New York for a couple of days in a compartment on the sleeper—went to see Kohn's, Fricks's, Friedsam's, Sir Joseph Duveen, Morgan Library. Miss Frick has 3 Vermeers on a single wall, I nearly swooned. Sir Joseph was a messy old bird—hopped about and pirhouetted and chuckled—said he's got Henry Ford to buy pictures."[84]

Another class project was to compare the four museums in the Boston area: the Isabella Stewart Gardner, a private collection; the Worcester Museum, a major

museum in a small city that, under Henry Francis Taylor, changed to a more modern direction; the school museum of the Rhode Island School of Design, a local institution endowed by the Nicholas Brown family; and the Boston Museum of Fine Arts, a national museum that dwarfed the others. One of the problems they were asked to confront was to describe how the collections were formed. Sachs arranged for his students to visit with the directors of the various institutions who would speak to them about museums and the behind-the-scenes activities.[85]

The students also visited galleries, particularly the pre-Columbian gold vaults of Sachs's friend Joseph Brummer. Sachs considered Brummer and Curt Valentin the most helpful dealers for museums and for his students. Brummer, who became an American citizen in 1921, was a sculptor who had studied under Rodin. Sachs called him a "most gifted, versatile and discriminating dealer,"[86] who gave Constantin Brancusi his first American exhibition. Valentin, who began as a dealer in Germany in the Buchholz Gallery, came to the United States and opened a branch in New York in the 1930s. He then went into business for himself under his own name and, according to Sachs, had "the best gallery for modern sculpture in America."[87] His charismatic persona strongly attracted Barr and they became close friends. Valentin proved hugely generous to the Museum through the years.

Sachs told stories that illustrated his strategy of interesting benefactors in the Fogg. One related to Felix Warburg, who had donated half a million dollars to the Fogg building fund. This contact dated back thirty years; Sachs had always known the family, and Warburg, ten years older than Sachs, also loved and collected prints. Sachs told his class that at one time he warned Warburg that a dealer was treating him unfairly. Another time Sachs alerted Warburg about an extraordinary collection of prints that had come on the market, and Warburg bought it. Having made an ally of Warburg, Sachs approached him as an equal donor in establishing a strong collection of prints at the Museum of Fine Arts in Boston (before World War I). Neither man had any connection with Boston, but they made these gifts "from a purely disinterested desire to further interest in prints." By the time Sachs had to raise money for the new Fogg, Warburg had been primed.[88]

About the same time, Warburg asked Sachs, as a family friend, to look after his son Edward W. W. Warburg, who was entering Harvard. However, young

Warburg chafed under the sharp scrutiny of Sachs and scoffed at the introductory letters he gave to his students because many times the recipient didn't know Sachs and the student would be embarrassed.[89] The younger Warburg finally took advantage of his connection with Sachs when, in 1929, Lincoln Kirstein, John Walker, and he mounted exhibitions at the Harvard Society for Contemporary Art with some of the works of art that came from Sachs's network.

Sachs revealed other successful strategies in acquiring gifts for the Fogg. For example, invited by Henry Francis Taylor to see the Degas prints on view at the Worcester Museum, he boned up on the artist's works. As a result, his detailed knowledge earned him the respect of Taylor, and the Fogg received the entire collection as a gift.

Learning from Sachs, Barr in his own career also enticed prospective donors by advising them on their collections and by mounting exhibitions from which the collector could buy a painting, which, he hoped, would later be given to the Museum of Modern Art. Barr's work at the Museum was informed by Sachs's belief that a permanent collection provided a "stabilizer or measuring rod against which temporary exhibitions might be evaluated."[90] Barr learned the intricacies of the international art market from Sachs as well as techniques of museology such as care of art works, conservation, installation, lighting, acquisitions, documentation, patronage, and how to improve visual memory.

Perhaps the most significant organizational framework that Sachs attempted to put in place in the museum world was a moral order. Recognizing lapses in decorum, Sachs stressed the need for ethical behavior by a museum staff. Some of it was self-evident, some of it an attempt to overcome ignorance in a developing field, and some was in reaction to the questionable pressure exerted by dealers on museum personnel. Included in the ethical stance that Sachs advocated was a more responsible personal mode of conduct. He proposed avoidance of destructive activities such as gossip and jealousy while emphasizing cooperation, courtesy, and generosity as key practices for museum staff.

The single most important rule, rigidly followed by Sachs, was that the museum collection came before a personal collection. Sachs felt that to keep the lines between them clear, a curator should not collect in the field in which he curated. He

also suggested a corollary: "no museum official or worker may honourably accept any commission, gift or tip which may be offered by a business concern as an inducement to do business with it. Only the museum itself is entitled to the discount customarily allowed with a large volume of business or prompt payment of bills."[91]

Barr adhered to these stringent requirements. During the years that he made acquisitions for the Museum of Modern Art, he refused all personal gifts by artists and bought for himself only what the trustees refused to acquire for the Museum. Only once was he forced to violate his own rules—when Picasso said that he would sell his *Minotauromachy* print (fig. 18) to the Museum only on the condition that Barr accept another one as a gift.

Not so strangely, considering the nature of the museum world, Barr's taciturn and secretive temperament helped him observe Sachs's dictum of maintaining the proper distance in relationships with dealers. Barr had no problem in being circumspect with dealers, artists, or patrons. Sachs thought Barr not only taciturn but "humorless as well."[92] Still, Barr was his "favorite and most gifted student."[93] He was wrong, however, in his judgment of Barr's humor. Barr was, again, simply being circumspect.

On another subject, Sachs admonished museum administrators not to "expect services of lecturers etc. for nothing—it pauperizes the profession." In contrast, Berenson's questionable behavior in mind, he advised them not to make attributions for personal gain. Further, "Do not interfere with negotiations by another museum. Cooperate by exchange, sale, or otherwise so a rare object may be placed where best studied and kept in association with closely related objects. A museum should give willingly and courteously any information regarding finances, methods and researches which may be asked by another museum."[94] Considering the sudden spurt of newly founded museums, Sachs demonstrated his creative genius by seeking to establish an all-encompassing art world structure, even though it was naïve and idealistic to expect a lack of rivalry.

Sachs spelled out the prescribed relations of a director with the trustees: although the director had the right to expect wide privileges, he still was responsible for keeping the trustees completely informed. Furthermore, Sachs said, "He should not expect or ask any action from his trustees until they understand what he

18. Pablo Picasso, *Minotauromachy*, March 23, 1935. Etching and engraving, printed in black, plate 19 1/2 × 27 3/8 in. (49.6 × 69.6 cm). The Museum of Modern Art, New York, Abby Aldrich Rockefeller Fund.

asks them to consider; if the action is contrary to his wishes he should patiently wait until conditions have changed before presenting the matter again. As curator, have your director understand just what you have in mind. Use your reason to force your point not your personality alone."[95]

Barr was said to have "a fine Italian hand" in dealing with trustees.[96] That is, without seeming willful, he could maneuver the trustees to support his proposals for the museum; unfortunately, it was an ability that, at times, would work against him.

Sachs preached about the use of authority: "Don't use any 'pull.' Avoid favoritism. During business hours stick strictly to business. Be sincere, frank, but tactful." On every level, Barr fit the description of an ideal museum administrator. According to Margaret Barr, her husband was "charming and tactful, circumspect,

serious, diplomatic—never said a tactless thing."[97] In Sachs's opinion regarding the relation of director with staff: "the director should see that the staff are given every opportunity for advancement within the organization. Avoid breaks in enforcement of rules. Be fair." In his view of the relation of staff to director: "Be loyal. Have a sense of responsibility, a respect for authority."[98]

Interspersed throughout Sachs's lectures were homilies that reflected the moral tenor of the times—notions that Sachs believed would give guidance to and create a professionalism in his young students: "No one will succeed in the museum world if he intentionally gives pain; nor should one be too reticent. As the scholar grows so does the museum man; there is no substitute for experience; success begets self-confidence. No one person can have all the best qualities: find out where your strength lies, and build on it."[99]

Sachs also strongly believed that the aesthetic taste projected by the museum in its exhibitions, collections, publications, and so forth should be in the control of one man, ideally the director. Decisions made by committee, he thought, offered no "taste" at all. Through the years, Sachs's fidelity to this concept gave Barr the strong support he needed in his relations with the trustees.

Because Barr fulfilled Sachs's expectations of the ideal director, after Barr's first year at the Museum of Modern Art his mentor praised him highly. Sachs realized that the combination of connoisseur and scholar was rare and difficult to maintain.[100] He told his classes: "The director is going on knowledge that he accumulated in calmer days; no man can live under pressure and not regress in the field of art. A director must have time to move about—time for travel, study and leisure. He cannot go without looking at works of art every day of his life."[101]

The most effective technique in training museum personnel, according to Sachs, was what was to be learned from doing a "'real' project" rather than classroom work. His students visited bookshops and print shops to make suggestions for acquisitions by the Fogg Museum. In effect, they were performing Sachs's own job. Or they would mount exhibitions, obtaining loans from Duveen, Kraushaar, and Wildenstein, who, Sachs said, were the most cooperative. He felt that students would learn on the job just as he had done upon arrival in Harvard in 1915, when he curated a show of Italian engravings.[102]

Sachs also established important new aesthetic parameters in the area of installation. Students were taught to hang works of art chronologically and in one low line, contrary to the European method of "skying" the works and covering every available space.

Denman Ross, who was given a gallery at the Fogg to mount his collection, refused to follow Sachs's suggestions because he felt that too many works would then be denied space. Sachs used this as an object lesson for his students. He visited the Ross Study Room with his class to compare it to the Fogg's oriental gallery. To Sachs, the Ross Room represented "from one of the greatest and most catholic collectors in America—the worst possible example of modern installation."[103] Ross was not interested in the appearance of the room as a whole but in the accessibility of the individual object; Sachs disagreed. Although he did feel that every object in a museum should be available for study, "the room itself should be a work of art, created by an artist to arouse the interest of artists."[104]

Keeping to the letter of this law, Barr became famous for his installations, hanging his exhibitions at the Museum of Modern Art with the education of the viewer in mind, as well as presenting a pleasing spectacle. In Barr's exacting view, nothing escaped his scrutiny for quality; he was known, for example, by his colleagues at the Modern for standing an inordinately long time contemplating and choosing the lettering on the washroom door.

Pointing to the example of scientific historical museums, Sachs promulgated the mounting of "clear and informative" labels, instituting an innovation for art museums. He considered showmanship and administration the most significant contributions of American museums. Barr practiced this formula when he mounted the modern print exhibition for Sachs in 1925, and he continued it at the Museum of Modern Art.

The attributes of a trained curator, listed by Sachs, did not differ too greatly from those of a university scholar; these included several abilities: to select the "best of a type";[105] to be conversant with the literature of the field; to publish learned articles, authoritative catalogues, and catalogues raisonnés.[106] The curator was responsible for the care of objects in the museum, calling on the expertise of the conservator when appropriate. In addition, the cultivation of a visual memory was

required to aid the curator in making prompt decisions in auction rooms or the marketplace; further, he needed to confirm with care first impressions for possible acquisitions.

Sachs repeatedly stressed the significance of forming a collection of the highest quality and of "bringing to bear upon their interpretation the highest curatorial scholarly standards. In America the Museum is a social instrument—highly useful in any scheme of general education."[107] The concept of the museum functioning as an educative tool was democratic in aim and peculiarly American.

Sachs also explicitly charged the curator with the responsibility for being a connoisseur. He defined *sensibilité* as a combination of knowledge, senses, and instinct.[108] Besides books and photographs, "he must also, each day, study originals."[109] Sachs explained that the connoisseur, before the development of art history in universities, gained knowledge "by travelling, collecting, by comparison of works of art, by combining visual experience with the knowledge of literary sources, laying the foundation for the art historian."[110] Sachs, of course, was talking about himself. Citing some of the great connoisseur-scholars of the recent past, Sachs mentioned Berenson, who combined "instinct, *sensibilité* with solid scholarship. Something more than connoisseurship has developed within the last fifty years."[111] Sachs was coming to grips with the fact that the connoisseur had moved into the academic environment where he studied art as if it were a scientific discipline, as opposed to the approach of the nineteenth century when he would have valued and studied art for its moral utility as part of the genteel tradition.

This new breed of art historian included Heinrich Wölfflin, Alois Riegl, and Max Dvorák in Europe; Chandler Post and Arthur Kingsley Porter at Harvard; Allan P. Marquand, Frank Mather, Charles Morey, Albert Friend, and Millard Meiss at Princeton; Walter Cook, Walter Friedlander, and Richard Offner at New York University. Sachs saw these scholars as unsatisfied with limiting themselves to analysis and classification of single works of art. "Their aim," he wrote, "is to interpret the stylistic development and cultural background of whole periods and to set the works of art in relation to a complex background."[112] Two concepts distill Sachs's artistic philosophy: modern art as inseparably linked in history to traditional art, and the romantic notion of the rebellious genius, unencumbered by extrinsic fac-

tors, as the taproot of innovative art. Inherited from Norton, these concepts were passed on, whole, to Barr.

With this attitude intact, Sachs manned the staffs of the most important museums of America with his students, including A. Everett Austin of the Wadsworth Atheneum, John Walker of the National Gallery, James Rorimer of the Metropolitan Museum of Art, Henry Sayles Francis of the Cleveland Museum, Otto Wittmann of the Toledo Museum, Henry Francis Taylor of the Worcester Museum (later of the Metropolitan Museum), James Plaut of the Institute of Contemporary Art in Boston, and, of course, Alfred Barr of the Museum of Modern Art.

Sachs complemented Forbes both in personal style and in his market knowledge. Less conservative than Forbes, Sachs was more open to the new trends in art. Perhaps his interest in modernism was the result of the climate of the times; more likely, however, it reflected his close relationship with Barr. Mongan confirmed that Sachs was "not terribly taken with contemporary art. He was able to see if any artist had a command of line—what his gift was. Barr taught Sachs modernism." Sachs, she said, appreciated Barr's "sensitivity and conviction," so that a recommendation of a work of art by the young student required a second look by Sachs—a respect accorded no other source.[113]

Barr conscientiously followed Sachs's lead in museum techniques and ethics, but Sachs's ability to grow with Barr into areas of radical art was restricted. He made purchases of works by twentieth-century artists such as Hopper, Levine, or Matisse but resisted pure abstraction or expressionism. Sachs's ultimate ruler was "good taste," in keeping with the Harvard educational tradition initiated by Norton; an early Picasso drawing, *Mother and Child* (fig. 19), was as far as Sachs would go. Counteracting this limiting factor was Sachs's unmistakable passion in his approach to all forms of art. An attitude akin to aestheticism placed him in Berenson's rather than in Norton's camp.

Mindful of the excesses of Norton's literary style, Berenson pushed the parameters of the discipline toward a formalist perspective. Sachs and Berenson occupied pivotal positions between the founders of the Art History department and the scholars who would develop a more radical art criticism that would eventually be labeled "formalism."

19. Pablo Picasso, *A Mother and Child and Four Studies of Her Right Hand,* 1903–1904. Black crayon on tan wove paper, 38 × 26.7 cm. Fogg Art Museum, Harvard University Art Museums, Bequest of Meta and Paul J. Sachs.

Barr greatly benefited from Sachs's formalism, but he was able to move beyond it. He built a structure that combined Morey's historical categorizing with the formalist leanings of Sachs.

BARR LECTURES ON MODERN ART

Toward the end of his graduate studies at Harvard in 1925, at the request of Sachs, Barr gave a lecture on a survey of nineteenth- and twentieth-century prints to his fellow students. This was part of the print course that he thought required at least five lectures devoted to twentieth-century prints, as he later wrote Sachs in his critique of the course.[114] In demonstrating the knowledge he had accumulated, Barr initiated his career in modern art. The notes for this lecture reveal Barr as a somewhat petulant though well-informed graduate student who complained that it was impossible to cover the subject in the hour that Sachs allotted to him.[115]

Barr arranged the slides of the prints he showed in categories of subject matter—animal pictures, portraits, landscapes, and so forth—instead of presenting them chronologically. He suggested that this was "a novel and somewhat naïve way" aimed at demonstrating how "the same pictorial material [could be] approached in diverse interesting ways [with] emphasis on the texture of fur and feathers, the suggestion of movement, of the play of light, of sculpturesque form, of composition, or of decorative qualities."[116] Though Barr might appear to be succumbing to the illustrative elements of the works of art, not unexpectedly, he treated the subjects with a formalist approach that stopped short of any interpretation while stressing the technical concerns of the artist. Rather than declaiming on each slide, he showed many slides, with an occasional sentence of exposition. Barr said that he would emphasize "neither personalities nor chronology nor nationalities." His purpose was to show a series of comparisons from which students could draw their own conclusions: "I hope you will not find anything I say worth writing down—it will take your eye from the screen."[117] The result was that he spoke very little, a pattern of lecturing he maintained for the rest of his career.

Barr covered the nineteenth century as well as the work of Picasso and Matisse, describing etchings, drawings, lithographs, and woodcuts in terms of light, atmosphere, composition, decorative line, and simplification. Again, he followed the lines of influence from one artist to another, as he had done for Sachs with the artists of the earlier centuries. Typical brief descriptions were statements such as these: "Max Liebermann is the greatest of the German Impressionists. His draughtsmanship is close to Manet, but even more dashing" and "Camille Pissarro adds a new note of simplification to the etchers of atmosphere and light."[118] After commenting on many nineteenth- and early twentieth-century modern printmakers such as Eugène Delacroix, Pierre Bonnard, Edouard Manet, and Henri Matisse, he summed up Pablo Picasso's draftsmanship in the etching *L'Aveugle*: "This early work by Picasso is I think one of the great etchings of the twentieth century. His tendency toward simplification is apparent."[119]

Also in the spring of 1925, Sachs broke new ground when he allowed Barr to receive academic credit for "Special Study, Engraving, Etching and Drawing," for which Barr mounted an exhibition of avant-garde works at the Fogg, accompanied by wall labels. Barr thanked Sachs for "your *carte blanche* which enabled me to assemble the material for my experiment with modern prints."[120] The first full-blown installation of Barr's career, it revealed the formalist pattern and tone he would adopt for the Museum of Modern Art. Wary of rhapsodic rhetoric, his prose was limited by the struggle to find categories and vocabulary to position the work. The concepts he expressed in the catalogue showed a remarkable range of knowledge and comprehension of modern art that only deepened over the next forty years.[121]

Although the exhibition was, on the whole, a demonstration of the avant-garde movement of the School of Paris, it opened with a display of English graphic artists:

England is singularly rich in calligraphic decorative draughtsmen such as Blake, Burne-Jones, Charles Ricketts and Aubrey Beardsley. But she was singularly poor in naturalistic draughtsmen. Among such continental masters as Daumier, Menzel and Forain, Charles *Keene* is the only Englishman worthy of mention. His

line is admirably brief and profoundly witty. He was one of the greatest English artists and is much neglected in England and America.[122]

(When the name of the artist was underlined by Barr, it indicated specifically the artist whose mounted work the label was describing.) He still used the word "decorative" to describe paintings whose forms were flattened; only subsequently, perhaps in the 1930s or 1940s did the term acquire for him a pejorative connotation as the "merely" decorative.

In the wall label for a Chagall drawing, Barr displayed how currently informed he was about the new movement of dada, but here, stretching its definition, he might instead have meant the newer movement, surrealism. He also noted modernism's affinity with children's art—a concept that intrigued him continually as he followed the lead of the avant-garde artists:

> The art of Marc *Chagall* is partially DADA—that is, it recognized no rules, no precedents, and no traditions. In drawing and composition it suggests no aesthetic intention of a visual nature. The interest is literary more than pictorial, psychological but not logical. It lies in the assemblage of objects and ideas the relation between which is tenuous but piquant. The selection of these objects is not always rational—the representation of them is intentionally naïve. Like Stravinsky, the musician, Chagall looked to Russian folk art for stimulation. The result is perhaps comparable to Hey Diddle Diddle the Cat and the Fiddle—or to the drawing of an untrained child—but there are subtly sophisticated overtones. Dadaism came as a reaction against all order and discipline in art and life. The movement was short-lived and carefully futile—but it had certain emancipating effects.[123]

The baffling phrase "no aesthetic intention of a visual nature" probably connotes Barr's lasting disapproval of Chagall's work.

Barr retained the concepts he learned at Harvard; his descriptions utilized the language of formalism and were inserted into the chronology of art history viewed with modern eyes. In his description of Renoir, Barr observed that in his later work

the impressionist studied light not for itself "but as a means of evoking form by abstract light and shade—much in the manner of the Italian masters of the Renaissance."[124]

In discussing Redon, Barr revealed his fascination with those artists whose aim was to express the ephemeral order of human experience. Contrary to the general opinion that he overvalued the rationality and progressive aspects of abstract art, Barr's view of modernism was tempered by his mystical bent; he discussed the concept in a historical context: "One may mention Goya and other predecessors in strangeness but this does not explain Odilon Redon. Though he was born in 1840, he is very modern because he strove to explore the esoteric regions of his own spirit."[125] Although Barr resisted those who attempted psychoanalytic interpretations of art, as a man of his time he believed in the unconscious as a source of creative expression.

Barr displayed a thorough understanding of Cézanne's work and his contribution to modernism. He had an abundance of critical writings from which to draw because the importance of the artist was well documented, particularly in the formalist descriptions of Fry and Bell. Reacting negatively to Ruskin's demands for moral content in art, the English critic Fry contended that Cézanne became "a supreme master of formal design. . . . All is reduced to the purest terms of structural design."[126] Using these criteria, Barr noted that Cézanne, under Pissarro's supervision, "strove to evoke plastic forms by powerful synthetic drawing, to arrange these forms in an aesthetically interesting composition, while retaining the vitality of Impressionistic color. In so doing, his interest in simplifying—or synthesizing—caused him to depart from what is strictly representational or natural in appearance. The impressionists made a similar departure from "natural" color to emphasize brilliancy of light. Cézanne's composition is founded on Poussin and the old masters."[127]

In the catalogue, Barr placed the origins of modernism toward the last half of the nineteenth century with Daumier, Manet, and Degas "who inspired most of the progressive draughtsmen of the period." He described the Gauguin lithograph on view as dependent on Manet's *Olympia* for its subject matter and for its "decorative conception," again apparently referring to flattened forms: "The exotic wood-

cuts by *Gauguin* done in Tahiti show the beginnings of the decorative phase of Post-Impressionism just as the Cézannes show the beginning of the structural phase. Done in the early nineties, they are a landmark in the renascence of the original woodcut which has developed so remarkably in the last twenty years. The beauty and variety of surface comes from the cutting—and ingenious mixture of scraping, gouging, and hatching."[128] The phrases "decorative phase" and "constructive phase" evolved in Barr's lexicon into the two streams of "biomorphic" and "geometric" abstraction delineated in his benchmark catalogue, *Cubism and Abstract Art,* of 1936.

In dealing with a Picasso work on display, Barr initiated what would be a lifelong preoccupation, the classifying of the Spanish artist's variegated styles. Barr followed Picasso's work, beginning with his early dependence on Steinlen, his adaptation of "Negro sculpture," and his creation of cubism with Braque, which the artist then deserted "for a return to nature and to Ingres," according to Barr, who then inserted one of his elegant and pithy remarks in characterizing Picasso's draftsmanship: "But it is Ingres' line simplified and continuous in contour, based however on profound knowledge."[129] Understanding the artist's complexities, Barr considered Picasso to have "the most inventive intelligence in modern art." His bias nonetheless prevented him from extending similar treatment to Chagall.

Barr described a "mathematical progression" from impressionism to cubism. He proposed a starting point in prints by Pissarro because the impressionist never "lost his preoccupation with light and air, so that drawing and modelling are mollified by the atmosphere, while his figures which are essentially part of the landscape as the trees and cows, lose their differentiation."[130] Barr was anticipating himself. This statement foreshadows his famous description of *passage* in cubism that became ubiquitous in critical writing in America but actually was initiated by Pissarro. In writing about Pissaro, Barr's taste wavered, for he predicted that "his modest art bids fair to outlast Monet's."[131] He never overcame his prejudice against Monet.

Like most of the critics of the 1920s, Barr mistakenly saw Derain as one of the leaders of contemporary postimpressionism. He thought that the artist carried Cézanne's simplifications to the point of stylization. And although Derain showed

the same interest in figure arrangement as Cézanne, his form drawing was more conventional. He sacrificed "natural appearance for unity of design even more than Cézanne."[132]

In describing Archipenko's work as "the last phase of 'denaturalization'" (an unusually cumbersome word), Barr articulated his grasp of cubism, which is correct if somewhat limited.[133]

> Cubism was the invention of Picasso and Braque but it was inspired by Cézanne who pointed out that natural forms if simplified to geometrical essentials become cubes and cylinders. This was the first stage of Cubism. Having reduced the form to cubes and cylinders and spheres it isn't a difficult step to juggle them somewhat, to combine in one picture the front and back of the same figure, to substitute the concave for the convex.[134]

In Barr's formalist point of view, Archipenko accomplished all of this by "the aesthetic sensibility of the artist."[135] Barr thus initiated what he would later be criticized for: he affirmed the continuing historical thread in art that was in each case radically manipulated by the individual artist rather than finding parallel changes in the social context. His admiration of Archipenko was demonstrated at the "Cubism and Abstract Art" exhibition in 1936 when Barr included more of his sculptures than those of any other artist.[136]

In the catalogue for the 1925 exhibition, Barr then turned to Matisse and what he called the alternative phase of modernism, with emphasis on the "decorative" form of art. "Matisse took his cue from Gauguin but drew his inspiration from Persia and the Primitives. Like Picasso he has emerged from the period of distortion which many found so annoying, but has retained what he found valuable in Barbaric art just as Picasso retained what he found of value in cubism. The print at the right shows his interest in pattern, the aesthetic possibilities of arrangements of figures, tables, rugs, and other 'interior decorations.' Vermeer of Delft, Manet, and Whistler often set themselves the same problem."[137] Although here Barr has clarified the situation by separating interest in "interior decoration" from "decorative art," the two seem always to be in each other's way.

Limited by the availability of prints, but also perhaps by his knowledge, Barr's description of modernism in this catalogue is confined to the School of Paris and to a few English and American artists who demonstrate a contemporary but traditional bent. Perhaps that was all that was available to him as loans from collectors or galleries known to Sachs, or all that would be comprehensible in 1925 to this most conservative audience.

Nonetheless, Barr had found his voice in this, his first catalogue. His message was clear: modern art can be approached rationally, objectively, and without hysteria or (his favorite word) prejudice. Barr's formalist point of view, for which he was temperamentally suited, had been reinforced.

BARR'S ORAL EXAMS

After this exhibition at the end of his graduate year, Barr unexpectedly took his general examinations at Harvard. His mentor Sachs wrote to Morey, Barr's first professor at Princeton, exclaiming how well their student had done:

> I have no hesitation in saying that he acquitted himself better than any other candidate in an oral examination during the time I've been here. It was a fine performance and reflects credit on him and on you and on the others who have trained him. What impressed me and everyone else was that in addition to having a mind stored with facts one got the impression that he had thought deeply and ranged widely over the whole field. I predict that he is going to be a scholar of distinction. We have all enjoyed him here this winter; his influence on the students has been stimulating in every way.[138]

But Barr was not satisfied with his performance. He insisted in a letter to Sachs that he had "an excellent good time in spite of my continual and embarrassing ignorance." He included a list of exactly what fields were covered and how many minutes were devoted to each subject—a preternatural accomplishment for a young man taking oral examinations: "Nothing was asked in entire field of paint-

ing with exception of 150 years in Italy . . . nothing of the foreign influence in Spain, nothing in modern sculpture, in Germany or in Italy." The most recent painter discussed was Bougereau, he complained. And, with a typical graduate student reaction, he was peeved by the fact that no philosophical questions were posed; he was unable to display his knowledge of broad tendencies, development, and background, nor his grasp of large-scale perspectives.[139]

Conspicuously, Barr was confident that he could be forthright in his complaints. But he acquitted himself in a more outstanding way than his modesty would permit him to acknowledge; he was neither "ignorant" nor "unphilosophical." He had already established a synthesized historical perspective for himself which he used to great advantage in approaching a modernist aesthetic. Sachs wrote about his student: "Barr . . . has the ability to express his mature thoughts [about modernism] with more clarity than any one else who is at present giving time and attention to this fascinating and difficult subject."[140]

Sachs's own experiences—as an "amateur" who learned through collecting without benefit of a formal education—led him to emphasize the art object as the primary source of knowledge and to promote the specialist as an elite professional who could teach the masses. The order he was able to bring to his experiences was his special contribution, turning his private collection into a public resource and his contacts and knowledge into a technical manual that fulfilled the needs of a newly formed museum culture. The adherence to an objective point of view—without interpretation—led to the establishment of standards and practices in exhibitions, collections, publications, and museum ethics that are taken for granted in the art experience of today.

As defined at Harvard, the art system, ever widened, changed from a position of elite dilettantism to one of democratic professionalism. Although Sachs saw the museum as an opportunity for mass education, he also saw the need to retain an intellectual appeal to an elite who would support the museum with gifts of works of art. In 1939, at the time of the opening of the new Museum of Modern Art building, this was still a debated question. Both strategies were put into effect. Patronage and the mounting of temporary or permanent exhibitions reached new levels

of informed competence. The designation "amateur" or "dilettante" lost its posture of eminence to the scholarly "connoisseur."

Modernism and the discipline of art history emerged synchronically in the last quarter of the nineteenth century.[141] Originality, freedom, genius—residual qualities of the romantic epoch—were the irreducible conditions of modernist theory and the basis of a system of stylistic evaluation in the discipline of art history; both could loosely be compared to a scientific model. In due course, the ambitions of the art world and the art history academy to approximate the rigors of scientific structure prepared the way for a school like Harvard to accept modernism as a subject for serious consideration.[142]

Sachs's method of connoisseurship and museology was deeply ingrained in Barr's later curatorial patterns. Barr's interest in prints, stimulated by Sachs, eventually led to the founding of the department of Prints and Drawings at the Museum of Modern Art. The Print and Drawing gallery at the Museum bears Sachs's name. More than that, Sachs's networking power enabled Barr, in 1929, to become the first director of the Museum of Modern Art. Sachs's insistence and Barr's concurrence would organize the Museum around an educative process. Sachs's best student, Alfred Barr—an exemplar of the connoisseur-scholar—brought university standards into the museum world.

3

BARR AS TEACHER, 1925 TO 1927

In the fall of 1925, Barr returned to teach at Princeton at the request of Morey, who had a paternal interest in the young scholar. Sachs approved of Morey's plan: "Boy is coming on fast. A year [at Princeton] with Bert Friend, Ernest De Wald and George Rowley will do him a lot of good. After that a valuable man anywhere."[1] Barr knew all three professors. Friend and DeWald were specialists in medieval art; Rowley's forte was Chinese art.

FIRST TEACHING JOB

The atmosphere at Princeton was charged with interest in the new arts. Barr found friends with mutual interests in modernism who would gather on Sundays at George Rowley's salon where his wife Ethel Rowley held musicales. Barr met Jere Abbott (fig. 20), his future assistant, at this time. Creative in music, drawing, and

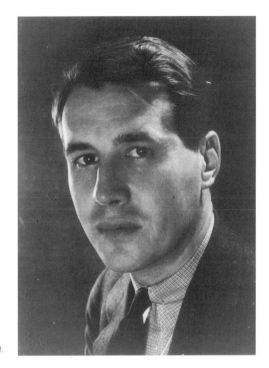

20. Photographer unknown, Jere Abbott.

photography, Abbott had studied music and art in Paris the previous year. He had abandoned his aspirations of becoming a concert pianist and was at Princeton doing graduate work in art history. He also attended the Sunday salons, listening with other students to such modernist composers as Maurice Ravel, Erik Satie, Francis Poulenc, and Georges Auric.[2] According to Mrs. Barr, the students' experience with modern music encouraged a modernist point of view in art.[3]

Barr's duties at Princeton included serving as preceptor in a course in Italian painting given by his former professor, Mather, and one in modern painting given by Mather, Baldwin Smith, DeWald, and Rowley.[4] But Barr was by now more advanced in his thinking than the conservative curricula of Princeton would allow.[5] In mounting an exhibition of works from the collections of students at Princeton, he wrote to his parents that from Abbott he had secured a Marie Laurencin oil, two

Speicher drawings, and a Bellows lithograph; another student had an Odilon Redon lithograph, a Degas lithograph, a few Luks drawings, and a Vlaminck painting; and Albert Friend lent two small Maillol bronzes.[6]

Because he had so little time, Barr asked his mother to read and send him a critique of *A Primer of Modern Art* by Sheldon Cheney that he planned to use in his classes. She responded that she liked it. Barr's eventual estimation of Cheney was that although he was "enthusiastic and well intentioned," he didn't seem to have a "discriminating or first-hand understanding of his subject."[7] Cheney defined modern art as "expressive form," a substitute for Clive Bell's "significant form"—both in contrast to imitative "real form." Cheney went so far as to call expressive form "a fourth dimensional sort of form that goes beyond composition."[8] Cheney's statement, freighted with his emotional responses, was the kind of approach that Barr avoided. He later discredited Cheney's effort to decipher modernism, declaring that it was ridden with mistakes.

Both Cheney and Barr referred to Willard Huntington Wright's 1915 *Modern Painting: Its Tendency and Meaning* as a source for their thinking about modern art. Barr said that he had read it in 1919 as a sophomore in college. Five years before Barr made the journey, Cheney visited Europe in 1922 and became familiar with the ideas of the Bauhaus. In his book, Cheney's discussion of contemporary architecture, theater, and decorative arts in each of the countries of Western Europe paralleled Barr's interest in the multidisciplinary aspects of modernism.

By the end of the year, encouraged by Barr, Abbott decided to go to Harvard. Abbott wrote to Sachs that he had been studying fine arts for two years and would now like to concentrate on drawings, a course not offered at Princeton. Abbott listed a facility with languages, and a "reasonably keen eye" as his qualifications, and mentioned Barr in passing.[9] Sachs answered: "Any Princeton student and any friend of Mr. Barr's is welcome indeed."[10]

BARR PROPOSES THE FIRST COURSE ON MODERN ART

In a letter Barr had started in the summer of 1925, as the critique of Sachs's print course, but didn't send until he was at Princeton in October, he made a plea for a course in modern art to be given at Harvard. He opened the letter by apologizing for what he considered his excessive long-windedness: "This letter seems to have reached almost Paulene proportions. I seem to have achieved some of the enthusiasm and much of the tactlessness of the evangelist."[11] Appealing to Sachs's pride in his professorial position at the university, Barr argued that most other departments at Harvard seriously concerned themselves with contemporary culture. Having attended music lectures while doing his graduate work, he described the advanced attitude of the music department, and then discussed the English department, which explored contemporary literature both "conservative and novel"; the science department was up-to-date as a matter of course, investigating such modern scientists as Marconi, Steinmetz, Bohr, and Einstein.

Barr's vision of a course on modernism also included modern ethics as it had been examined by the contemporary philosophers George Santayana, Benedetto Croce, Miguel de Unamuno, Ernest Hocking, Frederick von Hegel, and Henri Bergson. Modern stagecraft, he observed, made English 47 "famous." He continued:

> Yet in fine arts the names of van Gogh, Gauguin, Seurat, Matisse, Derain and even Paul Cézanne were not mentioned. The discussions of Post-Impressionists were limited to 15 minutes of ridicule—Picasso in his Picabia stage was thrown on the screen and after the tittering subsided the professor told three funny stories. There was no attempt to condemn in a rational manner. Students' ignorance and prejudice were fortified. The last day of class, one hour was devoted to fashionable, but insignificant artists, such as Zorn, Sargent, Sarolla, Segantini, and Zuloaga. How can one keep silent in face of obscurantism? It is important to deal fairly with modern art.[12]

Barr also complained about George Edgell, the professor teaching the course in modern art, who, he gibed, had the spirit of Harvard men for "20 generations—his knowledge of art stops with Monet, Rodin, and Sargent. Derain, Maillol, de Segonzac, Lachaise, Bourdelle are beneath his horizon or contempt." To soften his harsh criticism, Barr found some areas connected with the fine arts of Harvard, however slight, to be positive about: "I bow in troubled acquiescence, but am encouraged by the Post-Impressionists in Forbes' house—Mr. Porter's increasing interest—Pope's lectures—his 2 Demuth water colors—above all your own fine modern prints and drawings."[13]

On January 1, 1926, he again wrote to Sachs from Princeton to plead the cause of modernism at Harvard:

> Only two men have the understanding or interest to give a course on modern art—Mr. Pope and yourself. Pope is more at home in technique and esthetic problems of modern painting. He is familiar in modern literature, especially poetry, modern theater, modern architecture, modern music. On the other hand you are more a part of civilization that has given these things birth (1875–1925.) You know French [sic], German [sic], Italy and East Europe, socially economically and spiritually, if I may use so vague a term. The patrons of neoclassical art are your friends, if not the artists themselves. Moreover you lecture with more conviction that Pope. Lastly I feel that you are on the verge of enthusiasm for modern things.[14]

He suggested that both Pope and Sachs could teach the modern course and that professors from other departments could contribute lectures on their specialties. "Professor Hill of the music department for a couple of lectures; Virgil Thompson [sic], Hill's assistant, has written very entertainingly on recent music. [Bliss] Perry on poetry."[15] Although Barr knew Edgell and Post were antagonistic, he welcomed diverse opinions, even the "moribund opinions" of the critic Royal Cortissoz or the eclectic system of "lively arts" proposed by Gilbert Seldes. Barr thought that Thomas Craven "could give his sober and very thoughtful opinions on modern painting. Modern art deserves a variety of attitudes as much as contemporary

art."[16] Barr would have read Craven's essays in the *Dial* as early as 1923, and Seldes, an early editor of the *Dial* (1920–1923), published his essays on "The Seven Lively Arts" in the magazine.

Barr himself, aggressively seeking outlets for the establishment of modernism in the United States, had the opportunity to present the first course in modern art in America (if not in the world) at Wellesley College in the spring of 1927. He had been offered teaching positions at Oberlin College and Smith College but turned them down because Alice Van Vechten Brown, director of the Farnsworth Museum at Wellesley, opened the way for Barr to create his own course in modernism. Barr reported that he went to Wellesley because they agreed that he could give a seminar course in twentieth-century art. "I can't say the course was an entire success," he would later say; "I took the license to teach as I liked."[17] The outline of the course followed the general precepts that he had suggested to Sachs for Harvard, and would eventually be an analogue for the structure of the Museum of Modern Art and its contents. Barr would often insist that the multidepartmental plan at the Museum consisted of "simply the subject headings of the Wellesley course."[18]

He wrote to his parents about the offer to teach Italian painting at Wellesley for a year, and modern painting the second semester, "both of which I know better than any other two subjects."[19] Barr also taught a survey for the school year 1928–1929 that was remarkable for the attention paid to the analysis of artistic means— the technique he learned at Harvard.

Wellesley's method integrated the art history survey with technical training in a course they called "laboratory work." Even earlier than Harvard, but influenced by Norton and Moore, the Wellesley method was initiated by Brown, who reformed the department in 1897 with the stipulation that the laboratory work would "count toward the degree on the same basis as scientific experiments."[20] Practicums in egg tempera, gesso, and gilding were similar to the exercises developed at Harvard, although the technical courses at the Fogg were not directly associated with the historical material. Brown was highly successful with her method, and the results rivaled those at Harvard. She would later boast: "The studio laboratories developed here to teach the techniques of the historical styles, such as gold ground panel painting as it was done in Trecento Italy, are so dis-

tinctive a feature of our curriculum that the system is widely known as 'The Welles-
ley Method.'"[21] Competitive with Harvard and Princeton, Wellesley College
claimed to have made available the first course of study leading undergraduates
to a major in art history.

Barr communicated to his parents in minute detail the agenda for the modern
course he would teach. He considered this letter of some importance because, as
he later related, it was "the first time I had to set up a broad approach to contem-
porary art."[22] He called the course Tradition and Revolt in Modern Painting and
described the comprehensive curriculum:

> Vision and Representation. Pictorial organization. The place of subject matter.
> The achievement of the past—especially the nineteenth century. The 20th cen-
> tury, its gods and *isms*. The painter, critic, dealer, collector, the museum; the
> academies; the public. Contemporary painting in relation to sculpture, the
> graphic arts, architecture, the stage, music, literature, commercial and decora-
> tive arts. Fashionable aesthetics; fetish and taboo. Painting and modern life. The
> Future.[23]

His enthusiasm was boundless but his common sense won out. He reduced the cat-
alogue entry to "Art 305: Contemporary Painting in relation to the past, to the
other arts, to aesthetic theory and to modern civilization."[24] His other course, The
Italian Tradition in European Painting, was not only a history of Italian painting of
the late medieval and Renaissance periods but also connected the Renaissance
tradition to modern art.

As sources for his modern art class, Barr drew upon museums, galleries, pri-
vate collections, the theater, ballet, movies, architecture, advertisements, typog-
raphy, industrial design, magazines, music, and dime store objects. In short, he
evoked twentieth-century life although the century was only twenty-seven years
old. In his efforts to delineate a style, he introduced into its narrative everything
that was touched by that style.

BARR AND J. B. NEUMANN

Barr was repeatedly helped by those European dealers who emigrated to the United States in the 1920s, such as J. B. Neumann, Pierre Matisse, Joseph Brummer, Valentine Dudensing, and Karl Nierendorf. But he turned primarily to the persuasive radical art champion Neumann (fig. 21) to further has education in modernism and to secure material, books, and reproductions for his course. Neumann also was a source for the current gossip of the art world for Barr's modern art class.

A German art dealer, Neumann had maintained a gallery in Berlin for thirteen years[25] and other galleries in Bremen, Düsseldorf, and Munich. Karl Nierendorf ran the Berlin gallery for him after Neumann emigrated in 1924 to open a gallery, the New Art Circle, in New York, located on West 57th Street. Neumann's galleries in both countries were a direct consequence of post-World War I interest in modern art and its expanding market. His intention was to promote American art in Germany and German art in America. He contributed to Barr's early interest in German avant-garde art at a time when the interest of most Americans had not advanced beyond the School of Paris. Neumann's devotion to Edvard Munch, Max Beckmann, Georges Rouault, and Paul Klee ultimately had its influence on Barr.

Neumann's approach was didactic; he constantly gave lectures to attract a broader public, and his loquacity was legendary. The collector Duncan Phillips, reporting on a lecture Neumann had given on Rouault, characterized the dealer for Barr:

> It was an outpouring of sincere, genuine feeling, highly emotional and communicating that emotion to others. There was not much analysis or art criticism in the talk but Rouault's own character was told about with such admiration and reverence that the audience listened respectfully and applauded with enthusiasm. It was a most unconventional lecture, very personal, almost naive, curiously fascinating in its combination of angelistic ecstacy with enlightened understanding of the expressionist language. He ranks Rouault at the top. [It] might be embarrassing to anyone sponsoring the lecture.[26]

21. Otto Dix, *Portrait of J. B. Neumann,*
1922. Graphite on off-white wove paper,
51 × 41.2 cm. Busch-Reisinger Museum,
Harvard University Art Museums.

Barr, in fact, had taken comfort in Neumann's knowledge and willingness to
share it with him. A long and mutually supportive relationship developed between
them after Barr wrote to Neumann in July of 1926, reminding him of the "ignorant
young man with whom [he] had lunch a fortnight ago at Childs [Restaurant]."[27] In
the fall, Barr again wrote to Neumann from Wellesley, holding him to his promise
that he would import books and prints for Barr at "dealer's prices." Barr thought
this would help him stretch the $200 he had for materials.[28]

Barr and Neumann decided to work together to create a bibliography of books
and reproductions of modern art. In the same letter, Barr wrote: "Boston is very
dead so far as contemporary art is concerned. Sargent and Dodge McKnight are
still the last word, but there are many who would be interested if they could
see good originals or perfect reproductions. Professor Sachs is increasingly
interested."[29]

A similar complaint by Barr appeared as a letter to the editor in the *Harvard Crimson* of October 30, 1926, and was subsequently reprinted widely.[30] Barr here protested the insipid taste of the public and the museums in Boston and Cambridge, although he conceded that he exception was the "splendid collection of drawings" at the Fogg "carried through to Picasso." He also complained that it was very hard to find examples of the work of such living masters as Matisse, Bonnard, Picasso, and Derain in Boston and Cambridge, despite the reputation of the area as a cultural center. Further, "it is even more astonishing that the great founders of the contemporary tradition (Cézanne, Van Gogh, Seurat, Gauguin) . . . are equally neglected." The only painters to be found were such "fashionable virtuosos as Zuloaga and Sargent." Barr and his friends agreed that Sargent was popular but without merit as a modernist. An inveterate letter writer, Barr chronically complained in print about the lack of interest in modern art by the public and the museums.

AN EMBARRASSING PUBLIC LECTURE

In the important year of 1927, Barr was struggling on many fronts to solidify his position on modernism. Highly active at this time, he was creating a network through letters, lectures, and by mounting exhibitions. He declined a request by Sachs to help with his nineteenth-century French painting course but consented to give a lecture on the subject, and Sachs thought it was important enough to include the general public in the university audience.

Two weeks after the lecture, in a painfully specific letter to Sachs, Barr exposed his youthful tribulations in shaping a personal scholarly demeanor. He called the letter of February 14, 1927, an *apologia*—his attempt to defend himself against the severe criticisms of his lecture by the audience and by Sachs.[31] Unfortunately, the letter was long, repetitive, and approached peevishness.

In contrast to Sachs, who relied on an energetic enthusiasm to get his point across, Barr struggled to overcome his youth and shyness with a dispassionate stance. He had opened the lecture with a quote from Petronius, expecting the au-

dience not only to understand the Latin but also to understand that a hostile reaction to new art was as old as Petronius. Bristling, Barr said in his letter that he had read only four lines in Latin, hoping to appeal to the audience's "sense of humour" as he related present-day attitudes toward modern art to Petronius's conservative analysis of art of the first century: "an entertaining passage which contained 4 or 5 superficial attitudes toward painting . . . The application to modern problems was entirely original."[32] A student reviewer of the lecture, having an advance copy from Barr, was laudatory in her criticism. She found amusing the reference to Petronius, in which the ancient critic "bewails the decadence of modern painting, and casts slurring remarks upon 'the short cuts of these Egyptian charlatans' (the post-impressionists of his day) as compared with the 'verisimilitude of the old Masters (Apelles and Zeuxis).'"[33]

The most awkward situation for the audience was Barr's long silences that accompanied a pair of slides. Purposeful on his part, this was his method of comparative art history, which he thought would make the visual examples meaningful. Barr goes on to explain his intellectual stance that others took as "cold neutrality and lack of enthusiasm." This assessment of his demeanor was a continuing problem. He believed that his use of irony and silence was a positive means to bring his audience to a gradual understanding of modern art that "bypassed a too easy route." He complained that his irony was taken literally and therefore his feelings were not understood: "Needless to say my neutrality was deliberate." He realized that his technique in showing slides at too slow a pace and without comment made his audience uncomfortable: "I am told that I lost almost entirely the interest which I had won by my mildly amusing introduction." His intention was to present an alternative to the usual lecturers "who poured forth a continuous and mellifluous eloquence a net of words to minds titillated by easy explanations—too often it (the audience) leaves believing that it has understood in an hour's passive listening what it takes years to comprehend. . . . [They] probably had never troubled to investigate for themselves the extremely difficult problem—the art of our own day. Should I compromise? . . . My lecture was planned then to strike about the middle level of the audience that is students in your French painting course who had historical background and a certain amount of aesthetic experience."[34] The antinomy

between "easy" and "difficult" art was the guideline Barr set for himself in assessing modern art of quality. Furthermore, the concept of aesthetic experience within a historical background was the center of his formalism and he invoked it no matter how far from abstraction figurative works of art took him.

In his lecture, Barr pointed out the similarity between the "colour-fugues" of Gauguin and medieval glass, as well as the parallels between the powerfully modeled nudes of Renoir and Rubens, and of Picasso and Correggio. He showed the audience the rhythmic contours of Matisse's work, prefigured in an "Egyptian Post-Impressionist" wall painting, and the "Surrealiste mysticism of Redon anticipated in a Grunewald altar piece." Léger's cubist tendencies were seen as growing out of "Piero della Francesca, Veronese, the early Corot, Picasso and primitive Negro sculpture." After following the historical influences upon modern artists, his second tack emphasized the "formal and esthetic" in contradistinction to "the narrative or illustrative function of art." He demonstrated that the formal elements of a design are expressively significant, bypassing the literal transcription of the "surface aspects of nature." He brought his audience's attention to "the growing tendency to consider subject material merely as the incidental medium through which to express the abstract phenomena of plastic, palpable form and rhythmic line."[35]

In his letter to Sachs, Barr continues his self-abasement: "I regarded myself as a showman carefully arranging an exhibition—but by silence and neutrality permitting them to form their own opinions. I gave [the students] very little information or dogmatic verdict which they could carry away in note books. . . . I hope to bring home the conviction that art is especially so because it depends so largely upon esthetic feeling. They went away uneasy and resentful." Barr ultimately took responsibility for his disappointing performance: "As to the lecturer he is divided against himself and feel that I failed to do what was expected of me. I should have conformed to precedent and avoided experiment." On the bottom of the page Barr added by hand: "Probably I'm a bad boy and need another spanking. I was quite used to Mr. Morey's paternal punishment and rather miss it here I hope you'll feel free to supply the lack. I hope sometime to have your frank criticism of the lecture and memorandum."[36] Sachs penciled on a copy of the letter: "It wasn't very good. I expected a great deal. He showed his inexperience."[37]

VANITY FAIR AS A SOURCE OF MODERNISM

Barr frequently cited the *Dial* magazine as one of his primary sources for learning about modernism. But *Vanity Fair* also had a role in shaping his modernist aesthetic view. He first subscribed to the magazine in 1918 as a freshman at Princeton. Frank Crowninshield, the editor under the publisher Condé Nast, would become one of the founding trustees of the Museum of Modern Art in 1929. Founded in 1914, the magazine published news and works of new writers, artists, and photographers. Although similar in content to the literary magazines known as "little" for their small readership, *Vanity Fair* was published as a slick, sophisticated journal in a large format. Crowninshield wrote a series of profiles on contemporary artists that Alfred Barr read as a boy. In some cases, as with the piece on Paul Klee, these served as his introduction to the field.[38]

Crowninshield's early interest in photography—he was a friend of Alfred Stieglitz—made the pages of *Vanity Fair* an outlet for modern photographs. He published photographs by Charles Sheeler, Edward Steichen, and Stieglitz, among others, treating them as important works of art with captions of critical evaluation,[39] and Barr shared the interest. Photography was among the diversified arts that he covered in his course at Wellesley, and it became one of the most important departments of the future Museum.

Crowninshield started collecting art at the beginning of the century and was an early convert to avant-garde works. In 1913, he acted as a voluntary press agent for the Armory Show. He published illustrations of modern art in the magazine, including works by Picasso, van Gogh, Gauguin, and Rouault, sculpture by Despiau, and paintings by Braque, Modigliani, Pascin, and Segonzac.

In August of 1927, Crowninshield published a modern art questionnaire by Alfred Barr (cultural quizzes had been a continuing feature of the magazine).[40] The purpose of Barr's questionnaire was to present readers with the diverse contributions of the most advanced thinkers in all the arts; it incidentally reflects his own thinking as he grasped the complexities of modernism. Barr wrote that his questionnaire had been invented in 1926 as a preliminary examination to assess the background of students for a course in modern art at Wellesley College. The cat-

egorical question he posed was: "What is the significance of each of the follow-
ing in relation to modern artistic expression?"[41] This broadened the scope of the
questionnaire to include particulars of the art scene other than the identities and
contributions of visual artists. His grasp of the mechanics of the changes in the
"passing world which interests me so much"[42] was comprehensive, his proclivities
broadly based.

His questionnaire listed fifty creative people and movements, and the answers
that followed gave a brief description of their contributions. The list "covers with
careful proportion modern expression in architecture, sculpture, painting, graphic
artists, music, prose, drama, poetry, the stage, decorative and commercial arts,
movies, ballet, and modern criticism chosen from French, British, Italian, Russian,
Germanic, and American sources."[43] Nine artists made the list, but only one was
American. Matisse was on it but not Picasso, who had not yet reached the requi-
site importance in Barr's view. At this early date, Barr felt Picasso "may be of less
permanent influence" than Matisse.[44] In most of its particulars, this list corresponds
to Barr's wide-ranging interests for the next forty years—until he retired from the
Museum of Modern Art in 1967. Sixteen years after Barr's retirement, *Esquire* pro-
filed fifty people from various fields who "have dramatically changed American
life during the last half century." Barr's grasp of the significance of cultural changes
in all its ramifications and his documentation of the sources of that change were
what secured him a place on *Esquire*'s list of "the 50 who made a difference."[45]

Of particular importance in Barr's narrative of modernism is that in 1926, in
addition to German expressionist art, Barr was already conversant with the con-
tributions of the Soviets. Among the artists included was Alexander Archipenko,
the Russian emigré, "famous for his masterly and highly sophisticated fusion of late
renaissance elegance with the cubistic formula." For the entry "Vsevolod Meier-
hold," his answer was: "The most important figure in the contemporary Russian
theater opposing constructivism to the super realism of Stanislavsky and the
Moscow Art Theater." (Stanislavsky's company had appeared in New York in
1925 and was broadly acclaimed.) For the question "What is Suprematism?" the
answer was: "Russian ultra cubism in which painting is reduced by an almost
scholastic dialectic [emphasis added] to the just disposition of a black square in a

white circle. Malevich and Rodchenko are masters of the pictorial quintessence."[46] Barr learned about the Russian artists from the Katherine Dreier exhibitions and the book *Modern Russian Art* by Louis Lozowick, published by the Société Anonyme.[47] Another important source for Barr's knowledge of Russian art would have been his close friend Neumann.

The artists in the *Vanity Fair* questionnaire could be arranged in groups according to media. The field of music included, among others, George Gershwin, Les Six, and Arnold Schönberg. The theater's inclusions were Max Reinhardt, *The Hairy Ape* ("Eugene O'Neill's violent tragedy of maladjustment in the machine age"), Luigi Pirandello, and Meyerhold; ballet was represented by *Petroushka.* Critics included Forbes Watson, Gilbert Seldes, and Roger Fry, "the most brilliant English Art critic supporting the modern aesthetic attitude (*ma non troppo*)." Literature featured Joyce, the Imagists, H. D., a quotation from Gertrude Stein, Jean Cocteau, and Harriet Monroe, among others. The category of film mentioned the *Cabinet of Dr. Caligari* by the German film producers UFA. From the visual arts, only five artists were named: Henri Matisse, whom he considered "very possibly the greatest living painter"; Miguel Covarrubias, a Mexican draftsman and caricaturist; an American artist, John Marin, known for his watercolors; Wyndham Lewis: "English painter, critic and novelist. Founder of *Vorticism*"; Fernand Léger, French cubist; and two sculptors, Aristide Maillol, whom Barr called "one of the greatest living sculptors," and the aforementioned Archipenko. Besides suprematism, the only other avant-garde stylistic movement discussed was *Sur-realisme:* "A new and increasingly powerful cult prevalent in Europe. . . . Devoted to the exploration of the subconscious, believing in the artistic validity of dreams, it is an expression of faith in Twentieth Century psychology."[48] (Barr used the French spelling because no English equivalent had yet been defined for this newly established ism.)

Several figures and movements were included under the general title of architecture: the Bauhaus,[49] Frank Lloyd Wright ("among the first American architects to become conscious of modern forms as an expression of modern structure"), Le Corbusier, the New York zoning law of 1916 ("of infinitely greater importance to American architecture than all the stillborn and sentimental archaism of the so-called revolutionary architects"). The category of industrial arts included the Frankl

firm of furniture manufacturers and Edgar Brandt, "distinguished for his wrought iron in the modern manner." Saks Fifth Avenue was also included because of its advertisements and shop windows ("this department store has done more to popularize the modern mannerism in pictorial and decorative arts than any two proselytizing critics"). Barr took to task the philosopher Oswald Spengler because his cyclical theory of history announced the decadence of our civilization: "If, however, decadence is the inability to create new forms, the personalities and works of art included in this questionnaire are at least attempting a refutation."[50]

At Wellesley, the only student who passed the *Vanity Fair* test was Ernestine Fantl, who upon graduation worked first with Neumann (recommended by Barr) and later with Barr at the Museum. She became the curator of the Architecture department after Philip Johnson resigned in 1934. It was beyond optimism at this time for Barr to expect students to be familiar with the material in the questionnaire, most of which would only subsequently be covered by Barr, almost verbatim, in his course.

BARR DELIVERS THE FIRST COURSE IN MODERNISM

The Wellesley course, "almost the first course in modern art offered in any college,"[51] was devoted to the art of the last hundred years. It covered painting of "tradition and revolt," contemporary art as it developed from the art of the nineteenth century. Barr may have used slides in this first course,[52] but he also used reproductions "since modern art cannot be fully understood without color."[53] If he used some slides, they would necessarily have been black and white. Barr later wrote that in the 1920s,

> I used large colored reproductions for teaching purposes. . . . Artists were better reproduced on the whole at that time than they are now [1947] for there were very good repros available of Bonnard, Feininger, Leger, De Chirico, Kandinsky and Chagall. These were mostly through German publishers though our own *Dial* portfolio was a great help too.[54]

22. Jere Abbott, *The Necco Factory,* from *Hound & Horn* 1, no. 1
(September 1927), p. 36.

The modern art class was structured so that timely topics were discussed at the
start of each class before "carefully prepared problems" were introduced. "Prob-
lem-solving" was a scientific rubric often used by Barr and contemporary critics.
Barr organized the class into a "faculty," a form of a seminar that divided the sub-
ject into categories, giving each student responsibility for reporting its develop-
ment to the class. Barr's outline of the course followed the history of painting from
"the forerunners of modern painting"—Cézanne, Seurat, van Gogh, Gauguin, Re-
don, and their followers—through the movements of cubism and futurism, and
what he labeled "minor 'isms,'" which included "the post-war classicists and the
superrealists." (It would be a few years before the term "surrealism" took hold.)

The student "faculty" studied "industrial architecture, America's distinctive con-
tribution to art."[55] Having read Le Corbusier's book *Towards A New Architec-
ture,* Barr was inspired to send his students to see factories, such buildings as the

Motor-mart and the Necco factory in Cambridge (fig. 22).[56] His students rode the Boston & Albany Railroad from Wellesley to Boston in order to inspect the stations along the way that had been designed by the important nineteenth-century architect H. H. Richardson. "I had the students pick out the best one," Barr said. He also took his class to see an expressionist performance in Yiddish of *The Dybbuk*.[57]

Barr focused on industrial and decorative objects, including the automobile and furniture, as works of importance, an idea that would later become part of his plan for the Museum of Modern Art. One of the fundamental aspects of his taste was that he found utility objects, such as refrigerators and filing cases, more interesting than intentionally decorative forms. Associated with the course was a competition for a "Still Life." Each student spent a dollar in the local "five and ten," choosing the best-designed objects, which were then arranged on tables as "constructive theatre."[58] The most modern materials, such as aluminum or papier mâché were required. The prize was a papier mâché dinosaur; a photograph of the dinosaur, by Abbott, was published in *Hound & Horn* by Lincoln Kirstein a few months later. Barr included graphic arts in the broad spectrum of modern art, encompassing etchings, woodcuts and other prints, as well as cartoons, comic strips, and magazine covers such as those of the newly founded *New Yorker*. "Advertising is the happy hunting ground of this group, showing how the modern pictorial study has filtered into the ordinary environment of life."[59]

The "faculty" covered all the areas of modern life that Barr found interesting: theater arts, the Russian ballet, and the Fernand Léger and George Antheil film *Ballet mécanique*, which involved modern music. In one form or another, music was a constant presence in Barr's life and career. Recordings of such composers as Richard Strauss and Claude Debussy as well as jazz were "hunted down." A recital devoted to Schönberg, Stravinsky, Les Six, and other significant composers was announced.[60] Randall Thompson, a music professor at Wellesley, and Jere Abbott gave a concert of Stravinsky, Milhaud, Bartók, and Satie after the final take-home essay exam.[61]

The history of the movie also was covered. At this time, the "stupendous settings" of the German film *Metropolis* were mentioned. Barr planned that one of the students would concentrate on modern criticism and aesthetics, stressing themes

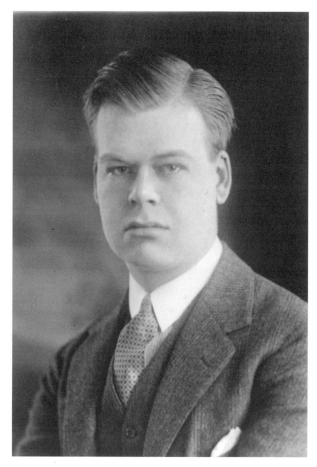

23. Henry-Russell Hitchcock, 1921.

of "primitive and barbaric art, the psychology of expressionism, the discipline in cubism and constructivism, and the importance of the machine."[62] This was only a few months before Barr would choose between the machine and primitive art as the source of modern art for a dissertation topic.

While teaching at Wellesley, Barr commuted half an hour to Cambridge where he roomed with Abbott. On occasion, he attended Sachs's museum course with

Abbott and made lifelong friends with the students he met at the course. Among these was Henry-Russell Hitchcock (fig. 23), studying for his master's degree in the history of architecture, and Barr invited him to lecture to his class at Wellesley. Barr credited Hitchcock with introducing him to modern architecture: "I felt that Russell knew things."[63] According to Hitchcock, Barr's Wellesley lecture attracted professors as well as students because of the freshness of the subject matter.[64] In his lecture, the first in a long distinguished career as an architectural historian, Hitchcock stressed the Dutch architect J. J. P. Oud as well as Le Corbusier. Oud and Le Corbusier, with Mies van der Rohe and Gropius, would become the centerpieces of Hitchcock's and Barr's modern architectural theory and the "Modern Architecture: International Exhibition" of 1932. In documenting the activities of the avant-garde and putting them into perspective, Barr was poised between the seemingly paradoxical roles of creating the parameters of the modernist style as a peripheral member of the avant-garde and of being a scholar in the field.

Erwin Panofsky summed up the astounding accomplishments of the newly established American discipline of art history:

As the American art historians were able to see the past in a perspective picture, undistorted by national and regional bias, so were they able to see the present in a perspective picture undistorted by personal or institutional *parti pris*. In Europe where all the significant "movements" in contemporary art had come into being . . . there was, as a rule, no room for objective discussions, let alone historical analysis. . . . In the United States, such men as Alfred Barr and Henry-Russell Hitchcock . . . could look upon the contemporary scene with the same mixture of enthusiasm and detachment and write about it with the same respect for historical method and concern for meticulous documentation as required of a study on fourteenth century ivories or fifteenth century prints. Historical distance (we normally require from sixty to eighty years) proved to be replaceable by cultural and geographical distance.[65]

PATRONS OF MODERNISM

Barr's relationships with four contemporary collectors and patrons of the arts, three of whom he included in the *Vanity Fair* quiz, helped prepare the way for him. They were Alfred Stieglitz, Albert Barnes, John Quinn, and (not listed in the quiz) Katherine Dreier. All four were buyers of modern art at the 1913 Armory Show, where, as its historian Milton Brown noted, "a new era in American collecting was opened."[66] Barr did not experience the Armory Show firsthand, but he felt its shock waves ten years later; the collections that helped educate his eye were initially shaped by this exhibition. Although Arthur Jerome Eddy and Quinn were the major patrons of the most advanced work of the show, other collectors included Dr. Albert Barnes, Walter C. Arensberg, A. E. Gallatin, Edward W. Root, Hamilton Easter Field, Stephen C. Clark, and Lillie Bliss. The collections of the latter two would play dramatic roles in the history of the Museum of Modern Art in later years. Brown wrote that the Armory Show was the first opportunity America had to see a collection of works by the postimpressionists Cézanne, Gauguin, and van Gogh, who were already in the old master ranks on the European market.[67] More than sixteen years would elapse after the Armory Show before the Museum of Modern Art institutionalized these masters as the progenitors of modern art.

While still a student at Princeton, Barr had become personally acquainted with Stieglitz, visiting his gallery 291.[68] After many such visits Barr was impressed with Stieglitz's importance in establishing photography as a fine art: both in the quality of his photographic work in his efforts at his gallery. Barr thought Stieglitz "a pioneer and prophet of modern art," saying that the gallery owner was "the only art dealer who employs the Socratic method without destroying patronage."[69] Considering Stieglitz's reputation for loquacity, Barr's sharp wit and tactful grace were evident in this description. They both had a reputation for tenacity and endurance: Stieglitz was known for his monologues; Barr's silences were equally legendary. Although both were keenly aware of the importance of patrons, Stieglitz demanded a purity of purpose from the collector and could be counted on to be rude to those he considered unworthy. Barr, on the other hand, would overlook many slights in order to bag his quarry. Both men shared an abiding interest in the

machine, an uncompromising dependence on quality of workmanship, and a be-
lief in the value of teaching to entrench modern art in the marketplace. What
Stieglitz had prepared in 291 for a frustratingly small audience and jeering critics
before World War I, Barr consummated in the 1930s to a surprisingly full house.
America was ready to be shown and taught.

Both men were convinced of the certainty of the power of art. The Stieglitz pose
was to maintain the power by protecting the art object from the contamination of
money; only with "love" could a patron buy the works of his artists. Barr struggled
for the same independence as Stieglitz and succeeded, despite frequently being
put in a position of compromise in later years at the Museum of Modern Art under
the pressures of an unusually strong and manipulative board of trustees, unques-
tionably guided by the arts' monetary value. More rigorously intellectual than
Stieglitz, Barr nevertheless had the opportunity to use patrons to advantage to
flesh out his vision. Barr dedicated the catalogue *Cubism and Abstract Art* to the
"pioneers" Stieglitz, Arthur Jerome Eddy, and Katherine Dreier (although the iras-
cible photographer never approved of a formal museum for modern art, believing
it would stultify creativity).

Barr's commentary on John Quinn in the *Vanity Fair* quiz tells a good deal about
both men: "John Quinn: American lawyer and bibliophile, who before his death
was the most emancipated among the great American collectors of modern art.
Pictures from his collection are now in the Louvre and the Art Institute of Chi-
cago."[70] Usually precise in his use of words, Barr ostentatiously applied the word
"emancipated" to those people with avant-garde tastes in art who had freed them-
selves from "prejudices," a word he frequently used in describing antimodernist
feelings that encumbered appreciation of the avant-garde. Barr told Quinn's bi-
ographer, Benjamin Reid, that he thought Quinn had the best collection of early
modern art in the United States, covering the decade or so from the Armory Show
to the collector's death in 1924, and that "he had excellent Cézannes and Seu-
rats, but they were less extraordinary than his Picassos, Matisses, Brancusis, etc."
Barr thought Quinn's only competitor at the time was the Russian collector Sergei
Shchukin, whose "extraordinary collecting" ended with World War I. Shchukin,
he thought, had better paintings but not better sculpture. Quinn, he wrote, "had

'nerve' . . . taste, intuition and courage. As a great collector, Quinn was prone to the obsession of a hunter, acquisitiveness, astute judgment and love."[71]

Quinn had experienced at first hand the crucible of modern painting and sculpture from 1911 to 1924. He was extremely active in the art market in New York, and, although he bought American artists, most of whom were connected with Stieglitz, he was most drawn to the European avant-garde, for which Barr most admired him. What intrigued Barr, who would attempt the same thing for the Museum of Modern Art, was that Quinn successfully limited himself to contemporary art works of quality for his renowned collection.

Barr might have become aware of the collection when Quinn loaned many of his paintings to the Metropolitan Museum of Art for the exhibition of French paintings in 1921, the first display of modernism at the Metropolitan Museum.[72] Although the exhibition was essentially conservative in character, it did bring forth an anonymous protest from an irate citizen, who called it "propaganda for Bolshevistic art,"[73] an epithet that Barr took serious exception to all his life.

When Quinn died in 1924, he already had witnessed the conservative tempering of work from the artists of the first wave of modernism. But Quinn kept the radical energy flowing by lending his collection to the Sculptor's Gallery, operated by his friend Arthur B. Davies. In March of 1922, Quinn loaned works by seven modernists to the gallery, including, notably, those of Wyndham Lewis, Jacob Epstein, and Henri Gaudier-Brzeska.[74]

Barr's open-ended aesthetic philosophy was extremely close to Quinn's, who, espousing no theory, wrote that "great art always seems like a miracle. One recognizes its greatness, but can no more give the formula of the miracle than one can define art in words."[75] Like Sachs, Quinn believed that a great collection was a work of art, and he decided in 1919 "to restrict his acquisitions to works of museum rank."[76] The artists Brancusi, Matisse, Picasso, Rousseau, and Seurat, whose works Quinn collected in the last six years of his life, were those who primarily occupied Barr's thoughts. Quinn considered Rousseau's *The Sleeping Gypsy* (see fig. 17), the last picture he purchased prior to his death, the "greatest picture of modern art,"[77] and Barr would pursue the painting for thirteen years before it finally became part of the permanent collection of the Museum of Modern Art.

Along with many others, Barr was disappointed that Quinn's collection had been dispersed in a sale and lost to American museums. The possibility remains that had Quinn's collection been the nucleus of a new modern museum, a different history might have been written about the Museum of Modern Art—without the name of Alfred Barr. Barr considered Quinn "one of the most remarkable Americans of his time, as well as the greatest American collector of modern art . . . an heroic figure. Had he lived another decade what a wonderful president of the Museum of Modern Art he would have made. How I wish I had known him."[78]

The third pioneering collector mentioned in Barr's questionnaire was Albert Barnes, whose collection of avant-garde art in the Barnes Foundation in Merion, Pennsylvania, included the impressionists and postimpressionists, as well as Matisse, Picasso, and Derain.[79] Barr distinguished the Barnes Foundation as "a privately owned institution for education in the aesthetic appreciation of the fine arts." This succinctly summed up his own aspirations, which would come to flower two years later with the founding of the Museum of Modern Art. Barr was keenly aware of the need for enlisting a broad-based patronage for artists, both public and private, whose aesthetic interests would be of a high quality. His education and experience with Sachs reinforced this as a strategy that he used to his advantage in the Modern.

In 1926 Barr visited the Barnes Foundation with two friends.[80] However, after reviewing Barnes's new book, *The Art in Painting*, for the *Saturday Review of Literature*,[81] he was never allowed into that museum again. Barnes seemed to have an automatic dislike for scholars. Meyer Schapiro and Kenneth Clark, among many others, were also refused access to his museum. When Barr wanted to check the colors of the Matisse works in the Barnes collection for the book he was writing on Matisse (color analysis had become an important part of his training at Harvard), he was stymied. (Barr's office copy of his book on Matisse—both text and illustrations—is filled with color notations in his handwriting.) It was left to Margaret Barr to surreptitiously ascertain the colors of Barnes's Matisse paintings while she accompanied the important visitors Albert Einstein, Thomas Mann, and Erwin Panofsky to the museum.[82]

Barr's aesthetic philosophy became apparent in his analysis of Barnes's philosophy. He was pleased that Barnes's book presented "a systematic and confident statement of what is central in the 'modern' attitude toward painting. . . . Banishment of subject matter is recommended so that one may consider painting only in terms of color, line, mass, space, plastic form." He continued: "Mr. Barnes will find many, especially among those whom Aldous Huxley terms 'the absurd young,' who are more or less in sympathy with his position. Among them is the reviewer who has frequently found himself engaged in a long analysis of a painting without the slightest consciousness of subject matter until some philistine undergraduate brings the discussion to earth by asking why the Madonna has such a funny chin."[83] Barr was in accord with Barnes's formalist approach to past masters, and he found Barnes "brilliant" in his analysis of modern painting. "The plastic developments of Renoir and Cézanne are very thoroughly analyzed by the man whose Renoirs and Cézannes should be the envy of every museum in the country especially the Metropolitan," Barr wrote.

Although he would later change his mind, Barr took the occasion of this *Saturday Review* article to downgrade vorticism, futurism, and synchromism "and the other ephemeral teapot tempests which though long dead are still made to resound in academic kitchens." In the Barnes review, Barr gave evidence of the subtle basis of his own formalist aesthetic which, never rigid, went through several fluctuations through the years. He quoted Barnes: "The design in these two paintings [a Titian and a Cézanne] is very similar, showing irrelevance of subject matter to plastic value." But then, apparently irritated, Barr turned sharply in another direction: "But what price plastic value! Do we, after all, profit largely by reducing Titian's noble tragedy to the terms of apples upon a crinkly napkin? Mr. Barnes will yet drive us to rereading Ruskin, and the tearful contemplation of those 'positively saint-like animals of Edwin Landseer, R.A.'"[84]

Barr's modern aesthetic allowed latitude for discussion of expressive content. Emotion as an expressive "quality," partly musical, partly poetic, and, by definition, part of the aesthetic experience (although largely unarticulated by him) was as much a part of his analysis of form as the purging of subject matter would come to be in his definition of abstract art.

In the same review of Barnes's book, Barr confirmed his awareness of the knotty issue of the relative position of form to content raised by the advent of abstract art and its relationship to music—an issue that has been unremittingly examined for two centuries. He wrote: "If by the literary canons of the last century [Barnes] seems to over-emphasize the rhetoric of painting, by the canons of music he is merely revealing essentials. In the light of history and experience neither fashion is final, though at present the latter is crescent."[85] The notion of the visual arts yielding to the same critical evaluation as music had begun in the early nineteenth century with the writings of Eugène Delacroix and continued in the critical writings of Baudelaire, Ruskin, Pater, and Whistler. Matisse expressed the idea again in the twentieth century in "Notes of a Painter."[86]

Curiously, in the *Vanity Fair* quiz, Barr omitted Dreier from the list of contemporary patrons of modern art, although she would become important to Barr in his long career. Aided by Marcel Duchamp and Man Ray, Dreier founded the Société Anonyme, a group dedicated to promoting avant-garde artists from Europe and America. She set precedents by mounting exhibitions and providing documentation and, indeed, claimed the very name Museum of Modern Art for the Société Anonyme. Barr later acknowledged his debt to Dreier, of whom he had first become aware in 1923 at Vassar College when the Société Anonyme installed a Kandinsky exhibition. Barr would write to her: "In 1929 when we opened our doors, the Museum of Modern Art quite unwittingly assumed the second half of the Société Anonyme's name. Since then we have followed your lead not only in name, but in several more important ways as our exhibitions and collections clearly show. Your foresight, imagination, courage, and integrity have been a frequent and important example to us."[87] Dreier had added "1920"—the year the Société Anonyme initiated its activities—to the title of her organization to avoid confusion with the Museum of Modern Art.[88]

When Dreier was arranging the most extensive exhibition of international modern art since the Armory Show, Barr was about to give the first course in modern art at a college level. After seeing the large exhibition of avant-garde art staged by the Société Anonyme at the Brooklyn Museum in 1927, Barr carried on a flurry

of correspondence with Dreier in an attempt to mount a similar exhibition at Wellesley. Although it never came to fruition, Barr gained a friend and ally.

Many of the functions of the Société Anonyme were prototypes for the future Museum of Modern Art. It had a reference library that included works from various European countries; it mounted exhibitions and circulated them throughout the country at college museums, galleries, and other museums; it had symposia and lectures, a permanent collection, and even published books and pamphlets. Not unlike Stieglitz, Dreier introduced the most avant-garde artists to the American public. The first exhibition of paintings of modern art, on April 30, 1920, included works by van Gogh, Francis Picabia, Juan Gris, Jacques Villon, Joseph Stella, Man Ray, Marcel Duchamp, and Constantin Brancusi, among others. An artist herself who had two paintings in the Armory Show, Dreier bought two prints from the show, one by Redon and the other by Gauguin. But her taste changed, and she found great success in her role as a promoter of the avant-garde artists. Over a period of twenty years, she profoundly altered the history of radical art in America.[89] On visiting Germany in 1922, she saw the first exhibition of Russian artists such as Wassily Kandinsky, El Lissitzky, Kazimir Malevich, Liubov Popova, and the Hungarian Naum Gabo and bought their works. These artists, as well as the avant-garde of Germany and Holland, were among the roster of artists shown at her exhibitions.

In the international show that Dreier arranged for the Brooklyn Museum in 1927, 307 works by 104 artists from 23 countries, representing almost every modern movement of the time, were shown. It was the first time that the surrealists Joan Miró and Max Ernst were shown in America, as well as the first significant showing of examples of neoplasticism by Piet Mondrian, constructivism by El Lissitzky, and the Bauhaus artist László Moholy-Nagy.[90] Barr attended this exhibition and was deeply impressed by its all-inclusiveness; it was his first exposure to some of these artists.

The correspondence between Dreier and Barr began in 1927 after he had asked her, in conversation, to send the catalogue of the Brooklyn exhibition to Wellesley College as a gift. Dreier agreed and then wrote to him: "I cannot tell you how much I appreciate the work you are doing and if in any way I can assist

you . . . though of course our funds are not great. But we have the material and if the expense of traveling could be met we could always help out."[91] Barr, enthralled with his new friend, wrote a few days later to compliment her on the catalogue of the Brooklyn Museum show, extolling the typography and the cover and particularly the contents. "Since my talk with you I've been pondering the possibility of a modern show in Boston. Nothing has happened here since the exhibition of the Birch Bartlett collection over a year ago and that was composed of old masters by van Gogh etc with a few Matisses and a Friesz. Please send a list of the permanent stock. Please send photographs of your pictures. I have spent all my money on a few necessary books and cannot pay for photographs. Some day I may find someone to finance our modern course."[92]

Four days later Barr wrote to her of his plans for two modern exhibitions, one at Wellesley and one at the Grace Horne gallery in Boston, a space consisting of one large and one small room. He felt that Boston was not ready yet for an exhibition limited to Société Anonyme artists, but a few better-known names, such as Picasso, Matisse, and Vlaminck, would make a show at the Grace Horne gallery more attractive.[93] At Wellesley, the director, Alice Van Vechten Brown, was also hesitant about mounting an "ultra modern" show because the College was so "conservative." Barr bemoaned the fact that the exhibition of reproductions of Matisse, Seurat, Léger, Mondrian, Rodchenko, Klee, and others that he had installed the month before at Wellesley had "stirred up much wrath."[94]

Barr suggested to Dreier that perhaps the "7" artists from Stieglitz's gallery would find more acceptance. He asked for her help in obtaining them since they had already appeared in her shows and also because of Stieglitz's prickliness and his own lack of experience: "He is an uncertain person to deal with. Would it be too great an imposition to ask you to approach him in this matter to effect, as it were, an introduction? I'm afraid of missteps. Could you roughly estimate cost of 200 Société Anonyme pictures from New York, including installation?"[95] The future museum director also initiated what would become a long-time strategy, tempered by his ever-present humor: "Boston is very self-conscious socially—a list of patrons and patronesses for the Horne exhibition could be invaluable. Have you influential friends and acquaintances whom you would suggest? The sanction of

the Cabots and Lowells is not necessary, but it would add to the humour of the situation."[96]

Dreier's reply was not hopeful. The artists from the Stieglitz gallery were restricted to Dreier's Museum of Modern Art because, she wrote, "he really feels that we are doing important work and it was within walking distance of his gallery which of course Boston is not. Anything outside of walking distance is not permitted to exhibit his things. That is his rule and regulation and so we all have to abide by it."[97] Dreier addressed the question of obtaining loans of the other artists that Barr requested. She knew of only one Picasso, which was to be found at the Feragil Galleries. The dealer "did not quite know, but said you can have a Derain and besides a Rivera, a Braque, a Fresnay and a Fournier. I do not know whether Boston knows them." She also said a Matisse was available through Valentine Dudensing and a Vlaminck through the Rheinhardt gallery. "If you could collect $100 for matting, expressage and insurance I could let you have an excellent little exhibition with Matisse, Picasso, Villon, Klee, Campendonck, Moholy-Nagy, Schwitters, Kandinsky, Dottori, the Swiss painter Hodler etc. It would be very worthwhile."[98] These exhibitions never materialized.

His exchanges with Dreier demonstrate that his grasp of the complexity of modern art was thorough, but that his point of view was not as narrowly radical as hers. They were both, in their own ways, struggling to make order out of a changing scene. Although, as he reported to Dreier, he was prepared to mount a show largely made up of abstract paintings from the recent Vassar exhibition that she said she would loan him, Barr thought that a "good Schrimpf or Mense or Dix portrait or Carra 'metafist' combine or Marchand would be of interest." He continues: "Servarchix will do for the better known Mondrian or Doesberg and Lissitzky represents the Constructivists of Russia. Malevich and Rodchenko are missing . . . Moholy-Nagy will do for the Bauhaus. I wish I could have another Chirico. 'The Lovers' leads people astray by its superficial appeal." He thought that the greatest omission, and a serious one, was "the group about Le Corbusier. Yet all in all the list will be a revelation to Boston. I suppose Klee, Campendonk, and Chagall are out of the question."[99]

Dreier's return letter set the limits of her involvement with modern art and with Barr. She was unable to fulfill his requests because the show that was going to Vas-

sar would require heavier crating to travel to Boston, and Vassar would not pay for it. In addition, the pictures were scattered in the Brooklyn warehouse and in Dreier's home in Buffalo. Her letter turned scolding:

> I would never include a Dix in any exhibition I arranged so you could never get it through me. Carra's pictures never reached us because his pictures were held for duty in Paris in connection with a prior exhibition. As for Schrimpf, he belongs absolutely to the theater world, unless it were an exhibition including the modern theater, he also would not be included. [She later recanted saying she mistook him for Schlemmer.] Besides I know of no Dix, Carra or Schrimpf in this country, do you? I could include an early Malevich and a Mense which were exhibited at Sesqui-centennial. You seem to forget that Kandinsky and Klee are much more important than Moholy-Nagy at the Bauhaus. M-N is still of 2nd rank compared to Kandinsky and Klee who are of the first rank. All 3 are at the Bauhaus.[100]

Kandinsky and Klee were Dreier's favorite artists at the Bauhaus,[101] Kandinsky serving as a vice-president of the Société Anonyme.

Barr's reply was dated March 7, 1927. "Thanks for your letter of March 4. You are entirely adverse to Otto Dix. Of course, frequently he scatters filth, but I have seen reproductions of rather fine portraits by him. Schrimpf who has emerged at the New *Sezession* at Munich the same. I didn't know Schrimpf was connected with theater. I have much to learn from you. I knew that Kandinsky and Klee had now joined the Bauhaus. I still feel that Moholy-Nagy though less an artist represents more clearly the total character of the Bauhaus."[102] He was right; this information probably came from Neumann because Barr's visit to the Bauhaus did not occur until the next fall. Barr then asked Dreier for information: Was a "mechanistic constructivist ideal" allying itself to the Le Corbusier group in Paris? And was the Mondrian–van Doesburg group in Holland with the Russians? Obviously Barr understood the activities of the avant-garde but was still searching for particulars.

Dreier's answer was dogmatic. She felt that Dix was the leader of the new realism found in the Neue Sachlichkeit, which had "nothing to do with our point of view." She saw his art as a "normal continuation out of the past." But she would

have considered him if he could find no other patron: "When I said that I would never show Otto Dix, I had in mind that, in the first place, he had built up his reputation out of filth and in the second place his pictures are of such enormous monetary value that I need not handle them."[103] (Barr wrote an article on Dix in June of 1929, three days before he was invited to join the Museum of Modern Art as director.[104] Reacting to Dreier's point of view, he did not submit it for publication for two years because he was afraid it would be considered reactionary. In the article, however, Barr, as a self-taught authority on military battles, indulged himself with a poetic description of Dix's painting *War.* He considered the painting "a masterpiece of unspeakable horror. We cannot find its equal except in that other dreadful masterpiece, the Altarpiece of Isenheim."[105])

Dreier's letter continued in the same unrelenting tone:

> Neither do I follow you when you feel that Moholy-Nagy interprets the Bauhaus more than Kandinsky and Klee—unless you feel that Gropius alone is its leader. But why sidetrack two such powerful personalities with such tremendous international influence covering such long periods of years. I must say I do not follow you. And who is the Le Corbusier group in Paris? If you want to be up to date Mondrian and Doesberg [sic] have separated and Mondrian feels that Doesberg in no way represents his point of view. He has simply commercialized the outward expression. I always try not to be sidetracked by temporary manifestations. . . . There are so many half-baked people and so many half-baked ideas that if one is not careful one finds that one is representing their point of view instead of the main current. And it is the main new developments which I want to follow.[106]

This exchange of letters reveals how much Barr learned form Dreier and how much he was influenced by her, although he was never as exclusively committed to the abstract painters as she was. His understanding of abstraction was more comprehensive, accounting for his interest in Moholy-Nagy. Besides the groups dedicated to such movements as cubism and expressionism, Dreier would arbitrarily admit artists whom she thought were in "the same spirit as us" or were "individualists." Barr defined the parameters of modernism more broadly.

Barr learned a great deal from Dreier because she had had the benefit in 1922 of meeting the artists at the Bauhaus and at a large exhibition of Russian artists in Berlin. She visited Germany again in 1924. In 1926, when she made a three-month swing through Europe to collect works for the Brooklyn exhibition, she revisited the Bauhaus and saw her old friends Kandinsky, Klee, Moholy-Nagy, as well as others whom she had been supporting in America. She corresponded regularly with Kandinsky, a vice president of the Société Anonyme, and she was well known and highly respected at the Bauhaus. Dreier reinforced some of Barr's views. But whereas Dreier was motivated by the sense that art's universal appeal was embedded in its social and spiritual message—ideas she drew from the writings of Ruskin and Morris,[107] from theosophy, and from the spiritualism of Kandinsky—Barr's predilections were neither so romantic nor based on such spiritual notions. She was dedicated to show each radical ism in its purity; in contrast, Barr's method was to synthesize the overall view and demonstrate by comparison.[108]

BARR'S FIRST MODERN EXHIBITION

Without the help of Dreier, Barr mounted a show at Wellesley in April of 1927 entitled "Exhibition of Progressive Modern Painting: From Daumier and Corot to Post-Cubism."[109] He wrote that the works—still lifes, landscapes, and figure painting—were installed "not according to nationality, chronology, or the exigencies of interior decoration, but according to subject matter. Such a division permits the visitor to compare various pictorial treatments of a similar natural problem."[110] Again, for Barr, narrative took second place to a formal treatment, continuing the approach he had developed at Harvard as a student.

Barr's aims were more broadly didactic than Dreier's. In the introduction to the catalogue he wrote for the exhibition, he apologized that because of his limited means he was frustrated in obtaining illustrations for his full description of the evolution of modern painting. He regretted the fact that works by the nineteenth-century artists Constable, Delacroix, Ingres, Courbet, Manet, Cézanne, van Gogh, Gauguin, and Seurat were unavailable; also missing, he complained, were

the twentieth-century artists Matisse, Picasso, Derain, Braque, and Segonzac.[111] He then described the sequence of events in this history. The first decade of the twentieth century found the painters Matisse, Rouault, Munch, Derain, Bonnard, the fauves and those of Die Brücke using the art of the ancestors of modernism— Cézanne, Renoir, Degas, van Gogh, and Gauguin. This first group of modernists, he continued, "experimented with color and form as elements in expressive design but retained many vestiges of natural appearances."[112] Barr was struck by the fact that this group was the first to appreciate, with more understanding than their immediate predecessors, medieval and barbaric art, Negro sculpture, children's drawings, as well as Persian miniatures, Henri Rousseau, and El Greco. He expanded this mode of thought that summer when he decided to investigate primitive sources of art for his dissertation.

Barr then discussed the various abstract movements that had evolved before the war, saying that they were "more self-conscious and systematic."[113] He understood that cubism, led by Picasso, passed through various phases of abstract painting suggested by the work of Cézanne and Negro sculpture. His interpretation of cubism reflected his wide reading in the subject. In a reasonable thumbnail sketch of the style, he said that the movement revealed "complex theories of the relation between mental and visual concepts of objects, and the disintegration of natural forms to be recombined in pictorial compositions."[114] Other artists discussed by Barr were Klee, the futurists and their interest in the machine and the time element, and Kandinsky, who sought "a direct emotional *Expressionism* through form and color without any reference to nature, tradition or mental discipline. This was a period of extremes."[115] Derived from the first two periods, pre- and post-World War I, Barr conjectured that many new attitudes and movements developing currently were replacing those extremes. He nonetheless thought that "Cubism and Expressionism are still powerful as ideas if not as styles."[116]

In the late 1920s, abstraction was replaced by figurative representation and a conservatism set in among artists that confused the issues surrounding modernism in ways unsettling to Barr. His next heading in the catalogue revealed this conservatism: "Four post-war movements may be selected as apparently important." The first group consisted of the neorealists, who seemed to hold a particular fascina-

tion for Barr. He called the movement "a reaction against expressionism, cubism, etc. Hopper, the American, expresses a more spontaneous *Dinglichkeit*."[117] For the second group, the neoclassicists, Barr wrote: "They emphasize judgment, the intellect, formal beauty, restraint and deliberation. Many of them were former cubists."[118] Among these painters Barr included Karfiol, Metzinger, Sheeler, and Dickinson. Barr again projected formal concepts onto an art that had retrogressed into the figurative (Karfiol had not been a cubist). The third group, the constructivists, held a more important place in Barr's narrative of modernism, with its emphasis on the machine. These artists, he thought, expressed "the post-war spirit of discipline and reconstruction, as well as a more universal instinct to build and organize. Their interests are related to architecture, carpentry, mechanics."[119]

The last group, the superrealists, also held a fascination for Barr, with their insistence on the subconscious, "the intuitive imagination uncensored by the intellect, the only valid source of artistic expression." He admitted that in this exhibition only "Chagall seems *sur-réaliste* and doubtless, there are 'impurities' even in his painting."[120] With this essay, Barr succeeded in outlining the story of early twentieth-century modernism almost as it was happening.

In this introduction to the history of early modernism, Barr significantly articulated the basis of his formalism, allowing that some painters focus on the "real" world and others on the "inner creative sense," which produces imagined forms unlike natural ones. The common thread connecting both types of artists—which makes Barr's formalism inclusive—is their "desire to *organize* and *intensify*." He continues:

> The desire to *organize* resolves itself into problems concerning the arrangement and composition of various elements in the picture. This necessity for order leads to an interest in the relations between forms rather than in the forms themselves, whether these forms are thought of as colors and lines or as painted fruit, bottle, trees or figures of men and women or imagined objects.[121]

He recognized the need to "*intensify*" as the source of "simplification, elimination, distortion of what is seen either in the real world or in the world of the imagination."

Barr's wall labels for each artist's work documented his formalist approach. For Man Ray's *Still Life* he wrote that the artist's painting was analogous to his photography in two ways: as experiments with abstractions and, more importantly, "[he] explores and exploits the qualities peculiar to the medium. The thick sensuous texture of the paint as well as its color are important to him."[122]

For the portrait *Woman at Window* by Degas, the sharpness of Barr's analysis is clear. He compares the artist to Manet who, he writes, established the problems that Degas would then refine: "The subtle values needed to overcome the complicated relation of interior to exterior light, the figure darkened in contrast to the brilliant window, the thin flat painting, the avoidance of defined contour and the studied informality of composition suggest Manet. Degas, however, has substituted for Manet's snapshot journalese an atmosphere psychologically laden."[123] Here "psychologically laden" as an expressive quality, unencumbered by interpretation, assumes a formalist position.

This 1927 catalogue marked Barr's maturation in his understanding of modernism, despite the fact that he still clung to his estimation of Monet as expressed in his 1925 catalogue for Sachs's class at Harvard: "It seems likely that he will take rank somewhat below Sisley who surpassed him as a colorist, and Pissarro who rarely permitted his preoccupation with light to exclude the study of form, color and composition as did Monet."[124]

Contrary to a generally held notion that Barr was singleminded in his adherence to abstract art—or to the controversial notion that art could only "progress" in that direction—Barr's view of modernism embraced what may seem to be contradictory modes. Barr's use of objective analysis emerged in the first quarter of the twentieth century as abstract art was developing, but it was not coterminous with it; his formalism was an analytical approach, encompassing structure and technical processes, and was applied to all works of art, regardless of genre, media, style, or period. His vision was inclusive, placing pure abstraction and poetic expression—as in surrealism, for example—in apposition. He was fascinated with the rational, the objective, and the classical; but he was equally enthralled with the irrational, the mystical, and the uncanny. The tension between these two types of approach had for Barr, in retrospect, a creative relevance. His strength

lay in his ability to examine seemingly contradictory positions of art and to deliver, in clear prose, a reasonable account of their relationship. This juxtaposition represented the crux of his critical stance: cubism, surrealism, even social realism were discussed in the same formal terms, leaving modernism open-ended. Some of the more single-minded members of the art world thought he faltered in the cause of advancing the radical abstractionists.

It was his habit to analyze—as did Albert Barnes—a Titian or a Vermeer according to "plastic" forms. His formalism did not coincide with geometric rationalism, nor was he concerned only with pure abstract art. His interest in "magic"—that is, myth, irrational forces, and mysticism—was deeply ingrained in his personality, surviving intact from childhood. He was drawn to German expressionists and French surrealists, as well as to the English artist Samuel Palmer, the Swiss Henry Fuseli, and the German Caspar David Friedrich—all favorites of his. At one point, for instance, he approached the Renaissance master Andrea Mantegna both formally and intuitively: "I tried to suggest that beneath [Mantegna's] realistic and archeological surface there lay a rich vein of poetry almost nay decidedly mystical."[125] For Barr, superintending all formalist schematic evaluations was the "magic" of the immediate aesthetic experience.

Barr considered the artist's originality or rebellion—frequently referred to by him as "reaction"—to be the driving force of style changes in the history of art. According to Barr, these reactions were manifested in stylistic formal changes throughout the history of art regardless of source or political contingency. As a connoisseur, his notion of formalism paid close attention to forms, technique, and compositional structure, assessing modernism in a system of relationships. He held that describing classifications within the modern style, one could discern a movement. "Formal analysis" as a method that Barr applied to the whole of art history, removed from any ideological context, can be differentiated from the term "formalist art" as a synonym for abstract art, that he and others in contemporary discourse sometimes used interchangeably.

4

THE LITTLE MAGAZINE AND MODERNISM AT HARVARD

Among all the manifestations of modern art that fomented avant-garde ideas in the early part of the century, the upsurge of the "little magazine" ranked as a pivotal influence on young rebels who were open to the new. (They were termed "little" because of the size of the readership.) From the beginning of the century, the leading journals the *Little Review* and the *Dial*—predecessors of such magazines as *Tendenz, Secession,* and *Broom*—were published by American writers, both in America and Europe. They carried representations of modernism in various media, introducing Harvard students like Lincoln Kirstein and Barr to the exciting cultural events taking place in Europe. Kirstein contributed to the distinctive literary history of the 1920s with his own journal, *Hound & Horn,* whose table of contents featured the same brilliant writers as the earlier magazines.

Kirstein (fig. 24) was a freshman at Harvard in the fall of 1926, the same semester that Barr was sporadically auditing Sachs's museum course and teaching the history of Italian Renaissance art at Wellesley; perhaps mistakenly, Kirstein re-

24. Lincoln Kirstein. Yale Collection of American Literature,
Beinecke Rare Book and Manuscript Library.

called that Barr was his tutor at Harvard.[1] Individually, both men were travelling
to New York to visit the avant-garde galleries. Their paths crossed serendipitously
when, in the summer of 1927, Barr met Kirstein in London. Barr reported to Sachs,
as was his custom, commenting that Kirstein was "a boy of considerable talent and
of very great intelligence, taste and energy." He added that Kirstein felt that he
was regarded with "a certain suspicion in Cambridge" due to his interests in mod-
ernism.[2] Despite Barr's lack of success in introducing modernism to a university au-
dience with his ill-fated lecture, he and Kirstein were part of a radical group at
Harvard that was making gains in this area by their writings and the exhibitions
they mounted.

Both young men were in Europe to absorb cultural experiences as well as to pursue more specific aims. Barr was doing research for his doctoral thesis on the machine and, alternatively, on primitivism as sources for modern art. Kirstein was seeking help from Ezra Pound and T. S. Eliot for his literary journal of arts criticism,[3] having spent his freshman year with his housemate Varian Fry preparing for the publication of *Hound & Horn;* Kirstein had brought a preview copy of the first issue with him. Both Kirstein and Barr were intent on importing to America the artistic culture that had aroused them in Europe.

Harvard students were traditionally encouraged to broaden their horizons with the implicit message that America had not yet caught up with the cultural opportunities found in Europe. At the beginning of the century, England and then France were the centers for the arts that drew young intellectual expatriates to find a usable past. The Harvard coterie of the late 1920s followed earlier generations of students who finished their education in Europe, although neither Barr nor Kirstein was an expatriate in the usual sense of the term, which connoted either a two-year sojourn or a self-conscious recognition of oneself as an expatriate.[4] On returning to America, having assimilated the spirit of modernism in Europe, Barr and Kirstein were among those who confronted the conservators of tradition.

THE PRODIGIOUS LINCOLN KIRSTEIN

Kirstein's work did not have to coincide with earning a livelihood. He was born on May 4, 1907, in Rochester, New York. His father, Louis Kirstein, had started out poor and was self-educated but with tremendous drive and energy, becoming the president of Filene's department store when the family moved to Boston. He passed on to his son his qualities of temperament, together with an unusually early financial inheritance. His mother's family was wealthier and she provided the cultural environment that sent the young Kirstein in the direction of the arts.

At the age of fifteen, Kirstein began sojourns in Europe, becoming intimately acquainted with artists and writers through his sister, Mina, with whom he was close although she was ten or twelve years his senior. In London she introduced

him to members of the Bloomsbury group: Lytton Strachey, the Sitwells, Roger Fry, and E. M. Forster (who, ten years later, became his "mentor and friend").[5] Another member of the group, John Maynard Keynes, took him to Diaghilev's Ballets Russes every night, where he acquired firsthand knowledge of the ballet.[6] In a long list of acknowledged mentors, Diaghilev would become Kirstein's lodestar.

Kirstein's talents and passions in artistic life were multifarious. A dilettante in an older sense of the word that was not pejorative, he was versatile and interested in a broadly based culture nourished by literature, history, photography, radio, dance, and films, as well as painting, sculpture, and architecture. Barr also described himself as having "the questionable faculty of being interested in almost everything."[7] Not yet organized by specializations, objects of all media—whether fine art, folk art, or industrial products—were more easily taken as an evolving whole in that era.

Kirstein attributed his broad understanding of art to his training at a stained-glass factory. By the age of sixteen he had decided that he wanted to be a portrait painter in the style of Hans Holbein, John Singer Sargent, and Thomas Eakins.[8] Sargent painted murals in the Boston Public Library and Kirstein's father, who was president of the library, was in touch with him. Considering his son too young to enter Harvard, on the advice of Sargent the elder Kirstein found a job for the budding artist as an apprentice in a stained-glass studio. Kirstein acknowledged that his technical training prepared him for a new way of thinking about art: "I came to consider familiarity with digital mastery, combined with instruction in the materials of painting and the means of rendering, as the basis of critical judgment."[9] The curriculum at Harvard would add to this point of view.

The contrast between Barr and Kirstein in their early years is revealing. As a very young man, Kirstein's ambition was to become one of the creators—either artist, writer, or dancer. Although he experimented with all three, his ultimate position would be that of patron and historian of the creators. While Barr consistently attempted to maintain an objective, balanced view of modernist art and artists, purposely avoiding spiritual associations, Kirstein, more erratic in temperament, followed an impulsive path, overindulging in emotional responses associated with the link between divine creation and cultural process. In an introductory letter for

Kirstein, the artist Pavel Tchelitchew wrote to Edith Sitwell that "Kirstein is overenthusiastic about everything he likes—so be careful."[10] While Barr's passions were fully restrained and disciplined, Kirstein's energies overflowed into a myriad of projects. His explanation: "As an adventurer . . . I embraced the advance-guard taste of Alfred Stieglitz and progressive Manhattan galleries. Essentially this was opportunism. The fun was in the energy expended in a crusade, and the opportunities this afforded to have contact with movers and shakers."[11]

Intellectual curiosity about the "new" and "opportunism," both by-products of endemic enthusiasm in the 1920s, gave modernism its broad artistic base and its international scope. Kirstein did not seem to be using the term "opportunism" in a pejorative sense; rather he tried to portray the sense of excitement rife in the period. Taking their cue from nineteenth-century romanticism, concepts of the "new," "genius," and "originality" would harden into an aesthetic philosophy whose assumptions were not generally questioned until the 1970s.

Kirstein shared these interests with a circle of students around Sachs; although still elitist in aim and manner, they rebelled against the tradition of gentility at Harvard in the 1920s—a tradition that derived in a straight line from the Norton-Ruskin-Berenson nineteenth-century dictum of "good taste." The concept of elitism, though shifting in the decades after the 1920s to a more pejorative meaning, was a fully self-conscious position at the time, concerned with maintaining the standards of a hard-won culture. Their justification for expanding the limits of acceptable art was to awaken the uninitiated to its pleasures.

Kirstein's prodigious energy matched the sweep of his interests. More than that, he had the ability to travel his own path, indifferent to the opinions around him. In his own words, "being a rich boy, and having gone to very permissive schools, I never really suffered from unnecessary scruples about personal morality or societal pressure."[12] His aim, not unlike that of others of his generation, was to make his life a work of art—to live on the aesthetic edge. Kirstein's expressive manner and his rhetoric—at once flamboyant and eloquent, masked and revealing—echoed his temperament. As with Barr, his wit, caustic and to the point, hid a resolve that was unyielding.

Yet Kirstein, inconsistently, was drawn to students from aristocratic Boston families whose sense of dignity and responsibility he unabashedly admired. Indeed, surrounded by the more conservative "genteel tradition," modernism presented a conflict for Kirstein. He and his cohort still were enthralled with Norton, who along with Henry Adams—whose books *The Education of Henry Adams* and *Mont-Saint-Michel and Chartres* had become cult items with Harvard students—created a fascination at Harvard with medieval Europe that gripped generations of students.[13] According to another Harvard graduate, Van Wyck Brooks, modern America offered these Harvard professors nothing. They escaped to historical Europe "from the vulgarity of the American present . . . [The] hatred of modern civilization that one heard expressed on every side predisposed one in favour of anything that was not modern."[14]

Inspired by Adams, Kirstein, with his mother and brother, visited Mont-Saint-Michel and Chartres in 1932.[15] Barr mentioned Adams as a hero as well; the summer before he went to Princeton, he read *Mont-Saint-Michel and Chartres*, given to him as a graduation present by his Latin teacher, and in 1924 he anticipated Kirstein's journey. Barr claimed that the experience of reading Adams's book influenced the beginning of his interest in art.[16]

Kirstein was a self-confessed nineteenth-century man drawn into the twentieth century by his enormous curiosity. He wrote: "After all, there was modern art and what a success that was becoming. And I was forced to feel, in spite of [my] prejudice, that there was some irreducible courage, both in art and life, a defiance, however gross or unseemly, of which I could not help being envious."[17]

Following the tradition of taking a grand tour, Kirstein roamed the Western world and gained a knowledge of contemporary art in the process. This route, taken before the advent of graduate schools, was carried out principally by those, like Kirstein, who were able to afford a higher education in the first place, and who were also more likely to have had the advantage of being exposed to the arts. Of course, Barr, supported by a tradition of higher education from his clerical family but not by financial resources, accomplished the same goals with a dedication not usual in his peers.

THE EXPATRIATES

The decade of the 1920s saw the influence from abroad shift from England when a surge of restless young artists and writers swelled the numbers of expatriates seeking adventure in Paris. The Harvard graduates who went to Paris when Kirstein did enjoyed the city as a "post-graduate course."[18] This was the period of the greatest number of international student and teacher exchanges since the movement had its modest beginnings in the early part of the nineteenth century.

In his study of expatriates, Warren Susman maintained that "by the close of the 1920s it is extremely difficult to find major figures in the intellectual and cultural life of the United States who had not visited abroad."[19] Susman held that the artistic revolution known as the modern movement was truly international because of the sojourns of the expatriates. And, as Barr proved, the question of artistic influences could be mapped at the beginning of the modern movement by tracking the pattern of the comings and goings of the artists: Russians to Berlin in 1922; Hungarians and Dutch following the Russians, adding to the radical architecture movement; Spaniards to Paris bringing cubism; French to Moscow and Berlin, influencing expressionism; Americans on a grand tour. The two countries with the most intense cross-cultural activity were Russia and the United States. American painters consistently sought their education in Europe.

Europeans were especially interested in the machine age phenomenon burgeoning in America and welcomed Americans for any information they could impart about the new technology, architecture, film, and jazz. Philippe Soupault, a French writer and member of the Paris dada group, wrote *The American Influence in France* in 1930, satisfying an appetite for books on the subject. He expounded on the fascination of Frenchmen with things American: "The American cinema," he wrote, "brought to light all the beauty of our epoch and all the mystery of modern mechanics."[20] He understood the aesthetics of the machine as the close relationship between "art and life."[21] The machine, a leitmotif in the writings of expatriates in the little magazines that Barr had access to, became the central source of modern art in Barr's "Cubism and Abstract Art" chart of 1936 (see fig. 5).

Meanwhile, Barr was at a pivotal point of his career. He joined the large number of young intellectuals in France who supported themselves by working for American newspapers based in Paris or sending articles to home newspapers and journals. In their writings, they criticized, with irony and some bitterness, the lack of opportunity and support for the arts in America. The decade is known by the testimonies of men with creative intellect who were in constant touch with the cultural events of the time and who supported each other. Barr became part of the newly recognized "intellectual generation."

HOUND & HORN

Reacting strongly to the outpourings of young American radicals in Europe, Kirstein, on returning to Harvard from Christmas vacation in his freshman year, in January of 1927, developed the idea of a Harvard quarterly with his Gore Hall housemate, Varian Fry. His intention was to create with *Hound & Horn* an educated audience at Harvard for the new manifestations of arts and letters in the international scene. The title came from a poem by Ezra Pound, "The White Stag":

'Tis the white stag, Fame, we're a-hunting,
Bid the world's hounds come to horn![22]

The magazine was a diversion from the stodginess of his Harvard classes and, to the detriment of his grades, took almost half his time.[23] In his memoirs, half a century later, Kirstein wrote with candor: "I was an adventurer and *Hound & Horn* was my passport."[24]

As with other high bohemian expatriates in publishing before him—such as Harold Loeb of *Broom* and James Sibley Watson, Jr., and Scofield Thayer of the *Dial*—family money financed *Hound & Horn* from 1927 to 1934. The Kirstein fortune kept it going during the Depression when many other little magazines folded.

Kirstein later characterized *Hound & Horn* as "a kind of Harvard *American Mercury* and *London Criterion* and *North American Review* all in one," adding: "People used to say the book reviews were the best part of the magazine. That and the chronicles of painting, architecture, etc."[25] Kirstein's interest in architecture, film, and photography, which were the more experimental arts in the 1920s, was borne out in the magazine and contributed to its importance as a commentary of modern life. Varian Fry supported Kirstein in these aims as a founding editor: "With these schemes to found the *Hound & Horn* we had also another, to bring to the consciousness of Harvard the recent developments, in art and literature, it seemed to us to be ignoring, to its own cost. I was an admirer of Joyce, you of Eliot. We had both read Gertrude Stein, looked at Picasso, listened to Stawinski [sic]. They seemed to us important, and we felt that Harvard undergraduates ought to know more about them than they did."[26]

THE DIAL

Barr often declared that the *Dial*—the most widely read and prestigious of the little magazines in the 1920s—served him as a source for modernist ideas. Kirstein followed its example mainly in its overall elegant physical appearance and its format of book reviews and short notices describing the artistic scene.[27] He commented that "*The Dial* would maintain a distinction of artistic and literary values unequalled in America, before or since."[28] Essentially, both Kirstein and the *Dial's* publishers were conservative modernists.

The *Dial* had been revived in 1919 by two wealthy young Harvard graduates, Scofield Thayer, class of 1912, and James Silbey Watson, Jr., class of 1916. Their rehearsal for this project was their efforts with the *Harvard Monthly,* which they tried to make "aesthetic." Influenced by George Santayana, they were committed to art as well as literature and criticism. Santayana's articles appeared in the *Dial* with those of Ezra Pound, Roger Fry, Thomas Craven, Gilbert Seldes, T. S. Eliot, and Henry McBride, among others; they made its reputation. Although areas such

as architecture, abstract art, films, and photography were overlooked or viewed negatively by the magazine, its overall enthusiasm for new international ideas and freshness in contemporary works gave it a place in the avant-garde movement. Thayer traveled to Vienna and Berlin and bought works of art by artists unknown in America, such as Gustav Klimt and Egon Schiele and other Central Europeans. His collection of works of modern art hung in the *Dial* offices and was reproduced in a folio called *Living Art*.[29] On the initiative of Barr, who had purchased a copy of *Living Art*, an exhibition of the *Dial* facsimiles and photographs from the folio were put on view at the Fogg in 1926 and at Wellesley in January of 1927, after which Barr gave the folio to the Fogg permanently.

Besides the reproductions of modern art appearing monthly in the *Dial*, it contained essays by Henry McBride, one of the most knowledgeable critics of the time.[30] Beginning at a propitious time, 1913—the year of the acclaimed Armory Show—McBride wrote a weekly column as an art critic for the New York *Sun;* in 1920, and until its demise in 1929, he wrote on modern art for the *Dial*. In those years, he was in the small circle of critics who understood and supported the modernist cause. Kirstein believed that McBride belonged in the ranks of Heine and Baudelaire, both of whom, he wrote, "(together with Ruskin) mark the peak of modern art criticism."[31] McBride wrote of such Europeans as Matisse, Picasso, Cézanne, Brancusi, and Miró, as well as the American painters that the pioneer Alfred Stieglitz promoted in his gallery.

Like Kirstein, McBride acquired the background for his critical writings in Europe: in 1907 he met the Berensons; in 1910 Roger Fry and Bryson Burroughs took him to visit Matisse.[32] His most important contact was Gertrude Stein, on whom he relied to keep him informed of unfolding artistic events in Europe. McBride was the first to print a piece of Stein's in the *Sun* and it was he who interested Frank Crowninshield in publishing her work in *Vanity Fair* in 1917.[33]

McBride's coverage of the art scene was comprehensive. From him the intellectual avant-garde learned about the Walter and Louise Arensberg collection and about their salon of poets and artists. In the first article McBride wrote for Thayer and Watson in July 1920, "Modern Forms: . . . devoted to the consideration of

the less traditional type of art," he described the Arensbergs' percipient patron-age of Marcel Duchamp's work, inspiring them to display his piece *Air from Paris* in their home.[34]

Curiously, McBride's taste failed when it came to the German expressionists. He attacked Max Beckmann as an "unentertaining and uninstructive Schopen-hauer."[35] However, Barr and his Harvard friends were interested in the German avant-garde artists early on; as Barr wrote in 1926, they considered "post-war German Expressionism the most vital of contemporary movements."[36]

EZRA POUND

Playing the role of the expatriate beyond perfection, Ezra Pound was an agitator and a catalyst for modernist art as well as an important link between the Harvard circle and the international movement.[37] Pound saw Paris as a "laboratory for ideas"; arriving there in 1920, he sent "Paris Letters" to the *Dial*. For the better part of three decades, beginning in 1912, his writing for most of the little magazines reported what was occurring in Europe. He appeared as poet, essayist, letter writer, editor, or foreign correspondent in more than a hundred little magazines, the most important of which were *Poetry,* the *Dial,* the *Little Review, Blast,* and *The Enemy;* the latter two were his own publications.

By the time Kirstein came on the scene in 1927, most of the other magazines had folded. Although he must have sensed that Pound was coming to the end of his three decades of inspirational influence in the arts, Kirstein nevertheless enlisted his support for *Hound & Horn.*[38] Kirstein and Pound, the poet he "most passion-ately admired," were in constant correspondence, although Kirstein complained that Pound "eventually helped me so much that he threatened to turn it into a per-sonal house-letter." But Kirstein also admits that without Eliot and Pound the mag-azine "would not have caused a ripple."[39]

Pound's ploy was to use the little magazines to agitate for an American renais-sance. Although his writings were peppered with criticism of American culture, the

leadership he displayed in the arts was motivated by his belief that Americans could create and nurture their own culture without imitating the Europeans. In the 1910s and 1920s, this idea ran counter to that of other expatriates critical of life in the United States. Not until the end of the 1920s, when a good many returned to America, was a sense of the possibilities in American life revived.

Pound arranged his residence in foreign capitals to acquaint himself with the culture of those countries. He then used his knowledge to nurture an American culture. In an important essay, "The Renaissance," first published in *Poetry*, he outlined a three-part program: "First that we should develop a criticism of poetry based on world-poetry, on the work of maximum excellence. . . . Second that there be definite subsidy of individual artists, writers, etc." He called on Rockefeller, for instance, for monetary assistance: "If you endow sculptors and writers you will begin for America an age of awakening which will overshadow the quatrocento." The third important development, according to Pound, would be the creation of a center, a "vortex" supported by the millionaires that would establish "the deliberate fostering of genius, the gathering in and grouping and encouragement of artists."[40] Unwittingly, Pound was forecasting the establishment of the Museum of Modern Art.

Iris Barry, a poet in Pound's circle, later emigrated to the United States from England to become first the librarian and then founder of the film department at the Museum of Modern Art. Writing in 1931 about "The Ezra Pound Period," she described Pound in London during World War I: "Pound did 'believe' in the arts as other men from time to time have 'believed' in patriotism, or liberty or the suffrage or religion. He was at his most personal when he wrote 'Artists are the antennae of the race, though the bullet-headed many will never learn to trust their great artists.'"[41]

Pound promoted visual artists as strenuously as he did writers; his aesthetic principles were formulated on the interactions of all the arts. In London before World War I, the coterie around Pound included T. S. Eliot, Wyndham Lewis, and Henri Gaudier-Brzeska.

The sense of experimentation, extrapolated from scientific methods, served the avant-garde on every level and can be found throughout Pound's writings. He believed in the creatively new, in freedom for the artist (or, more succinctly, individualism), in abstraction rather than realism, and in the formalist aesthetic in all the arts. In defining vorticism, a short-lived art movement based partly on cubism and futurism, he touched on such ideas as "forms well organized," "automatic painting," and "form motif," demonstrating his deep involvement in modernism in both poetry and the visual arts at this early date.[42] He complained about the architecture of London: "I do not know that anyone has attempted to formulate an aesthetic of good city building. London is such a chaos, the task of reform looks hopeless."[43] Although he admits that "the cinema asks for 'criticism,' it asks to be taken seriously," Pound didn't see it as art but rather as theater.[44] Years later, the most interesting innovation of *Hound & Horn,* outdistancing the *Dial,* was its extended coverage of architecture and film, reflecting how important they had become as art forms.

Kirstein had set out in 1927 to meet Pound. He never did, although he corresponded with him regularly. He wrote, however, that having grown beyond the authors that Pound championed, he and the other editors balked at Pound's eccentric choices: "We made a fine alliance with Pound for advice, help, and contributions. We printed nearly everything he sent us, but finally, in spite of his lovely poems and his marvelous letters, we couldn't face the coterie of lame duck discoveries he was always capriciously harboring, and we were relieved to let him be obscene about us in other 'little' magazines."[45]

The poet T. S. Eliot was also a significant influence in the movement. "The Waste Land" first appeared in America in 1922 in the *Dial,* and Eliot received the magazine's annual award as the most brilliant poet of that year. That combination, in addition to a critical review of him by Edmund Wilson[46] (at that time a little-known writer), greatly expanded Eliot's following in America. The relationship between Eliot and the *Dial* made both their reputations. Kirstein remembered reading "The Waste Land" at the age of fifteen. Reminiscing about its magical effect on him, he reflected: "It seemed to fuse past and present, to make certain assertions

about renewal or repetition of seasons and epochs. It became a text from which we quoted at increasingly frequent and appropriate moments."[47] Kirstein's poetic nature compelled him to look to Eliot as "Authority, our authority, but he represented the living past, the potential present and the fact of achievement by a living artist as a professional."[48]

Kirstein had an intimate knowledge and admiration of Eliot's *Criterion,* and he used that journal as a model for *Hound & Horn.* "We strove," he wrote, "to attain an elitist progressive tone and stance through the late twenties and early thirties . . . aided by the immediate interest of Pound and Eliot, [it] grew into something wider than undergraduate enthusiasm."[49]

Many writers who appeared in the myriad of other little magazines were also published in the *Dial* and eventually found their way into the pages of *Hound & Horn,* including William Carlos Williams, Conrad Aiken, W. B. Yeats, Malcolm Cowley, E. E. Cummings, and Yvor Winters, as well as those (in addition to Pound and Eliot) with a more direct effect on the artistic avant-garde. Among the more than 600 journals printed between 1912 and 1946 devoted to publishing little-known and unappreciated artists, the *Dial* had a unique format that *Hound & Horn* would later copy, devoting more than half of each issue to critical essays, book reviews, art, music, and theater commentary as well as art reproductions.

MALCOLM COWLEY

Although the *Dial* printed some radical material, it was on the whole more conventional and less daring than smaller journals such as the *Little Review, Broom,* and *Secession,* all American magazines published in Europe. One of the more prominent writers and editors was the Harvard expatriate Malcolm Cowley, class of 1920, whose book *The Exile's Return* bore witness to the "long adventure" of a group in Europe who graduated from college between 1915 and 1922.[50] Cowley wrote that the avant-garde writers "fell into the habit of identifying themselves with the century. . . . The generation belonged to a period of transition from val-

ues already fixed to values that had to be created."[51] Although not recognized by Cowley, Barr and Kirstein could easily have belonged to this group. Barr graduated from Princeton in 1922, but the period would have had to be extended to 1930 for Kirstein.

Cowley's generation, educated in the years of the nascent reaction to the genteel tradition and having experienced the cynicism of war, joined the intellectual rebellion against these values and prepared the way for Kirstein's generation. As the more typical expatriate, Cowley condemned American civilization, blaming an insensitive public for ignoring its creative geniuses: "Life in this country is joyless and colorless, universally standardized, tawdry, uncreative, given over to the workshop of wealth and machinery."[52] As with Kirstein, Cowley's culture hero was Eliot, a Harvard boy from St. Louis who made good. Because Eliot concerned himself with problems of form and matter, Cowley felt he was on his side: "His poems, from the first, were admirably constructed. He seemed to regard them moreover as intellectual problems—having solved one problem he devoted himself to another."[53] Following Eliot, Cowley and his group bolted to France to immerse themselves in French literature, seeking "leisure, freedom, knowledge, some quality that was offered by an older culture."[54]

MATTHEW JOSEPHSON

Cowley provided the impetus for Matthew Josephson, one of the community of writers newly arrived from America in 1921, to write of the generation who found an urgent need to establish literary outlets upon returning from World War I: "We would enjoy publishing our own work, and at the same time throwing rocks at the Philistines, as our European contemporaries were so joyously doing."[55] They both were involved with the same roster of fellow poets that Cowley encountered when he was at Harvard and that Josephson met about 1919 when he attended Columbia University. It included Kenneth Burke, Richard Blackmur, Hart Crane, William Slater Brown, Robert M. Coates, John Brooks Wheelwright, and Allen

Tate, all of whom figure prominently in Kirstein's *Hound & Horn* and in his memoirs. Wheelwright, Harvard class of 1920 and related to Henry Adams, was the kind of "proper orthodox Brahmin"[56] to whom Kirstein was attracted; he was a poet who served Kirstein as a mentor, especially in architecture.

Cowley and his group were in the first wave of American expatriates who went to Europe after World War I. The American and European avant-garde, as conceived by Josephson, appeared in the first issue of *Secession* in April of 1922. The magazine was financed by Gorham Munson, another scion of a wealthy family, and published in Vienna, Berlin, Florence, and New York. It contained work by, among others, Cowley, Louis Aragon, Guillaume Apollinaire, Josephson, Wheelwright, and Tristan Tzara. Its editorial policy states that "*Secession* exists for those writers who are preoccupied with researches for new forms."[57]

Josephson's contribution in the first issue was a short essay on Apollinaire that spelled out the program of "experiment and innovation" in the magazine: "Apollinaire . . . forerunner of almost everything of importance that will take place in the literature of the next generation, urged the poets of this age to be as daring as the mechanical inventors of the airplane, wireless, cinema and phonograph."[58] It was a call to American poets to pay heed to the machine age that was reshaping their country.

After a falling out with Munson, Josephson moved over to *Broom* (where he had been a contributor since its inception) as associate editor. Calling itself "An International Magazine of the Arts," *Broom* was published from November of 1921 to January of 1924 in Rome, Berlin, and New York, successively, creating "a sort of bridge between the culture of the two continents by presenting significant selections of the art and literature of contemporary Europe and America side by side."[59] Rather than following the educative aims of the *Dial,* Josephson and the editor Harold Loeb planned to represent a "militant modernism . . . sponsoring the avant-garde of postwar Europe, the German as well as the French experimenters, and the youth of America."[60] A conservative publication under the original editors, it became more radical when Josephson took it over after the fall of 1922, using the writings of his cohort such as Cowley.

The progressive character of the journal was nourished by the atmosphere in Berlin in the early 1920s and the activities of the Bauhaus. The avant-garde artists included in *Broom* were the dadaists, the de Stijl group, and the Russian constructivists who gathered in Berlin in 1922 to attend a conference on modern art. Josephson included his new-found friends in *Broom* in translation. He considered the "handsome reproductions of the School of Paris artists"—Picasso, Matisse, Gleizes, Gris, Derain, and Léger—the best part of the magazine. Several of these artists, as well as the Russian El Lissitzky, designed "remarkable covers for it." Realizing that these artists were almost unknown in America in 1921–1923, he used *Broom* to help win over a discriminating audience with this pioneering effort.[61]

Josephson and Cowley had penetrated the circle of dadaists in Paris, and dadaism had an immediate radical effect on the expatriates. Its material and philosophic expression of resistance to conformism leaped across borders.

In Paris, Josephson and Cowley fell in with the dadaists' most prominent successors, the surrealists, having been introduced to them by the American dadaist Man Ray. This intermingling of American and European artists was encoded in the little reviews dedicated to experimental ideas. In *Life among the Surrealists,* Josephson told of the American contribution to this outpouring of rebellion and of his contributions to the literary movement of the avant-garde.[62] He described the cultural scene in Paris and Berlin encountered by expatriates in the first half of the 1920s, registering names current and active in every art, such as Erik Satie, Les Six, Man Ray, Tristan Tzara, Philippe Soupault, and Louis Aragon. (Barr named many of these artists in his Wellesley quiz before he began his trip in 1927 to Europe.)

Josephson sought to use the dadaist and surrealist movements as models to begin an American literary movement in Europe. He translated and published their writings and called on "the poets of my generation to turn their thoughts to the realities of our Machine Age and to sing of our 'new America.'"[63] Josephson wrote further of the machine:

In the first decade of the century "alienation" in the United States was seen as
a result of the mechanization of life. Industry was the culprit. Expatriation was
the only route to "individualism". By the twenties the direction had changed so
that the answers were sought in an international exchange of culture and the in-
tegration of industry and the arts. This integration has been a continual battle
since then.[64]

Josephson and Cowley returned to the United States in the summer of 1923 re-
newed by their European experiences. They continued their relationship and pub-
lished *Broom* from New York, introducing to America the unknown European
radical painters and writers with a fresh view of American industrialism. Cowley
characterized the philosophy of *Broom* as "at first art-for-art's sake, then machine
loving."[65] Josephson came to the same conclusion regarding the benefit of Euro-
pean experiences that Barr and Kirstein came to later: "We who had learned a
few things during our apprentice years abroad would now apply ourselves to the
challenging American scene and bring to bear upon it the new insights we had
gained. America, for all its Babbitts, was our frontier; the idea of putting our artis-
tic roots down here again was deeply satisfying."[66]

An overlapping of the generations occurred in the development of the little
magazines and at one time or another all their contributors were published in
Hound & Horn. The groups surrounding Cowley and Kirstein saw the problem of
individualism threatened by industrialism as the central issue of their times. Like
Pound, they hoped that creativity would counteract the deadening effects of a ma-
chine culture and provide a new civilization. Barr, in contrast, chose to use the best
of machine-inspired art as a basis for modernism. In time the others followed suit.

While spending the year 1927–1928 abroad researching his thesis, Barr sent
articles to American magazines describing the art scene in the various countries
that he visited. Following the path of the expatriates in two ways, he fed American
publishing's need for news from abroad and compared American museums to
their like in Europe, finding American institutions impoverished. Barr employed the
concept of freedom for the artist in contrast to the growing isolationist and provin-

cial conservatism in the United States. This desire for intellectual freedom bound him to the expatriate movement despite the fact that he neither claimed to be one nor spent the requisite two years in Europe. While his more pessimistic fellow students fell under the influence of Oswald Spengler's prophecy of doom, the usual pattern of successive civilizations in *The Decline of the West,* Barr picked his way through the culture and nominated modernism, with the machine at its center, as a style that would clear the path for escape from a homogenizing civilization.

HOUND & HORN AND THE VISUAL

By the fall of 1929, Kirstein had been publishing *Hound & Horn* for two years. Blackmur and Fry left, leaving Bernard Bandler and Kirstein as editors. Bandler, Kirstein's classmate, joined the staff just after graduating from Harvard earlier that year, and it was he, Kirstein said, who formulated the critical stance of the magazine for the next four years. Distancing himself from any intellectual issues that involved the magazine, Kirstein pointed to Bandler who, as an apostle of Harvard professor Irving Babbitt's humanism, spurred the revival of the new humanism in the magazine in 1929.

Cowley treated Babbitt's humanism with disdain: "Babbitt and his disciples liked to talk about poise, proportionateness, the imitation of great modes, decorum and the inner check."[67] The phrase "inner check," in opposition to the "freedom" of the romanticists, most closely identified Babbitt's philosophy and became the pivotal point of argument both before World War I and again in the late 1920s and 1930s.

In his struggle with science and romanticism, Babbitt defined the issues for the age. Closely aligned with Harvard's prevailing conservative idealist culture with its emphasis on "good taste," the new humanism, revived from a decade earlier, was hotly debated in the pages of contemporary radical journals. At the center of the fray in 1929 was Eliot, who wrote an essay for *Forum* and continued the discussion in *Hound & Horn* with a piece entitled "Second Thoughts on Humanism."[68] Eliot's essay helped propel the magazine into an international position.

The real impact of the magazine, however, was in its aesthetic stance, which was objective and technical and would later be well known as the "new criticism." The magazine's interest in the techniques of art overshadowed any contemporary ideological issues that its editors pursued from time to time such as humanism, or agrarianism, or Marxism.[69]

The editors of *Hound & Horn* were all poet-critics, including Allen Tate, Yvor Winters, and Kirstein himself. Like the generation of students before them, they provided for themselves that which they could not find elsewhere: a vehicle for their writings and a communication with the other writers of the world. Kirstein claimed that *Hound & Horn* had a definite function to fill: "to provide as good technical criticism for intelligent laymen as possible with the minimum of rhetoric and rhapsody"[70]—criticism that was the best work of the journal.

An aesthetic not yet known as "formalism" had been taking shape in the first quarter of the twentieth century. Maintaining the standards of professionals, the Harvard undergraduates contributed to a new critical stance by eschewing moralistic interpretation to examine structural and formal means. An editorial comment in *Hound & Horn* decried adhering to any special dogma: "Criticism has no meaning and no value until a work of art has first justified itself aesthetically, until it is accepted as a work of art. . . . Consequently our standard for judging the arts is technical."[71]

Much has been written about *Hound & Horn* from a literary point of view; little is known of its artistic concepts. It mostly followed the *Dial* in its elegant physical appearance, as well as in its format of book reviews and short notices describing the artistic scene. The cover of the first issue was by Rockwell Kent; carefully chosen, it was uninspired in its modernity, with an illustration of a stylized hound and deer (fig. 25). Varian Fry soon resigned over the policy of broadening its coverage that changed the magazine from a "Harvard Miscellany"—the subtitle on the masthead—to a magazine that became internationally renowned by documenting the changing intellectual climate in America. Its influence far outdistanced the usual undergraduate endeavors.

The first issue in September of 1927 was notable for its diversity. In addition to an homage to Eliot, the magazine examined some of the issues that concerned

25. Rockwell Kent, cover of *Hound & Horn* 1, no. 3 (Spring 1928).

Barr. Barr's close intellectual companion, Henry-Russell Hitchcock, wrote an article entitled "The Decline of Architecture," that later became the opening chapter of his book *Modern Architecture: Romanticism and Reintegration*.[72] Articles on film that were early examples of film criticism also appeared. (In a 1928 issue, Hitchcock also reviewed eleven "movie magazines," many of which he didn't like. More important was his observation that "the life of the historian of the movies in the future will be an amusing, if not an easy one, when he wades through these accumulating masses of not altogether spurious documents.")[73] Jere Abbott's articles on the new work of the Russian *régisseur* Sergei Eisenstein, written in 1927 on his trip to Russia with Barr, were published in *Hound & Horn;* Barr would write articles on Eisenstein that appeared in *transition* and *Arts*. Also in the first issue was an article entitled "Mr. Bell and Mr. Fry" by Robert Tyler Davis in which the author described Roger Fry's attempt to differentiate an aesthetic response from any other response.[74] He commended Fry for bringing the existence of an aesthetic sensibility into public awareness—one of the central concerns of formalism.

The first of many examples of the art of photography also appeared in the inaugural issue. Photographs of the Necco factory in Cambridge by Jere Abbott indicated the lively interest of the Harvard circle in modern architecture. Hitchcock, in September of 1928, would write about modern architecture and the new international style (not yet officially named) of Le Corbusier, Gropius, and Oud—the first appearance of the phrase in his writings.[75] When Hitchcock's first book surveying modern architecture appeared in 1929, *Hound & Horn* published a perspicacious review by Barr: "In modern architecture, Henry-Russell Hitchcock, Jr. establishes himself as very possibly the foremost living historian of his subject. American books on modern architecture, with the exception of Lewis Mumford's, have been as provincial, as ill-formed, as complacent, and as reactionary as are most American architects and American schools of architecture. This book is not."[76]

Kirstein's commitment to the art of photography was total; the magazine published photographs by Harry Crosby, Ralph Steiner, and Walker Evans, among others. In 1932, Kirstein proposed to Evans that he photograph the Victorian houses of New England; the resulting work, in addition to appearing in the pages

of *Hound & Horn,* became an exhibition and a monograph in 1933 for the Museum of Modern Art.

When Kirstein looked back at the activities of *Hound & Horn,* he described it as "juvenilia," observing that "it could never compare in quality to the *Criterion* under Eliot, *The Dial* under Marianne Moore, the *Little Review* under Jane Heap, or *transition* under Eugene Jolas. [Nonetheless, it] provided a sense of the vitality of a few working intelligences who were interested enough in general principles to apply these to particulars."[77] Yet he admitted as well that the magazine provided an arena to work out ideas then in fashion. Kirstein's memoirs, among others from the small, closely knit group of agents of revolt in that era, were testimony to the radically changing intellectual and cultural climate of the 1920s and early 1930s.

But Kirstein underestimated the results of his endeavors. *Hound & Horn* still holds a high position among the magazines it modeled itself after. In the standard history of the little magazine, the editors hold that *Hound & Horn* demonstrated "advance guard criticism and editorial selection at their best and most interesting along with *The Dial* and *Symposium,*"[78] a consequence of the policy of eclecticism the magazines followed. Because the editors of *Hound & Horn* were interested in the quality of the writing itself rather than its historical or cultural context, regardless of national boundary, the result was a reshaping of international literature.

Toward the end of the journal's existence, Barr wrote to Kirstein to praise one of the last issues, noting that *Hound & Horn* had lost some of its "preciousness." The magazine remained, he thought, "the only periodical where one can publish and read articles of some length and thoroughness."[79] Kirstein and Barr, the two young students, each in his way had found a means to break with tradition and prepare for a more open cultural world. Kirstein erred when he belittled his work with *Hound & Horn,* but he had already turned to other interests, especially the ballet, which became his life's work.

More important to the narrative of modernism was that, in addition to *Hound & Horn,* in "an effort parallel and comparable to the magazine,"[80] Kirstein established the Harvard Society for Contemporary Arts, which anticipated the Museum of Modern Art. Kirstein devalued the effort, writing in 1934: "We were going to

affect the whole cultural life of the University. This we never even made a dent on."[81] But his perspective was too close to the fact. History was yet to be made.

From the expatriates' criticism of America at the beginning of the decade, a concern for cultural development at home would grow by the decade's end. Writing in 1927, Barr complained about the neglect of modern art in American museums in contrast to what he was experiencing in London.[82] Barr and Kirstein joined a number of expatriates in the rush back to the United States to argue for a freer international climate to encourage American artists. Kirstein was convinced that "this country is the one place to do something."[83] He and his fellow aestheticians—among them Hitchcock, A. Everett Austin, Philip Johnson, and Barr—confirmed the truth of his observation as they founded institutions of modern art that shaped history by documenting it.

5

THE EUROPEAN TRIP

During the academic year 1927–1928, in the middle year of his teaching contract at Wellesley, Barr realized his goal of spending a year of study and research abroad. Resourcefully living "hand to mouth" enabled him to achieve his plan of working every other year to finance his European trip. Because he still needed financial help—he received no pay that year—he applied for a Sachs Fellowship at Harvard. In the application he made known his wish to study contemporary European culture—including sculpture, decorative arts, music, theater, painting—in order to gather material for his thesis, "The Machine in Modern Art." Having been primed by Sachs, he also planned to prepare bibliographies of books on modern painting, sculpture, graphic arts, and related criticism in French, English, German and Italian, as well as a brief critical bibliography for more popular use in America. He also wanted to find facsimiles of modern pictures to facilitate teaching. Barr was denied his application; instead, a fellowship of four hundred dollars was personally funded by Sachs. Barr wrote his thanks to Sachs from Moscow: "I do

not pretend I have anyone but you & you alone for making any future study possible. . . . Putting it in the form of a scholarship makes it possible."[1]

BARR JOINS THE REBELS IN EUROPE

Barr arrived in London on July 28, 1927; Jere Abbott, his roommate at Harvard with whom he planned the trip, joined him later. Barr had with him the usual letters and cards of introduction from Sachs to various museum directors, dealers, collectors, and professors. Among the more recognizable names were Julius Meier-Graefe, Paul and Léonce Rosenberg, Professor Paul Ganz, Dr. Max Friedländer, Dr. Ludwig Justi, Dr. Wilhelm von Bode, Paul Haviland, Baron Robert von Hirsch, and Auguste Pellerin. Barr provided current information about these contacts for Sachs. In addition, Sachs was delighted with the bibliographies Barr compiled in England, Holland, and Germany and told him that he would order the books listed: "You know in recent years I have added many items on modern art and I am glad to get any assistance that I can in making the section of the Fine Arts library at Widener as distinguished as possible."[2]

He traveled throughout Europe gathering books, photographs, and information for articles and broadened his concept of modernism as an international movement; he was having art experiences that few of his contemporaries, European or American, had encountered.[3] Contrary to the predominant interests of collectors and therefore most dealers in New York in postimpressionist and School of Paris painting, Barr sought out artists of the Dutch, German, and Russian schools who enriched his definition of modernism. He had been taking that direction for two years, and he strongly reinforced it during his travels in Europe; he gathered material that would serve him well for the next ten years.

Barr wrote to Sachs that he was trying to decide between two subjects for his dissertation, either the machine or primitivism as sources for modern art. He had discussed these topics with his students at Wellesley as important for the modern styles of cubism, constructivism, and expressionism. Sachs urged him to choose primitivism; agreeing with him, Barr decided to establish analogies between

primitivism in painting and graphic art as well as other arts, seeking "its source in romanticism, Nazarenes, pre-Raphaelites, Japanese prints."[4] Most likely he thought that a thesis on the machine would be too radical for his professors. During his two-month stay in England, where he made a systematic study of contemporary English art, he made contact with Roger Fry, Laurence Binyon, and Wyndham Lewis, who were interested in his project of primitive art in relation to modern styles.[5]

While in Europe, Barr applied for a fellowship to pursue the research for his dissertation; he asked Sachs for a recommendation for an archaeological fellowship at Princeton, hoping that a subject with a modern emphasis would not count against him with his mentor, Morey, who was more traditionally tied to historical approaches. Sachs wrote to the committee at Princeton about Barr's serious work in modern art: "I hope the fact that Professor Barr has chosen a subject in a modern field will not prove an obstacle. He is better qualified than any other man of his generation."[6]

Barr wrote to Forbes Watson, editor of *The Arts,* that his thesis would be an analysis of the present anarchic condition of European and American taste as it had developed in the last fifty years from the "various waves of enthusiasm for the medieval, oriental, pre-Hellenic, African, children, pre-Columbian, Victorian, subconscious etc., etc."[7] Barr had a strong interest in children's drawings and the artistic work of the insane, both of which he knew were sources for the modernist artist.[8] After having studied hundreds of drawings in connection with his thesis, when he visited Sachs's friend Professor Paul Ganz in Basel, he became enthralled with the drawings of Ganz's young son. "These are exceptional," he wrote Sachs, "both in decorative design and imaginative quality. They throw a valuable light upon Paul Klee and also in motives used in Bosch."[9]

Later Barr admitted only the machine as the topic of his thesis, having edited out the version focused on primitivism. Although he researched the explorations of artists on art and the machine in England, Germany, and Russia, he also wrote an article on Russian icons from research material for the alternate dissertation. Barr's manipulation of his thesis notes is one reflection of the increased scholarly and artistic interest in the development of abstract art in relation to the machine.

not pretend I have anyone but you & you alone for making any future study pos-
sible. . . . Putting it in the form of a scholarship makes it possible."[1]

BARR JOINS THE REBELS IN EUROPE

Barr arrived in London on July 28, 1927; Jere Abbott, his roommate at Harvard
with whom he planned the trip, joined him later. Barr had with him the usual let-
ters and cards of introduction from Sachs to various museum directors, dealers,
collectors, and professors. Among the more recognizable names were Julius
Meier-Graefe, Paul and Léonce Rosenberg, Professor Paul Ganz, Dr. Max Fried-
länder, Dr. Ludwig Justi, Dr. Wilhelm von Bode, Paul Haviland, Baron Robert von
Hirsch, and Auguste Pellerin. Barr provided current information about these con-
tacts for Sachs. In addition, Sachs was delighted with the bibliographies Barr com-
piled in England, Holland, and Germany and told him that he would order the
books listed: "You know in recent years I have added many items on modern art
and I am glad to get any assistance that I can in making the section of the Fine Arts
library at Widener as distinguished as possible."[2]

He traveled throughout Europe gathering books, photographs, and information
for articles and broadened his concept of modernism as an international move-
ment; he was having art experiences that few of his contemporaries, European or
American, had encountered.[3] Contrary to the predominant interests of collectors
and therefore most dealers in New York in postimpressionist and School of Paris
painting, Barr sought out artists of the Dutch, German, and Russian schools who
enriched his definition of modernism. He had been taking that direction for two
years, and he strongly reinforced it during his travels in Europe; he gathered ma-
terial that would serve him well for the next ten years.

Barr wrote to Sachs that he was trying to decide between two subjects for his
dissertation, either the machine or primitivism as sources for modern art. He had
discussed these topics with his students at Wellesley as important for the modern
styles of cubism, constructivism, and expressionism. Sachs urged him to choose
primitivism; agreeing with him, Barr decided to establish analogies between

primitivism in painting and graphic art as well as other arts, seeking "its source in romanticism, Nazarenes, pre-Raphaelites, Japanese prints."[4] Most likely he thought that a thesis on the machine would be too radical for his professors. During his two-month stay in England, where he made a systematic study of contemporary English art, he made contact with Roger Fry, Laurence Binyon, and Wyndham Lewis, who were interested in his project of primitive art in relation to modern styles.[5]

While in Europe, Barr applied for a fellowship to pursue the research for his dissertation; he asked Sachs for a recommendation for an archaeological fellowship at Princeton, hoping that a subject with a modern emphasis would not count against him with his mentor, Morey, who was more traditionally tied to historical approaches. Sachs wrote to the committee at Princeton about Barr's serious work in modern art: "I hope the fact that Professor Barr has chosen a subject in a modern field will not prove an obstacle. He is better qualified than any other man of his generation."[6]

Barr wrote to Forbes Watson, editor of *The Arts,* that his thesis would be an analysis of the present anarchic condition of European and American taste as it had developed in the last fifty years from the "various waves of enthusiasm for the medieval, oriental, pre-Hellenic, African, children, pre-Columbian, Victorian, subconscious etc., etc."[7] Barr had a strong interest in children's drawings and the artistic work of the insane, both of which he knew were sources for the modernist artist.[8] After having studied hundreds of drawings in connection with his thesis, when he visited Sachs's friend Professor Paul Ganz in Basel, he became enthralled with the drawings of Ganz's young son. "These are exceptional," he wrote Sachs, "both in decorative design and imaginative quality. They throw a valuable light upon Paul Klee and also in motives used in Bosch."[9]

Later Barr admitted only the machine as the topic of his thesis, having edited out the version focused on primitivism. Although he researched the explorations of artists on art and the machine in England, Germany, and Russia, he also wrote an article on Russian icons from research material for the alternate dissertation. Barr's manipulation of his thesis notes is one reflection of the increased scholarly and artistic interest in the development of abstract art in relation to the machine.

RESEARCH IN ENGLAND

Barr had an arrangement with Forbes Watson to do a series of articles for *The Arts* based on his trip. From his researches in England he wrote the article "Modern Art in London Museums."[10] He thought it noteworthy that museum galleries showed a cross section of contemporary English painting, and he made a systematic study of the works, listing them in their respective categories. He found painters "of originality and charm in London even though they rarely approach the greatness of the French or the vigor of the Germans."[11]

Barr enjoyed the examples of "continental" paintings that had found their way across the Channel and confidently enumerated what masterpieces were missing. He marveled that the Tate had six Daumiers; in America only the Duncan Phillips collection in the Phillips Memorial Gallery could surpass that with seven paintings by the French artist. Barr mused that the Tate's French collection was "almost innocent of vulgarity." He lauded the Tate for not placing paintings by Gérôme, Bougereau, Meissonier, and so forth next to those of Ingres or Manet, which would give the academics equality in the eyes of the public for whose instruction and cultivation the museum was supposedly established. His characteristic sense of irony, or in this case sarcasm, was surprisingly unleashed in this article: "The Tate Gallery, the shrine of Watts and Alma-Tadema, the sepulchre of Royal Academicians, has been desecrated by the works of the greatest modern masters."[12]

After listing the impressionist works at the Tate, Barr turned his attention to the *Baignade* by Seurat, which he called the earliest and most beautiful of the seven canvases the artist had produced. And again he lamented that, aside from the *Dimanche à la Grande Jatte* at the Art Institute in Chicago and *Les Poseuses* in the Barnes Foundation in Merion, no Seurats were in any of "our great Eastern museums."[13] As an artist, Seurat had the traits that appealed to Barr's turn of mind: scientific, analytical, rational, orderly. Characteristically, Barr justified Seurat's importance by relating the artist's work to the underlying principles of the classicism of Piero della Francesca, Raphael, and Poussin: "Surely Seurat as much as any painter since the baroque, belongs in museums where his clarity of thought

and austerity of purpose, his evident understanding of his great ancestors, would powerfully influence students and public."[14]

Having seen the results of a campaign at the Tate by Samuel Courtauld, who in 1924 donated 50,000 pounds "to be spent on French pictures of the latter part of the nineteenth century,"[15] Barr inventoried the transformations that had taken place in London's museums in the preceding ten years (between 1918 and 1928), comparing them to their American counterparts, to the disadvantage of the latter. "England," he wrote, "takes a chance of being wrong in purchasing painting by its most extreme modernists as well as its 'safe' conservatives. Several American galleries nearly eliminate their chance of being right by selecting almost entirely from the work of Academicians."[16] Barr's concern was the larger cultural problem of the neglect of modern art in the United States, particularly on the east coast, which lagged behind Chicago and Detroit where a start had been made. He warned America to take heed of London where he noted, a similar neglect had been rectified over the prior decade. "But what startles one is the number of pictures by masters who are still almost unbelievably neglected in our own great museums of New York, Boston and Washington."[17] Although full of facts, the article had a self-righteous tone, a failing of Barr's early writing. After viewing the London galleries, he wrote: "The American visitor [was] green with envy."[18]

BARR AND NEUMANN

After two months of gathering material in England, Barr wrote to Neumann describing his reactions. He thought Cézanne was "too deep to be understood and liked by everybody." Significantly, he told Neumann, "I wish you were here so that we might talk about the trip to Russia and Germany."[19] He was disappointed that Neumann was not coming to Europe, and because he hated traveling alone so much, he decided not to go to Holland until Abbott arrived.

Barr was dependent for guidance on Neumann, whom he found "most lovable and other-worldly."[20] Before Barr left the United States, the art dealer Neumann, generous with his time and knowledge, had suggested which artists and dealers

he should see in Germany.[21] Barr had written to his parents that Neumann "will open many doors in Germany for Jere and me."[22] Barr candidly wrote to Neumann: "I want to talk to you about my thesis because I can learn more from you than anyone else."[23]

Neumann had come to New York in 1923 to establish a *Kunstgemeinschaft* (community of artists) similar to the ones he had participated in with the Novembergruppe and the Arbeitsrat für Kunst in Berlin. He replicated the community of artists in his galleries both in Germany (Berlin, Munich, Düsseldorf) and New York.[24] Neumann's passion for modern art was supported by his belief in sacrifice; like Stieglitz, he was an idealist who placed his enthusiasm for art before money. He lectured widely, including to Barr's class at Wellesley. His contemporaries in the art world remarked on Neumann's insouciance when, in order to visit other art exhibitions offered in New York or to lecture, he closed his gallery.[25] The film historian Jay Leyda complained: "Your office habits are hard on your out-of-town friends.[26]

Neumann called his gallery an "Art Center," where artists could meet and exchange ideas—a continuing tradition comparable to Stieglitz's 291. Like Stieglitz, he published documentation in the form of catalogues, books, and magazines for his gallery artists. Neumann also provided an evening's entertainment at the gallery, with lectures, concerts, and performances. His pioneering of German art in America was as steadfast and insistent as Stieglitz's support of his stable of Americans. Neumann's knowledge of avant-garde art in Germany, particularly the Bauhaus, and Russia greatly enhanced Barr's education in modern art.

HOLLAND, THEN GERMANY

At the end of October, 1927, Barr and Abbott went to Holland where Barr visited the Hook to see the architecture of J. J. P. Oud, then on to Rotterdam, the Hague, Haarlem, and Amsterdam where he viewed both the museums and private collections. He studied the work of Oud, Piet Mondrian, Gerrit Rietveld, Theo van Doesburg, and other members of de Stijl in Amsterdam.

Their itinerary then took them to Germany and, significantly, a visit to the Bauhaus, of which he would later write: "Young Americans visited the Bauhaus at Dessau as a place of pilgrimage where the philosophy and practice of modern design were in process of clarification. They talked with Gropius, Kandinsky, Feininger, Klee, Moholy-Nagy, Albers, Bayer, and Breuer, as with a new order of men engaged in transforming the artistic energies of our time from a rebellious into a constructive activity."[27]

The roots of the Bauhaus can be found in three German organizations in which Neumann had participated. One was the Deutscher Werkbund, a society of artists and representatives of industry that considered architecture the "true index of a nation's culture as a whole";[28] another was the Novembergruppe that derived its name from the Armistice, founded in 1918 by, among others, Walter Gropius. Calling itself a "union of creative radical artists,"[29] it was an association of artists, architects, composers, writers, film producers, critics, and art historians—many of whom had been active before the war—who believed in the necessity of a major social and spiritual change to recharge the cultural environment. As the most concrete point of contact with the public, architecture quickly became the most urgent and central focus of the group and attracted other arts in its service.

Gropius also was one of the organizers of the third group, the Arbeitsrat für Kunst, formed at the end of World War I as well. Its membership was more locally centered in Berlin and its members were mostly architects, while the Novembergruppe drew its members from all over Germany. This "Workers' Council for Art" was revolutionary in its artistic and political goals as well, working toward liberating art from the confines of tradition. Free from the past, the guiding principles of the Arbeitsrat would work for the masses and not just the elite, and architecture would lead the way. Their means to accomplish these socialistic aims were specific, politically radical, and antiwar. A pamphlet produced in December of 1918 by the Arbeitsrat under the chairmanship of Bruno Taut envisioned the various visual disciplines contributing to the new architecture, a concept important to the future Bauhaus. "There will be no frontiers between the applied arts and sculpture or painting. Everything will be one thing: architecture."[30]

Taut's thinking had taken shape before the war in his activities with the Werk-bund. In an article for *Der Sturm,* he presented an idea that had great influence on Gropius and would reverberate in Barr's working philosophy: "Everywhere one hears talk of constructing pictures. An architectural idea lies behind this expression . . . which must not be taken simply as a metaphor, but which corresponds to architectural thinking in the simple sense of the word. A secret architecture goes through all these works and holds them together; in the same way it happened in the Gothic period."[31]

In the intense expressionist atmosphere engendered in the Arbeitsrat, Gropius, then chairman, wrote a pamphlet for the group's "Exhibition of Unknown Architects." Organized by Max Taut (brother of Bruno), Gropius, and Adolfe Behne, the show exhibited utopian and visionary architectural designs by the Arbeitsrat in Berlin in April of 1919 at the Kabinett J. B. Neumann. The ideas had been developed before the war, but, as little building had occurred since then, it was only architecture on paper. Gropius's pamphlet *Cathedral of the Future* foreshadowed the ideals of the Bauhaus in calling for the unification of painting, sculpture, and architecture:

> Architects, sculptors, painters, all of us must return to the crafts. For there is no art as a profession. Artists are craftsmen in the original sense of that word, and only in rare and divine moments of illumination which lie beyond their own will power, can art unknowingly burst into bloom from the frames of "Salon Art" that are around your paintings.[32]

In the same month, for the opening of the Bauhaus school in Weimar, Gropius issued his Bauhaus manifesto, a four-page leaflet that included many of the ideas of the Arbeitsrat. His final sentence was: "Let us together, then, will, conceive, and create the new building of the future, which will encompass architecture and sculpture and painting in one unity and which will rise eventually toward heaven, from the hands of a million craftsmen, as the crystal symbol of a coming new faith."[33]

For the cover of the manifesto, Lyonel Feininger produced a woodcut, *Cathedral for the Future* (fig. 26), resembling in spirit and fact the Gothic cathedral and

26. Lyonel Feininger, *Cathedral for the Future*. Black ink on green paper, 30.2 × 18.6 cm. Busch-Reisinger Museum, Harvard University Art Museums, Gift of Mrs. Lyonel Feininger.

emphasizing the place of architecture in the curriculum of the Bauhaus. Glass was the material and the metaphor for creating a new utopia. Intrinsically decorative in its ability to incorporate light, the property of transparency allowed the structure of the building to be revealed—not unlike the future designs for the skyscrapers of the International Style.[34] The unity of the Gothic style and the cooperation of artisans and builders were aspirations upon which the Bauhaus was built, fashioned after the *Baühutte,* the group of artisans working in medieval times on a Gothic project that included both construction workers and artistic technicians.[35] Barr's aesthetic encompassed both periods of stylistic influence.

THE BAUHAUS SCHOOL

Barr's visit to the Bauhaus in 1927 helped him formulate a structural notion of mod-
ernism which, at the appropriate time, served as the model for the Museum of
Modern Art and its formalist aesthetic. As Barr envisioned it, the unity of style in
all the arts, including industrial design, was the single most important idea gov-
erning the founding of the new museum. Another premise from the Bauhaus on
which Barr based his aesthetic philosophy—the international scope of modern
art—was looked upon with suspicion in America, given the regionalist attitudes of
the time. Barr would later write:

> This multi-departmental plan [of the Museum] was, insofar as I can understand
> its evolution, inspired by Rufus Morey's class in Medieval art, which I took as
> an enthusiastic sophomore in 1920, and equally important, the Bauhaus of
> Dessau. Morey who used to lose his temper and swear about the Bauhaus,
> would be surprised at this parentage, but there are real similarities between the
> Bauhaus and that Medieval art course when you come to study them.[36]

Barr had seen photographs of the Dessau school designed by Walter Gropius
at the "Machine-Age Exposition" mounted by the *Little Review* before he left New
York (fig. 27): "I had looked forward with great anticipation to the Bauhaus and
felt that it had lived up to my expectations."[37] Remarkably, considering the pro-
found effect that it had on him, he spent only four days there.

The closeness of art and everyday life had been an increasingly important con-
cept since the middle of the nineteenth century, but it took a radical twist at the
Bauhaus, where social change was a strong motivating force. The Bauhaus, not
unlike the arts and crafts movement developed by Ruskin and Morris, was dedi-
cated to the idea of improving industrial products with the cooperation of artists
and craftsmen; central to this ideal was architecture as the core of *Gesamtkultur.*
The workshops of the Bauhaus were led by artists—"masters"—with apprentices
assigned to them who were trained by working directly with materials in much the
same manner as medieval guildsmen. The emphasis on craftsmen, which pre-

27. Walter Gropius, the Bauhaus building, 1925–1926,
Dessau, Germany. Gelatin silver print, 56 × 99.4 cm.
Busch-Reisinger Museum, Harvard University Art Museums.

vailed in the early days of the Bauhaus, gave way to the unity of the arts under the
primacy of architecture when László Moholy-Nagy joined the Bauhaus in 1923.
By 1927, the spirit of the Bauhaus had changed from expressionism to an objec-
tive rationalism.[38] Drawn to this rationality as his continuing guide, Barr absorbed
the lessons of the Bauhaus teachers. He was éxultant at his chance to discuss art
with "the already legendary band" of international artists. "They formed," he

wrote, "a dazzling constellation of artist-teachers such as no art school has ever known before or since."[39]

Convinced that a great deal of the new conception of space in architecture had come from the avant-garde painters, Gropius hired them for the Bauhaus faculty (fig. 28). Feininger was the first artist that Gropius invited to the Bauhaus in 1919. The shy artist was at first hesitant, but he accepted because Gropius assured him that he would have the freedom to teach as he liked. The Bauhaus masters conducted classes devoted to such varied arts as typography, pottery, rug making, photography, book binding, and stagecraft, as well as the principles of painting and sculpture. The cabinet workshop was led by Gropius and later Marcel Breuer, the metal class by Moholy-Nagy, and weaving by Georg Muche. Gerhard Marcks and Max Krehan were in charge of the ceramics class, and Feininger taught printing with Carl Zaubitzer. Other classes included stained glass under Klee and Albers, wall painting under Kandinsky, sculpture with Oskar Schlemmer and Josef Hartwig, and the Bauhaus theater under Lothar Schreyer, then later under Schlemmer.

In 1922 in Berlin, the Galerie Van Diemen staged a large exhibition of Russian art, "Erste Russische Kunstausstellung"; the Russian artists Lissitzky, Ilya Ehrenburg, and later Naum Gabo from Hungary came to Berlin, bringing attention to the works of Rodchenko and Malevich. Intermingling with these artists were van Doesburg, representing de Stijl; Matthew Josephson and Harold Loeb, the editors of *Broom;* the American painter Louis Lozowick; Alexander Archipenko; the dadaists Tristan Tzara and Hans Arp; Joseph Peters and Georges Vantongerloo from Belgium; architects J. J. P. Oud and Cornelis van Eesteren from Holland; Frederick Kiesler from Vienna; and Walter Gropius from Weimar. Although internationalism has never ceased to have its political problems, the rise of art movements that were establishing their own manifestoes and organizations was spreading ideas across geographic boundaries. Berlin was becoming as important a center for art as Paris. Gropius played a singular role in artistic circles not only by bringing his architectural vision into being but by acting as a magnet for some of the most creative spirits in the West.

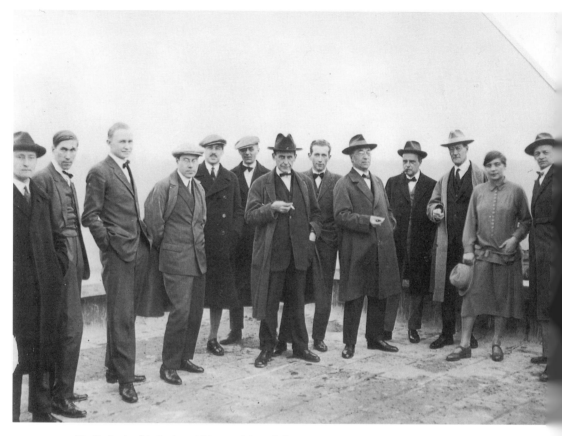

28. The faculty of the Bauhaus, 1926. From left: Josef Albers, Hinnerk Scheper, Georg Muche, László Moholy-Nagy, Herbert Bayer, Joost Schmidt, Walter Gropius, Marcel Breuer, Wassily Kandinsky, Paul Klee, Lyonel Feininger, Gunta Stölzl, Oskar Schlemmer.

The goals and concepts of the Bauhaus first came to world attention in the summer of 1923 with an exhibition of its work. But it was the documentation, an integral component of avant-garde art in general and the German experience in particular, that spread the word of the Bauhaus. In due course, from 1925 until 1930, fourteen books were published by the Bauhaus,[40] although fifty had been planned. As a senior at Princeton in 1922 (the year he first saw a work by Klee in *Vanity Fair*), Barr was already aware of German expressionism. He had read

some of the Bauhausbücher as well as the catalogue of the Bauhaus exhibition *Weimar, 1923,* and in 1925 had seen the show of the Blaue Vier—a group that included Feininger, Klee, Kandinsky, and Alexej von Jawlensky—at Daniel's Gallery in New York, staged by Galka Scheyer, a good friend of Neumann.

Among the things Barr remembered most vividly from his Bauhaus visit were

the gentle charm of Klee, and his interest in music, the sound of Frau Klee playing a Mozart sonata, his little collection of odds and ends of shells and minor curiosities, and his interest in children's drawings; . . . Moholy-Nagy's sullen expression when I asked him whether he or Lissitzky first used photomontage; the students at work on their various exercises, particularly *Formlehre* [the introductory course and the most esteemed part of the Bauhaus curriculum]; Lux Feininger's enthusiasm for the Bauhaus jazz band [Barr bought photos of the jazz band from Feininger's son]; and Gropius' unsmiling earnestness and English plus fours. The Bauhaus idea did have an important influence on me well before I went to Dessau. Gropius' ideal of bringing together the various visual arts influenced my course in modern art at Wellesley in 1926–27. It included architecture, industrial design, graphic arts, painting, sculpture, films, photography. A few years later the Bauhaus also influenced my plan for the Museum of Modern Art. However, long before the Bauhaus I'd been much influenced by Rufus Morey's course in Medieval art, at Princeton in 1919 of such breadth and depth that it led me for better or worse into art history as a vocation.[41]

Barr remarked that it was the two hours with Feininger that he remembered "most clearly and with the greatest delight."[42] Gropius had named Feininger "form master" in charge of the graphic workshop in the fall of 1919. He stayed until the Bauhaus closed in 1933. Following his visit with Barr and Abbott, Feininger wrote to his wife Julie on December 6, 1927:

This morning I spent almost two hours with two charming young American academics (Harvard men). They have been in Berlin and in Dresden at the Fides [a Dresden art gallery where Feininger's works were on exhibit]. They brought a

letter of recommendation from Frau von Allesch [an artist and friend of Barr's working in New York]. All day yesterday they wandered about Dessau. They saw the Bauhaus and went to a church concert in the evening, and they were enthusiastic about everything. One is a professor—but like a boy, though 25 years old—and is intensely interested in my work. He saw it at the Blue Vier show in California [sic; Barr was never in California]. He is going to write about German art, of which nothing at all has been written in England or in America. The professor . . . bought a watercolor of mine at the Fides Sommerwolken [it was Abbott who bought the painting]. . . . Tomorrow I shall take them to Klee. . . . They have been at Moholy's and are now at Schlemmer's. Kandinsky is not well enough to receive them. [Barr wrote that he saw Kandinsky.] You can imagine how much we had to talk about.[43]

Tough persistence and idealistic strength brought the Bauhaus through turbulent years of economic hardship, political maneuverings, and changing artistic philosophies within the school. Feininger's eloquent letters bear witness to its circumstances: "For years now we have had to fight and bear up against hostility; we have been humiliated and degraded. No wonder our former high spirits have been sobered."[44] Barr's interest and empathy made him welcome at the Bauhaus. He wrote to Neumann of his plans to write an article on Feininger, and that he hoped to see Emil Nolde, Erich Heckel, and Karl Schmidt-Rotluff in Berlin. Barr also wrote to Neumann that all the artists were most cordial and that they all asked for him.[45]

Barr had come well prepared to Dessau. He had already focused on eliminating the hierarchy that privileged fine art over useful objects, dividing the artist and the industrial designer. "Experimentation" and "the laboratory" were not only part of his education and his philosophy; they also embodied his sense of the beautiful. What was new for him was the school's physical plant, which he found to be the most important building in the new architectural style. He was also understandably excited at the opportunity to talk to the artists who had made all this happen.[46]

Gropius was identified with the institution he had founded, and he was committed to the concept that "ideas die as soon as they become compromised."[47] Barr followed him in both practice and belief.

TWO MONTHS IN MOSCOW, 1927–1928

After their two-month stay in Germany, Barr and Abbott left Berlin from the Schlesischer Bahnhof and arrived in Moscow two days later, on December 26. Barr wrote in a diary he kept on this visit: "To our immense relief Rozinsky is waiting for us. He speaks very good English."[48] (Rozinsky was a person who knew music and accompanied them to various concerts.) Despite a well-thought-out journey through Europe in the year 1927–1928, the trip to the Soviet Union has been described as "spontaneous." Margaret Barr wrote in the foreword to Barr's published diary of his trip: "The thought of Russia never crossed their minds."[49] Abbott also believed that it was unplanned.[50] According to him, little information was available about Russia in the United States. But Barr, of course, was well prepared. Abbott thought that the inspiration for the two young scholars going to Russia was an artist they met through Wyndham Lewis: "an extraordinary London 'character,' Nina Hamnett, who knew all the art crowd and was enthusiastically Communist in spirit."[51] She considered herself part of the international art world and had been to St. Petersburg in 1909 at the age of nineteen with a fellow art student who was Russian. It may have seemed to Abbott that "there was discussion about Russia. We decided to go there. It was that simple." But the letter Barr wrote to his mentor Neumann reveals that he had already planned the Russian segment of the trip. Before Abbott arrived, Barr had written from London, in August of 1927, that he wished Neumann was with him to plan the trip to Germany and Russia.

Barr's trip to Russia was a significant part of his modernist education and key to his program for the Museum of Modern Art. According to Philip Johnson, "the Constructivists were on his mind all the time. Malevich was to him, and later to me, the greatest artist of the period. And you see, the Constructivists were cross disciplinary, and I'm sure that influenced Alfred Barr, both that and the Bauhaus."[52]

Three kinds of documents survive to record the bold perspective Barr was framing for modernism: his journal, the letters he wrote during his stay, and the articles he wrote (substantiated by the journal and letters). The significant differences between the articles and the more subjective journal and letters were the latter's tone of wonder and breathless, unabashed enthusiasm for the revolutionary spirit of the Russians. As he made whirlwind visits around the USSR, he wrote:

> We feel as if this were the most important place in the world for us to be. Such abundance, so much to see: people, theaters, films, churches, pictures, music and only a month to do it in for we must attempt Leningrad and perhaps Kiev. It is impossible to describe the feeling of exhilaration; perhaps it is the air (after Berlin); perhaps the cordiality of our new friends, perhaps the extraordinary spirit of forward-looking, the gay hopefulness, of the Russians, their awareness that Russia has at least a century of greatness before her, that she will wax while France and England wane.[53]

Because the Russians were busy trying to organize the country in a transitional period and there were few visitors, Barr and Abbott had freedom to travel in the Soviet Union without supervision. Looking back on their experiences, Abbott commented: "We went anywhere we pleased; life there was less regulated and easier than it was ever to be again" (fig. 29).[54]

On the day he arrived in Moscow, Barr and his friends arranged a "*kino* party" (throughout his diary, the cinema was referred to by the Russian word *kino*) to see *The End of St. Petersburg* directed by V. I. Pudovkin. "The film is excellent," Barr wrote, "a propaganda, revolutionary 'October' theme, but superbly photographed and directed. Its bias gave it dignity and punch."[55]

Barr wrote to Sachs that Moscow, with its dozen or so museums, was "more absorbing than Berlin. The high point of our year."[56] One of his first visits was to the Shchukin collection at the First Museum of Modern Foreign Painting (then part of the Museum of New Western Painting). Barr thought that only the work in the Barnes Foundation and the Reber collection in Lugano were superior to it. He listed eight Cézannes, forty-eight Picassos, forty Matisses, and a dozen Derains in the

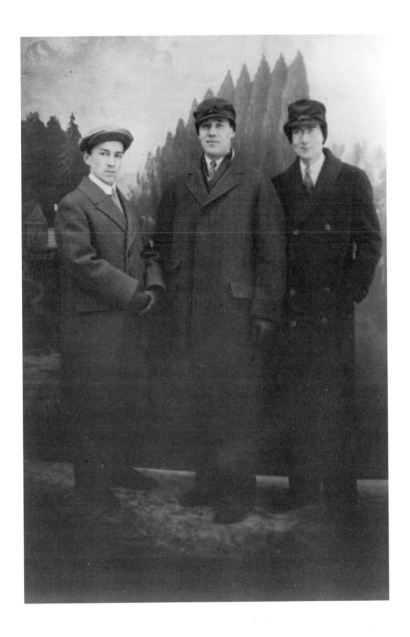

29. Alfred H. Barr, Jr., Jere Abbott, and their interpreter, Petra Likhatchew, Moscow, February 13, 1928. The Museum of Modern Art Archives: Alfred H. Barr, Jr. Papers, 9.F.71.

Shchukin collection. He wrote: "The early Picassos are particularly valuable historically since the development of cubism is here better illustrated than anywhere else, though there are too few Braques and Henri Rousseaus. We wonder if the Morosov is equally fine."[57]

A few days later, on Sunday, January 8, 1928, they went to the Morosov collection (the second part of the First Museum of Modern Foreign Painting), which he then considered as fine as the Shchukin collection. The merchant Morosov had assembled "eighteen Cézannes, eleven Gauguins, a finer lot though fewer than the First Museum. The great Van Gogh 'Billiard Room (Café at Night),' a wall of superb Matisses, many Marquets, Friesz, Rouault, Derain. The finest Bonnard I've seen, also some large and regrettable Daphnis and Chloe décors by Maurice Denis—too sweet and milky—the usual Monets, but six good Sisleys. Curiously we have seen no Seurats in Moscow."[58] Seurat was assuredly on the top of Barr's list of impressionists and postimpressionists and Monet at the bottom. On a second visit to the Shchukin collection, Barr decided that although the Gauguins and Cézannes were inferior to those of the Morosov collection, the Rousseaus were compensation.

ICONS

One of the strongest attractions to Russia for Barr was his desire to study medieval icons for his thesis. When they were cleaned and exhibited in Moscow in 1913, a group of icons had an instant influence on the artists and scholars who saw them. Barr was fortunate to have arrived in Moscow at the time that the Central Institute had prepared this exhibition of icons, cleaned during the ten years since the revolution. With great enthusiasm he wrote of the "recovery of ikons which goes on from year to year since the founding of the state laboratory by Igor Grabar. The cleaning methods resemble Fogg's enlightened policy." He wrote to Sachs that he was reading Pavel Muratov's new book *Les Icones russes*[59] and that an icon exhibition was being mounted in Berlin, Paris, and London "as epochmaking as the great Musselman one of French and Flemish works of the first decade of the century."[60]

Barr's diary has as many entries on viewing icons as on viewing modern art. He was preparing a paper describing the development of icon painting in the Middle Ages,[61] a survey that became the only accessible article in English about the subject until 1954.[62] "Tomorrow to Sergievo so I spent the rest of the evening cramming Kondakov, whose book on icons is not as lucid as one might wish nor is the archaeology of icons at all a simple affair: Suzdal, Pskov, Moscow, Novgorod, telling them apart is beyond me at present. The Rublev *Trinity* looks interesting."[63]

Not until he went to the Ostrouk Museum in Moscow was he "finally conquered by Russian icons: We spent two hours going over them again and again."[64] He borrowed Muratov's book from the museum, finding the text superficial but the illustrations very exciting. "[It] will correct much of Kondakov."[65] Further along in the diary, he reported that after finishing the book he felt "eager to see and talk icons; a great new field is opening up, if only material (books and photographs) were available here. I spent the afternoon in a vain hunt for books. Found a set of Grabar for 40 rubles, but the plates are bad."[66] But he and Abbott did find great bargains in a junk market: "Jere bought a very good provincial icon triptych for 10 rubles. . . . We also got some small brass icons and I a little panel of the Prophet Elijah being fed."[67]

At one point, after working for seven continual hours at the library doing research in the Russian journals *Apollon* and *The Golden Fleece* for his thesis, Barr went to the Tretyakov Gallery to see Victor Midler: "He was very pleasant, seems to know about the important Russians of my particular problem: Larionov, Chagall, Goncharova, etc. Is going to try to get photographs of paintings I listed. I have little hope."[68] Barr was trying to link these artists, in Paris at that time, to the icon tradition.

Barr had to visit "the cellar" of the State Tretyakov Gallery to see works by Goncharova, Larionov, and other members of the Bubnovy Valet (Jack of Diamonds). The upper part of the gallery was "a barren waste of nineteenth-century story pictures, portraits, and allegories";[69] repression of the modernist artists had started. Although Barr wrote of frustrating hunts for material such as books and photo-

graphs, he was one of the last scholars for many years who could roam freely among both the icons and avant-garde work in Russia.

THE LEF

Many people were helpful as Barr and Abbott made their way through the cornucopia of culture in Moscow: from Cambridge, Henry Wadsworth Longfellow Dana, who was doing research on the Russian theater, stayed at their hotel and at times accompanied the two young students; Diego Rivera, "the famous Mexican painter,"[70] showed Barr a complete set of his Mexico City frescoes and Barr bought a watercolor from him.[71] Barr wrote to Sachs that he thought "a friend of yours" (Dana) and May O'Callahan would be most helpful in introducing him and Abbott to the Russian cultural set.

Two days after Barr arrived, O'Callahan took him to visit Sergei Tretyakov, a member of the futurist movement and the founder of the magazine *Lef* 1923–1925 and *Novyi Lef* 1927–1928, who lived in an apartment in the Dom Gostrak building, an example by Moisei Ginzburg of the new constructivist architecture—"an apartment house built in the severely functional style of Gropius and Le Corbusier" (fig. 30).[72] Ginzburg, part of the group OSA (Society of Contemporary Architects), which he helped found, developed constructivist architecture, "which functionally arises from the purpose of a given building, its material construction and production conditions, answering the specific task and promoting the socialist construction of the country."[73] Barr wrote that Ginzburg was a "brilliant young architect" who had written "an interesting book on the theory of architecture (illustrations are good). . . . Though his work lacks the boldness of Lissitzky or Tatlin, it is certainly more concerned with actual problems."[74] Clarifying his estimation of Ginzburg's apartment building, Barr remarked that "only the superficials are modern, for the plumbing, heating, etc. are technically very crude and cheap, a comedy of the strong modern inclination without any technical tradition to satisfy it."[75] Writing in his diary, Abbott concurred:

30. Moisei Ginzburg, Dom Gostrak apartment house, Moscow, 1927.

Their apartment is in one of the new apartment houses which, in its architecture comes quite directly from the prevalent International Style in Europe, that is, it is a combination of Bauhaus and certain elements of the French manner as represented by Le Corbusier and Lurçat, or in this country by Neutra. . . . The apartment house of the Tretyakovs is excellent as architecture but poor as a piece of construction. The Russian is not used to the materials of modern building. Cement and steel confuse him . . . in the medium of modern construction he shows an absolute lack of feeling. Poor joints, badly matched sections, and in general a sloppiness marks much of the newer work, the design for which is nevertheless, frequently concise and in the main, excellent.[76]

Barr exchanged information with Ginzburg, who gave him back numbers of Soviet magazines of contemporary architecture. Barr, in turn, gave him the addresses of Peter Smith and Henry-Russell Hitchcock as sources for articles on American architecture. He told Ginzburg that American architects were "reactionary," to which Ginzburg's wife's responded: "Russian architects and American engineers should combine."[77]

At Tretyakov's Barr met members of the LEF, a loosely banded group of constructivist artists. Heavily involved with this group on his visit to Moscow, Barr wrote an article about them that mentioned Tretyakov, Aleskandr Rodchenko and his wife Varvara Stepanova, and Vladimir Mayakovsky, as well as two articles about their most celebrated member, Sergei Eisenstein. Both Tretyakov and Rodchenko wanted to be *régisseurs* and Barr noted that "to distort Pater, all the arts in Russia, including music, tend constantly toward the condition of the cinema."[78] Barr recognized that both he and this group were attracted to the same modes of art—architecture and film—but for very different reasons. "Their spirit," he said, "is rational, materialistic, their program aggressively utilitarian. They despise the word aesthetic, they shun the bohemian implications of the word 'artistic.' For them, theoretically, romantic individualism is abhorrent. They are communists."[79] Barr's political responses were characteristically liberal, their source an innate humaneness rather than an ideological stance. His notion of "purity" as a criterion of a modern aesthetic led him to proclaim Eisenstein, the Russian Communist *régisseur*—the artist who embodied the metaphor of the machine for Barr—as the artistic genius of the twentieth century.[80]

Barr noted with some puzzlement that Tretyakov was uninterested in everything that did not conform to his objective, descriptive, self-styled journalistic ideal of art. The more radical forms of painting had no relevance to his way of thinking: "When I asked about Malevich and Pevsner and Altman he was not interested— they were abstract artists, he was concrete—a unit in a Marxian society. He was more interested in Rodchenko who had left suprematism painting for photography. He showed us a [manuscript] of poems for children written by himself and illustrated by Rodchenko with photographs of paper puppets—fine in composition

and rather witty. This volume had been vetoed by the government official because the pictures were not realistic illustrations of the verses."[81]

Barr's concern was with the formal aesthetics, theirs with the socialist realism aims of propaganda and utility. There were times, he thought, that "propaganda was aesthetically unpleasant . . . but revolutionary drama is young."[82] Yet Barr did not let the propagandistic nature of Soviet artistic endeavors dampen his excitement: "Apparently there is no place where talent of an artistic or literary sort is so carefully nurtured as in Moscow. . . . We'd rather be here than any place on earth."[83]

Though Barr did not comment in his diary about the various incidents of censorship that he encountered—he admitted to having very little interest or understanding of Russian politics at that time[84]—his growing awareness of the repression of avant-garde art registered alongside his appreciation of the abundance of culture. In addition to the more than twenty-five repertory theaters that so impressed him, he went "madly from museum to concert to churches to movies—I have never felt so rushed in my life."[85] He wrote to Sachs about his daily excursions: "Music in Moscow is curiously backward, but architecture grows more important everyday. For the most part, the new international style springs from Frank Lloyd Wright then Le Corbusier and Gropius is employed. Unfortunately the Russians' technique does not approach their power of invention."[86]

EISENSTEIN

Barr's visit to Russia coincided with the tenth anniversary of the October Revolution. Eisenstein's film *October* or *Ten Days That Shook the World,* intended to celebrate the event, was behind schedule. Barr's description of Eisenstein revealed why he was so taken with the man: "He was extremely affable, humourous in talk, almost a clown in appearance."[87] Asked later to explain what he meant, Barr replied: "I think the clown simile which several people seem to have used in connection with Eisenstein is based on his general physiognomy, the tipped-up nose, the baldish head, the wide mouth, the mobile expressive face—wasn't he an ac-

tor at one time—the continuous sense that he was playing a rather self-mocking humourous role."[88]

Barr visited Eisenstein in his studio and watched the director edit his film. He realized that Eisenstein's art was achieved by intercutting scenes, creating a montage of the raw material of the shooting, and he respected Eisenstein as an artist who "rose above the demands of objective narrative clarity and propaganda to produce pure Kino of the subtlest quality." He recognized the director's ability to produce "superb pictorial composition" and to intensify the emotional effect with a "sense of kinetic and dramatic form."[89] Barr described a particularly emotional scene that has since become justly famous in *October* (fig. 31):

> During the July demonstrations an old white horse is killed on the drawbridge over the Neva. Near it a child has fallen face down, her head just over the crack between the two sections of the bridge. Slowly the two huge jaws of the bridge are opened; the child's long hair slips over the edge down into the widening crevice. Repeating this motion in the same tempo, the dead horse sags horribly and then slides sacklike. Suddenly, in a vertical shot taken from the river, one sees the white carcass far above, dangling head down as the great arm swings it up and away. Macabre, yet beautiful, if we may use an unfashionable adjective, as Goya's "Disasters of War" are beautiful.[90]

Barr identified the use of rhythm, discontinuity, and surprise camera angles as new innovations in cinematography, although he placed the film in the documentary genre.[91] In articulating Eisenstein's achievement—a method, he wrote, that causes the viewer's reaction to emotionally "transcend" the narrative content—Barr instanced a formalist approach. He understood that the full measure of the new media would be reached by exploiting the particular nature of the moving camera, and realized that this approach raised Eisenstein's films above the merely propagandistic. He thought that "even in Russia," *October* was lost as good propaganda: "It is too subtle, too metaphorical, too abstract in its sequences, too careless of narrative clarity; it is in other words too fine a work of art."[92]

31. Sergei Eisenstein filming
October, 1922.

Barr's writings on avant-garde films were among the earliest about this newly
acclaimed art. "Movies," he wrote unerringly, "required a new critical appara-
tus."[93] Like Ivan Punin, whom Barr called "the finest Russian critic of modern art,"[94]
he purged his writings of turn-of-the-century intuitive literary principles, focusing his
thoughts on a rational consideration of historical organic developments. Although
Marxian aims did not enter his own philosophy, his self-imposed objectivity re-
quired him to describe the Russian approach of political inclusiveness without in-

jecting judgmental rhetoric: "In the kino at least the revolution has produced great art even when more or less infected with propaganda. . . . The film in Russia is more artistically, as well as politically, important than the easel picture."[95] Convinced of the importance of Eisenstein, Barr was "thoroughly disgusted by the spiritual poverty and triviality of most American films." He knew that the article he wrote would be difficult to place because "unfortunately there [was] a good deal of 'radical' social theory and 'red flag' in the article since Eisenstein's a Communist."[96]

RODCHENKO

When he went to visit Rodchenko's studio, Barr was puzzled by not seeing any paintings, and Rodchenko would not talk about them. Rodchenko admonished him: "'That's all in the past—look at what I'm doing now'. . . . Several weeks later he had found out we were safe and so he showed us his paintings."[97] Before the war, influenced by Malevich, Rodchenko did some suprematist painting as well as geometric drawings; after the October Revolution, along with Stepanova and others, he became a founder of constructivist art. Rodchenko was experimenting with line and color in abstract art to "discover its own essence,"[98] a line of investigation also conceived at the Bauhaus in the basic course.

Barr was not daunted by the fact that neither Rodchenko nor his wife Varvara Stepanova (fig. 32) spoke anything but Russian: "Both were brilliant, versatile artists. Rodchenko showed us an appalling variety of things—suprematist paintings (preceded by the earliest geometrical things I've seen, '1915' done with a compass)—woodcuts, linoleum cuts, posters, book designs, photographs, kino sets. He has done no painting since 1922—devoting himself to the photographic arts of which he is a master."[99]

Barr ended the diary entry for that day disconsolate that he had found no painters. And he would have a difficult time finding what he was looking for. The editors of the magazine *Lef* were responsible for the call to reject easel painting and to develop "real" utilitarian work. Such artists as Popova, Stepanova, Rod-

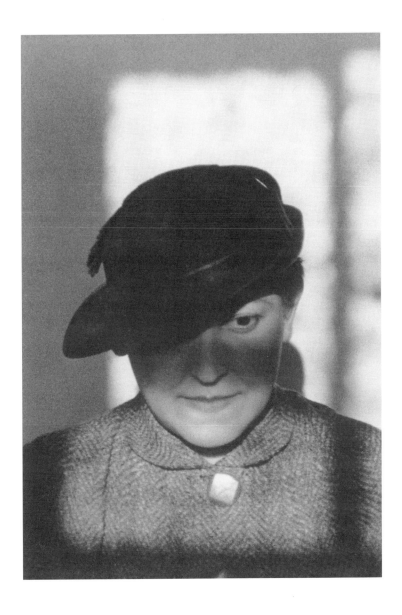

32. Aleksandr Rodchenko, *Varvara Stepanova*, Moscow, 1936.
Gelatin silver print, 14 7/8 × 10 in. (37.8 × 25.4 cm). The Museum of Modern Art, New York, The Parkinson Fund.

chenko, Alexandra Exter, and Aleksandr Vesnin responded by denouncing "easel painting" in 1921–1922.[100] Barr visited Rodchenko a second time, commenting that "Rodchenko showed much satisfaction at having delivered the death blow to painting in 1922." He found the artist answering the questions that he had prepared in a "disgruntled" manner: "[Rodchenko insisted] that the past bored him utterly and that he couldn't remember at all when he had painted this way or that. Fortunately Stepanova . . . his brilliant wife was a great help. She also picked out photographs of his painting and promises to send others of his kino sets, photomontage, photographs, constructions, etc."[101]

Prophetically, Barr wrote to Neumann that someday he would like to mount an international abstract show that would include Malevich, Popova, Rozanova, Rodchenko, Lissitzky, and so forth: "Lenin was wrong and Trotsky and Lunacharsky right. Constructivism in the post-war period was not revolutionary nor was it particularly Russian. It belonged to the international abstract movement of the 20s."[102] Barr met Anatoly V. Lunacharsky, Lenin's director of education, on his trip to Moscow. Having lived in Paris, Lunacharsky was far more aware of the significance of avant-garde art and more liberal in his views than Lenin. Appointed by Lenin to the education post, he closed the old traditional schools in 1920 and reorganized them, supporting the most avant-garde artists and appointing them as teachers at the new schools. In assessing Lunarcharsky, Barr chose to ignore the constructivist's utilitarian framework that since 1920 had employed laboratory investigations into form, material, and technology as a means to find solutions for practical ends.

The characteristics inherent in various materials and the nature of the means the artist employs to use that material were some of the principles of functionalist formalism that Barr was developing for his own critical standards. He appreciated Rodchenko's set designs for Eisenstein's films and magazine covers for *Lef*. From 1918, Rodchenko turned to examinations of forms in real space in an attempt to discover the properties inherent in artistic elements before he became a theorist for the movement.[103] From 1913 until 1920, the constructivist artist Tatlin, after his Parisian visit to Picasso, experimented with constructed reliefs that predated the constructivist movement.

Most of the artists Barr met in Russia were involved with Meyerhold's theater. Stepanova and Popova, for example, designed constructivist stage sets for his productions. Barr felt that stagecraft was the most successful of the constructivists' art forms, seeing in it a comprehensive, satisfying coordination of sculpture, painting, and architecture. He had seen models of these projects previously in a theater exhibition mounted for the *Little Review* in 1926.

In the evenings, if they were not going to a concert, Barr and Abbott would attend a Meyerhold production, and Barr, who could speak German, interviewed the director in that language. When Meyerhold was asked if he found the obligation "to propagandize a stimulus or a handicap, he replied that his theater was an expression of the time-spirit and dealt with revolutionary material naturally and inevitably."[104] Barr admitted that he found the social or political issues in the theater had a "vitalizing power . . . [and were] a relief from eternal woman. No one makes love in *Potemkin*."[105] At one point, Barr noted with a certain amount of wonder: "In the evening with the grandson of Longfellow [Henry Wadsworth Longfellow Dana] and the granddaughter of Tolstoy to see the nephew of Chekhov in *Hamlet* at the Second Moscow Art Theater."[106]

KINO

Barr showed Stepanova stills from *Hands* (fig. 33), an experimental film produced in Germany in 1925 by an American filmmaker, Stella Simon, a student of the photographer Clarence White. Simon had given him the stills when Barr saw the film in Berlin the month before.[107] Stepanova asked Barr to write a critique of the film for the Soviet journal *Kino,* a film magazine she helped edit. Published in Russian in February of 1928 while Barr was still in Moscow,[108] the article paid homage to the great documentary style of Eisenstein's work during the previous ten years in Russia. But he reminded his readers of the alternative cinematic experimental style outside of Russia with the same artistic abstract aims of painting and music. This was successfully achieved, he held, by Léger in *Ballet mécanique*[109] and by the technical experiments of Man Ray in *Emak Bakia* and Hans Richter in using meth-

33. Stella Simon, still from *Hands,* 1925. The Museum
of Modern Art, New York.

ods such as changing from positive to negative projection, cutting frames, filming
from unusual points of view, and employing quadruple exposure. In them, he says,
"we can note first of all the aspiration to fantasy, dada and surrealism and sec-
ondly the revelation of a purely esthetic pleasure using more or less abstract com-
position." The significance of the object becomes secondary, and it is sacrificed
just as in an expressionist or a cubist painting.[110]

Barr saw the film *Hands* as a synthesis of two alternatives: an achieved objectification, representing the Russian realist view, and elements of abstraction similar to those in painting and music, representing a more purely aesthetic approach. He wrote: "Simon avoids tricky devices such as double exposure and out of focus shots, but reveals the natural properties of photography as such, including the kinetic elements of cinema."[111] The movement of the hands, varied and expressive, is the only subject matter of the film, occurring against a background of different objects. "Complex compositions," he wrote, "which are like suprematist pictures or constructive reliefs, produce pictorial effects."[112]

VKhUTEMAS

Barr and Abbott were so intensely interested in the Moscow art school known as VKhUTEMAS (an acronym in Russian for the Higher State Art-Technical Institute established in 1920) that they visited it three times. Lissitzky, Vladimir Tatlin, and Rodchenko all taught there. At first Kandinsky, returning to the Soviet Union in 1914, had been the school's guiding inspiration, envisioning an institution with broad aims: it would focus on experimental research in theory and practice; and it would have a multidepartmental, interdependent basis, encouraging a perspective that would emphasize the position of the viewer's reaction, both physically and mentally.[113] But his theories were rejected as too romantic and psychological, and he returned to Germany and the Bauhaus in 1921, bringing with him ideas from the Russian school.[114] According to Gropius, Kandinsky, along with Klee and Feininger, provided a "spiritual counterpoint" to the rational, objective teachings that became the hallmark of the Bauhaus.[115] VKhUTEMAS was the Russian equivalent of the Bauhaus; Moholy-Nagy, Kandinsky, and Lissitzky were the conduits for the affinities shared by the two schools. Like the German school, VKhUTEMAS included departments of architecture, printing, typography, graphic arts, posters, furniture making, and techniques of materials. The constructivists, like the teachers at the Bauhaus, considered their technical experiments and formal explorations "laboratory work," as Sachs considered his work at the Fogg.[116]

VKhUTEMAS also had a basic course, much in the same spirit as the *Vorkurs* of the Bauhaus. Barr observed that Lissitsky and the constructivist architects Aleksandr, Viktor, and Leonid Vesnin (all brothers) plus three or four others, taught architecture; Rodchenko and Tatlin taught metal work; David Sterenberg, Robert Falk, and four or five others taught painting; and other artists taught sculpture, furniture design, ceramics, and graphic arts. The school had one hundred faculty members in all. Barr seemed to have a comprehensive understanding of the school's functioning: "In each art the fundamentals of material, technique, and composition are supposedly thoroughly taught. This seemed successful in furniture and metalwork, where Tatlin's and Rodchenko's constructivism made a thorough knowledge of materials necessary. In architecture there were many compositional problems carried out in clay and cardboard and metal but we saw few signs that the actual problems of construction were being faced."[117]

34. Marcel Breuer, Wassily chair, 1929, manufactured by Thonet. Busch-Reisinger Museum, Harvard University Art Museums, Anonymous Gift.

During the 1920s there were several points of contact between the Soviet artists and the German Novembergruppe and the Arbeitsrat für Kunst.[118] By 1927, the artists of the Bauhaus school suggested to those of the Soviet school that they should plan a more active cooperation, with an exchange of student exhibitions as well as an exchange of students themselves and a continuing correspondence.[119] Because the two schools were conceived along the same lines, the products that resulted could sometimes be compared: a chair, almost identical to the Breuer tubular-steel chair, produced in the Bauhaus in 1925, and named the "Wassily" (fig. 34),[120] was wrought by a student in Rodchenko's workshop at VKhUTEMAS.[121] Because the workshop in metal and woodworking was also taught for a while by Lissitzky, who brought back to Russia ideas from the Bauhaus and the de Stijl group, it is hard to determine in which direction the ideas traveled.

Realizing the direct cross fertilization of the two schools by artists such as Lissitzky and Kandinsky, Barr acknowledged their similarities but also felt their differences. When Rivera introduced him to David Sterenberg, a cubist painter who had worked with Rivera in Paris before the war and who had a key position in the administration of the school, Barr asked him about the chief differences between the two schools. Sterenberg responded that the Bauhaus aimed to develop the individual whereas the Moscow workshops worked for the development of the masses; the reply was too "superficial and doctrinaire" for Barr.[122] He felt that the work at the Bauhaus seemed as social and communal in spirit as the Moscow school. The difference, he thought, lay in the grasp of the theoretical as it was manifested in technique: the Moscow school was more practical but far less efficient than the Bauhaus school, whose organizing genius, Walter Gropius, kept its standards high. In the Russian school, Barr speculated, "a good janitor to direct storage and clean up rubbish would be a boon." But he felt that both time and money were on the side of people such as Lissitzky and Tatlin to eventually develop the techniques needed.[123] This entry in Barr's diary has the poignancy of unfulfilled dreams, written when a century and a country were young in spirit. There was, no doubt, precision and innocence in Barr's observations, but only with hindsight could his implicit judgment be discerned.[124]

35. El Lissitzky, *Abstract Cabinet,* 1927 and 1928.
Sprengel Museum, Hannover.

LISSITZKY

Barr had a letter of introduction to Lissitzky from Gropius and he was impressed at how well it was received. Lissitzky, Kandinsky, and Gabo had participated in the art circle of Germany in the early 1920s. These artists moved freely into Germany and exercised an influence not only on the Bauhaus but on all of Central Europe. Malevich visited Germany in 1927; although Barr rightfully placed him at the center of the art and theory of Russian avant-garde art, it was Malevich's compatriots who brought Russian theory to Germany. Lissitzky, a great propagandist, was in Germany for the first large avant-garde Russian exhibition in 1922 and spread Malevich's ideas to the Bauhaus. The dynamism of the diagonal axis that Lissitzky learned from Malevich was, Barr said, a characteristic of "much geometrical abstract painting in Russia and Germany and in modern typography and advertising in art all over the world."[125] Lissitzky actively collaborated with the de Stijl artists and indirectly had an influence on the typography and poster productions of the Bauhaus. His Proun paintings, which he called "the transfer points from painting to architecture," were based on Malevich's perspective drawings.

Lissitzky's most famous architectural project was the *Abstract Cabinet,* an exhibition space that he designed in 1927–1928 for the Sprengel Museum in Hannover (fig. 35). The gallery was a cubic space designed as a visual unity, incorporating the floor and ceiling as well as the walls—a total environment that enabled the viewer to participate in the activity of the displayed works. The walls were covered with metal strips painted black on one side, gray on the other, and white on their edges. As the viewer moved around the room, the walls changed color. Panels were inserted that could easily be moved to change the arrangement of the paintings. Barr could not have missed this exhibit on his trip in 1928, and he displayed pictures of this room in the "Cubism and Abstract Art" exhibition in 1936.[126]

The director of the Hannover museum was Alexander Dorner, a forward-looking administrator who exhibited and bought the works of all the avant-garde artists in the 1920s. Dorner had tried unsuccessfully in 1925 to obtain works by Malevich through Lissitzky. In 1927, Malevich traveled from Leningrad to Poland

36. Kazimir Malevich, *White on White*, installation view at the
exhibition "Cubism and Abstract Art," The Museum of Modern
Art, New York, March 2–April 19, 1936.

and Germany with an exhibition of his works but departed before the exhibition
was over. He left his works with a friend, Hugo Häring, who in turn sent them to a
firm of forwarding agents. Dorner received a box of Malevich's works from the
forwarding agents that contained a large number of suprematist paintings, many
earlier works, as well as drawings and theoretical charts. A few years later,
serendipitously, Barr would benefit from these events when in 1935 the Nazis,
who considered modernism degenerate, were closing down museums and selling

the modernist works at auctions. At that time, Barr visited Dorner in preparation for his "Cubism and Abstract Art" exhibition. Dorner, in order to protect the Russian's work from the Nazis, sold two paintings and two drawings to Barr for the nominal price of two hundred dollars and loaned him seventeen others. Dorner shipped him the Malevich works as "technical drawings and Barr crossed the border in 1935 with two paintings wrapped around his umbrella."[127] In the 1930s, when the only Soviet exhibitions seen in the United States were socialist realist paintings, Barr was exhibiting the most radical revolutionary art, such as *White on White* by Malevich (fig. 36) and other suprematist compositions, both oils and drawings, as well as the earlier work, *Women with Pails,* at the "Cubism and Abstract Art" exhibition.[128]

TATLIN

Barr's fascination with the Russian avant-garde artists was supplemented by his purchase in Germany of the most complete description available of avant-garde art in Russia, Konstantin Umansky's *Neue Kunst in Russland, 1914–1919.*[129] Finding no satisfactory books in Russian on Soviet painting, he had to be content with Louis Lozowick's book and Umansky's,[130] neither of which included the activities of the constructivists. With the advent of the 1917 revolution, the practical aims of the Soviets demanded a change in the direction of the avant-garde artists to meet more pressing needs in the factory. Umansky included in his book the plans for Tatlin's *Monument to the Third International,* a symbolic tower representing all that was salient in Russian avant-garde art and reflecting the revolutionary changes in Soviet society: socialist realism, constructivism, dynamism, the importance of the machine, and the underlying "death" of art. Umansky wrote that in 1915,

> Tatlin developed Machine Art which stems from Picasso's and Braque's experiments of 1913. Art is dead—Long live art, the art of the Machine with its construction and logic, its rhythms, its components, its metaphysical spirit—the art of the Counter Reliefs. This finds no material unworthy of art: wood, glass, pa-

per, metal sheeting, iron screws, nails, electrical fittings, slivers of glass scattered across surfaces, the ability of separate parts to move, etc., all of these have been declared legitimate instruments of the new art language. The grammar and aesthetic of this language require the further mechanical training of the artist and a closer relationship to his omnipotent ally the sovereign machine.[131]

When Barr met with Umansky, head of TASS (the Soviet foreign news agency), Barr asked him for his ideas about proletarian art. Umansky noted that "the various modern movements were far beyond the grasp of the proletariat and then suggested that a proletarian style was emerging from the wall newspaper with its combined text, poster and photomontage." Barr was impressed with his answer, finding it "interesting and acute."[132] Typically, Barr recognized the passionate elements of the aspirations of Soviet artists and the experimental freedom in which they worked, while he ignored the social content of the aims of their artistic designs. His analysis also ignored the economic restraints attendant upon an emerging, developing system where scarcity was the rule. This was true, in general, of the West's attitude toward constructivism—including Germany, where the Russian avant-garde was first exhibited in 1922, and Paris, where in 1925, at the Exposition Internationale des Arts Décoratifs et Industriels Modernes, Russian art was received enthusiastically. Konstantin Melnikov's Soviet Pavilion and the furniture designed by Rodchenko for the Worker's Clubhouse won prizes for the VKhUTEMAS.[133]

LENINGRAD AND BEYOND

There was so much to see in the Soviet Union that a trip originally planned for two weeks was expanded to ten.[134] From Moscow, Barr and Abbott went to Leningrad for two weeks and then on to Krakow, Warsaw, and Vienna. In April, Barr wrote to Neumann describing his trip from Vienna to Munich to see private collections, to Salzburg where he saw the Pacher altar, and to Stuttgart to see "some modern

things" at the Valentine gallery.[135] In Frankfurt, with an introductory letter from Sachs, he went to see the collection of Robert von Hirsch. He wrote to Sachs that the collection was chosen with a very personal taste for small, unusual pictures. The "characteristic example fails to interest [von Hirsch]."[136] To Neumann he wrote: "You would like it. Small pictures of great quality: Ingres, Renoir, Rembrandt, and drawings."[137]

Barr visited Marny, Darmstadt, and Mannheim where he found "wonderful small museums."[138] He wrote to Sachs that since the war Germany had "blazed the way in museum techniques." He was agreeably surprised to find in Darmstadt a small museum "so beautifully arranged and with more care than any art museum I have seen in America"; and he thought that Mannheim had the finest public collection of modern pictures that he had seen outside of Russia.[139] In Mannheim, he talked with the museum's director, H. F. Hartlaub, and was able to obtain photographs of Otto Dix and George Grosz. The experimental methods in these German museums greatly impressed the future museum director and later would provide him with a basis for organizing the Museum of Modern Art. He made sure Neumann knew that the Max Beckmann show had been "a great success" in Mannheim. Barr went then to Mainz, to Strasbourg where he reported buying a Grosz drawing, and to Colmar where he visited the Grünewald altarpiece. He continued in his letter to Neumann: "Jere now has a Nolde, Schmidt-Rottluff, Hofer, Feininger, Klee, Rohlfs, a good beginning though I think he should get a Beckmann. I'm still interested in German art. I hope to write several short articles: one on Dix, Grosz, Schrimpf, Feininger, the *sogenannte* [so-called] *Neue Sachlichkeit,* one on Feininger, one on Schmidt-Rottluff (as typical of the *Brucke*). . . . We must talk about these things."[140]

He visited the Pressa, a book exhibition in Cologne with which Lissitzky was involved, as well as Düsseldorf and Essen. By April he was in Basel where he visited Paul Ganz. He wrote to Sachs about Ganz's collection of paintings and drawings by Fuseli, an artist in whom Barr had great interest ever since he had seen an exhibition in 1924: "I am convinced that in twenty years he will rank above David and a little below Blake and Goya. It will be wise to secure drawings by him."[141]

This is clearly a reflection of Barr's natural inclination toward painters who took a mystical approach to their subject matter, an approach antithetical to his attraction toward more abstract intellectual forms of art. In May he was in Paris where he visited the offices of *transition,* one of the little magazines. He left for New York from England in June of 1928.

Poignantly, Barr wondered in his diary "if this journal will ever be worth the time and trouble."[142] Nevertheless, filled with enthusiasm and gratitude to Sachs, ten days later he wrote to his sponsor that perhaps at some time he and Mrs. Sachs would hear parts of this journal.[143] To add to Sachs's store of information for his museum course, both Barr and Abbott made lists of such things as influential people to see and hotels at which to stay. Abbott sent Sachs a letter with names, addresses, and brief characterizations of every Russian scholar, private individual, writer, architect, critic, designer, ballet person, and collector they had met.[144] Sachs replied, "I have no hesitation in saying to you that this is the first time in all these many years that anyone has done for me what I have been trying to do for so long for other people."[145]

BACK AT WELLESLEY

In the autumn of 1928, Barr resumed teaching at Wellesley. The following spring he introduced a series of lectures and exhibitions that incorporated the material he had gathered on his European travels, including an exhibition of photographs of Russian icons. The *Wellesley College News* described the lecture on Russian medieval painting, quoting Barr: "Painting in Russia should be thought of as a long struggle between Greek (Byzantine) classicism and a native (barbaric) tendency toward vigorous but primitive flat geometric design."[146] The department of Art announced "A Course of Five Lectures on Modern Art" by Barr, to be given in April and May. For the first lecture, a wide range of international art was covered, characterized by Barr as "The Demon of the Absolute,"[147] an example of Barr's sardonic turn of mind. *The Demon of the Absolute* was the title of a book by the

philosopher Paul Elmer More at Princeton, a conservative thinker and colleague of the "new humanist" Irving Babbitt.

In the first lecture, Barr covered the trends since World War I, which included "the neo-renaissance in Derain; the decorative in Matisse; the cubistic in Picasso." The course description added that "the formalist attitude toward Medieval, Renaissance, and Baroque painting" would also be explored. His first use of the term "formalist" referred to "the importance of composition as found in the High Renaissance and Baroque that characterized the movements following Impressionism."[148] Barr covered a great deal of ground in this first lecture, most of which he had seen at first hand on his trip.

"The Disintegration since Cubism" was the theme of the second lecture. Barr illustrated the conservative trend in the 1920s that included the latest style of Picasso, whom he called "the pseudo-classic mannerist," and the return to figurative painting in the "new objectivity" of Otto Dix. An additional movement—away from abstraction—was surrealism and the life of the imagination, which he followed for his students through its sources of "the child, the savage, the lunatic, and the dream." This led to the "'metaphysical' of De Chirico, the fantastic and grotesque of Chagall and Klee," and, finally, "sur-réalistes as the ultimate devotees of spontaneity." Barr registered the dichotomy in his conclusion that the move away from abstraction could be labeled "Descartes versus Rousseau."[149]

In the third lecture, "Modern American Painting: A Cross-section," Barr covered the European influence on American artists, beginning with the impressionist generation in America—the Cézannists, abstraction, and the precisionists. He then turned to the indigenous American scene, which included the "sentimental" and the "literary." He ended with the question, "What is 'American' painting?"—a question that would continue to haunt him. He felt that contemporary critics were so at odds with each other that it was impossible to arrive at a consistent point of view from their various opinions.[150]

Focusing on the Bauhaus at Dessau in the fourth lecture, Barr discussed the movement as a paradox between the romantic expressionist's "exploitation of the individual [Kandinsky, Feininger, and Klee] and the constructivist's interest in the tech-

nique of living in a general collective society."[151] A more precise description of the intrigues of the Bauhaus had yet to be written; here Barr stressed the national and international influences of the school acknowledged as the leader in design.

The fifth and last lecture concentrated on the LEF group. The notice from the Art department described a talk that literally followed Barr through his trip in Russia. One of the topics was "'Chicagoism' and the cult of materialistic efficiency in a collectivist society." Barr was referring to the focus of the Russian artists on technical experiments in the VKhUTEMAS, particularly in architecture. Abbott referred to this in his diary: "We . . . found in Russia the love of the American mechanical sense . . . Indeed there is here, it could be said, considerable 'Chicagoismus'. There is in Europe . . . an almost unfortunate striving for American manner and the so-called American efficiency yet with little knowing how it is done and little realizing how concentrated American business is."[152]

Barr mounted the exhibition "Modern European Posters and Commercial Typography" at Wellesley from May 2 to 22, 1929, illustrating the idea that "modern art is not entirely separated from the utilitarian ends of modern life." He also underscored the fact that the posters were made by artists who "embody the principles of such modern movements as cubism, futurism, neo-plasticism and suprematism."[153] Wall labels identified each item, the country it came from, and its significant connection to modern art.[154] Barr became well known later for the wall labels he wrote for exhibitions at the Museum of Modern Art. When he first saw a version of a wall label in Russia, he wrote to Sachs about it and enclosed an illustration of one from the Tretyakov Gallery: "Such a label eliminates individual titles for each picture and makes the picture readily located thru the plan of the wall above the inscription and relates the wall label to the catalogue. . . . There are none in America."[155] The total Wellesley exhibition—posters, examples of typography on stationery, catalogue covers, book and periodical covers mostly from Germany and Russia (all items that he had collected on his trip)—would become part of the "Cubism and Abstract Art" exhibition and was given to the Museum of Modern Art in 1936 from Barr's personal collection.[156]

INTO THE FUTURE

Barr received a Carnegie Resident Fellowship in the spring of 1929 to finish his doctorate at New York University under Philip McMahon, providing him the opportunity to write on modern art that had not been granted at Princeton or Harvard. He wrote on his application that he planned to concentrate in "modern art, especially history and criticism of painting. [My] thesis would probably concern some aspect of the influence of primitive and e[x]otic forms upon modern European painting."[157]

But unexpectedly, at the end of his second year of teaching at Wellesley in June of 1929, Barr was invited by Sachs to become the founding director of the Museum of Modern Art. Overwhelmed by the prospect, Barr was coy in writing about other men who might be better suited for the job, among them H. F. Hartlaub of the Mannheim museum, which had a "most active modern collection." He also suggested to Sachs another man with "colossal energy, great executive ability, most constructive imagination, and possessed by a passion for works of art. He has had great practical experience in all that pertains to great museums. He is able to guide men and control resources. I mean of course yourself." But unable to contain himself, he changed course: "The fact that you are even considering me as a possible participant in this great scheme has set my mind teeming with ideas and plans." Coming full circle, Barr poignantly revealed his dream and his dedication: "This is something I could give my life to—unstintedly."[158]

6

MODERNISM TAKES ITS TURN IN AMERICA

In the decade of the 1920s, a mounting flurry of activities occurred in the modern art arena in America. These began with the remarkable efforts in 1920 of the founding of the Société Anonyme by the artists Katherine Dreier, Marcel Duchamp, and Wassily Kandinsky and were followed by various demonstrations of avant-garde art in galleries and museums.[1] Directly, and indirectly, they all played a part in the formation of the Museum of Modern Art. However, the most important precursors of the Museum—founded in the closing year of the decade on November 7—were the Newark Museum, which began as a library in 1909; the Wadsworth Atheneum in Hartford, Connecticut, where A. E. Austin became the director in 1927; and the Harvard Society for Contemporary Art, initiated in February of 1929.

A. Conger Goodyear, first president of the Museum of Modern Art, reached even further back in time than the scattered efforts of the 1920s when he wrote his history of the Museum's first decade. He attributed the Museum's genesis to the ex-

citement generated by the Armory Show of 1913, particularly to one of the show's organizers, the artist Arthur B. Davies.[2] Davies's influence on Lillie Bliss was profound. Having begun a collection of the artist's works in 1907,[3] Bliss, with his guidance, added to it with purchases of other modern works from the Armory Show, which she attended every day.[4] In 1922, upon her mother's death, Bliss was released from the deceptive arrangement of hiding her collection because of the older woman's disapproval of modern art. She then moved into a larger apartment, with the encouragement of Davies, enabling her to display her modern art collection in a more advantageous environment—a three-floor gallery created for that purpose.[5]

The close relationship between Davies and Bliss probably did not go beyond friendship, although much has been made of the double life that Davies led commuting between two households.[6] An accomplished pianist, Bliss played for him at his studio and listened attentively to his dreams of establishing a museum for modern art. Davies became even more passionate, if not frantic, about this concept when in 1924 John Quinn died and his significantly important collection of modern art was dispersed.

Also included in Davies's circle were Mary Quinn Sullivan and Abby Rockefeller, two close friends, who benefited from his advice on art. Sullivan was an amateur artist and art teacher who opened an art gallery with her own collection of modern art in 1931. Rockefeller, upon Davies's death, wrote to his son: "I feel that I owe [your father] a very great deal, because he inspired and encouraged me to acquire modern paintings, and without the confidence which his approval gave me I should never have dared venture into the field of modern art."[7]

Davies had promoted the idea of a museum for modern art in long conversations with these three friends. It has become legend that after he died in 1928, Rockefeller (fig. 37), Bliss (fig. 38), and Sullivan (fig. 39) were moved to fulfill his vision. Upon Rockefeller's chance meeting with Bliss in Egypt that winter, the momentous decision was made that led to the establishment of the Museum of Modern Art, a decision soon reinforced by Sullivan when she and Rockefeller happened to sail home from abroad on the same boat. This course of events, which might appear casual or serendipitous, was, in fact, the result of actions by

37. Mrs. John D. Rockefeller, Jr. (no date).

38. Lillie P. Bliss, 1927.

39. Mary Quinn Sullivan (no date).

three ambitious, socially aware women who were conscious of the gap in American museology resulting from the absence of readily available European modern art. They were reacting to an idea that many in the New York art world had been zealously promoting for years. Davies, Walt Kuhn, and Walter Pach, organizers of the Armory Show, championed the creation of a museum for modern art, as did McBride in the *Dial* and Forbes Watson in *Arts*. They all realized that the important Quinn collection could be the core of such a museum. Kuhn, reminiscing twenty-five years after the Armory Show, reported how he and Davies had urged Lillie Bliss to establish a permanent place to exhibit contemporary art, saying that not until after the death of Davies did Bliss accede to their vision. Bliss asked Kuhn "to steer the ship," but he declined the offer.[8]

The Bliss collection would become critical to the establishment of the permanent collection of the Museum of Modern Art, but it was Abby Rockefeller's drive, tact, and money, as well as her collection, that brought into being the paradigmatic institution devoted to modernism. Her commanding presence, most often in the background at her insistence, was felt by the entire Museum staff, but Barr was the most affected. She became his greatest ally, and he would claim that Abby Rockefeller (more than the other two women) was crucial to the institution's success.[9]

The composer Virgil Thomson, a peripheral member of the Harvard circle, in his usual acerbic manner labeled the Museum of Modern Art a "Rockefeller institution,"[10] which was not inaccurate. From the start, more often than not a Rockefeller was a member of the board of trustees in one capacity or another, and, in the manner of interested trustees, they bequeathed many works of art to its collection. The founding of the Museum counteracted the popular belief that, as a symbol of American wealth, the Rockefeller family was tied to conservative taste. Although Abby's husband, John, Jr., did not share her interest in modern art, he gave her a limited amount of money to support it.

By establishing the Museum, Abby Rockefeller satisfied her natural inclination for creative endeavors while providing a socially significant addition to the community. Her motive was more broadly beneficent than establishing a museum to be a repository for new art. She claimed that she was interested in helping modern American artists gain an appreciative public and in giving future genera-

tions more choices than those of the past. Reflecting on the traditional art works that she and her husband had been collecting, she held that they would not have relevance for the present generation of either collectors or artists. "So my thought turned," she wrote Goodyear, "to the art of the present, and those who were developing it."[11]

For a European tour through Germany and Vienna in 1924, Rockefeller was fortunate to have had as her guide William Valentiner, the new director of the Detroit Institute of Art, who became a friend and another mentor for her in modern art, particularly German art. Valentiner, who had emigrated to America from Germany in 1908, started his own collection of German expressionists in 1920 and arranged the first exhibition of German expressionists in New York at the Anderson Galleries in 1923;[12] according to Valentiner, they had been "judged favorably."[13] When he became director of the Detroit Institute of Art in 1924, he acquired paintings of the German expressionists for the museum. One of the first works Abby Rockefeller acquired on Valentiner's advice was a painting by the German expressionist Erich Heckel. Valentiner's was another voice that encouraged her to found the Museum of Modern Art.[14]

In the next decade, with the advice of Edith Halpert, who opened the Downtown Gallery in 1928, and Holger Cahill,[15] curator of the Newark Museum, Abby Rockefeller collected a cross section of art by rising young Americans produced in the United States between 1915 and 1925. Dorothy Miller, who became Barr's assistant and Cahill's wife, described the collection as "not imposing Museum pieces" but as having an "informality."[16] The artists, who included Charles Demuth, George "Pop" Hart, Charles Burchfield, John Marin, Maurice Prendergast, Max Weber, and William Zorach, among many others, were represented by oil paintings, watercolors, drawings, sculpture, and posters. Like Bliss, Rockefeller had a gallery built in the top floor of her home to display her modern art and to avoid her husband's criticism. In 1928, Mrs. Rockefeller became highly enthusiastic about the work of "Pop" Hart and amassed a complete set of his watercolors and pastels, which she hung in the Topside Gallery of her home. Cahill wrote and Halpert published a monograph on the artist; Halpert commented: "The fact that Mrs. Rockefeller . . . is now so thoroughly interested in American art, is of very

great importance to the public, not accustomed to interesting itself in native Art. She is setting an excellent example by establishing a private gallery in her home for the exhibiting of work she owns by American artists."[17]

IMPORTANT PRECEDENTS

Despite the sparks of interest in modern art ignited in important New York circles, few outlets existed in the 1920s for American artists to show their work. Thus when John Cotton Dana, director of the Newark Museum, began to emphasize the acquisition and exhibition of current American artists, the institution on the other side of the Hudson River became a focus of artistic interest. In 1926, at Dana's request, Cahill put together a show, selecting from the works of a loosely confederated group of Americans called the Society of Independent Artists, Cahill's former employer; forty paintings and a dozen sculptures were shown, both avant-garde and conservative works. Lectures by Walter Pach and Jerome Myers accompanied the exhibition.[18]

More than a decade earlier, in 1912, Dana installed the pioneer exhibition in the United States of German industrial arts, foreshadowing the Museum of Modern Art by twenty years. He placed the everyday object parallel to a work of art, articulating his philosophy several years later in *The Gloom of the Museum*:

> This fact will in time be recognized . . . that the oil painting has no such close relation to the development of good taste and refinement as have countless objects of daily use. The genius and skill which have gone into the adornment and perfecting of familiar household objects will then receive the same recognition as do now the genius and skill of painting in oils. Paintings will no longer be given an undue share of space and on them will be expended no undue share of the museum's annual income. It is doubtful if any single change in the general principles of art museum management will do as much to enhance museum influence as will this placing of the oil painting in its proper relation with other objects.[19]

Upon Dana's invitation, Karl Ernst Osthaus, director of the German Museum for Art in Commerce and Industry at Hagen, and the Deutscher Werkbund selected an exhibition. For the first time Americans saw prints by Käthe Köllwitz, Wilhelm Lehmbruck, and Carl Hofer, ceramics by Ernst Barlach, as well as textiles, glass, metalwork, wallpaper, leather, and advertising art and books. Anticipating the Bauhaus, the exhibition included photographs of the latest German architecture. Dana recognized that "the modern movement in the decorative arts is really a movement toward machine art."[20] Barr was too young to have seen the first German industrial show, but he might have been aware of the second, which opened at Newark in 1922 while he was at Princeton. On the occasion of this show Cahill came to work at the Newark Museum.

In 1927 Cahill expanded the museum's collection of sculpture and arranged an impressive show by living Americans. Among these were Jacob Epstein, John Flanagan, Gaston Lachaise, and William Zorach. Cahill considered Dana "the most liberal and farseeing American museum director of his time, and also the most courageous."[21] In treating manufactured products seriously as objects of design, in acquiring works of contemporary American artists for the museum, and in initiating an education program, the Newark Museum may be seen as a pioneering antecedent of the Museum of Modern Art, although Dana's overall scheme was neither as comprehensive nor as focused as Barr's. Modernism was not at the core of Dana's museum.

In the fall of 1930, Cahill mounted a folk art exhibition, having seen folk art objects in the studios of avant-garde artists such as the Zorachs and Robert Laurent in Provincetown, Massachusetts, and Ogunquit, Maine, in the late 1920s. He reported that the modernist artists had "rescued old paintings and carvings from farmers' attics and antique dealers' basements. The artists collected this work, not because they considered it quaint, or curious, or naïve, but because of its genuine art quality, and because they saw in it a kinship with their own work."[22] Cahill understood at this early stage that the influence of American primitive art on contemporary art was complex—parallel to the relation of European art to African and South Pacific art—and needed exploration.

About the same time, Edith Halpert discovered folk art at the home of her artist friends in Ogunquit and devoted a section of her Downtown Gallery to it. As she also considered it one of the sources of American art, she suggested that Abby Rockefeller collect folk art as a background to her modern art collection. Cahill and Halpert developed a very close working relationship and succeeded in bringing folk art into prominence, both academically and commercially. With Cahill and Halpert as her advisors and with a historical sense unusual for the time, Mrs. Rockefeller added her famous collections of folk art to that of her contemporary American art.[23]

THE HARVARD SOCIETY FOR CONTEMPORARY ART

The establishment of the Harvard Society for Contemporary Art by Lincoln Kirstein in December of 1928 has been frequently cited as preparing the way, nine months later, for the founding of the Museum of Modern Art with his fellow student, Alfred H. Barr, Jr., at the helm. For instance, Monroe Wheeler, a trustee of the Museum of Modern Art, was quoted as saying: "Make no mistake, the Museum of Modern Art began in Harvard."[24] The probability is that modernism was ripe for importation from Europe and interested young men, such as Kirstein and Barr, were at the vortex of the movement. Undoubtedly the modern concepts developed at the Harvard gallery were an unwitting dress rehearsal for those of the more ambitious Museum of Modern Art: most of the exhibitions mounted at the Harvard Society would, within the year, begin to reappear at the Museum of Modern Art. Before the Museum was founded, Mrs. Rockefeller paid a visit to the Harvard Society and told Paul Sachs that she wanted to copy in New York "en gros what they were doing."[25]

Kirstein gave Barr and Jere Abbott credit for supplying the Society's "less-informed enthusiasms with pinpointed, wide-ranging data,"[26] which included information for their catalogues and suggestions for future exhibitions. Barr and Abbott, while not completely involved in the activities, watched naïve, would-be

curators struggle to coordinate exhibitions and in the process, Kirstein related, learned the mechanics of "obtaining loans and being polite to lenders."[27]

Nevertheless, as was the case with *Hound & Horn,* Kirstein was a driving force and benefactor for the gallery. He wrote: "*Hound & Horn* cost worry, hard labor, money, but there was still enough left over for the Harvard Society for Contemporary Art."[28] Rather than the promotion of "modern" art—which, for Barr, connoted a disciplined sense of history—Kirstein's stated focus was on "contemporary" art, which satisfied his own curiosity about "the difference between 'originality,' 'personality,' and 'quality,' and whatever connected these in the present context."[29] Yet because Kirstein tended to measure contemporary visual art against the traditional works of Hans Holbein, Corneille de Lyon, and Jean-Auguste-Dominique Ingres, for instance, modern art was found wanting and he would eventually defect from the ranks of the rebels.[30]

Kirstein attributed his interest in promoting the visual arts to the *Dial* folio *Living Art,* which he owned.[31] He enlisted his fellow students to help him establish the gallery, among them Edward M. M. Warburg, a family friend who remained a collaborator for decades. Warburg, scion of a banking family, spent the better part of his life in philanthropy. After helping Kirstein with the Harvard Society and later supplying the introductory money for the ballet that Kirstein launched in Hartford in 1933, he remained a patron of the arts, eventually joining the board of trustees of the Museum of Modern Art. He summed up the establishment of the Harvard Society with these words: "Kirstein had taken a year out before entering Harvard. He was miles ahead of all of us (as well as most of the faculty) in his knowledge of the arts, as well as literature. It was at his suggestion that we started the H.S.C.A. He was the moving force. I helped raise money and build up membership and by working alongside Lincoln learnt more than I ever got out of my classes."[32]

The third member of the triumvirate working to bring modern art to Harvard was John Walker III, who would later become Berenson's assistant at I Tatti and, subsequently, director of the National Gallery of Art in Washington, D.C. Walker mingled with a social class at Harvard that ordained themselves "the Lads." They were well born and rich, and Kirstein was drawn to them, fascinated, he wrote,

by their "depthless self-satisfaction."[33] Kirstein used Walker's connections to the patricians at Harvard to further the cause of the new gallery. And, as Warburg wrote, "Walker was a solid scholar in the arts and knew the collectors, the dealers and the art world politics."[34]

The executive committee of the Harvard Society for Contemporary Arts consisted of Kirstein, Walker, and Warburg (fig. 40). Early on, Agnes Mongan became part of this inner circle that held daily meetings at Schrafft's restaurant in Harvard Square during the winter of 1928–1929. While Walker only attended once in a while, Mongan was a constant presence; she found Kirstein and War-

40. Lincoln Kirstein, Edward Warburg, and John Walker III, December 1928, founders of the Harvard Society for Contemporary Art.

THE HARVARDITES

Sponsors for the Exhibit of Contemporary Art at Harvard

ohn Walker III, Lincoln Kirstein, and Edward M. M. Warburg, the founders of the Harvard Society for Contemporary Art.

burg "exhilarating."[35] She was useful to Kirstein, coaching him in "the whole Berenson method [of connoisseurship]."[36] At the time, Mongan was in Sachs's museum course and would soon become his research assistant, enabling her to advise Kirstein on his dealings with Sachs. When Kirstein and his friends had complained to Sachs that the Boston Museum of Fine Arts lagged behind New York and Chicago institutions in showing contemporary art, Sachs challenged them to create a gallery themselves, but couldn't or wouldn't give them space to use at the Fogg Museum.[37]

Thus on December 20, 1928, a notice in the *Harvard Crimson* recorded that a dinner had been held at Sachs's home, Shady Hill, for museum officials, collectors, painters, and undergraduates where plans for the Harvard Society for Contemporary Art were formulated.[38] The gallery, committed to the latest in the arts, opened in two rooms over the Harvard Cooperative Society store (the Coop) that supplied the material needs of undergraduates. The opening announcement claimed that the gallery was the result of a cross fertilization of "movers and shakers" from Harvard, Princeton, New York, and the major cities of Europe who were interested in "modern art and decoration."

As Barr wrote in *Arts* that year, the gallery was "elegantly refitted with a silvered ceiling, steel cafe chairs and severe, highly polished metal-topped tables."[39] In his article, Barr commended the directors of the Fogg for their "courageous and vigorous" support of contemporary art at the Coop. At the same time, with his usual tact, he accepted their explanation for not exhibiting contemporary art themselves, which they would have deemed tantamount to endorsing it. Barr unaccountably considered this a reasonable position for a museum to take in order to avoid making "a frequent practice of passing judgment upon art the value of which is more than likely to be transitory."[40]

However, closer to the truth was the fact that Denman Ross, who was associated with both the Boston Museum of Fine Arts and the Fogg as a teacher, trustee, and generous donor, had a significant influence, and he was vehemently opposed to modern art. Involved in devising universal rules for the forms of art, he couldn't abide the breaking of those rules. Not surprisingly, Ross fought the inclusion of modern art at the Fogg. In his book *Painter's Palette* (1919), he explained the logic

of his dissent: "Apart from interest and ideas, is the Art of Painting; with its material, its modes, its methods, and its laws. In disregarding the Art so established; in using strange materials; in following unprecedented methods and modes; in disobeying the rules and laws of the Art; you are not expressing yourself in the Art but experimenting with it; perhaps with a view to changing it. That may or may not be worthwhile. In the meantime the Art of Painting is the same for all painters, for all artists."[41] John Walker, reminiscing about Ross, claimed that he was "as determined as Hitler to prevent the dissemination of what he considered decadent art."[42] To circumvent Ross and relieve some of the pressure brought by students demanding access to modern art, Sachs and Forbes offered assistance to the Society in raising money, securing loans, and having the staff of the Fogg Museum help in packing and shipping for the exhibitions at the Coop.

Although he needed the help of the directors of the Fogg, Kirstein was unable to get along with Paul Sachs and condescendingly described him: "[Sachs's] brief height, as well as a hyper-active intelligence, made him awkward; he hated being a Jew. Affable, suspicious, he never cared for me: I had discourteous contempt for his shyness and lack of ease."[43] In the case of the Boston Brahmin Forbes, Kirstein, characteristically, was unabashedly worshipful: "Edward Waldo Forbes, on the other hand, was a grandson of Ralph Waldo Emerson. When I was an undergraduate this lent him the mantle of an imperial inheritance . . . a puritan connoisseur, but a dear friend. . . . He founded a laboratory for conservation and restoration which did much to temper the museum's former compulsory aesthetic of Ruskinian and Paterian 'appreciation.'"[44]

But, through Sachs, Kirstein could approach the great collectors who had been awakened to modernism by the Armory Show. Although John Quinn's collection had been dismantled and Albert Barnes's collection was unattainable, many others were available to him, including those of Duncan Phillips and Adolph Lewisohn. Also available were the collections of the men selected for the board of trustees of the Harvard Society, such as John Nicholas Brown, class of 1922, a wealthy descendent of an old Providence family and a formidable collector of prints. In addition, among the trustees were Edward Forbes and Philip Hofer, whose collecting of books and drawings would eventually lead him to a curator-

ial position at the Morgan Library and then to establish the department of printing and graphic arts at the Harvard Library. Other trustees were Arthur Pope, the popular professor on the Harvard roster, Paul Sachs, Arthur Sachs (who shared his brother's interests), and Felix Warburg, father of Edward. Except for Felix Warburg, who was a friend of Sachs, they all had attended Harvard. In the second year of the Harvard Society, A. Conger Goodyear, already involved with the Museum of Modern Art, joined the board of trustees.

Kirstein planned to exhibit art works from various countries. The decorative arts would include furniture, glass, ceramics, and textiles; in addition to painting and sculpture, drawings, etchings, lithographs, and photographs would be shown. Works that were not from private collections would be for sale, and income from these sales and membership dues would sustain the organization.[45] They did so for two years under Kirstein, Walker, and Warburg. After they graduated, the Society continued with a different committee of undergraduates until 1934.[46]

To avoid criticism of their decisions on what constituted significant art, Kirstein and his friends called the project an "experiment," the byword of the avant-garde, and equivocated by saying the choices were "frankly debatable." But, in fact, Kirstein had learned his lessons well in the studios of artists and poets; he was the acknowledged leader and he selected the art with unerring taste. Years later he commented, "With Eddie's money, Johnnie Walker's social contacts and my brains there was just no stopping us."[47]

The Harvard Society for Contemporary Art opened with "An Exhibition of American Art" on February 19, 1929; almost a year later, a similar show would be seen as the second offering at the Museum of Modern Art. The Harvard Society focused on broad international modernism. The intent for its first exhibition was to show the surfacing of an American liberal tradition, primarily from the school of Robert Henri. According to the catalogue, "The exhibition is an assertion of the importance of American art. It represents the work of men no longer young who have helped to create a national tradition in emergence, stemming from Europe but nationally independent."[48] Essentially, they were men who comprised the first wave of modernist artists in America.

The author of the catalogue divided the artists into two categories. He suggested that artists in the first category shared, with Albert Ryder, an abstract lyricism that reached back to El Greco and to Blake, who inspired a "tradition of visual poetry." This, more than likely, came from the pen of Kirstein, who published his own poetry in *Hound & Horn,* had researched a major undergraduate paper in Europe on El Greco, and was taken with the work of Blake.[49] The realists comprised the second category, with Thomas Eakins cited in the catalogue as their precursor: "The clarity of [Eakins's] serious vision, the directness of his optical approach," was seen as continued by George Bellows, John Sloan, and Edward Hopper.[50]

The students also were able to show two artists from Stieglitz's gallery who were more radical and did not fit into the categories of lyricism or realism. Using the vocabulary of abstraction then current, Georgia O'Keeffe's *Lily,* lent by Paul Sachs, was described by the writer as "decorative formalism" and Marin's *Landscape* as an "analytic abstraction." Stieglitz himself was represented by a photograph of O'Keeffe's *Hands.* Although there was an attempt at objective criticism, the categories were too broadly defined; the disciplined mind of Barr was required to achieve more finely wrought descriptions. Taken together, the paintings in the Coop exhibition were of high quality and represented contemporary artists of the 1920s whose reputations have maintained their rank in the art world.[51]

The sculpture in the exhibition presented the more radical trends of the contemporary artists. Only three works were included: *Nude* by Archipenko, *Woman* by Lachaise, and *Plant Form* by Robert Laurent. In a published *Summary* of the Society's year's activities, the Lachaise sculpture was called the most important work of art shown during the year, reflecting a weighted example of Kirstein's taste.[52] Earlier in the 1920s, Lachaise had been actively promoted by the *Dial* and *Vanity Fair.* Kirstein would write a monograph on the sculptor for an exhibition he directed at the Museum of Modern Art in 1935.[53]

Barr was busy with his own exhibitions and lectures at Wellesley and remained on the periphery of these activities at Harvard, offering the group the knowledge of the avant-garde that he had recently gained from his year abroad. Warburg mentioned that Barr was an unofficial advisor at the planning sessions of the

shows. Barr described the strategy of the Society in an article for *The Arts:* "Instead of the expected blare of brazen modernity, the first exhibition has been a most skill-ful *ginoco piano* admirably calculated not to offend even the most backward."[54] (This same criticism would be leveled at Barr's conservative opening exhibition at the Museum of Modern Art the following November.)

Barr admired in particular three pictures: Helen Frick's early George Bellows, Stieglitz's *Hands,* and "Edward Hopper's row of toothless grimacing, patch-eyed 'Garfield' houses, their ugliness intensified until it is transformed."[55] In calling the Stieglitz "one of the few really great photographs," Barr revealed his hesitation in wholeheartedly accepting photography as an art.[56] He felt that "the decorative *objets* were, on the whole, chosen with care but, with the exception of Varnum Poor's plate, they deserve the label 'modernistic,'"[57] a term he used at the time in a pejorative sense. He felt that the "streamline" design was a superficial accom-modation to modernism.

The second exhibition the students mounted, "The School of Paris," was in-tended as a supplement to an exhibition of French art held simultaneously at the Fogg Museum. The Fogg's show (fig. 41), more than three times larger than the one in the Coop, had works of art from all the leading museums, galleries, and collectors. The exhibition was more sedate, covering the period from 1800 until the 1920s, and, offering the work of established painters, was in keeping with the taste of the general public in the 1920s.[58] Barr called the Fogg exhibition of French painting the "finest exhibition of Modern French painting since The Armory Show of 1913."[59]

Both exhibitions were possible because they enlisted the cooperation of col-lectors and dealers closely involved with Sachs. The student group showed paint-ings lent by Crowninshield, Frederick Clay Bartlett, Jr., the Valentine Gallery, Charles Daniel, and Duncan Phillips, among others. An extensive list of contem-porary artists was included: Guy de Segonzac, Amedeo Modigliani, Man Ray, Georges Rouault, Chaim Soutine; among the many cubists were Georges Braque, Roger de la Fresnaye, Juan Gris, Fernand Léger, Maurice de Vlaminck. They also showed Brancusi's *Golden Bird,* which they said "presented this master for the first time in Boston or Cambridge."[60] Joan Miró and Giorgio De Chirico, then consid-

41. French exhibit, March 1929, Gallery XIV, Fogg Art Museum.

ered surrealists, also were included. The comprehensiveness of the show was im-
pressive; artists considered the most radical of their generation were shown.

Picasso, Derain, and Matisse, acknowledged leaders of the School of Paris,
were not in the students' exhibition since they were adequately represented at the
Fogg. Nevertheless, the introduction to the catalogue of the Society's show traced
their contributions.[61] Kirstein commented on the use of primitive art by Matisse and
on the "intellectual approach to pure form" by Picasso. His appreciation extended
to Picasso's "amazing ingenuity . . . [from which] so much of the surprise, the
bravura, the originality of modern painting in Paris springs." Carrying a useful
thought to an ultrarefined end, Kirstein credited Derain who, passing through a pe-
riod of cubism, "emerged with heightened draughtsmanship, a sense of composi-
tion in the great French tradition and a restricted palette." He noted the influence
of Picasso on Vlaminck, Utrillo, Kisling, and Segonzac, who were seen in the ex-
hibition.[62]

The Society included decorative objects that helped shape the modern style—
by designers such as Donald Deskey in the American show,[63] and Raoul Dufy's ce-
ramics and textiles and Lalique ashtrays in the French exhibition.[64] The show
reflected the comprehensiveness of modernism as it was pursued in *Hound &
Horn.*

The third exhibition by the Harvard Society, held in April of 1929, was a ret-
rospective memorial show of the works of Maurice Prendergast, a Bostonian. Wal-
ter Pach, who wrote the notes in the catalogue, was an active supporter of the
cause of modernism as an artist and an art critic, writing books and giving lectures
on the subject, including one at the Newark Museum. He called Prendergast a
"genuine man of his generation [who] had the splendid adventure of the pioneer."
Pach's discovery of Cézanne (as early as 1904) as the touchstone painter for all
subsequent artists of radical aims was proudly confirmed in the Prendergast cata-
logue.[65] He recognized Prendergast as the first American artist to appreciate
Cézanne and build on him.[66] Barr would later refer to Prendergast as having "un-
der French influence . . . developed a kind of decorative expressionism unsur-
passed by any other American."[67]

In May of 1929, with the showing of a model of the Dymaxion House, a "machine for living in" that could be mass-produced, designed by Buckminster Fuller, a Harvard graduate, the Harvard Society moved fully into the modern vernacular. Fuller, imbued with the possibilities of technology, became a popular lecturer at Harvard and appeared again at the Coop the following year. As his reputation became international, the Harvard Society enjoyed it with him.

The second academic year opened with an exhibition called "The School of New York" whose purpose was "to show the younger American artists, in some cases the students of the first group shown."[68] Among the sculptures exhibited were an abstraction by Isamu Noguchi, lent by the Marie Sterner Gallery; an abstraction by John Storrs, lent by the Dudensing Gallery; *Woman's Head* by Gaston Lachaise; and *The Dowager* by Alexander Calder. These artists are still numbered among the more radical of that generation. Some of the most progressive American painters of the time also were shown: Stuart Davis, Peter Blume, Preston Dickinson, Stefan Hirsch, and Bernard Karfiol. The Downtown Gallery supplied a great many of the works for the exhibition, along with the Rehn Gallery and the Kraushaar Gallery.

In January of 1930 Alexander Calder returned to the Coop with a one-man show and also gave two performances of his miniature circus, attended by Barr and Philip Johnson;[69] Calder had already given these performances in Paris in 1926 and in New York in 1928. The Weyhe Gallery held his first exhibition of wire animals and caricature portraits in 1928, and in 1929 the gallery showed his wooden sculptures. These wire sculpture portraits and the wooden animals were included in the Harvard exhibition.[70] Including Calder in this early history of modernism was perhaps the single most important contribution of the Society. Calder's first one-man show at the Museum of Modern Art did not occur until 1943, nearly fifteen years later.

The Harvard Society was always one step ahead of the Museum of Modern Art, showing work never before seen in exhibition in America; its size and the nature of the enterprise allowed it to present more radical artists. Thus, coinciding with the opening of the Museum in New York, the student gallery mounted a more contemporary exhibition of Derain, Picasso, Matisse, and Despiau. The students

considered the exhibition "the most important activity of the Society's first year."[71] While Goodyear was combing Europe for paintings to show at the first exhibition at the Modern and Barr was scouring the United States for the Museum's opening exhibition, Frank Crowninshield, among others, loaned six Despiau sculptures to the Harvard exhibition, and the Valentine Gallery (formerly the Dudensing Gallery) supplied the majority of the paintings.

In his notes on the artists, Kirstein maintained a loyalty to Derain; in calling him "an academic painter working soberly and strongly with a set of restricting, helpful principles of solidity, economy and precision," he was expressing his own unfashionable values. He found Matisse surpassing van Gogh in brilliance with his "use of pattern, calligraphic drawing and a freshness of drawing." But his estimate of Picasso carried Kirstein to the edge of prophecy: "Only the critic of fifty years from now can fully appreciate how profoundly he has altered, controlled, and assimilated European painting of the first quarter of the twentieth century." He admired Picasso's exuberance. "His energy is colossal, not only in the field of painting but also in the graphic arts, as a sculptor, and as a brilliant stage decorator."[72] Kirstein's closing lines of the catalogue echo the criticism so frequent in *Hound & Horn:* "[The artists] are interested in the intensity achieved by a statement of the unexpected, the shocking and the ugly." This penetrating interpretation, which was usual in Barr's assessments but not in Kirstein's, revealed a willingness on Kirstein's part to give value to psychological meaning in modern art. But this trenchant estimation of the leaders of the modern movement turned to chagrin on Kirstein's part in the next decade.[73]

The Society continued through the year with exhibitions that constituted the very edge of modernism in the 1920s—Mexican art, German art, international photography, and work from the Bauhaus. The *Summary* published at the end of the year stated that the Mexican exhibition was "the largest and most comprehensive" showing of these artists in America before "the great Carnegie traveling exhibition"—a historical retrospective starting with the "indigenous resources of the descendants of the original Aztecs to twentieth century French cubism."[74] The majority of the prints were lent by Weyhe; Warburg had acquired two drawings by Diego Rivera that appeared in the show.[75]

The exhibition "Modern German Art," offered in April of 1930 at Harvard, "depended heavily on the graciousness of Dr. Valentiner of the Detroit Institute of Arts."[76] Paintings by Max Beckmann, George Grosz, Erich Heckel, Carl Hofer, Ludwig Kirchner, Paul Klee, Oskar Kokoschka, and Karl Schmidt-Rottluff were among those included, as well as sculptures by Rudolf Belling, Georg Kolbe, and Wilhelm Lehmbruck.[77]

In October of 1930, into its second year, the Harvard Society mounted an "Exhibition of American Folk Painting" in connection with the Massachusetts Tercentenary Celebration. This exhibition was current with Cahill's in Newark, and both were early examples of the developing interest in folk art. The catalogue, written by Kirstein, voiced a response to the freshness of the artists: "By folk art we meant art, which springing from the common people is in essence unacademic, unrelated to established schools, and, generally speaking anonymous."[78] Kirstein and his cohort, like the artists of that generation, considered folk art to have a "direct quality" that they associated with modernism.[79]

One of Kirstein's overriding interests was photography, a medium that had only been considered an art in America after the pioneering work by Stieglitz. Kirstein wrote the introduction and notes on the artists for the photography exhibition at Harvard in November of 1930, modeled on a highly influential exhibition of photography, "Film und Foto," organized by the German Werkbund in 1929. The students were able to gather the works of Berenice Abbott, Eugène Atget, Margaret Bourke-White (then in her twenties and just starting out), Walker Evans, Charles Sheeler, Ralph Steiner, and Edward Weston, as well as the accepted masters Steichen, Stieglitz, and Strand. The photography historian Maria Morris Hambourg, in a detailed summary of the history of photography in this period, noted that Kirstein's exhibition, like the German one it so faithfully emulated, was "the first to demonstrate the confluence of European, utilitarian, and artistic trends that was beginning to occur in photography in the United States."[80] Kirstein's interest in photography remained strong and his taste unerring as he later demonstrated in the exhibitions he mounted for the Museum of Modern Art.

By the end of 1930, the Museum of Modern Art had been well launched. Philip Johnson was in Germany gathering material for an architecture book he was

preparing with Henry-Russell Hitchcock; two years later this work would develop into the famous "Modern Architecture" exhibit. But events were still progressing at Harvard. In early 1931 Johnson brought back material from the Bauhaus and lent it to Kirstein and the Society for one of the first "comprehensive" exhibitions of the German school presented in the United States.[81] Barr and Jere Abbott also had much to offer the Society as a result of their European trip, loaning material for the exhibition that they had collected at the Bauhaus in 1927. Although Kirstein wrote the catalogue, Johnson was credited with supplying the information for the history of the Bauhaus, together with Alfred V. Churchill, who was a professor at Smith College and a friend of Feininger, and Helmuth von Erffa, once a student at the Bauhaus.[82] Kirstein also mounted a display of photographs of views of the Bauhaus as well as the fourteen books that the Bauhaus had published.[83] In summary, these Harvard students brought the complete achievement of the Bauhaus to the attention of the Boston public. Strangely, despite her nearly comprehensive avant-garde collection, Katherine Dreier was not approached to be a lender.

A major exhibition of the Society's third year was "Drawings by Pablo Picasso," held January 22–February 13, 1932, "which consisted of oil paintings and larger water colors illustrating the development of his various periods." The drawings supplemented the paintings "and presented Picasso as perhaps the greatest draughtsman of our time."[84] Although the Harvard Society continued for another two years, with this show Kirstein completed a stunning record of bold undergraduate achievement that presaged his remarkable career in literature and the performing arts.

THE MUSEUM OF MODERN ART IS LAUNCHED

In the spring of 1929, only a few months after the first exhibition of the Harvard Society, Abby Rockefeller began her campaign for the Museum of Modern Art. A. Conger Goodyear (see fig. 78), who had been asked to leave the board of trustees of the Albright Knox Museum in Buffalo because he had acquired Picasso's *La Toilette*, a painting considered too radical for the Buffalo gallery, was invited to

the first executive meeting she called. As the only male representative, he was chosen to be president of the newly formed board of trustees and was highly active at the Museum during his ten-year tenure. He asked Paul Sachs to become a founding trustee and, as Sachs related it, he accepted on the condition that he name the first director, claiming that he couldn't contribute financially at the level that had given the other trustees power.[85] Goodyear also asked two other trustees to be on the first board: Josephine Boardman Crane, a close friend of Rockefeller, and Frank Crowninshield, editor of *Vanity Fair*.[86]

At Sachs's suggestion, Barr was invited to Rockefeller's home in Bar Harbor, Maine, in July of 1929 to be interviewed for the position of director for the new museum. Rockefeller later wrote to Sachs that she liked Barr, "and felt that his youth, enthusiasm and knowledge would make up for his not having a more impressive appearance."[87] Goodyear was in agreement: "I was a little disappointed in his personality, but I think he has a very wide knowledge and great enthusiasm which will be useful to us particularly in starting the project."[88] Commonly, their goal was to present "only the best" at the Museum.[89]

Barr couldn't believe his good luck; he had been fortunate, or deliberate, in his cultivation of Paul J. Sachs. He wrote to Rockefeller the following August 12:

> How pleased I am and delighted that we are so sympathetic in our ideas. It wasn't at all to be expected that we should agree so spontaneously and completely on almost every question concerning our great enterprise. I feel now a certain *entente* between us which gives me greater confidence in suggesting to the committee a German exhibition, for instance, or the small periodical library, or the need for a uniform artificial lighting. Jere Abbott . . . was also overjoyed to learn of your remarkably unconventional and youthful tastes in art.[90]

Alfred Barr had just the right combination of talent, education, and temperament, if not the presence, to be chosen for the job. But more than that, he was passionately devoted to bringing order and scholarship to an admittedly complex situation engendered by the very nature of modern art.

The success of his fourteen-year tenure as director of the Museum would be due not only to his formal education but also to his self-education both in America and during his trip to Europe in 1927. In his visits to the museums of Europe, he had learned about installation techniques: the wall labels in the Russian museums, the movable walls in the German museum in Hannover, the advanced German museums of Essen, Hamburg, Berlin, Dresden, Stuttgart, Halle, Frankfurt, Cologne, Munich, Darmstadt, and Mannheim "which were one of the principal inspirations of our Museum in its early days."[91]

The patrons who backed the newly established Museum of Modern Art envisioned not only a "treasure house" for their collections of modern art but also a modern gallery whose relationship would be to the Metropolitan as the Luxembourg was to the Louvre in Paris or the Tate to the National Gallery in London. These smaller galleries could display paintings "still too controversial for universal acceptance." In addition to holding twenty exhibitions in the first two years, Barr and the trustees decided that the Museum would "establish a . . . collection of the immediate ancestors, American and European, of the modern movement." His enthusiasm was such that he envisioned achieving "perhaps the greatest museum of modern art in the world."[92]

Barr drew on his recent experiences in Europe in writing the brochure *A New Art Museum,* known as the "1929 Plan." He conjectured in his original draft for it: "In time the Museum would probably expand beyond the narrow limits of painting and sculpture in order to include departments devoted to drawings, prints, and photography, typography, the arts of design in commerce and industry, architecture (a collection of *projects,* and *maquettes*), stage designing, furniture, and the decorative arts. Not the least important collection might be the *filmotek,* a library of films."[93] Calling the plan "ambitious," Barr admitted it was edited by the trustees to read: "In time the Museum would expand . . . to include other phases of modern art."[94] Nonetheless, within a few years Barr, persistent, was able to carry out his plan to create curatorial departments that had their own exhibitions and that, taken together, institutionalized the structure of modernism. The first expansion was a department of architecture in 1932; in 1935 the film library came into being; industrial arts were exhibited in 1933; later, departments of drawings and prints and photography were added. Goodyear would write that the plan "was

radical . . . because it proposed an active and serious concern with the practical, commercial and popular arts." With studied understatement, he also wrote: "Looking back it is evident that there has been a continuing undercurrent of influence toward the complete realization of the 1929 plan."[95]

Barr relied on Abby Rockefeller for support in his sometimes troubled relationship with Goodyear; she was the central force holding the conflicting temperaments in check. Until 1939, when she retired because she did not want to intrude on her son Nelson's position as president of the Museum,[96] Barr saw her constantly. He revealed to Nelson Rockefeller his great attachment to her: "Because we saw each other so frequently and cared so much for the same institution and perhaps because I was very young (younger than my age) we used to talk together with great candor, even intimacy, so that after I used to feel almost as if she were a second mother, she was so thoughtful and kind."[97] It was her courage and belief in art, particularly modern art, that sustained Barr; few had realized, as he did, the fortitude that stiffened her resolve. He wrote to Nelson Rockefeller: "Not only is modern art artistically radical but it is often assumed to be radical morally and politically, and sometimes indeed it is. But these factors which might have given pause to a more circumspect or conventional spirit did not deter [Mrs. Rockefeller] although on a few occasions they caused her anxiety, as they did us all."[98]

Despite her interest and experience in American art, when it came time to determine the critical content of the opening exhibition of the Modern, Mrs. Rockefeller, with Mary Sullivan and Lillie Bliss, chose to have an exhibition of the "fathers" of modernism—the postimpressionists Cézanne, van Gogh, Seurat, and Gauguin. The show "Paintings by Nineteen Living Americans," favored to open the Museum by Sachs, Barr, and Crowninshield, had to wait for second turn.

The choice of a European show for the grand opening of the Museum was a portent of future controversies. Barr was the target of never-ceasing harangue by the museum-going public and the art world, accusing him of leaning toward the European avant-garde, and he was constantly defending his choices. He claimed that, while his expertise was in European and not American art, the record of exhibitions and acquisitions in the Museum proved that the institution treated both equally—an argument that remained unconvincing, especially to American

artists. Barr's desire to have an American exhibition for the opening was based on his opinion that a show with Alfred Ryder, Thomas Eakins, and Winslow Homer would be more interesting than the four postimpressionists. Nevertheless, the men yielded to the wishes of the three "adamantine"[99] women.

The Museum of Modern Art was a huge success from the opening exhibition. For this, ninety-eight paintings of Cézanne, Gauguin, van Gogh, and Seurat (fig. 42) were shown in the gallery—one large, two medium-sized, and three small rooms on the twelfth floor of the Heckscher Building at 730 Fifth Avenue (fig. 43). Goodyear's trip to Europe produced thirty works of art borrowed from cooperating collectors and dealers in London, Paris, and Berlin. The trustees' commitment to show works of quality made the Museum of Modern Art, in the long run, the success that it was. The exhibition proved that the taste of Americans—the show consisted overwhelmingly of works from private donors, including the trustees—could be seen in their acquisition of many fine examples of late nineteenth-century French painting and in the fact that exhibitions that included artists from Paris were more than twice as popular as most other shows.[100]

In his first catalogue, *First Loan Exhibition: Cézanne, Gauguin, Seurat, van Gogh,*[101] which accompanied the show Barr set himself a high standard that he adhered to for his subsequent catalogues and that influenced all others in the field. His prose has frequently been called "clear," his scholarship "precise," and his monographs "benchmark," published with an elegance of layout that he insisted on. Goodyear gave Barr high praise: "To a wide acquaintance with the art of the past as well as the present, he adds a fine flair for the first-rate, a constant quiet enthusiasm, a clairvoyant anticipation of new developments and above all a lucid mastery of the written word. His catalogues and other publications are a lasting contribution to the literature of modern art."[102]

In this first of many publications, Barr used descriptive, emotionally charged language laden with poetic flourishes. This was a rare indulgence discarded in later writings, in which the austerity of objective formal analysis within a context of historical continuity prevailed. Out of the chaos inherent in modernism—a label he insisted was more descriptive of the period than "contemporary"—he fashioned a narrative of synchronic movements in an effort to impose order on recent

42. Installation view of the exhibition "Cézanne, Gauguin, van Gogh, Seurat," The Museum of Modern Art, New York, November 7–December 7, 1929.

43. Heckscher Building, Fifth Avenue looking south from 59th Street, 1921. Collection of The New-York Historical Society.

artistic developments. What to some appeared limited and arbitrary designations in fact reflected his urge to classify and thus place the modern period in a historical continuum.

From the first catalogue, Barr established what he would become famous for: delineating the cross currents of historical developments in modernism—showing, for instance, how Gauguin's work led to German abstract expressionism by tracing his spreading influence throughout Europe. In writing of the two paintings *Meyer De Haan* and *Yellow Christ,* Barr encapsulated Gauguin's style: "[His works] completely contradict Impressionism. For soft contours they substitute rigid angularities; instead of hazy atmosphere they offer color surfaces, laquer hard. Instead of denying to painting all 'literary' flavor Gauguin saturates these works with positive psychological content."[103]

Although Barr noted psychological intentions, he did not analyze them; he was more interested in formal considerations, observing for example how, in later paintings in Tahiti, Gauguin's "high-keyed barbaric dissonances in color gave way to . . . deep sumptuous harmonies."[104] Barr's subsequent writings lost some hyperbolic tone, but his habits of carefully plotting the details of the artist's development, of tracing his influences, and of positioning him in the thrust of history became only more entrenched.

Van Gogh's life and work particularly seemed to move Barr. Perhaps it was the artist's troubled life, beginning with his "thwarted boyhood as the son of a Dutch Protestant pastor,"[105] that captured Barr's imagination (himself the son of a Protestant pastor). Charting van Gogh's development, Barr noted that it was not until the painter arrived in Paris and fell under the spell of the impressionists that his palette lightened. And in Provence where he "discovered himself . . . his brush swirled and leapt in staccato rhythms as if he found joy in the very action of his hand and wrist." Describing *Les Paveurs,* Barr continued again almost to the point of hyperbole: "The muscles of the tree trunks bulge as they dig their roots into the earth. He diagrams the crackling energy radiating from a bunch of grapes. He sees with such intolerable intensity that painting alone can give him release from his torment. Van Gogh the evangelist is transmuted into van Gogh the artist, the seer, the mystic, apprehending, making visible the inner life of things."[106]

Barr noted van Gogh's trips to the south of France and his friendship with Gauguin in Arles. But, revealing his own classical leanings, he felt that in the end "the inner character of his work, trenchant, disproportioned, lacking in 'taste,' but burning in spiritual ardor, seems defiantly un-French." More expressionist than classical, van Gogh's influence was most evident with the German expressionists: "Van Gogh is in fact the archetype of *expressionism*, of the cult of pure uncensored spontaneity."[107]

Of Cézanne, Barr proclaimed that "men of such stature do not live today."[108] Although Gauguin's contributions were recognized immediately while it was twenty-five years after Cézanne's death before his innovations were understood, Barr claimed that Cézanne's influence was more pervasive. "However time may rank Cézanne," he wrote, "it is certain that his influence during the last thirty years is comparable in extent to that of Giotto, Roger van der Weyden, Donatello or Michelangelo."[109] Barr's enthusiasm and his feeling for innovation led him to nominate this period as equal to the revolutionary events of the Renaissance. Cézanne's use of the great masters, the "synthesis of his baroque and Impressionist" tendencies, was precisely what appealed to Barr's sense of order: "Twice [Cézanne] defined his program: 'We must make of Impressionism something solid like the art of the museums.' And, again: 'What we must do is to paint Poussin over again from nature.' In these pregnant sentences he insists both upon the importance of tradition and the validity of contemporary discovery."[110]

These quotations from the artist, which Barr returned to repeatedly, occurred similarly in the writings of the English critic Roger Fry. Barr had met Fry in London in 1927 and he followed Fry's formalist point of view, expressed that year in *Cézanne: A Study of His Development*. Fry's empirical analysis of "the very stuff of the painting," of coming to grips "with the actual material of his paintings,"[111] expressed a habit that would rule Barr's life and career. Barr, like Fry, spoke of the planes of light reproduced by planes of color and the inner reality accomplished by the composition of those colors. Again sounding like Fry, Barr wrote: "But a great Cézanne is immanent; it grows around one and includes one. The result is at times almost as hypnotic as listening to great music in which strength and order are overwhelmingly real." Barr almost reluctantly implies that the artist's paintings, in the end, have a transcendent effect. Although he admitted that Cézanne was

broadly copied, Barr thought the artist's "essential power . . . inimitable."[112] Formalism may have been in the air, but Barr's formal analysis was pervasive in all his writings and translated itself into the organizational structure of the Museum.

The fourth painter in the pantheon of modern masters was Georges Seurat, whose greatness was not appreciated, according to Barr, until forty years after his death. Though Barr hailed Seurat as a scientific logician, he blamed his theories for masking the true caliber of his formal innovations. In addition to his extraordinary color, Barr remarked on the ordering of the space, particularly in his great masterpiece *Dimanche à la Grande Jatte:*

> No Cézanne or Renoir approaches the precision and perfection of such organization. We must look back to Perugino and Mantegna for comparable clarity, and to Tintoretto and Rubens for comparable complexity. . . . Seurat was the inventor of a method, the constructor of a system without parallel in the history of art for its logical completeness. What other man, artist, or layman, came so near realizing the 19th century illusion of possible perfection through science? But Seurat, the artist, was greater than Seurat, the scientist. In his work, from the least drawing to the most elaborate composition, great intelligence is completed by consummate sensibility.[113]

Barr described the influence of Seurat on the modernists who came after him, including even the cubists, but he could find no painter of comparable classicism. By placing the four founding fathers of modernism within the context of both the past and future, Barr demonstrated, in his first important contribution to the literature of criticism, the continuity of tradition and modern art.

The show was overwhelmingly successful with the critics and the public. Goodyear reported that 47,000 people crowded into the small gallery in a month and 5,300 tried to get in on the last day.[114] Reviewers were highly enthusiastic about the quality of the works displayed; Forbes Watson wrote: "In one move our youngest museum has stamped itself upon the public's imagination by the superb quality of the pictures it has chosen to exhibit, by good taste, elegance, dignity, seriousness of purpose."[115]

For the second show, Barr did a reprise of the Harvard Society's American show with many of the same artists. Unfortunately, the selection of paintings for the Museum of Modern Art exhibition, generated by a consensus of the trustees, was an uninspired show with no definite focus. In addition to the artists shown at Harvard, the New York show had Preston Dickinson, Lyonel Feininger, "Pop" Hart, Bernhard Karfiol, Walt Kuhn, Yasuo Kuniyoshi, Ernest Lawson, Jules Pascin, Eugene Speicher, and Max Weber. (Shown at Harvard but missing in New York were Benton, Davies, Prendergast, and Boardman Robinson.)[116] The response to this show was tepid, but the number of visitors increased with the next exhibition, "Painting in Paris," that emphasized the work of Picasso, Matisse, Derain, Bonnard, Braque, Rouault, and Segonzac.

An exhibition of German art opened at the Museum in 1931 with essentially the same artists as had been shown by the Harvard Society the previous year, with one important difference—Barr's accompanying informative catalogue. In it he noted: "Many believe that German painting is second only to the School of Paris and that German sculpture is at least equal to that of any other nation."[117] He described German art as different from either French or American art; rather than focusing on "form and style as ends in themselves," the German artists indulged in romantic feelings and emotional values "and even in moral, religious, social and philosophical considerations. German art is as a rule not pure art."[118] Barr seemed to oscillate between an attraction to the supreme order of French art and a fascination with the imagination obsessed by the dark underside of feelings in, for instance, surrealism or German expressionism.

Barr compared the German expressionist group Die Brücke with their French contemporaries, the fauves. Common sources were primitive art and the influence of Gauguin and van Gogh; in addition, the Germans used the inspiration of medieval art to avoid any imitative style. The expressionists, Barr wrote, "all used more or less 'unnatural' color, frequently in a bold decorative pattern. They drew with a heavy, usually angular outline."[119]

By now, Barr's writing had been reduced to minimal exposition; emotive excesses had disappeared. He described the second generation of expressionists, the Blue Rider group, as "less naïve, more belligerent and more doctrinaire."

Among the independent artists who did not belong to any group were Oskar Kokoschka, who was "feverishly" intense (intensity was a quality that Barr promoted in later writings), and Paula Modersohn-Becker, one of the "most advanced" artists in Germany (he always noted women artists appropriately). Barr saved his most lavish praise for Max Beckmann's style, which, for "strength, vitality and breadth of feeling, is unequaled in Germany." But he wondered about Beckmann's place in history: "Whether the genuine greatness of his personality will be realized in his paintings so that he will take his place among the half dozen foremost modern artists" remains a question.[120]

Barr reported on the more conservative postwar painting and especially on the Neue Sachlichkeit as represented by George Grosz, Otto Dix, and Georg Schrimpf. The new objectivity designated "artists who were turning both from expressionism and from abstract design to concentrate upon the objective, material world."[121] He recognized their sources in fifteenth-century artists such as Crivelli or Perugino, as well as the German painters Dürer, Holbein, and Grünewald.

The fall of 1931 saw the Museum's first loan exhibition for a major European artist, and one of the few major retrospective shows during Barr's tenure:[122] the Matisse show of 162 works covering 34 years. With it, Barr initiated his comprehensive scholarship on that artist. The catalogue, *Henri-Matisse,*[123] could be considered a prospectus for the publication twenty years later of Barr's acknowledged masterpiece, *Matisse: His Art and His Public;*[124] both have the same tone and shape.

Barr's thorough research of the life and work of Matisse, including drawings, lithographs, and sculptures, established a standard in the field. In the monograph's conclusion, he attempted to analyze the "character" of the work within an art historical context. Using Matisse's own words from "Notes of a Painter,"[125] Barr demonstrated his method of categorizing the development of the artist. In Matisse's work he found an inner consistency, despite surface changes, that manifested itself in recurring cycles. "An observer working from the outside might discover consistency in the sequence of inconsistencies." Barr was referring both to the alternation between tonal and bright colors among paintings and to the oscillating pattern that developed in his oeuvre between a "fairly 'realistic' style and one

so stylized and abbreviated that it approaches the 'abstract.'"[126] Barr hung the works in the exhibition chronologically, a method demonstrating the development of Matisse's oeuvre that he would employ again in his work on Picasso.

Transcending stylistic changes, the unity Barr observed in the paintings was a manifestation of Matisse's claim: "What I am after, above all, is expression."[127] Expression was interpreted by Barr to mean "the art of composition—composition of shapes and colors, the ability to create order out of the accident and confusion of ordinary visual experience."[128] He analyzed Matisse's style more deeply than did most criticism: "Resounding color was balanced by constant researches into the problems of design, not merely decorative design but structural design as well."[129] He felt that Matisse's emphasis on form, following the dictates of Cézanne, took a rebellious path as a reaction to the impressionists.

In a review of the exhibition, the historian Meyer Schapiro also took a formalist tack, suggesting, however, that Matisse's work was rooted in impressionist art whose subject matter was "already aesthetic . . . [and that] the art of painting resides in the coherent combination of shapes and colors without respect to their meanings. . . . The flatness of the field or its decomposition into surface patterns, the inconsistent, indefinite space, the deformed contours, the peculiarly fragmentary piecing of things at the edges of the picture, the diagonal viewpoint, the bright, arbitrary color of objects . . . constitute within the abstract style of Matisse an Impressionist matrix."[130] The "privacy and autonomy" of the individual sensibility, unfettered by objective reality, were initiated by the impressionists, thereby opening the way to abstract design and modernism in the next century. When Schapiro further stated that "sensibility operates instantaneously, in the very act of seeing,"[131] he brought a psychology of perception into his formalist analysis that anticipated the work of the phenomenologists. Freer than Barr in facing more complex artistic issues, Schapiro found the language to describe more finely the results of the radical artists. Only five years later, Schapiro, uneasy with the confines of the formalist attitude, took Barr to task for not considering art in a cultural, social, or psychological context.[132] Despite Schapiro's concerns, the formalist approach in criticism held sway until the 1970s, when a multiperspective scholarship ensued.[133]

After Matisse, the Museum showed the work of Diego Rivera—150 pieces, including seven frescoes commissioned for the occasion. The exhibition broke all prior attendance records. Barr had seen Rivera in Russia in 1927 and subsequently persuaded Abby Rockefeller to collect his works despite the artist's revolutionary politics.[134] (Rivera fell out of favor in 1934 when his provocative mural for Rockefeller Center was destroyed by the agents of the complex.) In all, fifteen temporary exhibitions were held at the Heckscher Building, attracting more than 500,000 people, who proved the need to establish a more permanent museum. But before moving in 1932 into a brownstone owned by Abby Rockefeller at 11 West 53rd Street, the Museum organized "Modern Architecture: International Exhibition," which Barr considered one of its most important accomplishments. Modern architecture in its relation to painting was the symbolic embodiment of all that Barr and the Museum represented. The exhibition (discussed in the next two chapters) completely changed how architecture was viewed in America.

In 1932 Barr took a leave of absence for a much-needed rest. Between 1927 and 1931 he had written seventeen articles, the catalogues for the Museum's shows, and eleven lectures and papers, in addition to sustaining the enormous pressure of the first three years as the director. Cahill, introduced to the Museum by Rockefeller, replaced him as acting director. At this time, Cahill curated the show "American Folk Art: The Art of the Common Man in America, 1750–1900," comprised solely of works that he and Dorothy Miller had purchased for Mrs. Rockefeller's collection, who lent them anonymously.[135]

THE MULTIMEDIA MUSEUM

Board members, meanwhile, were looking for avenues of support for the institution. Crowninshield believed the close personal relationships between Barr and Kirstein and his friends could be used to advantage and suggested that Goodyear, as president of the Museum, enlist "a lot of the young boys . . . of Harvard."[136] Kirstein, Warburg, and Johnson were asked to join the junior advisory committee in 1930, soon after the Museum opened.

Barr, as well as Kirstein, was interested in photography as an art form. He had always included photography sections in the art surveys he organized, although he was overruled when he proposed to include photography in the American show.[137] Kirstein went on to write many articles and books on photography, including the catalogues for the exhibitions that he curated for the Museum: "Murals by American Painters and Photographers" in 1932 and "Photographs of Nineteenth-Century American Houses by Walker Evans" in 1933.[138] The Evans exhibition was the first one-man photography show at the Museum, displaying Kirstein's collection of photographs of the Victorian houses of New England, which he then gave to the Museum. It had been Kirstein's suggestion to photograph the houses, and he and a fellow student, John Wheelwright, accompanied Evans on the trip.[139]

Not until 1937 did a major exhibition of the history of photography occur, curated by Beaumont Newhall, the newly hired librarian of the Museum who had been recommended to Barr by Hitchcock. Having obtained money from a trustee, Barr unceremoniously asked Newhall if he would like to mount a photography exhibition. Newhall was a self-taught amateur in photography with a master's degree from Harvard, where he had studied with Sachs. He began work at the Museum of Modern Art by helping Barr hang an exhibition. Barr warned Newhall that he was joining a three-ring circus, where every day was like an opening of a new exhibition.[140] The photography exhibition, a complete history with almost 800 pieces, took over the whole Museum.[141] The show then circulated throughout the country, and the catalogue by Newhall, *The History of Photography: 1839–1937*, sold out. Although the show was Barr's idea, fulfilling his desire to create a multimedia museum, he did not interfere with anything Newhall proposed. Newhall mounted a second Walker Evans show, and this, with the historical survey, not only established Newhall as the leading photography critic but also established his formalist aesthetic as the most influential perspective on photography at the time. The next year he mounted a Cartier-Bresson show with Kirstein, and on the strength of these exhibitions Newhall became the first curator of a photography department established in 1940. In his seven-year tenure, Newhall was responsible for thirty photography exhibitions.

Barr's familiarity with the new art of the cinema had been demonstrated before he came to the Museum; his attendance at rare showings of interesting films had spurred him on at Harvard.[142] His trip to Europe had reinforced the idea that the cinema was indeed an art form, and he proceeded to write articles about Eisenstein and other avant-garde filmmakers. Preparing for the future on his sabbatical leave in Rome in 1932, Barr wrote "a carefully graded list of films which I thought worthy of inclusion in a film collection."[143] That same year he wrote:

> That part of the American public which could appreciate good films and support them has never been given a chance to crystallize. People who are well acquainted with modern painting or literature or the theatre are amazingly ignorant of modern films. . . . Those who have made the effort to study and to see the best films are convinced that the foremost living directors are as great artists as the leading painters, architects, novelists and playwrights. It may be said without exaggeration that the only great art peculiar to the twentieth century is practically unknown to the American public most capable of appreciating it.[144]

The curator who established the film department in 1935 was an Englishwoman, Iris Barry, introduced by Philip Johnson and hired as a librarian. She had been a founder in 1925 of the Film Society of London and had written reviews of films for the *Daily Mail* there. In 1935 Barr gave her the job of creating a film library after he raised money from the Rockefeller Foundation and from John Hay Whitney, who was interested in films. As director of the film library, she collected prints from all over the world and established a film conservation program. With an early focus on the art of film that was chronologically congruent with the rise of modernism, the Museum built one of the best collections of films in the world and saved many films from extinction. Increasingly after 1939, when the new building "provided a projection room, space for the still collection, film books and periodicals, scenarios and their literary sources and, most important, the auditorium designed especially for film showings,"[145] the new department became an important model for film study.

What had been inaccessible and in danger of disintegrating and being lost forever now became available for study by students across the country. In the winter of 1934–1935, lacking an auditorium, the Museum showed its first series of films at the Wadsworth Atheneum in Hartford, headed by A. Everett Austin, Jr. Like Cahill, Dana, and the Newark Museum, as well as Kirstein and the Harvard Society, Austin and the Wadsworth Atheneum were indispensable to the spread of modernism in the United States, often in advance of the Museum of Modern Art.

THE FIRST MODERN MUSEUM APPEARS IN HARTFORD

A pivotal player in the art world of the Harvard coterie, Austin was a young man competing for attention with Barr in promoting modern art. That he was known to his friends as Chick reflected his flamboyance and the appeal of his personality. He graduated from Harvard in 1922; after a year with the Harvard-Boston Museum of Fine Arts Egyptian Expedition, he returned to Harvard in 1923 for graduate studies in architecture, remaining for three years and assisting Forbes in teaching the Techniques of Painting course.[146] At Harvard he met Barr, who took the course, and Hitchcock; they all attended Sachs's course together. In 1927, at the recommendation of Forbes and with the concurrence of Sachs, Austin was appointed acting director of the Wadsworth Atheneum; soon after he became the director, a post he retained for nearly twenty years. Too flamboyant for the trustees at the Atheneum, Austin moved to the John and Mable Ringling Museum of Art in Sarasota, Florida, in 1946.[147]

Having absorbed the atmosphere of Harvard, Austin transported its artistic climate to Hartford. He was functioning in a smaller, less sophisticated arena than Barr at the Museum of Modern Art, but at the time it was a more permanent setting. Austin was able to create an international center for art that for a time outran the Museum in New York. Members of the artistic clique—highly ambitious, mutually supportive riders of the Boston–New York axis—called the Wadsworth Atheneum "the New Athens."[148]

In 1930 Kirstein sent Austin the exhibitions that had been shown at the Coop. Within weeks after they appeared at Harvard, Austin showed Fuller's "Dymaxion House," "Modern Mexican Art," and "Modern German Art." Fuller lectured at the Atheneum as did Hitchcock, and Austin presented the very latest in theater, music, and films at his museum. The first experimental films were shown in 1929 and included *Metropolis, Fall of the House of Usher, Berlin: Symphony of a City, The Cabinet of Dr. Caligari,* and *Ballet mécanique.*

In the summer of 1930, Kirstein wrote to Austin expressing the hope that he would continue the same arrangement of exhibitions the following year: "We have got to save cash so the exhibitions will be both easier to handle, less exciting and more practical."[149] At Kirstein's suggestion, Austin contracted to install the photography exhibition that had been shown in November of 1930. In May of 1931, Austin showed "Picasso Drawings and Lithographs," loaned from the Harvard Society. Kirstein included accompanying catalogues with every exhibition.

Austin went in his own direction with such benchmark exhibitions as "Five Young French Painters" (featuring Christian Bérard, Kristians Tonny, Pavel Tchelitchew, Eugène Berman, and Leonid Berman); the James T. Soby Collection; and the "Newer Super-Realism," presenting the work of Salvador Dalí, Max Ernst, André Masson, Joan Miró, Léopold Survage, Pierre Roy, Giorgio De Chirico, and Pablo Picasso. Soby, living in Hartford, was discovered by Austin as a collector of modern paintings; he became his assistant and served on the board of trustees.

Another important connection for Austin and for the spread of the Harvard influence was Julien Levy. He met Austin as a freshman when he took Forbes's Techniques of Painting course. Levy opened an art gallery in New York in 1931, having spent the ritual apprenticeship in Europe after attending Harvard.[150] Levy's gallery was the incubator for the avant-garde artists and photographers of the 1930s, and Barr and Austin used it as a source of new works. Levy, who had been interested in photography and film since 1925, opened his gallery with an exhibition of American photography. He attributed his wakened interest to his long acquaintance with Stieglitz and to Duchamp, who introduced him to Man Ray.[151] Levy said that between 1931 and 1933 he showed the most avant-garde photographers at his gallery: Berenice Abbott, Eugène Atget, Margaret Bourke-White,

Brassaï, Evans, André Kertész, George Platt Lynes, Man Ray, and others, but his effort to establish a market in prints was a failure.[152]

Although the neoromanticists (Bérard et al.) reached Hartford through the Julien Levy gallery, their original American contact had been Virgil Thomson, who brought Berman and his friends into the Gertrude Stein circle in Paris. Levy met Tchelitchew there; he discovered Berman's art through Hitchcock later, when they both attended the Kirk Askew salon in New York.[153]

The model for social evenings in avant-garde circles, where exchange of ideas and sharing radical notions of the period were encouraged, emerged in America and Europe before World War I in such circles as those of the Steins, the Arensbergs, Mabel Dodge, Muriel Draper, and the Stettheimers.[154] In his memoirs, Levy described the remarkable salon of Constance and Kirk Askew that thrived in the 1930s, bringing together the growing cognoscenti of the modern art circles (some of whom had met at Harvard). Although the Askew salon attracted people from all the arts, the coterie around the Harvard group were the most numerous. Every Sunday "a small group of regulars came . . . and provided the dependably witty core of the parties."[155] Among those he mentioned who gathered at the Askews' were the Barrs, Hitchcock (who had been Levy's tutor at Harvard), Agnes Rindge from Vassar, Allen Porter, Virgil Thomson, Chick Austin, Philip Johnson and his sister Theodate, Gilbert Seldes, and Muriel Draper, who would appear with Lincoln Kirstein "in tow."[156]

Hitchcock, with Rindge, Kirstein, and James Soby, championed the neoromanticists and lobbied to get them into the collection of the Museum of Modern Art. But as Johnson recalled, Barr never was enthusiastic about these artists. Tchelitchew's *Hide-and-Seek,* acquired by the Museum in 1940, became, perversely, the most popular painting in the Museum's collection despite Barr's criterion that modernist art should be "difficult."

Levy promoted the surrealists as well, but he conceded to Austin's wish to have the first showing of the newest European movement at the Atheneum instead of his gallery. The movement was so new that no equivalent American word for the French *surréalisme* existed. Levy reported debates among Barr, Austin, and himself about what to call the current ism, "Chick proposing 'Newer Super-Realism,'

Barr electing 'Super-Realism' and I maintaining that the French 'Surrealism' was in fact untranslatable."[157] The show was held at Hartford in the fall of 1931; when it went to Levy's gallery after the new year, it turned the gallery into an instant success.[158]

In the remembrances of his friends, all of whom figure prominently in the history of the establishment of modernism in America, Austin emerged most strongly as a theatrical personality, another high bohemian committed to the artistic life (fig. 44). Not unlike his good friend Kirstein, who was considered the "'father' of modern American Ballet," Austin was described as an American counterpart of

44. James T. Soby, photographer: A. E. Austin, Agnes Rindge, Allen Porter, Henry-Russell Hitchcock, and Constance Agnew in the Soby living room, Farmington, Connecticut, 1940.

Diaghilev by Eugène Berman: "Both had in common a tremendous imagination and daring, a fantastic vitality, absolute unerring taste, both were equally discerning of the qualities and values of the newest 'avant-garde' manifestations and of the best in any form of the arts of past centuries and cultures."[159] But neither Kirstein nor Austin was as interested in making an impact on the visual arts as was Barr. Temperament was the deciding factor. Kirstein and Austin were drawn to performance as an art form.

In 1934 Austin created a sensation when he opened an addition to the Atheneum in the International Style called the Avery wing.[160] The new wing opened with the first Picasso retrospective held in America, ahead of the Museum of Modern Art by five years.[161] Sending his congratulations, Kirstein wrote: "I know next week will make you very happy indeed because you will open the most distinguished museum in the world—whose distinction comes from the concentration of all your energies into courage and great taste."[162]

At the time, however, the more important event that celebrated the opening of the wing was the world premiere of the Gertrude Stein and Virgil Thomson opera *Four Saints in Three Acts,* produced by The Friends and Enemies of Modern Music. The group had been giving concerts in private homes and moved to the Atheneum when the new wing was built. Austin's flair for promotion and his consummate interest in the theatrical and the modern had inspired him, years before, to found a subscription society to support modern music. The first concert, in 1928, included the music of Stravinsky, Milhaud, Schoenberg, Poulenc, Ives, Satie, Hindemith, and Antheil, an unerring choice of modernist composers. In memorializing Austin, Thomson recalled a concert given in "Chick's own house, where five American composers—Roy Harris, Aaron Copland, George Antheil, Paul Bowles and myself—all played works by one another."[163] Thomson, who had also attended Harvard, was one of the inner circle, and when he and Stein looked for a sponsor for their opera, Austin, known to be interested in experimental theater, was their logical choice. The production at the Atheneum was wildly successful, with the members of the Harvard circle supporting it generously.[164]

The word that characterized the period, used constantly by the protagonists involved, was "exciting," a state of mind that seemed to accompany the innovative

artistic "happenings." Thomson recalled the reception that awaited the premiere of his opera in February 1934, as a "notoriety . . . unparalleled since that of Marcel Duchamp's painting, 'Nude [Descending a Staircase].'"[165] Thomson was not immodest in his assessment of the opera as one of the landmarks of modernism in America.

The New York contingent was strongly in evidence at the opening. Julien Levy reported attending and bursting into tears, as did Kirk Askew, "because they didn't know anything so beautiful could be done in America."[166] Many came from the Museum of Modern Art—trustees Rockefeller and Crane; Alfred Barr and some of his staff, including Philip Johnson, Allen Porter, and John McAndrew; Agnes Rindge, Philip Goodwin, and Jere Abbott (then director of the Smith College Museum); Soby, assistant to Austin; Hitchcock, who had arrived in Middletown, Connecticut, in 1929 to head the Wesleyan Art Museum and remained close to Austin; and Katherine Dreier, a great admirer of Austin's.[167] Hitchcock said about the era:

> There were two people in the country who were doing new exhibitions in those years. One of them was Chick Austin and the other was Alfred Barr, and they were obviously doing them from different angles, Barr's was much more the approach of the scholar, and his catalogues were monuments of scholarship which have been standard works ever since. But certainly nothing showed to the outside world comparable to Chick's building up of that collection, providing the setting for it, and then presenting the parallel events. He had charisma. He bubbled over with ideas, and they were so stimulating that every one was willing to work with him and for him. But he was no scholar, no researcher . . . in the art world he knew what was going on as soon as it started.[168]

Barr congratulated Austin: "I admire your extraordinary initiative and courage in putting on this opera and this Picasso exhibition. Either one would be enough for any ordinary mortal museum director."[169] As he later conceded, Austin "did things sooner and more brilliantly than any of us."[170] Barr had tried to mount a Picasso retrospective in 1932, but Picasso had been unwilling to cooperate. In addition, the trustee Stephen Clark had been afraid that a Picasso exhibition would prevent the Museum from raising much-needed money. Only after the permanent

home of the Museum of Modern Art was opened in 1939 was Barr able to proceed with this long-deferred show.

Austin was not only one of the central figures of the Harvard circle, geographically and spiritually; he was also important as the person who introduced his assistant Soby to Barr. According to Margaret Barr, her husband had "completely honest and trusting relationships with only two men," James Soby and Philip Johnson.[171] Soby was much loved by those who worked with him and, most unusual, with the artists he wrote about; he had an open charm and an irreverent sense of humor that complemented Barr's concentrated seriousness. Their letters included gossipy quips about "Old Howard," their code name for the Museum.[172]

Soby (fig. 45), beneficiary of a cigar and/or a telephone booth inheritance (both have been mentioned),[173] called on Austin in early 1930 and invited him to see recent acquisitions to his modern art collection. "He grabbed me by the arm," Soby wrote, "hustled me to his car, and we sped to see the Matisse and Derain at my West Hartford house. He could not have been more excited if the pictures had been his own."[174] Soby joined Austin at the Atheneum to work closely with him for a decade, helping with catalogues and backing him with acquisitions, before joining Barr in New York.

Soby's collection, which would be bequeathed to the Museum of Modern Art, reflected his long association with Austin, especially in the works of Balthus and Tchelitchew. Soby also wrote landmark catalogues and books and directed exhibitions for the Atheneum. *After Picasso,* his first book, was a study of the painters who had interested Austin and Levy, the surrealists and neoromantics.[175] Soby was appointed assistant director of the Museum of Modern Art in January of 1943, and he assumed the job of director of the department of painting and sculpture after Barr was fired that October.[176] But after eighteen months he resigned, finding the job uninteresting and the board too difficult to get along with.[177] He stayed on at the Museum, however, writing, mounting exhibitions, and contributing to the acquisition committee. Barr and Soby were each in awe of the other's talent; they enhanced each other's commitment to art as well as the commitment of those around them. Barr had the dedication and knowledge; Soby had the sociability. Soby said that he had worked "in tandem" all his life—ten years with Austin and twenty-five years or more with Barr—with no regrets.[178]

45. Man Ray, *James T. Soby*, 1937.

KIRSTEIN RENOUNCES MODERNISM

Barr maintained a friendship with Kirstein through the first two decades of the Museum's existence, but their paths diverged and Kirstein busied himself in founding a ballet company with the help of Austin and Warburg. Eventually Kirstein's interest in modern art was subverted and his relationship with Barr disintegrated beyond repair.

In 1948 Kirstein wrote an article, "The State of Modern Painting," in which he aligned himself with those who opposed modernism and called the practitioners of abstraction "an abstract Academy of decorative improvisation." Unaccountably, he dismissed Matisse as a "decorator in the French taste, the Boucher of his epoch." Kirstein added that the Museum of Modern Art had done its job too well "in promulgating its useful catalogues, which remain as textbooks long after the closing of their exhibitions. Young painters," he thought, "imitate the art of the last fifty years instead of the last five hundred."[179]

Registering his hurt, for many months Barr went out of his way to avoid meeting Kirstein. Several years later Barr defended himself privately:

> What irked me chiefly about Kirstein's piece was his "authoritative" assertion that the Museum "showed only one kind of art," a palpable untruth; furthermore, I despised his damning the painters whom he disliked by name while proposing a group of young painters as the hope of the future when they were actually quite well-known and had mostly been exhibited fairly recently by the Museum—I mean people like Cadmus and Tooker and Jared French. Anyway Kirstein and I are on quite friendly speaking terms now and I am glad to think that the bitterness on both sides has dwindled, since I have been fond of him for many years.[180]

Kirstein never regained his youthful enthusiasms for modern art and relations between the two men worsened, as witnessed by Kirstein's self-absorbed denunciation in *Raritan:*

By 1933 I was deeply involved with the foundation of the Museum of Modern Art, where Alfred Barr taught me about contemporary art. In his long life, and in my long association with him, I never heard him make a qualitative judgment about the essential or historical nature of a gift. He judged art as anthropology; for whatever the object, he judged its essence as of that genus, species or order. From a passionate love affair with modern art, Alfred led me into my equally passionate loathing of it, particularly for those talents considered most modern and who so considered themselves.[181]

Kirstein recognized that Barr's ethical sense claimed freedom as the ruling aesthetic value for the artist: "anybody could do what he liked."[182]

Kirstein's interest in the human body as form, whether in painting, sculpture, athletics, the dance, or even literature, was paramount; it severely limited his interest in or understanding of abstract art. But in his diary of the New York City Ballet, the dance company that embodied the art form that preoccupied him most of his adult life, he takes for himself what he denied Barr: "I began to realize that there was something like design comparable to musical notation or a rationally laid out palette. Structure was as important as personality or expression. Soul was a word then uttered far more than now; it began to have a specious sound. . . . Craft, skill, pattern supporting the dance began to suggest themselves, and personality seemed a suspicious ingredient."[183]

AMERICAN ARTISTS FIND THEIR CHAMPION

The person who would become Barr's most important colleague as his curator of American painting began as his assistant in 1934. Dorothy Miller (fig. 46) was steadfastly faithful to Barr, her influence equal to Soby's or Johnson's. Miller was a product of the museum apprentice class, an innovative practice initiated at the Newark Museum in 1925. Six to eight students would be selected from recent college graduates to be given "practical training in general museum work, an opportunity not offered elsewhere."[184] Miller was among the first eight students,

along with Dorothy Dudley, the future registrar of the Museum of Modern Art, and Elinor Robinson, who was later Abby Rockefeller's art secretary; they spent nine months in apprenticeship.

Miller had attended Smith College because, she said, "it had the best art department, then, and the best teacher, Clarence Kennedy. [But] painting was not taught at Smith College and art history stopped with Cézanne and Picasso's blue period."[185] It was at this time that the Newark Museum director, Dana, sent a letter to Smith College's art department looking for students who would be interested in an apprentice course in museum work. Initially no one applied because of the $200 that he asked for tuition. So, instead of charging them, he decided to put the apprentices to work and give them $50 a month. Miller reflected on the experience of doing by learning: "We worked as guards, handled African and Oceanic things (Polynesian and Melanesian), modern paintings, a few old things mostly 19th century American art, minerals, Old English China and lace, a junior museum with live animals—a little bit of everything."[186]

In 1934 Miller worked with Lee Simonson on a theater arts exhibition and catalogue for the Museum of Modern Art. Barr asked her to continue with the Museum, but she left to work with Cahill on the "The First Municipal Art Show," held in the RCA Building at Rockefeller Center. The show was a major undertaking: 1,500 works by 500 artists gathered in 31 galleries. Seven judges, including the directors of the Modern, Metropolitan, Brooklyn, and Whitney museums, selected the invited artists. Cahill fell ill early on and Miller managed it. Among the artists represented was Alexander Calder; Barr bought from the show *The Universe*, 1934, a motor-driven mobile of painted iron pipe, wire, and wood with string.[187] McBride wrote about the exhibition:

One of the most puzzling items on display, is a "mobile" by young Alexander Calder of Paris and New York. In it some globes are suspended on wires and there are other contraptions that suggest a wireless apparatus, or possibly a recording instrument for Professor Einstein. Many people will pass it right by, mistaking it for a heating device or something of that sort; yet it was one of the first things sold, going to the Museum of Modern Art; and the purchase does

46. Alfred H. Barr, Jr., Dorothy Miller, and James Thrall Soby (no date).

great credit to the new museum, for the "Mobile" is precisely the kind of exploring art that a modern museum should feature.[188]

Barr again asked Miller to join the Museum and help with the Lillie Bliss catalogue, but she turned him down for the second time; Helen Franc edited it in her stead. Miller wanted to finish her work on the second municipal show, where she had the task of hanging 5,000 works from the Society of Independent Artists. No jury was used, the show being open to all comers in "salons like the French; the artists were charged a one dollar fee for entering."[189]

Finally in the summer of 1934, she "gathered her courage" and went to Barr to ask for a job. At that time five people were working at the museum. She reported that Barr looked "vague." "You know Alfred had this marvelous thing, he'd be with you and talking to you and then he'd start thinking of something else and then after a while he'd come back and see that you were there and say: 'Well, only the

trustees can decide whether I may hire an assistant. Where will you be in the next month?'"[190] Barr wrote to Miller on June 27, 1934, that he would take her on beginning September 1, 1934. "I have one condition to make; that you study German as intensively as you can, many of the best works on French and European painting are generally in German."[191] Barr seemed to have no real interest in American art (an allegation he continually defended himself against), and he used Miller's abilities and experiences to fill that void.

Of all the many devoted and admiring people surrounding Barr, and there were many, particularly women, Miller was his greatest promoter. She confided: "Alfred Barr knew how to do everything, just automatically. He knew how to publish books, he knew how to arrange exhibitions and gather them. He just told us all what to do and we did it with him. You see, supervising everything. It was a marvelous experience. It was absolutely great. And we were all so young that we stayed up all night every other night working. It was great."[192]

Later, as the Modern's curator of American painting, she would be among those responsible for diverting the course of modern art from Europe to America. Intermittently between the years 1942 and 1963, Miller was charged with installing the series of exhibitions of new American artists, exhibitions that brought to prominence the New York School.[193] The series as a whole described the current American scene and did a great deal to make individual reputations for artists such as Robert Motherwell and Arshile Gorky.[194] But ever loyal to Barr, she reported that it was his idea "like practically everything good at the museum."[195] Probably the climactic exhibition occurred in 1958–1959 when the huge "New American Painting" traveled to Europe. The exhibition of seventeen artists opened in Basel and toured the principal cities of Europe.[196] Subsequently, it had a significant effect in promoting the New York School internationally and of establishing New York as the center of the art world.[197]

Many times Barr struggled with his critics over his seeming neglect of American art. He justified his programs: "I think that statistics will show that we have been more concerned with the American art than with the art of all foreign countries combined."[198] Barr claimed that in the 1930s the Museum of Modern Art was the only museum displaying European modern art, and it was the purpose of the

founders of the museum to choose the best quality in works of art no matter what the country of origin and "without prejudice." He felt that the artists, dealers, critics, and public had a misconception that the Museum (really Barr) was only concerned with "foreign" art. "This impression has been caused in part by the character and reputation of the trustees' collections, partly by the success of certain foreign exhibitions, and partly by the fact that in New York of the three principal museums concerned with modern art only the Museum of Modern Art deals with foreign art."[199] In the 1930s there was no Guggenheim Museum, and the Whitney confined itself to twentieth-century American art, as did the Metropolitan Museum of Art.

In 1938, describing the collecting patterns of the past decade, Miller wrote that she saw a growing interest in American art that was competing with the interest collectors had in European and ancient art. She mentioned Duncan Phillips, Ferdinand Howald, and William Preston Harrison as collectors of the American avant-garde along with John Cotton Dana and Gertrude Vanderbilt Whitney. She felt that Mrs. Rockefeller had influenced other collectors to buy American artists, although the depression held them back. "Of the very large collections in this country Mrs. Whitney and Mrs. Rockefeller majored in American art." Miller suggested that most collectors preferred "safer more clearly charted regions of established artists where the landmarks have been surveyed by critics and students. American art in both past and present has suffered for lack of sensitive and discerning 'amateurs' who point out to critics and later collectors the paths they should follow."[200]

Barr's credo was that "our similarities to other peoples, particularly of Western Europe, are far more significant than our differences. Yet I believe that American art is in the end more valuable to us for what it tells us about America than for its contribution to any international tradition."[201] One strategy for showing the Museum's commitment to American art was to emphasize its collections in departments other than painting and sculpture, to counteract "the tendency on the part of the public to identify art with painting and sculpture—two fields in which America is not yet, I am afraid, quite the equal of France."[202] Barr's tactic was to publish a compilation of all the collections to stress the fact that "no other Museum in the country has done as much to further the interest of American photography,

American films, American architecture, and American industrial design."[203] It was, indeed, his interest in technology and the proliferation of the modern style into the other media that, more than anything else, made the Museum of Modern Art unique.

THE MUSEUM REACHES A MILESTONE

In the show "Modern Works of Art: Fifth Anniversary Exhibition, November 20, 1934–January 20, 1935," Barr displayed works of art that included not only painting and sculpture but also architecture and industrial art, which celebrated the Museum's success and simultaneously suggested a plan for a future permanent collection.[204] Never missing a chance to educate the public, Barr took the occasion to write a survey of modernism. He set forth his aim in the opening paragraph: "Words about art may help to explain techniques, remove prejudices, clarify relationships, suggest sequences and attack habitual resentment through the back door of intelligence. But the front door to understanding is through experience of the work of art itself."[205]

Although he began with the impressionists and repeated the assertion that Cézanne dominated the "painting of our period," it was Seurat he presented as the artist who made "something solid and enduring" of impressionism. Barr credited van Gogh and Gauguin with having great influence on future artists "but no more than the tragically romantic legends of their lives." Barr then asserted: "Decorative expressionism with its two-fold implication of spontaneous freedom and pure aesthetic experience reached its logical extreme in the work of Kandinsky."[206]

The thumbnail survey of modernism in the catalogue continued with cubism, a style that Barr said tended toward "more analytical research into the problems of design." Influenced by cubism, the Russian suprematist artists, he said, had carried the geometric forms to "an extreme." Laying the foundation for his later work on the isms of modernism in the exhibition "Cubism and Abstract Art," he wrote: "Fauvism and cubism in Paris, expressionism in Germany, futurism in Italy, these were the principal advance-guard movements of the heroic age of 'Modern Art'

before the war. They had a world-wide influence not only on painting but on sculpture, decorative arts and architecture."[207]

Barr continued with descriptions of dada and surrealism, and then the rediscovery of conservative traditional values in the 1920s. He was trying to make sense of what proved to be a temporary break in the trajectory of modernism; he had seen once before, in 1931, the new trends as a reaction to "the decorative or expressionist distortions of Matisse or Modigliani, and the formal and abstract experiments of cubists."[208] He took note of the variety of interests of contemporary painters: "Side by side work the classicist and the romantic, the devotee of machinery and of ruins, the master of abstract design and of insistent realism, the neo-primitive and the neo-baroque, the painter of gigantic political murals and of miniature and private hallucinations."[209]

Creation of a permanent collection, which Barr had envisioned for the Museum in the 1929 plan, was delayed by the depression; but on the death of Lillie Bliss on March 12, 1931, Barr saw his chance. Bliss had stipulated that if a sufficient endowment fund was raised to maintain her collection, she would leave it to the Museum. She had believed that this would give the growing institution a foundation that would lead to permanence. Barr leaped to the task of persuading the trustees that it was imperative to acquire Bliss's significant collection in order to attract other collectors and lenders to give to the Museum; he thought that the trustees should not be daunted by the state of the economy in raising the endowment for her bequest. His vision prompted him to write an impassioned plea to Mrs. Rockefeller noting the "utmost seriousness" of the situation, adding that he was "determined to do everything in [his] power to save the Bliss Collection for the Museum." He reasoned that both the public and collectors expected the Museum to fulfill the conditions of the bequest. "And to do so will prove the stability and permanence of the Museum, . . . failure will involve great loss of prestige."[210]

Barr had mobilized those trustees who were his friends in this fight—such as Sachs and Nelson Rockefeller—to talk to the recalcitrant trustees particularly Stephen Clark, who was the most hesitant. He reported to Mrs. Rockefeller: "I think everything possible is being done by those who feel under real obligation to Miss Bliss's memory and to the conception of the museum which you and she and

Mrs. Sullivan had in the beginning."[211] His efforts hit the mark, and funds were raised from 125 donors.[212] In meeting the conditions of the Bliss bequest, the Museum of Modern Art broke through the experimental phase of its five-year existence to achieve the status of a permanent institution.

The Museum was now in proud possession of some of the finest late nineteenth-century French paintings. In addition to the work of Bliss's two favorite painters, Cézanne (eleven oils and ten watercolors) and Seurat (one oil and the largest group of drawings held by a museum in this country), were works by Redon, Degas, Renoir, Daumier, Pissarro, Toulouse-Lautrec, and Gauguin, as well as the more contemporary painters Picasso, Derain, and Matisse. Some of the most important artists of the modernist movement were in the collection.[213]

In "Modern Works of Art: Fifth Anniversary Exhibition," Barr showed a prospective collection for the Museum, with eighteen of the works from Lillie Bliss. Most of the works in the exhibition would become part of the permanent collection, if they were not already; many were bequeathed by the trustees. The show attracted other donations, among them works by Brancusi, Calder, Dalí, Grosz, Lachaise, Marin, and Sheeler. Future gifts included works by De Chirico, Duchamp, Mondrian, Pevsner, and Picasso.[214] *Three Musicians* by Picasso, which dominated the exhibition in the main gallery, was not acquired until 1949; it was a painting that for years Barr obsessively worked to acquire. In the catalogue, Barr called the painting Picasso's "greatest cubist composition."[215]

The guidelines for classic modernism having been proposed, they were revered by some and sneered at by others who thought them too inflexible.[216] Its enemies called the Museum of Modern Art a "Picasso museum," while its friends accepted Barr's adroit articulation that contemporary art was "so complex that it defies generalization."[217] Barr had left the door open in describing what he called the three periods of the last fifty years: the first was impressionism in the late nineteenth century; the first decades of the twentieth century saw "the concentrated interest . . . upon the purely aesthetic values of design"; in the third period, after 1920 (until 1934), "the traditional values of resemblance to nature and of subject matter with its numberless associations have been discovered."[218] Barr's openness to the complexities of modernism were unjustly ignored.

ARCHITECTURE, BARR, AND
HENRY-RUSSELL HITCHCOCK

At the core of Barr's modernist aesthetic was the new architecture that had been evolving, particularly in Europe, before and after World War I. This focus led him to establish the first department of architecture in a museum. He would later say: "In my opinion the Architecture Department has exerted a more active, tangible, and salutary influence in its work than any other department of the Museum."[1] Barr and Henry-Russell Hitchcock were present almost at the inception of the new architecture, which gave each of them a sharp awareness of its importance. In only seven years, from 1925 to 1932, Barr and Hitchcock, together and separately, developed an architectural aesthetic that culminated in the exhibition popularly known as "The International Style" at the Museum of Modern Art.[2] The exhibition caused as much of an upheaval in architectural taste in America as the Armory Show had earlier in art.

In the concurrent development of the two men as historians, the predominant influence is impossible to decipher; more likely, theirs was a parallel maturation

shaped largely by the Fogg Museum's emphasis on connoisseurship. Even so, and noting his habitual modesty, Barr must be taken at his word when he said that Hitchcock "was teacher and theorist for both Johnson and myself."[3] He later elaborated that it was Hitchcock's "knowledge and pioneering which first interested me seriously in modern architecture and which afforded Johnson and myself our chief critical guidance."[4] Philip Johnson recalled: "Of our generation he was the leader of us all."[5]

HITCHCOCK THE HISTORIAN

In the fall of 1926, Hitchcock was registered for Sachs's museum course while working toward his master's degree in fine arts—the course that Barr attended sporadically.[6] The group around Barr and Hitchcock, together with the group around Kirstein, came to be regarded in the 1930s as the "East Coast Establishment,"[7] and Hitchcock, known as a dandy and a gregarious man with a talent for friendship, was at its center.[8]

The artistic revolution that had altered the course of Western painting before World War I did not continue on its radical path in the 1920s. Architecture, in contrast, influenced by the innovative spirit of prewar painting, resumed its rapid development after the armistice. Barr's and Hitchcock's predilection for experimentation enabled them to recognize the innovative style of the new architecture and participate in its history. As Hitchcock wrote to Barr in 1928, "You are with me that faith in art rests in films and architecture."[9]

By the fall of 1926 when they attended Sachs's course, the two were already well acquainted. For the next six years, Barr and Hitchcock defined architectural principles that would be used in the exhibition catalogue *Modern Architecture: International Exhibition* in 1932. Their writings from 1927 to 1932 provided the conceptual building blocks for this seminal exhibit and for what would become known as the International Style.

Hitchcock wrote the first book on the beginnings of modern architecture, *Modern Architects: Romanticism and Reintegration,* during this period, and Barr invited

him to lecture on architecture to the class he taught on modern art in the spring of 1927 at Wellesley, thus initiating a partnership (Philip Johnson would join later) that helped shape the course of American architecture.

Hitchcock had early ambitions to become an architect, with plans to attend the Ecole des Beaux-Arts in Paris after his graduation from Harvard, the conventional path for some Americans intending to become architects. After graduating in 1923 he spent the next year at the university's School of Architecture, which, he wrote, "had nothing to do with modern architecture."[10] He had made his first trip to Europe in 1922 without becoming aware of modern architecture, although he later proclaimed: "The year 1922 was of great importance for contemporary architecture, for in it appeared also the first really fine and wholly new work of Le Corbusier and Gropius."[11] It was also the year Mies van der Rohe made an important contribution with the model of his Glass Skyscraper that was exhibited in Berlin. For Barr and Hitchcock from the beginning of their researches, J. J. P. Oud, Le Corbusier, Walter Gropius, and later Mies van der Rohe were the determining architects of the new style. In his lecture to the Wellesley students in 1927, Hitchcock centered his remarks on Le Corbusier (fig. 47) with references to Gropius and Oud and their contemporary work in Europe.

Hitchcock spent 1924–1925 in Europe on a Sheldon Fellowship for his master's degree, doing research on a historical project that he described as "fantastically ambitious: the use of brick in architecture through the ages."[12] From this came his second article on architecture, "Banded Arches before the Year 1000," published in 1928 in *Art Studies*, the journal of the Harvard-Princeton Art History Club.[13] Though it was intended as a longer project, Hitchcock turned his attention to modern architecture wholeheartedly instead.[14] His scholarship, as shown in this article, ranged over the entire history of architecture that he would later seamlessly connect to its modern forms.

It was his good fortune to be in Europe at the time of the Exposition des Arts Décoratifs in Paris. "The year was now 1925," Hitchcock wrote, "and 1925 can be seen in retrospect as a major date in the development of a purely twentieth century architecture." He deemed the exposition "a cross section of architectural design as then practiced in various major and minor countries of the world."[15] Just

47. James Thrall Soby, photographer: Henry-Russell Hitchcock, Robert Jacobs,
James Thrall Soby, Le Corbusier, October 1935, Farmington, Connecticut.

as important for young architects of the day, this year saw the move of the Bauhaus to Dessau where Gropius constructed the Bauhaus building, one of the icons of modern architecture.

Hitchcock complained that the advanced work of Frank Lloyd Wright was missing in the Paris exposition, as was the revolutionary work of the Russian constructivists.[16] Wright was, indeed, missing. The United States government turned down the offer to participate in the exposition for a supposed lack of anything modern to exhibit. Hitchcock complained that those in charge of the American involvement in the Paris exposition overlooked those modern objects "designed for comfort and not for beauty" and therefore assumed not to be art.[17] He suggested, however, that modern decorative objects were being imported to the United States from Europe by small shops and department stores and this style "gives promise of becoming here, as it is very certainly in Europe, a vital and developing style."[18] As to a representation of Russian architecture, Hitchcock seemed to have missed a workers' clubroom designed by Konstantin Melnikov, who had won a competition the year before with a design that featured a facade of glass and was the sensation of the exposition.[19] The interior was designed by Rodchenko with geometrical and functional furniture—painted in four colors of white, red, grey, and black—as austere in its modernity as Bauhaus furniture (fig. 48).[20] Because Le Corbusier's architectural projects were hidden behind the Grand Palais, Hitchcock also missed the most radical architecture at the Exposition, Le Corbusier's Pavillon de l'Esprit Nouveau, an apartment unit recreated from a 1922 project. He also missed Le Corbusier's Plan Voisin, "an adaptation of his vision of a wholly new City of Three Million, also of 1922, for rebuilding a large part of the center of Paris."[21]

On his return to Harvard, 1925–1926, Hitchcock reentered the department of Fine Arts as a student of the medievalist A. Kingsley Porter; his aim was to receive a master's in fine arts while he financed himself as a part-time teaching fellow. At this time, he relinquished his ambition to become an architect and chose instead to become an architectural historian, inaugurating a scholarly career that was to be among the most preeminent in the field.

Hitchcock followed the archaeological method of his mentor Porter, whose seminars, he wrote, were "far more exciting" than the traditional courses Harvard of-

48. Aleksandr Rodchenko, Workers' Club, Soviet Pavilion, Exposition Internationale des Arts Décoratifs et Industriels Modernes, Paris, 1925. The Museum of Modern Art Archives: Alfred H. Barr, Jr. Papers, 13.I.E.

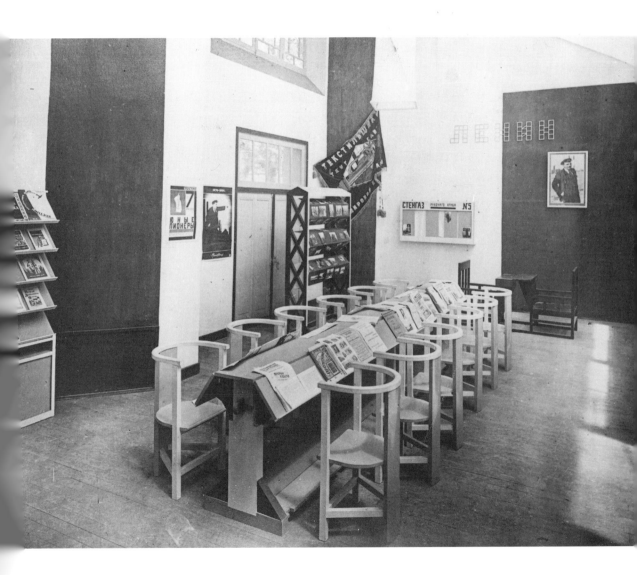

fered in the school of Architecture.[22] Like most professors at the Fogg in the first decades of the twentieth century, Porter was inspired by the connoisseurship of Berenson. In his influential formalist mode, Berenson wrote that few writers in English had approached architecture "from the point of view of the aesthetic spectator," perceiving it rather as a builder would or from a religious perspective.[23] While Hitchcock was keenly aware of the technical elements of architecture and the historical context of contemporary buildings, his approach primarily was anchored in the visual rather than the theoretical.

THE INFLUENCE OF LE CORBUSIER THE RATIONALIST

Barr and Hitchcock were additionally influenced by Le Corbusier's *Vers une architecture,* which embodied a French rationalist modernity. Though Le Corbusier used machines as analogues for his conception of modern architecture, he was not a functionalist and his view was less moralistic than that associated with the social ethic found in Germany, Holland, Russia, and other Eastern European countries. While Barr was at Princeton in the fall of 1925, he learned about Le Corbusier's Pavillon de l'Esprit Nouveau at the Paris exposition and saw copies of *Vers une architecture,*[24] as well as *La Peinture moderne* written by Le Corbusier and the painter Amédée Ozenfant. Both books impressed him profoundly.[25] Hitchcock recalled that he too had digested *Vers une architecture* by late 1926: "We Harvard graduate students did not wait for the appearance of the work as *Towards a New Architecture* in 1927 . . . to read the book; we had our own copies of one of the Paris issues, soon worn out by repeated reading."[26] They were attracted to Le Corbusier because he extolled the engineer's direct use of geometry in planning the mass of the building. "Thus," Le Corbusier wrote, "we have the American grain elevators and factories, the magnificent 'first fruits' of the new age."[27] Le Corbusier, in fact, presented a simple methodology for the architect that described mass, plan, rhythm, and order governed by a mathematical spirit.

In Le Corbusier's view, "architecture is stifled by custom."[28] He would have architects now look to the steamship, the automobile, and the airplane produced by

engineers because "a house is a machine for living."[29] Le Corbusier's phrase, quoted by all who were interested in modern architecture, would be confused with the German functionalists' concerns, but Le Corbusier's aesthetic was, from the beginning, more than machine parts or geometry valued for its own sake. An underlying harmony that sought eternal truths stretched Le Corbusier's tenets toward an architecture with a "new spirit"—the model for "architecture as art" that would prevail in America. Hitchcock in 1929 foresaw that in America the "aesthetic conscience, more 'pure' than that in Europe, is far less likely to forget architecture-the-art for architecture as a part of sociology."[30]

Despite the fact that construction, ordered by proportion and geometry, was in Le Corbusier's theory the basis of architecture, ultimately he thought that the "imponderable" ruled the theory and created architectural beauty. Le Corbusier wrote: "This is genius, inventive genius, plastic genius, mathematical genius, this capacity for achieving order and unity by measurement and for organizing, in accordance with evident laws, all those things which excite and satisfy our visual senses to the fullest."[31] In Le Corbusier's vision, mere practicality, which the most fastidious engineer employed in building a factory or bridge, fell short of architectural beauty: "Architecture means plastic invention, intellectual speculation, higher mathematics. Architecture is a very noble art. . . . But we must first of all aim at the setting up of standards in order to face the problem of perfection."[32]

Barr was undoubtedly attracted to Le Corbusier's poetic turn of mind; the architect's reach toward goals of truth and perfection, coupled with his statement that "art is poetry," were important components of Barr's own definition of modern art. Barr wrote that "difficulty" in understanding modern painting was a necessary and wanted attribute because the easy ones "wear thin. . . . By their poetry they have the power to lift us out of humdrum ruts."[33]

The strong affinity of the two young Harvard students for Le Corbusier did not preclude their appropriating useful concepts from the camp of the German functionalists, such as Hannes Meyer and Bruno Taut, and from Mart Stam of Holland. Although the Dutch architects were guided by the aesthetics of de Stijl painters, they too were more apt to design for workers' housing using principles of reproducibility and therefore would fall under what Hitchcock would call the architec-

ture of "sociology." The political spasms in Germany and Russia after World War I greatly influenced artistic aims in those countries. In Russia, a materialist "constructivist" movement was encoded into the fabric of everyday life to advance a Communist society. In Germany, artists saw art as an equal partner with socialism in determining the future of a country laid waste by war; functionalist solutions developed alongside industrial advancement and were shaped by them.

Hitchcock might have missed the work of Le Corbusier at the exposition in Paris, but he was cognizant of the well-publicized competition for the Palace of the League of Nations—particularly Le Corbusier's project—and it contributed to his awareness of modern architecture. In addition, the equally publicized Deutscher Werkbund's international housing project at Weissenhof in Stuttgart, organized by Mies van der Rohe, brought the new architecture to Hitchcock's and the world's attention. In the brief span of two years (between 1925 and 1927), three projects—the Paris exposition, the League of Nations competition, and the Weissenhofsiedlung project—moved the new architecture from the state of utopian dreams prevalent earlier in the decade to elaboration and at least partial demonstration.

FUNCTIONALISM VERSUS ARCHITECTURE AS ART

Housing designed by international architects in 1927 for the Weissenhof project in Stuttgart—sponsored by the Deutscher Werkbund and directed by Mies—gave international prominence to the new functional architecture. The overall plan conceived for the project by Mies resembled cubist painting and suprematist, constructivist, and de Stijl sculpture; flat roofs and white exteriors were the elements common to interconnected cubist masses (fig. 49).[34] These elements, although not used for the first time, when brought together in one place demonstrated a common visual language of the new style.

Twenty-one structures providing sixty dwellings held to Mies's plan of white geometric facades with flat roofs (with two exceptions: Mart Stam's blue facade and Hans Scharoun's curved roof).[35] Both white geometric facades and flat roofs were significant elements of modern architecture. Architects from five countries, with a

49. Ludwig Mies van der Rohe, Weissenhofsiedlung, 1927, model of early scheme. The Mies van der Rohe Archive, The Museum of Modern Art, New York.

predominance of Germans, had been invited to participate. A congeniality of style prevailed at Weissenhof, despite the fact that various aesthetic philosophies—functionalist, elementarist, rationalist, constructivist among them—were represented. The concept of architectural internationalism had been established.[36]

Functionalism is a complex concept that changes with each architect, each country, and each decade, beginning with, for instance, the American architect Louis Sullivan's dictum that form follows function. Throughout the history of modern architecture, the technical experiments of functionalism existed parallel to formal considerations such as those of Le Corbusier and Mies. Taking these two views as broadly opposed, however, provides an understanding of the synthesis that Barr and Hitchcock achieved.

Mies's understanding of the new movement changed after the Weissenhof project and was not confined to functionalism. His training had begun in his father's

stonemason shop in Aachen, and his literal "feel" for materials, his heightened awareness of space, and the translation of these into design superseded any social aims that he might have shared with his fellow German architects.[37] Mies's struggle between functionalism and architecture as art was revealed in the foreword to the catalogue of the Weissenhofsiedlung: "The problem of the modern dwelling is an architectural problem, with all due respect to its technical and eco-

50. Le Corbusier, Double House, Stuttgart, 1927, view from the street.

nomic aspects. It is a complex problem, thus to be solved by creative powers, not simply by calculation and organization."[38]

Hitchcock visited the Stuttgart exposition in the summer of 1927[39] and wrote sketchily about it in his notebook: "When one arrives at the two houses of Le Corbusier, one walks here in a new air: it is to be raised to a plane infinitely higher. The refined forms and serene lines of this mad architect . . . find their *Ursprung* in the ship's hull, in the airplane's wing, but are here how translated! how raised on high!"[40] His positive reaction to the double house (fig. 50) put him in Le Corbusier's camp, and revealed his grasp of the elements of modernism embodied in it. Hitchcock visited the Weissenhofsiedlung as he did any building he wrote about,[41] and recognized that Oud's, Stam's, and Le Corbusier's works were the benchmarks of the new architecture. Of all those architects producing in the new style in Germany, he recognized later that only Gropius and Mies van der Rohe could compare with Le Corbusier and the Dutchmen Oud and Stam.

The most socially concerned group of modern artists were the architects. Unrealized visionary projects, or paper architecture, abounded in postwar Germany alongside housing for the workers. Modern architecture flourished, enhanced by the participation of Russian and Dutch artists, and was not interrupted until the rise of National Socialism in 1933. The epicenter of this international efflorescence was the Bauhaus, to which Barr and Hitchcock separately found their way.

Even more than Mies and Le Corbusier, Barr and Hitchcock saw international modern architecture in purely aesthetic terms. They were unconcerned with its social and political foundations despite the fact that "International" had serious political connotations.

WALTER GROPIUS AND THE BAUHAUS

The socialist orientation of European avant-garde architects shaped their method and design. They tended to use names for the new architecture that called attention to the functional and ideological factors, such as Neue Sachlichkeit (new objectivity), Neues Bauen (new building), and Internationale Architektur.[42] In a broad

sense the term "functionalist" was tied to low-cost housing in Germany, an idea strongly advocated by the Deutscher Werkbund before World War I and continued immediately after the war in Germany and Holland. The Werkbund played a seminal role not only in architecture but also in raising the taste and standards of industrial products. Standardization of component parts in low-cost housing, with no added decorative elements, was elemental in functional architecture. Included in this group of socially minded architects was Gropius, who contributed a factory building to the Werkbund's exposition of 1914, a groundbreaking show of the new architecture.

If Le Corbusier provided the aesthetic approach to the new architecture, the Bauhaus supplied the structural foundation upon which Barr developed his formalist methodology. The concept of the unity of art and technology, which Barr would ultimately refer to as "machine art," as well as the Bauhaus concept of architecture as "a total work of art," had a profound effect upon Barr and his subsequent plan for the Museum of Modern Art.[43] The concepts of the Bauhaus were transported to America, first by Barr in the very organization of the Museum of Modern Art in the early 1930s as a multidepartmental museum and then in the late 1930s by Mies, Gropius, Moholy-Nagy, and Albers, all of whom would emigrate to America and, without political aims, reconstruct various art schools in the image of the Bauhaus.[44]

Primarily a functionalist architect as a practical matter, Gropius kept an idealist dream in reserve: "The boon of imagination," he wrote, "is always more important than all technique, which always adapts itself to man's creative will."[45] For him, architecture was an imaginative art to which all should strive but few would attain. But first, architecture must be a *Gesamtkultur,* a learned craft that could be accomplished by the cooperation of artists, craftsmen, and architects.[46] Gropius, Mies, and Le Corbusier had all apprenticed in Peter Behrens's office in the first decade of the twentieth century and thus were mindful of the impetus to design new appliances. The experience enabled them to experiment in fields adjacent to architecture that broadened their horizons. The concept of a *Gesamtkunstwerk*—the equal participation of painter, sculptor, and architect in a total work of art—was demonstrated in a perverse way because, even though Gropius believed in

the primacy of architecture, an architectural workshop did not exist at the school until the Bauhaus moved to Dessau in 1925. Unable until that time to finance architectural projects that would enable students to participate in a workshop situation, Gropius would not hold classes that would be merely theoretical architecture. To overcome this situation, some students were invited to Gropius's office in Berlin to participate in his projects. The societal and ethical aspects of functionalism remained intact in Germany and Russia until the German architects emigrated to the United States in the 1930s. The term "functionalist" would come into general use in the mid-1930s in the United States as an epithet for all the new architecture, to the confusion of many.

Hitchcock remained aligned with Le Corbusier's dictum that art and engineering had to join to create architecture. He was concerned that if the functionalist theory was correct, then "all conscious aesthetic additions to technical perfection are 'embellishment'. . . . [And] there can be no . . . 'modernist'—that is, aesthetically-conscious-contemporary-architect and the very presence of an architect in our civilization is an anachronism: making Mendelssohn and Le Corbusier 'shams.'"[47] But Hitchcock found a way to retain the "art" of architecture purged of the functionalist point of view: "We must accept all of technics; but we need not accept that technics are all."[48] He explained this difference:

> In the complex technical problem that is a building, many interchangeable solutions of details are equally satisfactory scientifically, and the choice among those interchangeable solutions becomes therefore free from technical limitations . . . [and] it may be entirely controlled by the consciousness of the designer, in which case it is intelligent and ordered. In the first case there is no architecture; in the second there is.[49]

The argument continued for decades between formalist-oriented and functionalist-oriented architects in Germany, Holland, and Russia. The confusion was exacerbated when the show "Modern Architecture: International Exhibition" at the Museum of Modern Art defined the new architecture as the "International Style,"

concentrating on the aesthetic qualities of the new development but including a section on housing and examples of factory construction.

HITCHCOCK'S WRITINGS

In the first article that Hitchcock wrote on modern architecture, "The Decline of Architecture," which appeared in *Hound & Horn* in September of 1927, he bemoaned the fact that "modern taste tends to find the virtues of contemporary architecture solely in the perfection of its technics . . . there reposes the danger that by it architecture may shortly come to be pronounced dead." Hitchcock attempted to redeem architecture from the mechanistic argument: "The finest fragments of contemporary building are to be found in factories and laboratories where the builders sought only the perfect technical solution of their practical problems." Nevertheless, he perceived that architectural changes in style were a gradual development, a confluence of individual decisions, and that the aesthetic results of the individual choices of modernist architects prevailed over "the perfect technical solution of their practical problems."[50]

Hitchcock's strength (like Barr's) was in his ability to register visually individual objects—in Hitchcock's case, buildings—and categorize them in a historical stylistic context. His basic critical position was that architects achieve a new style by building on each other's work and that of other artists, and that architecture, or any other art, was not prescribed by the *Zeitgeist* but conditioned by historical precedent.[51]

Barr and Hitchcock found the illustrations in *Internationale Architektur,* one of the Bauhausbücher (Bauhaus books) edited by Gropius, to be an excellent means to acquaint themselves with the new architecture.[52] The book presented the work of thirty-six architects from Germany, Holland, France, Belgium, Russia, and the United States. Frank Lloyd Wright, who influenced the European architects early in the century, was represented, as were anonymous American corn silos, long admired by the European architects. Factories, acknowledged for their "functional" style and designed by architects of all the countries, were illustrated, particularly

Gropius's two prewar monuments—the Fagus factory of 1911 and the factory he built for the Werkbund exhibition in Cologne in 1914. Oud seemed to have had the most in realized architecture, and Mies contributed imaginative projects.

Photographs in the book make evident how Mies could create an ordered project out of the works of the various architects and thus organize the Weissenhofsiedlung. The work of the 1920s generally had a number of shared characteristics, such as concrete elevations, ribbon windows, and flat roofs. Conveying the idea of a cohesive style, it caught the attention of Barr and Hitchcock.

Hitchcock wrote a review of the second edition of *Internationale Architektur*, claiming that among the various activities of the Bauhaus, the work done in architecture was the most significant. Of all the books the Bauhaus issued on architecture, he reflected, two were preeminent—one by Gropius and one Oud; "[they] have been perhaps the most valuable, with covers and typography designed by Lucia Moholy-Nagy as modern and as interesting as the buildings illustrated within."[53]

BARR'S WRITINGS

Following Gropius's lead in emphasizing factories, Barr chose the Necco factory for his first article on architecture (see fig. 22).[54] He introduced his essay with three pithy statements that illustrated his aesthetic. The first was by Ernest Renan: "Architecture is the criterion of the integrity, the judgment, and the seriousness of a nation." The second quotation was by William Richard Lethaby, an English architect: "The enemy is not science but vulgarity, a pretence to beauty at second hand."[55] The third quotation was by Le Corbusier: "Écoutons les conseils des ingénieurs américains. Mais craignons les architectes américains" (Listen to the advice of American engineers. But fear their architects).[56]

Barr's belief in Le Corbusier and the engineering aesthetic was reflected not only in the last epigram but also in the article as a whole. Among the architects to be "feared" was, specifically, Frank Lloyd Wright. At this time, Hitchcock and Barr, and a few years later Johnson, overlooked the value of the American architect's

work as Wright passed through a dormant period in the 1920s and did not make his presence felt again until the middle 1930s. Hitchcock admitted that he treated Wright "purely historically putting all emphasis, as the Europeans did, on the work of the Prairie years and its international influence. Thus I ranked him a forerunner—or worse . . . just an 'old romantic.'"[57]

Writing on the Necco factory, Barr struggled with the definition of modern architecture and the problem of decoration. Deposing the authority of the Beaux-Arts tradition, Barr asserted that in composition the engineer had transcended the functionalist's dictums and had attained "architecture" in the Necco factory. "We will find then that F. C. Lutze, engineer and chief designer of the Necco factory, has achieved architecture positively by manipulation of proportions and masses, and by the restrained use of handsomer materials than were structurally necessary; negatively by the utmost economy in decorative motive and by the frank acknowledgment of utilitarian necessity both in plan and elevation."[58]

Making an analogy to the *utilitas* of the Romans, Barr contended that "one might almost evaluate American architecture by its degree of removal from American architects." Barr dismissed most of American architecture as derivative of traditional styles. But to prove the worth of functionalist architecture, he lauded buildings left in the hands of the engineer: "Whether or not the Gothic masterbuilder was primarily an engineer or an architect, his cathedral by general consent is architecture."[59] Barr suggested that those elements of decoration that proceed from *utilitas* and *firmitas,* though unfamiliar to the American public, with time would be acceptable within the parameters of what is considered beautiful.

The tone and composition of the article suggest a thoughtfully considered lecture, placing a factory building, which Barr deemed to be the most advanced form of modern architecture, in a historical context to the extent of comparing it unfavorably to factories of more advanced designs by the de Stijl architect W. M. Dudok and the German Erich Mendelsohn. Barr then suggests: "It will exist for the new generation not merely as a document in the growth of a new style, but as one of the most living and beautiful buildings in New England."[60] This twofold approach to works of art—as documents in history and as aesthetic objects—continually served him in charting the vagaries of modern art. Barr visited the Necco

building with his students to show them the local example of modern architecture, and his hyperbole was probably a result of the lack of such models.

Both Barr and Hitchcock demonstrated a full-scale understanding of the tenets of the new architecture in 1927, five years after it had its start in Europe. Hitchcock wrote to Barr: "Your Necco thing was very good and I hope you continue to write on architecture—what you say is well put and much needed. The ornament situation lies in the lap of the future. I may care to touch it."[61]

HITCHCOCK'S APPRECIATION OF OUD

Among Hitchcock's articles that prepared the way for his book on modern architecture was "The Architectural Work of J. J. P. Oud." It opened with two postulates used by "the greatest architects" of the contemporary world who were "establishing the style of the future." The first stated that "proportion," which the architect chose, was all the ornament that was needed: "Architecture should be devoid of elements introduced for the sake of ornament alone: to the engineering solution of a building problem nothing should be added. Architecture should by means of fine proportions make ornamental all the elements necessary in building." Having told Barr he was about to say something on "ornament," this was the result. The second principle emphasized architecture as art, an emphasis that would become firmly entrenched: "Through geometry the engineering solution of the building problem as a whole and in detail must be subject to the creative inspiration of the architect."[62]

Hitchcock placed Oud at the head of a group of architects reacting against the "eclectic romanticism and expressionistic picturesqueness of the Amsterdam school," evidenced in the work of H. P. Berlage. He found in Oud's emphasis on horizontality and his use of projecting roofs an influence that could be traced to Wright. But even stronger than this, he thought, was the influence on Oud of cubism, particularly the work of Theo van Doesburg. Hitchcock documented, as had Barr, what would become the trademarks of the new style: the use of concrete and of ribbon windows by Oud, Le Corbusier, and Gropius, as well as what he called

the negative use of ornament—using "the potentialities of the new manner and the new material for making the essential constructional elements ornamental."[63]

Finding genius in the housing design of the Hoek van Holland executed in 1926–1927 by Oud, Hitchcock established the project as part of the canon of the International Style, along with the Weissenhofsiedlung. In closing this comprehensive article, he compared Le Corbusier with Oud, and by emphasizing their differences established what he considered the "art" of the new style. He suggested that comparing the two architects would demonstrate that "the rigidity of the contemporary architectural aesthetic and the standardization of materials by no means exclude individual character or produce monotony."[64] This statement demonstrated that the principles established by the young critics were not dogmatic and unyielding.

In these few years, 1927–1930, articles by Hitchcock appeared in every type of magazine, from *Hound & Horn, Art Studies,* and *The Arts* to *House Beautiful.* He also wrote reviews of international architecture books for *Architectural Record.* In articles and reviews alike, his aim was to spread the concepts of the new style. In "Four Harvard Architects," published in *Hound & Horn* in 1928, he described the range of "good" architecture then current in the United Sates, examples of which could be found in Boston, from the classical revival of the Boston State House to "the new style dependent on steel, concrete, and glass, which is hardly yet consciously in existence in America."[65]

After describing in detail the three traditional types of architecture and displaying a formidable array of knowledge, he turned to the innovative work of Peter van der Meulen Smith, a close friend of his at Harvard. (The article seemed to be an excuse to introduce the architecture of his friend Smith, who had died that year in Germany; Hitchcock dedicated to him his 1929 book *Modern Architecture: Romanticism and Reintegration.*) Smith worked in the Paris office of André Lurçat and knew Le Corbusier and probably was instrumental in introducing Hitchcock to their work.

Hitchcock spelled out the current conditions of modern architecture, which he felt were more widely accepted in Europe: "In America it is only existent either unconsciously in the work of engineers in such buildings as factories and garages,

or consciously in foreign work done in America by such architects as the Austrian Neutra in Los Angeles or the Swiss Lescaze in New York."[66] Hitchcock favorably compared Smith's plans to those of Gropius in Germany or Andrei Burov in Russia, both of whom used steel and glass in new ways. Smith saw the development of a new style as dependent on revolutionary means of construction using wholly new materials and "on intellectual experimentation in design toward a full expression of the potentialities of these new means of construction."[67]

According to Hitchcock, Smith was the first American to use the new methods; his porch roofs were constructed by a cantilevered slab that enabled the designer to plan for a glass front (curtain wall) for the living room. Hitchcock continued: "The interest of this young architect is that as an American, as a Harvard graduate, he is the first to bring this manner of building to our shores—or rather the first to develop an American version of what is very definitely not a French, nor a Dutch, nor a German, nor a Russian, but an international style."[68] Both Hitchcock and Barr used the term "international style" often in describing the evolution of modern architecture. But what was then written in lower case letters would, at Barr's insistence, become the International Style—the style of the architecture exhibition "in the new manner" installed at the Museum of Modern Art.

THE RUSSIANS

One of the pieces resulting from Barr's travels to Russia in 1927 was "Notes on Russian Architecture," a discussion of postwar modern work in the Soviet Union. Barr assessed the abstract designs of Malevich and Lissitzky, as well as constructivist experiments (such as Tatlin's model for a *Monument to the Third International*), as the beginning of a "quasi-architectural activity of a profoundly novel character."[69]

Barr rated the taste of "Soviet bureaucrats . . . [as] only a little more advanced than that of their American counterparts." There was, of course, no hope for private patronage in the Soviet Union to advance the state of architecture: "As a result, the suppressed modernity of the younger men who had for a time little hope

of realizing their ideas has found release in fantastic paper architecture which has made them the object of wonder and derision at more than one international show. These romantically impossible *projects* are, however, far more encouraging than the flirtations with *Les Arts Décoratifs* which too often pass for modern architecture in America."[70] (Barr considered the Art Deco style "modernistic," a corruption and compromise of modernist architecture. This purist aesthetic was justified insofar as it aided him in defining a developing modernism.)

He began with a discussion of several unsuccessful examples of transitional architecture in Moscow: the Izvestia building, which housed the newspaper, by G. B. Barkine; and the 1924 Moscow Mosselprom Trust building which, he wrote, though industrial in style, was similar to prewar German and American factories, except that it was decorated with "bold pilaster strips and red and blue 'spandrels.'" Another building that missed its mark, he thought, was the Lenin Institute Library in Moscow, designed by Iakov Chernikov: "It is a huge, gloomy, dark gray mass, unhappy in its proportions and monotonous in fenestration." But Barr praised the architect for not attempting to apply decoration. He saw the new and costly Moscow Telegraph building designed by Fedor Ivanovich Rerberg as the worst example of the older architects, built as it was in "a painful compromise style, with rusticated basement and Gothic reminiscences." The younger architects, he wrote, severely criticized this "bastard" style.[71]

Barr then cited the Dom Gostrak apartment house by Moisei Ginzburg (see fig. 30), whom he had just met in Moscow, as an obvious example of "the international style of which Le Corbusier, Gropius, and Oud are perhaps the finest masters."[72] Because he was not yet convinced of the mastery of Mies van der Rohe, the latter was conspicuously omitted. Thus by early 1928, both Hitchcock and Barr were descriptively using the phrase "international style" to demonstrate the ubiquity of the new architecture. Barr quoted at length from one of Ginzburg's articles in which the architect expounded on the "constructivist or functional method" that could lead the architect to "purely utilitarian and structural requirements. . . . The final task of the new architect, the correlation of the exterior volumes and the grouping of architectural masses, their rhythm and proportions, depends upon this primary utilitarian structural method. The one should be the natural function of the

other." Though the Dom Gostrak demonstrated "a theoretical mastery of a prob-
lem" by Ginzburg, Barr was unhappy with the "technical incompetence" of the
Russians: "The interior techniques are pathetic: the piping crude, door fixtures
bad, garbage chutes impracticable, doors even too wide; though of these faults
almost all must be blamed upon the lack of any fine tradition of craftsmanship in
construction rather than upon the architect."[73]

The extent of Barr's critical acumen was impressive. In Ginzburg's maquettes for
a workers' club and dormitory, he found the influence of Gropius's Bauhaus build-
ings at Dessau. Le Corbusier's influence could be detected in a farm building de-
signed for Eisenstein's film *The General Peasant Policy* by Andrei Burov, which Barr
claimed to be "the finest of modern Russian buildings in its severity and elegance.
The slender supports are even more daring than those used by Le Corbusier in his
larger house at Stuttgart."[74] Barr concluded that if "the all-important element of
technical efficiency—which is after all a matter of time (and foreign experts per-
haps)" is omitted, then he found the modern architecture in Russia to be as ad-
vanced as that of any other country. Unfortunately what he saw in VKhUTEMAS
(the Moscow Higher Schools for Arts and Techniques), the Russian counterpart of
the Bauhaus, did not live up to "the perfect efficiency and clarity of intention" of
its model. The architectural section of the school was under the direction of Lissitzky
and one of the Vesnin brothers; Barr reported: "Students are supposedly given a
thorough training in modern materials and the composition of masses through
plaster and cardboard maquettes. I did not find evidence that actual problems of
modern construction were being closely studied." But he did conclude that Russian
architecture was as "advanced" as its European counterparts: "Of the French ar-
chitects, Le Corbusier is the most respected; of the Dutch, Oud and Rietveld; of the
Germans, Mies van der Rohe. . . . Frank Lloyd Wright is greatly admired as a pi-
oneer who is no longer to be imitated."[75]

Although Barr was only twenty-six years old at the time and contemplated the
alien culture through his own prejudices and aesthetic views, he retained an un-
derstanding of the rawness of the emerging revolutionary events. He empathized
with the radical architects who had no private patronage with which to realize
their projects. In this article, Barr demonstrated a conceptual understanding of the

International Style that anticipates Hitchcock's book. And because he had visited the eastern European countries, he had a knowledge of Russian architecture that Hitchcock lacked and therefore did not include in his book.

HITCHCOCK'S FIRST MAGNUM OPUS

Hitchcock spent the year 1924–1925, the summers of 1926 and 1927, and another fifteen months in 1928–1929 in Europe. These sojourns resulted in the pioneering book *Modern Architecture: Romanticism and Reintegration,* published in 1929. In it he extrapolates the basis for identifying the radical architecture of the 1920s, almost as it was happening. The first of its three parts (which he claimed was expanded to fit the demands of his mentor, Kingsley Porter) is called "The Romantic Tradition" and spans architecture from 1750–1850; in "The New Tradition," the second part, Hitchcock analyzes works by those he would later label the first generation of modern architects.[76] Here he examines the architecture that he calls "transitional," which, with elements of extreme simplicity, changed the face of the old tradition without being completely new—works by architects such as Berlage, Behrens, van de Velde, Perret, and Wright. In the third part, Hitchcock deals with the "The New Pioneers"—the architects who, he subsequently observed, would appear three years later in the exhibition "Modern Architecture: International Exhibition."[77]

In a segment describing Gropius's office building built for the Deutscher Werkbund exposition of 1914, which gave "aesthetic expression to engineering without thought of the architectural effects of the past," Hitchcock recognizes the transition between the "new tradition" and the "new pioneers." Its monumentality and certain details—simplifications of, rather than logical derivations from, engineering—kept this example in the transitional mode. Of course, Hitchcock placed Gropius among the new pioneers: "The glass towers studied purely as volume, the long side windows and the open facade of the machine hall are clearer and more unarchitectural in the sense of the time than anything hitherto produced by an architect."[78] This describes the break with the past that Hitchcock was seeking in the

new architecture—a complete release from the materials and structural syntax of what had gone before. Hitchcock succumbed to the easy solution of calling the new project "unarchitectural" in his struggle to describe the new phenomenon.

In Gropius's earlier Faguswerk factory, completed in 1911, Hitchcock found the possibilities of the new architecture more fully explored: this building

> set the terms from which their aesthetic was to derive. . . . Here the entire main building was treated as volume rather than mass. Moreover in this elaborate complex of buildings the lyricism of the grouping, especially of the chimneys and other purely industrial features, was not as with Behrens vaguely medieval but wholly dependent on a free study of the natural proportions and relations between the parts.[79]

Because the walls were no longer load-bearing but light and transparent, Hitchcock found them a most significant element of the new architecture. (As early as 1926 Sigfried Giedion had explained the logic of this new architecture: "The immediate sources are ships, railroad cars, airplane cabins. Why? Because in all of these it is not the walls but the framework that is load-bearing, hence the partitions are only thin insulators."[80])

PAINTING TOWARD ARCHITECTURE

The vital connection between the avant-garde painters and the revolutionaries of architecture developed synchronically in various countries:[81] in France, Le Corbusier was himself both a painter and architect; in Russia, maturation in the painting of Malevich, Tatlin, and Lissitzky spilled over into the architectural projects of the suprematists and constructivists; the German expressionist painters were involved in the *Gesamtkultur* of the Bauhaus;[82] the de Stijl painters and architects in Holland acted as a group and, in turn, played a role in the work at the Bauhaus. As the artists frequently traveled between countries, a cross pollination of ideas bore fruit and eventually developed into the new style. The international involve-

ment of painters and architects was a cornerstone upon which Barr and Hitchcock built, in their separate ways, their own aesthetics. Hitchcock's view, collaterally with Barr's formalist aesthetic, placed the influence of abstract painting (which, he said, began "to appear around 1910") in an important position: "The possibilities of achieving on another scale and in three real dimensions the effects then found in painting to be of aesthetic significance occurred thus to many men about the same time during the period of the War. These effects were not particularly present in the architecture of the New Tradition. Pictorially it still left itself to evaluation according to the Romantic principles of the 'picturesque.'" He mentioned the reviews *De Stijl* and *L'Esprit Nouveau,* both published by groups of artists that proselytized for the new architecture, and remarked on the association of the architect Oud with the de Stijl painters and of Le Corbusier with the painter Ozenfant—both groups, he said, dealt with "extreme abstract painting and sculpture."[83] Barr for his part later remarked that "in De Stijl the aesthetics and forms were developed in painting before architecture. Oud's Café de Unie of 1925 in Rotterdam was his most unfortunate work; it was too dependent on Mondrian in design." Beyond that, Barr connected the founding of Russian constructivism with the artists Tatlin, Pevsner, and Gabo, a movement later adapted by architects. He mentioned Lissitzky, who called his pictures Prouns—by which the artist meant "the transfer point from painting to architecture."[84]

The general feeling was that the architects of the German expressionist movement at first affected Gropius's work at the Bauhaus, which was later rectified and shaped by functionalism and by his association with the artists of the de Stijl movement; both group efforts were marked by the collaboration of painters, sculptors, architects, and designers. Rietveld, a member of de Stijl since its founding in 1919, was more advanced than Le Corbusier and built an important house at Utrecht in 1924. Another member of de Stijl, van Doesburg (painter, sculptor, architect, critic, and writer), came to Germany and divided his time between Berlin and Weimar. From 1920 to 1925, the forms developed by the Dutch influenced the masters of the Bauhaus. Primary colors, asymmetric balance, and the partition of space into volumes by means of freely abutting and interpenetrating rectangular planes were seen by Barr as being directly influenced by de Stijl artists.[85] "From

the mysticism and transcendentalism of the Expressionists," wrote Barr, "the Bauhaus turned toward clarity, discipline and the desire for a consciously developed style on architecture and the allied arts."[86]

Lyonel Feininger was instrumental in introducing the Bauhaus school to the de Stijl group, of which he had learned in 1919 by reading their periodical.[87] Barr had maintained a close tie with Feininger since his visit to the Bauhaus in 1927 and noted his role in bringing van Doesburg and the Bauhaus together.[88] The Hungarian Moholy-Nagy (painter, photographer, and master teacher) also contributed the rational, architectonic approach observed at the Bauhaus in 1923—a seeming ninety-degree turn from German expressionism.

GENERAL PRINCIPLES OF THE NEW STYLE ESTABLISHED

The principles that guided the new pioneers as they broke with traditional architecture were spelled out in Hitchcock's *Modern Architecture* of 1929 and three years later would be incorporated into his formulation of the International Style. According to Hitchcock, the most important formal element—the ferroconcrete structure—allowed the architect to compose in terms of volume rather than mass. The new pioneers also emphasized "a strenuous unification; instead of diversity and richness of surface texture, they strive for monotony and even poverty, in order that the idea of the surface as the geometrical boundary of the volume may most clearly be stressed." Ornamentation, he reiterated, although perhaps not gone forever, if used as before would obstruct the composition of the whole. In order to survive, ornamentation "would have to be intimately derived from the design of the whole and utterly subordinate to it."[89] The aesthetic quality of the building would become apparent in its proportions rather than through applied decoration. Hitchcock opposed the theorists who claimed that engineering principles and not aesthetic issues were the concerns of the new architects.

However, he had the ability to detect the formal elements of the new architecture—stripping it of doctrinaire social purposes—and to proclaim a new style that carried the International Style across time and place and the exigencies of the eco-

nomic depression of the 1930s. The German architects bristled at the word "style," which they felt negated their philosophy. They were more content with the label Neue Sachlichkeit which, they felt, described their method more precisely. But Hitchcock persisted: "Engineering may change completely from year to year, but the aesthetic of the New Pioneers has already shown a definite continuity of values separate from and even on occasion in opposition to, those derived purely from the practical and the structural."[90] Discarding the names applied to the new architecture by artists, including "pure" or "time-space" or "elementarist" or even "technical," Hitchcock felt it was enough "to call the architecture of the New Pioneers the international style of Le Corbusier, Oud and Gropius, of Lurçat, Rietveld and Mies van der Rohe"—a style that was attracting its share of architects in both Europe and the United States.[91]

In examining the 1920 Citrohan designs by Le Corbusier, Hitchcock called them a definitive breakthrough that went beyond the "simplifications" of the "new tradition." In Hitchcock's opinion, Le Corbusier was more advanced in the "new aesthetic" than any other architect. Only the rich, he commented, could afford Le Corbusier's extravagant methods and the luxury of glass, which was hard to heat; and he presciently noted that in lesser hands Le Corbusier's "original ideas tend to become contradicted. Furthermore, it is he, not the practical Germans converted wholesale to his earlier theories, who has succeeded in destroying the validity of the New Tradition by offering, however prematurely, rhapsodic expression of ferro-concrete construction. But his lyricism surpasses a rigid machine aesthetic."[92]

Noting that Oud's work and writing lacked the attention Le Corbusier's had received, Hitchcock showed his partiality to Oud. He recognized Le Corbusier as "the lyrical visionary" and Gropius "above all [as an] organizer," but he considered Oud "primarily and completely the architect. . . . The future holds more possibilities for Oud than for Le Corbusier or Gropius who have spent more extravagantly their creative energies."[93] Hitchcock proved not to be prophetic in this instance.

Hitchcock commended the younger generation of architects in Germany for turning en masse to the new principles. For lack of realized architectural examples by Gropius following his outstanding prewar factories, Hitchcock relied on the ex-

ceptional interior designs of the Bauhaus school done in the first half of the 1920s. But the Bauhaus buildings, Hitchcock wrote, reflected Gropius's interest in the development of architecture "as an answer to recent sociological needs" (fig. 51). Unlike Barr, who was able to ignore Gropius's social concerns, Hitchcock used this ethical stance against the Bauhaus director. Yet he admitted that with the erection of the Bauhaus buildings, Gropius achieved the greatest success of all the new pioneers.[94]

51. Lucia Schulz Moholy, photographer; Walter Gropius, architect: Bauhaus masters' housing: Director's House, Dessau, 1926. Gelatin silver print, 68.8 × 98.2 cm. Busch-Reisinger Museum, Harvard University Art Museums, Gift of Walter Gropius.

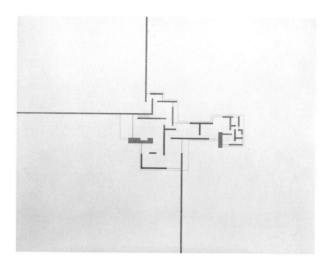

52. Ludwig Mies van der Rohe, Brick Country House, 1924,
ground-floor plan. Ink on illustration board, 30 × 40 in. (76.2 ×
101.6 cm). The Mies van der Rohe Archive, The Museum of
Modern Art, New York, Gift of the architect.

Turning to Mies, Hitchcock compared his country house of 1924 (fig. 52) to the
designs of de Stijl in that the "exterior and interior flow together" (fig. 53).[95] Hitch-
cock extolled the originality and success of Mies's use of extraordinary materials
in the interiors of the apartment house at Stuttgart and the interior and exterior of
the Barcelona pavilion in 1929. Hitchcock would only designate Mies an archi-
tect of "promise"; not until Philip Johnson joined him to do research for their book
The International Style did he give Mies his full measure. "It is probable that the in-
fluence of abstract painting on architecture will prove also to have been but tem-

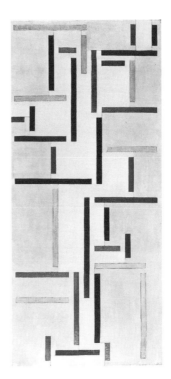

53. Theo van Doesburg, *Rhythms of a Russian Dance*, 1918. Oil on canvas, 53 1/2 × 24 1/4 in. (135.9 × 61.6 cm). The Museum of Modern Art, New York, Acquired through the Lillie P. Bliss Bequest.

porary. Indeed it may already appear that its point of view is better satisfied by architecture than by painting, and that it will be continued in architecture alone."[96]

Barr later described the four founding architects of the International Style more succinctly: "Le Corbusier is perhaps the greatest theorist, the most erudite and the boldest experimenter; Gropius the most sociologically minded, Mies van der Rohe the most luxurious and elegant, while Oud of Rotterdam possesses the most sensitive and disciplined taste."[97]

Hitchcock recognized that the issue in America was to raise already existing engineering feats to the level of architecture. He predicted that in addition to France, Holland, and Germany, America and its propensity for skyscrapers would play an important role in developing a new architecture. But again he missed the mark in predicting that architects would remain with the new style as long as it was fruitful and perhaps that would be "for far more than a century." Optimistically, Hitchcock thought that this time span for the new architecture would be a conservative estimate.[98]

BARR'S REVIEW OF HITCHCOCK'S BOOK

In a review of Hitchcock's *Modern Architecture: Romanticism and Reintegration* in 1930, Barr displayed the confidence and knowledge necessary to write a critical article in this field. He complained that "the disintegration of architecture through the development of an eclecticism of taste describes the actual condition of American building even in our own time."[99] Barr, like Hitchcock, lauded the nineteenth-century American architect H. H. Richardson and downgraded Frank Lloyd Wright as a transitional architect. Barr complained of Wright's inability to separate his architecture from his romantic theories; in later years, both historians would compensate for their shortsightedness.

Barr called the third section, "New Pioneers," the most important part of Hitchcock's book: "The New Tradition is comparable genetically to such essentially derivative styles as the Renaissance and Baroque, but the style of the New Pioneers seems more original even than the Byzantine or Gothic, and has been far more abruptly and self-consciously created."[100] He was imposing on the new style a responsibility of originality that it was not quite able to fulfill. Although busy with the opening year's activities of the new museum, in writing this review Barr showed his own high level of enthusiasm for modern architecture and his conviction of the need to justify its merits. He was also perhaps the best equipped intellectually to explain its nuances.

In focusing on the principles of the style, Barr synthesized the functionalist and aesthetic programs of the architects:

> They insist that the design of the facade is a function of the interior, that the interior should be conceived as volumes limited by planes rather than as the arrangement of masses, and that the whole should be a composition of elements primarily utilitarian and structural. The role of the architect should be that of an engineer who, with the judgment of an architect, chooses among several equally adequate solutions of a utilitarian problem that which is aesthetically the most satisfactory.[101]

The phrase "with the judgment of an architect" pinpoints architecture as art in Barr's as well as Hitchcock's aesthetic philosophy.

In agreement with Hitchcock, Barr placed Le Corbusier as "the leading theorist" of the new movement, but he felt that his architecture "though brilliant and original, is frequently inefficient as *machine à habiter*." He also saw Gropius as the leading new pioneer in Germany and modern architecture as having the widest acceptance there. Barr disagreed with Hitchcock's suggestion that America was "next in importance" to Germany, France, and Holland in developing the new architecture. Because of his trip to the Soviet Union, he recognized that Czechoslovakia, Poland, the Soviet Union, and Switzerland were "far ahead of the United States in accepting and understanding the principles of the New Pioneers."[102]

Barr's remark that "as a historian Mr. Hitchcock is more than adequately learned, precise, and admirably synthetic" was a projection of qualities that he himself possessed. Barr complained that "at times [Hitchcock's] method and ideology seem too erudite for the ordinary reader," but on the whole he found him "convincing" and "persuasive." Barr, in his usual evasive manner, was expressing a criticism veiled as a compliment and avoiding a confrontation. Indeed, Hitchcock mocked his own inability to write in a clear manner. If Hitchcock surpassed Barr as an architectural historian by writing this early history of modern architecture, Barr's interest in architecture, accompanied by clearheaded thinking

and writing that were adjuncts to his meticulous scholarly style (habits that Hitchcock did not pick up until much later), made an inestimable contribution to its development.

Barr noted Hitchcock's concession that the new pioneers "have indeed effected a reintegration of utilitarian with aesthetic purpose more completely even than the Gothic," but he parted with the author's "Spenglerian melancholy" in prophesying the future and being disappointed in the "puritanical austerity" of the new architecture. Barr intimated that future architects would solve that problem. He felt, along with Hitchcock, that architectural ornament was a negative factor but that "the ornament of the future will derive not from geometry, nor from modern painting, nor from any of the other sources of 'modernist' decoration, but rather from mechanical devices such as steam radiators, electric bulbs, hydrants, mailing chutes, radio dials, electric fans, neon tubes. These objects are at present merely utilitarian but already it is fashionable to consider them ornamental."[103]

This was the same comprehensive understanding of the aims of the new architects that he had already shown in his article on the Necco factory. More than that, it revealed Barr's architectonic grasp of proportion and composition—basic qualities of his aesthetic approach. He was so in sympathy with the cause of modern architecture that he happily announced a prejudice on his part in Hitchcock's favor. But he equally regretted that Hitchcock had not paid more attention to the Bauhaus building which, in his opinion, "remains the most imposing single achievement of the New Pioneers."

If Hitchcock could deal with stylistic categories in the tradition of Wölfflin and Frankl, or even Riegl's "will to form," Barr had the ability to get closer to the objects with unerring, continuing analytical acuity. Barr eschewed abstract theorizing about art, perhaps because he felt insufficiently grounded in philosophy, but his taste and his choices added up to judgments as heavily weighted as any theory of art.

In the end, Barr's sharp sense of humor revealed itself, softening any harsh interpretations that might have been made in the Hitchcock review: "And lastly the author's style is perhaps a little too much influenced by the German, and his spelling by the French: '-ism' is, after all preferable in English to '*isme*' and '*neo*'

to 'néo'. But these idiosyncrasies are to be pardoned in one whose first and second names have suffered voluntary post-baptismal hyphenation."[104]

Barr concluded the review with a critique of the book's physical appearance, which he found severely inadequate. This resulted in Hitchcock's attempt at another architecture book that would prove fortuitous, leading to the department of Architecture at the Museum.

The two arts, architecture and cinema, which replaced the earlier radical movements of painting and sculpture, were flourishing as the most modern spheres of activity on the continent. Although painting and sculpture were eventually to be Barr's main concern, the establishment of departments of architecture and cinema—firsts of their kind anywhere—at the Museum of Modern Art would be his outstanding achievements in museology.

8

PHILIP JOHNSON AND BARR: ARCHITECTURE AND DESIGN ENTER THE MUSEUM

In 1932, when the modern architecture movement was barely ten years old, Barr, Hitchcock, and Philip Johnson organized its first exhibition in America. From the beginning, the curators of "Modern Architecture: International Exhibition"[1] hoped to present what was truly modern, neither decorative nor modernistic, but what in their view obeyed the imperatives of objectivity and freedom. Applying their own aesthetic values, the curators incorporated ideas of Oud, Le Corbusier, Mies van der Rohe, and Gropius, stripping them of ideological content. The radical European architects of the 1920s with utopian aims were nationalistic, motivated by the needs of their societies to improve living conditions after World War I. The American promoters of the International Style, in contrast, were intent on presenting the newest and the best aesthetic developments in a cohesive fashion.

The creation in 1932 of the autonomous curatorial department of Architecture was one of the first major projects initiated by Barr that signified the multidepartmental nature of the Museum. Barr's interest in creating a multidepartmental mu-

seum and in raising the standards of industrial products was documented in the charter of the Museum, which specified "the purpose of encouraging and developing the study of modern arts and the application of such arts to manufacture and practical life."[2] Philip Johnson headed and personally financed the newly created department of Architecture, which evolved from the success of the exhibition "Modern Architecture."[3] This exhibition, Hitchcock bragged, "was not a history of the subject, but rather, at least for the United States, an event in its history."[4] Johnson described the architecture exhibition as "a cry of faith, a belief in a creed, a belief in a mission, a messianic show if you will. . . . Hitchcock codified it, Alfred Barr gave it a name, and I did the propaganda and screaming. We prognosticated a revolutionary change in the architecture world."[5]

JOHNSON AND BARR

Johnson (fig. 54), along with Lincoln Kirstein, Edward Warburg, and John Walker, was a member of the circle of young students at Harvard who brought modernism to the campus with the exhibitions of the Harvard Society for Contemporary Art. Johnson became one of the mainstays of Barr's efforts at the Museum of Modern Art. They met in 1929, and Johnson used the word "symbiotic" to describe their friendship; from the first, they talked for hours.[6] Their accord extended to ideas, without certainty of who originated what. They could communicate without using words or attend an exhibit and instinctively arrive in front of the same picture. Johnson remarked that his relationship with Barr was similar to Barr's with Jim Soby; they each could agree on a picture by signaling "with grunts."[7] Johnson reported that Barr was "mad about" architecture and that it was his greatest success.[8]

Born in Cleveland in 1906, Johnson received a B.A. in classics from Harvard in 1930. Focusing on philosophy, he had no art history or architecture classes as an undergraduate.[9] Like many of his cohort who would enter the museum world at that time, he began as a rich dilettante enamored of architecture and particularly of modern architecture.

54. Carl Van Vechten, Philip Johnson (no date). Yale Collection of
American Literature, Beinecke Rare Book and Manuscript Library.

There are as many versions as people in the Harvard circle regarding who met whom and at what time and place.[10] But, in fact, Hitchcock, Johnson, and Barr gravitated toward each other because of their mutual interests, especially in what then constituted a revolution in architectural thought. Johnson had read Hitchcock's article on Oud (published in *The Arts* in 1928), which, he said, had a profound influence in turning him away from philosophy and toward architecture.[11] Johnson remembered that his mother, who was then president of the Wellesley Alumnae Association, introduced him to Barr at the graduation of his sister, Theodate Johnson, from Wellesley in June of 1929. Barr remembered meeting Johnson at the poster exhibition Barr had mounted the previous month at Wellesley when he was teaching his modern art course there. Theodate Johnson took credit for introducing Johnson and Barr at the time Johnson came to see her in a performance of *Antony and Cleopatra* at Wellesley.[12]

In any case, both men had the same perspective—young rebels drawn ineluctably to the "new." Johnson said that his first exposure to modern art was at 291, where he came under the spell of Stieglitz: "As a student anything that was modern or different or revolutionary I was for it in general—it was in that mood that I met Alfred."[13] Johnson credited Barr with changing his life—"a Saul/Paul conversion"[14]—to the cause of architecture. "[He] had faith in me personally. He was older . . . [and] far more brilliant at analyzing the world. Alfred Barr had faith in my ability to criticize and evaluate the dream in architecture that interested him and felt that I was good enough to do that. He represents not only a friend, but a guru and a direction in my life."[15]

In the fall of 1929 on a trip to Heidelberg to study German, Johnson visited the new architecture and architects in Germany, guided by a list supplied by Barr. At a museum in Mannheim, he met John McAndrew, then a budding architect. They had mutual friends and interests; Johnson rented a car and traveled with McAndrew to various monuments—to Dessau to see the Bauhaus and to Stuttgart to see the Weissenhofsiedlung. Having studied fine arts at Harvard (graduating in 1924 in the same class as Hitchcock), McAndrew studied architecture at the Harvard Graduate School and became one of the group who would make an impact on the art world as shaped by the Museum of Modern Art.[16]

On October 16, 1929, Johnson wrote a letter to his new-found friend that was still addressed formally to Dear Alfred Barr: "It would be hopeless to catch up on all the things we have been seeing. Today naturally I am reminded of you having just come to the Bauhaus for the first time. John McAndrew and I have been traveling, rather fast to be sure, but traveling all over Germany and Holland to find modern architecture. We still think that Oud's Hook houses are the Parthenon of modern Europe. That is putting it a little strongly, but they are splendid."[17] Johnson compiled a two-page letter to Barr of all he had seen in Holland and Germany: Oud's new *Siedlung* of 700 houses in Rotterdam, which "lacked the genius and . . . the utter charm of the Hook buildings"; also in Rotterdam, they saw the van Nelle factory by Brinkmann and Van der Vlugt, another important example of the International Style. Johnson mentioned problems he had in locating some of the items on Barr's list. (Remarkably, Johnson intuitively used the term "International" in this letter as though it were already an accepted label for the style, writing how surprised he was that Mendelsohn "whom you know from the Einstein Tower had become 'international.'") Johnson continued: "We found accidentally a new house of [Mendelsohn's] in the most beautiful suburb of Berlin that is plain white plaster with Brass window frames. There are no conceits, perfectly plain masses give the effects. I have always thought he had good taste, but this gives him restraint as well."[18] "Taste," of course, was a Harvard preoccupation, and "restraint" seems to have been its steady companion. Johnson had knowledge of the canons of the new architecture, although Mendelsohn failed to rise into the upper ranks of the architects who founded the International Style.

On reaching Dessau, Johnson was "thrilled at the sight of the Bauhaus. It is a magnificent building."[19] He and McAndrew were escorted through the Bauhaus by an American architecture student who was in the second half of the program, working on chairs and other objects of interior design. Johnson was impressed by the teaching method—better, he thought, than at any American school of architecture.

While in Germany, Johnson began foraging in the world of collectors. He was enamored of Paul Klee's work; at an exhibition in Dessau he purchased a "charming one." But Johnson was not secure in his taste. He protested to Barr, "I cannot

get John to like them, and since I have no intellectual way of basing my appreciation or idiosyncrasy, he thinks of course I am a dodo. I find that my reactions to painting are horribly primitive, so I really must learn something about it. I think I better go back to Harvard and take courses. I wish your thesis was done and published. I want to read it." He ended his letter to Barr with regards from the Feiningers who "are delighted with your new museum."[20] Johnson and McAndrew made an impression on Feininger that was similar to the one made by Barr a few years earlier. Feininger's correspondence reveals a poignant picture of the deep struggle the artists endured to maintain the Bauhaus and modernism; he was therefore always pleased when Americans visited and voiced their appreciation.

During the winter of 1929–1930, in his final year at Harvard, Johnson commuted often to New York. Barr's wife, Margaret, recalled the young Johnson: "He would . . . join Alfred and me and several other friends at meals in a Chinese restaurant on West Fifty-sixth street right under the museum, which in its first years was in the Heckscher building. The conversation was incredibly exciting and youthful. One idea would pile onto the next. Philip was very much part of this group from the start. He was handsome, always cheerful pulsating with new ideas and hopes. He was wildly impatient, could not sit down. He looked just the way he looks now. His way of speaking, of thinking, that quickness and vibration have not changed at all."[21]

JOHNSON AND HITCHCOCK

Sometime in that same year, Johnson met Hitchcock through either Alfred or Margaret Barr. Mrs. Barr claimed to have made the introduction; she knew Hitchcock from her teaching days at Vassar in 1927.[22] But Hitchcock surely knew Johnson by the fall of 1929 in any case, as he wrote to Virgil Thomson then that Johnson was coming to visit him for a week.[23]

Johnson recalled the spontaneity of his joining with Hitchcock on a new project—research for a book on the International Style. Hitchcock, Johnson, and Thomson had gathered in Paris on May 27, 1930, to witness the marriage cere-

mony of the Barrs.[24] A few weeks later Johnson and Hitchcock began their travels, visiting what would later become keystone works of modernism—the Villa Savoye in Poissy-sur-Seine by Le Corbusier, Gropius's Bauhaus, and the Tugendhat house in Brno by Mies, among others.

The book, intended for popular use, was to be a simplification of the last part of Hitchcock's large book of 1929, *Modern Architecture: Romanticism and Reintegration*. Johnson had evidently been planning to assemble a book on modern architecture himself, writing to his mother from Europe:

> But the book. I cannot put it off any longer although we just got the idea [the] day before yesterday. It had been in mind for a year as you know, but I really didn't want to take the risk of alone carrying through such an ambitious plan when I knew so little about architecture really. And Russell has had the idea because he realized that his book was badly illustrated. So what the plan is now is to rewrite in a more popular way paying close attention to the buildings illustrated, parts of his book and incorporate about 150 full page half tones. The text will be first and then the pictures in a bunch. Of course one disadvantage perhaps will be that the book will be in German. . . . The text will practically be a translation of Russell's big book.[25]

In Barr's review of Hitchcock's *Modern Architecture: Romanticism and Reintegration* he called the illustrations "parsimonious" and suggested that the book would be improved by at least "three times [their] number." Most likely Barr gave Hitchcock the idea of doing another book by writing in the review that the publishers might consider "a really sufficient corpus of plates selected and annotated by Mr. Hitchcock."[26]

Johnson learned much from Hitchcock as an "apprentice," but, as he wrote to his mother, although he was struggling hard, he was succeeding in having an independent view.[27] His job was to collect the photographs, a project he pursued assiduously. After sixty years, Johnson still insists that the "theory and scholarship were by Hitchcock, the inspiration and drive were by Alfred Barr. I did the leg work, made all the mistakes and prophesied a few of the prophecies that now

seem prescient."[28] He wrote at the time: "The text is getting bigger and bigger in our minds but also more important. . . . We are discussing subjects which lie much nearer to my heart than most of the old ones, such as new materials, construction, functionalism, and the fundamental esthetic, especially of the style."[29]

Johnson and Hitchcock had problems convincing German publishers to print another architecture book. The argument that no books covered "the whole style and nothing but the style" made no impression.[30] Architecture as art was conceived of in contradistinction to functionalism. Johnson and Hitchcock developed the book as "an attack on the functionalists" and a way to defeat "Gropiusism."[31] A letter from Johnson to Oud, written in 1930, supports this proposition: "We shall not approach the theme from the historical side but in terms of problems of style. Naturally the critical analysis will be purely aesthetic, to the great disappointment of our German *sachlich* friends who think of nothing but sociology."[32]

It is clear from Johnson's correspondence with his mother and Hitchcock's letters to Virgil Thomson that the only thing on their minds in the summer of 1930 was the book that came to be called *The International Style*. The "Modern Architecture: International Exhibition" at the Museum of Modern Art did not take shape until the fall.

Johnson and Hitchcock visited most of the monuments and their respective architects in a journey that took them to France, Belgium, Holland, Germany, Sweden, Denmark, and Switzerland. At the end of the summer, Hitchcock went to England while Johnson went to Czechoslovakia and Austria. According to Johnson, these visits to the actual monuments gave them "a tremendous advantage" over their contemporaries in architecture criticism, particularly because they had no "national bias."[33]

Johnson remembered his work with Hitchcock as something arranged by Barr: "Alfred Barr put me together with Hitchcock. He wanted me to be in the museum with Hitchcock because he thought I would extend his feelings of architecture."[34] Not until March 26, 1931, did Hitchcock write to Thomson about the architecture exhibition at the Museum of Modern Art, which, he said, Philip Johnson was preparing "for a year from now." From both Hitchcock's and Johnson's correspondence, it appears that the assembling of scholarly material for the book pre-

ceded concrete plans for an exhibition, although Barr, from the beginning, had in-
tended to include a department of architecture at the Museum.

In the fall of 1930, less than a year after the Museum opened, Barr, Johnson,
and Hitchcock solidified their thinking in terms of using the material Hitchcock and
Johnson had been organizing for the *International Style* book to prepare an exhi-
bition at the Museum.[35] At Barr's request Johnson wrote the first proposal for the
exhibition, which was in the hands of the trustees by December 1930.[36]

Under Hitchcock's and Barr's tutelage, in one year's time, Johnson had become
a critic of architecture. In the proposal for the exhibition, Barr listed Johnson's ac-
complishments in the field in order to sell the trustees on the project: "Mr. Johnson
has devoted one year to studying the entire field both here and abroad. He has
established contacts with architects, collected numerous data and photographs,
and in general laid the necessary groundwork."[37]

JOHNSON AND MIES

Included in the proposals that Johnson wrote were statements that Mies van der
Rohe would direct the exhibition.[38] (Mies had gained a reputation for installing
exhibitions in Berlin and Barcelona.) By March of 1931, Johnson was still hopeful
that Mies would install the show; he wrote to Mrs. Rockefeller: "It is extremely en-
couraging to know that when the time arrives, probably September, for the show
to be designed that we can have the greatest architect do it. Your cooperation and
interest mean a great deal to us especially in this preliminary period."[39]

Johnson's relationship with Mies suffered the extremes of cordiality and inac-
cessibility. On the one hand, he complained to Barr that Mies got angry if he was
pursued; on the other hand, a few days after being pursued Johnson found him ea-
ger to design a new house "especially for us."[40] Barr was reluctant to exhibit plans
for buildings that had not been erected. Whether for this reason or another not
known, Mies never went ahead with his design of a house for the architecture
show, although he had promised to send the model from Berlin by October 15.[41]
Nor did he agree to go to America to install the show. Mies's political problems at

the time with the Nazi attacks on the Bauhaus seem a plausible excuse for his erratic behavior toward Johnson.[42]

It fell finally to Johnson, with Barr's help, to put the show together. Hitchcock, teaching at Wesleyan at the time, was unavailable to help curate the show, although he did write the major portion of the catalogue. Through Johnson's advocacy with a reluctant Barr and Hitchcock, Mies became an equal protagonist in the exhibition, together with Le Corbusier, Gropius, and Oud. Johnson's promotion of Mies as one of the important architects of the International Style would be his most significant contribution to the historiography of modern architecture.

On many occasions, Johnson has claimed that the Propyläen Kunstgeschichte books on modern art were his sources of knowledge, particularly Gustav Platz's *Die Baukunst der neuesten Zeit,* which he bought in Berlin in 1928 and where he discovered Mies.[43] Mies had only five drawings in this book: the brick country house, 1924 (fig. 55); the concrete country house, 1923;[44] the concrete office building, 1923 (fig. 56); the glass and steel office building, 1922 (fig. 57); and the 1921 Friedrichstrasse office building in glass and steel (fig. 58), none of which

55. Ludwig Mies van der Rohe, Brick Country House, 1924, elevation (drawing no longer extant). The Mies van der Rohe Archive, The Museum of Modern Art, New York.

had been built. To the young Johnson, coming upon these drawings with fresh eyes in 1928 (more likely, 1929), they had no equals. On the 1929 trip, Johnson also visited the Weissenhofsiedlung in Stuttgart,[45] directed by Mies. The combination could have been an "epiphany" for Johnson—a word he frequently invoked to describe his reaction to architecture monuments.

Johnson persisted in his early judgment in the monograph he wrote on Mies in the 1930s (unpublished until 1947 when it accompanied the exhibition on Mies installed by Johnson at the Museum of Modern Art). Mies's presentations had such clarity of design, he held, that his drawings were works of art: "In the first few years after the war, Mies van der Rohe published a series of projects so remarkable and so different from one another that it seems as if he were trying each year to invent a new kind of architecture." Johnson called the Weissenhofsiedlung in Stuttgart "the most important group of buildings in the history of modern architecture."[46] At one point, Johnson stood alone in defending Mies:

56. Ludwig Mies van der Rohe, Concrete Office Building, 1923, perspective. Charcoal and crayon on tan paper, 54 1/2 × 113 3/4 in. (138.8 × 289 cm). The Mies van der Rohe Archive, The Museum of Modern Art, New York, Gift of the architect.

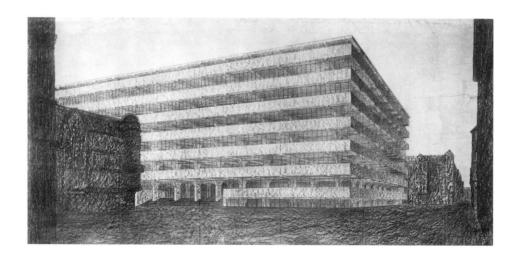

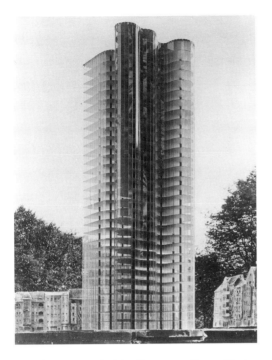

57. Ludwig Mies van der Rohe, Skyscraper in Glass and Steel, Berlin, 1922, model (no longer extant). The Mies van der Rohe Archive, The Museum of Modern Art, New York.

The Bauhaus crowd, and especially the functionalists, the literal minded believers in what was called *die Neue Sachlichkeit,* rather suspected Mies's modernity. They felt that architecture was now at last purely functional: it was a technic, a technic only, of building buildings. Naturally the architects who talked this way created much more interesting architecture as art than they would ever admit. But Mies stood apart to defend the art of the architect saying that architecture merely as a tool was the business of the engineer.[47]

On first encountering Mies in 1930, Johnson wrote how delighted he was to meet a German architect "who has no illusion about *Sachlichkeit* or technic or material things. [Mies] uses all as stepping stones and not as ends in themselves

58. Ludwig Mies van der Rohe, Office Building in Glass and Steel, Friedrichstrasse, Berlin, 1921, competition project. Charcoal and graphite on brown paper mounted to board, 68 1/4 × 48 in. (173.3 × 121.9 cm). The Museum of Modern Art, New York, Gift of the architect.

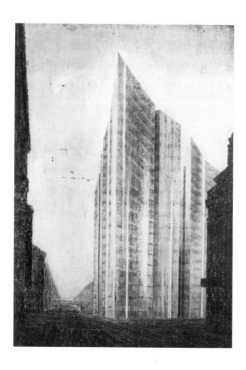

59. Ludwig Mies van der Rohe, Tugendhat House, Brno, Czecho-slovakia, 1928–1930. The Mies van der Rohe Archive, The Museum of Modern Art, New York.

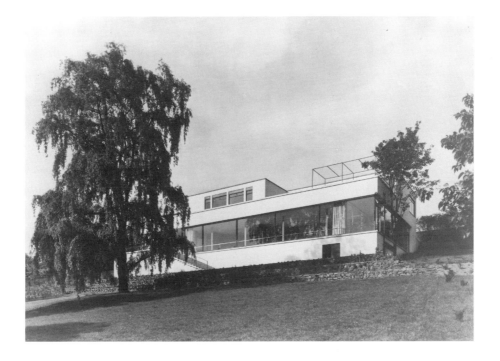

60. Ludwig Mies van der Rohe, Philip Johnson's apartment, c. 1930.
The Mies van der Rohe Archive, The Museum of Modern Art, New York.

as Gropius and his school do."[48] Johnson considered Mies a "radical experimenter,"[49] an innovator; as such, he went beyond the techniques of form follows function and fit firmly into the aesthetic framework that Barr constructed for the Museum of Modern Art.

Hitchcock, who favored Oud, and Barr, who preferred Le Corbusier, resisted Johnson's urgings to consider Mies for the exhibition.[50] But Johnson had become passionate about Mies on viewing his Tugendhat house in Brno (fig. 59).[51] He succeeded in convincing Barr and Hitchcock that Mies clearly belonged in the forefront of the new architects along with Oud, Gropius, and Le Corbusier. He succeeded so well that a photograph of Mies's Tugendhat house was used on the cover of the exhibition catalogue.

When Johnson first met Mies, he asked him to design his apartment in New York, where he moved after graduating from Harvard (fig. 60).[52] Mies accepted the commission.[53] By August 11, 1930, Barr, who had an apartment in the same building as Johnson, was writing to him about the possibility of removing the steel bucks in the door frames. He warned that it would be expensive but, "if you are having Mies do an expensive job with your furniture, it would certainly be worthwhile." Barr the perfectionist was presumably appealing to Johnson the purist.[54]

Johnson suggested that Barr's article on Russian architecture (which he wrote on his trip there in 1927, comparing Moisei Ginzburg's architecture unfavorably to the International Style of Le Corbusier, Gropius, and Oud) "started the whole thing, but he never mentioned Mies. He never heard of Mies. He didn't like Mies." And Johnson thought that Mies was "too elegant" for Hitchcock. When they visited apartment interiors in Germany in 1931 designed by Mies, Hitchcock complained, "That just isn't my dish of tea," Johnson related. "But of course" he added, "for me it was it."[55]

Yet by the fall of 1931, Hitchcock was thoroughly imbued with Mies's accomplishment, acknowledging the architect's importance in a review he wrote of an "exposition of city planning, architecture, furniture and related technical matters" that Mies arranged in Berlin in the summer of 1931. Because this section of the exposition—exhibits of marbles, woods, and textiles selected by Mies and installed

by Lilly Reich, plus Mies's one-story country house in the center of the floor—was controlled by a "single positive taste . . . [it] displayed the serene order."[56]

In this article, Hitchcock defined the parameters of what he unofficially called "the international style," which he divided "between the 'functional' manner of Gropius and Breuer and the more expensive 'post functional' manner of Mies van der Rohe."[57]

THE INTERNATIONAL STYLE

The first three principles for the establishment of a new architecture developed by Hitchcock in the latter 1920s were reiterated in *The International Style: Architecture since 1922,* published in 1932. The first principle placed the emphasis on volume, as distinguished from mass; the second was fulfilled by the use of regularity, which replaced classical lateral symmetry with vertical and horizontal repetition; the third was proscription of ornamentation, incorporating the principle of proportion as the basis of decoration described in Hitchcock's first article on Oud.[58] The elegance of materials was added to broaden the concept of ornamentation; it underscored the logic of the formal elements of the style and the concept of architecture as art.[59]

Also doch ein Baustil was the original title of the book planned for German publication, ultimately called *The International Style.* The original title became the last line in the English version: "We have an architecture still."[60] The plan was to publish the book in German as an attack on the German critics,[61] a position Johnson supported: "Our whole aim—Hitchcock's and mine was to beat out the functionalists. The whole point of the book. While to Alfred Barr it was to illustrate this great new movement which he was going to be one of the propagandizers of. And so he insisted on International Style. So we bought it. Well I bought it first and then Hitchcock did."[62]

Barr mentioned the concept of "postfunctional" as well in connection with Mies in his preface to *The International Style,*[63] but unlike Hitchcock's usage in the text, he capitalized the phrase International Style: "For [Hitchcock and Johnson] have

proven beyond any reasonable doubt, I believe, that there exists today a modern style as original, as consistent, as logical, and as widely distributed as any in the past. The authors have called it the International Style."[64]

Much has been written about the origins of the phrase International Style not only because both terms of the phrase are freighted with political implications but also because, from the beginning, the critical merits of the book and exhibition have been continually reevaluated with no definitive estimation of whether its influence has prevailed.[65]

In his foreword to the 1932 exhibition catalogue, Barr commented that the style was called "international because of its simultaneous development in several different countries and because of its world-wide distribution."[66] In fact, Barr more precisely defined the term "international," likening it to the spread of the late Gothic style in painting as it crossed the boundaries of Europe in the fifteenth century, interpenetrating and fusing the various national styles, so that the result came to be known as "the international style."[67] By relating the spread of modern architecture internationally to the similar history of the Gothic international style, he also implied that the modernist forms in architecture, painting, and sculpture imitated the coherence of the Gothic period.

The labeling of the International Style can then be connected to both sources: first, as in the Middle Ages, architecture was considered the representative mode of homogeneous style that pervaded fine arts and crafts; second, the style was literally formed as the concerned artists traveled from country to country spreading various concepts that had a synergistic effect on the forms. Although Barr's appellation has firmly established itself, the name and the naming have caused confusion from the time it was first used.

Barr anticipated the furor that the exhibition would evoke but had confidence that American architecture would be transformed. In the opening sentence of his foreword for the catalogue, he expectantly proclaimed: "Expositions and Exhibitions have perhaps changed the character of American architecture of the last forty years more than any other factor."[68] Sixty years later, the reprise of the 1932 exhibition at Columbia University substantiated Barr's original premise, and in a re-

view of the 1992 exhibition Brendan Gill affirmed it: "The exhibition has since come to be seen as a turning point in the history of American architecture."[69]

In contrast, the architect Robert A. M. Stern, known for his conservative views, writing in 1982 proffered a minority opinion:

> Forgetting the myth for a moment, the Museum of Modern Art's Modern Architecture exhibition of 1932 appears in retrospect to have had virtually no direct impact on the course of architectural practice in the U.S. As one looks back 50 years to the occasion of the show, one can see clearly the real reason it, its catalogue, and the book *The International Style* made so little a mark on events was that they did not initiate anything nor tell anything to anyone likely to effect change. Clearly the MoMA was doing what it has done so well since—preaching to the initiated while fiercely believing it was all the time making conversions among the heathen.[70]

This negative opinion, coming at the nadir of modernism and the peak of post-modernism, contributed to temporary criticism; by 1992, ten years later, a renewed interest in the International Style had clearly emerged.

STYLE VERSUS FUNCTIONALISM

Barr neutralized the term "international" by incorporating the precepts of the functionalists into his choices and definitions while ignoring any political specters associated with the word. In his 1929 article "The Necco Factory," he replaced the polemics of functionalism, evinced by the social stance of the Dutch, the Germans, and the Russians, with the ethical issues pertinent to formalism. He sought to wed the rationalism of the machine with its aesthetics and the purity of mathematics with the purity of form—a synergy accomplished, he suggested, by the freedom of the architect's choice. Architecture as an art superseded engineering in his aesthetic; a disciplined "taste" accompanied any technological decision as a method of the International Style.[71] Despite every effort on his part, he complained that the term

"International Style" (and with it, modern design) often was used interchangeably with the work "functionalism."[72]

This did not negate the centrality of the motif of the machine as the basis of painting, sculpture, and architecture in Barr's view of modern art. In the chart he constructed for the jacket of the "Cubism and Abstract Art" exhibition catalogue (see fig. 5) that traced the history and scope of modernism, the "Machine of Esthetic" dominated the lower half of the diagrammatic scheme as the most prominent source for cubism, suprematism, constructivism, de Stijl, the Bauhaus, futurism, purism, and dadism—all of which (except dadaism) fed into modern architecture.[73] The industrial culture was the formative source for the language of abstraction and the geometry of advanced art.

Barr was aware that "to many this assertion of a new style will seem arbitrary and dogmatic."[74] Such prominent architecture critics as Giedion, Lewis Mumford, and Buckminster Fuller later complained about the selectiveness of the choices made by the curators of the exhibition and the restrictiveness of their canons. For instance, architects such as Hans Scharoun and Hugo Häring were bypassed in the curators' attempt to display a cohesive style.[75] But Barr claimed that the new style was "an architecture comparable in integrity and even in beauty to the styles of the past."[76] Johnson acknowledged that "the more socially conscious critics of the modern movement . . . found [International Style] a term too artistic, too restrictive, too prescriptive. . . . But if 'style' is to refer quite simply to architectural forms that look amazingly alike during a certain period, then the International Style is a style."[77] Hitchcock persisted with his argument that the functionalists, in spite of themselves, made artistic decisions: "Consciously or unconsciously the architect must make free choices before his design is completed."[78]

Hitchcock and Johnson had to prove this point not only to the critics but to the European architects as well, who believed that to label the new architecture a "style" negated the objectivity and inevitability of functionalism and the social imperatives of its aims.[79] Hitchcock integrated the two points of view by arguing that functionalism "derives its sanctions from both Greek and Gothic architecture, for in the temple as well as the cathedral the aesthetic expression is based on struc-

ture and function." Furthermore, he suggested that technical progress forced almost all industrial buildings "into the mould of the international style."[80]

Barr's summation of his aesthetic followed a classical trajectory: "For even more than the great styles of the past [the International Style] requires restraint and discipline, the will to perfect, as well as to invent."[81] The functionalists resisted the concept of aesthetic choices, but with the emergence of critical evaluation the tide of history overtook them, and the International Style became a formula that ignored their logical consistency. Barr later explained his position:

> The style which we saw developing during the 20's and early 30's has changed and matured subsequently. It still remains, I believe, the central tradition in modern architecture. The last thing I want to do is to advocate a rigid definition of or a dogmatic adherence to a style. We were trying to describe something that happened and because we thought it was good we advocated its study and emulation, but we didn't advocate its preservation without change.[82]

Barr's aims for the Museum were served by associating the International Style with painting rather than with the functionalist ideals of the left. While he followed the lead of the technological, material, and structural imperatives laid down by the four European leaders in architecture, he was also aware of how these leaders, particularly Le Corbusier and Mies van der Rohe, were perhaps tending to a "postfunctionalist" (or aesthetic) position.[83] He agreed with Hitchcock and Johnson that the theoretical vacuum left by the architects in the problems of design had to be filled.[84] In his preface to *The International Style,* Barr summarized the formal qualities described in the book: "The distinguishing aesthetic principles of the International Style as laid down by the authors are three: emphasis upon volume—space enclosed by thin planes or surfaces as opposed to the suggestion of mass and solidity; regularity as opposed to symmetry or other kinds of obvious balance; and lastly, dependence upon the intrinsic elegance of materials, technical perfection, and fine proportions, as opposed to applied ornament."[85]

Johnson and Hitchcock, audaciously confident in *The International Style,* proclaimed that "after ten years of existence and growth [the new architecture] may

now be studied for itself without continual reference to the immediate past."[86] The task, clear to them, was to separate the purity of the new style from those architects who had experimented in other directions. Hitchcock wrote: "There is now a single body of discipline, fixed enough to integrate contemporary style as a reality and yet elastic enough to permit individual interpretation and to encourage general growth." He added the important qualification that the constants they found in the new style were elastic and would encourage new developments: "The idea of style as the frame of potential growth, rather than as a fixed and crushing mould, has developed with the recognition of underlying principles such as archaeologists discern in the great styles of the past. The principles are few and broad."[87] Overwhelmingly, through the years, however, critical analysts ignored this part of their argument and condemned the three curators for artificially limiting the canons of the new style.

As Barr described in the preface, the chapters of the book *The International Style* were organized according to the three principles of volume, regularity, and avoidance of ornamentation, with a chapter interposed on surface materials. After a short history of the development of modern architecture, Hitchcock discussed these three principles, accompanied by approximately eighty photographs of architecture. Barr was critical of the organization of the book as the photographs did not illustrate the text.[88] Johnson, although he credited Hitchcock with suggesting the theory and ideas, complained that only because he had been the editor was *The International Style* readable. Hitchcock concurred: "The text after being translated out of Hitchcock into what we fondly hope is English is now being translated into German."[89]

THE EXHIBITION AND ITS CATALOGUE

Though it was written with the same three principles of volume, regularity, and avoidance of ornamentation in mind, the exhibition catalogue, *Modern Architecture*, differed from the book. It consisted of monographs of the architects with accompanying chronologies and bibliographies—a scholarly work commensurate

with Barr's usual finely wrought catalogues. Hitchcock wrote most of the text; Johnson added a short history of modernism in architecture, in which he included the work of Henry Hobson Richardson and Frank Lloyd Wright and took note of such precedents as nineteenth-century bridges and engineering and twentieth-century cubist painting and sculpture. Johnson also wrote the section on Mies; the section on housing was Mumford's contribution.

In choosing the architects to be included in the exhibition, Johnson remembered that "the Europeans picked themselves."[90] Each architect was asked to send a model of his work. Gropius was represented by a model of the Bauhaus, Mies by the Tugendhat House, Le Corbusier by the Villa Savoye, and Oud by the Pinehurst project (commissioned by Johnson's family but never executed). Accompanying photographs of the architects' works, some three feet by six feet, lined the walls.

In another room, labeled "The Extent of Modern Architecture," smaller photographs of the work of thirty-nine architects from sixteen countries were installed. Because this section was conceived a few months before the opening, the choices were limited to what was at hand.[91] Although Barr knew well the Russian architects such as Moisei Ginzburg, the Vesnin brothers, and Andrei Burov, the Soviet Union was represented by only two buildings, by Nicolaiev and Fissenko.[92] In 1927, Barr had glowingly compared the Russians to the leaders of the international style. But according to Johnson, they didn't "fit." He remarked in hindsight: "We were very narrow-minded and anything that was slightly offbeat like Mendelsohn or Häring or especially the constructivists or Lissitzky was a little bit off our purist angle. It didn't fit the three points that we were making so we wrote out the constructivists. And besides, the constructivists never got around to building. Melnikov wasn't a good architect; and Lissitzky was a Johnny-come-lately. And Tatlin only did that one model. And Malevich, the greatest of them all, only did the maquettes."[93]

According to Johnson, in 1931 the design world in America was interested in the Paris of 1925, the Art Deco style: "In the world of Industrial Design, the accepted style was the *moderne* of the teardrop shape, applied even to toasters and refrigerators—not the Bauhaus machine art we at the museum favored."[94] This was the "half-modern" or "modernistic" compromise that Barr abhorred as "su-

perficially modern."[95] To quiet the objection that the exhibition was another import from Europe, and to satisfy the trustees, the curators were obliged to give equal space to American architects.[96] Johnson's explanation was that "out of misbegotten nationalism or, rather, a desire to encourage lagging American design, we arbitrarily decided to include four Americans."[97]

Aside from Wright, the other American architects included were Richard Neutra, an Austrian émigré, who, Johnson thought, was the only International Style practitioner among the four; Raymond Hood, "not a design innovator, but an astute planner"; and the Bowman brothers of Chicago, "a very young international style-minded team who made seductive sketches" but had not executed any designs.[98] Johnson would say years later that he invented the Bowman brothers because there was so little to choose from in the style in America.

The fifth American entry (contrary to Johnson, there were five, including Wright) was that of Howe and Lescaze, esteemed by all three curators as builders of the Philadelphia Savings Fund Society tower in the International Style. The models supplied by the American architects were of projected rather than actual buildings. This went against Barr's usual object-oriented policy but was unavoidable.[99]

Frank Lloyd Wright was excluded from the book *The International Style* despite the fact that he was a source for the European architects of the new architecture. Wright was hard to place: though his organic approach was the philosophic opposite of the functionalists' machine ideology, Hitchcock remarked that Wright was a romantic individualist (a forerunner in the same rank as Behrens or Perret or van de Velde), not an adherent of the style.[100] But he insisted that Wright be included in the exhibition, placing him (in the catalogue entry for the exhibition) close aesthetically to Le Corbusier.[101]

A Museum publicity release credited Johnson with pointing out that many elements of the International Style had their origin in America in the work of Wright. Though he was quoted as saying, "It was in America and by Americans that the true modern architecture of today was given the impetus which started it on the way to its present well-advanced stage of development,"[102] Johnson refuted this statement privately. He wrote to Oud that Wright "was included only from courtesy and in recognition of his past contributions."[103] Johnson thought Wright was

a historic figure, the greatest architect of the nineteenth century, but out of touch with modernity.[104]

At Hitchcock's insistence—and with the help of Wright's friend, the critic Lewis Mumford—Wright was prominently displayed in the exhibition (fig. 61); the model of his House on the Mesa held a focal place in the main gallery, along with the models of Le Corbusier, Mies, and Oud, while Gropius was moved to a smaller gallery together with the Bowman brothers, a significantly lesser position. This was done despite the fact that Barr no longer thought Wright "a pioneer . . . to be imitated."[105] As Terence Riley, later curator of architecture at MoMA, conjectured, the placement of Wright was perhaps meant to underscore the international quality of the exhibition;[106] Wright's model fit in with the other models of private homes—Mies's Tugendhat House, Le Corbusier's Villa Savoye, and Oud's Pinehurst House.

The technical and commercial aspects of the new architecture were not ignored: the van Nelle Factory in the Netherlands, Figini and Pollini's Electrical House in Italy, and Nicolaiev and Fissenko's Electro-Physical Laboratory in Moscow, along with Howe's Philadelphia Savings Fund Society building, among other skyscrapers, counterbalanced, if they did not equal, the star quality of the private villas.

Housing was a central issue of the new architecture in Europe and found its way into the Museum of Modern Art exhibition. The section displaying housing helped bring the subject to the forefront of architectural discourse and, in Barr's thinking, neutralized the aesthetic point of view of the exhibition. But Hitchcock believed that he had proved his point—that architecture was an art—by focusing on the aesthetic design that prevailed even in the *Siedlung* which, as he wrote, "raises the question of what is meant by function in architecture more pertinently than any other type of building."[107]

Johnson was blunt about their conciliatory approach in arranging the housing section of the exhibition: "The great leftist public intellectuals were all gung-ho for housing—housing was part of German Marxist socialist interpretation of modern architecture—that's why we got Mumford."[108] But it is not so clear that Barr agreed with this view, as he considered Lewis Mumford the only critic of substance writing on architecture. Although not steeped in European socialist ideology, Barr

61. Works by Frank Lloyd Wright, installation view at the exhibition "Modern Architecture: International Exhibition," The Museum of Modern Art, New York, February 10–March 23, 1932.

was, like many Americans, a liberal humanitarian who believed in "progress." In Mumford they secured a highly regarded social critic and historian whose essay for the catalogue covered the issues of housing as broadly as any socially concerned European architect.[109]

Although the exhibition's installation, with its strong lighting focused on pedestals, suggested a Miesian space, it is probable that Barr made many of the decisions that guided the inexperienced Johnson through the process. The installation itself had a distinctive effect, similar to that produced by exhibitions that Barr had installed previously.[110] By demonstrating the ubiquity of the modern style in everyday life, the Museum overcame the quality of remoteness that characterized the treasure-house museum.

Barr's 1929 plan evidenced his interest in securing "maquettes and models" of architecture for the Museum. He was able to brag in a letter to Abby Rockefeller: "The finest collection in America of enlarged photographs and models of modern architecture is now the property of the department of architecture."[111] Unfortunately, that cache of photographs and models had mysteriously disappeared by the time Riley reprised the original exhibition.[112] More importantly, Barr's attitude toward architecture was revealed in the letter soliciting encouragement for the "brilliant . . . Philip Johnson who arranged some of the most original and important exhibitions held by the Museum."[113] All told, between 1932 and 1934, Johnson mounted eight exhibitions of architecture and design.

Only 33,000 people came to see the 1932 exhibition,[114] yet the International Style, flourishing after World War II, has not diminished its hold on the imagination of the architectural world. Despite the fact that the critics found much to object to—even later critics who found Hitchcock's and Johnson's work unsatisfactory—the exhibition remains in the consciousness of those sensitive to the history of architecture.[115]

The department of Architecture, largely financed by Johnson, was established in the summer of 1932 with Johnson directing it. The various departments in the Museum, all founded by 1940, were established by people who had an intense and unique interest in their particular materials, Johnson being the prime example.[116]

INDUSTRIAL DESIGN

The addition of industrial design was the logical outcome of the artistic interest in the machine aesthetic and an extension of the "Modern Architecture" exhibition. Each medium participated in the machine aesthetic in accordance with its own essential character: for painting and sculpture, the unfolding of the artist's fascination with the machine had an ironic aspect; photography, film, and architecture were inextricable from the processes of the new technology; and industrial objects entered the Museum through the literal practice of finding beauty in the design of a useful object, the customary category of the decorative arts. Nevertheless, the cross fertilization of the various arts—influences felt before World War I and greatly encouraged by their direct application at the Bauhaus after the War— gave Barr the justification to display machine art prominently at the Museum in 1934.

In the spring of 1932, after returning from a disappointing industrial design show at the New York Art Center, Barr suggested to Johnson that they put on their own machine art exhibition. "We were both disgusted with the quality of the work shown at the Art Center and with its principle of choice which seemed to lie with the designers or the manufacturers rather than with the quality of the objects."[117]

Barr enlisted the help of Abby Rockefeller to implement his plan: "I am very happy over Philip's work—but he writes that he receives very little encouragement or interest from within the museum. Sometime if the chance arises could you not say a few encouraging words to him; it would stimulate and reward him more than anything I can think of. I feel that his work in architecture and the industrial arts would be of equal importance to anything we do in painting or sculpture."[118] Because Barr and Johnson had difficulty convincing the trustees that such an exhibition was worthwhile, in the spring of 1933 Johnson presented a small show, "Modern Art 1900 and Today," in which he juxtaposed art nouveau artifacts with the more severe designs of the Bauhaus. Thus art nouveau entered the Museum twenty years before it became the subject of interest for scholars. The "Machine Art" exhibition was mounted finally in the spring of 1934 (fig. 62). Johnson's as-

62. Installation view of the exhibition "Machine Art," The Museum of Modern
Art, New York, March 5–April 29, 1934. Photograph by Wurts Brothers.

sistant, Ernestine Fantl, a former student of Barr's at Wellesley, described the show and its ramifications:

> In the end 402 objects were chosen ranging from industrial units like ball bearings and propellers, household and office equipment like a lavatory flush valve, door knobs, dictaphones and vacuum cleaners, kitchen equipment from kettles to Lily cups, hospital supplies, house furnishings and accessories, to scientific instruments (micrometers, microscopes, slide rules, anemometers, laboratory glass and porcelain (retorts, petri dishes battery jars). This catalogue today does not sound revolutionary, but it was the first time such objects had been shown at a Museum of Art and the first time they were installed as objects of beauty. . . . "Machine Art" established a standard of taste.[119]

(Fantl became head of the department of Architecture and Industrial Art when Johnson left later that year. She was also responsible for mounting the poster exhibitions, another first in the annals of museology. Barr would later lament that poster design, an interest of his since the exhibitions he mounted at Wellesley, had remained a low priority in America compared to progress in other fields.[120])

From the first industrial exhibition, the Museum gained the reputation for establishing standards in design. Subsequently, competitions were held and classic designs discovered (such as the Eames chair). The exhibitions evolved into what would simply be called "good design" shows, directed by Edgar Kaufmann, Jr., from 1950 to 1955—shows intended to influence the manufacturers directly.

Placing machine-made objects in a gallery setting had many precedents, but the most immediate model for the "Machine Art" exhibition at the Museum was the "Machine-Age Exposition" mounted in 1927 by the *Little Review*.[121] This radical little magazine, edited by Jane Heap and Margaret Anderson, covered in depth the innovative movements in Europe and America in the 1920s. Heap had opened a gallery in 1924 in the office of the magazine at 66 Fifth Avenue where she held various exhibitions. Under its auspices a groundbreaking show in 1926 on the international theater was organized by Frederick Kiesler. The exhibition—too large for the gallery—was held at the Steinway Exposition Hall.[122] Russian constructivist

stage sets exhibited there were displayed again in Barr's "Cubism and Abstract Art" exhibition at the Museum in 1936. The catalogues for Heap's theater and machine age exhibitions appeared as complete issues of the *Little Review*.

Barr had visited Heap's "Machine-Age Exposition" before he left on his trip to Europe; in a footnote to his foreword to the catalogue of the Museum's "Machine Art" show, he hailed it as an important pioneering effort encompassing "fantastic drawings of the city of the future, 'modernistic' skyscrapers, constructivists, robot costumes, theater settings, and factories, together with some excellent machines and photographs of machinery."[123] The show juxtaposed modern painting and sculpture with engineering and the industrial arts. What was unique was the display of the actual machine parts and machines, in addition to their products, mounted as if they were works of art set among other defined works of art. Photographs of European modern architecture were shown, including Russian buildings as well as constructivist art and set designs. Barr remarked that when he told the Russian architect Burov that one of his *esquisses* had been illustrated in the catalogue of the "Machine-Age Exposition" in New York, he was delighted.[124]

The show asked the public to be aware of the intrinsic beauty in the machine, its parts and its products, and to see it as a source for the art of their own time. Heap explained her philosophy:

> The artist and the engineer start out with the same necessity. No true artist ever starts to make "beauty" . . . he has no aesthetic intention—he has a problem. No beauty has ever been achieved which was not reached through the necessity to deal with some particular problem. . . . The experiment of an exposition bringing together the plastic works of these two types of artist has in it the possibility of forecasting the life of tomorrow.[125]

Barr, imbued with the idea of the machine as the inspiration for painting, later would say of Fernand Léger's work *Three Women:* "Esthetically the 'Three Women' may be compared to the beauty of a superb motor running smoothly, powerfully, all of its complex parts moving in silent rhythmic perfection. . . . Léger has been attacked . . . for 'dehumanizing' art by mechanizing his figures; but has he not

at the same time helped to humanize the machine by rendering it esthetically assimilable?"[126]

THE "MACHINE ART" EXHIBITION

Barr incorporated three epigrams in the foreword to the catalogue *Machine Art.* The first was from Plato's *Philebus,* which Barr used to establish the concept of the intrinsic beauty of "geometry": "By beauty of shapes I do not mean, as most people would suppose, the beauty of living figures or of pictures, but . . . I mean straight lines and circles, and shapes, plane or solid, made from them by lathe, ruler and square. These are not, like other things, beautiful relatively, but always and absolutely."[127] The second was from St. Thomas Aquinas: "For beauty three things are required. First, then, integrity or perfection: those things which are broken are bad for this very reason. And always so a due proportion or harmony. And again clarity: whence those things which have a shining color are called beautiful."[128] This quote reasserted the criteria used in *Modern Architecture,* that found a coherence in the new style whose proportion and harmony were unbroken by added ornament as well as an interest in new materials that were decorative in themselves. Having established the rationale for finding beauty in mundane objects, Barr's third epigram asserts interpretation: "Industrial civilization must either find a means of ending the divorce between its industry and its 'culture' or perish."[129] These three quotes formed the basis for the ideas Barr elaborated in his foreword, incorporating the criteria of geometry, repetition, and surface beauty or materials: "Perfection of surface is, of course, made possible by the refinement of modern materials and the precision of machine manufacture. A watch spring is beautiful not only for its spiral shape but also for its bright steel surface and its delicately exact execution."[130]

Barr commented briefly on the importance of understanding the function of the object for appreciating its visual beauty, but he again invalidated the German concept that function is the prime delineator of form: "For most people the beauty of that ingenious engine, the Gothic vault, is augmented by a knowledge of the me-

chanics which govern its structure and visible form." Thus the knowledge of function is reduced to a mere enhancer of aesthetic pleasure. Continuing, he ensured his aesthetic emphasis: "Fortunately, the functional beauty of most of the objects is not obscure and in any case, so far as this exhibition is concerned, appreciation of their beauty in the platonic sense is more important." Finally, he bluntly reiterated that "function does not *dictate* form, it merely indicates form in a general way." Barr concluded (seemingly to justify the inclusion of machine art in a museum) by listing the various international art movements that had been influenced by the machine, noting in particular the Italian futurists and the Russian suprematists and constructivists. He also claimed that "Machine Art has been the principal influence which has purged the best post-war architecture from the compromises of both 'modernistic' and revivalist architects."[131]

Despite Barr's and Johnson's disclaimers, the "Machine Art" show at the Museum continued to be perceived as the showcase of "functional" design. In fact purity of design was the irresistible attraction for Barr and his followers; functionalism was only an apparent quality. Barr unquestionably was guided by the Bauhaus aesthetic but did not accept its principles in totality. For him the ruling aesthetic choice was first originality and then restraint. Philosophically, he placed himself at a distance from the functionalists, but he has been challenged as if he were identical to them.

The strongest criticism leveled against Barr's formalist emphasis, in both architecture and industrial arts, was that it ignored the degree of efficiency of an object or building.[132] In the standards of the Museum of Modern Art Design department, good design was inherent in the machine and functionality was implied by good design, but neither position could withstand close scrutiny. Johnson described the conundrum accurately when he wrote of "seemingly undesigned machines . . . [which] became in the 1920s a matter of conscious esthetic choice."[133] Nonetheless, taking poetic license, the Museum invented the phrase "machine art" because in its view it constituted "the chief *design* characteristic of our age."[134]

Inculcating the concept of good design in the public's awareness was as broadly (or narrowly) successful as the establishment of the concept of a new architecture. The didactic emphasis of the Museum, in general, appeared to have

found its mark. The "Machine Art" show set the standards for the Design department.[135] For designers and manufacturers, it became a mark of distinction to be included in subsequent design shows; the ultimate accolade was inclusion in the Museum's permanent collection of industrial objects (initiated when Johnson purchased 100 items from the "Machine Art" exhibition for the Museum).

Barr's inclusion of the alternative media of films, photography, and industrial design was calculated to enhance "design," with the aim

> of dignifying [these media] through exhibition under the same roof with some of the best paintings, sculptures, etc. of the present and recent past. We have attempted the same thing in relation to fine design in furniture, utensils, cars, etc. And vice versa, we hope that showing the best in these arts of popular entertainment and of commercial and industrial design will mitigate some of the arcane and difficult atmosphere of painting and sculpture. The presence of such works of non-utilitarian quality helps emphasize the fact that films and artifacts are present on a qualitative basis.[136]

Although Barr did not mount an exhibition of the work of the Bauhaus until six years later, the inclusion of industrial art in Johnson's department was no doubt inspired by Barr's fealty to the concepts of the German school and to his objective of finding valid quality in modern life. As Barr stated in his foreword to the "Machine Art" catalogue, "We must assimilate the machine aesthetically as well as economically. Not only must we bind Frankenstein, but we must make him beautiful."[137] Although the idea of mounting such exhibitions was not his alone, it completed the picture of a multidepartmental museum whose strength and uniqueness was in its comprehensive direction. Each time he proposed a new department it was a struggle, though ultimately successful.[138]

THE 1938 BAUHAUS EXHIBITION

The philosophy of the Bauhaus underlay both the architecture and machine shows, but not until 1938, five years after the school was forcibly closed by the Nazis, did Barr invite Gropius, his wife Ise, and Herbert Bayer to organize the show "Bauhaus: 1919–1928" at the Museum (fig. 63).[139] Barr admitted it was "overdue," but still interesting since many American schools were "modeling themselves on Bauhaus lines."[140] Gropius had just accepted a position in the School of Architecture at Harvard and could supply the material for the exhibition. As Barr related in the preface of the catalogue, the Bauhaus was not moribund: "[It] lives and grows through the men who made it, both teachers and students, through their designs, their books, their methods, their principles, their philosophies of art and education." Barr was referring to some of the leaders of the Bauhaus, who, having fled the Nazis, were able to establish schools of architecture and design in America. Considering the times and Barr's unremitting effort to keep the aims of the Bauhaus alive in the Museum, it was not a casual remark. Barr's esteem for these men was evident: "In modern times there have never been so many men of distinguished talent on the faculty of any other art school or academy."[141]

Barr listed what he considered the lasting contributions of the school. He called the Bauhaus building at Dessau "the most important structure of its decade"; he believed the training of future artists for involvement with industry rather than craftsmanship to be primary; he applauded the central core of the school that brought together the various arts and in so doing blurred the distinction between "fine" and "applied" arts. Barr wrote: "It is harder to design a first rate chair than to paint a second rate painting—and much more useful." An essential in the curriculum, he noted, was the experience of working directly with materials—experimentally and practically: "The study of rational design in terms of technics and materials should be only the first step in the development of a new and modern sense of beauty." Barr's last dictum proscribed the past as a refuge for the architect or designer and catapulted the student into "the modern world in its various aspects, artistic, technical, social, economic, spiritual, so that he may function in society not as a decorator but as a vital participant." The "decorative" had, in Barr's language,

63. Installation view of the exhibition "Bauhaus: 1919–1928," The Museum of Modern Art, New York, December 7, 1938–January 30, 1939.

evolved into at least a superficial if not a pejorative term that was further weak-ened when contrasted with Barr's concept of "purism."[142]

Rather than a "retrospective revision," Barr saw the Bauhaus exhibition as a representative collection of photographs, articles, and notes describing the chronology of the school. He considered the years 1919–1925, at Weimar, to be "experiments" in expressionism, and viewed the teaching of formalist methods in the years from 1925 to 1928 at Dessau as the period when the school "really found itself."

The Bauhaus survived as an idea of openended creative pedagogy and as a recognizable style of industrial design. Although Gropius found these two direc-tions contradictory, Barr nimbly lifted the style out of its context and found that "German industrial design, thanks largely to the Bauhaus, was years ahead of the rest of the world."[143]

Ever diligent as a scholar, Barr reported that the exhibition and catalogue were the most "complete and authoritative account of the Bauhaus so far attempted." Because some of the material could not be brought out of Germany, he hoped that in the future, a "definitive work on the Bauhaus . . . a well ordered, complete and carefully documented history, prepared by a dispassionate authority" could be achieved.[144] The catalogue remained for many years the only documented, stan-dard reference for information on the Bauhaus. Although the "Modern Architec-ture" and "Machine Art" shows had been resounding critical successes, the Bauhaus exhibition was, according to some critics and Barr, a dismal failure. The installation had been confusing; in this respect Gropius and Bayer did not have the aesthetic refinements of Johnson.[145]

THE ROLE OF ARCHITECTURE

Barr considered the establishment of the department of Architecture his most im-portant success,[146] and one of his greatest disappointments was losing the oppor-tunity to choose an architect for the Museum's new building later in that decade. He thought it imperative to obtain an exponent of the International Style, such as

Mies van der Rohe or Le Corbusier—one who could best create an ideal building for an ideal collection that would exemplify in its very walls the excitement of modern art. In this he was derailed by the interference of the trustees; they rejected a European in favor of another American architect, Edward Durrell Stone, who was to cooperate with Philip Goodwin, an architect as well as one of the trustees. Although Barr was bitter that the building did not reflect his aesthetic values, he spent a great deal of time making sure that the details of the interior were responsive to the needs of an "ideal" museum. The new building opened on May 10, 1939, with the exhibition "Art of Our Time," a celebration of the tenth anniversary of the Museum's founding. In addition to painting and sculpture, it included architecture, industrial arts, films, and photography, a compendium of the interests of the contemporary art community.

9

THE DIRECTORSHIP AT FULL THROTTLE

The knowledge and contacts painstakingly accrued by Barr in the 1920s were first used to full advantage in 1936 when he mounted the seminal exhibitions "Cubism and Abstract Art" (fig. 64) and "Fantastic Art, Dada, Surrealism" (fig. 65).[1] Taking his lead from Sachs, Barr's purpose was to educate the public as well as the artists of the 1930s. Although these exhibitions described the development of abstract art and surrealism, the historical context was limited to a stylistic chronology that ignored all other social, political, or psychological contingencies. Both exhibitions were set in the tradition of academic scholarship with accompanying documentation. They had a lasting influence on criticism into the 1960s, setting the terms for discussion in the formalist focus of the critic Clement Greenberg, and surviving with provocative concepts for the diverse criticism that developed in the 1970s.

Although demonstrations of abstraction of one kind and another in the United States and Europe served as precedents for the "Cubism and Abstract Art" show,

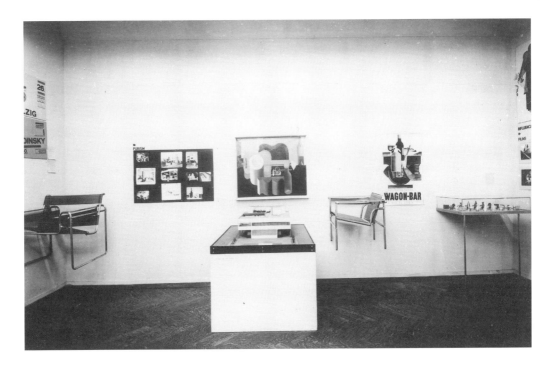

64. Installation view of the exhibition "Cubism and Abstract Art,"
The Museum of Modern Art, New York, March 2–April 19, 1936.

this exhibition was the first that developed a teleological scheme at once inclusive and historical. Barr explained that it represented a scholarly attempt to establish modernism within the tradition of art history by "illustrating prototypes and analogies, sources, development, decadence, influence and recent revival."[2] The cubist historian Daniel Robbins, after combing through the early critical writings on cubism, noted that it was only in 1936 with Barr's catalogue *Cubism and Abstract Art* that "a genuine historical concept of cubism emerges." By his reasoning, "Barr was a trained historian, who sought objective truth, was not partisan to the currents and counter movements of European, especially Parisian art politics, and who by dint of diligent research commanded access to documents and ideas that had never before been pulled coherently together."[3]

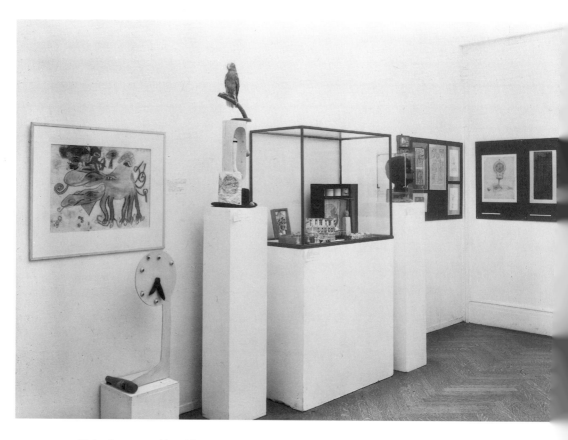

65. Installation view of the exhibition "Fantastic Art, Dada, Surrealism," The Museum of Modern Art, New York, December 7, 1936–January 17, 1937.

"CUBISM AND ABSTRACT ART"

The arts prominent in the 1920s that had helped Barr form his overview of modernism were conspicuous in the "Cubism and Abstract Art" exhibition; aspects of architecture and industrial arts as shown in "Modern Architecture: International Exhibition" in 1932, the "Machine Art" exhibition of 1934, and the development of experimental film were all represented. In his usual modest manner, Barr disclaimed any "pioneer effort," paying homage instead to Alfred Stieglitz, Arthur Jerome Eddy, and Katherine Dreier. He then actually acknowledged his own role: "The plan of the exhibition is a development of a series of lectures based upon material collected during 1927–28 and given in the Spring of 1929."[4]

This comment was made to mask his feelings of inadequacy in writing the exhibition catalogue in only six weeks,[5] having relied heavily on his familiarity with resources from the 1920s. Also, the anxiety that Barr felt in attempting to chart the constantly changing direction of modernism was transformed into a precept: "The truth," he mused, "is that modern art cannot be defined with any degree of finality either in time or in character and any attempt to do so implied a blind faith, insufficient knowledge, or an academic lack of realism."[6]

Major contributions to museology, Barr's catalogues were written with meticulous care as well as grace and sensitivity to language, displaying a verbal acuity that belied his very considerable effort. His writings were aimed at a public in need of more sharply defined concepts to understand the new art, and, he hoped, help them move beyond their "prejudices";[7] one of his favorite quotes explains his fascination with the term: "Art teaches us not to love, through false pride and ignorance, exclusively that which resembles us. It teaches us rather to love, by a great effort of intelligence and sensibility, that which is different from us."[8]

The catalogue for "Cubism and Abstract Art" remains an important historical document (as does that for "Fantastic Art, Dada, Surrealism"). It set abstraction within a formalist framework that—ignoring the intellectual byways of French symbolism, German idealism, and Russian Marxism of the previous thirty years—was shaped by the scientific climate that had started a century before.[9] Barr relieved formal analysis of any interpretive responsibility by conveying, in empiricist tones,

only what could be seen. Furthermore, he assumed a systematic perspective that resembled a scientific approach.

He set the tone in the opening line of his introduction: "Sometimes in the history of art it is possible to describe a period or a generation of artists as having been obsessed by a particular problem." Problem-solving had been the byword for artists since the beginning of the century. Using scientific tropes, Barr precisely defined two categories of abstraction by contrasting them: either they were determined by the verb "to abstract" or by the noun "abstraction." He described those paintings ruled by the verb form as "near abstractions" and those governed by the noun as "pure abstraction." He found the rationale for abstraction in a formalist aesthetic: "A work of art . . . is worth looking at primarily because it presents a composition or organization of color, line, light and shade. Resemblance to natural objects, while it does not necessarily destroy these esthetic values, may easily adulterate their purity. Therefore, since resemblance to nature is at best superfluous and at worst distracting it might as well be eliminated."[10]

Although Barr bemoaned the limits placed on art by the demands of abstraction, in his logic the "artist prefers impoverishment to adulteration." In proto-Greenbergian language, he proclaimed that "an 'abstract' painting is really a most positively concrete painting since it confines the attention to its immediate, sensuous, physical surface."[11] Barr's flight from interpretation was partly a result of his herculean effort to assess the territory of abstraction, to find order in the myriad of forms that constituted modern art, and to present it as an undeniable part of scholarship without the political or transcendental contingencies that may prompt artists. In doing so, he found content in comparing techniques of "how forms work."

Surely one of Barr's sources was the book *The Isms of Art,* written in three languages—French, German, and English—by Lissitzky and Hans Arp.[12] It was presented as a series of photographs, sequenced in reverse from 1924 to 1914, which, with no text but simple quotes from representative artists, display the abstract movements—all the isms. The table of contents lists Proun, compressionism, Merz, neoplasticism, purism, dada, simultanism, suprematism, metaphysics, ab-

stractionism, cubism, futurism, and expressionism. The authors had firsthand knowledge of international art.

Almost the identical roster is covered in *Cubism and Abstract Art,* with a few differences. Because surrealism had just been named in 1924, Lissitzky and Arp were still listing the surrealists under dada; notably there were no fauves on their list, but there were in Barr's book; what Barr called orphism, they called simultanism; Barr did not include Chagall, while Lissitzky and Arp did. Both books listed compressionism, which included Baumeister and Schlemmer. Only Barr discussed synchromism, calling Stanton McDonald-Wright and Morgan Russell "Paris-Americans." Barr's book was more comprehensive, starting with the roots of abstraction in impressionism and postimpressionism and ending with "the younger generation," which included Calder and Man Ray, the only other Americans who appeared in either book. In the preface to *Cubism and Abstract Art,* Barr reiterated what he had been rehearsing for ten years: his own interest in movements that crossed national frontiers, so that one artist's influence on another contributed to the theoretical importance of an international movement. This factor of ubiquity was literally and figuratively transmitted by the central motif of the machine.

Avoiding controversy, Barr tactfully wrote that he regretted that the "exigencies of time and space" necessitated omitting otherwise interesting artists and movements. He then quickly offered a poor excuse for not including American abstract artists—the fact that an exhibition of that category of art had been held "only last year" at the Whitney Museum of American Art—a dodge that Barr used masterfully. More to the point, his interest in historical orthodoxy, the enfolding narrative that embraced innovation, precluded American art because it did not contribute to the creation of the international abstract art movement. Only Calder and Man Ray were considered international.

Barr's ever-present struggle to ratify both abstraction and figurative art was manifested by the statement in his preface that "ten years ago (1926) one heard on all sides that abstract art was dead."[13] Earlier he had viewed the conservative trend in the 1920s as a return to "a more normal balance between 'form' and 'content';" sensing a trend away from interest in design, expressive distortion, or concern with the naïve and primitive, he described three dominating styles that had

evolved since World War I: "*Sachlichkeit* or the new objectivity" in Germany, "the construction of mysterious scenery in order to evoke a mood of strangeness or melancholy," and surrealism, "the experiment with the fantastic and the grotesque." All were concerned with the "power of subject matter"—equal in almost every case to the interest in design, and he implied, maybe surpassing it.[14] That he concluded they could live side by side was evidenced by the two exhibitions that he mounted six months apart in 1936. Although Barr grappled with the retreat of abstraction in the 1920s, he did not abandon cubism for surrealism. Indeed, he said that he was drawn to abstract art for its formal values and "for its absolute, physiological honesty. Some of it I like to look at, just that. And in all of it I respect their insistence on the absolute. I don't have the courage to participate in this absolutism myself, but I respect it."[15]

Barr was faithful to the sequence of change rather than to any particular style within the spectrum of modernism. Infidelity to abstract art was hardly the issue; he consistently followed the lead of the artists and rarely allowed his feelings to influence his decisions. He believed that "artists made more sense about art—including their own—than most critics, historians, and estheticians do."[16]

The first claim on Barr's attention was the links of creative innovations that constituted the aggregate, modernism; apparently paraphrasing Riegl's *Kunstwollen*, Barr judged, with a narrow focus that ignored reasons, that "by a common and powerful impulse [which he labeled 'exhaustion'] the [abstract artists] were driven to abandon the imitation of natural appearances."[17] Originality as the prime mover of modern art was highlighted in his claim that "in several cases the earlier and more creative years of a movement or individual have been emphasized at the expense of later work which may be fine in quality but comparatively unimportant historically";[18] works of quality in an artists's oeuvre, an imperative in Barr's system, thus assumed a relatively secondary role. He placed the beginnings of abstract art before World War I with a painting by Malevich in 1913 that "has absolutely no dependence on natural forms," or *Fugue in Red and Blue* by Franz Kupka, "probably the first pure-abstraction in Western Europe."[19] The purity of style, the originality of invention, and the influence of the artist in an international

matrix were the essential theoretical factors for understanding the chronology of the movement.

Barr's interest in precise terminology was the basis from which he categorized the various art movements chronologically, forming classifications similar to the taxonomies of zoologists and botanists—a turn of mind shaped, no doubt, by his consuming lifetime devotion to the study of birds and butterflies.[20] He was aware of a "continually shifting scope, value and even meaning of the terminology which we apply to the great periods of European art. These changes came about not as exercises in terminology but because our concepts of these periods and of their value have changed." He noted from his own experience that the "imperial fortunes" of classifications were related not only to "the changing concept of scholars but also to changing tastes generated by living artists and by their admirers."[21] Having searched for responsible standards that would edify a range of art consumers and present his criticism with an aura of integrity and thoroughness, Barr aspired to establish modernism in a historical framework.

KAHNWEILER'S PRECEDENT

Barr's catalogue was in fact a position paper that divided Picasso's and Braque's major breakthroughs of "analytic cubism" and "synthetic cubism" into historical sequences that led to the various movements of abstract art. These terms were originally used by Daniel-Henry Kahnweiler in a generally more descriptive manner, based on the conceptual idealism of Immanuel Kant. In reference to the cubist work at Cadaquès by Picasso, Kahnweiler wrote: "Instead of an analytical description, the painter can . . . also create in this way a synthesis of the object, or in the words of Immanuel Kant, 'put together various conceptions and comprehend their variety in one perception.'"[22] Barr's use of the terms "analytic" and "synthetic" cubism was more specific than Kahnweiler's, and has been reused by every critic who has discussed cubism ever since. Barr developed the idea further by categorizing the subspecies of cubism and then connecting cubism with the emergence of abstraction. By focusing on the processes involved and constructing an overview of cu-

bism and abstract art, Barr unwittingly suggested the fate of modern art that would eventually turn toward art as process.

Commenting that Kahnweiler "remains one of [Cubism's] soundest historians,"[23] Barr, in recognizing the importance of *Les Demoiselles d'Avignon* for the creation of cubism, was possibly also in Kahnweiler's debt.[24] Barr's description of analytic cubism closely followed Kahnweiler's in linking the work of Cézanne with the efforts of Picasso and Braque as they turned their attention to "the representation of the three-dimensional and its position in space on a two-dimensional surface."[25]

Again going beyond Kahnweiler, Barr set the stage for Greenberg when he noted that Cézanne was revered "for his abandonment of deep space and emphatic modeling, for a compact composition in which foreground and background forms are fused into an angular, active curtain of color."[26] Barr, typically, found a word for this process: "*passages*—the breaking of a contour so that the form seems to merge with space."[27] The term found its way permanently into the critical vernacular.[28] Barr brought the descriptive terms that had been used by the contemporary critics of cubism into focus but ignored the approach that lent weight to the "conceptual" view. The descriptive phrases he used for the cubist forms accurately recreated the sensation of movement: "facets that slip[29] . . . deformation . . . overlapping . . . transparent planes . . . simultaneity"; and again, "the simultaneous presentation of different views of an object in the same picture."[30] In another place, other phrases continued the notion: "flattening . . . modulations . . . disintegration . . . subtle equilibrium between the planes which seem suspended *in front of* the canvas and those which recede behind it."[31]

Naming the moment of the emergence of "synthetic cubism" in 1912[32]—the progression from "three-dimensional, modelled, recognizable images to two-dimensional, flat, linear form, so abstract as to seem nearer geometry than representation"—provided a systematic foundation for future critical thought. Barr was among the first in America to call attention to the significance of collage (which included *papier collé*) in the advent of synthetic cubism.[33] The use of literal textures "is not merely a surface enrichment but an emphasis upon the sensuous tactile reality of the surface itself," in contrast to traditional painting, which "took the eye

and mind past the surface of the canvas to represented objects."[34] He described the collage mode as "Cubist realism—that is, an emphasis not upon the reality of the represented objects but upon the reality of the painted surface."[35] Representation had been replaced by a process that "destroyed . . . [the] traditional technical integrity of the medium."[36] Barr's exegesis came close to present-day semiotic theory when he discussed the importance of collage: "Collage strengthened the awareness of the picture surface while at the same time it increased the range, variety and remoteness of the pictorial metaphor. (By pictorial is meant . . . the relation between the picture and the object or scene represented.)"[37] Both Barr and Clement Greenberg—the most influential critic in the wake of Barr—called this stylistic change either logical or inevitable.

BARR PAVES THE WAY FOR GREENBERG

Following Barr's course, Greenberg went further: "The collage medium," he said, "has played a pivotal role in twentieth century painting and sculpture, and it is the most succinct and direct single clue to the aesthetic of genuinely modern art."[38] In one of his most important essays, "Collage," which became a model of formalist criticism, appearing to be satisfied with Barr's concept of cubist "realism," Greenberg took it one step further. Cubist realism—that is, the placing of newspaper atop the canvas—"called attention to the physical reality of the work of art and made that reality the same as art." It was not only the departure point of Picasso's and Braque's invention of synthetic cubism, but also, according to Greenberg, "with a logic all its own" it initiated constructivist sculpture: "Without collage there would have been no Pevsner, Gonzalez, or Giacometti." Greenberg developed a context of "literal flatness" to explain the new forms. "Collage as employed by the cubists always emphasized the identity of the picture as a flat and more or less abstract pattern rather than a representation."[39]

Greenberg's formalist ideas were succinctly expressed in the essay "Modernist Painting" in 1965: "Because flatness was the only condition painting shared with no other art, modernist painting oriented itself to flatness as it did to nothing

else."[40] Greenberg also proposed the concept of the "search [for] the absolute" by the avant-garde in their journey to abstract art which, in fact, confirmed Barr's notion of the "reality" of the "invented" object. Greenberg wrote: "Content is to be dissolved so completely into form that the work of art or literature cannot be reduced in whole or in part to anything not itself."[41] Like Barr, his focus was on purity: "The purely plastic or abstract qualities of the work of art are the only ones that count."[42] This authoritative stance was not substantially distant from Barr's phrasing of the "sensuous tactile reality of the surface itself." Greenberg led the way in art criticism in the 1950s and 1960s with the same conceptual underpinnings as Barr: treating modernism as an epochal style that had evolved from traditional art, following the categorical formalism of Heinrich Wölfflin, ensured its continuity with all that had gone before; the method of formal analysis devoid of emotional interpretation was akin to that of Berenson; and most conspicuously, the purity emanating from abstraction displays the willfulness of the modernist artist. The two formalist critics, Greenberg and Barr, were concerned with epochal styles, history, quality, purity, and, above all, originality.[43]

Barr and Greenberg both explained their understanding of modernist art as a function of "looking" that ignored the affective correlates of the aesthetic experience. Looking assumed a qualitative stance that was translated as "taste" acquired through experience. Both critics had the reputation of having an "eye," the ultimate accolade. While they both dismissed psychological and cultural factors as inessential, focusing instead on "quality," they validated abstract art within a changing context that was historically "inevitable," supported by the authority of traditional art.[44] Greenberg agreed with Barr that there was "nothing in the nature of art which compels it to be so," only its "historical justification."[45] And both used clear, unevocative, objective language with a voice laden with disinterestedness; whereas Barr's reticent descriptive language only suggested formalism by implication, Greenberg's rhetoric, more assertive in style, prescribed the universal formalist principles of modernist art.[46] Greenberg followed Barr's formulation of cubism as the central art form, and collage as the precipitating instance that furthered abstract art and, incidentally, reinforced formalist art criticism.

THE CHART: MODERNISM IN TIME AND SPACE

Using his familiar approach of categorizing styles, Barr developed a comprehensive synthesis of abstract art as it progressed in the first third of the twentieth century in the catalogue *Cubism and Abstract Art*. Barr later observed: "The purely formal language of analytical cubism . . . [was] strong enough, intense enough to influence, perhaps even to generate, the *style* of the visual arts in the Western world during the ensuing twenty years."[47]

By setting forth the genealogy of modern art in a now-famous diagram (see fig. 5) that delineated its complex interlocking movements, Barr profoundly affected the way modern art has been viewed; teleologically described—that is, possessing the quality of being directed toward a definite end or having an ultimate purpose—Barr's innate idealism came to the fore.

The schematic diagram on the cover of the catalogue traced the unfolding of modernist art chronologically, nationally, and stylistically. Lines in sequential historical phases, moving from cubism to architecture with the machine as their center, diagrammed the modern movement that Barr witnessed in postwar Germany in the 1920s and reflected the assembling of Russian and Dutch artists at the Bauhaus and their influence on German artists. An eminent scholar of cubism, Robert Rosenblum, observed that since the comprehensive distillation on the cover chart, "most scholars have only been refining, amplifying, or diluting Mr. Barr's initial presentation of the Gospel of modern art in 1936."[48]

An earlier chart entitled "A Brief Survey of Modern Painting" (1932) that accompanied a circulating exhibition from the Museum was a less complex initial approach by Barr. It begins with Courbet and the generation of 1850 and ends in 1925 with the superrealists. After the impressionists, Barr inserted expressionism, dividing the artists into *die Brücke* under "psychological" and *les Fauves* under "decorative," with Rouault falling between them. By the time of the "Cubism and Abstract Art" exhibition, the chart was more clearly defined and those two concepts were dropped; only abstract expressionism remained. Also absent from the later chart were the determining characteristics of "superrealism"—fantasy-spontaneity, the miraculous, disintegration, and enigma. Similar in configuration,

the early chart includes Japanese prints and African sculpture as sources for modern art, but it omits the machine aesthetic and architecture, concepts that Barr had not yet worked through.

In the "Cubism and Abstract Art" chart and in the text, Barr divides abstract art into two main polarized currents, both of which, he wrote, emerged from impressionism: "The first and more important current finds its sources in the art and theories of Cézanne and Seurat and passes through the widening stream of Cubism and finds its delta in the various geometrical and Constructivist movements which developed in Russia and Holland during the war." He describes this current as "intellectual, structural, architectonic, geometrical, rectilinear and classical in its austerity and dependence upon logic and calculation." Mathematics lurked in the background of this phase, for Barr, in the figures of Apollo, Pythagoras, and Descartes as they "watch over the Cézanne-Cubist geometrical tradition."[49]

Turning to "biomorphic" abstraction, he wrote: "The second . . . current [which] has its principal source in the art and theories of Gauguin and his circle, flows through the fauvism of Matisse to the Abstract Expressionism of the pre-War paintings of Kandinsky." The movement that made this strain no longer secondary was surrealism; Barr examined the connections of the two "isms," and only eight months later he mounted the "Fantastic Art, Dada, Surrealism" exhibition. He claimed that "biomorphic" abstraction went underground for a few years, but resurfaced strongly with the abstract artists associated with surrealism. Choosing his descriptive words with "lapidary" precision, he lists the characteristics of the second style of abstraction: "intuitional . . . emotional . . . organic or biomorphic . . . curvilinear . . . decorative, and romantic rather than classical in its exaltation of the mystical, the spontaneous and the irrational." Countering the gods and philosophers of classical abstraction were Dionysus, Plotinus, and Rousseau, who maintained influence over "the Gauguin-Expressionist-non-geometrical line." As examples of the two styles, painted twenty years before, Barr mentioned a suprematist work by Malevich contrasted with an *Improvisation* by Kandinsky. In the contemporary works of the 1930s, Barr contrasted Mondrian, Pevsner, and Gabo with Miró and Arp. Quipped Barr: "The shape of the square confronts the silhouette of the amoeba."[50]

Barr began to develop this polar opposition on his European trip in 1927. In his article "Dutch Letter," he reported his discovery of the ubiquity of the modern style as found in posters, book jackets, objets d'art, textiles, typography, furniture, and architecture in Holland. Still not sure of his observations, he noted with hesitation, "to simplify the problem dangerously," two styles or sources of style exist, the "barbaric" and the "purely geometric."[51] The chronological chart of 1936 was plotted in five-year periods from 1890 to 1935; the artistic sources of abstract art—Japanese prints, Near Eastern art, and African sculpture—were outlined in red and were joined to the various movements with red arrows. The machine aesthetic, also outlined in red—the only nonart mode—played the major role, along with cubism, as a source and influence, respectively, in avant-garde art from 1910 to 1935. The bracing of a style by its incursion into each country constituted the intellectual narrative of the chart.

The diagram itself approximated that of a football play or military skirmish (both lifelong interests avidly pursued by Barr). This modernist "grid" implied that the style was in the world and could not be "pure"—that is, removed from influences. Movement by movement, in a sequential narrative, art works attained content in a historical context. In subjectless abstract art, the meaning conveyed by forms was of a synthesis of science and intuition as they crossed geographic boundaries, shaped quotidian objects, or generated invention; and forms begot new forms.

Barr's diagrammatic scheme has become an icon. Its basic premise, little altered, has attained the aura of an artifact. As an outsize poster, it has hung in a dominant place in the library of the Museum of Modern Art. Like any other work of abstraction, it has been called "a visual machine for the generation of language" by the critic William J. T. Mitchell, who wrote: "Much of this language may be trivial chatter, or misguided. Much of it may be the refinement and detailed elaboration of myths, as is a large portion of the art historical writing that grows out of Barr's work. But there is no use thinking we can ignore this chatter in favor of 'the paintings themselves' for the meaning of the paintings is precisely a function of their use in the elaborate language game that is abstract art."[52]

Although Barr protested that the "Cubism and Abstract Art" exhibition was not conceived in a "controversial spirit,"[53] the narrative sequence—giving each movement the empowerment of historical necessity and the spectator the knowledge of a connoisseur—attained a "heraldic" position that generated battles of interpretation: the purity of the form versus its significant content; a painting as an analogue for perception of light, space, and so forth; a painting as a metaphor of spiritual inspiration, or as an act of rebellion by the avant-garde in a moral or political quest.[54] The underlying polemical issue was that between a formalist position and a contextual-interpretive one. Barr's avoidance of political, economic, or social relevance in his schematized historical development of modernism created a neutral discourse that could be filled in from any ideological point of view.

Over a period of time, Barr made corrections to the chart (see fig. 6): "Omit the arrow from 'Negro Sculpture' to 'Fauvism.'" He thought that Matisse used Negro sculpture more in his sculpture and that it was "generalized and very well assimilated."[55] He added a red arrow from machine aesthetic to futurism. The futurists, he wrote, "were the first group of painters to embrace the modern world of machinery as an essential part of their program."[56] Barr neglected to connect Brancusi to Negro sculpture in the chart, but he did in the text.[57]

COLLISION WITH MEYER SCHAPIRO

After describing the artistic tendencies that erupted from cubism, such as orphism, synchromism, synthetic cubism, collage, and sculpture, Barr identified the abstract art that issued from Russia—the suprematist and the constructivist movements— that brought distinction to his exhibit. He wrote: "In the history of abstract art Malevich [fig. 66] is a figure of fundamental importance. . . . He stands at the heart of the movement which swept westward from Russia after the War and, mingling with the eastward moving influence of the Dutch 'Stijl' group, transformed the architecture, furniture, typography and commercial art of Germany and much of the rest of Europe." Using the analogy of the machine, Barr wrote that Malevich established "a system of absolutely pure geometrical abstract composition." And almost

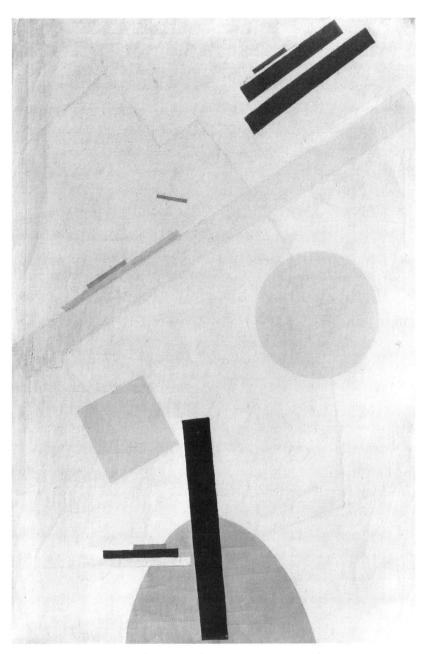

66. Kazimir Malevich, *Fundamental Suprematist Element*, 1916–1917. Oil on canvas, 38 1/2 × 26 1/8 in. (97.8 × 66.4 cm). The Museum of Modern Art, New York.

in passing, his narrative took a climactic leap: "Malevich suddenly foresaw the logical and inevitable conclusion towards which European art was moving."[58]

Barr was criticized by Meyer Schapiro in 1936 for ignoring the economic, political, and cultural context of art and for what Schapiro called his historicism—the internal delineation of a formalist methodology.[59] Barr traced formal distinctions as they evolved in separate cultures, and analogized them to the complexities of historical dialectics. Schapiro questioned Barr's idea of the "inevitable" progression of art. Because of his socialist inclinations, Schapiro insisted on the importance of examining the social conditions of a work of art which, he insisted, Barr did not take into account.[60] Schapiro rejected any breach between abstract art and realistic art in his schema: "All renderings of objects, no matter how exact they seem, even photographs, proceed from values, methods and viewpoints which somehow shape the image and often determine its contents. On the other hand there is no 'pure art,' unconditioned by experience; all fantasy and formal construction, even the random scribbling of the hand, are shaped by experiment and by nonesthetic concerns."[61]

Although Schapiro rightly called into question Barr's seeming indifference to broader cultural contingencies, innovation was of primary importance in Barr's lexicon, overshadowing any other reason for art's coming into being; rebellion had its own force, discontinuous from the effects of world forces, and remained unexamined by Barr. Nevertheless, there was an overlap in their writings: Barr's overriding formalist approach had an implicit charge of the artist's expressive content that was supported indirectly by Schapiro's sensitive response to the work and his deep empathy with the artist. Barr's idiosyncratic history of modern art, which he developed and elaborated in catalogues and exhibitions as self-evident and independent of cultural forces, became enormously influential despite criticism by such an important critic as Schapiro. This achievement, carefully skirting interpretation, was strengthened by Barr's characteristic inward monitor of integrity in scholarship and responsibility in tone. Perhaps Barr's sensitivity to prejudice and injustice made it difficult for him to trust his own impartiality when it came to art.

But abstract art is freighted necessarily with the symbolizing urge of human language, and Barr's quest for purity ignored, at a cost, Malevich's and Kandinsky's

metaphysical or transcendental content uncovered by recent scholarship, as well as all other intentional aims.[62] Barr's underlying approach was to not "burden the arts with social and political responsibility in the sense they might serve as a substitute for ethical, moral and religious factors. Artists help us to understand each other."[63] While he was mapping historical changes that had canonic status—a hierarchy seemingly protected from dissolution—Schapiro was carving out areas of interpretation that did not take critical hold until three or four decades later.[64] Barr took note of Schapiro's interest in the metaphoric symbolism of cubist motifs, but Barr's preference was to give credence to the artists' disclaimers of any interest in subject matter. He viewed the references to objects in the artists' studios or words and letters painted on the surface of the canvas as a "direct rather than a symbolic inventory." Barr left the door open a bit when he wrote: "In any case the iconography of Cubism should not be ignored."[65]

Barr and Schapiro shared a humanistic point of view, accessible in Schapiro's writings but found only indirectly in Barr's. Clement Greenberg and Meyer Schapiro have retained their respective positions as the leading American art critic and art historian of the twentieth century, overshadowing the scholarly contributions of Barr. However brilliant their insights, Schapiro, the cultural historian, and Greenberg, the formalist critic, nevertheless have more similarities with Barr than differences.[66]

In Barr's approach, subject matter and how it was handled was important only in futurism, dadaism, and surrealism (and particularly, American art). With formalist logic, he then identified the "style" of figurative art, rather than its "avowed program," as the deciding factor that involved it in politics. He described the political implications of Italian futurists, Russian suprematists, dadaists, constructivists, surrealists, and the political troubles of the German social democrats and the International Style. In typical fashion, true to his sympathies with artists who suffered rejection, Barr concluded: "This essay and exhibition might well be dedicated to those painters of squares and circles (and the architects influenced by them) who have suffered at the hands of philistines with political power."[67]

CUBISM INTO ARCHITECTURE

One of the most important precepts of Barr's formalist aesthetic, which emerged
from his European experiences in 1927, was that abstract painting and architec-
ture shared the organizing principle of design. Barr began this discussion in *Cu-
bism and Abstract Art* with Picasso's cubist drawing, *Standing Female Nude,*
1910 (fig. 67), which he described as "a counterpoint of straight line edges, ver-
tical and horizontal, with the curved contours of cross sections—architecturally

67. Pablo Picasso, *Standing Female Nude,* 1910. Charcoal
drawing, 19 × 12 1/4 in. The Metropolitan Museum of Art,
Alfred Stieglitz Collection, 1949 (49.70.34).

speaking a combination of plan and elevation in one drawing."[68] Mondrian's work, as seen in *Composition in Brown and Gray*, 1913–1914 (fig. 68), was strongly affected by Picasso's abstraction, which Mondrian had observed on a trip to Paris in 1910; this is further reduced to a syncopated rhythmical pattern of horizontal and vertical lines alone in *Composition*, 1915.[69] Barr proposed a direct line of progression from the "plus and minus" abstractions of Mondrian to geometrical qualities in the *Rhythms of a Russian Dance* by van Doesburg (see fig. 53), transformed again to the "broken, asymmetrical, orthogonal" plan of Mies's brick

68. Piet Mondrian, *Composition in Brown and Gray*, 1913–1914. Oil on canvas, 33 3/4 × 29 3/4 in. (85.7 × 75.6 cm). The Museum of Modern Art, New York.

country house of 1924 (see fig. 52).[70] And, he observed, "By sheer perfection of sensibility [Mondrian] has impressed his style not only upon a host of younger painters but also, directly and through Doesburg and Rietveld, upon architects and commercial architects."[71] When van Doesburg came to the Bauhaus he brought with him the clarity and discipline of de Stijl. Barr recognized that Gropius's design for the director's house in Dessau, 1926 (see fig. 51), was directly influenced by the de Stijl group because it was "handled as if it were an abstract painting like Doesburg's Cow. The facade is essentially a pictorial and not an architectural conception." Barr concluded: "In the history of art, there are few more entertaining sequences than the influence by way of Holland of the painting of a Spaniard living in Paris upon the plans of a German architect in Berlin—and all within twelve years."[72] Barr's discussion of paths of influence as "entertaining sequences"—a suggestion understated by a touch of irony that elevated the viewer immediately to a position in the company of the elite—situated the art in a narrative that enhanced its aesthetic value.

Barr's grid remains a mythic chart, generating threads of narrative that constitute an epic: according to one critic, "stations of the cross in the theatrical passion play of modernism."[73]

PLURALISM

Turning his attention in the *Cubism and Abstract Art* catalogue to surrealist art, Barr resolved a dilemma that had troubled him since the 1920s, when artists, both in Europe and the United States, turned conservatively toward figurative art. Constantly assailed by adherents of abstract art on one side or figurative art on the other, Barr may have been confused for a time about the continuing fortunes of abstract art. Perplexed in his attempt to create order out of the many directions art was taking, he temporarily lost his orientation. By the time he wrote the two catalogues *Cubism and Abstract Art* and *Fantastic Art, Dada, Surrealism* in 1936, he was surer in his perspective.

As much as Barr could be labeled a formalist, it was not at the expense of fig-
urative art; his method in both cases (and generally) was formulated within the
context of perception, or experience, of the object. Irving Sandler, the editor of
Barr's selected writings, distorted some of the elemental details and overstated
Barr's defection from abstract art when he wrote that "Barr rejected formalism as
the modernist approach." Sandler's main thrust was that "Barr's conception of
modern art and its interpretation changed over the years."[74] Misunderstanding
Barr's point of view, Sandler saw him changing from a purely formalist approach
(formalism equated with abstraction) to a "pluralistic" one. Sandler uses as an ex-
ample, Barr's description of the work of Oskar Kokoschka whose works, Barr
wrote, "do not always hold up structurally, but they reveal a mastery of color and
electric drawing, and a direct, vivid, emotional response to the visual world." They
achieve their effect "not through balanced formal organization, but through vehe-
ment drawing and volcanic color."[75] Barr did not betray his interest in the formal
means of achieving effects. He merely had shifted the means from the "balanced"
into the "vehement" and "volcanic" column of formalism; the "emotional re-
sponse" was limited to a quality on a par with any other formal quality. Sandler
confused the dialectics of history, exemplified in Barr's acclamation of those artists
who were "venturing in other directions,"[76] with Barr's taste.

Barr used formalist analysis with every work of art he encountered, although
he sometimes, like Sandler, tended to confuse "formalist analysis" with "formalist
art,"—that is, abstraction. That Barr's modernism was openended is assured, but
Sandler's conclusion that Barr would "remain anti-formalist"[77] has no validity. Nor
is there evidence for Sandler's claim that Barr had a "preference for Surrealism
over Cubism."[78]

Far from having abandoned it, Barr finds abstraction in surrealism. The final
group he analyzed in the *Cubism and Abstract Art* catalogue consisted of works
exemplifying abstract tendencies in surrealist art:

> From a strictly Surrealist point of view an abstract design is merely a by-product.
> For instance a Picasso *collage* considered not as a pattern of line and texture
> but from the point of view of subject-matter, as a representation of a still life, is

69. Pablo Picasso, *Seated Woman*, Paris, 1927. Oil on wood, 51 1/8 × 38 1/4 in. (129.9 × 96.8 cm) The Museum of Modern Art, New York.

sufficiently bizarre to excite the Surrealism emotion of *disquieting* amazement. But, to reverse the point of view, Masson's pastel, and Tanguy's drawing whatever their Surrealist significance may be, are even more abstract than Picasso's *collages* and may be considered one of the results of the early 20th century impulse toward abstract design.[79]

Though Barr distinguished between psychological expressive force and formalist composition, he treats them both objectively as devices or qualities of formalist technique. Expressive psychological motifs are described by formalist analysis.

Barr placed Picasso as both the leader and inventor of cubism before World War I and as a surrealist after the war.

Seated Woman, 1927 [fig. 69] by Picasso is possibly the greatest twentieth century painting in *America* because it combines magnificently elements of abstract design and elements of Surrealist mystery. It is, however impossible to understand and appreciate such a picture as the *Seated Woman* first without past study of the picture itself and secondly without long acquaintance with the history of art and especially with the history of the art of our own time which in two of its important phases had culminated in Picasso's work.[80]

SURREALISM

With "Fantastic Art, Dada, Surrealism," Barr presented an exhibition whose artistic aims, he said, were "diametrically opposed in spirit and esthetic principles" to the cubist exhibition. Expecting ridicule and controversy, Barr wrote in the catalogue preface: "Surrealism as an art movement is a serious affair and for many it is more than an art movement; it is a philosophy a way of life a cause to which some of the most brilliant painters and poets of our age are giving themselves with consuming devotion."[81]

One of the objects causing the most controversy and notoriety was the fur-covered teacup, plate, and spoon (fig. 70) by Meret Oppenheim. Placating

70. Meret Oppenheim, *Object,* 1936. Fur-covered teacup, saucer, and spoon; cup, 4 3/8 in. (10.9 cm) diameter; saucer, 9 3/8 in. (23.7 cm) diameter; spoon, 8 in. (20.2 cm) long; overall height 2 7/8 in. (7.3 cm). The Museum of Modern Art, New York.

Goodyear, who wanted it removed from the traveling exhibition, Barr wrote: "A good many people will always object to any new aesthetic. The aesthetic of form and color and of distorted or disintegrated objects which so exasperated the people in the Armory Show is now generally accepted. But the aesthetic of surrealism: fantasy, incongruity, spontaneity, and humor, though it is already a dozen or twenty years old is still exasperating to some of our friends who are likely to call it silly or absurd."[82]

Barr found antecedents for surrealist imagery as far back as the fifteenth century, particularly in the work of Hieronymus Bosch, where the primary juxtaposition was between "reason" and the "imagination," that is, fantastic, lyrical imagery that was found in poetry and dreams. Bringing the use of visionary paintings up to date, Barr related that the artists of the seventeenth century initiated such technical devices as "the composite image, distorted perspective, and the isolation of anatomical fragments" that were now used by the surrealists. But he found that the fantastic works of past art had a more "rational basis, magical, satirical, moralistic or scientific . . . [than] the art of the recent Dadaists and Surrealists." Past fantastic artists included Piranesi, Fuseli, Blake, Goya, and Redon. He mused: "It is probable that at no time in the past 400 years has the art of the marvelous and anti-rational been more conspicuous than at the present time."[83]

Barr understood the endurance of this tradition as a "deep seated and persistent interest which human beings have in the fantastic, the irrational, the spontaneous, the marvelous, the enigmatic and the dreamlike." Logic and irrationality have always faced each other, sometimes in confrontation, sometimes in cooperation. But in Barr's narrative, to harness the "spontaneous" was to join with the "metaphors and similes of poetry"—in contrast to the rationality of the artists of the movements of abstraction who were concerned with external reality and the "composition of color and line into formal design."[84]

After explaining the history of the dada movement as comprised essentially of iconoclasts who rebelled against both modern culture in general and "modern" artists in particular, he mentioned that they used the formal techniques of the earlier abstract movements. "The Dadaists had been anticipated by Kandinsky, Klee, Chagall, de Chirico, Duchamp, and Picasso." From the "ashes" of dadaism sprang the movement of surrealism: "The Surrealists preserved the anti-rational character of Dada but developed a far more systematic and serious experimental attitude toward the subconscious as the essential source of art. They practiced 'automatic' drawing and writing, studied dreams and visions, the art of children and the insane, the theory and technique of psychoanalysis, the poetry of Lautréamont and Rimbaud." In short, they found visual techniques to transpose one of the most important intellectual discoveries of twentieth-century life. While cubist objects, he

reasoned, "appealed largely to a sense of design or form . . . Dada and Surrealist objects have primarily a psychological interest—bizarre, dreamlike, absurd, uncanny, enigmatic . . . ; objects of 'concrete irrationality.'"[85]

As a young graduate student, Barr had discovered the surrealists in 1925, soon after the movement started. He wrote an explanation of surrealism for a friend, Jean Frois-Wittman, an analyst-in-training, that revealed a far deeper understanding of the complex precepts than the objective language he used in the catalogue.

> The sur-realistes [translated in 1929 as Surrealists] shun the intellect in favor of the subconscious. They rebel against the analytical in order to rehabilitate the imagination. They explore the pre-logical functioning of images before they are tested by the reality-adapted intelligence while they remain pure inorganic, imaginal material. For logic is the easiest way for a mind so lazy that it cannot think outside its conceptual cage; naturally agoraphobic, the rational mind fears freedom. . . . Superrealism [later changed to Surrealism] asserts absolute freedom for the imagination. [The] mental life of some psychotic patients [is] capable of producing magnificent ideas—new, unforeseen relations as moving, as full of lyricism and pure poetry as the dreams, the legends or the myths.[86]

In his introduction to the exhibition catalogue a decade later, Barr did not allow himself the self-indulgence of such personal insight. He reverted to his usual objective stance, feeling restrained by the exigencies of making himself understood by a broader public. He also was unable to extend his narrative beyond description because "we are still too close to it to evaluate it." Barr used an essay by Georges Hugnet for the catalogue of the exhibition because, he wrote, the French poet's approach was historical.[87]

In the earlier *Cubism and Abstract Art* catalogue, he had attempted a description of the surrealist movement by dividing the surrealist work into two kinds: automatic pictures and dream pictures. In the category of "spontaneous impulse," he slotted Masson, Miró, Arp, and, sometimes, Ernst and Picasso. For the second dreamlike work, he suggested De Chirico, Tanguy, Dalí, Magritte, and again Ernst, who "used a technique as realistic and deliberate as that of a Flemish or Ital-

ian master of the 15th century." On the chart he had constructed for the cover of
the *Cubism and Abstract Art* catalogue, Barr placed the first kind of surrealist paint-
ing on the left-hand side at the end of the sequence that followed the genetic line
from Gauguin and Redon, through Matisse to Kandinsky, and then Klee of the Blue
Rider group.[88]

Barr then proceeded to do what he had always done; he analyzed the formal
qualities of their paintings. "The art of Masson or Miro at its most characteristic is
flat, two-dimensional and linear. Masson's drawing 'Furious Suns,' in spite of its
vehemence, suggests the half-conscious (but not disorderly) scrawl of an absent-
minded man, or the scribbling of a child of four." Barr here made note of the im-
portance of children's drawings to the modernist artist. And again in Miró's work,
which he considered "almost meditative, wandering, like a river over a flat
plain . . . his forms have the convincing gusto of primitive cave paintings or chil-
dren's water colors."[89] Cognizant of the ongoing interest in "biomorphic" forms,
Barr noted the use of Arp's "'shape,' a soft irregular curving silhouette half-way be-
tween a circle and the object represented" in the work of Miró, Tanguy, Calder,
and Moore.[90] Having made bewildering accommodations to the pressures of the
art world (such as circling around and backing up with the issue of the dominance
of American or European art in the Museum, or of how modern the Modern should
be), since his clear-eyed observances of the 1920s, Barr, "at the risk of general-
izing," cautiously predicted: "the geometric tradition in abstract art, is in the de-
cline. . . . The non-geometric biomorphic forms of Arp and Miro and Moore are
definitely in the ascendant. The formal tradition of Gauguin, Fauvism and Expres-
sionism will probably dominate for some time to come the tradition of Cézanne
and Cubism."[91] In fact, the exhibition "Cubism and Abstract Art" and its catalogue
in no small measure helped realize the prophecy of the ascendancy of "biomor-
phic forms" in the next generation of abstract expressionists.

PICASSO, 1939

During the years 1937 and 1938, Barr was busy fulfilling a long-held plan of
Goodyear's to send an exhibition of American Art to France: "Trois siècles d'art
aux Etats-Unis" opened at the Jeu de Paume in Paris in 1938.[92] He was also busy
overseeing construction of the new Museum building; just before the outbreak of
war in 1939, its completion was marked by: "Art in Our Time: An Exhibition to
Celebrate the Tenth Anniversary of the Museum of Modern Art and the Opening
of Its New Building Held at the Time of the New York World's Fair." Next came the

71. Pablo Picasso, *Two Nudes*, Paris, late 1906. Oil on canvas, 59 5/8
× 36 5/8 in. (151.3 × 93 cm). The Museum of Modern Art, New York,
Gift of G. David Thompson in honor of Alfred H. Barr, Jr.

first of many retrospectives: "Picasso: Forty Years of His Art," a show for which Barr had worked long and hard. Until then he had been hampered by museum politics, world politics, and the temperament of the artist. Margaret Barr asserted: "How many years A[lfred] has hoped and worked and schemed for this!"[93] In the catalogue, Barr dealt systematically with Picasso's changes of style from 1898 as a youth of "extraordinary talent" to 1937 when he painted *Guernica*.[94]

After describing the blue period and then the rose, Barr singled out *Two Nudes* (fig. 71) of 1906 as "the logical conclusion of these two tendencies." He surmised that Iberian sculpture had led Picasso to deny traditional convention or beauty. He

72. Pablo Picasso, *Les Demoiselles d'Avignon*, Paris, 1907. Oil on canvas, 96 × 92 in. (243.9 × 233.7 cm). The Museum of Modern Art, New York, Acquired through the Lillie P. Bliss Bequest.

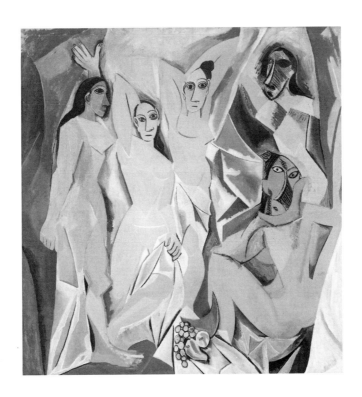

considered Picasso's new direction "an assertion of his growing interest in objective esthetic problems, in this case the creation of volumes and masses and their composition within the painted space of the picture."[95]

It was with the painting *Les Demoiselles d'Avignon* (fig. 72) that Barr, in an unsurpassed unflinching pronouncement, set the stage for future critical debate by proclaiming the advent of cubism:

> For the breaking of natural forms . . . into a semi-abstract all-over pattern of tilting, shifting planes is already cubism. . . . *Les Demoiselles* is a transitional picture, a laboratory or better a battle field of trial and experiment; but it is also a work of formidable dynamic power unsurpassed in European art of its time. Together with Matisse's *Joie de Vivre* of the same year it marks the beginning of a new period in the history of modern art.[96]

Although many interpretations would be generated by *Demoiselles*, the naming of the initiation of cubism by Barr became the central fact upon which subsequent histories of modernism turned, whether it would be confirmed or contested.[97] After examining Picasso's preliminary drawings for *Demoiselles*, in the course of which he had removed some motifs, Barr concluded: "All implications of a moralistic contrast between virtue (a man with the skull) and vice (the man surrounded by food and women) have been eliminated in favor of a purely formal composition which as it develops becomes more and more dehumanized and abstract."[98]

As Barr concedes, one explanation for Picasso's invention of cubism could be found in his statement to his dealer Kahnweiler around 1908: "In Raphael painting it is not possible to establish the distance from the tip of the nose to the mouth. I would like to paint pictures in which that were possible."[99] Barr referred to this statement as an illustration of the "*mensurational* character of most cubist drawings."[100] Picasso seemed to be preparing the groundwork for the tilting planes of cubism that would replace traditional one-point perspective with a phenomenological one.[101] But in today's fascination with interior analysis, neither Picasso's admission of an attraction to depicting sensual distance nor Barr's adherence to

analyzing formal composition explains Picasso's obsession with scrambled facial features.

Commenting only that a picture is "mysterious" or filled with "tension," Barr perhaps was following Picasso's protestations concerning interpretation. "When I begin a picture," Picasso remarked, "there is somebody who works with me. Toward the end, I get the impression that I had been working alone—without a collaborator." Picasso's claim that his inspiration came from some unknown exterior point, an "oceanic" feeling commonly described by artists, relieved him of any responsibility of intention. And if he had no conscious intention, there could be no interpretation: "How could anyone enter into my dreams, my instincts, my desires, my thoughts, which have taken a long time to mature and to come out into the daylight, and above all grasp from them what I have been about—perhaps against my own will?"[102] By restricting himself to formal analysis, Barr was following Picasso's dictum that cubism was a "language peculiar to art 'dealing primarily with forms.'"[103]

Still, Barr's formalist descriptions when viewed in their totality at times approach a lyrical understanding. In comparing Matisse's *Joy of Life* with Picasso's *Demoiselles d'Avignon,* he wrote: "Matisse's nymphs lolling in a bosky meadow or dancing a Dionysian round in the distance could scarcely be further removed from Picasso's *filles de joie* in their curtained interior. Matisse's figures are scattered sparsely over a perspective as wide and deep as a vast ballet stage; Picasso's loom like giantesses on a shallow, crowded, cabaret-like platform. Matisse's style is spacious, easy, curvilinear, flowing; Picasso's rectilinear, cramped, angular, rigid. Lastly, the effect of Matisse's *Bonheur de vivre*—enjoyment of the good life—fulfills its title, but the effect of *Les Demoiselles d'Avignon* is forbidding, formidable even frightening."[104]

Ignoring biography, the contingency of history, and the pressure of influences, Barr accounted for the twists and turns of Picasso's stylistic changes by the preconceptual "genius" of the artist. This intuition of Barr's was a belief that became a method. It insisted that the work of art was autonomous and that the ideals of "freedom," "truth," and "perfection" were its fundamental enfranchisement. The creative intuition as a primordial force was the underpinning of the writings of such

73. Pablo Picasso, *Three Musicians*, 1921. Oil on canvas, 79 × 87 3/4 in. (200.7 × 222.9 cm). The Museum of Modern Art, New York.

philosophers as Konrad Fiedler and Henri Bergson at the beginning of the century and Jacques Maritain in Barr's time. Barr once wrote that

> the whole argument of 'order' seems to me weak, if actually applied to . . . works of art. Order can be intuitive—indeed I would think it probable that the deepest order in art is intuitive rather than intellectual or rational. Artists have themselves the right to establish their own standards of visual reference and that the standards of Pollock, Kline, and Motherwell are every bit as valid as the standards of such artists as Villon or Feininger, whose works have obvious or-

der. In short, one man's order is another man's chaos . . . or better one man's or-
der is another man's prison.[105]

Picasso's oeuvre lends itself to dismantling into a schema of separate manageable
units of formal relationships perhaps more than any other painter's of this century;
yet psychobiographical associations have been irresistible.

Barr saw the *Three Dancers* of 1925 in the Tate Gallery as the start of Picasso's
involvement with surrealism. He felt that compared to the *Three Musicians* (fig. 73)
whose distortions were "objective and formal," the convulsive emotional violence
of the left-hand figure of the *Three Dancers* "cannot be resolved into an exercise
in esthetic relationships, magnificent as the canvas is from a purely formal point of
view." Barr saw the *Three Dancers* as "a turning point . . . almost as radical" as
the *Demoiselles d'Avignon* in Picasso's art, a judgment made conditional by the
word "almost." The work, especially in the left-hand dancer, Barr wrote, fore-
shadowed later periods in which "the psychologically disturbing energies reen-
force or, depending on one's point of view, adulterate his ever changing
achievements in the realm of form."[106]

MATISSE

As important as Barr's contribution to the literature on Picasso was, his book on
Matisse is considered his masterwork. Dedicated to his three mentors, Morey,
Mather, and Sachs, as a "work in progress," *Matisse: His Art and His Public,* pub-
lished in 1954, maintained its critical reputation for twenty years as a model
monograph without rival, and only recently has important scholarship revised
some of his work and supplemented it. Barr's monograph deals with the imma-
nence of Matisse's art—meticulously making material distinctions between the
works of art and the interplay of those works with their background of art histori-
cal influences. Embedded in these analyses are the critical and public responses
to them. Spearheading the positive reactions to Matisse's oeuvre in the early part
of his career were "his loyal friends and supporters"—the four Steins, Hans

Purrmann, Edward Steichen, Marcel Sembat, and Sergei Shchukin. Barr contin-
ues: "They formed the nucleus, but his public, by which we mean to include all
those who responded to his art . . . his teachers and fellow students, then his col-
leagues and the first purchasers of his academic still lifes, then little by little the crit-
ics who began to see his paintings at the big annual Salons organized by artists,
and then in a modest way the dealers." Barr used the artist's reception as "coun-
terpoint to the history and analysis of Matisse's art."[107] In addition, the structure of
the book contains the biography of Matisse, chronologically divided into seg-
ments, as an introduction to the paintings of their period. Barr's intention had been
simply to revise and update the catalogue of the 1931 exhibition, but that task
grew as he compliantly shaped a monumental icon of modernism.

Calling Barr "the father of us all" (referring to future scholars of Matisse), John
Elderfield, a curator at the Museum and a Matisse specialist, lauded the founding
director and "his astonishing reconstruction and ordering of Matisse's oeuvre." He
continued: "From diverse, contradictory and often very incomplete evidence, Barr
fashioned a masterful synoptic study that was also extraordinarily compelling as
narrative, and offered, truly for the first time, a fully argued *idea* of Matisse."[108] El-
derfield cautions that Barr's dating of Matisse's works and the sequence he applied
is no longer valid, despite Barr's rigorous objectivity and documentation. Barr fore-
saw problems: "Setting Matisse's works in a sound chronological sequence has
proven . . . difficult."[109] Matisse was uncooperative because he was uninterested
in dating his work. Barr submitted seven questionnaires to Matisse through the of-
fice of Pierre Matisse or John Rewald that were mostly answered by members of
Matisse's family.

But Barr found that a "a clear historic sequence is essential for an understand-
ing and appreciation both of his development and his importance as an artist."[110]
Despite his reservations, the chronology that Barr established for Matisse's paint-
ings was sustained, if not in the particulars then in a general way by later schol-
arship. Jack Flam groups the work into five periods: Fauve, 1900–1908; Ex-
perimental, 1908–1917; Nice, 1917–1929; Renewed Simplicity, 1929–1940;
Reduction to Essentials, 1940–1954.[111] This follows Barr's chronology overall with
a few minor differences.

The structure of Barr's book is a model of clarity. Sections of information within a time format, defined and distinct, are grouped together to create a schedule of the artist's life, with the accompanying work, patrons, and critics, and along the way explicit and implicit connections are made. Here and there masterworks are illustrated in full-page color, with a legend in a formalist mode that explains the picture dispassionately. The book is thorough, objective, and formalist.

John Elderfield mounted the show "Henri Matisse: A Retrospective" at the Museum of Modern Art in 1992; he said that Barr's book on Matisse was "still the only rigorously art-historical study of virtually Matisse's entire career. . . . [It] was acknowledged to be the greatest monograph that had appeared on a modern artist. Such was its prestige that it seemed actually to discourage further detailed study. Barr has done more for Matisse's reputation than Picasso because Picasso was speaking for himself. Only over the past ten to fifteen years has new scholarship been developed on Matisse."[112] The Matisse book, together with Barr's writings on Picasso, comprise his most important publications. In turn, the exhibitions of those artists and the accompanying catalogues served to help focus attention on Picasso and Matisse as the two most significant artists of the twentieth century. As much as Barr disclaimed being a tastemaker, with the seminal influence of his contribution to the reputations of these two figures he could not avoid it.

The retrospective that Barr mounted in 1931 was the largest one-man show that the Museum had attempted till then, and it contributed to Matisse's international reputation. Twenty years later, in 1951, another retrospective exhibition, no larger than the first, cemented Matisse's place in twentieth-century art. An elegant, well-documented book accompanied the exhibition, appearing after the fact, for Barr was always notoriously late with his writings.

Barr and Matisse were a good match—more so than Picasso and Barr; Barr admired those characteristics in Matisse that he possessed himself: "extraordinary fairmindedness and objectivity."[113] Gratifying his obsession with taxonomy, Barr managed the chronology of Matisse in a clear, coherent structure, mimicking what Jack Flam called Matisse's "bourgeois respectability." Flam, a Matisse scholar, called the book

the most complete and reliable account of Matisse's life and art. Barr's book is not only the best thing we have on Matisse but also one of the best monographs available on any modern artist. For anyone writing on Matisse, it is both a paradigm and an obstacle: a paradigm because of its admirable combination of comprehensiveness and perceptive attention to detail, an obstacle because its organization has come to seem to embody the persona of Matisse himself: neat orderly reasonable.[114]

Flam suggests that Barr's lack of interpretation of individual paintings was a result of Matisse's family "looking over his shoulder."[115] Citing the portrait of Yvonne Landsberg, 1914, as an example, he quoted Barr as hoping that Matisse would "forgive some speculative interpretation of the portrait. One wonders whether Matisse may not have been influenced, perhaps unconsciously, by the Italian Futurists and their theories."[116] In question were the "curved lines which spring from the contours of the figure . . . [and] appear to be systematically developed from the curves of the figure itself."[117] Barr then overdetermined the influences on Matisse that led him to this device, citing sources such as Bergson's *élan vital* "with its suggestions of *being* as change flux or growth," the cubists' merging the figure with space, and an early drawing by Matisse in preparation for the portrait in which the figure of the girl was surrounded by magnolia buds. Barr summed it up—again calling Matisse's inspiration "unconscious"—as an "analogy between a budding flower and the shy, closed personality of his model, for this once transgressed the essential empiricism of his art . . . to produce in the *Yvonne Landsberg* a form, a portrait and a visual metaphor of exceptional mystery and beauty."[118]

It was a poetic fantasy; the journey through the field of Barr's descriptions of the paintings is littered with sensual hedonism. Consider his description of Matisse's *The Egyptian Curtain* (1948):

Instead of following the obvious and comparatively easy formula of leaving his bright window rectangle simply as part of his background wall with the table in front, he has hung a curtain right up against the front plane or picture and

placed the table, spatially, between it and the window. And what a curtain! A barbaric modern Egyptian cotton with the most aggressive and indigestible pattern. And, one might also exclaim, what a window! In all Matisse's score upon score of views through windows the most astonishing is this explosive palm tree with its branches whizzing like rockets from the point where the black mullions cross. Matisse set the bristling palm and the strident curtain side by side in direct competition with each other. . . . [H]e challenges the sensibility of the beholder by balancing dissonances, tension against tension.[119]

The viewer's response has been directed by the excitement of the prose, equaling Matisse's intention. Barr ends his explication of the painting with another implication: "Matisse painted *The Egyptian Curtain* within a year of his eightieth birthday."

Matisse's reputation as one of the most important radical artists of the twentieth century was immediately enhanced by the retrospective in 1951. Although he was given retrospective exhibitions in 1948, 1949, and 1950 in Philadelphia, Nice, Lucerne, and Paris, Matisse had still not attained the role of leader along with Picasso. Barr's speculation was that neither artist "was temperamentally inclined to controversy, and neither had serious ambitions to figure as the leader of a coterie or movement. Both were highly individualistic, and the influence each exerted on others, though very great, was incidental to the development of his own art."[120]

In the end, it seems that it was Picasso who stood his ground in Barr's own inventory of artists. He wrote:

Some kinds of art should be restful and easy—as Matisse said, like a good armchair. Other kinds, like Picasso's, challenge and stimulate us. They are often hard to understand at first but, like our minds and muscles, our artistic sensibilities are strengthened by exercise and hard work. I have never thought of art as something primarily pleasant—but as something which stirs us to a fresh awareness and understanding of life—even of the difficulties, confusions and tragedies of life as well as its joys.[121]

Barr reported that Greenberg entered the fray concerning whether Picasso or Matisse was the more important artist on the side of Matisse. Declaring Picasso the painter of greater historical importance, Greenberg claimed that Matisse possessed a "sensuous certainty" that made him "the greatest master of the twentieth century." Barr then balanced Greenberg's enthusiasm, which at times, he comments, can be "reckless exaggeration," with a quote from Robert Motherwell: "Matisse may be the greatest living painter but I prefer Picasso: he deals with love and death." To which Barr replied "but Matisse deals with love and life."[122]

The strongest criticism of Barr's Matisse book has been that he paid no attention to iconographic or psychological elements. But Barr's ability to add poetry to his discourse elicited a sensual response to the work of art that nourished the aesthetic experience of his audience. He disdained intellectual theorizing not only because he felt inadequate but in deference to the interests of his public.

BARR'S HIDDEN AGENDA

Barr acknowledged his intellectual dilemma of being caught between the art of the machine aesthetic and the art of expression—between objectivity and subjectivity. Although he saw it as a problem of twentieth-century aesthetics, in a rare youthful moment of self-revelation he noted: "I had the feeling that my emotions were too ephemeral to be indulged—ephemeral because at any moment I could turn on the cold light of my mind and make it disappear. Most youths would long before have suppressed this objectivity instinctively. I couldn't because of my habit and nature."[123] Barr's quandary may prove to have been the creative source of his consequential work. He fits into the description of the closely examined scholar-cum-artist:

> The significance of a writer, whether poet or philosopher or historian . . . does not reside principally in the conscious intention behind his work, but rather in the precise nature . . . of the conflicts and imaginative inconsistencies in his

work. . . . Any form of civilized life is sustained at the constant of some denial, or reversal of feeling, and of some self-deception, at the cost of fabricating myths and speculative hypotheses, which will seem, to an entirely detached and scientific eye at some later date, a kind of madness or at least an indulgence in illusion. . . . It is generally only in retrospect that we can see why a concern that might at the time have seemed marginal, scholastic, academic in the abusive sense of this word, was in fact a working out in apparently alien, or even trivial, material of an exemplary conflict of values, which had a much wider relevance.[124]

Challenged by "Spenglerian gloom"[125] in his student days, Barr and his Harvard coterie turned to modern art as the means by which the crisis state of the world would be righted. He evoked Maritain's more positive philosophy in *Art and Scholasticism* for "the light thrown upon art and aesthetic theories of our own bewildered age, stricken by war, and by peace, and recoiling bitterly from the optimistic naturalism of the last century."[126] Later Barr wrote: "Art is a *visual* demonstration, a revelation of modern life. But by life I do not mean merely the world of ordinary experience—people, families, landscapes, streets, food, clothes, or the collective life of work, politics and war, but also the life of the mind and the heart—of poetry and wit, science and religion, the passion for change or for stability, for freedom or perfection."[127]

"Perfection" along with "freedom" and "truth" comprised, for Barr, the working imperatives of an artist's sensibility. Freedom to experiment liberated the artist from the exigencies of the past; truth was meant to emulate the scientific process rather than any philosophical good; and perfection allowed the artist to participate in progress—in the perfectibility of man. For him, these ethical concerns justified modern art as a style worthy of scholarship beyond the constricted values of formalism. His taste, the choices that were assembled in exhibitions or collections, added up to judgments as heavily weighted as theories of art.

EPILOGUE

After fourteen years at the helm, Alfred Barr's tenure as director of the Museum of Modern Art came to an end when Stephen Clark (fig. 74), chairman of the board of trustees, precipitously fired him on October 13, 1943. Barr had been having difficulties for the preceding six years on a variety of fronts: his taste was running ahead of the trustees', his writings were always behind schedule, and, in the area of administration (which he disliked), competing forces were undercutting his efforts.

Barr's correspondence reveals a man with chronic frail health and an insomniac disposition. One can speculate (as his good friend Philip Johnson did) that Barr was subject to "psychosomatic"[1] manifestations as a result of an intense inner life as well as from stresses caused by the trustees. His enemies ranged over a broad front of staff members, hostile critics of modern art in general, or adherents of one mode of art or another. In 1932, after three years of constant pressure, he was given the year off, arranged by Abby Rockefeller, to recuperate from what

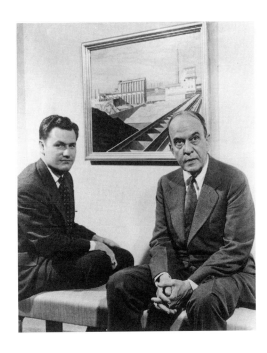

74. Nelson A. Rockefeller and Stephen C. Clark, 1939.

was called a "nervous breakdown." While Barr was in Europe, on April 24, 1933, she wrote informing him of an executive committee meeting that had taken up the question of how "we could best cooperate with you in your effort to be really strong when you return to the Museum." She felt that the "whole attitude of the Committee was most sympathetic and understanding." The solution was to give Alan Blackburn the responsibility of the "business matters of the Museum."[2] Even so, it eventually was Barr's failure at his administrative duties—he was too slow and deliberative—that forced him out of the director's job. That Barr ran into trouble early on should not be a surprise; his vision was too liberal, progressive, and freethinking for some of the trustees. As a passionate, strong-willed visionary, he had to contend with powerful people protecting both their predilections in art and their money. While Barr was considered "a god" by those who agreed with his taste and his policies,[3] those who disagreed thought of him as the enemy. In countering a critic's vitriolic attack on him as a "Svengali,"[4] Barr protested that it

was not his "diplomatic ability" and "expert maneuvering" that had led to what she saw as the Museum's "deplorable policies and actions," but the "tactless, stubborn insistence" for which he was well known.[5]

BARR'S BATTLE WITH THE TRUSTEES

Besides Barr's perceived weakness as an administrator, the trustees were irritated by the surrealist show of January 1937, and particularly by such works as Man Ray's *Observatory Time—the Lovers* (fig. 75), the painting of the blown-up lips of Lee Miller, and the fur-lined tea cup (see fig. 70) by Meret Oppenheim, which

75. Installation view of the exhibition "Fantastic Art, Dada, Surrealism," The Museum of Modern Art, New York, December 7, 1936, with Man Ray, *Observatory Time—the Lovers*.

gained notoriety when Emily Genauer vociferously complained about it in her article "The Fur-Lined Museum."[6]

From the beginning, Barr found Conger Goodyear contentious, but it was not until the surrealist show that he found himself in serious trouble; he lost the support of Abby Rockefeller. Goodyear wrote to Mrs. Rockefeller about his dismay with the surrealism show: "The present exhibition in the museum has been rather disturbing to me and I think its reception by the public and the critics has been far from flattering. The unfortunate part of the exhibition is that it includes a number of things that are ridiculous and could hardly be included in any definition of art."[7] He recommended that committees have more supervision of works selected for shows.

Although the surrealist exhibition was the cause of Rockefeller's and Goodyear's initial dismay, it soon escalated: "It would seem wise to me," she wrote, that "we should from now on have a director who directs. One who has the confidence and sympathy of the trustees and who is able to help raise money, as well as interest people in giving their collections. As you know, I greatly admire and respect and trust Alfred Barr. I have often said I feel that he *is* the Museum. Because of the catalogues he has made the greatest possible contribution to the study of modern art in America, but I feel that he is neither physically nor temperamentally suited to cope with the intricate problems of the management of the Museum or the management of the trustees."[8] Goodyear replied that he agreed with her and that despite the fact that Barr was temperamentally unsuited to handle many of the problems that are usually the director's responsibility, he nevertheless could take credit "for a very large part of the unquestioned success that the Museum has had during the past seven years . . . a most surprising success."[9]

Exasperated by Barr's indirect methods, they brought in Artemas Packard from Dartmouth College to make a study of the situation and to recommend solutions. Rockefeller and Goodyear began an action that would place a president of the Museum over Barr. Although Barr constantly praised those he worked with, including the board of trustees, the impression remains that his accomplishments at the Museum were made through outmaneuvering rather than cooperating with them.

Barr survived this assault and, in January of 1938, he survived the organizational charts prepared by Tom Mabry, the business administrator who succeeded Blackburn. Emphasizing Barr's ability to install exhibitions ("dramatization of material," Mabry wrote, "is his genius"), Mabry planned to confine Barr to the role of director of exhibitions and curator of the department of painting and sculpture. The hierarchy was changed to build up the various departments with capable men who would contribute material for exhibitions that would then be directed by Barr.

Barr, indeed, had built a reputation for showmanship in installing exhibitions for which, wearing dark glasses to protect his weak eyes, he would exhaust himself—finishing the job by propelling himself around in a wheelchair.[10] In 1934, he had written to his old friend Edward King about his method of installation, which followed a didactic plan: "Hanging pictures is very difficult, I find, and takes a lot of practice. I feel that I am just entering the second stage of hanging when I can experiment with asymmetry. Heretofore I followed perfectly conventional methods, alternating light and dark, vertical and horizontal."[11] Flouting the European convention of skying, the paintings were also hung lower than usual by Barr, perhaps as a result of his Harvard training where exhibitions were installed to accommodate Sachs's short stature or, as one historian conjectured, to establish an "eye to eye" relationship to enhance "the awareness of the object's, and the individual's independence. This aestheticized, autonomous, seemingly 'neutral' exhibition method created an extremely accommodating ideological apparatus for the reception of modernism in the United States."[12] It reinforced the concept of the artist as hero and genius, working within the myth of the American dream, an idea Barr shared with Sachs.

Mabry had missed the point. The dramatization of an installation was not just showmanship but a planned panorama of juxtapositions of works of art that echoed and resonated as a synthesis, thereby increasing the viewer's understanding of the individual works but ignoring the conventional method of hanging pictures according to size or shape and formal qualities. Asymmetry fulfilled a plan that helped Barr describe historical relationships. He also developed techniques that enhanced the exhibition and were widely copied, such as movable

walls, effective lighting, and wall labels that provided biographical, technical, and historical background.

More trouble arose when Barr indulged his sense of whimsy by installing a shoeshine stand at the entrance of the Museum at Christmastime in 1942. Barr's explanation was on a wall label: "Joe Milone's shoe-shine furniture is as festive as a Christmas tree, jubilant as a circus wagon. It is like a . . . baroque shrine or a super juke-box. Yet it is purer, more personal and simple hearted as any of these. We must respect the enthusiasm and devotion of the man who made it."[13]

However, the event that precipitated his dismissal occurred the following year, 1943, when a retrospective of the primitive paintings of Morris Hirshfield, a retired Brooklyn manufacturer of slippers with no formal artistic training, particularly provoked Clark and a few other conservative enemies. Although other people were involved in the show, Barr was blamed. Among other things, one of the nude models Hirshfield painted had two left feet, presumably, because salesmen's samples were made only for left feet. (Just as likely was the explanation that Hirshfield couldn't manage to paint an image of the right foot.)

FIRED

By 1939, Goodyear had retired and Mrs. Rockefeller was slowly withdrawing in favor of Nelson. Clark was left in charge as chairman of the board. As a collector, Clark unreasonably prided himself on his ability to be independent in his selections. He never employed the services of a dealer, advisor, or curator; he felt that his own experienced eye was judgment enough. According to Dorothy Miller, Barr's assistant and close colleague, "he couldn't bear it if he thought that somebody knew more than he about art."[14] He was resistant to works by artists after the early modernists; unable to tolerate Matisse, Clark sold those works in his collection. He also was known to imperiously remove a painting he didn't like from the wall of an exhibition.[15] But it was not only Barr's and Clark's differences in taste that caused the upheaval. The Museum had incurred deficits for three years in a row[16] and Clark felt that a stronger, more decisive man than Barr was needed to

lead the Museum. Barr's weakness was that he could not delegate responsibility; his anxiety was that the completed tasks would not meet his high standards.[17]

Barr's neglect of his writings particularly rankled Clark; the trustees had materially gained from the worldwide reputation Barr had secured for the Museum from his catalogues and exhibitions.[18] In the spring before he was fired, Barr had written to Clark outlining his aims for publishing. The letter revealed his preoccupations. He was thinking about redoing *Cubism and Abstract Art:* "This is the only catalogue I have written which approaches the scale of a book. It might do for a Ph.D."[19] In fact, he revised the Picasso catalogue instead and wrote *Picasso: Fifty Years of His Art,* submitting it to Harvard for a doctoral degree that he obtained in 1947. He also intended to write a brief survey of modern painting, which he did in 1943, published as *What Is Modern Painting?*[20] He thought he would also do a short history of modern art, but that was not accomplished.

He also seemed to be explaining away his inadequacies to Clark: "During my dozen years at the Museum I have lived more or less hand to mouth so far as my reading and intellectual life are concerned. Whatever knowledge I have accumulated has been the result of juried visits to artists' studios, and dealers to borrow or buy pictures, and forced marches while preparing catalogues."[21] Barr bemoaned the fact that he had no time to read men who did have the time to think deeply about the subject: Sigfried Giedion, Herbert Read, Edward Rothschild, R. H. Wilenski, and Lionello Venturi; and he had only casual knowledge of the work of Alfred Whitehead, Jacques Maritain, Wyndham Lewis, Oswald Spengler, and others "who have written on the general critical state of modern culture of which modern art offers such important evidence."[22]

Monroe Wheeler was appointed director of exhibitions in 1940 to relieve Barr of administrative duties that had been restricting his ability to write. In 1943, James Soby was appointed assistant director of the Museum to further ease Barr's position. But Clark was not satisfied with Barr's progress, and after many skirmishes along the way, Clark, hiding behind the issue of publications, attempted to fire Barr. Barr was informed by letter from Clark on October 13, 1943, that he had to step down as director; his services would be best utilized as a writer and a scholar. He was told that his lack of productivity did not justify his salary, which

would be cut in half, and the position of director would be abolished. He was to vacate his office and work outside the Museum: "A small and efficient executive committee [would] coordinate the various departments and maintain the cultural standards of the museum."[23]

Clark wrote to Abby Rockefeller that he had appointed Barr "advisory director" of the Museum, relieving him of administrative routine duties and enabling him to devote his entire attention to writing. Soby was appointed director of the department of Painting and Sculpture, and a coordination committee consisting of department heads would take over running the Museum with John Abbott as chairman. Clark was astonished at "how few friends Alfred Barr has among the Trustees and staff."[24] But this was a misperception; the curatorial staff remained loyal to him.

BARR'S TENACITY

The poignancy of Barr's reaction (while writing a letter in response to Clark, "he didn't get out of his pajamas for a month")[25] was indicative of his psychic terrain, shaped in a bygone era. The moral tenor of the art world in the 1930s—his idea that art would change the world—engendered his mourning; this was the man who had told his mentor that he could "devote his life unstintedly" to the museum.

Barr wrote to Mrs. Rockefeller that he was distressed at the action of the board, but not because he was "discharged from the directorship for that position had become so thankless, so ambiguous and so difficult that I am glad to have been relieved if it."[26] He was most upset that he had been unable to present his case, which revolved around the needs of the Museum. He admitted he had not been able to establish "an easy and sympathetic rapport" with Clark "even with the best intention on both sides."[27] He thought that he had caused Clark worry and exhausted his patience but "after talking with both his friends and mine, I begin to think that he really has not understood the character of my responsibilities or the nature and value of my work in the Museum."[28]

Barr also wrote to Sachs raising points he knew would appeal to his mentor. Sachs had supported the idea of a permanent collection for the Museum of Modern Art as a measuring tool that could be used by viewers in assessing temporary exhibitions.[29] But Barr felt that Clark was resistant to an educational approach to gathering a museum collection, and he bemoaned the fact that Clark thought Barr's only use to the museum was as a scholar and writer.[30] As for Clark himself, he wrote to Abby Rockefeller on October 28, 1943, that Barr had requested to "be allowed to keep a small office . . . to work on his History of Modern art. If Alfred has an office of any kind, or even a desk, in the Museum it would surely invite trouble as his satellites would begin to gravitate around him and he would soon be back where he stood before." Clark's estimation of him was meant literally: "As soon as [Barr] leaves we will get rid of a number of esthetes . . . but Soby, although a friend of Barr's, is in an entirely different story."[31] Dorothy Miller was patently loyal: "It was Alfred's directness and honesty and passionate, passionate feeling about things that put Stephen Clark off and made him feel that he couldn't work with this man. Without knowing it, Alfred made Clark feel like a fool because Alfred was always right."[32]

Soby, having worked at the Museum of Modern Art since 1937, was incensed that Barr had been asked to step down. He was the only trustee who recognized the significance of Barr's work, and he tried, with Margaret Barr, to persuade Barr to resign and said he would resign with him. He knew that Mabry and Hawkins had been disparaging of Barr with Clark. But Barr couldn't conceive of anyone undermining him. Soby remarked: "His loyalty to them was unshakable, and to the Museum, absolute, to the point of self-immolation."[33] Barr, always persistent, would not budge, though he had received many offers to join other museums, including the Fogg. His single-minded sense of what was best for the Museum provided him with a value system, bolstered by self-righteousness, that superseded his relationships with museum people who feared him. Although he was considered thin-skinned, it was only in regard to the activities of the Museum, not to his personal fortunes.

Persuading other members of the board that an injustice was being done, Soby managed to keep Barr in the Museum. A small office was constructed in the Li-

brary, and a stream of curators seeking his advice found the path to his door. Soby changed his mind about leaving and accepted the position as director of the department of Painting and Sculpture and stayed through January of 1945. By then, Clark had begrudgingly made peace with Barr.

Knowing the seriousness of Barr's intent, and the pertinacity that enabled him to carry it through, to say nothing of his intelligence and courage, Clark capitulated, and in 1947 Barr became director of the collections,[34] with Dorothy Miller as his assistant, confirming Clark's prediction that he would return to power.[35] He did perhaps his best and most permanent work between the years 1947 and 1967. Besides assembling an incomparable collection of modern art, he expanded his Picasso book and wrote the monograph on Matisse. He also compiled the catalogue of the Museum's holdings, *Painting and Sculpture in the Museum of Modern Art, 1929–1967.*

For several years, Barr felt he had been utterly betrayed by Abby Rockefeller because she allowed him to be fired without coming to his defense, even though she wrote to Barr that she thought it was for his own good. Yet by 1948 Barr had come to realize that, in the long run, Mrs. Rockefeller might have been correct in suggesting that he not be the director of the Museum.[36] He had been reestablished, and could admit that the Museum had became too complex and the job of administrative director too big for his abilities or interests.

THE NEW DIRECTOR

After many years of involvement with the Museum, Nelson Rockefeller became president in 1939; he brought René d'Harnoncourt to the Museum in 1944. He had employed d'Harnoncourt as head of the art section of the Office of the Coordinator of Inter-American Affairs in Washington (CIAA) in 1943, having been impressed by an exhibition that d'Harnoncourt, as guest curator, had mounted in 1939 at the Museum of Modern Art, "The Indian Arts of the United States." Known for his grace and charm and his ease with the board, d'Harnoncourt (fig. 76) soon rose to an executive position; he was named director of the Museum in 1949. As

a person who was more able to placate the trustees, he complemented Barr and allowed him to concentrate on the collections. Barr realized the effectiveness of the partnership, and they worked in tandem until Barr retired in 1967.

Barr wrote that the ideal museum director needs, among other things, administrative, promotional, financial, and diplomatic ability. Moreover, he needs understanding of and sympathy for professional integrity—all this in addition to some professional achievement in his own field. "I had some abilities as a writer, curator, showman, etc. and perhaps a modicum of professional integrity, but I was inadequate as a fund raiser, general administrator and diplomat." Barr opined that the expectations for the founding director were overwhelming because of "the amount of detailed professional work which had to be done by an inadequate staff." Realizing this, the trustees helped with the administrative, promotional, and financial responsibilities. Barr admitted: "The really able and successful museum director is the man who can wisely gain his point or take his stand without sacrificing his personal or professional integrity, but at the same time without unneces-

76. René d'Harnoncourt and Alfred H. Barr, Jr., at d'Harnoncourt's birthday party in the Abby Aldrich Rockefeller Sculpture Garden, Museum of Modern Art, 1961.

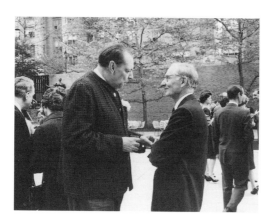

sary conflict and friction, obviously I was unable to do this." And he knew that d'Harnoncourt did.[37]

One of the pleasures of reading Barr's letters is to recognize his objectivity and rigorous integrity; it leaps from the page. When he wrote the *New Yorker* profile of Barr and the Museum in 1953, Dwight Macdonald found Barr's objectivity constant even when it subverted his own interest, "a very rare trait, at least in 'profile' subjects."[38] Barr had been hesitant about doing the profile and had turned down four previous overtures. Aside from the "fear of personal embarrassment," he was uneasy about the close identification of the Museum with himself and tried unsuccessfully to circumvent it. When his contribution to the Museum came up, he emphasized the roles of different staff members such as d'Harnoncourt, Soby, and Dorothy Miller. D'Harnoncourt, he thought, was an expert on primitive art, as well as "the world's foremost master of museum installation. He is also in many ways a highly *effective* museum director—far more than I was because, while he has strong convictions and professional integrity, he is able to persuade where I could only argue."[39] As for d'Harnoncourt, he often repeated that his "duty at this museum is to preserve and nourish the genius of Alfred Barr,"[40] a sentiment that Barr didn't fully appreciate.

BUILDING THE COLLECTION

From 1947 until his retirement in 1967, Barr served as director of the museum collections, in a second career as important as the first, in which he indulged his catholic taste to ensure an expansive modernist aesthetic in the collections of the Museum of Modern Art. With Dorothy Miller as curator of collections, and with Soby's help as chairman of the acquisitions committee, Barr built a permanent collection that is perhaps his most lasting achievement.

The story of the making of the Museum's collections is necessarily complex, deeply embedded in the policies of the Museum and, since the late 1960s, in multicultural politics. The potent combination of art and money, whether in the marketplace, with the patron, or in the functioning of the Museum presents an

inherently explosive situation. The taste of the trustee can conflict with that of the director, and the inherent character of a patron's power can demand conditions that they attach to their gifts.

From the beginning, Barr campaigned for a permanent collection. In his first brochure in 1929, *A New Art Museum,* he wrote that since "New York alone, among the great capitals of the world, lacks a public gallery where the works of the founders and masters of the modern schools can today be seen . . . the ultimate purpose will be to acquire, from time to time, either by gift or purchase, the best modern works of art." His professed aim was educative: through the collections, "students and artists and the general public could gain a consistent idea of what is going on in America and the rest of the world."[41] Although the galleries of the Société Anonyme and A. E. Gallatin's Gallery of Living Art were in place, Barr felt that they didn't have the institutional strength to fulfill the purposes he envisioned.

In 1933, Barr presented a 22-page, long-range plan for building a collection. It contained a diagram of a metaphoric torpedo that has been often repeated: "The Permanent Collection may be thought of graphically as a *torpedo moving through time* [fig. 77], its nose the ever advancing present, its tail the ever receding past of fifty to a hundred years ago."[42] Barr's vision of an ideal collection had him in thrall; he believed that a fluid collection could be maintained by constantly refining it, and thus keeping it continuously modern.

These issues were endlessly debated: Should the collection be "modern" or contemporary? Should it be classic, with only major works, or also representative, with minor ones? Should it be historical or only qualitative? Should it function like the Tate in London or the Luxembourg in Paris—feeding works that were ten, twenty, or fifty years old to the Metropolitan Museum of Art? Should American art be treated on a par with European? Barr intended to use the arrangement that the Musée du Luxembourg had with the Louvre of selling off the older paintings to the Metropolitan in order to purchase the latest art. He confided to Sachs: "The word 'modern' is valuable because semantically it suggests the progressive, original and challenging rather than the safe and academic which would naturally be included in the supine neutrality of the term 'contemporary.'"[43]

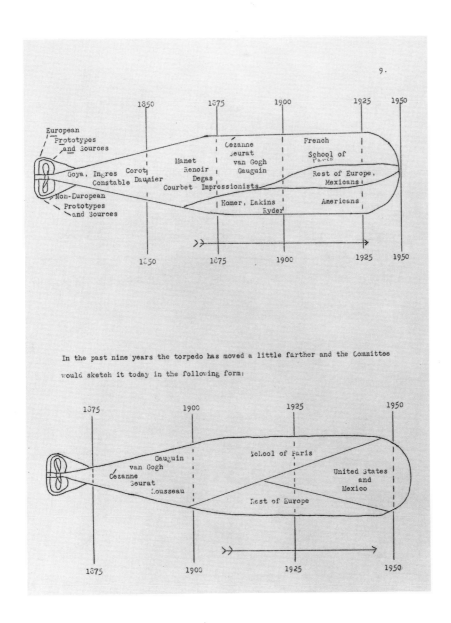

9.

77. "Torpedo moving through time" diagrams of the ideal permanent collection of the Museum of Modern Art, as advanced in 1933 (top) and in 1941 (bottom). Prepared by Alfred H. Barr, Jr., for the "Advisory Committee Report on Museum Collections," 1941. The Museum of Modern Art Archives, New York: Alfred H. Barr, Jr. Papers, 9a.15.

A dialogue began with the Metropolitan in 1932 that did not reach fruition until an agreement was reached in 1947. Paintings from the Bliss collection, like Picasso's *Woman in White* (fig. 78) and Cézanne's *Dominique Aubert, the Artist's Uncle* were sold to the Metropolitan. But in 1953 the dialogue ended and the Museum decided to retain a collection of masterworks. Second thoughts on the collection's ultimate purpose and the value of the works of art were at work. The official establishment of a permanent collection was at hand. It kept in mind the purposes of the Museum, allowing room for both experimental avant-garde art and the ability to retain those works that illustrated the ancestors of modernism. Barr was also mindful that "of our guesses nine out of ten would eventually prove a mistake."[44] Although he was known for his driving passion to acquire objects of quality in painting and sculpture, or any other artifact that entered that museum,

78. Alfred Barr, A. Conger Goodyear, and Cornelius N. Bliss with painting *Woman in White* that was given to the Metropolitan Museum of Art, as the Lillie P. Bliss Bequest is officially deeded to the Museum, 1934.

he consistently filled in the collections with "pioneer" works that had precipitated a moment of change, whether historically, technically or aesthetically.[45]

Space and funds have been continual problems for the Museum. Until 1949, when Barr, Miller, and Soby mounted the entire collection for the trustees, no one had a concept of its scope. Barr listed his guiding acquisition policy as: "Securing the best works by the best artists; Collecting their work in breadth and depth and in all relevant media; Collecting good work by secondary artists; Taking chances with the work of young artists; Searching for good work throughout the world; Other things being equal selecting paintings with vertical formats rather than horizontal—the vertical takes less wall space."[46] In order to lure potential donations to the Museum, Barr was continually mounting exhibitions of the collection until he finally secured space to have it permanently on view.

Barr called the Bliss bequest the "cornerstone" of the collection.[47] Two other women gave most generously in the 1930s: Abby Rockefeller, with gifts of art and funds;[48] and Olga Guggenheim, who gave money for works of masterpiece quality—Picasso's *Girl before a Mirror* (fig. 79) was the first of many such works that greatly enhanced the collection. Barr had an ideal collection in his mind, and he would doggedly pursue particular works for years, such as Picasso's *The Three Musicians*, or Rousseau's *The Dream* that he particularly wanted or needed, making suggestions to a trustee for its purchase to fill the lacunae. He saw his role as advisor to the patrons of the Museum.

On January 15, 1947, he wrote to Abby Rockefeller: "Picasso's *Minotauromachy* [see fig. 18] I believe to be the greatest single print thus far produced in our century. I have looked at it literally hundred of times as it hangs in our living room. It has never worn thin or lost its fascination. The allegory seems to me to reveal dramatically and poetically something of the mystery, the groping paradox, the pathos of man's nature—half beast, half angel—a subject for art which is both immediate and eternal."[49] He had convinced her to donate funds for the purchase of the print, even though she "felt neither affection nor admiration" for it.[50] "In general," he wrote, "her taste did not include the more radical forms of modern art, or those forms which discovered the expressive power of what is ordinarily called ugliness, or art which attacked the social problems of the day. At the same time

79. Pablo Picasso, *Girl before a Mirror*, 1932. Oil on canvas,
64 × 51 1/4 in. (162.3 × 130.2 cm). The Museum of Modern
Art, New York, Gift of Mrs. Simon Guggenheim.

she . . . [bought] a painting from the exhibition of Ben Shahn's remarkable gouaches on the theme of Sacco and Vanzetti."[51]

Continuing to mature as a connoisseur after he became director of the collections, Barr was materially aided by his friends and trustees who donated to the Museum. Philip Johnson, in particular, gave more than 2,200 objects—more than any other donor. He was known for donating those paintings that Barr had trouble getting passed by the board. His first gift was the painting *The Bauhaus Stairway* by Oskar Schlemmer (fig. 80). Barr found the Schlemmer painting in 1933 in Stuttgart and cabled Johnson for permission to buy it in his name.[52] Schlemmer's *Bauhaus Stairway* perhaps had a particular significance for Barr not only because of his experiences with the Bauhaus in 1927, but also because of his bout with Nazism in 1932. He had written a series of articles to warn the world about the dangers it would be facing. To him the warning sign was the repression of the freedom of the artist.

Besides gifts from trustees, other works of art given to the Museum were from people who had longstanding relationships with Barr and the Museum—donors such as Soby, Sidney Janis, Peggy Guggenheim, Katherine Dreier, Sadie May, J. B. Neumann, David Rockefeller; Nelson Rockefeller began in 1942 to give money toward an inter-American fund for the Museum to acquire Central and South American works of art. He also made possible the Abby Aldrich Sculpture Garden designed by Philip Johnson. Nelson Rockefeller gave two of the most significant paintings in the collection: Rousseau's *The Dream* and Matisse's *Dance* (fig. 81). When asked which paintings he considered the most valuable in the collection of the Museum, Barr listed: van Gogh, *Starry Night,* Rousseau, *Sleeping Gypsy,* Picasso, *Les Demoiselles d'Avignon,* Léger, *Three Women,* Picasso, *Three Musicians,* Cézanne, *Bather,* and Matisse, *Red Studio.*[53]

At the twenty-fifth-anniversary celebration, Barr advised Sachs, who was speaking at the opening ceremony, to make sure he lauded Clark and Goodyear for their contributions to the Museum. Barr's canniness was intended to protect these possible donors from any slight.[54] But Barr's conflicts with Goodyear and Clark, despite his best efforts to ameliorate their differences, eventually caused the Museum to lose their collections. Clark left the acquisitions committee because he

80. Oskar Schlemmer, *The Bauhaus Stairway*, 1932. Oil on canvas, 63 7/8 × 45 in. (162.3 × 114.3 cm). The Museum of Modern Art, New York, Gift of Philip Johnson.

couldn't abide the work of Alberto Giacometti, and his split with the Museum came over the acquisition of a Jackson Pollock painting; for Goodyear, the break came when Mark Rothko was introduced.[55] Goodyear left his collection to the Albright-Knox Gallery in Buffalo, and Clark bequeathed his collection to the Metropolitan and various other museums, although he had given the first painting that the Museum received in 1930, Edward Hopper's *House by the Railroad* (fig. 82). Samuel Lewisohn, another trustee and old friend of Barr and Paul Sachs, also left his collection to the Metropolitan.

The problem of the balance between European and American art was taken out of Barr's hands with the advent of the success of abstract expressionism, but not without a lot of discussion in the press. An ongoing controversy has ensued over the Museum's perceived neglect not only of the abstract expressionists but also of American abstract art in general. Barr was accused of forsaking abstract

art when he mounted the Edward Hopper show in 1933, as well as "Romantic Painting in America" and "American Realists and Magic Realists" in 1943. His defense was that there was no arbitrary definition of modern art. He was accused of not acting fast enough to exhibit or buy radical American art despite Miller's "Americans" series of exhibitions.[56] Barr's reply, after citing all the evidence of the Museum's participation in the movement, defended its decisions:

> The Museum's record is far from perfect. Sometimes it was handicapped by lack of money, always by lack of time and space; occasionally it was retarded by differences of opinion, more often I know, by lack of vision. Furthermore—*pace* the partisans—the Museum has not, and I hope will not, commit itself entirely to one faction. Some of the Museum's friends have questioned this policy, urging

81. Henri Matisse, *Dance* (first version), 1909. Oil on canvas, 102 1/2 × 153 1/2 in. (259.7 × 390.1 cm). The Museum of Modern Art, New York, Gift of Nelson A. Rockefeller in honor of Alfred H. Barr, Jr.

82. Edward Hopper, *House by the Railroad,* 1925. Oil on canvas, 24 × 29 in. (61 × 73.7 cm). The Museum of Modern Art, New York, Given anonymously.

that the Museum align itself exclusively with the current past. Its bitterest enemies insist that the Museum has already done exactly that.[57]

In an introduction to his last book, the narrative of the museum holdings, *Painting and Sculpture in the Museum of Modern Art, 1929–1967,* Barr states: "The arrangement in this catalogue is experimental and sometimes inconsistent. Generally it resembles the way the Museum's Collection of Painting and Sculpture is installed in its galleries, that is, with some concern for both history and esthetics."[58] For Barr, history was the evolution of style, and his aesthetics were the critical ability to define that style with a display of the artist's best work.

Barr stated his aims:

> I have tried to raise the study of modern art to a scholarly level approaching that of older fields. Such research and publication require somewhat different techniques, but are otherwise fundamentally the same as the study of older art. The Museum publications are some evidence of this effort. Indeed, they have been accused of being more scholarly and elaborate than the subject justifies. I cannot agree with this since I think the subject is important. Though future scholars may find that we made mistakes in choosing some of our artists, they will be grateful for our monographs on those whom we have chosen wisely. I think of scholarship not only as a matter of facts, but also of criticizing and more importantly as an effort to arrive at broad conclusions and judgments. This is the most difficult thing. In the modern field I have tried to relate the present to the past and art to other human activities.[59]

Barr's achievement and reputation far outdistanced his immediate role as a popularizer of modern art. He functioned as an educator through his sensitive scholarly writings, his entrepreneurial exhibitions that were displayed with informative wall labels, and through the collections he directed. The purpose of showing movies, a popular art, was "to raise the question of quality and of the lasting value of the established films, by dignifying them through exhibition under the same roof with some of the best paintings, sculptures, etc. of the present and recent past. We have

attempted the same thing in relation to fine design in furniture, utensils, cars, etc. and vice versa. We hope that showing the best in these arts of popular entertainment and of commercial and industrial design will mitigate some of the arcane and difficult atmosphere of painting and sculpture."[60] He felt that because "in our civilization a general decline in religious, ethical and moral convictions, [has taken place] art may well have increasing importance quite outside esthetic enjoyment."[61]

In October of 1979, a special issue of *Art News* was devoted to the celebration of the fiftieth anniversary of the Museum of Modern Art. On the cover was Barr, his hand to his forehead, listening to music, a characteristic pose (fig. 83).[62] The image was a fitting tribute to the man who—though he appeared at times to be contending with more adversaries than he could possibly handle—fashioned the Museum so that it was universally esteemed as a model of its kind.

In the last article of the special issue, "Paradigms, Watershed and Frosting on the Cake," fifty well-known people from the art world were asked to choose "people, objects and events—epochal and nostalgic—that reflect MoMA's 50 years."[63] It was impossible for them not to mention Barr's name; many specifically talked about his "eye." The artist and museum director John Coplans said simply, "Alfred Barr's eyes";[64] Philippe de Montebello, director of the Metropolitan Museum of Art, expanded upon "the eye and the mind of Alfred Barr" by mentioning two works Barr had acquired in the 1930s: Picasso's *Les Demoiselles* and Malevich's *White on White*.[65] The capability of the "eye" commands a sensitivity for forms in individual pictures, whether of color, shape, or composition. But more than that, it presupposes a worthy collection of works. The reputation of the Museum of Modern Art, in the long run, rests on the permanent collection amassed by Alfred Barr. Shunning interpretation but endowed with poetic insight that he revealed in flashing glimpses, Barr arrived at a comprehensive historical record of modernism that has had lasting value.

Preternaturally modest, he was also justifiably proud of having created what was considered the "best" collection of modern art in the world. He had accomplished his aims: "The Museum collections as exhibited should be for the public the

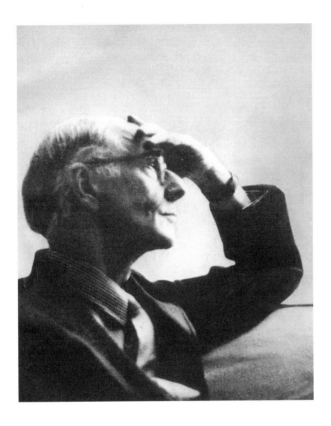

83. Russell Lynes, *Alfred Barr.*

authoritative indication of what the Museum stands for in each of its departments. They should constitute a permanent visible demonstration of the Museum's essential program, its scope, its canons of judgment, taste and value, its statements of principle its declaration of faith."[66]

Despite Barr's protestations, Margaret Barr would claim: "Alfred single-handedly changed the taste of our time."[67]

NOTES

ABBREVIATIONS

AAA Archives of American Art
 Alfred H. Barr, Jr. Papers
 Katherine Gauss Papers
 J. B. Neumann Papers
CORP Columbia University Oral History Research Program
FAM Fogg Art Museum, Harvard University Art Museums
MoMA Museum of Modern Art, New York
 Archives: Alfred H. Barr, Jr. Papers (AHB)—partially available in
 microfilm at the AAA
RAC Rockefeller Archives Center
YUL Yale University, Beinecke Rare Book and Manuscript Library
 Katherine Dreier Papers
 Dwight Macdonald Papers
 Virgil Thomson Papers

PREFACE

Epigraph: Alfred H. Barr, Jr., *What Is Modern Painting* (New York: Museum of Modern Art, 1943), p. 3.

1. In *Good Old Modern: An Intimate Portrait of the Museum of Modern Art* (New York: Atheneum, 1973), Russell Lynes wrote a chronological history of the museum but he did not consider Barr's goals and achievements with critical acumen. Alice Goldfarb Marquis's book *Alfred H. Barr, Jr.: Missionary for the Modern* (Chicago: Contemporary Books, 1989), purporting to be a biography, without art historical underpinnings, goes wide of the mark. Irving Sandler's introduction to *Defining Modernism: Selected Writings of Alfred H. Barr., Jr.* (ed. Irving Sandler and Amy Newman, with a complete bibliography of Barr's published writings compiled by Rona Roob; New York: Harry N. Abrams, 1986) is a brief and cursory overview of Barr's aesthetic. Helane Ruth Messer, in her unpublished dissertation "MOMA: Museum in Search of an Image" (Columbia University, 1979), gives a behind-the-scenes perspective on the functioning of the Museum and its inherent problems. Her main point is that no long-term plan had been established for the Museum from its inception in 1929 until the 1960s when her study ends.

2. Terence Riley, *The International Style: Exhibition 15 and the Museum of Modern Art* (New York: Rizzoli, 1992), p. 11.

3. Dwight Macdonald, "Action on West Fifty-Third Street," Part I, *New Yorker* 29 (December 12, 1953), p. 59. Macdonald conducted many interviews in connection with this *New Yorker* "Profile" (which continues in the December 19, 1953, issue); transcripts of the interviews are in the Macdonald Papers, YUL.

PROLOGUE: KNOWING ALFRED BARR

1. Alfred H. Barr, Jr., "A Drawing by Antonio Pollaiuolo," *Art Studies* 4 (1926), pp. 73–78. The drawing was in the collection of Paul J. Sachs at Harvard.

2. Barr, interview by Dwight Macdonald, Macdonald Papers, YUL.

3. Edward King, interview with author, 1982.

4. Alfred H. Barr, Jr., *Picasso: Forty Years of His Art* (New York: Museum of Modern Art, 1939); *Picasso: Fifty Years of His Art* (New York: Museum of Modern Art, 1946).

5. Barr to F. R. Barr, May 13, 1954, MoMA Archives, NY: AHB, 12.II.3.a. Barr wrote that his family had emigrated to northern Ireland from Scotland in the latter half of the seventeenth century; they then migrated to western Pennsylvania "in the so-called Scotch Irish wave in the mid-eighteenth century."

6. Russell Lynes, *Good Old Modern: An Intimate Portrait of the Museum of Modern Art* (New York: Atheneum 1973), p. 31.

7. Dwight Macdonald, "Action on West Fifty-Third Street," Part I, *New Yorker* 29 (December 12, 1953), p. 79.

8. Philip Johnson, in *Memorial Service for Alfred H. Barr, Jr.* (New York: Museum of Modern Art, 1981), unpaginated.

9. Margaret Barr refused to talk to Alice Marquis or to me. The archives Mrs. Barr left of Barr's childhood were not made available to me nor, I presume, to Marquis, so that she was unable to write about the early years.

10. Alice Marquis, *Alfred H. Barr, Jr.: Missionary for the Modern* (Chicago: Contemporary Books, 1989), p. 3.

11. Ibid., p. 170, citing II Samuel 5:12.

12. Alfred H. Barr, Jr., "Letter to the Editor," *New York Times,* September 25, 1960.

13. The residuum of his religious life was made evident when Barr served as First President of the Society for the Arts, Religion, and Contemporary Culture from May 1962 to September 1965. Barr's aim was to promote religious art of quality.

14. Barr to Gauss, December 23, 1921, Gauss Papers, AAA. These papers contain Barr's letters to Katherine Gauss over a period of many years, but especially from 1921 to 1929. They had known each other in Greensboro, Vermont, where they spent their summers with their families and at Princeton where Gauss's father, Christian Gauss, was Dean of the College. Barr took Dean Gauss's course on Dante and a course in Italian.

15. Edward King, interview by author, 1981. Meyer Schapiro, in *Memorial Service for Alfred H. Barr, Jr.,* commented that Barr won the respect of artists by the "purity, the selflessness of his support of contemporary art" despite their questioning of his judgment or taste.

16. In 1932, after two years as director of the Museum of Modern Art, Barr found it necessary to go abroad for a year to revive himself mentally and physically.

17. Philip Johnson, Macdonald Papers, YUL.

18. Barr to Committee on Fellowships, Mills College, February 11, 1937, MoMA Archives, NY: AHB [AAA: 2166; 425].

19. Barr to Frank Crowninshield, May 12, 1945, MoMA Archives, NY: AHB, 12.I.3.a.

20. Aline B. Saarinen, *The Proud Possessors* (New York: Random House, 1958), p. 197.

21. Barr, interview by Macdonald, Macdonald Papers, YUL.

22. King, interview by author, 1981.

23. Barr to Gauss, December 20, 1923, Gauss Papers, AAA.

24. For example, Barr letter to Mrs. A. Philip McMahon, January 10, 1931, MoMA Archives, NY: AHB [AAA: 2164; 456]. In a letter to Doctor Steven Kayser, March 31, 1959, Barr wrote: "Speaking is a torture for me." MoMA Archives, NY: AHB [AAA: 3150; 279].

25. King, interview by author, 1981.

26. These observations are excerpted from a personal interview with Edward S. King in 1981 by the author as well as subsequent correspondence between the author and King. Through the intervention of Barr (see Barr's letter to King, June 27, 1934), King was ap-

pointed to one of the five curatorial positions at the Walters Gallery on Charles Rufus Morey's recommendation; subsequently, King was the gallery's administrator from 1945 to 1959 and director from 1951 to 1966.

27. Abbott graduated from Bowdoin College in 1920 and attended graduate school at Harvard from 1920 to 1921 to study physics, having renounced a career as a concert pianist. After teaching physics at Bowdoin for two years, he went to Europe to study art for a year in 1923. From 1924 to 1926 he was enrolled at Princeton's department of Art and Archeology.

28. Alan Porter, interview by Macdonald, Macdonald Papers, YUL.

29. Ibid.

30. Jere Abbott interview by author, telephone conversations, 1982.

31. Barr to Neumann, November 15, 1926, Neumann Papers, AAA. Barr was responsible for the sale of the Corot painting to Wellesley College soon after. Four years later he wrote to Alice Van Vechten Brown, chairman of the art department, asking if he could buy back the painting for himself: "Making its acquaintance again, all my old affection and desire for it are aroused again." Barr letter to Brown, October 8, 1930, MoMA Archives, NY: AHB [AAA 2164; 580]. When he was refused, his response was that he was relieved since he really didn't have the money to buy it. Barr letter to Myrtilla Avery, October 29, 1930, MoMA Archives, NY: AHB [AAA 2164; 581].

32. Johnson, quoted in Grace Glueck, "Alfred H. Barr, Jr., Museum Developer," *New York Times,* August 17, 1981, p. 16.

33. Johnson, in *Memorial Service for Alfred H. Barr, Jr.*

34. Barr to Gauss, January 23, 1922, Gauss Papers, AAA.

35. Barr to Gauss, September 30, 1921, Gauss Papers, AAA.

36. Ibid.

37. Ibid.

38. Robert Hughes, "What Alfred Barr Saw: Modernism," *Esquire* 100 (December 1983), p. 407. Among the most important women in this capacity were Abby Rockefeller, Lillie Bliss, and Mary Sullivan, founding trustees of the Museum of Modern Art, as well as Olga Guggenheim and Sadie May, two benefactors of the museum. Among the women on his staff were Dorothy Miller, his assistant; Elodie Courter, in charge of the circulating exhibitions; Ernestine Fantl, head of the Architecture department; Iris Barry, curator of the department of Films; and Dorothy Dudley, who developed a system that became the model for all museum registrars.

39. Barr to Gauss, 1929, Gauss Papers, AAA.

40. Legend has it that they met at the opening day of the Museum of Modern Art. But in an interview with the author, Lily Harmon repeated a confirmation from Mrs. Barr that they had met later.

41. Margaret Scolari Barr, "'Our Campaigns': Alfred H. Barr, Jr., and the Museum of Modern Art: A Biographical Chronicle of the Years 1930–1944," *New Criterion,* special issue (Summer 1987), p. 24.

42. Johnson, interview with author, May 1991.

43. Agnes Mongan to Bernard Berenson, Harvard Center for Renaissance Studies, I Tatti Archives, Florence, Italy.

44. Barr, *The Inkwell* (Baltimore) 2 (7 June 1918), p. 2. Barr graduated *cum laude* and gave the valedictory speech. He was editor of the paper in his senior year.

45. Barr to Gauss, November 1921, Gauss Papers, AAA.

46. Meyer Schapiro, in *Memorial Service for Alfred H. Barr, Jr.*

47. Alfred H. Barr, Jr., "Matisse, Picasso, and the Crisis of 1907," *Magazine of Art 44* (May 1951), p. 163.

48. Maurice Merleau-Ponty, "Cézanne's Doubt," in *Sense and Non-sense,* trans. Hubert L. Dreyfus and Patricia Allen Dreyfus (Evanston: Northwestern University Press, 1964), p. 20.

1 THE PRINCETON YEARS

1. Marilyn Aronberg Lavin, *The Eye of the Tiger: The Founding and Development of the Department of Art and Archeology, 1883–1923* (Princeton: Princeton University Press, 1983), p. 5.

2. Which college or university could be considered to be first in the field depends in part on the definition of a "department." Priscilla Hiss and Roberta Fansler, in *Research in Fine Arts in the Colleges and Universities of the United States* (New York: Carnegie Corporation of New York, 1934), p. 38, credit Princeton with offering the first undergraduate course in Archeology in Roman Antiquities in 1831 and offering archeology as a supplement to classical studies from 1843 to 1868. Lectures in the history of architecture were given between 1832 and 1855, and a "Lecturer on the Fine Arts," the Reverend William Armstrong Dod, was appointed in 1855. Hiss and Fansler claim that Princeton "was the first to offer continuous and consistent graduate work in the field" (p. 38). Harvard, for its part, maintained that Charles Eliot Norton was widely influential in his role as founder of its department.

3. Allan P. Marquand, from a speech printed in *Dedication of McCormick Hall* (Princeton: Princeton University Press, 1923), p. 7; quoted in Lavin, *The Eye of the Tiger,* p. 9.

4. Lavin, *The Eye of the Tiger,* p. 7.

5. Dwight Macdonald, "Action on West Fifty-Third Street," Part I, *New Yorker* 29 (December 12, 1953), p. 79.

6. The German art historian Heinrich Wölfflin (1864–1945) is generally credited with initiating the comparative technique of defining styles, especially in his book *Die classische Kunst* (Munich, 1899). By describing the contrasting forms of the work of art—discriminating, for instance, between painterly or linear rather than iconographic or specific religious,

social, or political conditions of the age—he implicitly initiated the "formalist" method. Alois Riegl (1858–1905), a historian of the Vienna School, applied his aesthetic principle of *Kunstwollen,* sometimes known as "the aesthetic urge" or "the will to form," to artist, object, various arts, and artistic period, as well as to an entire nation.

7. Charles R. Morey, "The Academic Point-of-View," parts I and II, *Arts* 11 (June 1927), pp. 283–287, and 12 (July 1927), pp. 40–44. In this article Morey demonstrated the confluence of religion, politics, and art from ancient Greece to the nineteenth century.

8. Erwin Panofsky, "Charles Rufus Morey," *American Philosophical Yearbook* 1955 (Philadelphia: Philosophical Society, 1956); p. 484.

9. Lavin, *The Eye of the Tiger,* p. 21.

10. Charles Rufus Morey, "The Sources of Medieval Style," *Art Bulletin* 7 (1924), pp. 35–50, with the chart as the conclusion to the article on p. 50.

11. Erwin Panofsky, "Epilogue: Three Decades of Art History in the United States," in *Meaning in the Visual Arts* (Garden City, N.Y.: Doubleday Anchor Books, 1955), p. 328. Originally published as "The History of Art," in *The Cultural Migration: The European Scholar in America,* ed. W. R. Crawford (Philadelphia: University of Pennsylvania Press, 1953).

12. By the time of Morey's death, in 1955, the Princeton Index contained over 500,000 cards and 100,000 photographs, representing an investment of some $750,000.

13. Mrs. Barr to author, 1980.

14. Margaret Scolari Barr to Bernard Berenson, Harvard Center for Renaissance Studies, I Tatti Archives, Florence, Italy. Aside from the Index, Barr was completely devoted to Morey and Morey's methods. Monroe Wheeler, interview by author, October 1981.

15. "A Brief Survey of Modern Painting," MoMA Archives, NY: AHB [AAA: 3262; 928].

16. Alfred H. Barr, Jr., *Cubism and Abstract Art* (New York: Museum of Modern Art, 1936).

17. *Italian Masters Lent by the Royal Italian Government,* preface, notes, and charts by Alfred H. Barr, Jr. (New York: Museum of Modern Art, 1940).

18. Margaret Scolari Barr, interview by Paul Cummings, 1974, AAA.

19. Ibid.

20. Barr to Gauss, September 1924, Gauss Papers, AAA: "I'm glad you liked the Russian sheet others yet to come are: Italian Operatic and modern; French classical; French operatic, Austrian and Spanish; German classical; German romantic etc.; The music drama Wagner, Strauss, Debussy; Modern music-Berlioz, Chopin, Saint-Saens, Ravel, etc."

21. Barr to Gauss, September 21, 1922, Gauss Papers, AAA.

22. A. Conger Goodyear, *The Museum of Modern Art: The First Ten Years* (New York: Museum of Modern Art, 1939), p. 137.

23. Morey retired in 1945.

24. Rona Roob, "Alfred H. Barr, Jr.: A Chronicle of the Years 1902–1929," *New Criterion* (Summer 1987), p. 3, made note of this. Although the Princeton catalogue lists Smith as the professor for course 404, Modern Painting, the Princeton registrar claimed that Mather was the professor and Mather and Smith the preceptors. The Princeton catalogue for that period (p. 287) listed Modern Painting as a senior course, describing the course as "the theory and development of Modern Painting . . . traced to the year 1900. Artistic movements will be related to their cognate tendencies in literature and politics. Especial attention will be given to the growth of romanticism in painting with its sequels in realism and impressionism."

Barr's complete academic record supplied by the registrar appeared as follows: Sophomore, 1919–1920: 301, Ancient Art; 302, Medieval Art, Morey. Junior, 1920–1921: 303, 304, Ancient and Medieval Architecture, Howard Crosby Butler, Preceptors Butler and Smith; 404, Modern Painting, Mather, preceptors, Mather and Smith; 305, 306, Architectural Drawing. Senior, 1921–1922: 401, Renaissance and Modern Sculpture, Morey; 403, Italian Painting, Mather; 306, Northern Painting; 406, Modern Architecture, Butler; 407, 408, Classical Architecture; 409–410 Free-Hand Drawing, Edwin Avery Park; 404, Ethics of Christianity, Howard Crosby Butler. (Butler was the first director of the School of Architecture, which was separated from the Department of Fine Arts in 1919.)

Graduate School, 1922–1923: 509, History of Ornament and Decoration, Smith; 527, Italian Sculpture of the Early Fifteenth Century, Marquand; 531 Early Florentine Painting, Mather. Second term: 510, The History of Ornament and Decoration Smith; 538, Mediaeval Illumination of Manuscripts, Morey; 550, Van Eycks and Early Flemish Painting, Mather.

25. Penina R. V. Petrick, "American Art Criticism 1910–1939," Ph.D. dissertation, New York University, 1979. Petrick analyzed nine of the most important critics on the American art scene in the early decades of the century whose writing was, she felt, on the whole "superficial" (p. 276). She considered Mather to be the most scholarly of the critics (p. 68) but among the most conservative, having been influenced by the "New Humanist" philosophy (p. 4), the traditional force that avant-garde students rallied against.

26. Mather was born July 6, 1868, in Deep River, Connecticut. He taught English and Romance languages at Williams College from 1896 to 1900, where he had received his B.A. in 1889. He received a Ph.D. from Johns Hopkins University in 1892. From 1900 to 1906, he was an editorial writer at the *New York Evening Post* and assistant editor of the *Nation*. He also served as art critic for the *Post*, 1905–1906 and 1910–1911. In 1910 he became professor of Art and Archeology at Princeton, where he taught until 1933. In 1922 he became director of the Museum of Historic Art at Princeton, where he remained until 1948. Over the course of twenty years, Mather wrote articles for *Scribner's*, the *Nation*, the *Review*, *Art in America*, *International Studio*, and *Saturday Review of Literature*.

27. Milton W. Brown, in *The Story of the Armory Show* (New York: Joseph Hirshhorn Foundation, New York Graphic Society, 1963), described Mather's writing of the event as "vituperative" when Mather compared the experience to visiting a "'lunatic asylum'" (p. 136).

28. Frank J. Mather, "Recent Visionaries, the Modernists," in *The American Spirit in Art* (New Haven: Yale University Press, 1927), p. 155.

29. Ibid.

30. Ibid. Sheldon Cheney, who wrote one of the first survey books on modernism, also lumped most modernists under the term "expressionism." Sheldon Cheney, *A Primer of Modern Art* (New York: Horace Liveright, 1924).

31. Mather's antiromanticism was in agreement with the new humanist movement whose ultraconservative philosophy had a revival in the late 1920s, particularly in the pages of *Hound & Horn.* Mather dedicated his book *Modern Painting* (New York: Garden City Publishing Co., 1927), a compilation of his Princeton lectures, to Irving Babbitt, whose writings, along with those of Paul Elmer More, advocated an aesthetic based on the concepts of restraint and excellence found in the classical period. More taught at Princeton and Babbitt at Harvard in the first decades of the twentieth century.

32. Mather, *The American Spirit in Art,* p. 156.

33. Ibid.

34. Ibid., p. 155.

35. Ibid.

36. Ibid.

37. Mather, *Modern Painting: A Study of Tendencies,* p. 358.

38. Ibid., p. 358.

39. Ibid.

40. Ibid.

41. Barr to Gauss, February 1922, Gauss Papers, AAA.

42. Roob, "Alfred Barr: A Chronicle," p. 3.

43. Bryson Burroughs, *Impressionist and Post-Impressionist Painting, May 3 to September 15, 1921* (New York: Metropolitan Museum of Art, 1921). Among the group of art lovers who requested the exhibition were Lillie P. Bliss, Arthur B. Davies, and John Quinn. Cézanne was represented by twenty-three pictures (although, as Burroughs suggested, his reputation was still in contention) and Monet by six.

44. Barr to Henry S. Canby, November 27, 1931, MoMA Archives, NY: AHB [AAA: 2164; 843].

45. Barr to Frank Mather, June 30, 1949, MoMA Archives, NY: AHB [AAA: 2176; 283]. Cortissoz and Berenson, he wrote, were sadly lacking in this humility.

46. Barr letter to his mother, March 18, 1924; quoted in Roob, "Alfred H. Barr: A Chronicle," p. 5. The Vassar catalogue for 1923–1924 (pp. 57–58) described the course Modern Painting: "A study of the development of the modern schools of painting in France and England from the end of the seventeenth century, in America from the eighteenth century, and in Holland, Germany and Spain from the nineteenth century. Special attention will be devoted to contemporary art." Barr taught the course together with Oliver Tonks and a Mr. Chatterton.

47. Barr to Dreier, May 9, 1950, Dreier Papers, YUL.

48. "Kandinsky Discussed," *Vassar Miscellany News,* November 14, 1923, p. 2.

49. "Lectures on Modern Art," *Poughkeepsie Star,* November 3, 1923, n.p.

50. The curator of the Taylor Hall art gallery at Vassar was Ethel Blackwell Jones, who had graduated from Vassar in 1921 and then spent a year at the Art Students League; she was curator from 1923 to 1926. Dreier communicated with Blackwell Jones late in 1923 and proposed the Kandinsky show there. Various biographical entries about Barr have claimed that he was instrumental in mounting the Kandinsky exhibition, particularly *The New Yorker* Profile, "Action on West Fifty-Third Street," by Dwight Macdonald. Perhaps Barr only helped hang the exhibition and Macdonald overstated Barr's responsibility for it.

51. Monroe Wheeler, interview by author, 1985. In a letter to William Burden, March 25, 1963, Barr confessed that he found it hard to admire the late pictures of Kandinsky. MoMA Archives, NY: AHB [AAA: 2191; 1322].

52. King interview by author, 1985.

53. King to author, December 1989.

54. Quoted in Roob, "Alfred H. Barr, Jr.: A Chronicle," p. 4. Barr told Macdonald about this incident, noting that the professors' failure to take the Brancusi torso seriously served only to increase his interest in modern art (Macdonald Papers, YUL).

55. Barr, interview by Macdonald, Macdonald Papers, YUL.

56. Barr to Gauss, February 1922, Gauss Papers, AAA.

57. Barr, interview by Macdonald, Macdonald Papers, YUL.

58. Quotes are from application for a fellowship at Harvard, in the Macdonald Papers, YUL.

59. Alfred H. Barr, Jr., "Modern Art Makes History, Too," *College Art Journal* 1 (November 1941–1942), pp. 3–6.

60. Margaret Scolari Barr, interview by Paul Cummings, April 1974, AAA.

61. Barr to Gauss, August 9, 1921, Gauss Papers, AAA.

62. Marquand, speech in *Dedication of McCormick Hall,* p. 15; quoted in Lavin, *The Eye of the Tiger,* p. 7.

63. William Cowper Prime and George B. McClellan, *Suggestions on the Establishment of a Department of Art Instruction in the College of New Jersey* (Trenton, N.J.: W. S. Sharp, 1882), pp. 4–5; quoted in Lavin, *The Eye of the Tiger,* p. 12.

64. Lavin, *The Eye of the Tiger,* p. 12.

65. See Caroline A. Jones, with an essay by John Coolidge and a preface by John M. Rosenfield, *Modern Art at Harvard: The Formation of the Nineteenth and Twentieth Century Collections of the Harvard University Art Museums* (New York: Abbeville Press, 1985), p. 90.

66. Charles Rufus Morey, in *Boston Transcript,* December 30, 1926.

67. Alfred H. Barr, Jr., *Matisse: His Art and His Public* (New York: Museum of Modern Art, 1951), p. 4. In the dedication, he called the book a "work in progress."

2 THE FOGG METHOD AND PAUL J. SACHS: BARR AND HIS HARVARD MENTOR

1. Barr to Gauss, September 1924, Gauss Papers, AAA. Barr's graduate record at Harvard listed his courses and grades: History of Engraving and Etching, Sachs, A; Methods and Process of Painting, Forbes A–; General Theory of Representation and Design, Pope, A–; Byzantine Art, Porter, B+; Study of Engraving Etching and Drawings, Sachs, A. The courses with Sachs and Pope were year-long courses; the other two, half-year courses.

2. Erwin Panofsky, "Epilogue: Three Decades of Art History in the United States," in *Meaning in the Visual Arts* (Garden City, N.Y.: Doubleday Anchor Books, 1955), p. 324. Originally published as "The History of Art" in *The Cultural Migration: The European Scholar in America*, ed. W. R. Crawford (Philadelphia: University of Pennsylvania Press, 1953).

3. Samuel Eliot Morison, ed., *The Development of Harvard University since the Inauguration of President Eliot, 1869–1929* (Cambridge: Harvard University Press, 1930), p. 130. The chapter on the Fine Arts department was written by George H. Chase, who in 1925 was named dean of the Graduate School, having served as chairman of the Art History department for fourteen years. Much of the information on the Harvard faculty comes from this chapter. According to Morison, in 1891 the Faculty of Arts and Sciences was organized into twelve divisions and many of these divisions contained subdivisions or departments. The Fine Arts Division did not have subdivisions so that it was variously known as a division or a department. Chase first mentioned it as a department on page 133, indicating Eliot's tenure from its inauguration in 1874 to 1898 when he retired. On page 137 he called it a division, referring to the period of rapid development between 1909 and 1919. Priscilla Hiss and Roberta Fansler in *Research in Fine Art in the Colleges and Universities of the United States* (New York: Carnegie Corporation, 1934) call it a division on page 24 and page 87. It is currently called a department. Patrice Donoghue, Reference and Holdings Management Archivist of Harvard University Archives, Pusey Library, sent this information and said that by circa 1939 Fine Arts was no longer referred to as a division.

4. Henry James, "An American Art-Scholar; Charles Eliot Norton," *Burlington Magazine* 14 (December 12, 1908), pp. 201–204.

5. Van Wyck Brooks, *Scenes and Portraits: Memories of Childhood and Youth* (New York: Dutton, 1954), pp. 103–104.

6. Selections of Charles Eliot Norton's writings, *Notes of Travel and Study in Italy* (Boston: Ticknor & Fields, 1859), appeared in the *Crayon* 3 (March–December 1856). It was the *Crayon* that was largely responsible for spreading Ruskin's ideas in America. Ruskin had a broad following in the United States. See Roger B. Stein, *John Ruskin and Aesthetic Thought in America: 1840–1900* (Cambridge: Harvard University Press, 1967), for an analysis of Ruskin's influence on American thought. Norton, and through him Ruskin, had a continuing influence on later generations of Harvard students. Ruskin responded to art emotionally and poetically and he was the first nineteenth-century English critic to communicate the convic-

tion that art must be taken seriously not only by the aristocracy but by all people to ennoble their lives. See Solomon Fishman, *The Interpretation of Art: Essays on the Art Criticism of John Ruskin, Walter Pater, Clive Bell, Roger Fry and Herbert Read* (Berkeley: University of California Press, 1963).

7. Morison, ed., *Development of Harvard University,* p. 130.

8. George Santayana, *Winds of Doctrine: Studies in Contemporary Opinion* (New York: Charles Scribner & Sons, 1913), pp. 187, 188. The essay "The Genteel Tradition in American Philosophy" was given by Santayana as a lecture in Berkeley, California, in 1911 and printed in the *University of California Chronicle* 13 (October 11, 1911).

9. Lincoln Kirstein, "Crane and Carlsen: A Memoir, 1926–1934," *Raritan* 1 (Winter 1982), 6–40; "Loomis: A Memoir," *Raritan* 2 (Summer 1982), pp. 5–40; "A Memoir: At the Prieure des Basses Loges, Fontainebleau," *Raritan* 2 (Fall 1982), pp. 35–50; "A Memoir: The Education," *Raritan* 2 (Winter 1983), pp. 27–65.

10. Kirstein, "A Memoir: The Education," p. 37.

11. Kirstein, "Loomis: A Memoir," p. 17.

12. Kirstein, "A Memoir: The Education," p. 43.

13. John Ruskin, *The Stones of Venice,* from *The Complete Works of John Ruskin,* 30 vols. (New York: Thomas Y. Crowell, 1907), 2:192.

14. Edward F. Forbes, "The Beginnings of the Art Department and of the Fogg Museum of Art at Harvard," *Cambridge Historical Society* 27 (1941), p. 15.

15. John Ruskin, *Elements of Drawing and Elements of Perspective* (New York: E. P. Dutton, 1907).

16. Morison, ed., *Development of Harvard University,* p. 133.

17. Paul J. Sachs, "Tales of an Epoch," pt. 1, v. 6, p. 883, CORP. Material on Sachs is in the Paul J. Sachs Director's Files, Fogg Art Museum Archives, Harvard University Art Museums, Cambridge. The Columbia University Oral History Research Office has a transcribed edition of the Paul Sachs Archives in fifty volumes. Both archives include his memoirs called "Tales of an Epoch," an unpublished typescript of an interview by Dr. Saul Benison, February 1958 and January 1959, hereafter referred to as "Tales," and a vast correspondence that he maintained, with what seems like every player in the art world, for the years between the 1910s and 1960s when he died. Unless otherwise noted, the material on Sachs comes from Columbia University.

18. Lincoln Kirstein, *Mosaic: Memoirs* (New York: Farrar, Straus & Giroux, 1994), p. 162.

19. Quoted in David Alan Brown, *Berenson and the Connoisseurship of Italian Painting* (Washington, D.C.: National Gallery of Art, 1979), pp. 38, 39.

20. Berenson's most successful and important book was *The Drawings of the Florentine Painters, Classified and Criticized and Studied as Documents in the History and Appreciation of Tuscan Art* (New York: E. P. Dutton and Company, 1903).

21. Brooks, *Scenes and Portraits,* p. 114.

22. Upon his death in 1959, Berenson bequeathed his home, the Villa I Tatti in Settignano, Italy, and its art objects to Harvard. It became the Harvard University Center for Italian Renaissance Studies. Margaret Scolari Barr became one of Berenson's confidantes and his link with Harvard; her correspondence with him, which can be found at the library of the Center, is full of chatty news of his friends at Harvard.

23. The history of the development of connoisseurship at Harvard was imparted to the author in a series of interviews with Franklin Ludden, a graduate of this method, Harvard, B.A. 1939, Ph.D. 1956, and Professor Emeritus in the department of History of Art, Ohio State University.

24. Denman W. Ross, *A Theory of Pure Design: Harmony, Balance, Rhythm* (New York: Peter Smith, 1933), pp. v, vi.

25. Ibid., p. 41.

26. Arthur Pope, *Tone Relations in Painting* (Cambridge: Harvard University Press, 1922), which subsequently became the first volume of the two-volume treatise *The Language of Drawing and Painting* (Cambridge: Harvard University Press, 1949); and *Art, Artist, Layman* (Cambridge: Harvard University Press, 1937).

27. This scientific enquiry was further explicated in an article he wrote for *Art Studies* in 1925, "A Quantitative Theory of Aesthetic Values."

28. Porter graduated from Yale in 1904, attended Columbia University as a graduate student, traveled continually, and wrote on medieval architecture. His reputation obviated the need for a doctoral degree, and he taught at Yale from 1915 to 1919.

29. Arthur Pope, *Catalogue of the Ruskin Exhibition in Memory of Charles Eliot Norton* (Cambridge: Fogg Art Museum, 1909). Pope also wrote a catalogue for a Degas exhibition that he curated for the Fogg in 1911, which Sachs deemed the earliest show of the artist's works in the United States. Pope wrote a catalogue for the exhibition *George C. Bingham, the Missouri Artist,* for the Museum of Modern Art, January 30–March 7, 1935.

30. Edward W. Forbes, "The Beginnings of the Art Department and of the Fogg Museum of Art at Harvard," *Cambridge Historical Society* 27 (April 22, 1941), p. 19.

31. Edward W. Forbes, "History of the Fogg Museum of Art," ca. 1947–1955, vol. 1, pp. 1–325, typescript, Forbes Papers, FAM.

32. Agnes Mongan, interview by author, October 1983.

33. Quoted in Rona Roob, "Alfred H. Barr, Jr.: A Chronicle of the Years 1902–1929," *New Criterion* (Summer 1987), p. 6.

34. Mongan, "Obituaries," *Art Journal* 25 (Fall 1965), pp. 50–51.

35. Ibid.

36. According to Franklin Ludden in 1987, Sachs repeatedly mentioned this agreement in class. Throughout his lifetime Sachs gave or bequeathed 3,000 works of art, of which 500 were drawings and over 2,000 were prints. *Fogg Newsletter* 3 (October 1965), n.p. Few items were left to his heirs.

37. Paul J. Sachs, course outline, p. 142, was quoting W. G. Constable, 1880–1976, first the assistant director of the National Gallery in London and in 1930 director of the Courtauld Institute. In 1940 he became the curator of painting at the Boston Museum of Fine Arts and lectured to students in the Sachs's museum course.

Beaumont Newhall, the founding curator of the Photography department at the Museum of Modern Art, graciously lent me a copy of notes of his class from 1930, painstakingly typed, of a semester's work by an unknown student; 243 pages long, it is a comprehensive record of the proceedings in the museum course (hereafter referred to as course outline). Milton Brown, a former student of Sachs's museum course at Harvard, also kindly lent me his later version, 1938, of the course outline.

38. Mongan, in Diane DeGrazia Bohlin, "Agnes Mongan (b. 1905): Connoisseur of Old Master Drawings," in Claire Richter Sherman with Adele M. Holcomb, eds., *Women as Interpreters of the Visual Arts, 1820–1979* (Westport, Connecticut: Greenwood Press, 1980), p. 415. Agnes Mongan: Bryn Mawr, B.A. 1927; Smith, M.A. 1929. Fogg Art Museum: research assistant, 1929; keeper of drawings, 1937; curator of drawings, 1947; assistant director, 1951; associate director, 1964; director, 1969–1971. The board of overseers of Harvard waited almost until she retired before they would name a woman as director of the Fogg. Mongan was one of the first to hold that position in the United States. (Ibid.) See also Janet Baker-Carr, "A Conversation with Agnes Mongan, Art Historian, Teacher, Editor, Museum Director," *Harvard Magazine* 80 (July/August 1978), pp. 50–54. With Paul J. Sachs, Mongan coauthored *Drawings in the Fogg Museum of Art,* 3 vols. (Cambridge: Harvard University Press, 1940, 2d ed. 1946).

39. Sachs, "Tales," pt. 1, v. 28, p. 55, CORP.

40. Sachs, "Tales," pt. 1, v. 1, p. 42, CORP.

41. "Paul J. Sachs," obituary, *Boston Sunday Globe,* February 21, 1965.

42. For Barr's appointment as director of the Museum of Modern Art, he was required to submit a résumé of all the collections he had visited. Among papers filed in his desk were some lists of paintings from collections that he had visited and grades that he had given these works of art. In the Johnson Collection in the Art Institute of Chicago, Picasso's unfinished sketch of *Supper Party* "(very Toulouse—painted 1912?)" received a B. In the same collection, Van Gogh's *Olive Trees,* an A. Most of the Seurat paintings at Knoedler received As. Barr's admiration for the French artist remained with him all his life. In the Birch Bartlett collection in Chicago, Van Gogh's *Bedroom* got an A but *La Berceuse,* a B; in Adolph Lewisohn's collection in New York, Gauguin's *Ia Orana Maria* was of A– quality, but a *Breton Landscape,* a B–. These estimations, among many others, were made in preparation for the opening exhibition in 1929. MoMA Archives, NY: AHB [AAA: 3261; 356].

43. Forbes, "The Beginnings of the Art Department," p. 12.

44. In 1927 Sachs was made a full professor and in 1933 he became chairman of the department of Fine Arts at Harvard. He was associate director of the Fogg Museum from 1924 until 1944 at which time Sachs and Forbes retired together. Agnes Mongan, *Memorial Exhibition—Works of Art from the Collection of Paul J. Sachs,* Cambridge, November 15, 1965–January 15, 1966.

45. A. Everett Austin, Jr., "The New Fogg Museum: The Study of Technique," *Arts* 12 (July 1927), p. 20. Austin was Forbes's assistant and he taught the course for a year. Forbes was influential in the selection of Austin as the new director of the Wadsworth Atheneum in Hartford, Connecticut, in 1927.

46. Edward W. Forbes, "The New Fogg Art Museum: The Study of the X-ray at the Museum," *Arts* 12 (July 1927), p. 20.

47. Sachs, "Tales," pt. 2, v. 15, p. 2367, CORP.

48. Ibid., pt. 2, v. 1, p. 3, CORP.

49. Ibid.

50. Ibid., pt. 1, v. 6, p. 880, CORP.

51. Ibid., pt. 2, v. 1, p. 12, CORP.

52. Ibid., pp. 5, 6.

53. Sherman and Holcomb, eds., *Women as Interpretors of the Visual Arts,* pp. 48–49.

54. Barr to Sachs, August 3 and October 10, 1925, Sachs Files, FAM.

55. Ibid.

56. Barr to Sachs, January 1, 1926, Sachs Papers, pt. 1, v. 28, p. 3893, CORP.

57. Ibid.

58. Macdonald Papers, YUL.

59. Barr to Sachs, August 3, 1925, Sachs Papers, pt. 1, v. 28, p. 3887, CORP. Sachs wrote "Correct" on a copy of the letter.

60. Barr worked on the Pollaiuolo paper, using his "Princeton training" in historical perspective. The paper appeared in the journal published by the Princeton-Harvard Fine Arts Club: "A Drawing by Antonio Pollaiuolo," *Art Studies: Medieval, Renaissance and Modern* 4 (Cambridge, 1926) pp. 73–78.

61. Barr to Sachs, August 3, 1925, Sachs Files, FAM.

62. Sachs to Barr, November 2, 1925, MoMA Archives, NY: AHB [AAA: 3263; 169].

63. Ibid. [170].

64. Ibid. When Norton died in 1908, Forbes briefly occupied Shady Hill; then, in 1912, Walter C. Arensberg, class of 1900, a classmate of Sachs, bought it. Sachs bought Shady Hill from Arensberg in 1919 and lived there for thirty-four years. He willed it to Harvard and it was subsequently demolished. "Shady Hill," *Harvard Alumni Bulletin* 57 (October 23, 1954), pp. 106, 107.

65. Sachs, written on Barr letter to Sachs, August 3, 1925, Sachs Papers, pt. 1, v. 28, p. 3887, CORP.

66. Sachs, "Tales," pt. 2, v. 1, p. 13, CORP. Arthur Kilgore McCoomb (1895–1968), Harvard 1921, M.A. 1922, taught at Vassar from 1924 to 1926 and at Harvard from 1927 to 1939. He was also a curator of decorative arts at the Metropolitan Museum of Art.

67. Sachs retired from Harvard in 1948. In twenty-seven years of teaching his museum course at Harvard, from 1921 to 1947, Sachs had 338 students. He placed 160 students in 85 of the 100 best museums in the land: 42 directors, assistant directors, and administrators; and 45 curators; the rest were docents and librarians. Sachs, "Tales," pt. 2, v. 1, p. 54, CORP.

68. Sachs, "Tales," pt. 2, v. 1, p. 13, CORP. Others attending in 1926–1927 were Walter Siple, Philip Hofer, Millard Meiss, and Hans Swarzenski. Hofer became a curator at the Morgan Library. John Walker and Agnes Mongan were in the course in 1928–1929, and Beaumont Newhall attended the course in 1930–1931. Newhall later became curator of the department of Photography at the Museum of Modern Art. Elizabeth Mongan, the sister of Agnes, attended the course in 1933 along with Charles Cunningham, Perry Rathbone, and Henry McIlhenny. McIlhenny became an important collector and volunteered to add his home to those visited by the students at vacation time. Elizabeth Mongan became curator of the Lessing Rosenwald Drawing Collection in the National Gallery at the recommendation of Sachs.

69. Barr to Miss Meigs, October 3, 1931, MoMA Archives, NY: AHB [AAA: 2164; 780].

70. Agnes Mongan, interview by author, 1983.

71. Sachs, "Tales," pt. 2, v. 1, p. 43, CORP.

72. Ibid., p. 52.

73. Course outline, p. 29.

74. Ibid., p. 197.

75. Ibid.

76. Ibid., p. 239.

77. Ibid., p. 1.

78. Ibid.

79. Ibid., p. 164.

80. Ibid., p. 3.

81. Sachs, "Tales," pt. 1, v. 28, p. 3879, CORP.

82. Ibid., p. 3876.

83. Ibid. *Masters of Popular Painting: Modern Primitives of Europe and America* (New York: Museum of Modern Art, 1938), edited by Barr, contains documentation that Frederick Clay Bartlett had seen the painting in 1897 at the Independent Exhibition.

84. Barr to Gauss, April 25, 1925, Gauss Papers, AAA.

85. Milton W. Brown, interview by author, October 1984.

86. Course outline.

87. Ibid.

88. Ibid.

89. MoMA Archives, NY: Oral History Project, interview with Edward Warburg.

90. Course outline.

91. Ibid.

92. Sachs, "Tales," pt. 1, v. 1, p. 19, CORP.

93. Mongan, interview with author, 1985.

94. Course outline.

95. Ibid.

96. A. Conger Goodyear, *The First Ten Years of the Museum of Modern Art* (New York: Museum of Modern Art, 1939), p. 20.

97. Margaret Barr, interview with Paul Cummings, 1974, AAA.

98. Course outline.

99. Course outline, p. 214.

100. Sachs, "Tales," pt. 2, v. 1, p. 43, CORP.

101. Ibid., pt. 2, v. 15, p. 2363, CORP.

102. Paul J. Sachs, *A Loan Exhibition of Early Italian Engravings (Intaglio)* (Cambridge: Fogg Art Museum, 1915).

103. Course outline, p. 25. Besides giving some 11,000 objects to Boston's Museum of Fine Arts, Ross also gave a large bequest to the Fogg that included a few outstanding works of art as well as study materials of drawings, paintings, textiles, engravings, and photographs.

104. Ibid., p. 26.

105. Sachs, "Tales," pt. 2, v. 15, p. 2362, CORP.

106. Ibid.

107. Ibid., p. 2359.

108. Ibid., p. 2363.

109. Ibid.

110. Ibid.

111. Ibid.

112. Ibid., p. 3269.

113. Mongan, interview with author, 1987.

114. Barr to Sachs, August 3, 1925, Sachs Files, FAM.

115. MoMA Archives, NY: AHB [AAA: 3150; 422–457].

116. Ibid. [437, 438].

117. Ibid. [438].

118. Ibid. [448, 446].

119. Ibid. [455].

120. Barr to Sachs, August 3, 1925, Sachs Files, FAM.

121. MoMA Archives, NY: AHB [AAA: 3263; 197–204].

122. Wall label, 1925, MoMA Archives, NY: AHB [AAA: 3263; 197].

123. MoMA Archives, NY: AHB [AAA: 3263; 198]. In *Art in Our Time: An Exhibition to Celebrate the Tenth Anniversary of the Museum of Modern Art and the Opening of Its New Building Held at the Same Time of the New York World's Fair* (New York: Museum of Modern Art, 1939), the catalogue that accompanied the exhibition, Barr wrote in the preface on p. 14: "The exhibition of paintings which begins with folk art is concluded with a group of *Painting by Children* between the ages of eight and twelve, whose best work need[s] no apology and is, of course, directly related to the problem of recovering that innocence of eye and imaginative freedom desired by so many artists of our period." The catalogue demonstrated Barr's acquaintance with the "remarkable revaluation of children's art which has come about during the past two decades." Barr to Arthur Lugee, June 19, 1947, MoMA Archives, NY: AHB [AAA: 2173; 245].

124. Ibid.

125. MoMA Archives, NY: AHB [AAA: 3263; 199].

126. Roger Fry, "Paul Cézanne," *Burlington Magazine* 31 (August 15, 1917); quoted in Judith Wechsler, ed., *Cézanne in Perspective* (Englewood Cliffs, N.J.: Prentice Hall, 1975).

127. MoMA Archives, NY: AHB [AAA: 3263; 200].

128. Ibid. [199].

129. Ibid. [201].

130. Ibid. [200]. William Rubin in "Pablo and Georges and Leo and Bill," *Art in America* 67 (March–April 1978), attributed the original use of the phrase "passage" to Pissarro.

131. MoMA Archives, NY: AHB [AAA: 3263; 200].

132. Ibid. [201].

133. Ibid. [202]. As early as 1920 Barr had become familiar with Archipenko's work and had seen an exhibition of his work at the Kingore Gallery in 1924.

134. MoMA Archives, NY: AHB [AAA: 3263; 204].

135. Ibid.

136. Roob, "Alfred H. Barr, Jr.: A Chronicle," pp. 5, 6.

137. MoMA Archives, NY: AHB [AAA: 3263; 201].

138. Sachs to Morey, June 12, 1925, Sachs Papers, pt. 1, v. 28, p. 3879, CORP.

139. Barr to Sachs, August 3, 1925, Sachs Papers, pt. 1, v. 28, p. 3887, CORP.

140. Sachs to Sam Lewisohn, November 18, 1926, Sachs Papers, pt. 1, v. 28, p. 3903, CORP.

141. See Rosalind Krauss, *The Originality of the Avant-Garde and Other Modernist Myths* (Cambridge: MIT Press, 1985), p. 221.

142. Courses on modernism entered the Fine Arts department at Harvard in the 1930s; Modern Painting was given first in 1936–1937 by Paul Sachs, Charles Kuhn, and Frederick Deknatel.

3 BARR AS TEACHER, 1925 TO 1927

1. Sachs to Morey, June 12, 1925, Sachs Papers, pt. 1, v. 28, p. 3879, CORP.

2. Rona Roob, "Alfred H. Barr, Jr.: A Chronicle of the Years 1902–1929," *New Criterion* (Summer 1987), p. 7.

3. Margaret Barr, letter to author, September 20, 1980.

4. Roob, "Alfred H. Barr, Jr.: A Chronicle," p. 7. According to Roob, Barr served as preceptor in three other courses: Smith's course in medieval architecture and Stohlman's courses in Renaissance sculpture and modern sculpture.

5. In December of 1925, Barr presented two papers at a meeting of the College Art Association held at Cornell University. The first was entitled "A Drawing by Antonio Pollaiuolo"; the second, "A Synthetic Course in Renaissance and Modern Art," was presumably about his teaching at Princeton in which he stressed aesthetics.

6. Roob, "Alfred H. Barr, Jr.: A Chronicle," p. 9.

7. Barr to Josef Albers, 1936, MoMA Archives, NY: AHB [AAA: 2166; 362].

8. Sheldon Cheney, *A Primer of Modern Art* (New York: Liveright, 1924), p. 92.

9. Abbott to Sachs, September 12, 1926, Sachs Papers, CORP.

10. Sachs to Abbott, September 21, 1926, Sachs Files, FAM.

11. Barr to Sachs, August 3, 1925, and October 10, 1925, Sachs Papers, pt. 1, v. 28, p. 3880, CORP.

12. Ibid., p. 3890.

13. Ibid., p. 3891.

14. Barr to Sachs, January 1, 1926, Sachs Papers, pt. 1, v. 28, p. 3895, CORP.

15. Ibid.

16. Ibid.

17. Barr to Macdonald, 1953, Macdonald Papers, YUL.

18. Ibid.

19. Barr to parents, February 1926, MoMA Archives, NY: AHB [AAA: 3262; 1150].

20. Myrtilla Avery, "Methods of Teaching Art at Wellesley," *Parnassus* 3, no. 4, p. 21.

21. Jewett Arts Center, *One Century: Wellesley Families Collect* (Wellesley, Mass.: Wellesley College Museum, April 13–May 30, 1979).

22. Barr, interview by Macdonald, Macdonald Papers, YUL.

23. Barr to parents, February 1926, MoMA Archives, NY: AHB [AAA: 3262; 1150].

24. Ibid.

25. J. B. Neumann (1887–1961). I am indebted to Lily Harmon, who wrote an unpublished manuscript on Neumann, for some of the material on him.

26. Duncan Phillips to Barr, January 25, 1941, MoMA Archives, NY: AHB [AAA: 2166; 1109].

27. Barr to Neumann, July 19, 1926, Neumann Papers, AAA.

28. Barr to Neumann, October 12, 1926, Neumann Papers, AAA.

29. Ibid.

30. Alfred H. Barr, Jr., "Boston Is Modern Art Pauper," *Harvard Crimson* 80 (October 30, 1926), p. 1. See *Defining Modern Art: Selected Writings of Alfred H. Barr, Jr.,* ed. Irving Sandler and Amy Newman, with a bibliography of published writings compiled by Rona Roob (New York: Harry N. Abrams, 1986), p. 285.

31. Barr to Sachs, February 14, 1927, Sachs Papers, pt. 1, v. 28, pp. 3915–3919, CORP.

32. Ibid.

33. "New and Conservative Trends in Art Opinion of Mr. Barr," *Wellesley College News,* January 27, 1927, p. 5.

34. Barr to Sachs, February 14, 1927, Sachs Papers, pt. 1, v. 28, pp. 3915–3919, CORP.

35. *Wellesley College News,* January 27, 1927, p. 5.

36. Barr to Sachs, February 14, 1927, Sachs Papers, pt. 1, v. 28, pp. 3915–3919, CORP.

37. Ibid.

38. Helaine Messer, "MoMA: Museum in Search of an Image," Ph.D. diss., Columbia University, 1979, p. 24.

39. Maria Morris Hambourg, "From 291 to the Museum of Modern Art, 1910–37," in Maria Morris Hambourg and Christopher Phillips, *The New Vision: Photography between the World Wars* (New York: Metropolitan Museum of Art, 1989), p. 30.

40. Alfred H. Barr, Jr., "A Modern Art Questionnaire," *Vanity Fair* 28 (August 1927), pp. 85, 96, 98.

41. Ibid., p. 85.

42. Barr to Gauss, 1927, Gauss Papers, AAA.

43. Barr, "A Modern Art Questionnaire," p. 85.

44. Alfred H. Barr, Jr., "Plastic Values," book review of *The Art in Painting* by Albert C. Barnes, *Saturday Review of Literature* 2 (July 24, 1926), p. 948.

45. Robert Hughes in *Esquire* 100 (December 1983), pp. 402–413.

46. Barr, "A Modern Art Questionnaire," p. 96. In this instance, his knowledge of "scholasticism" was directly related to the precepts of Morey.

47. On February 17, 1927, Barr reported to Dreier that he had just read for the second time the book published in 1925 by the Société Anonyme, *Modern Russian Art* by Louis Lozowick, which Barr thought was "admirably brief and clear." He sent a $2 check to cover the cost of sending Lozowick's book to Wellesley and to Ralph Steiner. Lozowick's stay in Berlin and Russia from 1922 to 1924 provided him with material for the book. Dreier Papers, YUL.

48. Barr, "A Modern Art Questionnaire," passim.

49. In addition to Neumann, Barr learned about the Bauhaus from Carl Zigrosser, who worked at the Weyhe Bookshop in New York City and managed the art gallery on the second floor. Zigrosser was one of the earliest Americans to visit the Bauhaus and corresponded with Gropius and Moholy-Nagy in the early 1920s. Hambourg, "From 291 to the Museum of Modern Art," p. 38.

50. Barr, "A Modern Questionnaire," passim.

51. Mary Bostwick, "Wellesley and Modernism," *Boston Evening Transcript,* Wednesday, April 27, 1927, sect. 1, p. 10, unsigned. Bostwick, also Barr's student, in an interview with the author, 1982, reported that she wrote for the *Boston Transcript* while attending Wellesley College.

52. Messer, "MoMA: Museum in Search of an Image," p. 30.

53. Bostwick, "Wellesley and Modernism," p. 10.

54. Barr, letter to Jane Sabersky, February 3, 1947, MoMA Archives, NY: AHB [AAA: 2172; 366]. Barr was referring to the *Dial's Living Art* portfolio, discussed in the next chapter.

55. Bostwick, "Wellesley and Modernism," p. 10.

56. Ibid. Barr wrote an article on the Necco factory for *Arts* 13 (January 1928), pp. 48–49, and Abbott took photographs of the building, illustrating the article, that were published in *Hound & Horn.*

57. Barr, interview by Macdonald, Macdonald Papers, YUL.

58. Ibid.

59. Bostwick, "Wellesley and Modernism," p. 10.

60. Ibid.

61. Abbott, interview by the author, 1982.

62. Bostwick, "Wellesley and Modernism," p. 10.

63. Barr, interview by Macdonald, Macdonald Papers, YUL.

64. Henry-Russell Hitchcock, interview by author, 1980.

65. Erwin Panofsky, *Meaning in the Visual Arts* (Garden City, N.Y.: Doubleday, 1955), pp. 328–329.

66. Milton W. Brown, *The Story of the Armory Show* (New York: Joseph Hirshhorn Foundation, New York Graphic Society, 1963), p. 105.

67. Ibid., p. 25.

68. Barr, interview by Macdonald, Macdonald Papers, YUL.

69. Barr, "A Modern Art Questionnaire," p. 85.

70. Ibid., p. 96.

71. Barr, letter to Benjamin Reid, July 24, 1968, MoMA Archives, NY: AHB [AAA: 2197; 1350, 1351]. Reid wrote *The Man from New York: John Quinn and His Friends* (New York: Oxford University Press, 1968).

72. Roob, "Alfred H. Barr, Jr.: A Chronicle," p. 3, wrote that Barr went to see the exhibition with Mather while he was at Princeton. William Lieberman thought that this exhibition probably turned Barr toward modernism (interview by the author, 1980).

73. From "A Protest against the Present Exhibition of Degenerate Modernistic Works in the Metropolitan Museum of Art" (New York, 1921; a privately published brochure).

74. It is not clear whether Barr saw that exhibition. He was finishing his undergraduate work at Princeton and didn't visit Wyndham Lewis until his trip to Europe in 1927.

75. John Quinn to Georges Rouault, November 14, 1907; quoted in Judith Zilczer, *The Noble Buyer: Patron of the Avant-Garde* (Washington, D.C.: Smithsonian Institution Press, 1978).

76. Zilczer, *The Noble Buyer,* p. 50.

77. Ibid., p. 53.

78. Barr to Mrs. Thomas Conroy, niece of Quinn, August 8, 1966, MoMA Archives, NY: AHB [AAA: 2197; 1365].

79. Barr, "A Modern Art Questionnaire," p. 85.

80. Roob, "Alfred H. Barr, Jr.: A Chronicle," p. 9.

81. Barr, "Plastic Values," p. 948.

82. Told to author by Franklin Ludden, 1989, as repeated by Panofsky. Margaret Barr was a friend of Panofsky's and taught him Italian.

83. Barr, "Plastic Values," p. 948.

84. Ibid.

85. Ibid.

86. Alfred H. Barr, Jr., *Henri-Matisse,* with "Notes of a Painter," translated by Margaret Scolari Barr in the catalogue accompanying the *Museum of Modern Art "Matisse"* exhibition (New York: Museum of Modern Art, 1931); reprinted in Barr's book *Matisse: His Art and His Public* (New York: Museum of Modern Art, 1951).

87. Nelson Rockefeller to Dreier, signed by Rockefeller but written by Barr, May 9, 1950, MoMA Archives, NY: AHB [AAA: 2172; 973].

88. Dreier to Nelson Rockefeller, January 7, 1948, MoMA Archives, NY: AHB [AAA: 2172; 971].

89. During those twenty years, 84 exhibitions were circulated and 143 lectures were given throughout the country. See Eleanor Apter, Robert L. Herbert, and Elise Kenney, eds., *The Société Anonyme and the Dreier Bequest at Yale University: A Catalogue Raisonné* (New Haven: Yale University Press, 1984), a compilation of all the exhibitions mounted by the Société Anonyme.

90. Ruth Louise Bohan, "The Société Anonyme's Brooklyn Exhibition, 1926–27: Katherine Sophie Dreier and the Promotion of Modern Art in America," Ph.D. diss., University of Maryland, 1980.

91. Dreier to Barr, February 4, 1927, MoMA Archives, NY: AHB [AAA: 2164; 45].

92. Barr to Dreier, February 9, 1927, Dreier Papers, YUL.

93. Barr to Dreier, February 13, 1927, Dreier Papers, YUL.

94. Barr to Dreier, February 27, 1927, Dreier Papers, YUL.

95. Ibid.

96. Barr to Dreier, February 13, 1927, Dreier Papers, YUL.

97. Dreier to Barr, February 19, 1927, MoMA Archives, NY: AHB [AAA: 2164; 42].

98. Ibid.

99. Barr to Dreier, February 27, 1927, Dreier Papers, YUL.

100. Dreier to Barr, March 4, 1927, MoMA Archives, NY: AHB [AAA: 3263; 1030].

101. Bohan, "The Société Anonyme's Brooklyn Exhibition," p. 122.

102. Barr to Dreier, March 7, 1927, Dreier Papers, YUL.

103. Dreier to Barr, March 14, 1929, MoMA Archives, NY: AHB [AAA: 3263; 1029].

104. Barr to James Thrall Soby, November 1948. MoMA Archives, NY, AHB, 9b; quoted in *Defining Modern Art: Selected Writings of Alfred H. Barr*, p. 147.

105. Alfred H. Barr, Jr., in *Arts* 17, no. 4 (January 1931), p. 244.

106. Dreier to Barr, March 14, 1929, MoMA Archives, NY: AHB [AAA: 3263; 1029].

107. Bohan, "The Société Anonyme's Brooklyn Exhibition," p. 17.

108. Barr thought Dreier's book on modern art, *Western Art and the New Era*, "muddled" and refused an invitation to review it since Dreier, he said, was a friend and an important collector. Barr to Henry Canby, March 4, 1930, MoMA Archives, NY: AHB [AAA: 2164; 503].

109. Alfred H. Barr, Jr., *Exhibition of Progressive Modern Painting: From Daumier and Corot to Post-Cubism* (Wellesley: Art Museum of Wellesley College, April 11–30, 1927), unpaginated. Lenders to the exhibition were the Fogg Museum, Paul Sachs, Mrs. John Saltonstall of Boston, Jere Abbott, and Walter Pach. Among galleries that lent works were Rehn, Brummer, Knoedler, and New Art Circle (J. B. Neumann). MoMA Archives, NY: AHB [AAA: 3263; 106–108].

110. MoMA Archives, NY: AHB [AAA: 3263, 92].

111. Ibid.

112. Ibid. [93]. In the first exhibition at the newly formed Museum of Modern Art, the ancestral list was simplified to Cézanne, van Gogh, Gauguin, and Seurat. (Renoir was considered at the time and then dropped.)

113. Ibid. [94].

114. Ibid.

115. Ibid.

116. Ibid.

117. Ibid. At the Modern in 1933, Barr was called to task by Ralph Pearson for giving Hopper a one-man show (*New Republic*, December 6, 1933, p. 104). The writer would not concede that Hopper was a modernist painter: "[The Museum] has signally honored a naturalistic, realistic painter whose work, in its viewpoint and procedure, is the reverse of that which characterizes the modern movement."

118. MoMA Archives, NY: AHB [AAA: 3263;94].

119. Ibid.

120. Ibid.

121. Ibid. [93].

122. Ibid. [96]. The phrase "peculiar to the medium" presages Clement Greenberg's point of view. In defining formalism and Greenberg's aesthetics, Sidney Tillim listed particulars that, if not based on Barr's writings, are similar to the point of limiting the authority of Greenberg's methodological originality. See Sidney Tillim, "Criticism and Culture or Greenberg's

Doubt," a review of *Clement Greenberg: The Collected Essays and Criticism,* in *Art in America* 75 (May 1987), pp. 122–127, 201. That Greenberg used "history to validate his claims to objectivity and disinterestedness" (p. 122) was a point of view he shared with Barr. But Tillim's claim that when Greenberg reconciled radical art with great traditional art he "contrived for modernism a historical patrimony it had previously lacked" (p. 123) ignores the contributions of Fry, Barr, Barnes, Dreier, and Cézanne. Barr's writings fit Tillim's definition of formalism: "Formalism, strictly practiced, limits what can be said about art to what can be seen (how does one describe an experience that is essentially a reflex?) and shields art from the contingencies of art's own cultural formation" (p. 124). Barr applied this definition of formalism to all historical periods even though, in the 1930s, he at times followed the contemporary discourse on art in defining formalist art as coterminous with abstract art.

123. MoMA Archives, NY: AHB [AAA: 3263; 103].

124. Ibid.

125. Barr to Gauss, Gauss Papers, AAA.

4 THE LITTLE MAGAZINE AND MODERNISM AT HARVARD

1. W. McNeil Lowry, "Conversations with Kirstein," part II, *New Yorker* (December 22, 1986), p. 52.

2. Barr to Sachs, September 12–16, 1927, Sachs Papers, pt. 1, v. 28, p. 3928, CORP.

3. Lincoln Kirstein, "A Memoir: The Education," *Raritan* 2, no. 3 (Winter 1983), pp. 51–52.

4. Warren I. Susman, "Pilgrimage to Paris: The Backgrounds of American Expatriation," Ph.D. diss., University of Wisconsin, 1953, p. 50. Published as *History and the American Intellectual, a Second Country: The Expatriate Image* (Indianapolis: Bobbs Merrill, 1961). Susman made a study of the movement of Americans sojourning in Europe during the years 1920–1934, documenting many of the concepts developed in this book concerning the cultural climate of the 1920s when modernism entered the university. He notes that the idea of the "cultural invasion" of Europe as a "new frontier" is a major theme in the intellectual history of the twentieth century (p. 187). Susman concentrates mainly on the American involvement in France, which he sees as "the end of the dominant Anglo-Saxon influence that occurred in much of American intellectual history in the nineteenth century" (p. 110).

5. Lincoln Kirstein, *Mosaic: Memoirs* (New York: Farrar, Straus & Giroux, 1994), p. 60.

6. John Russell, "Lincoln Kirstein, a Life in Art," *New York Times Magazine,* June 20, 1982, p. 27.

7. Barr to A. Phillip McMahon, May 11, 1937, MoMA Archives, NY: AHB [AAA: 2166; 536].

8. Kirstein, "A Memoir: The Education," pp. 34, 35.

9. Lincoln Kirstein, *The New York City Ballet* (New York: Alfred A. Knopf, 1973), p. 14. Kirstein incorporated his experiences at the studio in a first novel, *Flesh Is Heir: An Historical*

Romance (New York: Brewer, Warren & Putnam, 1932), which also describes the funeral of Diaghilev.

10. Parker Tyler, *The Divine Comedy of Pavel Tchelitchew* (New York: Fleet, 1967), p. 449. Tyler demonstrated throughout the book that Kirstein was Tchelitchew's "arch supporter" (p. 451).

11. Lincoln Kirstein, foreword to Mitzi Berger Hamovitch, ed., *The Hound & Horn Letters* (Athens: University of Georgia Press, 1982), p. xv.

12. Kirstein, "A Memoir: the Education," p. 49.

13. Henry Adams, *Mont-Saint-Michel and Chartres* (1905; Boston: Houghton Mifflin, 1913); *The Education of Henry Adams* (1907; Boston: Houghton Mifflin, 1918).

14. Van Wyck Brooks, *Scenes and Portraits: Memories of Childhood and Youth* (New York: Dutton, 1954), pp. 107–108.

15. Kirstein, *Mosaic: Memoirs*, p. 79.

16. Macdonald Papers, YUL.

17. Lincoln Kirstein, "Crane and Carlsen: A Memoir, 1926–1934," *Raritan* 1 (Winter 1982), p. 21.

18. Kirstein, in Lowry, "Conversations with Kirstein," Part II, p. 58.

19. Susman, "Pilgrimage to Paris," p. 249.

20. Philippe Soupault, *The American Influence in France,* trans. Babette and Glenn Hughes (Seattle: American Bookstore, 1930), p. 17.

21. Ibid., p. 20.

22. Ezra Pound, "The White Stag," in *Personae: The Collected Poems of Ezra Pound* (New York: New Directions, 1926, p. 25.

23. Lincoln Kirstein, foreword to *The Hound & Horn Letters,* p. xii.

24. Ibid.

25. Lincoln Kirstein, "The Hound & Horn, 1927–1934" (with a letter from Varian Fry as a note), *Harvard Advocate* 121 (Christmas 1934), pp. 6, 7. The "chronicles" had their start in 1930 (vol. 3, no. 3 of the *Hound & Horn*). The "Art Chronicle" was written by A. Hyatt Mayor, who joined the editorial staff at that time. Mayor graduated from Princeton in 1922, the same year as Barr, and they were the best of friends. He taught art history at Vassar for a year, although at that time he was primarily a linguist. In 1932 he joined the print department of the Metropolitan Museum of Art under his mentor William M. Ivins, Jr. He succeeded Ivins as curator in 1946 and retained the position until his retirement in 1966.

26. Varian Fry, "Note," in Kirstein, "The Hound & Horn, 1927–1934," p. 93.

27. William Wasserstrom, *The Time of The Dial* (Syracuse: Syracuse University Press, 1963), p. 87.

28. Lincoln Kirstein, prefatory essay to *The Flow of Art: Essays and Criticisms of Henry McBride*, ed. Daniel Catton Rich (New York: Atheneum, 1975), p. 8.

29. *Living Art: Twenty Facsimile Reproductions after Paintings, Drawings and Engravings and Ten Photographs after Sculpture by Contemporary Artists* (New York: Dial Publishing Co., 1923). 500 folios were printed. Among the works acquired were Picasso's *Mother and Child Near a Fountain*, 1901; Matisse's *Nasturtiums and the 'Dance II,'* 1912; Bonnard's *The Dressing Room*, 1914; and Braque's *Standing Figure*, 1924. Also in the collection were works by Edvard Munch, Vlaminck, Charles Demuth, John Marin, Cézanne, and Klimt.

30. See Milton W. Brown, *American Art from the Armory Show to the Depression* (Princeton: Princeton University Press, 1955), p. 89. McBride's early recognition of such artists as Léger, Miró, Max Weber, Stuart Davis, Joseph Stella, John Marin, Georgia O'Keeffe, and his friend Charles Demuth assured his recognition as a significant art critic. His columns also contained news of Matisse, Picasso, Braque, and Brancusi. He literally discovered Thomas Eakins in 1913 and was responsible for the artist's exhibition at the Metropolitan Museum of Art. Like Barr, he was criticized for placing European painters ahead of Americans, but in both cases the record shows that, quantitatively, Americans were represented more than Europeans at the Museum of Modern Art and in McBride's writings; see McBride, *The Flow of Art*, p. 26.

31. Kirstein, prefatory essay to McBride, *The Flow of Art*, p. 24.

32. Ibid., p. 19.

33. Ibid., p. 7.

34. Henry McBride, "Foreword," *Dial* 69 (July 1920), p. 61.

35. Kirstein, prefatory essay to McBride, *The Flow of Art*, p. 24.

36. Alfred H. Barr, Jr., "Modern Painting," review of *Evolution in Modern Art* by Frank Rutter, *Saturday Review of Literature* 3 (October 30, 1926), p. 252.

37. Pound was born in Idaho and educated at Hamilton College in New York and the University of Pennsylvania. He taught romance languages for a time before he left for Europe in 1908, where he stayed first in London, then in Paris, and finally settled in Rapallo, Italy. His Fascist leanings caused his imprisonment following World War II.

38. A detailed analysis of Pound's relationship with the editors of *Hound & Horn* appears in Leonard Greenbaum, *The Hound & Horn: The History of a Literary Quarterly* (The Hague: Mouton, 1966), 96–124. Although Pound didn't contribute a new author of note to the magazine, he did send them his own Cantos XXVIII, XXIX, and XXX, published in the issue of April–June 1930.

39. Kirstein, "A Memoir: The Education," pp. 51–52.

40. Ezra Pound, "The Renaissance," *Poetry* (March 1915), pp. 283–287, and (May 1915), pp. 84–91. An excerpt was reprinted in *Ezra Pound and the Visual Arts*, ed. Harriet Zinnes (New York: New Directions, 1980), pp. 268–269.

41. Iris Barry, "The Ezra Pound Period," *Bookman* 74 (October 1931), pp. 168, 169.

42. Ezra Pound, "Affirmations," *New Age* 14 (1915), p. 278.

43. Ezra Pound, in *New Age* (September 26, 1918), p. 320.

44. Ibid., p. 256.

45. Kirstein, "The Hound & Horn, 1927–1934," p. 8.

46. Edmund Wilson's essay later appeared in a revised form in *Axel's Castle* (New York: Scribner's, 1969).

47. Kirstein, foreword to Hamovitch, ed., *The Hound & Horn Letters*, p. xvi.

48. Letter from Kirstein to William Wasserstrom, 1958, in Wasserstrom, *The Time of The Dial*, pp. 124–125.

49. Kirstein, "Crane and Carlsen: A Memoir," p. 6.

50. Malcolm Cowley, *The Exile's Return* (1934; New York: Viking, 1951), p. 5.

51. Ibid., p. 89.

52. Ibid., p. 77.

53. Ibid., p. 111.

54. Ibid., p. 240.

55. Malcolm Cowley, quoted in Matthew Josephson, *Life among the Surrealists* (New York: Holt, Rinehart and Winston, 1964), p. 153.

56. Kirstein, *Mosaic: Memoirs*, p. 87.

57. Gorham Munson, "A Bow to the Adventurous," *Secession* 1 (April 1922), p. 19.

58. Josephson, *Life among the Surrealists*, p. 155.

59. Ibid., p. 168.

60. Ibid., p. 188.

61. Ibid., p. 169.

62. Ibid.

63. Ibid., p. 155.

64. Ibid., p. 28.

65. Ibid., p. 275.

66. Ibid., p. 248.

67. Cowley, *Exile's Return*, p. 34.

68. T. S. Eliot, "Second Thoughts on Humanism," *Hound & Horn* 2 (June–August 1929).

69. Greenbaum, *The Hound & Horn*, p. 58. Greenbaum credited Kirstein's growing interest in the political left and Russia for the spate of articles on "the class struggle," although Kirstein protested that he was not political.

70. Lincoln Kirstein to Roger Sessions, June 1931; quoted in Hamovitch, ed., *The Hound & Horn Letters*, p. 16.

71. Unsigned editorial comment, *Hound & Horn* 3 (October–December 1929), p. 56.

72. Henry-Russell Hitchcock, "The Decline of Architecture," *Hound & Horn* (advance issue), pp. 10–17; 1 (September 1927), pp. 28–35.

73. Henry-Russell Hitchcock, "Periodical Reviews," *Hound & Horn* 2 (September 1928), p. 95.

74. Robert Taylor Davis in *Hound & Horn* 1 (September 1927), pp. 18, 19.

75. Henry-Russell Hitchcock, "Four Architects," *Hound & Horn* 2 (September 1928), p. 95. Peter Smith was included in the article and grouped with the new international-style architects. He attended the Harvard School of Architecture and worked for Stone, Webster and Kendall Bros. in Boston and then the architect Lurçat in Paris. He died prematurely in Berlin in 1928.

76. Alfred H. Barr, Jr., "Modern Architecture, by Henry-Russell Hitchcock, Jr." (review), *Hound & Horn* 3 (April–June 1930), p. 431.

77. Kirstein, foreword to Hamovitch, ed., *Hound & Horn Letters*, p. xx.

78. Frederick J. Hoffman, with Charles Allen and Carolyn F. Ulrich, *The Little Magazine: A History and a Bibliography* (Princeton: Princeton University Press, 1947), p. 215.

79. Barr to Kirstein, October 25, 1933, MoMA Archives, NY: AHB [AAA: 2164; 1025].

80. Kirstein, foreword to Hamovitch, ed., *The Hound & Horn Letters*, p. xiv.

81. Kirstein, "The Hound & Horn, 1927–1934," p. 6.

82. Barr's article "Modern Art in London Museums," *Arts* 14 (October 1928), pp. 187–194, is discussed in chapter 5 below.

83. Lincoln Kirstein, letter to Yvor Winters, August 31, 1933; quoted in Hamovitch, ed., *The Hound & Horn Letters*, p. 3.

5 THE EUROPEAN TRIP

1. Barr to Sachs, January 17, 1928, Sachs Files, FAM.

2. Sachs to Barr, February 2, 1928, Sachs Files, FAM.

3. Barr to Sachs, January 17, 1928, Sachs Papers, pt. 1, v. 28, p. 3944, CORP.

4. Barr to Sachs, November 24, 1928, Sachs Papers, pt. 1, v. 28, p. 3990, CORP.

5. Ibid., p. 3992.

6. Sachs to Princeton University, November 27, 1928, Sachs Papers, pt. 1, v. 28, p. 3989, CORP. Harvard and Princeton turned Barr down for a scholarship, but New York University granted him one to work on a modern subject under Philip McMahon.

7. Barr to Forbes Watson, November 23, 1927, Forbes Watson Papers, Smithsonian Institution, Archives of American Art.

8. Several years later, Barr was roundly criticized for including artistic works from these two sources in the exhibition "Fantastic Art, Dada, Surrealism" in 1936. Katherine Dreier in particular withdrew her support of the exhibition because she thought that "the American public was not ready for comparative material." Dreier to Barr, February 27, 1937, MoMA Archives, NY: AHB [AAA: 2172; 992].

9. Barr to Sachs, April 14, 1928, Sachs Files, FAM.

10. Alfred H. Barr, Jr., "Modern Art in London Museums," *Arts* 14 (October 1928), p. 187. Barr wrote another article about his visit to Holland, "Dutch Letter," *Arts* 13 (January 1928), pp. 48–49, comparing the interest of the museums of Rotterdam, The Hague, and Amsterdam in modern art to the indifference of American institutions.

11. Barr to Sachs, September 27, 1927, Sachs Papers, pt. 1, v. 28, p. 3992, CORP.

12. Barr, "Modern Art in London Museums," p. 187.

13. Ibid.

14. Ibid.

15. Ibid., p. 192.

16. Ibid., pp. 190–191.

17. Ibid., p. 187.

18. Ibid., p. 190.

19. Barr to Neumann, September 29, 1927, Neumann Papers, AAA.

20. Barr to parents, April 2, 1927; quoted in Rona Roob, "Alfred H. Barr, Jr.: A Chronicle of the Years 1902–1929," *New Criterion* (Summer 1987), p. 13.

21. Dreier had also given him letters of introduction to Gropius at the Bauhaus, at Barr's request. Louise Bohan, letter to author, October 27, 1980.

22. Ibid.

23. Barr to Neumann from Oxford, August 1927, Neumann Papers, AAA.

24. Penny Beale, "J. B. Neumann and the Introduction of Modern German Art to New York, 1923–1933," *Archives of American Art Journal* 29, nos. 1–2 (1989), p. 3.

25. Ibid., p. 7.

26. Jay Leyda, letter to Neumann, no date, Neumann Papers, AAA. Leyda spent three years in Russia as Eisenstein's assistant in the 1930s and was helpful to Iris Barry in collecting prints for the film library at the Museum of Modern Art. He also facilitated obtaining works of art and documentation from artists in Moscow for Barr's "Cubism and Abstract Art" exhibition.

27. Alfred H. Barr, Jr., statement for *PM*, June 10, 1944, p. 12.

28. Hermann Muthesius, "Aims of the Werkbund" (1911), in Ulrich Conrads, ed., *Programs and Manifestoes on Twentieth Century Architecture,* trans. Michael Bullock (Cambridge: MIT Press, 1970), p. 27.

29. Dennis Sharp, *Modern Architecture and Expressionism* (New York: Braziller, 1963), p. 63.

30. Bruno Taut, "Ein Architektur-Programm," translated as "A Program for Architecture," in Conrads, ed., *Programs and Manifestoes on Twentieth Century Architecture,* p. 44.

31. Bruno Taut, "Eine Notwendigkeit," *Der Sturm* 4 (February 1914), p. 174; quoted in Marcel Franciscono, *The Creation of the Bauhaus at Weimar* (Bloomington: Indiana University Press, 1970), p. 97.

32. Walter Gropius, "Cathedral of the Future," quoted in Ulrich Conrads and H. G. Sperlich, *Fantastic Architecture* (London: Architectural Press, 1963), p. 138.

33. Walter Gropius, *Program of the Staatliche Bauhaus* (Weimar, 1919), quoted in Franz Schulze, *Mies van der Rohe: A Critical Biography* (Chicago: University of Chicago Press, 1985), p. 87.

34. Supporting this emphasis on glass as a principal material was the poetry of Paul Scheerbart, *Glass Architecture* (Berlin, 1914), and Bruno Taut's fantasies of crystal mountains in *Alpine Architecture* (Hagen, 1919); published together in English translation (New York: Praeger, 1972).

35. Alex De Jonge, *The Weimar Chronicle: Prelude to Hitler* (New York: New American Library, 1978), pp. 171–172.

36. Barr to George Rowley, May 20, 1949, MoMA Archives, NY: AHB [AAA: 2191; 911].

37. Barr to Jane Fiske McCullough, February 6, 1967, MoMA Archives, NY: AHB [AAA: 2196; 1198]. Barr answered questions on the Bauhaus that McCullough posed to him.

38. László Moholy-Nagy had been influenced by the Russian constructivists through the Hungarian artist Alfréd Kemény, who had visited the Soviet Union in 1921. See Christina Lodder, *Russian Constructivism* (New Haven: Yale University Press, 1983), p. 236.

39. Alfred H. Barr, Jr., "In Remembrance of Feininger" (memorial eulogy), MoMA Archives, NY: AHB [AAA: 3150; 480].

40. In their English translations, these are: Walter Gropius, *International Architecture: The Best of the New Architecture;* Paul Klee, *Pedagogical Sketchbook; An Experimental House by the Bauhaus; Bauhaus Stage Design;* Piet Mondrian, *New Design;* Theo van Doesburg, *Principles of the New Art; New Work from the Bauhaus Workshops;* László Moholy-Nagy, *Painting, Photography, and Film;* Wassily Kandinsky, *From Point to Line to Plane;* J. J. P. Oud, *Dutch Architecture;* Kazimir Malevich, *Suprematism;* Walter Gropius, *Bauhaus Buildings in Dessau;* Albert Gleizes, *Cubism;* László Moholy-Nagy, *From Material to Architecture.*

41. Barr to McCullough, 1967, MoMA Archives, NY: AHB [AAA: 2196; 1198].

42. Barr, "In Remembrance of Feininger," MoMA Archives, NY: AHB [AAA: 3150; 480]. Born in 1871 in America, Feininger lived in Germany from 1887 until 1937, when he re-

turned to America to live and work until his death on January 13, 1956. Feininger did not escape having his work in the large exhibition of "degenerate art" mounted by the National Socialists in 1937, even though he was an American. When he returned to America in 1937, Feininger was known by Barr but not by too many others, although he had appeared in the second exhibition of "19 American Living Artists" at the Museum in 1929. In 1944 Barr arranged a retrospective show for him at the Museum.

43. *The Letters of Lyonel Feininger,* ed. June L. Ness (New York: Praeger, 1974), pp. 160, 161.

44. Feininger to Julia Feininger, November 15, 1924; by permission of the Houghton Library, Harvard University, shelf mark bMS Ger 146 (485–490).

45. Barr to Neumann, Berlin, December 12, 1928, Neumann Papers, AAA. (Neumann was devoted to Edvard Munch, Max Beckmann, Georges Rouault, and Paul Klee.)

46. See Sybil Moholy-Nagy, *Moholy-Nagy: Experiment in Totality,* with an introduction by Walter Gropius (New York: Harper, 1950), p. 168.

47. Quoted from Gropius, "Exhibition for Unknown Architects," 1919, in Conrads, ed., *Programs and Manifestoes on Twentieth-Century Architecture,* p. 46.

48. Alfred H. Barr, Jr., "Russian Diary 1927–28," *October 7* (Winter 1978), p. 11.

49. Margaret Scolari Barr, foreword to Barr, "Russian Diary," p. 7.

50. Ibid., p. 8.

51. Jere Abbott, foreword to Barr, "Russian Diary," p. 7. Hamnett was a writer as well as an artist; her international friends included Amedeo Modigliani, Ossip Zadkine, Jacob Epstein, Ezra Pound, and particularly Henri Gaudier-Brzeska. Nina Hamnett, *Laughing Torso: Reminiscences of Nina Hamnett* (London: Constable, 1932).

52. Christopher Lyon, "The Poster at the Modern: A Brief History," *MoMA: Museum of Modern Art Members Quarterly* (Summer 1988), p. 1.

53. Barr, "Russian Diary," p. 12.

54. Abbott, foreword to Barr, "Russian Diary," p. 7.

55. Barr, "Russian Diary," p. 11.

56. Barr to Sachs, January 17, 1928, Sachs Papers, pt. 1, v. 28, p. 3999, CORP.

57. Barr, "Russian Diary," p. 17.

58. Ibid., p. 25.

59. Pavel Muratov, *Les Icones russes* (Paris: Editions de la Pléiade, 1927).

60. Barr to Sachs, January 17, 1928, Sachs Papers, pt. 1, v. 28, p. 3946, CORP.

61. Alfred H. Barr, Jr., "Russian Icons," *Arts 17* (February 1931).

62. George Heard Hamilton, *The Art and Architecture of Russia* (Baltimore: Penguin, 1954).

63. Barr, "Russian Diary," p. 27; the book Barr mentions, N. P. Kondakov's *The Russian Ikon* (Oxford: Cambridge University Press, 1927), was a summary of his *Russkaya ikona*, 4 volumes, published in Prague.

64. Barr, "Russian Diary," p. 29.

65. Ibid., p. 37.

66. Igor Grabar, *Istoria russkogo iskusstva* (Moscow: Knebel, 1910–1915).

67. Barr, "Russian Diary," p. 40.

68. Ibid.

69. Ibid., p. 30.

70. Ibid., p. 22.

71. Ibid., p. 15. Rivera was teaching fresco painting and composition at the Lenin Academy. In the first year of the Museum of Modern Art's existence, Barr gave Rivera a one-man show there.

72. Alfred H. Barr, Jr., "The 'LEF' and Soviet Art," *transition* 13–14 (Fall 1928), p. 267.

73. "Zayavlene ob'edineniya sovremennykh arkhitektorov 'OSA' v khudozhestvennyi otdel glavnauki Narkomprosa," April 1926, as cited in Lodder, *Russian Constructivism,* p. 118. Ginzburg gave Barr copies of this magazine, which Ginzburg edited with the Vesnin brothers from 1926 to 1930 and from which Barr quoted when he wrote about Russian architecture for *Arts.*

74. Barr, "Russian Diary," p. 39.

75. Ibid., p. 13. Barr also wrote "Notes on Russian Architecture," *Arts* 15 (February 1929), pp. 103–106, 144, 146.

76. Jere Abbott, "Notes from a Soviet Diary," *Hound & Horn* 2 (April/June 1929), p. 263. The fact that Abbott wrote "International Style" in upper case letters this early takes on importance for Hitchcock's and Barr's conception of the modern architecture exhibition in 1932 at the Museum of Modern Art. It demonstrated that the term for the new architecture was common parlance among the Harvard men who were in the modernist avant-garde.

77. Barr, "Russian Diary," p. 39.

78. Barr, "The 'LEF' and Soviet Art," p. 269.

79. Ibid., p. 267.

80. Barr to Sachs, March 7, 1928, Sachs Papers, pt. 1, v. 28, p. 3958, CORP.

81. Barr, "Russian Diary," pp. 14–15.

82. Ibid., p. 24.

83. Ibid., p. 15.

84. Barr to Marie Seton, April 19, 1950, MoMA Archives, NY: AHB [AAA: 2172; 1269].

85. Barr, interview by Macdonald, Macdonald Papers, YUL.

86. Barr to Sachs, January 17, 1928, Sachs papers, pt. 1, v. 28, p. 3946, CORP.

87. Barr, "Russian Diary," p. 30.

88. Barr to Marie Seton, April 19, 1950, MoMA Archives, NY: AHB [AAA: 2172; 1269].

89. Alfred H. Barr, Jr., "Sergei Mikhailovitch Eisenstein," *Arts* 14 (December 1928), p. 319.

90. Alfred H. Barr, Jr., "The Researches of Eisenstein," *Drawing and Design* 4 (June 1928), p. 155. The photographs used as illustrations of Eisenstein's films were given to Barr by the director and are part of the archives of the Museum of Modern Art.

91. Ibid.

92. Barr, "The 'LEF' and Soviet Art," p. 270.

93. Ibid., p. 25. A bibliography of indexed articles on the film from the 1920s and 1930s showed that they were scarce in number and poor in quality; about 200 such articles existed, but only ten appeared before Barr wrote his two on Eisenstein in 1928. The bibliography was included in a book of film articles by Lewis Jacobs, *The Emergence of Film Art* (New York: Hopkins and Blake, 1969; 2d ed. 1979).

94. Barr, "Russian Diary," p. 49. Barr mistakenly referred to him as Nikolai in the diary.

95. Ibid., p. 37.

96. Barr to Gauss, July 7, 1928, Gauss Papers, AAA.

97. Barr, interview by Macdonald, Macdonald Papers, YUL.

98. Lodder, *Russian Constructivism*, p. 22. Lodder is quoting from Rodchenko's manuscript "Liniya," a paper written for INKhUK, the Institute of Artistic Culture in 1921. INKhUK became the institution from which constructivism was launched (Lodder, p. 88 and passim).

99. Barr, "Russian Diary," p. 21. This assessment made in 1927 of Rodchenko as a photographer was confirmed forty-three years later when Rodchenko had a one-man photography retrospective at the Museum of Modern Art in 1971. In the catalogue *Cubism and Abstract Art*, Barr relinquished the status of the earliest geometricist to Malevich who, he said, was "the first artist to establish a system of absolutely pure geometrical abstract composition" (p. 122).

100. See Lodder, *Russian Constructivism*, p. 3 and passim.

101. Barr, "Russian Diary," p. 36.

102. Barr to Neumann, Neumann papers, AAA.

103. Lodder, *Russian Constructivism*, p. 22.

104. Barr, "Russian Diary," p. 21.

105. Ibid., p. 44.

106. Ibid., p. 26.

107. Barr to Iris Barry, January 27, 1947, MoMA Archives, NY: AHB [AAA: 2173; 15].

108. Alfred H. Barr, Jr., "Za grantsei: Ruki" [Abroad: Hands], *Sovetskoe kino* 1 (February 1928), pp. 26–27; MoMA Archives, NY: AHB [AAA: 3263; 30].

109. Ibid. (*Ballet mécanique* had a successful showing at Carnegie Hall in New York in 1926; we can assume it was attended by Barr.)

110. Ibid.

111. Ibid.

112. Ibid.

113. Szymon Bojko, "VKhUTEMAS," in Stephanie Barron and Maurice Tuchman, eds., *The Avant-Garde in Russia, 1910–1930: New Perspectives* (Los Angeles: George Rice & Sons, 1980), p. 79. The name was changed to VKhUTEIN in 1927.

114. Jelena Hahl-Koch, "Kandinsky's Role in the Avant-Garde," in Barron and Tuchman, eds., *The Avant-Garde in Russia*, p. 90.

115. Alfred H. Barr, Jr., *Cubism and Abstract Art* (New York: Museum of Modern Art, 1936), p. 70.

116. See Lodder, *Russian Constructivism*, p. 7.

117. Barr, "Russian Diary," p. 35.

118. Lodder, *Russian Constructivism*, p. 234.

119. "Bauhaus—VKhUTEMAS," *Izvestia* 5, no. 2 (1927), p. 5.

120. *Bauhaus: 1919–1928,* ed. Herbert Bayer, Walter Gropius, Ise Gropius, preface by Alfred H. Barr, Jr. (New York: Museum of Modern Art, 1938), p. 126.

121. No date was given for the chair. Barron and Tuchman, eds., *The Avant-Garde in Russia,* p. 80.

122. Barr, "Russian Diary," p. 35.

123. Ibid., p. 36.

124. VKhUTEMAS was closed in 1930 by Stalin, who replaced all art deemed progressive with work that promoted socialist realism.

125. Barr, *Cubism and Abstract Art.,* p. 124.

126. Mary Anne Staniszewski, *The Power of Display: A History of Exhibition Installations at the Museum of Modern Art* (Cambridge: MIT Press, 1998), p. 21, discusses the importance of Barr's visit to the *Abstract Cabinet* to his installation techniques.

127. Troels Andersen, *Malevich* (Amsterdam: Stedelijk Museum, 1970), pp. 57–58. Barr had received $1,000 from Abby Rockefeller—his first purchase fund—with which he bought two oil paintings by Malevich, three dada collages, an oil by Ernst, a collage by Kurt Schwitters, a large pastel by André Masson, and a gouache by Yves Tanguy. Alfred H. Barr, Jr.,

Painting and Sculpture in the Museum of Modern Art (New York: Museum of Modern Art, 1967), p. 625.

128. Seven oils by Malevich were listed in the "Cubism and Abstract Art" exhibition plus seven drawings, and "four placards, with mounted photographs and drawings illustrating the development of abstract art" (Barr, *Cubism and Abstract Art*, p. 216). The *Cubism and Abstract Art* catalogue remained the primary source for the study of these artists of the early Russian avant-garde until Camilla Gray, with Barr's help, published *The Russian Experiment in Art, 1863–1922* (London: Thames and Hudson, 1962).

129. Konstantin Umansky, *Neue Kunst in Russland, 1914–1919* (Potsdam: Gustav Kiepenheuer; Munich: Goltz, 1920). Umansky was a Russian who went to Germany to promote cultural exchange between the two countries. See Lodder, *Russian Constructivism*, p. 233.

130. Barr, "Russian Diary," p. 17.

131. Quoted in Lodder, *Russian Constructivism*, p. 234.

132. Barr, "Russian Diary," p. 46.

133. See Lodder, *Russian Constructivism*, p. 230 and passim.

134. Jere Abbott, foreword to Barr, "Russian Diary," p. 8.

135. Barr to Neumann, April 14, 1928, Neumann Papers, AAA.

136. Barr to Sachs, April 14, 1928, Sachs Files, FAM.

137. Barr to Neumann, April 14, 1928, Neumann Papers, AAA.

138. Ibid.

139. Barr to Sachs, April 14, 1928, Sachs Files, FAM.

140. Barr to Neumann, April 14, 1928, Neumann Papers, AAA.

141. Barr to Sachs, April 14, 1928, Sachs Files, FAM.

142. Barr, "Russian Diary," p. 29.

143. Barr to Sachs, January 17, 1928, Sachs Papers, pt. 1, v. 28, p. 3947, CORP.

144. Abbott to Sachs, May 9, 1928, from Paris, Sachs Papers, FAM.

145. Sachs to Abbott, May 21, 1929, Sachs Files, FAM.

146. *Wellesley College News,* March 21, 1929, pp. 1–2.

147. Barr, "A Course of Five Lectures on Modern Art," MoMA Archives, NY: AHB [AAA: 3262; 1121].

148. Ibid.

149. Ibid.

150. *Wellesley College News,* May 9, 1929, p. 1.

151. *Wellesley College News,* May 23, 1929, p. 1.

152. Jere Abbott, "Notes from a Soviet Diary II," *Hound & Horn* 2 (Summer 1929), p. 389.

153. Unsigned article, *Wellesley College News* (16 May 1929), p. 5.

154. Lyon, "The Poster at the Modern: A Brief History," p. 1.

155. Barr to Sachs, January 17, 1928, Sachs Papers, pt. 1, v. 28, p. 3947, CORP.

156. MoMA Archives, NY: AHB [AAA: 2165; 1148].

157. Roob, "Alfred H. Barr, Jr.: A Chronicle," p. 17.

158. Barr to Sachs, July 1, 1929, Sachs Papers, pt. 1, v. 28, pp. 4000, 4001, CORP.

6 MODERNISM TAKES ITS TURN IN AMERICA

1. Marius De Zayas's gallery opened in 1919; the Metropolitan Museum of Art had a showing of French art in 1921; in 1922 the Daniel Gallery showed modern French artists, and the Joseph Brummer Gallery exhibited Derain in February and Vlaminck in March. Neumann brought German art to the New Gallery in New York in 1923; Valentiner curated an exhibition of German art at the Anderson Galleries in 1923; and the Brooklyn Museum organized "Contemporary Russian Paintings and Sculpture" in the same year. The Whitney Studio, forerunner of the Whitney Museum, began showing modernists in 1923 and in 1924 showed works by Henri Rousseau and Aristide Maillol.

Also in 1924, Joseph Brummer offered a series of shows in his gallery that featured Matisse; the following year, Carl Zigrosser showed Matisse drawings and prints at the Weyhe Gallery. In January of 1926, the important memorial exhibition of sixty-five paintings from the John Quinn collection took place. The 1920s also saw the *Dial* and the *Little Review* exhibiting the latest in the visual arts. That same year, Edith Halpert opened her gallery devoted to American art, and Dreier mounted the "International Exhibition of Modern Art" at the Brooklyn Museum in the winter of 1926–1927. The Knoedler Gallery was active in showing French modern art, as was the F. Valentine Dudensing Gallery; and in 1927, the Museum of Living Art at New York University opened with the collection of E. A. Gallatin. Barr tried to interest Gallatin in the Museum of Modern Art but he eventually gave his collection to the Philadelphia Museum of Art. See William S. Lieberman, ed., *Art of the Twenties* (New York: Museum of Modern Art, 1979), and Susan Noyes Platt, *Modernism in the 1920s: Interpretations of Modern Art in New York from Expressionism to Constructivism* (Ann Arbor: UMI Research Press, 1985).

2. A. Conger Goodyear, *The Museum of Modern Art: The First Ten Years* (New York: Museum of Modern Art, 1939), p. 11.

3. Guy Pène Du Bois, in *Arts* 16, no. 9 (June 1931). According to Du Bois, Bliss owned eighty of Davies's oils and 300 to 400 drawings, prints, and watercolors (p. 608).

4. Alfred Barr wrote that Davies inspired Bliss to acquire five important paintings, including a Renoir landscape, an oil and pastel by Degas, and the two Redons, "the foundation upon which Miss Bliss began to build her collection." She also bought individual works by Daumier, Picasso, Matisse, and Pissarro, a group of Cézannes, and nine drawings by Seurat. Barr continued: "Seurat's painstaking methods of work, the scant ten years of his active

career and the importance of his art make this group of drawings unrivaled in America and one of Miss Bliss' most remarkable achievements as a collector"; quoted in Goodyear, *The Museum of Modern Art: The First Ten Years*, p. 5.

5. Bernice Kert, *Abby Aldrich Rockefeller: The Woman in the Family* (New York: Random House, 1993), p. 271.

6. See Brooks Wright, *The Artist and the Unicorn: The Lives of Arthur B. Davies (1862–1928)* (New City, N.Y.: Historical Society of Rockland County, 1978).

7. Abby Rockefeller to Arthur David Davies, December 18, 1928, Rockefeller Papers, RAC.

8. Walt Kuhn, "The Story of the Armory Show," *Art News Annual* (Summer 1939), p. 174; reprinted in *Arts Magazine* 58 (June 1984), 138–141.

9. Barr to Nelson Rockefeller, April 17, 1948, MoMA Archives, NY: AHB [AAA: 3264; 1000, 1001].

10. Virgil Thomson, conversation with the author, November 1986.

11. Abby Rockefeller to Goodyear, March 23, 1936, Rockefeller Papers, RAC.

12. Margaret Sterne, *The Passionate Eye: The Life of William R. Valentiner* (Detroit: Wayne State University Press, 1980), p. 9.

13. Ibid., p. 143.

14. Abby Rockefeller to Goodyear, March 23, 1936, MoMA Archives, NY: AHB [AAA: 3264; 1131]. She was also encouraged by Martin Ryerson, vice president of the Art Institute of Chicago, and by the editorials of Forbes Watson and articles by Leo Simonson. Ibid.

15. Holger Cahill (1887–1960) subsequently played a role in the history of the Museum of Modern Art, particularly in American art. Cahill entered the New York cultural scene in 1918 as a journalist and publicist; in 1921 he replaced Hamilton Easter Field as promoter of the Society of Independent Artists.

16. Dorothy C. Miller, "Contemporary American Paintings in Mrs. John D. Rockefeller's Collection," *Art News* 36 (1938 Annual), pp. 105–108.

17. Edith Halpert to Preston Harrison, December 12, 1928; quoted in Diane Tepfer, "Edith Gregor Halpert and the Downtown Gallery Downtown: 1926–1940: A Study in American Art Patronage," Ph.D. diss., University of Michigan, 1989, p. 138.

18. Barr also engaged Walter Pach as a lecturer at the Museum of Modern Art although he was skeptical of Pach's understanding of modern art.

19. John Cotton Dana, *The Gloom of the Museum* (Woodstock, Vermont: Elm Tree Press, 1917); quoted in Barbara Lipton, "John Cotton Dana and the Newark Museum," *Newark Museum Quarterly* (Spring–Summer 1979), p. 24.

20. *Newark Star,* August 14, 1923, p. 42.

21. Holger Cahill, *Max Weber* (New York: Downtown Gallery, 1930), p. 29.

22. Holger Cahill, "Folk Art: Its Place in the American Tradition," *Parnassus* (March 1932), pp. 1–4.

23. In little more than a year, Cahill and Halpert had bought 170 objects for the Rockefeller collection (Tepfer, "Edith Gregor Halpert," p. 150).

24. Russell Lynes, *Good Old Modern* (New York: Atheneum, 1973), p. 26. Before he joined the junior advisory committee of the Museum in 1935, Wheeler published art books in Paris. In 1939 he was director of publications; he added the job of director of exhibitions, which he held until 1967.

25. Edward Warburg suggested this idea in a letter to the author, August 15, 1984. Although Kert in *Abby Aldrich Rockefeller,* p. 291, reports that Kirstein denied the story that Abby visited the HSCA gallery, perhaps this was not an apocryphal anecdote. Abby Rockefeller's name (as Mrs. John D. Rockefeller, Jr.) first appeared as a member of the Fogg Visiting Committee on the 1929–1930 list and remained there through 1944; her husband's name had been on the list for a number of years before that. Information supplied by Phoebe Peebles, archivist of the Fogg Museum.

26. Lincoln Kirstein, *Mosaic: Memoirs* (New York: Farrar, Straus & Giroux, 1994), p. 173.

27. Ibid.

28. Ibid., p. 109.

29. Ibid., p. 169.

30. Lincoln Kirstein, foreword to Mitzi Berger Hamovitch, ed., *The Hound & Horn Letters* (Athens: University of Georgia Press, 1982), xiv. Kirstein was drawn to portraiture, particularly of himself, and the artists he chose to do his portrait tended to be conservative. The first one was by his Harvard professor Martin Mower; others were by Walker Evans, Gaston Lachaise, Isamu Noguchi, Paul Cadmus, Pavel Tchelitchew, Lucian Freud, James Wyeth, and David Langfitt. He also did a self-portrait. Having seen the work of Gaston Lachaise in the *Dial,* Kirstein commissioned him to do a bust of himself (finished in 1932) and persuaded Edward Warburg and George L. K. Morris to have theirs done.

31. William Wasserstrom, *The Time of the Dial* (Syracuse, N.Y.: Syracuse University Press, 1963), p. 106.

32. Edward Warburg, letter to author, April 18, 1981.

33. Kirstein, *Mosaic: Memoirs,* p. 92.

34. Warburg, letter to author, 1981.

35. Agnes Mongan, interview by author, October 1983.

36. W. McNeil Lowry, "Conversations with Kirstein," Part II, *New Yorker* (December 22, 1986), p. 57.

37. Mongan, interview by author, 1985.

38. *Harvard Crimson,* December 20, 1928.

39. Alfred H. Barr, Jr., "Contemporary Art at Harvard," *Arts* 15 (April 1929), p. 267.

40. Ibid.

41. Denman Waldo Ross, *Painter's Palette* (Boston: Houghton Mifflin, 1919), p. 39.

42. John Walker III, *Self-Portrait with Donors* (Boston: Little Brown, 1974), pp. 24–25.

43. Kirstein, *Mosaic: Memoirs,* pp. 162–163. Kirstein, ambivalent about his own spiritual life, converted from Judaism to Catholicism.

44. Ibid.

45. Barr, "Contemporary Art at Harvard," p. 267.

46. In the academic years 1932–1934, the executive committee of the Harvard Society for Contemporary Art included John P. Coolidge, later director of the Fogg Museum; R. P. Heller; J. S. Newberry; Otto Wittman, Jr., later director of the Toledo Museum; R. F. Evans; and P. T. Rathbone, later director of the Boston Museum of Fine Arts.

47. Quoted by John Russell, "Lincoln Kirstein, a Life in Art," *New York Times Magazine,* June 20, 1982, p. 26.

48. The brochure catalogues are in a scrapbook at the library of the Museum of Modern Art, a gift of Kirstein. Some of the essays were signed by Kirstein and some were unsigned. If Kirstein did not write them all, he had a hand in them and, unless otherwise noted, his authorship may be assumed.

49. The painters in the section of lyrical painters included Thomas Benton, Arthur B. Davies, Rockwell Kent, Kenneth Hayes Miller, and Maurice Sterne.

50. Kirstein wrote the introduction for Dorothy Miller and Alfred H. Barr, Jr., eds., *American Realists and Magic Realists* (New York: Museum of Modern Art, 1943).

51. A continuing source of support for the young students was the Weyhe Gallery run by Carl Zigrosser, which lent, for instance, prints to the American show by George Bellows, Arthur B. Davies, Edward Hopper, Rockwell Kent, John Marin, John Sloan, and Maurice Sterne. Watercolors by Charles Burchfield and Charles Demuth were also in the exhibition.

52. *A Summary of the Activities of Its First Year* [February 1929–February 1930] (Cambridge: Harvard Society for Contemporary Art, 1930).

53. Lincoln Kirstein, *Gaston Lachaise: Retrospective Exhibition* (New York: Museum of Modern Art, 1935).

54. Barr, "Contemporary Art at Harvard," p. 265.

55. Ibid., p. 267. Hopper's painting, donated by Stephen C. Clark, was the first work in the permanent collection at the Museum of Modern Art.

56. Although from the beginning, for intellectual reasons, Barr included photography as one of the arts he wanted in the structure of the museum, according to Beaumont Newhall in an interview by author in 1981, Barr was less than enthusiastic about the medium.

57. Barr, "Contemporary Art at Harvard," p. 267.

58. *Exhibition of French Painting of the Nineteenth and Twentieth Centuries, March 6–April 6, 1929,* foreword by Arthur Pope (Cambridge: Fogg Art Museum, 1929), p. 9 and passim. A few non-French painters were included such as van Gogh and Picasso. The exhibition started with David, Delacroix, Corot, Millet, Courbet, Fantin-Latour, Forain, Guys, Redon, Daumier, included almost all the impressionists (Degas, Manet, Bazille, Monet, Morisot, Sisley, Renoir), the postimpressionists (van Gogh, Cézanne, Gauguin), moving into the twentieth century with Picasso, Vlaminck, Villon, and Dufy. The critic for the *Chicago Post,* March 26, 1929, said the show was "one of the best collections of modern French art ever assembled in the country."

59. Alfred H. Barr, Jr., "Loan Exhibition," *Vogue* 74 (October 6, 1929), pp. 85–108.

60. *Summary of the Activities of Its First Year.* Brancusi's sculpture was borrowed from the Arts Club of Chicago. The writer of the catalogue *Sixty Years on the Arts Club Stage* (Chicago: Arts Club of Chicago, 1976) claimed that the first large exhibition of Brancusi sculptures was held in the United States in 1927 at the Arts Club. *The Golden Bird* was purchased from the exhibition; two years later it was shown at the Harvard Society. Barr's parents moved to Chicago in 1923 where the senior Dr. Barr taught homiletics at the Presbyterian Theological Seminary of Chicago. One can assume that Barr became familiar with the manifestations of modernism in Chicago from that date on.

61. *School of Paris, 1910–1928, March 20 to April 12, 1929,* unsigned (Cambridge: Harvard Society for Contemporary Art, 1929).

62. Ibid.

63. Under the heading Decorative Art, the catalogue listed: Ash and Cocktail Tray by Donald Deskey, Vases and Flowers by Robert Locher, Plates by Henry Varnum Poor, and Glass, Textile, and Pewter by E. Schoen.

64. Nicholas Fox Weber, *Patron Saints: Five Rebels Who Opened America to a New Art, 1928–1933* (New York: Knopf, 1992), p. 45.

65. Walter Pach, *Maurice Prendergast,* catalogue of the exhibition April 19–May 9, 1929 (Cambridge: Harvard Society for Contemporary Art, 1929). Pach had been the European advisor to the organizers of the Armory Show. See Milton Brown, *The Story of the Armory Show* (New York: Joseph Hirshhorn Foundation, New York Graphic Society, 1963); Sandra S. Phillips, "The Art Criticism of Walter Pach," *Art Bulletin* 65 (March 1983), pp. 106–122. Phillips describes Pach's education in Europe with William Merritt Chase and the influences of Julius Meier-Graefe, Leo Stein, Bernard Berenson, and Roger Fry. Phillips also traces the importance of Pach as a spokesman for modernism in America after the Armory Show, his influence extending to Walter Arensberg, John Quinn, Duncan Phillips, and the gallery owner Joseph Brummer. Barr had reservations about Pach's criticism because he was an artist rather than a scholar.

66. Walter Pach, *Queer Thing Painting* (New York: Harper & Bros., 1938), p. 224.

67. Alfred H. Barr, *Modern Works of Art: Fifth Anniversary Exhibition,* November 20, 1934–January 20, 1935 (New York: Museum of Modern Art, 1934), p. 14.

68. Lincoln Kirstein, *The School of New York,* 1929. The Harvard Society's *Summary of the Activities of Its First Year* proposed that this group "having perhaps a diversity of origin, had acquired their growth and influence from the vicinity of New York."

69. Weber, *Patron Saints,* p. 95. Calder found a "patron saint" in Barr, who bought many of his works for the Museum.

70. Carl Zigrosser, *A World of Art and Museums* (Philadelphia: Art Alliance Press, 1975), p. 43. Zigrosser claimed that the performance at Weyhe's constituted Calder's first exhibition anywhere. He further reported that Erhard Weyhe, an immigrant from the war in Europe, opened a bookshop in 1914 on Lexington Avenue in Manhattan; by 1919 he had expanded and incorporated a print gallery run by Zigrosser that included sculpture. Zigrosser wrote: "Sooner or later [the artists] and the scholars, the collectors and museum folk all came, lured either by a book or an exhibition. We were more than a gallery and bookstore, we were a lively institution, a meeting place for the elite of the art world at a time when there was a great deal of life and ferment in that world." (Ibid., pp. 59–60.)

71. Kirstein wrote the introduction and notes for the exhibition catalogue *Derain, Matisse, Picasso, Despiau; Novermber 7–22* (Cambridge: Harvard Society for Contemporary Art, 1929), unsigned. Picasso's *The Lovers* was loaned by Mary Hoyt Wiborg, sister-in-law of the artist Gerald Murphy. Later she loaned her paintings to the exhibitions mounted by the Museum of Modern Art.

72. Kirstein, *School of Paris,* unpaginated.

73. Lincoln Kirstein, "A Memoir: The Education," *Raritan* 2, no. 3 (Winter 1983), p. 43.

74. Harvard Society for Contemporary Art, *Annual Report* (second year, 1930–1931).

75. *Exhibition of Modern Mexican Art, March 21–April 12, 1930* (Cambridge: Harvard Society for Contemporary Art). The catalogue credited the notes to Anita Brenner from her book *Idols behind Altars* (New York: Payson & Clarke, 1929). In 1943, while associated with the Museum of Modern Art, Kirstein became deeply involved with Latin American art (not unrelated to the activities of Nelson Rockefeller, who gave $25,000 anonymously to the Museum for the purchase of works from South America). Kirstein wrote the catalogue *The Latin American Collection of the Museum of Modern Art* (New York: Museum of Modern Art, 1943). In the foreword, Barr called Kirstein's catalogue essay "a pioneer venture," p. 3.

76. Harvard Society for Contemporary Art, *Annual Report* (1930–1931).

77. Lincoln Kirstein, *Modern German Art: April 18–May 10* (Cambridge: Harvard Society for Contemporary Art, 1930).

78. Lincoln Kirstein, *American Folk Painting* (Cambridge: Harvard Society for Contemporary Art, 1930).

79. Harvard Society for Contemporary Art, *Annual Report* (1930–1931).

80. Maria Morris Hambourg and Christopher Phillips, *The New Vision: Photography between the World Wars* (New York: Metropolitan Museum of Art, 1989), p. 44.

81. Kirstein, in Harvard Society for Contemporary Art, *Annual Report* (1930–1931).

82. Lincoln Kirstein, *Bauhaus: 1919–1923, Weimar; 1924, Dessau: January 10–February 10* (Cambridge: Harvard Society for Contemporary Art, 1931). The list of lenders to the exhibition affords a comprehensive view of those on the front lines of modernism in the United States. Galleries included those of John Becker, E. Weyhe, J. B. Neumann, as well as those of Valentiner and the Detroit Institute of Arts. Barr and Abbott supplied examples of typography by Herbert Bayer, a composition of Moholy-Nagy, and photographs by Lux Feininger of architecture, Oskar Schlemmer's ballet, and the Bauhaus jazz band. Barr and Abbott also lent photographs of paintings by Albers, Feininger, Muche, Bayer, Klee, and Kandinsky. Johnson lent photographs of decorative arts and a Klee watercolor.

83. Kirstein, *Bauhaus.*

84. *Drawings by Pablo Picasso: January 22–February 13* (Cambridge: Harvard Society for Contemporary Arts, 1932). The program of exhibitions during the fourth year included: Picasso's illustrations of Ovid's *Metamorphoses;* a surrealism show; "Architecture and Interiors," which, only a year after the International Style exhibition by the Museum of Modern Art, demonstrated that particular phase of architectural development; an exhibition of Ben Shahn, including paintings of Sacco and Vanzetti; a photography show; and "Designs for the Theater."

85. Sachs to Barr, July 16, 1928, Sachs Papers, pt. 1, v. 28, p. 4004, CORP.

86. In addition to the seven founding trustees, Stephen C. Clark, who would become chairman of the board after Goodyear, was listed in the first catalogue, as well as William T. Aldrich, Frederick C. Bartlett, Chester Dale, Samuel A. Lewisohn, Duncan Phillips, and Mrs. Rainey Rogers. By July 16, 1929, they had raised $49,000 for the first two years' budget. From the board of trustees the founding trustees Rockefeller, Bliss, and Goodyear gave $5,000; Mary Sullivan, Mrs. Murray Crane, Crowinshield, and Sachs gave $1,000 apiece; Thomas Cochrane, Joseph Duveen, and Lillie Bliss's uncle Cornelius M. Bliss also gave $5,000 each; E. S. Harkness and Joseph Duveen gave $10,000 each. (Goodyear letter to Abby Rockefeller, July 15, 1929, Rockefeller papers, RAC.) The rest of the budgeted $100,000 was raised during the first year from a total of fifty-four people. This fact was important to the Rockefellers, who did not want to appear as the sole benefactors of the Museum.

87. Abby Rockefeller to Paul Sachs, July 12, 1929, Rockefeller Papers, RAC.

88. Goodyear to Rockefeller, July 16, 1929, Rockefeller Papers, RAC.

89. Ibid.

90. Barr to Rockefeller, August 12, 1929, MoMA Archives, NY: AHB [AAA: 3264, 1268].

91. Barr to Sachs, March 30, 1943, MoMA Archives, NY: AHB [AAA: 2169; 1059].

92. Alfred H. Barr, Jr., *A New Art Museum* (New York: Museum of Modern Art, 1929), unpaginated.

93. As quoted in Alfred H. Barr, *Painting and Sculpture in the Museum of Modern Art 1929–1967* (New York: Museum of Modern Art, 1967), p. 620.

94. Ibid.

95. Goodyear, *The Museum of Modern Art,* pp. 138, 139.

96. Margaret Scolari Barr, "'Our Campaigns': Alfred H. Barr, Jr., and the Museum of Modern Art: A Biographical Chronicle of the Years 1930–1944," *New Criterion,* special issue (Summer 1987), p. 59.

97. Barr, letter to Nelson Rockefeller on the occasion of Abby Rockefeller's death, MoMA Archives, NY: AHB [AAA: 3264; 1000, 1001].

98. Ibid.

99. Goodyear, *The Museum of Modern Art: The First Ten Years,* p. 16.

100. According to Goodyear's figures in *The Museum of Modern Art,* during the first ten years, the most popular shows after the first loan exhibition were: "Painting in Paris," 1931, "Diego Rivera," "American Painting and Sculpture," and "American Folk Art," 1932, "Fifth Anniversary Exhibition," 1934, "Vincent van Gogh," 1935, and "Fantastic Art, Dada, Surrealism," 1936.

101. Alfred H. Barr, Jr., *First Loan Exhibition: Cézanne, Gauguin, Seurat, van Gogh* (New York: Museum of Modern Art, November 1929).

102. A. Conger Goodyear, *Modern Works of Art, Fifth Anniversary Exhibition November 20, 1934–January 20, 1935* (New York: Museum of Modern Art, 1934), p. 10.

103. Barr, *First Loan Exhibition,* p. 13.

104. Ibid.

105. Ibid., p. 15.

106. Ibid., p. 16.

107. Ibid., p. 18.

108. Ibid., p. 23.

109. Ibid., p. 22.

110. Ibid., p. 20.

111. Roger Fry, *Cézanne: A Study of His Development* (New York: Macmillan, 1927), excerpted in Judith Wechsler, ed., *Cézanne in Perspective* (Englewood Cliffs, N.J.: Prentice-Hall, 1975), p. 85.

112. Barr, *First Loan Exhibition,* pp. 21, 22, 23.

113. Ibid., pp. 25, 26.

114. Goodyear, *The Museum of Modern Art,* p. 20.

115. Forbes Watson quoted in Goodyear, *The Museum of Modern Art,* p. 20.

116. *Paintings by Nineteen Living Americans,* foreword by Alfred H. Barr, Jr. (New York: Museum of Modern Art, 1929).

117. Alfred H. Barr, Jr., introduction to the exhibition catalogue *German Painting and Sculpture: March 12–April 26, 1931* (New York: Museum of Modern Art, 1931), p. 15.

118. Ibid., p. 7.

119. Ibid., p. 10.

120. Ibid., p. 11.

121. Ibid. Barr's reliance on Neumann cannot be overstated. The dealer certainly made Barr aware of the Neue Sachlichkeit exhibition at the Galerie Neumann Nierendorf in Berlin in April of 1927. Neumann's influence was disproportionately strong in the first two years of the new Museum. In 1930 Barr mounted an exhibition, "Weber, Klee, Lehmbruck, Maillol." Neumann had brought the works of Klee to New York to show in his gallery but, according to Neumann, because the Museum of Modern Art possessed better facilities for showing the works to a large public, the material was turned over to the Museum. Max Weber had been the first artist whose work Neumann had exhibited when he opened the New Art Circle in New York in 1924. He showed him again in 1925, 1927, and 1928. Neumann was especially helpful in securing loans of Daumier's works from the German museums for the "Corot, Daumier" show in 1930. In 1931 Neumann also helped Barr mount the "German Painting and Sculpture" exhibition. Neumann gave Klee's *The Mocker Mocked* to the Museum in 1939 as well as over one hundred prints by such artists as Max Beckmann, Ernst Heckel, and Ludwig Kirchner.

122. The early watercolors of Burchfield were shown in 1930; Paul Klee had a show in 1930; Diego Rivera had one in 1931; in 1933 a retrospective exhibition for Edward Hopper was held; in 1935 Kirstein mounted a Lachaise retrospective exhibition; in 1936 the Museum mounted a popular van Gogh exhibition; in 1939 Picasso was displayed in his first important exhibition at the Museum; in 1941 Klee had a one man-show; in 1942 Miró made his entrance.

123. Alfred H. Barr, Jr., *Henri-Matisse* (New York: Museum of Modern Art, 1931). As Barr explained, the catalogue used a hyphenated form of his name *Henri-Matisse* because the artist, in order to avoid confusion with a marine painter named Auguste Matisse, used this form from 1904 until 1931 when the other artist died (p. 9, footnote 1). This exhibition was a version of a larger retrospective shown at the Georges Petit Gallery in Paris in 1931.

124. Alfred H. Barr, Jr., *Matisse: His Art and His Public* (New York: Museum of Modern Art, 1951).

125. Matisse's "Notes of a Painter" are notes taken by Sarah Stein when she attended his class in 1908, which Barr published, translated by Margaret Barr, in the catalogue *Henri-Matisse* and later in *Matisse: His Art and His Public*. Barr considered "Notes of a Painter" one of the "most influential statements ever made by an artist." Alfred H. Barr, Jr., in *Magazine of Art* (May 1951), p. 170. Barr put his characteristic stamp on the "Notes" by interspersing subheadings in the text to make it more accessible to the public.

126. Barr, *Henri-Matisse*, p. 27. The changing phases of the work of Matisse have been a source of ongoing discussion among scholars. See John Elderfield, *Henri Matisse: A Retrospective* (New York: Museum of Modern Art, 1992), p. 14.

127. Matisse, "Notes of a Painter," in Barr, *Henri-Matisse*, p. 30.

128. Barr, *Henri-Matisse*, p. 28.

129. Ibid., p. 13.

130. Meyer Schapiro, "Matisse and Impressionism: A Review of the Retrospective of Matisse at the Museum of Modern Art, New York, November, 1931," *Androcles* 1, no. 1 (1932), p. 23. Schapiro emigrated from Lithuania as a child in 1907. He received a doctorate in art history from Columbia University in 1927, specializing in medieval art and lecturing on modern art; many of the abstract expressionists attended his lectures. Barr and Schapiro became friendly, and in 1935 Schapiro invited Barr to join a group of scholars who would present papers to each other. Schapiro joined the board of trustees of the Museum of Modern Art in the late 1930s.

131. Ibid., pp. 30, 29.

132. Meyer Schapiro, "The Nature of Abstract Art," first published in *Marxist Quarterly* (January–March 1937). This is discussed in chapter 9 below.

133. Elderfield in *Henry Matisse: A Retrospective*, p. 70, note 14, claimed that the formalist approach was institutionalized with the publication of Barr's *Matisse: His Art and His Public* in 1953.

134. The Museum's program of circulating some of its exhibitions throughout the country began with the Rivera exhibition.

135. Goodyear, *The Museum of Modern Art*, p. 42, credited Cahill with being "chiefly instrumental" in advising Mrs. Rockefeller on the folk art collection. This collection was divided in 1939; the majority of the works were installed in Williamsburg, Virginia; the rest went to Fiske and Dartmouth colleges and the Museum of Modern Art, which retained *The Manchester Valley* by Pickett. Three American museums (the Museum of Modern Art, the Whitney Museum, and the Newark Museum) have paintings by Pickett.

136. Lynes, *Good Old Modern*, p. 74.

137. Goodyear, *The Museum of Modern Art*, Appendix A, "The Director's '1929' Plan," p. 139.

138. The board room exploded when the Communist sympathies of some of the artists of the former show were revealed. Other members of the first advisory committee responsible for the show included Nelson Rockefeller, George Howe (chairman), Hyatt Mayor, and James Johnson Sweeney.

Kirstein later brought the exhibition "Photographs of Henri Cartier-Bresson" to the Museum and wrote the catalogue with Beaumont Newhall (1947). Hilton Kramer was exuberant about Kirstein's writing on photography, calling him "simply one of the two or three best writers we have, and . . . quick to recognize the artistic power of photography. . . . Mr. Kirstein's catalogue texts on Evans, Henri Cartier-Bresson and W. Eugene Smith remain classics in their field." Kramer, review of *Lincoln Kirstein, the Published Writings, 1922–1927: A First Bibliography*, in *New York Times*, January 7, 1979, p. 23.

139. Lincoln Kirstein, *By With To & From,* ed. Nicholas Jenkins (New York: Farrar, Straus & Giroux, 1991), p. 42.

140. Beaumont Newhall, "Alfred H. Barr, Jr.: He Set the Pace and Shaped the Style," *Art News* 78 (October 1979), p. 134.

141. See Maria Morris Hambourg, "From 291 to the Museum of Modern Art: Photography in New York, 1910–37," in Hambourg and Phillips, *The New Vision.*

142. In 1927, unsuccessful attempts were initiated at Harvard to start a film library; the same year, a symposium on the movies, headed by Joseph P. Kennedy, took place at the university's Business School.

143. Quoted in Richard Griffith, "The Film Collection of the Museum of Modern Art," unpublished typescript, p. 2, and in turn in Mary Lea Bandy, "Nothing Sacred: 'Jock Whitney Snares Antiques for Museum': The Founding of the Museum of Modern Art Film Library," in *The Museum of Modern Art at Mid-Century: Continuity and Change* (New York: Museum of Modern Art, 1995), p. 82. Barr used Paul Rotha's *The Film Till Now* (London: Jonathan Cape, 1930) for reference in studying the history of film (ibid.).

144. Alfred H. Barr, Jr. "Notes on Departmental Expansion of the Museum," typescript, June 24, 1932, pp. 5–6, Film Archive; quoted in Bandy, "Nothing Sacred," p. 78.

145. Publicity release, MoMA Archives, NY: AHB [AAA: 3260; 398]. John Hay Whitney was the first president of the Museum of Modern Art Film Library corporation, a post he held for more than twenty years; financial support was provided by the Rockefeller Foundation.

146. Kirstein published two watercolors by Austin, *La Cimiteria: Venice* and *The Old City: Carcassonne,* in *Hound & Horn* 1 (January 1928), p. 228.

147. *A. Everett Austin, Jr.: A Director's Taste and Achievement* (Hartford: Wadsworth Atheneum, 1958). This was the catalogue for a memorial exhibition for Austin, who had died the year before. Contributing authors constructed a picture of Austin's place in the history of museology and demonstrated the interpenetration of the activities of the players in this circle.

148. Eugene R. Gaddis, ed., *Avery Memorial: The First Modern Museum* (Hartford: Wadsworth Atheneum, 1984), p. 39. The basis for Gaddis's claim of the "first modern museum" was Austin's openness to the new art and to his design and execution of the interior of the Avery Memorial in classic Bauhaus austerity.

149. Kirstein letter to Austin, July 28, 1930, A. Everett Austin, Jr., Records, Wadsworth Atheneum Archives.

150. In 1927 Levy married Joella Loy, daughter of the poet Mina Loy. Joella later divorced Levy and married Herbert Bayer, one of the Bauhaus masters.

151. Julien Levy, *Memoir of an Art Gallery* (New York: Putnam, 1977), pp. 17–18.

152. Ibid., p. 69.

153. Ibid., pp. 35, 106.

154. See Steven Watson, *Strange Bedfellows: The First American Avant-Garde* (New York: Abbeville Press, 1993).

155. Levy, *Memoir of an Art Gallery*, p. 106.

156. Ibid.

157. Julien Levy, "Dealing with A. Everett Austin, Jr.," in *A. Everett Austin, Jr.*, p. 33.

158. Levy, *Memoir of an Art Gallery*, pp. 70–72. Eugene R. Gaddis, *Magician of the Modern* (New York: Alfred A. Knopf, 2000), p. 156, says that Levy's and Austin's shows were different, though related; he records Levy as wanting to secure some of the works in Austin's show for his own surrealist exhibition. In 1931, Levy bought Dalí's *The Persistence of Memory* from the Parisian dealer Pierre Colle. Dalí's works also were loaned from A. Conger Goodyear and Mrs. Louise Crane, each of whom had acquired a painting the same summer as Levy. The show also included works by Max Ernst; Joan Miró and Yves Tanguy were missing but Joseph Cornell made his first appearance. Levy proudly related that aside from his discovery of the artist Cornell, "a real 'coup,'" was the inclusion of "a seventeenth-century curiosity in the manner of Giuseppe Arcimboldo; a head viewed vertically with a landscape seen horizontally," which was lent by Barr from his personal collection and included in the surrealist show at the Museum of Modern Art in 1936 (p. 82).

159. Eugène Berman, "Legendary Chick," in *A. Everett Austin, Jr.*, p. 46.

160. The Avery Memorial was added to the Wadsworth Atheneum in 1932–1933. See Hitchcock, "A. Everett Austin, Jr. and Architecture," in *A. Everett Austin, Jr.*, pp. 39–43. The interior had cantilevered balconies of plain white plaster that provided a structural space beneath the resulting court for an auditorium, an integral part of the Atheneum's activities, as it was later for the Museum of Modern Art. See Helen Searing, "From the Fogg to the Bauhaus: A Museum for the Machine Age," in Gaddis, ed., *Avery Memorial*, pp. 19–30. Searing suggests that the court gives "the impression of an exterior facade, of the Bauhaus turned inside out . . . [but] the Fogg Museum, completed in 1927 by Sheply, Rutan and Coolidge, is as important to the design of the Avery Memorial as was the Bauhaus of 1926 by Gropius." Austin had studied the plan of the Fogg and found its courtyard practical (pp. 28–29).

161. The first exhibition of works by Picasso in America was held in the Stieglitz Gallery 291 in 1911. .

162. Kirstein to Austin, January 20, 1934; quoted in Gaddis, ed., *Avery Memorial*, p. 30.

163. Virgil Thomson, "The Friends and Enemies of Modern Music," in *A. Everett Austin, Jr.*, p. 60.

164. Weber, *Patron Saints*, pp. 217, 218. See also Steven Watson, *Prepare for Saints: Gertrude Stein, Virgil Thomson, and the Mainstreaming of Modernism* (New York: Random House, 1998).

165. Virgil Thomson, *Virgil Thomson* (New York: Knopf, 1966), p. 243.

166. Levy, "Dealing with A. Everett Austin," p. 36.

167. Gaddis, ed., *Avery Memorial*, p. 65.

168. Hitchcock, quoted in *A. Everett Austin, Jr.,* p. 14.

169. Barr to Austin, January 18, 1934, Austin Records; quoted in Gaddis, ed., *Avery Memorial,* p. 39.

170. Barr to Austin, June 1944, on the occasion of Austin's resigning from the Wadsworth Atheneum in 1945; quoted in ibid., p. 57.

171. Margaret Barr, quoted in Rona Roob, "James Thrall Soby: Author, Traveler, Explorer," in *The Museum of Modern Art at Mid-Century,* p. 182, n. 21.

172. Old Howard was the name of a burlesque theater in Boston that Soby accused Barr of frequenting because Barr had recognized Georgia Southern on a New York street. In his letters he constantly teased Barr about being "a ladies' man."

173. Lynes, *Good Old Modern,* p. 235, attributed Soby's inherited fortune to telephone booths; Soby listed it as cigars in "Genesis of a Collection," *The Collectors in America,* compiled by Jean Lipman and the editors of *Art in America* (New York: Viking, 1961), pp. 170–178.

174. James T. Soby, "A. Everett Austin, Jr. and Modern Art," in *A. Everett Austin, Jr.,* p. 32.

175. James T. Soby, *After Picasso* (New York: Dodd, Mead, 1935). Soby also wrote catalogues for exhibitions at the Museum of Modern Art on Salvador Dalí, 1942; Pavel Tchelitchew, 1942; "Romantic Painting in America," 1943; Georges Rouault, 1945; Paul Klee, 1950; Amedeo Modigliani, 1951; Giorgio De Chirico, 1955; Yves Tanguy, 1955; in addition, he wrote introductions for many other catalogues. See "A Bibliography of the Published Writings of James Thrall Soby," compiled by Rona Roob, in *The Museum of Modern Art at Mid-Century,* pp. 230–251.

176. James Thrall Soby, "The Changing Stream," in *The Museum of Modern Art at Mid-Century,* p. 207.

177. Dorothy Miller, interview by Paul Cummings, 1970, AAA.

178. Quoted in Roob, "James Thrall Soby," p. 176.

179. Lincoln Kirstein, "The State of Modern Painting," *Harper's* (October 1948), p. 51.

180. Barr to Dwight Macdonald, December 2, 1953, Macdonald Papers, YUL. Barr complained that the editors of *Harper's* implied that it was an "inside job" as "Kirstein, having worked in the Museum, was . . . writing somewhat as an apostate or deserter, whereas actually he had always been very conservative and 'humanist' in his tastes and was merely carrying on rather recklessly in print an argument which the Museum had heeded and acted upon often in the preceding twenty years." Barr said that considering the "moral support" he gave Kirstein when he launched the Harvard Society for Contemporary Art, he took Kirstein's criticism hard.

181. Kirstein, "A Memoir: the Education," p. 45.

182. W. McNeil Lowry, "Conversations with Kirstein," Part II, p. 57.

183. Lincoln Kirstein, *The New York City Ballet* (New York: Alfred A. Knopf, 1973), p. 13.

184. Russell Newcomb, *The Newark Museum: A Chronicle of the Founding Years, 1909–1934* (Newark Museum, 1934), p. 21. The author did not take into account Harvard's program, which was gaining momentum in 1925.

185. Dorothy Miller, interview by author, November 1981.

186. Miller, interview by Paul Cummings, May 26, 1970, AAA.

187. Gift of Abby Rockefeller to the Museum of Modern Art by exchange. Rockefeller made seven purchases from the exhibition.

188. Quoted in Lynes, *Good Old Modern*, pp. 122–123.

189. Miller, interview by Paul Cummings, 1970, AAA.

190. Ibid.

191. Barr to Miller, June 27, 1934, MoMA Archives, NY: AHB [AAA: 2165; 23]. Miller's positions at the Museum of Modern Art were: 1934, assistant to the director; 1935–1943, assistant and associate curator, painting and sculpture; 1943–1947, curator of painting and sculpture; 1947–1967, curator of museum collections.

192. Miller, interview by Paul Cummings, 1970, AAA.

193. The first exhibition, "Americans 1942: 18 Artists from 9 States," was held January 21–March 8, 1942. Morris Graves, who was known only to a few people in Seattle and had never had a one-man show, was included. After a hiatus of four years, the next show was "Fourteen Americans," September 10–December 8, 1946, when Loren MacIver, Robert Motherwell, and Theodore Roszak had their first exposure at the museum. Also included were Arshile Gorky, I. Rice Pereira, Isamu Noguchi, Mark Tobey, Saul Steinberg, and David Hare. Miller called it one of her best, but she regretted not including Jackson Pollock.

194. Miller, interview by author, 1982. What Miller called "perhaps the most controversial" of her exhibitions, "15 Americans," was organized for April 9–July 27, 1952. It increased the fame of Richard Lippold, Bradley Tomlin, Jackson Pollock, Clyfford Still, Mark Rothko, William Baziotes, and Herbert Ferber; Miller said it was the "biggest splash." She also said that McBride, who was 85 years old at the time, "loved it." The next exhibition of young American painters, "Twelve Americans," was held May 30–September 9, 1956, and introduced Raoul Hague, Sam Francis, Philip Guston, Franz Kline, Grace Hartigan, and Larry Rivers, among others. "Sixteen Americans" in 1959 exhibited Jasper Johns, Ellsworth Kelly, Louise Nevelson, Robert Rauschenberg, and Frank Stella among the better-known artists. The last show of this type was "Americans, 1963," with a roster that included Richard Anuszkiewicz, Robert Indiana, Marisol, Claes Oldenburg, Ad Reinhardt, and James Rosenquist, among others.

195. Miller, interview by author, 1982.

196. Of these artists, Baziotes, Brooks, Francis, Gorky, Gottlieb, Guston, Hartigan, Kline, Motherwell, Pollock, Rothko, Stamos, Still, and Tomlin comprised all but three of the group who had been included in her previous exhibitions during the decade 1946–1956.

197. Miller functioned closely with Barr and sometimes alone in organizing and mounting the exhibitions that involved American artists. Among these were: "The Sculpture of John B.

Flannagan," October 28–November 29, 1942; Niles Spencer's works prepared for circulating exhibition, June 22–August 15, 1954; "American Realists and Magic Realists" (with Barr), February 10–March 21, 1943; "Romantic Painting in America," November 17–February 6, 1944; "Lyonel Feininger," October 24–January 14, 1945; "Figures and Faces (Drawings)," 1955–1956; "Recent American Watercolors," for circulation in France, 1956–1957. Miller also edited *The Masters of Popular Painting*, with Cahill, 1938, and contributed to the organization and arrangement of contemporary American art for the New York World's Fair of 1939, including the Charles Sheeler exhibition, October 2–November 1, 1939.

198. Barr to Dorothy Miller, October 10, 1940, MoMA Archives, NY: AHB [AAA: 3262; 405].

199. Ibid.

200. Dorothy Miller, "Contemporary American Painting in Mrs. John D. Rockefeller's Collection," *Art News* 36 (1938 annual), pp. 105, 108.

201. Barr to Clark, April 22, 1943, Rockefeller Papers, RAC.

202. Barr to Dorothy Miller, October 10, 1940, MoMA Archives, NY: AHB [AAA: 3262; 405].

203. Ibid.

204. The Museum felt that it had indeed proved itself; it had mounted thirty-five exhibitions with an attendance of nearly one million.

205. Barr, *Modern Works of Art: Fifth Anniversary Exhibition*, p. 11.

206. Ibid., p. 14.

207. Ibid., pp. 14, 15.

208. Alfred H. Barr, Jr., "Postwar Painting in Europe," *Parnassus* (May 2, 1931), p. 20.

209. Ibid., p. 18.

210. Barr to Abby Rockefeller, November 6, 1933, MoMA Archives, NY: AHB [AAA: 3264; 1102, 1104].

211. Ibid. [1107].

212. A memorial exhibition of Bliss's collection was held at the Museum with a program of music and addresses marking the opening on May 14, 1931. Although only $600,000 was raised, the collection was put on view again in March of 1934 and a catalogue published. Bliss's brother, Cornelius N. Bliss, who replaced her on the Museum's board of trustees, had already lowered the stipulated amount of $1,000,000 to $750,000 to meet the three-year deadline she had imposed; he then accepted the $600,000 on the condition that the difference would be raised after the Museum gained the collection.

213. They all were the absolute property of the Museum except for *Pines and Rocks* by Cézanne, *Still Life [with Apples]* by Cézanne, and *The Laundress* by Daumier, all of which were never to be sold. In the event that the Museum wanted to deaccession the paintings, they were to be given to the Metropolitan Museum of Art.

214. See Alfred H. Barr, Jr., "Chronicle of the Collection of Painting and Sculpture," in Barr, ed., *Paintings and Sculpture in the Museum of Modern Art, 1929–1967* (New York: Museum of Modern Art, 1977), p. 621.

215. Barr, *Fifth Anniversary Exhibition*, p. 15.

216. Ibid., p. 17.

217. Alfred H. Barr, Jr., *Painting in Paris* (New York: Museum of Modern Art, 1930), p. 11.

218. Ibid.

7 ARCHITECTURE, BARR, AND HENRY-RUSSELL HITCHCOCK

1. Barr to Stevens, November 16, 1938. Notes for the reorganization committee, MoMA Archives, NY: AHB, 12.II.3.a.

2. The exhibition had the same title as its catalogue, *Modern Architecture: International Exhibition* by Henry-Russell Hitchcock, Philip Johnson, and Lewis Mumford, foreword by Alfred H. Barr, Jr. (New York: Museum of Modern Art, 1932).

3. Alfred H. Barr, Jr., "What Is Happening to Modern Architecture? A Symposium at the Museum of Modern Art," *Museum of Modern Art Bulletin* 15 (Spring 1948), p. 4.

4. Barr to Macdonald, December 2, 1953, Macdonald Papers, YUL. Hitchcock was born in Boston, June 3, 1903; he earned his A.B. in 1924 and M.A. in 1927 at Harvard. He taught at Vassar College in 1927–1928 (where he met Margaret Fitzmaurice Scolari, the future Mrs. Barr). He then had a long tenure at Wesleyan University (he took Jere Abbott's place when Abbott left to become Barr's assistant at the Museum of Modern Art) from 1929 to 1948, becoming a full professor in 1947. He was at Smith College as professor of Art in 1948. In 1949 he became director of the Smith College Museum of Art (again taking Abbott's place) and served until 1955, after which he taught at New York University. His books include *Modern Architecture: Romanticism and Reintegration* (New York: Payson & Clarke, 1929); *The Architecture of H. H. Richardson and His Times* (New York: Museum of Modern Art, 1936), which focused renewed interest in the nineteenth-century architect; *In the Nature of Materials: The Buildings of Frank Lloyd Wright* (New York: Duell, Sloan & Rennie, 1942), partially correcting Wright's place in American architectural history that Hitchcock had miscalculated; and *Painting towards Architecture: The Miller Co. Collection of Abstract Art,* foreword by Alfred H. Barr, Jr. (New York: Duell, Sloan and Pearce, 1948).

5. Joseph Giovannini, "Henry-Russell Hitchcock Dead at 83," *New York Times,* February 20, 1987, p. 16.

6. Hitchcock earned a master's in 1927. His plan was to get a doctorate, but Kingsley Porter did not accept his thesis, which probably consisted of material he developed for the book *Modern Architecture: Romanticism and Reintegration,* a topic that did not fall within either Chandler Post's or Porter's specialty. Because both professors did research in Spanish art and architecture, doctorate degrees for the first ten years were awarded only in the Spanish field. Only Post had the advanced degree in the department that enabled him to supervise graduate students.

7. Giovannini, "Henry-Russell Hitchcock Dead at 83," p. 16.

8. Helen Searing, "Henry-Russell Hitchcock: Architectura et Amicitia," foreword to Searing, ed., *In Search of Modern Architecture: A Tribute to Henry-Russell Hitchcock* (New York: Architectural Foundation; Cambridge: MIT Press, 1982), p. 3.

9. Hitchcock to Barr, August 12, 1928, MoMA Archives, NY: AHB 12.II.3.a.

10. Henry-Russell Hitchcock, "Modern Architecture—A Memoir," *Journal of the Society of Architectural Historians* 27 (December 1968), p. 228.

11. Henry-Russell Hitchcock, "J. J. P. Oud," *Arts* 13 (February 1928), p. 102.

12. Hitchcock, "Modern Architecture—a Memoir," p. 228.

13. Henry-Russell Hitchcock, "Banded Arches before the Year 1000," *Art Studies* 6 (1928), pp. 175–191. This was actually his first article, written before "The Decline of Architecture," which appeared in *Hound & Horn* in 1927.

14. Hitchcock, "Modern Architecture—a Memoir," p. 228.

15. Ibid.

16. Ibid.

17. Henry-Russell Hitchcock, "Some American Interiors in the Modern Style," *Architectural Record* 64 (September 28, 1928), pp. 235, 236.

18. Ibid., p. 238.

19. Stephanie Barron and Maurice Tuchman, eds., *The Avant-Garde in Russia: New Perspectives 1910–1930* (Cambridge: MIT Press, 1980), p. 276. See the catalogue *Exposition Internationale des Arts Décoratifs et Industriels Modernes. Section de l'U.R.S.S. Catalogue des oeuvres d'art décoratif et d'industrie artistique exposées dans le Pavillon de l'U.R.R.S. au Grand Palais et dans les galeries de l'Esplanade des Invalides* (Paris, 1925). See also the exhibition catalogue *Architectural Drawings of the Russian Avant-Garde,* June 21–September 4, 1990, by Catherine Cooke (New York: Museum of Modern Art), p. 25.

20. Christina Lodder, *Russian Constructivism* (New Haven: Yale University Press, 1981), pp. 155–156. Lodder wrote that this was "one of the earliest attempts to design a whole Contructivist interior environment, and one of the few ever achieved." She illustrated it with a photograph obtained from the A. H. Barr, Jr., Archives of the Museum of Modern Art. Barr most probably received this photograph with the group of photographs of Rodchenko's work given to him by the artist on Barr's visit to his studio in 1927.

21. Hitchcock, "Modern Architecture—a Memoir," p. 229.

22. Ibid., p. 228.

23. Bernard Berenson, "A Word for Renaissance Churches" (1902), in *The Study and Criticism of Italian Art,* 3 vols. (London: Bell, 1920), pp. 62–76; cited by David Watkin, *The Rise of Architectural History* (Westfield, N.J.: Architectural Press, 1980), p. 117.

24. Le Corbusier's book *Vers une architecture* (1923) was a compilation of his articles that appeared in *L'Esprit Nouveau* beginning in 1919, in which he illustrated his ideas with pic-

tures of automobiles and aeroplanes. This has been translated into English by Frederick Etchells as Le Corbusier, *Towards a New Architecture* (London: Architectural Press, 1927; rpt. New York: Praeger, 1960).

25. Henry-Russell Hitchcock, "Le Corbusier and the United States," *Zodiac* 16 (1966), p. 9.

26. Hitchcock, "Modern Architecture—A Memoir," p. 229.

27. Le Corbusier, *Towards a New Architecture*, p. 31.

28. Ibid., p. 92.

29. Ibid., p. 95.

30. Henry-Russell Hitchcock, "America-Europe," *i 10*, no. 20 (April 1929), p. 150; quoted in Helen Searing, "International Style: The Crimson Connection," *Progressive Architecture* (February 1982), p. 88.

31. Le Corbusier, *Towards a New Architecture*, p. 143.

32. Ibid., p. 148.

33. Alfred H. Barr, Jr., *What Is Modern Painting?* (New York: Museum of Modern Art, 1943), p. 3.

34. See Alfred H. Barr, Jr., *Cubism and Abstract Art* (New York: Museum of Modern Art, 1936), the catalogue he wrote for the exhibition of that title. Barr illustrated the concept of cubist masses with a sculpture by Georges Vantongerloo, *Volume Construction*, 1918 (p. 145). Malevich produced architectural models illustrated in *Die gegenstandslose Welt* (Munich, 1927) that closely resembled Mies van der Rohe's plan in Stuttgart.

35. I am grateful to Terence Riley for these two observations.

36. Architects who contributed to the Weissenhofsiedlung included Mies, Walter Gropius, Hans Scharoun, Richard Döcker, Peter Behrens, Hans Poelzig, Ludwig Hilberseimer, Adolf Schneck, Adolf Rading, the Tauts (Bruno and Max), all from Germany; J. J. P. Oud and Mart Stam from the Netherlands; Josef Frank from Austria; Le Corbusier from France; and Victor Bourgeois from Belgium. Hitchcock, in his *Modern Architecture: Romanticism and Reintegration,* placed Behrens (Mies's mentor) in the "transitional" generation that preceded the architects of the International Style.

37. See Franz Schulze, *Mies van der Rohe: A Critical Biography* (Chicago: University of Chicago Press, 1985), passim. The Weissenhof project also inspired Mies to resume his interest in the design of furniture, initiated earlier with Bruno Paul, and to bring forth his seminal designs in this medium (p. 131).

38. Quoted in Schulze, *Mies van der Rohe: A Critical Biography,* p. 137. Schulze reports that Mies was criticized for "loosening the bonds of *Sachlichkeit*" at Weissenhof which he had endorsed previously in the journal *G* (p. 134).

39. Rona Roob, "Alfred H. Barr, Jr.: A Chronicle of the Years 1902–1929," *New Criterion,* special issue (Summer 1987), p. 16, claimed that Barr saw the Weissenhof settlement in Stuttgart in March of 1928 on his trip with Abbott. In the article "Modern Architecture—a Memoir," Hitchcock quoted Barr (p. 228) as saying that he hadn't seen the project until

1933. It is possible that Barr and Abbott traveled through Stuttgart, as it appeared on Barr's passport, but did not make a stop.

40. Henry-Russell Hitchcock, "Towards a New Architecture," *Architectural Review* 90 (January 1928), p. 91.

41. Philip Johnson, preface to *Philip Johnson: Writings,* ed. Peter Eisenman and Robert Stern (New York: Oxford University Press, 1979), p. vii. Johnson wrote: "From an architect's point of view, what stands out in Russell's scholarship is his use of primary visual sources. I can bear personal witness that from his first travels in 1930 [sic] to the latest for his German Renaissance book, Russell saw every extant building he writes about. He is an 'eye' scholar."

42. Searing, "The International Style: The Crimson Connection," emphasized the notion that the coupling of the term "style" with "international" neutralized the political Marxist implications in the latter designation (p. 90).

43. The Bauhaus conception of *Gesamtkultur* had a long history in the development of modern art, beginning chiefly with Richard Wagner's ideas in the mid-nineteenth century.

44. Josef Albers created the Black Mountain School in 1933; Gropius became chairman of the School of Architecture at Harvard in 1937; Mies van der Rohe became director of the Armour Institute of Technology (later called the Illinois Institute of Technology) in Chicago in 1938; and Moholy-Nagy established the New Bauhaus School in Chicago in 1937, renamed the Institute of Design in 1939.

45. Walter Gropius, "Exhibition of Unknown Architects" (1919), in Ulrich Conrads, ed., *Programs and Manifestoes on Twentieth Century Architecture* (Cambridge: MIT Press, 1970), p. 47.

46. Hans M. Wingler, *The Bauhaus: Weimar, Dessau, Berlin, Chicago* (Cambridge: MIT Press, 1969), p. xviii.

47. Henry-Russell Hitchcock, "The Decline of Architecture," *Hound & Horn* 1 (September 1927), p. 31.

48. Ibid., p. 34.

49. Ibid., p. 31.

50. Ibid., pp. 31–33. The article also appeared in an advance issue of *Hound & Horn* published in the summer of 1927; its ideas were later incorporated in the first chapter of his book *Modern Architecture: Romanticism and Reintegration.*

51. In actuality, as well as theoretically, one does not exclude the other, as seen in more recent art history conceptualizations. Mies was much more philosophically inclined and felt the pressures of the *Zeitgeist* flow through his work. See Schulze, *Mies van der Rohe: A Critical Biography.*

52. Walter Gropius, *Internationale Architektur* (Berlin: Bauhaus, 1924–1925). The Bauhaus books were available in the United States at Weyhe Bookstore. Surely these books documenting modern art had their effect on Barr's series of catalogues on the exhibitions at the Museum of Modern Art.

53. Henry-Russell Hitchcock, review of Gropius's *International Architektur,* in *Architectural Record* 66, no. 2 (August 1929), p. 191.

54. Alfred H. Barr, Jr., "The Necco Factory," *Arts* 13 (January 1928) pp. 292–295. Jere Abbott had photographs of the Necco factory published in *Hound & Horn* (September 1927). Barr's article was probably written before he left on his trip in July of 1927. Barr would have had easy access to the Bauhaus books through his friendship with J. B. Neumann.

55. Clement Greenberg extended the concept to include "kitsch"; see "Avant-Garde and Kitsch" in *Clement Greenberg: The Collected Essays and Criticism,* vol. 1, *Perceptions and Judgments, 1939–1944,* ed. John O'Brian (Chicago: University of Chicago Press, 1986), pp. 5–22.

56. Le Corbusier, *Vers une architecture,* p. 42.

57. Hitchcock, "Modern Architecture—a Memoir," p. 230.

58. Barr, "The Necco Factory," p. 294.

59. Ibid., pp. 293, 294.

60. Ibid., p. 295.

61. Hitchcock to Barr, August 12, 1928, MoMA Archives, NY: AHB, 12.II.3.a.

62. Henry-Russell Hitchcock, "The Architectural Work of J. J. P. Oud," *Arts* 13 (February 1928), p. 97. By 1951, Hitchcock had changed his notion of decoration, holding that it was a matter of taste rather than principle. "The International Style Twenty Years After," appendix to the 1966 edition of *The International Style* (New York: Norton, 1966), p. 242.

63. Ibid., p. 101.

64. Ibid., p. 103.

65. Henry-Russell Hitchcock, "Four Architects," *Hound & Horn* 2 (September 1928), p. 41.

66. Ibid.

67. Ibid., pp. 46–47.

68. Ibid., p. 47.

69. Alfred H. Barr, Jr., "Notes on Russian Architecture," *Arts* 15 (February 1929), p. 103.

70. Ibid.

71. Ibid., p. 104.

72. Ibid.

73. Ibid., p. 105.

74. Ibid. (The last statement calls into question Barr's claim that he had not seen the Weissenhofsiedlung before 1933.) Barr may have known that Le Corbusier's influence had been felt by the Russian architects because Le Corbusier had sent copies of *L'Esprit Nouveau* to Lunacharsky as early as 1922. In 1924, Leonid Vesnin, having read *Vers une architecture,*

wrote to his brother: "We have gone further and we look more deeply." Cooke, *Architectural Drawings of the Russian Avant-Garde,* p. 29.

75. Barr, "Notes on Russian Architecture," p. 106.

76. See chapters 18–21 of his book *Architecture: Nineteenth and Twentieth Centuries* (Baltimore: Penguin Books, 1958).

77. Hitchcock, "Modern Architecture—a Memoir," p. 232.

78. Hitchcock, *Modern Architecture: Romanticism and Reintegration,* p. 156.

79. Ibid. By 1958, Hitchcock described the Fagus factory as a building with a modest curtain wall, more advanced than the later 1914 Werkbund building (*Architecture: Nineteenth and Twentieth Centuries,* p. 158).

80. Sigfried Giedion, "The New House," *Das Kunstblatt* 10, no. 4 (1926), pp. 153–157; quoted in Peter Serenyi, ed., *Le Corbusier in Perspective* (Englewood Cliffs, N.J.: Prentice-Hall, 1974), p. 33.

81. See Henry-Russell Hitchcock, *Painting toward Architecture,* foreword by Alfred J. Barr, Jr. (New York: Duell, Sloan & Pearce, 1948).

82. See Marcel Franciscono, *The Creation of the Bauhaus at Weimar* (Bloomington: Indiana University Press, 1970) for discussions of the expressionist strain in Gropius's aesthetic as well as resolution of the conflicting attitudes toward handicraft and the machine.

83. Hitchcock, *Modern Architecture: Romanticism and Reintegration,* pp. 158, 159.

84. Alfred H. Barr, Jr., "Columbia University Symposium on Functionalism and Expressionism," typescript, 1962, pp. 24–25.

85. Barr, *Cubism and Abstract Art,* p. 141. Barr revised the section on de Stijl for the catalogue *De Stijl 1917–1928,* with a foreword by Philip Johnson (New York: Museum of Modern Art, 1961), p. 10.

86. Barr, *Cubism and Abstract Art,* p. 156. But Barr felt that the Bauhaus went beyond the de Stijl influence in being functional rather than just relying on geometrical abstract designs. While de Stijl was limited to abstract design, the Bauhaus design was, "during the transitional period 1922–28, an eclectic fusion in various quantities of abstract geometrical elements with the new ideal of utilitarian functionalism" (ibid., p. 158).

87. In the issue of September 1919, de Stijl published its first reproduction of a Feininger painting together with part of an explanatory letter by the artist dated July 20, 1919.

88. Barr, *Cubism and Abstract Art,* p. 156. Franciscono, *Creation of the Bauhaus at Weimar,* claims that beyond the contributions of van Doesburg and de Stijl, the impulse toward rationalism was present within the Bauhaus from the start in Gropius's ideas and "the common Bauhaus interest in directness and simplicity of design" (p. 240). In the Columbia University Symposium on Functionalism and Expressionism (1962), Barr discussed Gropius's denial that he had been influenced by van Doesburg, while Sybil Moholy-Nagy described "the famous fight between Gropius and van Doesburg. Gropius called van Doesburg a useless aesthete, and van Doesburg called Gropius a Prussian boor . . . [and] the Bauhaus a

socialist labor movement." Barr's opinion was that the influence of de Stijl on Gropius's architecture could be clearly seen: "Gropius told me he felt emphatically that he was uninfluenced in his Bauhaus buildings. Indeed, Gropius had an almost fanatic insistence on his independence from De Stijl, but the influence shows in the forms. Possibly it was unconscious." Barr, "Columbia University Symposium" typescript, p. 25. Although Mies was not yet connected with the Bauhaus, Barr suggested that his architecture too was influenced by van Doesburg, who was in Berlin by 1920. Van Doesburg, Lissitzky, Hans Richter, and Mies founded a journal called *G* in 1923 in which they proselytized for the new architecture. Barr saw similarities in typography between de Stijl and the Bauhaus, and many of the Bauhausbücher, designed by Moholy-Nagy, were made under the influence of de Stijl and Russian constructivism.

89. Hitchcock, *Modern Architecture: Romanticism and Reintegration*, pp. 160, 161.

90. Ibid., p. 161.

91. Ibid., p. 162.

92. Ibid., pp. 165–170.

93. Ibid., p. 176.

94. Ibid., p. 189.

95. Ibid., p. 191.

96. Ibid., p. 159. By 1948, Hitchcock changed direction when he wrote the book *Painting toward Architecture.*

97. Barr, foreword to Hitchcock, Johnson, and Mumford, *Modern Architecture: International Exhibition,* p. 16.

98. Hitchcock, *Modern Architecture: Romanticism and Reintegration,* p. 206. Basing his estimate on previous examples of the longevity of styles, Hitchcock overestimated the continuity of the modern style of architecture, which seemingly thrived for about fifty years. The direction of the postmodernist style of architecture remains to be seen.

99. Barr, "Modern Architecture," review of *Modern Architecture: Romanticism and Reintegration* by Henry-Russell Hitchcock, Jr., *Hound & Horn* 3 (April–June 1930), p. 431.

100. Ibid., p. 432. He later edited that statement to state that the modern was equal in originality to the Greek and the Gothic.

101. Ibid., p. 432.

102. Barr, review of Hitchcock's *Modern Architecture,* p. 433.

103. Ibid., p. 434.

104. Ibid., pp. 434–435. Barr remained Hitchcock's unofficial editor, offering him avenues of restraint in his writings that were never completely accepted.

8 PHILIP JOHNSON AND BARR: ARCHITECTURE AND DESIGN ENTER THE MUSEUM

1. Two editions of the catalogue with the same materials emerged: the exhibition's catalogue bore its title—*Modern Architecture: International Exhibition*—by Henry-Russell Hitchcock, Philip Johnson, and Lewis Mumford, foreword by Alfred H. Barr, Jr. (New York: Museum of Modern Art, 1932); the other edition, with the same material, was titled *Modern Architects* (New York: W. W. Norton, 1932). A concurrent book with only similar material was also published: *The International Style: Architecture since 1922*, by Henry-Russell Hitchcock and Philip Johnson, foreword by Alfred H. Barr, Jr. (New York: W. W. Norton, 1932; rpt. 1966).

2. Alfred H. Barr, Jr., *Painting and Sculpture in the Museum of Modern Art, 1929–1967* (New York: Museum of Modern Art, 1977), p. 620.

3. As the importance of encouraging good design grew in the Museum, industrial art was added to the department of Architecture, after Johnson, for political reasons, left in 1935. Between 1940 and 1945, the two departments were separated and a department of Industrial Art was established, first under Eliot Noyes and then under Edgar Kaufmann, Jr. Johnson was reinstated as director of the rejoined departments, at first unofficially, in 1945, after a hiatus of ten years during which he received a degree in architecture at Harvard under Gropius. He became director in 1947 after mounting a successful retrospective exhibition of the work of Mies van der Rohe. Johnson wrote an impressive monograph to accompany the exhibition; the department was then called Architecture and Industrial Design. In 1951, it became the department of Architecture and Design under Arthur Drexler as curator. Drexler became director in 1956 when Johnson left. The emphasis on good design maintains the Museum's view of architecture as art and is a major factor in its collections and philosophy.

4. Henry-Russell Hitchcock, "Modern Architecture—a Memoir," *Journal of the Society of Architectural Historians* 27 (December 1968), p. 233.

5. Martin Filler, "Philip Johnson, Deconstruction Worker," *Interview* 18 (May 1988), p. 104.

6. Calvin Tomkins, "Philip Johnson," *New Yorker* (23 May 1977), p. 47.

7. Philip Johnson, interview by author, 1990.

8. Architecture was a natural predilection for Barr, who was drawn to order and form in art. In a conversation with the author in 1982, Jere Abbott reported that because Barr was so "orderly and mathematical," Bach was his favorite composer, appealing to his formal turn of mind. In homage, Bach was played at Barr's memorial service in 1981.

9. Philip Johnson, "Informal Talk" (1960), in *Philip Johnson: Writings*, ed. Peter Eisenman and Robert A. M. Stern (New York: Oxford University Press, 1979), p. 108. Johnson took seven years to graduate because he experienced emotional problems during his undergraduate days. During that time he made several trips to Europe; as early as age thirteen he visited the Parthenon with his mother.

10. Russell Lynes, in *Good Old Modern: An Intimate Portrait of the Museum of Modern Art* (New York: Atheneum, 1973), pp. 84–86, described each version in detail.

11. Philip Johnson, "Retreat from the International Style to the Present Scene" (lecture, Yale University, 1958), *Philip Johnson: Writings,* p. 85.

12. Theodate Johnson, interview by author, 1984.

13. Filler, "Philip Johnson, Deconstruction Worker," p. 104.

14. Philip Johnson, "Afterword," in *Philip Johnson: Writings,* p. 268. Johnson repeated this phrase many times, including in his eulogy at Barr's memorial service.

15. Filler, "Phillip Johnson, Deconstruction Worker," p. 107.

16. John McAndrew was curator of the department of Architecture and Industrial Art at the Museum from 1936 until 1940; Johnson left the first time in 1934, returning as director of the department from 1946 until 1954 and then becoming a trustee.

17. Johnson to Barr, October 16, 1929, MoMA Archives, NY: AHB [AAA: 2164; 442].

18. Ibid. In time, when their relationship became more intimate, Johnson would be called "Pippo" and Barr "Alfo." (Reducing the given name to an intimate endearment was a ritual that Barr used with his closest friends.)

19. Ibid.

20. Ibid. At this point (1929), although Barr had been planning to write on modern art for his thesis, he was already involved in the planning stage of the Museum of Modern Art.

21. Tomkins, "Philip Johnson," p. 47. By the time Margaret Barr wrote her memoirs in "'Our Campaigns': Alfred H. Barr, Jr., and the Museum of Modern Art: A Biographical Chronicle of the Years 1930–1944," *New Criterion,* special issue (Summer 1987), all she allowed Johnson was the first sentence of this paragraph; her relationship with him ended on a strained note.

22. The book *The International Style* was dedicated by Hitchcock and Johnson "to Marga Barr."

23. Hitchcock to Virgil Thomson, September 7, 1929, Virgil Thomson Papers, YUL. Margaret Barr had a strong friendship with Thomson and his companion Maurice Grosser. When she visited them in Europe, Grosser did a portrait of her in 1932 that Barr bought and hung in their apartment.

24. Johnson, interview by author, 1989. Johnson now says, inexplicably, that he wasn't at the wedding, but after the ceremony Hitchcock and he began their travels.

25. Johnson to Mrs. Homer H. (Louise Pope) Johnson, June 20, 1930, The Hague; MoMA Archives, NY: Philip Johnson Papers, IV.8; as quoted in Terence Riley, *The International Style: Exhibition 15 and the Museum of Modern Art* (New York: Rizzoli for Columbia Books of Architecture, 1992), p. 12. Riley researched in great detail the 1932 exhibition "Modern Architecture: International Exhibition," restaging the "curatorial process and the actual installation" at Columbia University from March 9 to May 2, 1992 (ibid., p. 10).

Johnson's statement in this letter that he and Hitchcock decided on June 18, 1930, to produce a book differs marginally from his later memory that they started research for the book

immediately following the Barrs' wedding (which was on May 27). Margaret Barr, "'Our Campaigns,'" p. 24.

26. Alfred H. Barr, Jr., "Modern Architecture," *Hound & Horn* 3 (April–June 1930), p. 435.

27. Johnson to Mrs. Homer Johnson, July 7, 1930, MoMA Archives, NY: Philip Johnson Papers.

28. Philip Johnson, introduction to Terence Riley, *International Style: Exhibition 15,* p. 5.

29. Johnson to Mrs. Homer Johnson, July 7, 1930, MoMA Archives, NY: Philip Johnson Papers.

30. Johnson to Mrs. Johnson, July 21, 1930, MoMA Archives, NY: Philip Johnson Papers.

31. Johnson, interview by author, 1989. Johnson related to Tomkins in 1977: "I've fought nearly all my life against 'Form follows function'" (Tomkins, "Philip Johnson," p. 78).

32. Quoted in Helen Searing, "International Style: The Crimson Connection," *Progressive Architecture* 63 (February 1982), p. 88. Searing wrote that the letter was published in Dutch in *Americana* (catalogue of the exhibition held in 1975 at the Kröller-Müller Museum, Otterlo), p. 102, and translated by Searing into English.

33. Johnson to his mother, August 6, 1930, MoMA Archives, NY: Philip Johnson Papers.

34. Johnson, interview by author, 1989.

35. Riley, *International Style: Exhibition 15,* comes to the same conclusion: "Evidence strongly suggests that discussions about a specific exhibition, based on Hitchcock's book-in-progress, began in New York only in the fall of 1930" (p. 93). Which was published first, *The International Style: Architecture since 1922* (Hitchcock finished writing the book by November of 1931) or the catalogue *Modern Architecture: International Exhibition,* remains unanswered.

36. Riley, *International Style: Exhibition 15,* p. 19. The full text appears in Riley as "Appendix 1: Preliminary Proposal for an Architectural Exhibition at the Museum of Modern Art by Philip Johnson," pp. 213–214. Johnson not only committed his energies to this project but, with the help of his father, largely financed it. Written into the proposal was a suggested committee that would direct its progress, consisting of Barr, Goodyear, Homer H. Johnson (Philip Johnson's father), Johnson (as committee secretary), G. F. Reber (a Swiss collector who had a strong group of Picasso paintings and whom Barr was assiduously cultivating), and Abby Rockefeller. Johnson volunteered his own services plus those of Alan Blackburn, Jr., a schoolmate from Cleveland, as the committee's executive secretary. In February of 1932, Blackburn became executive secretary of the Museum. By February 10, 1931, a revised proposal named Clark, Lewisohn, Homer Johnson, Reber, and Barr as the committee members and Johnson as the director of the exhibition. Riley, p. 216. Lewis Mumford and W. W. Norton joined later.

37. Quoted in Riley, *International Style: Exhibition 15,* p. 214.

38. Ibid., Appendices 1 and 2, pp. 215–219.

39. Johnson to Mrs. John D. Rockefeller, Jr., March 27, 1931, MoMA Archives, NY: Philip Johnson Papers; quoted in Franz Schulze, *Mies van der Rohe: A Critical Biography* (Chicago: University of Chicago Press, 1985), p. 180.

40. Johnson to Barr, July 11, 1931, MoMA Archives, NY: Philip Johnson Papers.

41. Johnson to Barr, August 7, 1931; quoted in Schulze, *Mies van der Rohe: A Critical Biography,* p. 180.

42. See Elaine Hochman, *Architects of Fortune: Mies van der Rohe and the Third Reich* (New York: Weidenfeld & Nicholson, 1989).

43. Johnson, *Philip Johnson: Writings,* p. 207.

44. The drawing of the concrete house (1923) is similar to the brick country house. It is no longer extant; an illustration can be found in Franz Schulze, ed., *Mies van der Rohe: Critical Essays* (New York: Museum of Modern Art, 1989), p. 51.

45. Ibid., p. 203, n. 25. (Terence Riley in *International Style: Exhibition 15* mistakenly suggests that Barr visited the Stuttgart project in 1928. Barr did not see it until 1933, but Hitchcock was there in 1927.)

46. Philip Johnson, quoted in Schulze, *Mies van der Rohe: A Critical Biography,* pp. 21, 42.

47. Johnson, *Philip Johnson: Writings,* p. 207.

48. Johnson to Oud, September 17, 1930, MoMA Archives, NY: Philip Johnson Papers.

49. Philip Johnson, *Mies van der Rohe* (New York: Museum of Modern Art, 1947), p. 42.

50. Johnson, interview by author, 1989.

51. Johnson to his mother, August 22, 1930, MoMA Archives, NY: Philip Johnson Papers.

52. Johnson, interview by author, 1989. Johnson wrote to his mother on July 21, 1930 to ask her permission to have Mies design the interior of his apartment (MoMA Archives, NY: Philip Johnson Papers). In a letter dated September 1, 1930, he wrote his mother describing Mies as "a man who keeps his distance, and impersonality at all times, only letting down graciously once in a while, thus honoring you as the nod of a god would." (Ibid.) Mies's Barcelona chairs have been in evidence in every office Johnson has had.

53. An illustration of Johnson's apartment designed by Mies was included in both the book *The International Style* by Johnson and Hitchcock and the exhibition "Modern Architecture."

54. Barr to Johnson, August 11, 1930, MoMA Archives, NY: AHB [AAA: 2164; 441]. Barr, in the midst of furnishing his own apartment, yearned for the same furniture designed by the modern architects that Johnson had, but he couldn't afford it. The Barrs waited two years for a dining room table from Herman Miller (Margaret Barr, "'Our Campaigns,'" p. 25).

55. Johnson, interview by author, 1989. This is the only instance when Johnson credited Barr rather than Hitchcock with initiating interest in the style.

By 1966 Barr called Mies "probably the greatest living architect and surely the most influential in his effect upon the architects of the 1940s and 1950s. He is the last of the great architects of the early and mid-twentieth century." Barr to Fiorello La Guardia, April 13, 1966, suggesting names in the arts to be considered for the Family of Man Award, 1966–1967. MoMA Archives, NY: AHB [AAA: 2193; 1009].

56. Henry-Russell Hitchcock, "Architecture Chronicle," *Hound & Horn* 5 (October 1931), pp. 95, 96. Hitchcock's reasoning had the same museological philosophy often expressed by Paul Sachs, a likely source for Hitchcock's ideas.

57. Ibid., p. 96.

58. Barr, foreword to Hitchcock, Johnson, and Mumford, *Modern Architecture: International Exhibition,* p. 14.

59. In a letter from Barr to G. Hayden Huntley, May 23, 1946, MoMA Archives, NY: AHB [AAA: 2173; 1047], Barr described his attitude about ornamentation: "I do not believe in the inevitability or essential character of popular interest in ornament. The International Style has become the International Style within twenty short years to the same degree it took the renaissance style a hundred years to spread over Trans-Alpine Europe. Or dialectically if the International Style is not the international style, what is? Of course, by the International Style we do not mean what we did fifteen years ago when we deliberately applied the phrase, I think, for the first time. The style has changed and grown and lost much of its asceticism, having been enriched both by materials and by newer and freer forms although still without ornament applied. . . . The style is very wide spread and has succeeded in eliminating a great deal of bad ornament, both traditional and modernistic."

60. Hitchcock and Johnson, *The International Style,* p. 95.

61. Hitchcock to Thomson, November 19, 1930, Thomson Papers, YUL.

62. Johnson, interview by author, 1989.

63. Barr, foreword to Hitchcock and Johnson, *The International Style,* p. 14.

64. Ibid., p. 11.

65. Riley, *International Style: Exhibition 15,* p. 91, came to the conclusion, after perusing the statements, written and oral, of all three "curators" (Riley's term for Hitchcock, Johnson, and Barr), that it was Hitchcock who first used the phrase "international style" with lower-case letters, but that it was Johnson and Barr who promoted the "wide currency" of the phrase with upper-case letters. After examining the occasions of its use, I find that "international style" with lower-case letters was freely used by all three in discussing the new architecture, that Barr indeed pushed for the upper-case letters—witness the fact that he was the only one to use this form in the book and catalogue, and that Barr and Johnson, both adroit publicists, popularized the label of the new architecture. An example of their ability to draw attention to their project was the exhibition "Rejected Architects" that they organized in 1931 with Julien Levy in a temporary location in a storefront owned by Levy's father. The works in the show were from architects excluded from the annual exhibition of the conservative Architectural League at the Grand Central Palace. Barr and Johnson hired a man to stand outside Grand Central Palace with a sandwich board that read "See Really Modern

Architecture, Rejected by the League, at 907 Seventh Avenue." Johnson continued promoting the International Style by writing two articles: "Rejected Architects," *Creative Art* 8 (June 1931), 433–435, and "The Skyscraper School of Modern Architecture," *Arts* 17 (May 1931), pp. 569–575.

66. Barr, foreword to *Hitchcock, Johnson, and Mumford, Modern Architecture,* p. 13.

67. In *Medieval Art* (New York: W. W. Norton, 1942), pp. 350, 351, note 90, Charles Morey defined the concept: "At the end of the fourteenth century these three modes—the lingering Parisian Gothic, Flemish realism, and Italian idealism with its Sienese version—began to coalesce into a manner that penetrated into all the national arts of Europe and is known in consequence as the 'international style.'" Although Morey's book was published ten years after the architecture exhibition, Barr most likely would have heard these stylistic categories in Morey's lectures at Princeton.

68. Barr, foreword to Hitchcock, Johnson, and Mumford, *Modern Architecture: International Exhibition,* p. 12. In 1987 Margaret Barr, "'Our Campaigns,'" was still predicting that the "Modern Architecture" exhibition "will affect architecture in the United States for many years to come" (p. 28).

69. Brendan Gill, "The Sky Line: 1932," *New Yorker* (April 27 1992), p. 94.

70. Robert A. M. Stern, "International Style: Immediate Effects," *Progressive Architecture* 63 (February 2, 1982), p. 106.

71. Gropius disavowed these concepts, flatly denying the idea of "style." As Reyner Banham observes in *Theory and Design in the First Machine Age* (New York: Praeger, 1960), functionalism was, in fact, complex and diverse and not automatically objective. Minutely analyzing the machine aesthetic, Banham concludes: "Nowhere among the major figures of the twenties will a pure Functionalist be found, an architect who designs entirely without aesthetic intentions" (p. 162). Banham took a middle course: "It is clear that even if it were profitable to apply a strict standard of Rationalist efficiency or Functionalist formal determinism to [a modern structure], most of what makes it architecturally effective would go unnoted in such an analysis" (p. 323). Sigfried Giedion, a renowned architectural historian and a champion of Gropius, completely ignored the term "International Style" in his book *Space, Time and Architecture: The Growth of a New Tradition* (Cambridge: Harvard University Press, 1941).

72. Alfred H. Barr, Jr., "What Is Happening to Modern Architecture? A Symposium at the Museum of Modern Art," *Museum of Modern Art Bulletin* 15 (Spring 1948), p. 6.

73. At the left-hand extreme of his chart, descending from "primitivist art," was fauvism, which influenced German expressionism and, in turn, fed into nongeometrical abstract art—all of which evaded the hegemony of the machine aesthetic. Surrealism, through dadaism, does not escape the machine aesthetic. (Chapter 9 discusses this dichotomy as the essence of Barr's struggle to create order in modernism.) Reyner Banham, in Penny Sparke, ed., *Designs by Choice: Ideas in Architecture* (London: Academy Editions, 1966), p. 20, lauds Barr's concept: "The Museum of Modern Art's catalogue of the exhibition *Cubism and Abstract Art* . . . is the monument of the one grouping that really kept stylistic, aesthetic (and thus culturally interesting) discussion of Modern architecture alive." Banham suggests that

this catalogue, along with the Museum's *Bauhaus 1919–1928* catalogue, "contained enough critical mass to detonate and demolish the whole myth of the Modern Movement as a persistence of the nineteenth century into our own times." This last comment was evidently meant as a correction to Nikolaus Pevsner's *Pioneers of the Modern Movement* as well as Giedion's *Space, Time and Architecture.*

74. Barr, foreword to Hitchcock and Johnson, *The International Style*, p. 11.

75. Johnson, interview by author, 1992. Johnson reiterated that he and Barr saw art and architecture as having the power to save mankind; they believed in the "perfectibility of man." The architecture show of 1932 included a section on urban development.

76. Barr, foreword to Hitchcock, Johnson, and Mumford, *Modern Architecture*, p. 14.

77. Johnson, "Afterword," in *Philip Johnson: Writings*, p. 268.

78. Hitchcock and Johnson, *The International Style*, p. 37.

79. See Richard Pommer and Christian Otto, *Weissenhof 1927 and the Modern Movement in Architecture* (Chicago: University of Chicago Press, 1991).

80. Hitchcock and Johnson, *The International Style*, p. 38.

81. Barr, foreword to Hitchcock and Johnson, *The International Style*, p. 14.

82. Barr to Mumford, February 27, 1948, MoMA Archives, NY: AHB [AAA: 2175; 548]. In 1959 he wrote again of the problem: "The academic style so usefully generated by Mies does take little cognizance of the problem of representative architecture and that its ubiquity can be boring, particularly for architects of the following generation. . . . The principal pressure comes from [the architects'] own restiveness with the limitations of the tradition in which most of them have been working until recently." Barr to Peter Blake, April 28, 1959, courtesy of Peter Blake.

83. Barr, foreword to Hitchcock and Johnson, *The International Style*, p. 14. By 1948, Barr's position had solidified. In a foreword to Hitchcock's *Painting towards Architecture: The Miller Co. Collection of Abstract Art* (New York: Duell, Sloan & Pearce, 1948), Barr wrote: "It is their passionate and concentrated investigation of form which has made painting and sculpture valuable to architects as never before in the history of art" (p. 8). Barr claimed that the revolutionary architects only pretended to derive their forms from technological requirements. "By 1930 the International Style had assimilated the lessons both of functionalism and abstract art" (p. 9).

84. Peter Blake, a curator of the department of Architecture and Design from 1948 to 1950, wrote that it was a valid and inescapable position: "How could you justify such exhibitions as the 1938 display of 'Useful Household Objects Under $5' unless you claimed that these pedestrian displays were in fact part and parcel of the Art of Our Time?" Peter Blake, "Architecture Is an Art and MOMA Is Its Prophet," *Art News* 78 (October 1979), p. 99.

85. Barr, foreword to Hitchcock and Johnson, *The International Style*, p. 13.

86. Hitchcock and Johnson in ibid., p. 28.

87. Ibid., p. 20.

88. In 1948 Hitchcock wrote *Painting towards Architecture;* Barr wrote the foreword. At the time, Barr wrote to Hitchcock criticizing the separation of text and illustrations (remarking that he had commented on this before); he felt that this approach was too abstract and confusing to the readers: "I read your article Painting Toward Architecture very carefully. I have one very serious criticism to make one which I used to make of your writing in the past whenever you asked me to look it over. I think your approach is much too abstract (no pun intended.) You are dealing not only with works of art, but, by implication, at least with a specific collection, yet there is scarcely any reference at all to specific objects in the whole 25 pages. I don't think you can expect the ordinary architect, much less the layman, to read a dissertation which deals almost entirely with style and form without giving more specific illustrations which after all are most conveniently at hand in the plates of the book itself. Presumably the Tremaines bought this collection in part to illustrate the relationship between abstract art and architecture." Barr to Hitchcock, January 23, 1948, MoMA Archives, NY: AHB [AAA: 2174; 732].

89. Hitchcock to Thomson, November 19, 1930, Thomson Papers, YUL.

90. Philip Johnson, "Beyond Monuments," *Architectural Forum* 138 (January–February 1973), p. 58. Hitchcock, teaching at Wesleyan at the time, had little to do with the curatorial aspect of the show.

91. Riley, *International Style: Exhibition 15,* pp. 62–63.

92. Ibid. Riley reports that Johnson chose the Russian photographs from those supplied by the Soviet Photo Agency located in New York, so his choice was limited (p. 208, footnote 20). My thanks to Riley for the information that the Russian architect Burov, who built "purist" buildings, sent photographs to Lurçat, who gave them to Hitchcock, at which point they finally came to Barr's attention.

93. Johnson, interview by author, 1990.

94. Johnson, "Beyond Monuments," p. 58.

95. Barr to Pat Mewhammer, March 2, 1951, MoMA Archives, NY: AHB [AAA: 2175; 351].

96. Riley, *International Style: Exhibition 15,* p. 40, wrote that this was anecdotal material that could not be substantiated. He felt that the trustees would not have pressured Barr into including American architects.

97. Johnson, "Beyond Monuments," p. 58.

98. Ibid.

99. Barr, from Paris to Philip Johnson, August 19, 1931, MoMA Archives, NY: Philip Johnson Papers, IV.8, quoted in Riley, *International Style: Exhibition 15,* p. 52. Barr wrote: "About models. I still feel it better from the public's point of view to have models of things already built. Why have Mies design a new house which would be of interest only in Europe now that the show would probably not come to Europe? Why not have him do the Brno house

since it is the largest and most luxurious private house in the style?" Oud's Pinehurst project, unbuilt, slipped through this prohibition as well.

100. Hitchcock and Johnson, *The International Style,* p. 27.

101. Hitchcock, Johnson, and Mumford, *Modern Architecture,* p. 36.

102. Johnson, publicity release, MoMA Archives, NY: Public Information Scrapbooks (27; 273).

103. Johnson to Oud, September 17, 1930, MoMA Archives, NY: Philip Johnson Papers, IV.8.

104. Much later, in an obituary for Wright that appeared in *Time* magazine on April 9, 1959, Barr wrote: "Frank Lloyd Wright rose above such minor virtues as good taste, economy, consistency and modesty to achieve an architecture of unparalleled originality and vigor. He was, I think, the greatest architect since Borromini." Although those are kind words, they still don't place him among the modernists of the International Style.

105. Barr, "Notes on Russian Architecture," p. 106.

106. Riley, *International Style: Exhibition 15,* p. 72.

107. Hitchcock, in Hitchcock, Johnson, and Mumford, *Modern Architecture,* p. 11.

108. Johnson, interview by author, 1990.

109. Three housing projects were shown—one designed by Stein and Wright in Radburn, New Jersey; one in Kassel, Germany, designed by Otto Haesler, who also provided the model for that section; and the third, designed by Ernst May, in Frankfurt-am-Main. To emphasize the need for new housing, photographs of slums were mounted in contrast to the new projects. Barr used the inclusion of a housing section to refute the criticism that the Museum viewed architecture only as art.

110. Barr's active role in directing the exhibition was evident in Riley's catalogue and in his suggestion that the installation resembled Barr's "minimalist" art exhibitions; *International Style: Exhibition 15,* p. 75.

111. Barr to Abby Rockefeller, February 4, 1933, MoMA Archives, NY: AHB [AAA: 3264; 1186].

112. Riley, *International Style: Exhibition 15,* p. 81.

113. Ibid.

114. The exhibition circulated to six different cities and launched the very successful concept of circulating exhibitions.

115. Barr felt that Gropius got his position at Harvard and Mies his at the Illinois Institute of Technology because of their "increased reputations" in America as a result of the Museum's architectural exhibitions and catalogues. Barr to Ranald MacDonald, May 7, 1949, MoMA Archives, NY: AHB [AAA: 2173; 69].

116. The other two examples were Beaumont Newhall and the department of Photography and Iris Barry and the department of Cinema.

117. Barr to Artemas Packard, April 10, 1936, MoMA Archives, NY: AHB [AAA: 2166; 285].

118. Barr to Abby Rockefeller, February 4, 1933, MoMA Archives, NY: AHB [AAA: 3264; 1186].

119. Ernestine Fantl, *With Tongue in Cheek* (London: Michael Joseph, 1974), p. 28.

120. Barr to Amy Loveman, March 3, 1937, MoMA Archives, NY: AHB [AAA: 2166; 523].

121. For a detailed discussion of the importance of the *Little Review* and Jane Heap's role in bringing the work of the artists involved in the machine aesthetic to America, see Susan Noyes Platt, "Mysticism in the Machine Age: Jane Heap and *The Little Review*," 20/1 1 (Fall 1989), pp. 18–44.

122. Ibid., p. 34. Kiesler assembled 1,541 stage designs from fifteen countries, incorporating mechanizations that furthered the concepts of the machine age. Kiesler's success with the design of radical stage sets in Vienna and Berlin in 1924 led Josef Hoffmann to invite him to recreate them in the Exposition Internationale des Arts Décoratifs et Industriels Modernes in Paris in 1925. Heap saw the show and Tristan Tzara suggested that she invite Kiesler to organize the same show in New York. Lisa Phillips, "Architect of Endless Innovation," in Phillips, ed., *Frederick Kiesler* (New York: Whitney Museum of Art and W. W. Norton, 1989), pp. 13, 14. Heap revised the original catalogue and published it as an issue of the *Little Review*. Heap's staging of the "Machine-Age Exposition" in 1927 was inspired by Kiesler's efforts to demonstrate the use of technology in constructivist stage sets.

123. Alfred H. Barr, Jr., foreword to Philip Johnson, *Machine Art* (New York: Museum of Modern Art, 1934), unpaginated.

124. Alfred H. Barr, Jr., "Russian Diary 1927–28," *October 7* (Winter 1978), p. 34.

125. Jane Heap, "Machine Age Exposition," *Little Review* 11 (Spring 1925), pp. 23–24.

126. Alfred H. Barr, Jr., ed., *Masters of Modern Art* (New York: Museum of Modern Art, 1953), p. 85.

127. Quoted by Barr, foreword to Johnson, *Machine Art*, p. 51. Banham, in *Theory and Design in the First Machine Age*, p. 205, discusses the practice of using an ordinary product as a work of art by Duchamp and his circle in the second decade of the century. He relates that before Barr, Duchamp had used Plato's proposition from the *Philebus* that absolute beauty resides in quotidian objects. Most likely, Barr was indebted to the painter Amédée Ozenfant, who used the Plato quote as early as 1916; Barr frequently cited *La Peinture moderne* by Ozenfant and Charles-Edouard Jeanneret (Le Corbusier) as one of the most influential books on his aesthetic.

128. Thomas Aquinas, *Summa Theologiae*, I, 39, a.8, quoted by Jacques Maritain in *Art et scolastique* (Paris: L. Rouart, 1927), p. 250. Maritain, whose name came up frequently in Barr's correspondence, offered an aesthetic response to art based on the writings of Thomas Aquinas. In his notes, probably made on his 1927 European trip, Barr writes of Maritain as one of "the leaders of the French Neo-Thomists which English readers have known

for some time through the translations in T. S. Eliot's *New Criterion.*" MoMA Archives, NY: AHB [AAA: 3263; 69].

129. Lawrence Pearsall Jacks, *Responsibility and Culture* (New Haven: Yale University Press, 1925).

130. Barr, foreword to Johnson, *Machine Art,* unpaginated.

131. Ibid.

132. Peter Blake reported that Barr was "secretly troubled" by the "inherent conflict or contradiction" between function and form, admitting that architects in general are inconsistent in their frame of reference as they bounce from "an esthetic base to a functional base to a socioeconomic-political base—meanwhile turning architecture criticism into a sort of pinball game." Peter Blake, "Architecture Is an Art and MoMA Is Its Prophet," pp. 99–100.

133. Johnson, *Machine Art,* unpaginated.

134. Philip Johnson, "Architecture and Design Collections," in Barr, ed., *Masters of Modern Art,* p. 222. (My emphasis.)

135. Until 1940, architecture and industrial design were in one department at the Museum. From 1940 to 1945, the department of Industrial Design under Eliot Noyes was independent. Johnson, who rejoined the Museum in 1946, reunited the two departments in 1949.

136. Barr, interview by Macdonald, Macdonald Papers, YUL.

137. Barr, foreword to Johnson, *Machine Art,* unpaginated.

138. Dorothy Miller, interview by Paul Cummings, 1970, AAA.

139. The catalogue is Herbert Bayer, Walter Gropius, and Ise Gropius, *Bauhaus: 1919–1928* (New York: Museum of Modern Art, 1938). Philip Johnson, having left the Museum, was listed as a volunteer who assisted in assembling and installing the exhibition. As Barr related in the preface (p. 6), work from the last five years of the Bauhaus was unobtainable; the exhibition showed only material until the year 1928, when Gropius resigned. (Subsequent directors of the school were Hannes Meyer and Mies van der Rohe.)

140. Barr to Ernestine Fantl Carter, September 21, 1937, MoMA Archives, NY: AHB [AAA: 2166; 340].

141. Barr, preface to Bayer, Gropius, and Gropius, *Bauhaus,* pp. 5, 6. When Johnson offered Barr one of two Schlemmer paintings—he said he would sell the other to Austin—Barr chose *The Bauhaus Stairway.* "I still think this is his best picture, certainly the best that has been available for many years and I am particularly pleased to have it because of the subject and because it was bought from under the noses of the Nazis." Barr letter to Johnson, 1943, MoMA Archives, NY: AHB [AAA: 2169; 845].

142. Barr, preface to Bayer, Gropius, and Gropius, *Bauhaus,* p. 6. In writing that the "study of rational design in terms of technics and materials should be only the first step," Barr interjects his own formalist philosophy—again, to neutralize Gropius's ideas of functionalism.

143. Ibid., p. 5. The Museum not only copied the organization of the school but used the sans serif lettering with which both institutions were identified.

144. Ibid., p. 7.

145. Mary Anne Staniszewski, *The Power of Display: A History of Exhibition Installations at the Museum of Modern Art* (Cambridge: MIT Press, 1998), chapter 3.

146. Barr, interview by Macdonald, Macdonald Papers, YUL.

9 THE DIRECTORSHIP AT FULL THROTTLE

1. Alfred H. Barr, Jr., *Cubism and Abstract Art* (New York: Museum of Modern Art, 1936); Alfred H. Barr, Jr., ed., *Fantastic Art, Dada, Surrealism* (New York: Museum of Modern Art, 1937).

2. Alfred H. Barr, Jr., *Bulletin of the Museum of Modern Art* (October 1933), p. 4. Barr mounted three other exhibitions that he offered as a historical view of modernism: "Masters of Popular Painting," 1938; "American Realists and Magic Realists," 1943; and "Romantic Painting in America," 1943.

3. Daniel Robbins, "Abbreviated Historiography of Cubism," *Art Journal* 47 (Winter 1988), p. 278.

4. Barr, *Cubism and Abstract Art,* p. 9. Barr gave the Museum a collection of posters, prints, paintings, and sculptures, as well as covers of catalogues, that he had gathered on his trip to Europe in 1927–1928. MoMA Archives, NY: AHB [AAA: 2165; 1148]. They appeared in the "Cubism and Abstract Art" exhibition.

5. Clark to Barr, October 13, 1943, MoMA Archives, NY: AHB [AAA: 2190; 1047].

6. Alfred H. Barr, Jr., "Modern and 'Modern,'" *Bulletin of the Museum of Modern Art* 1 (May 1934), p. 4.

7. Barr, *Cubism and Abstract Art,* pp. 13, 20.

8. Barr, interview by Macdonald, Macdonald Papers, YUL. Barr told Macdonald that it was written by Henri Verne, Director General of the National Museums of France, in a letter to Barr, March 25, 1931, and quoted by Barr in *An Effort to Secure $3,250,000 for The Museum of Modern Art, New York City* (New York: Museum of Modern Art, 1931), p. 67.

9. Barr's formalist aesthetic was derived from a long line of theorists, such as Heinrich Wölfflin and Roger Fry.

10. Barr, *Cubism and Abstract Art,* pp. 11–13.

11. Ibid., pp. 13, 11.

12. Lazar (El) Lissitzky and Hans Arp, *Die Kunstismen: 1914–1924* (Zurich: E. Rentsch, 1925).

13. Barr, *Cubism and Abstract Art,* p. 9.

14. Alfred H. Barr, Jr., "Post-War European Painting," paper read at 20th annual meeting of College Art Association, published in *Parnassus* 3 (May 1931), p. 21.

15. Barr to Macdonald, 1953, Macdonald Papers, YUL.

16. Barr to Joan Kalm, May 1962, MoMA Archives, NY: AHB [AAA: 2191; 1125].

17. Barr, *Cubism and Abstract Art,* p. 11.

18. Ibid., p. 9.

19. Ibid., pp. 12, 122.

20. In all likelihood, Barr was acquainted with the methods of Linnaeus, the Swedish botanist, who in the eighteenth century classified plants and animals by a system of double names, the first term designating the genus and the second the species.

21. Barr to Agnes Rindge, November 9, 1950, MoMA Archives, NY: AHB [AAA: 2172; 149, 150]. Unable to interest Erwin Panofsky, Richard Krautheimer, Millard Meiss, or Frederick Hartt in researching the changes that had taken place in the terms used to describe the stylistic periods of European art, he asked Agnes Rindge Claflin, chairman of the Art History department at Vassar College. They had been friends since his days at Vassar in 1923, and she was involved periodically in the Museum's activities.

22. Daniel-Henry Kahnweiler, *Der Weg zum Kubismus* (Munich: Delphin-Verlag, 1920), p. 34; *Way of Cubism,* trans. Henry Aronson (New York: Wittenborn, Schulz, 1949), p. 12.

23. Alfred H. Barr, Jr., *Picasso: Forty Years of His Art* (New York: Museum of Modern Art, 1939), p. 75. Barr expanded and formalized the classifications of cubism in this catalogue at the time of the Picasso exhibition. He further expanded and revised this book as *Picasso: Fifty Years of His Art* (New York: Museum of Modern Art, 1946).

24. Ibid., pp. 6–7. *Les Demoiselles d'Avignon* did not appear in the exhibition as the Museum did not purchase it until 1937.

25. Kahnweiler, *Way of Cubism,* p. 7. Robbins, "Abbreviated Historiography of Cubism," p. 281, cogently explicates the difference between Barr's view and Kahnweiler's philosophical approach to "analytic" and "synthetic" cubism. Barr did not follow, Robbins writes, the "idealist clues embedded" in Kahnweiler's text. Kahnweiler dealt with the cognitive difference between analytic and synthetic cubism; Barr "chose to stress the new, created reality of the independent work of art." This led to the eventual view of the painted surface as a self-reflexive object.

26. Barr, *Cubism and Abstract Art,* p. 26.

27. Ibid., p. 31. Robbins, "Abbreviated Historiography of Cubism," p. 279, writes that Barr established the primary importance of Cézanne's role in the development of cubism, above all, as Barr wrote, in his "'abandonment of emphatic modelling.'" (In 1925 Barr had given this role to Pissarro.) Robbins concludes: "It would be difficult to overestimate the importance of [Barr's] formulation, for it is the clear basis—the main pattern—of all subsequent discussions for the next forty years of the concept of the picture plane, its role in Cubism, and in the evolution of abstract art." Robbins also credits Barr with bringing attention to Cézanne's 1907 letter to Bernard about "the cone, the sphere, and the cylinder," a notion that has remained integral to any subsequent discussion of cubism; see Barr, *Cubism and Abstract Art,* p. 30.

28. Pissarro originally used the term to describe Cézanne's method. William Rubin discusses this in "Pablo and Georges and Leo and Bill," *Art in America* 67 (March–April 1978).

29. Barr invented the term "facet cubism" for the paintings of 1909–1910 and the term "rococo cubism" for the paintings of 1914–1915. Memo, May 5, 1959, MoMA Archives, NY: AHB [AAA: 3264; 1117].

30. Barr, *Cubism and Abstract Art,* p. 31.

31. Barr, *Picasso: Fifty Years of His Art,* pp. 70, 71.

32. John Golding in *Cubism: A History and Analysis 1907–1914,* rev. ed. (Boston: Boston Book & Art Shop, 1968), wrote that Ozenfant and Jeanneret in *La Peinture moderne* (1925) were the first to recognize 1912 as the break in analytic cubism, which they referred to as "hermetic Cubism." Barr said their book had a great influence on him.

33. Barr, *Cubism and Abstract Art,* pp. 78, 82; Barr, *Picasso: Fifty Years of His Art,* p. 80. In *Cubism and Abstract Art,* Barr placed the advent of synthetic cubism in 1913; in *Picasso: Fifty Years of His Art,* he changed the date to 1912–1913, explaining that the transition was gradual. Barr subsumed *papier collé* under the heading of collage.

34. Barr, *Picasso: Fifty Years of His Art,* p. 82.

35. Barr, *Cubism and Abstract Art,* p. 78.

36. Barr, *Picasso: Fifty Years of His Art,* p. 80.

37. Ibid., p. 84. An illuminating discourse on the beginnings of collage and its implications has developed that includes the semiotic idea of form as arbitrary sign rather than representation. See Yves-Alain Bois, *Painting as Model* (Cambridge: MIT Press, 1992); Rosalind Krauss, "The Motivation of the Sign," and Yves-Alain Bois, "The Semiology of Cubism," in William Rubin and Lynn Zelevansky, eds., *Picasso and Braque: A Symposium* (New York: Museum of Modern Art, 1992).

38. Clement Greenberg, "Collage," in *Clement Greenberg: The Collected Essays and Criticism,* vol. 2: *Arrogant Purpose: 1945–1949,* ed. John O'Brian (Chicago: University of Chicago Press, 1986), p. 259, first published as a review of the exhibition "Collage in the Museum of Modern Art," *Nation* (November 27, 1948).

39. Ibid., pp. 260, 261. In *Painting as Model,* Yves-Alain Bois credits Greenberg with recognizing that Picasso's *Guitar* construction of 1912 "is at once the origin of 'synthetic' cubism and of a new era in the history of Western sculpture" (p. 69).

40. Greenberg, "Modernist Painting," in *Clement Greenberg: The Collected Essays and Criticism,* vol. 4: *Modernism with a Vengeance, 1957–1969,* ed. John O'Brian (University of Chicago Press, 1993), p. 87. Greenberg, in an interview by Dwight Macdonald for the *New Yorker* Profile "Action on West 53rd Street," quarreled with Barr's taste: "Barr's taste is too slick, too chichi, he is too much impressed by bravura, by Surrealist and romantic fireworks." (Macdonald Papers, YUL.) Greenberg, who was known for his taste, was also known for "refusing to deal with . . . artists and movements that bored him such as Duchamp, Surrealism, Dada, Pop, and Conceptual art." Sidney Tillim, "Criticism and Culture or Greenberg's Doubt," *Art in America* 75 (May 1987), p. 122. Greenberg's peevishness was a re-

sult of his perception that Barr "was slow to get on the Pollock-Motherwell-Rothko band-
wagon" (Greenberg interview with Macdonald, Macdonald Papers, YUL). Robert Gold-
water had a different slant. He claimed that Barr had promoted Pollock and the abstract
expressionists, which, for Barr, was a "hair shirt." He thought that Barr "personally liked
magic, romantic, poetic, surrealist sort of pictures; but in his puritan way he thinks he should
like abstract art because it is harder to understand and enjoy—and Pollock was the hardest
of all; they are original, not derivative from Paris—this and for patriotic reasons—he has be-
come rather chauvinistic—he is proud and glad to be able to back a homegrown move-
ment." (Robert Goldwater, interview by Dwight Macdonald, Macdonald Papers, YUL.) In
response to Emily Genauer of the *New York Herald Tribune,* who had asked why he bought
so many of Pollock's works, Barr said he was "the Vermeer of our time" (quoted in interview
by Dwight Macdonald, Macdonald Papers, YUL).

41. Clement Greenberg, "Avant-Garde and Kitsch," in *Collected Essays and Criticism,*
vol. 1, *Perceptions and Judgments, 1939–1944,* ed. John O'Brian (Chicago: University of
Chicago Press, 1986), p. 8; first published in *Partisan Review,* Fall 1939.

42. Clement Greenberg, "Towards a Newer Laocoon," in *Collected Essays and Criticism,*
vol. 1, p. 34.

43. See Barbara M. Reise, "Greenberg and the Group: A Retrospective View," Part 1, *Stu-
dio International* (May 1968), pp. 254–257, and Part 2 (June 1968), pp. 314–316. Reise
states that Greenberg's experience with Marxian artists and writers committed him to a his-
torical perspective with the art he discussed and to a goal of reaching a broad public. John
O'Brian, the editor of Greenberg's collected essays, placed the critic: "The dissenting tone
of Greenberg's voice, quick to reject what seemed meretricious in contemporary culture, was
a tone characteristic of a group of New York critics and writers brought together by broadly
shared convictions about art and politics. Among them were Paul Goodman, Dwight Mac-
donald, William Phillips, Philip Rahv, Harold Rosenberg, Isaac Rosenfeld, Meyer Schapiro,
Lionel Trilling, Robert Warshow, and Greenberg himself. . . . It is stating the obvious to say
that Greenberg's hold on history and his rejection of the forms and arrangements of capi-
talism were Marxist in origin." (O'Brian, introduction to Greenberg, *Collected Essays and
Criticism,* vol. 1, pp. xix, xx.) Most of these writers appeared in *Partisan Review.* Barr's po-
litical goals were defensively liberal, but he also of course aimed for a broad public under-
standing. While he wrote antifascist or anticommunist articles, he always kept art separate
from its political context.

44. Greenberg's Marxist orientation became absorbed in a perspective of general "in-
evitable" historical progress that was the basis for his formalism. Barr's historicism was purely
stylistic. His liberalism found expression in the many humanitarian causes with which he was
involved, such as the help he gave to artist refugees from Hitler's Germany or the anti-Nazi
articles he wrote when he returned from Germany in 1933. A controversy developed in
1933 over the exhibition "Murals by American Painters and Photographers" mounted by
Lincoln Kirstein (see Russell Lynes, *Good Old Modern: An Intimate Portrait of the Museum of
Modern Art* [New York: Atheneum, 1973], pp. 98–101). The artist Hugo Gellert was de-
nied entry to the exhibition because of a painting titled *"Us Fellas Gotta Stick Together"—Al
Capone,* in which he placed the figures of John D. Rockefeller, Sr., Henry Ford, and Presi-
dent Hoover next to Al Capone. Barr wrote to the artist expressing his regrets about the mat-

ter, saying that the Museum had no "attitude towards politics as such": the objection was not "to the personification of the class struggle, only the personalization of these symbols." MoMA Archives, NY: AHB [AAA: 2164; 670].

45. Greenberg, "Towards a Newer Laocoon," p. 37.

46. Greenberg's debt to Barr cannot be overlooked. Tillim could have been writing about Barr when he said that Greenberg ignored "the social and psychological dynamics of style the importance of which he did not deny. He simply felt they were irrelevant to the issue of esthetic quality." Tillim, "Criticism and Culture or Greenberg's Doubt," p. 201.

47. Barr, *Picasso: Fifty Years of His Art,* p. 74. A justifiably strong statement that, in fact, underestimated the longevity of the influence of cubism.

48. Robert Rosenblum, foreword to Alfred H. Barr, Jr., *Cubism and Abstract Art,* reprint (Cambridge: Harvard University Press, 1986), p. 3. As many objections as laudatory comments can be found to Barr's chart. Attempting to define the categories of art evokes political and opportunistic judgments that change with the advance of criticism. Barr's contribution was that he set the stage for commentary.

49. Barr, *Cubism and Abstract Art,* p. 19.

50. Ibid. Both the art historian Robert Rosenblum and William Rubin, Barr's successor as curator of the department of Painting and Sculpture, called Barr's rhetoric "lapidary." Rubin claimed that Barr's vocabulary, precisely chosen, was the strength of his contribution to critical history. "Barr's language was so extraordinarily economical and pithy that it transcended even Meyer [Schapiro]'s language. There are phrases of Alfred that are as lapidary as anything that has been said about modern art." Rubin, interview with author, March 1994. Barr's agony over choosing the right word was legendary.

51. Alfred H. Barr, Jr., "Dutch Letter," *Arts* 13 (January 1928), p. 48.

52. W. J. T. Mitchell, "*Ut Pictura Theoria:* Abstract Painting and the Repression of Language," *Critical Inquiry* 15 (Winter 1989), p. 367. Mitchell was quarreling with Rosalind Krauss's notion of "grids" in *The Originality of the Avant-Garde and Other Modernist Myths* (Cambridge: MIT Press, 1985), p. 349. Confronting her notion of the grid as a mute object, he wrote: "The most fundamental message of Barr's diagram is its graphic refutation of the idea that the modernist 'grid' is a barrier between vision and language" (p. 366).

53. Barr, *Cubism and Abstract Art,* p. 9.

54. Mitchell, "*Ut Pictura Theoria,*" pp. 365, 366.

55. Alfred H. Barr, Jr., *Matisse: His Art and His Public* (New York: Museum of Modern Art, 1951), p. 139. Barr, by then, felt that the usefulness of primitive art to the modernist artists had been exaggerated by the critics (p. 100).

56. Barr, *Cubism and Abstract Art,* p. 58.

57. The corrected chart appeared in *Defining Modern Art: Selected Writings of Alfred H. Barr, Jr.,* ed. Irving Sandler and Amy Newman (New York: Random House, 1986), p. 92.

58. Barr, *Cubism and Abstract Art,* pp. 126, 122.

59. Schapiro, who combined scholarship in medieval art with a strong interest in modern art (which he began teaching at Columbia in 1933), served on the board of trustees of the Museum for a period. Schapiro asked Barr to join a discussion group in 1935 consisting of scholars and writers that would include James J. Sweeney, Erwin Panofsky, Robert Goldwater, Jerome Klein, Dimitri Tselos, Louis Lozowick, and Jere Abbott. (MoMA Archives, NY: AHB [AAA: 2165; 981].) Schapiro became a lecturer at Columbia in 1928 in medieval art and a full professor in 1936.

60. Meyer Schapiro, "The Nature of Abstract Art," in *Modern Art: 19th and 20th Centuries* (New York: Braziller, 1978), p. 190; first published in *Marxist Quarterly* (January–March 1937). Schapiro, in a long dissenting article, took Barr to task for being "unhistorical" in his view of abstract art in the catalogue *Cubism and Abstract Art.* Schapiro substituted social causes for changes in style, negating Barr's notion of the cultural "exhaustion" of the style. Still, Barr's and Schapiro's theories may not be mutually exclusive. Arthur C. Danto, "Narrative and Style," *Journal of Aesthetics and Art Criticism* 49 (Summer 1991), p. 208, proposes a theory of the "natural limit to a style, as there is to a personality," beyond which the artist couldn't go—a theory that supports Barr's notion of exhaustion.

61. Schapiro, "The Nature of Abstract Art," p. 196. Mitchell, "*Ut Pictura Theoria,*" reads more into Barr's chart than Schapiro would grant, seeing the sources of modernism that Barr represented by the red boxes and arrows, particularly "Negro Sculpture" and "Machine Esthetic," as "disruptive" elements in the self-referential narrative that is abstract art. "Barr's grid . . . opens onto a history and a social reality that complicates its self-representation as a quest for purity" (p. 367).

62. See Rose-Carol Washton Long, "Expressionism, Abstraction, and the Search for Utopia in Germany," in *The Spiritual in Art: Abstract Painting 1890–1980* (Los Angeles: Los Angeles County Museum of Art, 1986), pp. 201–217.

63. Barr to Dr. Berle, January 17, 1958, MoMA Archives, NY: AHB, 12.II.3.a.

64. See Wayne Dynes, "The Work of Meyer Schapiro: Distinction and Distance," *Journal of the History of Ideas* 42, no. 1 (1980). Dynes bemoans the fact that Schapiro's method of art history has been resisted by the profession while Giovanni Morelli's "system of style analysis undertaken in effective disregard of the cultural matrix" has carried the field (pp. 171, 172). Schapiro conceded that Barr's book was the "best that we had in English" on abstract art; Schapiro, "The Nature of Abstract Art," p. 187.

65. Barr, *Cubism and Abstract Art,* p. 15. In *Picasso: Forty Years of His Art,* Barr repeated his claim for the significance of "the sensuous tactile reality of the surface itself" but gave ground again to Schapiro: "[In cubism] the ever-recurring guitars, violins, bottles, playing cards, pipe, cigarettes and the fragmentary words referring to newspapers, music, and beverages constitute a fairly consistent 'subject matter or iconography' which may have more than incidental significance as references to 'artificial objects of private manipulation'" (p. 82). In *Picasso: Fifty Years of His Art,* again referring to Schapiro's article, Barr rescinded the compromise: "These subjects, both people and things, consistently fall within the range of the artistic and bohemian life and form an iconography of the studio and café. Whether they represent simply the artist's environment or whether they symbolize in a more positive

though doubtless unconscious way his isolation from ordinary society is a debatable question" (p. 84).

66. In Rubin's view, Schapiro, Barr, and Greenberg were the "pillars of modern criticism." And he placed the hierarchy in that order, with "Meyer the greatest of the three." He recognized that Schapiro brought great learning to his scholarship, more than Barr and certainly more than Greenberg. "But, on the other hand, Meyer couldn't have done Alfred's job." Rubin, interview by author, 1993.

67. Barr, *Cubism and Abstract Art*, p. 18. Barr was referring to the repressive climate in both the USSR and Germany, where he had personally witnessed the effects of this repression on artists. He aggressively fought any antimodernism evidenced in America.

68. Ibid., p. 42.

69. Ibid., p. 141. (Barr illustrates the point with a similar painting of 1916.)

70. Ibid., p. 157.

71. Ibid., p. 150.

72. Ibid., pp. 158, 156.

73. Mitchell, *"Ut Pictura Theoria,"* p. 366.

74. Introduction to *Defining Modern Art: Selected Writings of Alfred H. Barr, Jr.,* ed. Irving Sandler (New York: Harry N. Abrams, 198), pp. 13, 11.

75. Ibid., p. 12, quoting from Barr, "In Defense of Kokoschka" (letter to the editor), *Art Digest* (October 1, 1949), p. 4.

76. Barr, *Cubism and Abstract Art*, p. 12.

77. Sandler, introduction to Barr, *Defining Modern Art,* p. 12.

78. Ibid., p. 26.

79. Barr, *Cubism and Abstract Art,* p. 179.

80. Barr to Miss Brackett, December 30, 1930, MoMA Archives, NY: AHB [AAA: 2164; 532]. Picasso's *Seated Woman* was then owned by Mary Hoyt Wiborg, sister of Sara Murphy, the wife of the painter Gerald Murphy. Having been acquired by James Soby, the painting eventually became part of the Museum's collection. Picasso's role in surrealism was problematic. William Rubin in *Dada, Surrealism and Their Heritage* (New York: Museum of Modern Art, 1968), wrote that Picasso's art was "more a question of plasticity than of poetry" (p. 124). Picasso was never a formal member of the surrealists although he did participate in their activities and exhibitions.

81. Barr, ed., *Fantastic Art, Dada, Surrealism,* pp. 9, 8. Later, Greenberg would refuse to consider surrealism seriously. To him, "all roads" led to abstraction. Greenberg dismissed surrealism out of hand as being regressive, unsuited to the chronology of abstract art. Barr, on the other hand, divided modernism into categories that outdistanced the usual bounds of abstract art. In the Mary Flexner Lectures at Bryn Mawr College in 1946, his six presentations covered the ground more thoroughly than Greenberg's narrowly focused point of view.

Entitled "Dogma and Practice in Modern Art," they were: "Art Should be Modern—the Rise and Decline of the Machine" (February 11); "Art Should Be Pure—with a Glance at Utilitarian Consequences" (February 18); "Art Should Be Marvelous—Visual Poetry of Enigma and Fantasy" (February 25); "Art Should Be Intense—Anxiety, Violence, Ecstasy" (March 4); "Art Should Be National—Varieties of Racial and Regional Self-Esteem" (March 11); "Art Should Be Social—the State of the World, Propaganda, and Prophecy" (March 18). An account of the lectures appeared in the *Bryn Mawr Alumnae Bulletin;* a copy is in MoMA Archives, NY: AHB [AAA: 3265; 706].

82. Barr to A. Conger Goodyear, January 13, 1937, MoMA Archives, NY: A. Conger Goodyear Scrapbook.

83. Barr, ed., *Fantastic Art, Dada, Surrealism,* pp. 9–10. Barr borrowed Heinrich Fuseli's *Nightmare* from Professor Paul Ganz of Basel; he had seen it on his trip in 1927. Margaret Barr, "'Our Campaigns': Alfred H. Barr, Jr., and the Museum of Modern Art: A Biographical Chronicle of the Years 1930–1944," *New Criterion,* special issue (Summer 1987), p. 48.

84. Ibid., p. 9.

85. Ibid., pp. 11, 12.

86. Quoted in Rona Roob, "Alfred H. Barr, Jr.: A Chronicle of the Years 1902–1929," *New Criterion,* special issue (Summer 1987), pp. 7–8.

87. Barr, ed., *Fantastic Art, Dada, Surrealism,* pp. 13, 14.

88. He later changed his mind about Redon.

89. Barr, *Cubism and Abstract Art,* pp. 180, 182.

90. Ibid., p. 186.

91. Ibid., p. 200.

92. *Trois siècles d'art aux États-Unis: exposition organisée en collaboration avec le Museum of Modern Art, New York: Musée du Jeu de Paume, Paris, 1938 mai-juillet* (Paris: Éditions des Musées Nationaux, 1938), with a comparative chronology by Alfred H. Barr, Jr.

93. Margaret Barr, "'Our Campaigns,'" p. 55. Barr had been eager to mount a Picasso exhibition at the Museum of Modern Art in 1932 but was frustrated by Stephen Clark, a trustee, who thought such an exhibition would make it difficult to raise money for the Museum. Goodyear to Barr, November 9, 1932, MoMA Archives, NY: AHB [AAA: 2164; 691].

94. Barr, *Picasso: Forty Years of His Art.* In 1947, with added research, Barr revised the catalogue and considered it an important book. Margaret Barr characterized *Picasso: Forty Years of His Art* and *Picasso: Fifty Years of His Art* as works of "intense scholarship," recalling many investigations with subsequent "re-dating and new classifying" that had occurred. "In my husband's opinion, *Picasso: Fifty Years of His Art* was quite equivalent to the *Matisse: His Art and His Public.* But it was published when, as a result of World War II, there was a shortage of type. It was in italics because that only was available. It could not be reissued . . . because my husband had meticulously tailored it word for word so that the illustrations appeared just when the work of art was discussed." Margaret Barr letter to John

Walsh, Jr. February 12, 1980. MoMA Archives, NY: AHB [AAA: 2191; 546]. *Picasso: Fifty Years of His Art* was dedicated "for my wife Margaret Scolari-Fitzmaurice, advisor and invaluable assistant in the Picasso campaigns of 1931, 1932, 1936, 1939." Considering Barr's interest in military battles, use of the word "campaigns" could be construed as his characteristic combative stance in attaining his ends.

95. Barr, *Picasso: Forty Years of His Art,* p. 60.

96. Ibid., p. 62.

97. Golding placed the "first truly Cubist paintings" with Braque's paintings at L'Estaque in 1908 (Golding, *Cubism: A History and Analysis 1907–1914,* p. 66). William Rubin, "Cézannism and the Beginning of Cubism," in Rubin, ed., *Cézanne: The Late Work* (New York: Museum of Modern Art, 1977), agreed with Golding and went even further in disassociating the *Demoiselles* from the inception of cubism.

98. Barr, *Picasso: Fifty Years of His Art,* p. 57.

99. Kahnweiler, *The Way of Cubism,* p. 21.

100. Barr borrowed the quote from Kahnweiler and used it in *Picasso: Fifty Years of His Art,* p. 66.

101. In an unpublished paper, "The Noses of Picasso," I explore this quality in a drawing by Picasso (*Seated Woman,* 1932, oil on wood, illustrated in *Picasso: Fifty Years of His Art,* p. 176) where the lines delineating the fingers of a woman's portrait coincide with the outline of her profile—a "felt" condition of depth, described in Maurice Merleau-Ponty, *Phenomenology of Perception,* trans. Colin Smith (New York: Humanities Press, 1962), and an undifferentiated condition of the human situation that binds interior with exterior. Picasso's interest in the underside of the nose was illustrated many times in his oeuvre, but especially in the portrait of his mother that represents her with her head bowed as if she was cradling an infant. The first memory associated with the underside of the nose belongs to the nursing child; thus it incorporates the lingering urge for reconciliation with the mother. The portrait of his mother (*The Artist's Mother,* 1896, pastel on paper, Museu Picasso, Barcelona, illustrated in William Rubin, ed., *Picasso and Portraiture: Representation and Transformation* [New York: Museum of Modern Art, 1996], p. 233) confides this to us with shameless tenderness. The unseen child is present with a pervasive quality engendered by the mother's pose, and the artist recaptures what one writer calls "a kind of archaic self-regard and omnipotence." Harry B. Lee, "Spirituality and Beauty in Artistic Experience," *Psychoanalytic Quarterly* 17 (1948), p. 516.

102. Picasso's statement to Christian Zervos, quoted in Barr, *Picasso: Forty Years of His Art,* pp. 16, 19; originally published as "Conversation avec Picasso," *Cahiers d'Art* 10 (1935), pp. 173–178.

103. Barr, *Picasso: Fifty Years of His Art,* p. 74.

104. Alfred H. Barr, Jr., "Matisse, Picasso, and the Crisis of 1907," *Magazine of Art* (May 1951), p. 163.

105. Barr to Peter Blake, February 15, 1961, courtesy of Peter Blake.

106. Barr, *Picasso: Forty Years of His Art*, p. 125.

107. Alfred H. Barr, Jr., *Matisse: His Art and His Public* (New York: Museum of Modern Art, 1951), pp. 11, 12.

108. John Elderfield, "Matisse: Myth vs. Man," *Art in America* (April 1987), p. 13.

109. Barr, *Matisse: His Art and His Public*, p. 9.

110. Ibid., p. 10.

111. Jack Flam, *Matisse: The Man and His Art, 1869–1918* (Ithaca: Cornell University Press, 1986).

112. John Elderfield, *Henri Matisse: A Retrospective* (New York: Museum of Modern Art, 1992), p. 71, note 56. On p. 70, note 14, Elderfield suggests that the "formalist" understanding of Matisse's work as found in Clement Greenberg, *Henri Matisse (1869–)* (New York: Harry Abrams, 1953), had been institutionalized by the publication of Barr's book *Matisse: His Art and His Public*.

113. Alfred H. Barr, Jr., "Matisse, Picasso, and the Crisis of 1907," *Magazine of Art* 44 (May 1951), p. 170. Dwight Macdonald affirmed this trait in Barr: "I think you're actually capable of recognizing objectively reality even when it runs counter to your own wishes—a very rare trait." Macdonald to Barr, December 1, 1953, Macdonald Papers, YUL.

114. Jack Flam, *Matisse: The Man and His Art, 1869–1918*, p. 12.

115. Ibid., p. 388.

116. Barr, *Matisse: His Art and His Public*, p. 5.

117. Ibid., p. 184.

118. Ibid.

119. Ibid., p. 238.

120. Barr, "Matisse, Picasso, and the Crisis of 1907," p. 163.

121. Barr to Abby Rockefeller, January 15, 1947, MoMA Archives, NY: AHB [AAA: 3264; 1339].

122. Clement Greenberg, quoted in Barr, *Matisse: His Art and His Public*, pp. 265, 266.

123. Barr to Gauss, September 21, 1922, Gauss Papers, AAA.

124. Stuart Hampshire, "Commitment and Imagination," in Max Black, ed., *The Morality of Scholarship* (Ithaca: Cornell University Press, 1967), pp. 46, 51.

125. See Henry-Russell Hitchcock, "The Decline of Architecture," *Hound & Horn* 1 (September 1927), p. 29.

126. Alfred H. Barr, Jr., "Understanding Modern Art," *Wellesley Alumnae Magazine* 13 (June 1929), p. 304. Barr and Philip Johnson believed that art itself rather than any ideology based on functionalism would save the world. Interview with Johnson, 1992.

127. Barr to Stephen C. Clark, April 22, 1943, RAC.

EPILOGUE

1. Quoted in Alice Goldfarb Marquis, *Alfred H. Barr, Jr.: Missionary for the Modern* (Chicago: Contemporary Books, 1989), p. 346.

2. Abby Rockefeller to Barr, April 24, 1933, MoMA Archives, NY: AHB [AAA: 3264; 1178].

3. This was mentioned by both Philip Johnson and William Rubin in interviews with the author.

4. Emily Genauer, "The Fur-Lined Museum," *Harper's Magazine* 189 (July 1, 1944), p. 136.

5. Barr to William H. Trombley, April 5, 1954, MoMA Archives, NY: AHB [AAA: 2183; 437].

6. Genauer, "The Fur-Lined Museum," pp. 129–138.

7. Goodyear to Abby Rockefeller, December 15, 1936, MoMA Archives, NY: AHB [AAA: 3264; 1120].

8. Abby Rockefeller to Goodyear, December 16, 1936, MoMA Archives, NY: AHB [AAA: 3264; 1122].

9. Goodyear to Abby Rockefeller, December 17, 1936, MoMA Archives, NY: AHB [AAA: 3264; 1021].

10. Macdonald Papers, YUL.

11. Barr to King, October 10, 1934, MoMA Archives, NY: AHB [AAA: 2164; 411].

12. Mary Anne Staniszewski, *The Power of the Display: A History of Exhibition Installations at the Museum of Modern Art* (Cambridge: MIT Press, 1998), p. 70.

13. Barr to Macdonald, December 3, 1953, Macdonald Papers, YUL.

14. Dorothy Miller, interview by Paul Cummings, 1970, AAA.

15. Ibid.

16. Helaine Messer, "MoMA: Museum in Search of an Image," Ph.D. diss., Columbia University, 1979, p. 164.

17. Monroe Wheeler, interview by author, October 20, 1981.

18. Ibid.

19. Barr to Clark, April 22, 1943, Rockefeller Papers, RAC.

20. Alfred H. Barr, Jr., *What Is Modern Painting?* (New York: Museum of Modern Art, 1943). This was a revision of a 24-page pamphlet issued in 1934 that explained a circulating exhibition. It became a bestseller and was known in the Museum as Wimpy.

21. Barr to Clark, April 22, 1943, Rockefeller Papers, RAC.

22. Ibid.

23. Clark to Barr, October 13, 1943, MoMA Archives, NY: AHB [AAA: 2190; 1047].

24. Clark to Rockefeller, October 28, 1943, Rockefeller Papers, RAC.

25. Margaret Barr, interview by Paul Cummings, 1974, AAA.

26. Barr to Abby Rockefeller, November 19, 1943, Rockefeller Papers, RAC.

27. Ibid.

28. Ibid.

29. Paul J. Sachs, "Tales of an Epoch," Sachs Papers, pt. 2, v. 15, p. 2362, CORP.

30. Russell Lynes, *Good Old Modern: An Intimate Portrait of the Museum of Modern Art* (New York: Atheneum, 1973), p. 247.

31. Clark to Abby Rockefeller, October 28, 1943, Rockefeller Papers, RAC.

32. Dorothy Miller, interview by Paul Cummings, 1970, AAA.

33. James Thrall Soby, "The Changing Stream," in *The Museum of Modern Art at Mid-Century: Continuity and Change* (New York: Museum of Modern Art, 1995), p. 207.

34. Clark to Alfred Barr, November 16, 1943, MoMA Archives, NY: AHB [AAA: 2171; 570].

35. From 1947 to 1967, Barr mostly confined his activities to writing and building the collection. The few exhibitions he mounted were of the most important artists, which encouraged prospective donors to add to the collection. These included "Twentieth Century Italian Art," 1949, which he did with Soby; "Henri Matisse," 1951; "De Stijl," 1952; "Painting from Private Collections," 1955; "Picasso, 75th Anniversary Exhibition," 1957; "The Adele R. Levy Collection: A Memorial Exhibition," 1961; and "Recent Painting USA: The Figure," with William S. Lieberman, Dorothy C. Miller, and Frank O'Hara, 1962.

36. Margaret Scolari Barr, "'Our Campaigns': Alfred H. Barr, Jr., and the Museum of Modern Art: A Biographical Chronicle of the Years 1930–1944," *New Criterion*, special issue (Summer 1987), p. 69.

37. Barr, interview by Macdonald, Macdonald Papers, YUL.

38. Macdonald to Barr, December 1, 1953, Macdonald Papers, YUL.

39. Barr to Macdonald, Macdonald Papers, YUL.

40. Philip Johnson, in *Memorial Service for Alfred Barr* (New York: Museum of Modern Art, 1981), unpaginated.

41. Quoted in Alfred H. Barr, Jr., ed., *Painting and Sculpture in the Museum of Modern Art, 1929–1967* (New York: Museum of Modern Art, 1977), p. 620.

42. Ibid., p. 622. See Kirk Varnedoe, "The Evolving Torpedo," in *The Museum of Modern Art at Mid-Century*, p. 20.

43. Barr to Paul Sachs, October 5, 1929, Sachs Papers, pt. 2, v. 15, CORP.

44. Barr, quoted in Varnedoe, "The Evolving Torpedo," p. 47.

45. See Alfred H. Barr, Jr., "Chronicle of the Collection of Painting and Sculpture," in Barr, ed., *Painting and Sculpture in the Museum of Modern Art, 1929–1967,* in which Barr provides a detailed analysis of the acquisition of the collection and the changing aims of the Museum.

46. Barr, in Katharine Kuh, *The Open Eye* (New York: Harper & Row, 1972), p. 45.

47. Barr, ed., *Painting and Sculpture in the Museum of Modern Art, 1929–1967,* p. 651.

48. Of the 375 paintings and drawings in her collection, 181 were given to the Museum of Modern Art in 1935 and the rest to Dartmouth College, Fiske University, and the Newark Museum. Barr reported that Mrs. Rockefeller gave two more collections to the Museum in 1939: "thirty-six pieces of modern American and European sculpture including a number of pieces by Maillol, Despiau, Lehmbruck, Lachaise and Kolbe; and a remarkable group of American folk painting and sculpture, including one 20th century work, Pickett's masterpiece." Alfred H. Barr, Jr., ed., *Painting and Sculpture in the Museum of Modern Art* (New York: Museum of Modern Art, 1948), p. 8. Mrs. Rockefeller also gave purchase funds beginning in 1938, in addition to various other funds.

49. Barr to Abby Rockefeller, January 15, 1947, MoMA Archives, NY: AHB [AAA: 3264; 1339].

50. Barr notes to Mary Ellen Chase, February 6, 1950, MoMA Archives, NY: AHB [AAA: 2175; 1180].

51. Ibid. [1176].

52. Barr to Herzog Enrath, July 26, 1967 MoMA Archives, NY: AHB [AAA: 2194; 742]. Johnson also provided a fund from which Barr purchased paintings.

53. Barr, interview by Dwight Macdonald, Macdonald Papers, YUL.

54. Barr to Sachs, October 4, 1954, MoMA Archives, NY: AHB [AAA: 2172; 1240].

55. Dorothy Miller, interview by Paul Cummings, 1970, AAA.

56. Barr was continually criticized for not acquiring the work of the New York School early on, but the purchase of a Pollock in 1944 and a Motherwell, *Pancho Villa, Dead and Alive,* painted in 1943 and purchased in 1944, belies that accusation. In Barr's words: "Twelve paintings by New York abstract expressionists were acquired between 1947 and 1952; the artists were Baziotes, Gorky, Kline, De Kooning, Motherwell, Pollock (Number 1, 1948, his most important work until then, was purchased in 1950 and two others in 1952), Pousette-Dart, Rothko, Stamos, and Tomlin. Earlier, between 1941 and 1946, paintings by Gorky (two), Gottlieb, Motherwell, and Pollock had been acquired." (Barr, ed., *Painting and Sculpture in the Museum of Modern Art, 1929–1967,* p. 636.) Barr attended "club" meetings of the New York School in Greenwich Village and was respected by the artists. Despite the objections of the trustees, Barr bought the Pollock from an exhibition of Peggy Guggenheim, the first time a museum acquired a Pollock painting.

57. Alfred H. Barr, Jr., "The Museum of Modern Art's Record on American Artists," in *Defining Modern Art: Selected Writings of Alfred H. Barr, Jr.,* ed. Irving Sandler and Amy Newman (New York: Random House, 1986), p. 229. Despite the ongoing argument between

advocates of "modern" or "contemporary," Barr acquired twenty works by Picasso and Matisse in the 1940s and 1950s.

58. Barr, ed., *Painting and Sculpture in the Museum of Modern Art, 1929–1967*, p. 2.

59. Barr to George Rowley, May 20, 1949, MoMA Archives, NY: AHB [AAA: 2191; 911].

60. Ibid.

61. Barr to Dwight Macdonald, Macdonald Papers, YUL.

62. See *Art News* 78 (October 1979), special issue, *The Museum of Modern Art*.

63. Ibid., pp. 186–203.

64. Ibid., p. 188.

65. Ibid.

66. Alfred H. Barr, Jr., "The Museum Collections: A Brief Report," typescript, January 15, 1944; Barr, "Chronicle of the Collection," pp. 629, 630.

67. Margaret Barr, interview by Paul Cummings, 1974, AAA. In the middle 1970s Barr's memory began to fail, possibly because of Alzheimer's disease. He died in 1981.

ILLUSTRATION CREDITS

INDEX